ROMAN IMPERIAL ART IN GREECE AND ASIA MINOR

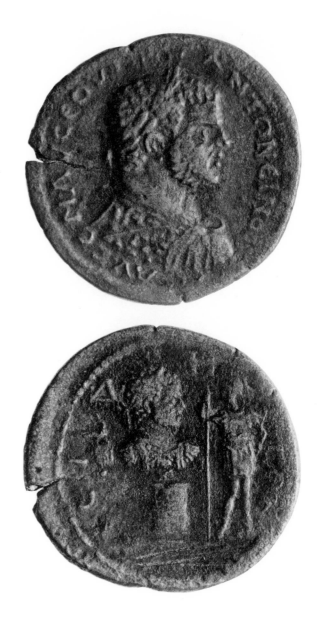

Large bronze of Caracalla

ROMAN IMPERIAL ART IN GREECE AND ASIA MINOR

CORNELIUS C. VERMEULE

THE BELKNAP PRESS OF
HARVARD UNIVERSITY PRESS
CAMBRIDGE · MASSACHUSETTS
MCMLXVIII

ARTHUR DARBY NOCK

In Memory

In tenui labor; at tenuis non gloria,
si quem
numina laeva sinunt auditque vocatus
Apollo.

Vergil, *Georgics*, iv.6–7

PREFACE

THIS BOOK has been written because there is a need for more books on Roman art. What has been published in the past deals mainly with material in Italy and the Latin West. There is a particular demand for a book on Roman art in the nations and provinces east of the Adriatic Sea.

The broad nature of Roman art is well known. Artistic developments from the Early Republic to Late Antiquity have been studied on a general basis and on the basis of trends in the provinces, influences on the main current of Greco-Roman classicism, and the emergence of new vocabularies in the late third century A.D. Still, the emphasis has always been on Rome and Italy as the hub of Roman Republican and imperial art. It is, I think, an accepted premise that the art of the Greek world in Roman times differs from the art of the Hellenistic kingdoms. It is also known, if only from its name, that Greek imperial art is related in many direct ways to Roman imperial art. In terms of both, such manifestations as schools of sculptors from Aphrodisias, Hadrianic eclectic classicism, Asiatic portraiture, and Alexandrine topographical nature in painting and mosaic can be spoken of and studied. Yet, in trying to come to grips with Roman official art in Greece and Asia Minor, a vitally creative force neither purely Hellenistic nor Roman, an art of great quality and influential originality, is encountered. In many ways, this art as a cohesive whole haunts us by its elusiveness, its qualities of Greek timelessness and Roman factuality. I believe a new picture of Roman art in the Hellenic world can be formed by tracing its development from the impact of Rome on the Hellenistic states in the second century B.C. to the flowering of Eastern Rome in the sixth century A.D., the age of Justinian.

The term Roman official art should be stressed. This book attempts to collect and survey the works of art and architecture in the East that have to do with the Roman state. These monuments may have been paid for out of the imperial revenues or they may be wholly the creations of

provincial cities and private individuals, Roman citizens or otherwise. The common denominator is one of subject: the buildings, statues, or reliefs must be commemorations of Roman rulers, chiefly emperors, or manifestations of Roman official civic and military history. The only group of private sculptures discussed are large sarcophagi with elaborate scenes in relief, because such creations were executed by major sculptors in an official imperial style often for magistrates of the Empire. The state sculptures of the imperial age in the East cannot be understood without examining these sarcophagi, particularly their relation to the official art of the fourth century A.D.

Many aspects of art in Greece and Asia Minor during the Roman period must await consideration in another book. Court silverware and Greek imperial coins each receive a chapter, because they involve imperial portraits and imperial scenes, whether allegorical or real. Statues of divinities, private portraits, sepulchral reliefs, small bronzes, terracotta statuettes, and textiles of the imperial age, to cite at random, are omitted. These works of art may be characteristic of the imperial period in the East, but they are in a sense better described as continuations of Hellenistic art in Greece and Asia Minor. The art that forms the basis of this book is made up of a series of creative impulses that owed their existence to the Roman Empire and to the institution of Roman Emperor as head of state, chief priest, first among equals, commander-in-chief of the armies, and, in the East particularly, god on earth.

No one who investigates the art of the Romans can escape a great debt to Eugénie Strong, who wrote four books and many long essays on Roman art at a time when everything Greek was considered worth investigating and anything worthwhile in Roman painting and sculpture was measured as an end product of the Greek experience. I hope to show that lovers of Greek civilization may take pride in the fact that the so-called "Roman" period in Greece and Asia Minor was really as great an epoch of Greek art as the several centuries immediately preceding. Jocelyn M. C. Toynbee's monumental work on the age of Hadrianic art, published in 1934, and her essays on Roman medallions, published during the following decade, have made this conclusion a restatement rather than a discovery. Her volume on art in the British Isles during the Roman period is a standard for measuring aims and organization of the present book. Other main debts of a general nature are to the excavators of the great Greek cities of Asia Minor and to the generations of epigraphers of all nationalities who have so thoroughly recorded the testimonia.

The first word of thanks belongs to the officers and staff of the American School of Classical Studies in Athens, who afforded the facilities to complete this work. The Trustees and the Director of the Museum of Fine Arts in Boston were generous enough to allow time from other

duties to study in Greece, Cyprus, and Anatolia. Grants from the American Council of Learned Societies and the Penrose Fund of the American Philosophical Society made essential travel possible. The German Archaeological Institute furnished many photographs from their admirable collection in Athens. Other institutions, noted in the list of illustrations, have been equally generous.

My four colleagues past and present in the Department of Classical Art in Boston, Mary Comstock, Alice Graves (Mrs. T. S. Plowden-Wardlaw), Julia Green, and Penelope von Kersburg, prepared the manuscript for publication. Miss Comstock is responsible for final arrangement of much that appears in the appendixes and of both indexes.

Boston, 1967

CONTENTS

CONTENTS

CONTENTS

ILLUSTRATIONS

ROMAN
IMPERIAL ART
IN GREECE
AND
ASIA MINOR

Greek Art
in an Imperial Polity

THE ROMANS CONQUERED Greece and Asia Minor only in a military sense. Even the duration of total political dominance was brief. From the point of view of art, Roman and Hellenistic cultural forces met as equals in the latter's ground to produce a civilization unlike what went before and markedly unlike what the Romans fashioned in the Latin West. The Greeks may have made the Romans use Hellenistic forms of art in their official endeavors, but the size and scope of these endeavors were enough to insure a change in the art of Greece and Asia Minor under the Romans.

The material presented in the following chapters is concentrated on the period from Augustus to Constantine the Great, a span of three and a half centuries. To be sure, Roman power had run in Asia Minor for over a century before Octavian became Emperor and in Greece for a slightly longer period, but in the last century of the Republic the independent cities of Asia Minor rather than the Hellenistic princes or the Roman satraps shaped the course of Greek art. Roman victories and Roman money bought commemorative monuments in Greece, and Asia honored the leaders of the Republic who came to its territories, but free enterprise ruled the type and location of these inscribed and sculptured dedications. Thus, Delphi, as home of the free Greek cities, contained the first Roman triumphal monument in the Greek world, that of Aemilius Paullus, and less than a century later Pergamon honored Mithradates as liberator of Asia with a large relief. The mythological presentation of Herakles freeing Prometheus scarcely hid the implied insult to Roman encroachments in the Hellenistic world.

As the Republic catapulted toward autocracy, Athens could afford to be on the wrong side in every war, yet set up the most traditional, dignified monuments to those who robbed her last liberties. A climactic moment was that day when the heads of Augustus' son and grandson by adoption or marriage, Nero Drusus and Germanicus, were substituted for those of the horsemen (Dioskouroi) by Myron and his son at the entrance to the Athenian Acropolis. The Athenians even went on to honor the

emperor Nero by inscribing his names and titles in letters of bronze on the eastern architrave of the Parthenon. This dedication may not have survived the great performer's career.

The interaction of Hellenistic and late Republican patronage on the arts was not completely suppressed by the imperatorial autocracy. In southeast Asia Minor and northwest Mesopotamia the Commagene dynasts built one of the grandest oriental-Hellenistic complexes at Nimrud Dagh, only a few decades before they could hold their territories merely on sufferance from the Romans. Over a century and a half later, the grandson of the last Seleucid ruler of Commagene lent his name to the largest Roman funerary monument in Athens, Philopappos on Mouseion Hill. Herodes Atticus is often cited as a man compelled to lavish patronage by his desire to rival the imperial family. This is partly true. In another sense, however, Herodes was the munificent continuer of Hellenistic traditions of private enterprise reaching back to the Attalid gifts to Athens and the completion of the temple of Apollo at Didyma.

Peisistratos began the Athenian temple of the Olympian Zeus as an autocratic enterprise, but the temple's Hellenistic constructions were carried out by a Roman architect using funds supplied by a Seleucid king. This was, in a sense, free enterprise, and, when Hadrian finished the giant shrine, he was completing the work of an overseas Macedonian whose connections with Athens were intellectual rather than political. The final word on the Olympeion was had by the citizens themselves and by the cities of Greece and Asia Minor. They turned the precinct into an apotheosis of the emperor Hadrian during his lifetime.

The fact that private citizens kept the initiative of commemoration both for their own kind and for Hellenistic rulers and Roman emperors provided continuity from Hellenistic Greece and Asia Minor to the Greek imperial period. Although the imperial family might become the focus of commemoration and pay for much building, the construction always bore the name of private citizens working through the city administration. The notion of the Greek city as a political unit was as strong in the art of the Antonine period as it was in Attica of the Periclean age. When Roman officials or wealthy Greeks did not initiate the commemorations, they were carried out under the initiative of the Boule and Demos of the city. To select at random, at Iconium in Lycaonia a long inscription built into the castle wall states that "the inhabitants of the Claudian city of Iconium have honored Lucius Pupius (whose family and titles follow), proconsul of Claudius and Nero in the province of Galatia; their benefactor and the restorer of their city." There are countless such inscriptions throughout the Greek imperial world.

TYPES OF MONUMENTS

Temples, functional architectural complexes, and statues in honor of

2

the imperial family and their representatives comprise the bulk of the Roman monuments in Greece and Asia Minor. Before A.D. 300 the great Antonine altar at Ephesus was practically the only monument in the Greek world that paralleled the state reliefs of imperial Rome. The temples begin in a systematic way with those dedicated jointly to Roma and Augustus in Athens and Asia Minor, although the cult of Roma had enjoyed a longer history in Athens and Asia Minor. The round temple to Roma and Augustus on the Acropolis can not be termed an intrusion, for its delicate carving recalls the Erechtheum and its inscription on the architrave is about all (save for statues now lost) that must have brought attention to the Roman imperium. There is no better example of sober functional architecture than the gateway to the Roman agora in Athens. Its Doric architecture harmonized with the surroundings, and the dedication to the grandson of Augustus was every bit as Greek as various Athenian dedications to their own famous citizens. Athenian statues of the imperial family show a literal continuity with those set up to the Attalid kings of Pergamon. The lofty monument to Agrippa at the left of the entrance to the Acropolis and the similar monument to Tiberius in front of the Stoa of Attalus were fashioned by replacing statues of Attalus II or Eumenes. The heads could have been changed, like the Dioskouroi of the Acropolis, or the Attalid statues could have been moved elsewhere in the city.

The memorable monuments of Roman art in Asia Minor are the combinations of architecture and epigraphy. By the third century there was hardly a city which did not have a gate, stoa, nymphaeum, or decorative arch incorporating a dedication to one of the imperial dynasties. At Carian Aphrodisias under Tiberius the long portico included sculpture of a decorative and commemorative sort, heads of Augustus and his family mixed with those of divinities, satyrs, personifications, and local heroes. The idea was revived here in the fourth century when a building was completed or rebuilt with tondo medallions of literati such as Menander, of personifications such as the Tyche of the city, of contemporary men of intellect and of members of the Constantinian house. An intervening stage is represented in the agora at Smyrna, as rebuilt late in the reign of Marcus Aurelius. The carving of the entryways included keystone busts of the imperial family.

The usual monument or building, however, lacked architectural enrichment of a specifically imperial nature. The frieze or architrave of a gate or colonnade was filled with giant, well-cut letters honoring the imperial family, the city, and those responsible for the building. The inscription was often repeated in both Greek and in Latin. Statues no doubt were placed in the immediate vicinity. Hadrian's Athenian gate, marking the "City of Theseus" and the "City of Hadrian," provided an unusual variation of such commemoration, for statues of Hadrian, and

3

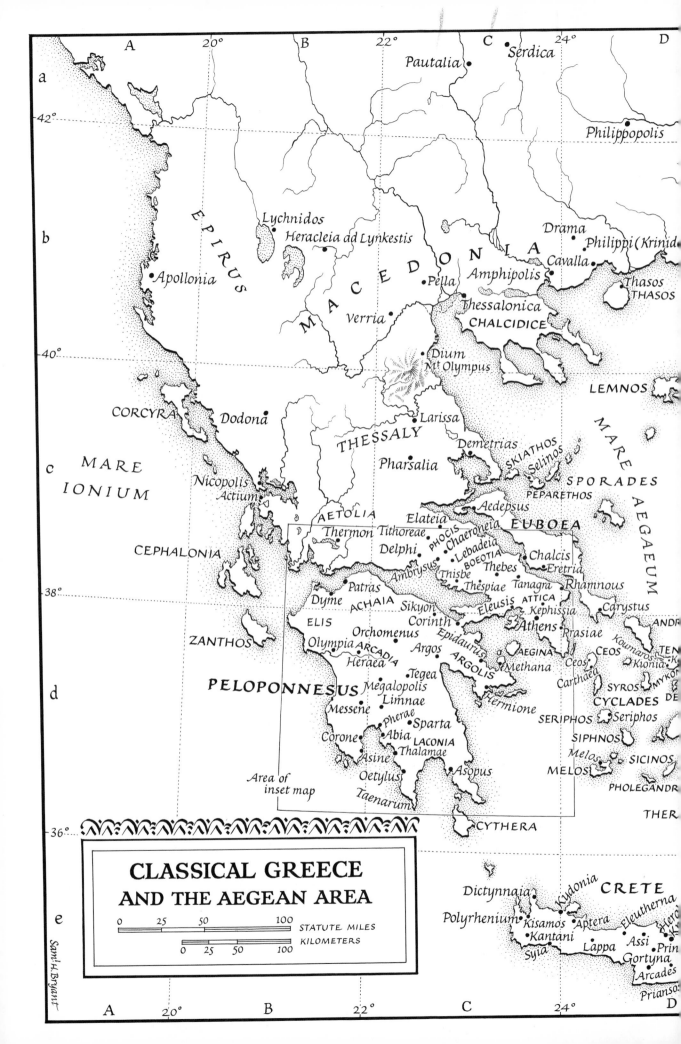

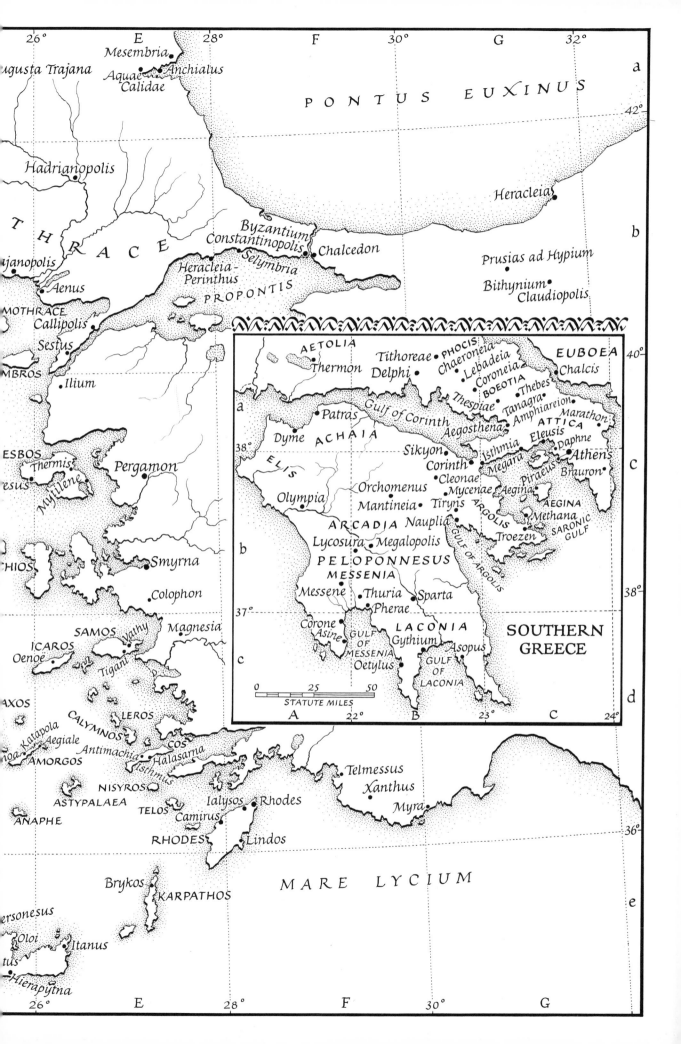

probably Trajan or Sabina, stood on the Athenian (traditional) side at the entrance to the Olympeion. The gate itself is of a type found at several places in western Asia Minor, at Eleusis and at Olympia.

The phenomenon of Hadrian's activity is unequaled in the Greek world. An overt admirer of Greek culture, he stimulated the imperial treasury, city administrations, and private citizens to unparalleled heights of activity. This building and commemoration had the emperor as its focus, both from traditions of the ruler cult and in gratitude for what he had done intellectually and materially. The completed Olympeion became as much a shrine of Hadrian, the "thirteenth Olympian," as a temple of the Olympian Zeus, and the building rightly emerged as "Hadrian's palace" in the late Middle Ages, when memories of Zeus had died and the inscriptions to Hadrian remained. The many statues of Hadrian the Philhellene set up in the temenos followed a Greek imperial tradition of city-dedications. This tradition may be traced back to the statues of grateful cities installed in Rome around an image of Tiberius. In another sense, the honors paid to Hadrian were carried almost too far. His statues, to the number of twelve or one for each tribe, were placed in the Athenian theater of Dionysos. Several were set among the choicest seats, in such a way as to block the view of the stage for many in the seats behind.

IMPERIAL STATUES

Imperial statues in Greece and Asia Minor fall into three categories. The first presents the emperor as a divinity or hero. This type is not used for empresses, despite the fact that Italy has yielded statues of the imperial consorts in various divine guises and degrees of nudity. The most popular model for statues of emperors as divinities seems to have been the Diomedes attributed to Kresilas. The best example of this group is the Hadrian from the library at Pergamon. The most striking heroic statue is the Trajan as Zeus or Poseidon, ruler of land or sea, in the Castro at Tigani on Samos, and the most famous is the Claudius as Zeus at Olympia. Roman aesthetic and religious influence is evident by the end of the second century A.D., when Septimius Severus appears as the cult image of Mars Pater in the impressive bronze found on Cyprus.

The second category is comprised of the statues of emperors and empresses in civic garb. The former are nearly always represented in himation rather than toga, and the latter in costumes modeled after the standard prototypes for draped statues used in the Greek world from early Hellenistic times. A Julio-Claudian, probably the young Tiberius, appears in a toga at Eleusis, where Roman emperors sought to be remembered as initiates in the mysteries. Nerva wears a himation in his memorial statue in the "Nymphaeum of Trajan" at Ephesus. Costume and historical events meet in the statue of Marcus Aurelius from Attaleia,

6

for the emperor is clad in the sagum or long cloak over a tunic, the dress he ordered his officers to wear when not on combat duty along the frontiers, in an attempt to make the legions appear less warlike to the citizens of the empire.

The third type, the cuirassed statue, is the most frequently found after the end of the Julio-Claudian period. The only surviving statue of Nero, from Tralles, presents him in the enriched field armor which was to enjoy great popularity in the Antonine period. Augustus or Agrippa had already been sculpted in armor commemorative of Actium, among the Hellenistic and Roman Republican leaders commemorated at the Amphiareion in Attica. Titus stood among the Julio-Claudians in the metroon at Olympia, wearing a cuirass of a style used throughout the Roman world. At least, it belongs to a group examples of which are not uncommon in Italy and North Africa. Hadrian saw a type of cuirassed statue developed for his likenesses spread from Athens or Corinth throughout the Greek imperial world from Greece to northwest Asia Minor to Crete to Syria and to Cyrene. Before the porphyry Tetrarchs, the last documented imperial cuirassed statue in the Greek world is the Septimius Severus in field armor from Alexandria.

THE THIRD AND FOURTH CENTURIES

The principal monuments of the decades from the death of Severus Alexander to the advent of the Tetrarchy are the milestones set up along the roadways of Asia Minor in use since Persian times. They give in Greek and in Latin the current titles of the emperors, but they cannot be considered a substitute for art, even the art of epigraphy. The gates rebuilt in the name of Claudius II at Nicaea about 270 are one of the major landmarks of Roman imperium during the years immediately after barbarian and Sassanian onslaughts in Anatolia. At Smyrna construction apparently was carried out in the agora about 240, during the reign of Gordian the Third. Under this emperor copies of Greek statues were made to adorn the great nymphaeum façade at Miletus. There are few if any new imperial statues during these dark years. On occasion older ones were reused by substituting new heads. The agora in Athens testifies to the fact that in these years many works of art were dragged from their pedestals and melted down or bundled (with their marble bases) into city walls built before or after the advent of the barbarians.

After 296 the Tetrarchs changed many aspects of the political system of the empire, and Roman art in the Eastern provinces also took on a decidedly different character. Its new aspect, as exemplified by the Arch of Galerius at Salonika, was no less firmly grounded in Hellenism than the Greek imperial art of previous decades. As the coinage demonstrates, Diocletian set out to make Latin the official language, even in the Greek world, and to centralize artistic expression in the work of uniform

7

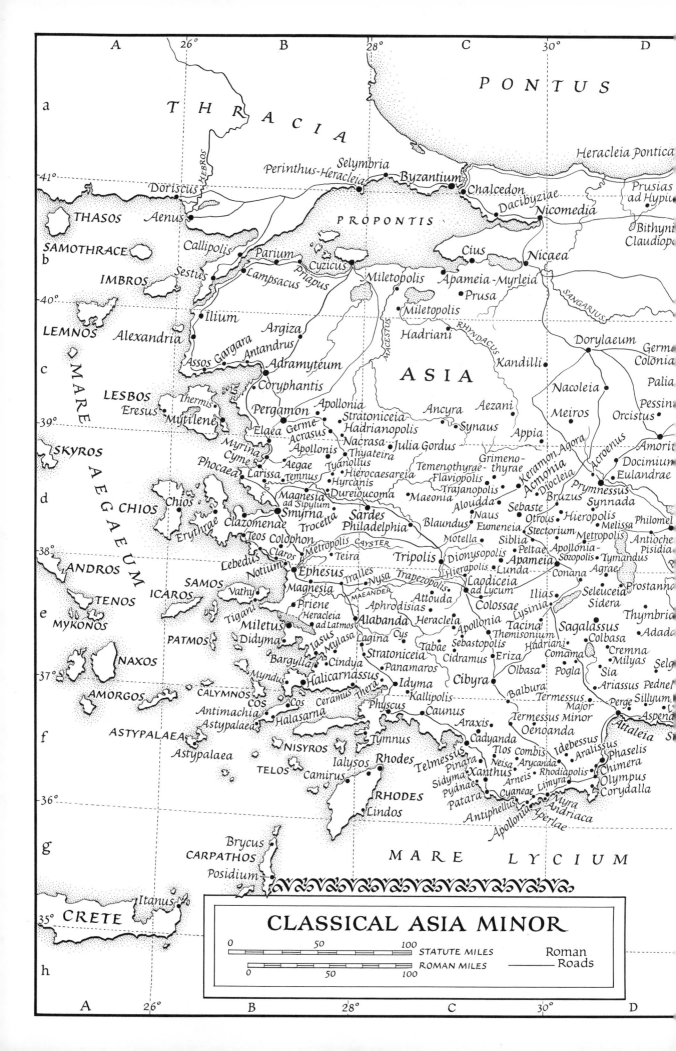

CLASSICAL ASIA MINOR

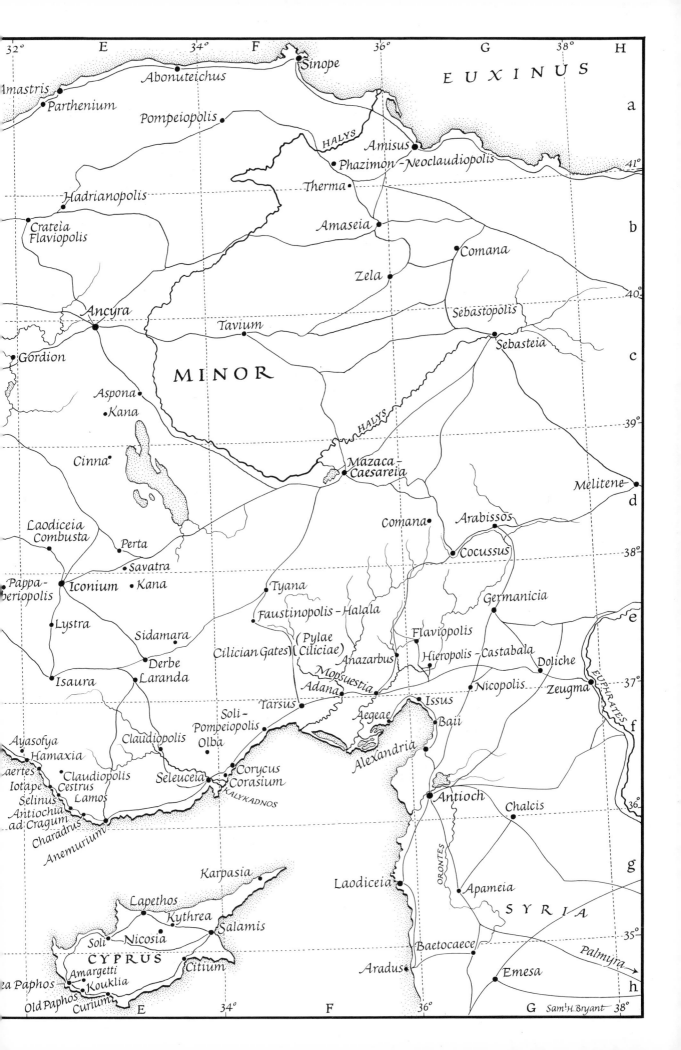

PONTUS EUXINUS

Amastris
Parthenium
Abonuteichus
Pompeiopolis
Sinope

E 32° 34° F 36° G 38° H

EUXINUS

a

Phazimon - Neoclaudiopolis
Amisus
HALYS
Therma

Hadrianopolis
Crateia
Flaviopolis
Amaseia
Comana

b

Zela
Sebastopolis

Ancyra
Tavium
Sebasteia

c

Gordion
MINOR
HALYS

Aspona
Kana

39°

Cinna
Mazaca - Caesareia
Melitene

d

Comana
Arabissos

Laodiceia
Combusta
Perta
Cocussus

38°

Savatra
Germanicia

Pappa- beriopolis
Iconium Kana
Tyana
Flaviopolis

e

Lystra
Faustinopolis - Halala
Hieropolis - Castabala
Doliche

Sidamara
(Pylae
Cilician Gates)(Ciliciae)
Anazarbus
Nicopolis
Zeugma

37°

Derbe
Laranda
Mopsuestia
Adana

Isaura
Tarsus
Issus
Baii

Soli - Pompeiopolis
Aegeae

Claudiopolis
Olba
Alexandria

Ayasofya
Hamaxia
Corycus
Corasium
Seleuceia

f

aertes
Claudiopolis
Cestrus
KALYKADNOS
Antioch
Chalcis

36°

Iotape
Lamos

Selinus
Antiochia
ad Cragum
Charadrus
Anemurium

ORONTES

g

Karpasia
Laodiceia
Apameia

Lapethos
Kythrea
Salamis
SYRIA

Soli
Nicosia

35°

za Paphos
CYPRUS
Citium
Baetocaece
Palmyra →

Amargetti
Aradus

Old Paphos
Kouklia
Curium
Emesa

h

E 34° F 36° G Sam¹ H. Bryant 38°

ateliers located in the major imperial capitals, cities such as Nicomedia and Nicaea, Salonika, Antioch on the Orontes, and Alexandria in Egypt. Egypt's porphyry statues are an individual manifestation within this new art. More official are the reliefs from the triumphal monument at Nicaea. Unfortunately, too little of this survives to do more than indicate that the reliefs came from something such as the tetrapod arch of Galerius at Salonika. The head of Diocletian from Nicomedia indicates that his early portraits could be magnificent work in a revived Hadrianic style.

The fourth century concludes this study. The early part of Constantine the Great's rule was essentially an artistic continuation of the Tetrarchy. Rome was still the center of activity, but after 325, Constantinople received the concentration of imperial attention necessary to make the city the new capital of the Greco-Roman world. Stimulated by this activity, the official Greco-Roman art flourished to its apogee in the columns of Theodosius and Arcadius in Constantinople. The linear expressiveness which transformed this art into the court expression of the Byzantine Empire began to be manifest in many major monuments and in the coin designs. A vigorous popular art in Greece and Anatolia, much of it going over to the service of Christianity as the century draws to a close, hastened the development of the two principal styles which are termed Byzantine. The first of these is the elegant, elongated linear concept of design and execution, associated with the court art of the imperial capital and other major centers. The second style, derived from popular art, was also linked with the Middle Ages in Western Europe. It emphasizes a simple, squat, expressive human figure with large head and eyes and an economy of gesture, and is manifest in fourth-century sarcophagi, Anatolian funerary stelai, and the Constantinian reliefs of Constantine's arch in Rome.

CONTRASTS BETWEEN EAST AND WEST

The effective limits of this book have been set between 30 B.C. and A.D. 350. The purpose has been to isolate and define the characteristics of Roman official art in the Greek world from the Dalmatian coast to Antioch in Syria. Philhellenes, especially modern historians of Greek aesthetics, tend to belittle the period as an alien divergence in the mainstream of Hellenism. Nothing is farther from the truth. Roman art in Greece and Anatolia remained different from Roman art elsewhere for more than three centuries because Greek imagination and inventiveness not only contributed the styles in which Roman art found expression but channeled the forms of Roman expression into courses that were very Greek in the Hellenistic tradition. When a uniform official art, numismatic and otherwise, came to dominate the empire after 296, this art was just as Hellenistic in concept as the Antonine baroque or the architectural decoration of Hadrian's reign. The linear phase into which

Greco-Roman designs and styles enter after 300 has something of its sources in Mesopotamia, but the way in which the Greek sense of sculptured form absorbs this aesthetic outlook finds many antecedents in Anatolian art of the period from 100 to 300.

There is no more pointed contrast between Greek imperial art and the art of the Latin West than in the carving of sarcophagi. To be sure, the contrast is slightly blurred or complicated by the fact that Greek and Asiatic sarcophagi were exported westward in antiquity, or brought to Italy and other countries during the Middle Ages and the Renaissance. Greek ateliers also migrated to Italy to produce sarcophagi in the second to fifth centuries. The emperor Hadrian encouraged such organization of the arts, for Aurelius Victor's brief *Epitome* 14 speaks of how he divided smiths, carpenters, masons, architects, and all kinds of workmen into "cohorts like legions." Despite the migration of guilds, an immediate and constant difference between Greek and Latin sarcophagi can be noted. The former continually stress the architectural and the decorative, the latter the presentation of Greek myths and scenes from Roman daily life in the narrative fashion of imperial state paintings and reliefs. The final phase in the East is characteristic. It deals with the great imperial porphyry sarcophagi in Constantinople which take the traditional form of pedimented temples in miniature and are enriched with symbols of Christianity and imperium, as well as the wreaths and garlands which the Greeks have always loved. In their awesome size and forceful symbolism, these are the quintessence of Eastern Roman imperial art.

COINS

The numismatic art of the Greek imperial period, from the middle of the reign of Augustus to the closing of the tetradrachm workshops in Alexandria at the end of the third century, cannot be stressed enough. In approaching these coins artistically, the obverses can be discounted; generally they show only the portrait and titles of the reigning emperor, and are little more than translations of what is seen in more competent form in the Roman imperial series. Unfortunately, the best die designers flocked to the mint of Rome and its subsidiaries, where pay was no doubt higher than in the provinces. An exception in this rule of quality can be made for the imperial silver tetradrachms or cistophori, where masterpieces of obverse and reverse detail are frequently found. Otherwise the greatest artistry is demonstrated in the large, medallic coins. These pieces belong almost exclusively to Roman Asia, and their great period corresponds to that of Roman imperial medallions — the years from Antoninus Pius through Severus Alexander. Pergamon and Ephesus produced fine examples. The ingenuity with which die designers fitted a view of a temple complex and its cult statue or a Hellenistic painting of the triumph of Dionysos within the limits of a small, irregular flan often

11

reaches a level of medallic art not achieved again until the Italian sixteenth century.*

Greek imperial coinage can be divided into three epochs: the years from Augustus through Trajan (circa A.D. 1–117); the period from Hadrian through Severus Alexander (117–235), the age of medallic productivity; and from Maximinus Thrax through Diocletian and his colleagues (235–300). During the first epoch Greek imperial coinage struggled unsuccessfully to express itself in terms of Greek coin types under Roman organization and uniformity. The second is the age of archaeological and literary numismatics. The third epoch contributed much — areas such as Palestine producing their most fruitful coinage — but in these years economic reorganization and barbarian pressures closed one mint after another in the Greek provinces. In the twenty-five years after Shapur's sack of Antioch (A.D. 260), the new styles from the East and elsewhere began to supersede Roman imperial coinage, and Greek numismatics had to await the Byzantine Empire for a final great period of artistic expression.

LOCAL CHARACTERISTICS

These chapters might have been titled "Roman Official or State Art in Greece and Asia Minor." Many aspects of art have been omitted. Copies of Greek statues, paintings, mosaics, terracottas, gems, and lamps are encountered in quantity in the Greek imperial world but not considered in detail because of their private or mythological rather than official subject matter. Official motifs became very popular in the decorative repertory of minor arts in the Latin West, but were less so in the Greek imperial world, which had a host of mythological designs on which to draw. In certain branches of minor art, however, notably court silver and official gems, the Greek contribution to Roman decoration was novel and important. Mythology and legends of the heroes gave Greek artists a perfect outlet for satirizing the deeds of the imperial family while appearing to honor and flatter their activities.

Architecture for its own sake has not been emphasized, though, as a vehicle of Roman official art, it has an important place. Simplicity was a keynote of Greek imperial commemorations, and a massive gateway with a noble inscription was often a major means of paying honors to the imperial system. There were exceptions, at Eleusis and Cyzicus, where tondo busts of Marcus Aurelius and Hadrian dominated the architecture of propylaea and temple. Statues were combined with inscriptions in a number of instances. They broke the monotony of Romano-Hellenistic architecture much more than the surviving ruins can

* Certain cycles, such as the Labors of Herakles, may be compared on the coins of a number of cities. But speculations about reflections of lost sculpture and painting return coins to their position as documents of antiquarianism rather than art.

indicate. The Hadrianic and Antonine portal complexes in Pamphylia and Cilicia must have been breath-taking in their combinations of bronze and marble statues and architecture.

Historians have stressed over and over again that the Greeks, whether in Romanized cities such as Corinth, in shrines of intellect such as Athens, or in the sprawling commercial centers of Anatolia, kept their city organization and their sense of local pride. Municipal competition led them to contest for imperial favors and for the privilege of remembering these bounties in monuments of art. This art is Roman in the sense that subjects and motivations are Roman, but it is Greek in design, style, and execution. And Roman official art was only one part of the tangible culture of the Greek imperial age.

Greek art in areas that were originally Greek preserved its own character throughout the Roman period. This art never completely conformed to the Roman official pattern created in the Italian peninsula, although in the period of the Tetrarchs it came near to doing so. Continuing Greek art, a product of civic initiative or free enterprise, influenced official imperial Roman art and was in its turn influenced. This counterplay resounded to the artistic advantage of both East and West in the Roman Empire and was a major force in shaping the official art of the Eastern Roman imperial or Byzantine state in the Middle Ages.

1. Orthostate blocks at Termessus Major

Roman Imperatorial Architecture

ROMAN IMPERIAL architecture is an art of political purpose and public commemoration. A long tradition of welding architectural form into political expressiveness existed in the East, and Rome fell heir to several centuries of this architecture. The tradition had been initiated and given its impetus from the pocketbooks of Philip, Alexander, and their successors. In the Latin West the triumphal arch, the altar with sculptures, or the architectural frieze appear as official vehicles of specific, compact impact. In Greece and Asia Minor, and in Syria also, buildings of practical purpose are dedicated by or to the rulers of Rome. Such dedications make these buildings more subtly but no less effectively instruments of imperial triumphal art. Roman notables of the later Republic had followed the Hellenistic tradition in enriching Rome with public buildings at private expense. In the Empire, for various political and economic reasons, this initiative passed to the imperial family. In Greece and the Hellenistic East under the Empire, however, private enterprise within the city-state framework continued to contribute much in the way of civic architecture (figure 1). The orientation was toward a Hellenistic–Roman triumphal art, for in most cases the dedication honored the local divinity and the emperor (or his family). Appropriately and individually enough, it was usually made in the name of the city and the people.

TRIUMPHAL ARCHITECTURE

Commemorative architecture and its decoration in the East under the Roman imperium present no immediately overwhelming characteristics. No monuments, before the special conditions of the fourth century in Constantinople, tell a tale of Roman *virtus* as do the columns of Trajan and Marcus Aurelius in the first imperial capital. These columns in Rome commemorate Dacian and German wars as much as the emperors themselves. In the East architecture is inevitably useful in civic fashion. When touching matters of the Roman state it is generally dedicated to

the emperor or his family. Roma and Augustus were celebrated in the early stages, but by the Flavian or Trajanic periods the emergence of the Greek as well as the Latin imperium meant that inscribed architectural dedications to the emperor and Diana Pergensis sufficed the South Asiatic city of Perge in its duties to pan-Romanism. Thus, in effect the city of Perge was doing no more for Vespasian or his successors than it had done for the Hellenistic successors of Alexander the Great.*

City-gates were the most popular vehicles of imperial expression. They were strategically located, practical, monumental, and enough like a triumphal arch to share the latter's usefulness without its pretensions. Triple-arched gates and entrances to public squares were set up in the old cities of the East (Aphrodisias, Ephesus) and in the newly founded or rejuvenated Roman colonies (Pisidian Antioch). In their sculptured enrichment decorative generalities in the classic Greek tradition far outnumbered any specific indications of Roman power. This is almost an unexcepted rule before A.D. 200, until the time of G. Julius Asper's gate at Pisidian Antioch, a structure evidently dedicated in 212. These gates or arches usually bore dedications in Greek and Latin to the emperor and (often) to the chief local divinity by the Boule and the Demos, through the offices of a local Roman of power or a local Greek of civic pride and wealth. The appeal to the man of taste, literature, and general intelligence is evident everywhere in Eastern Roman art, in architectural settings where the sledgehammer glories of empire are often proclaimed epigraphically in the Latin West. When Hadrian wished to indicate that he had paid for a great deal more than merely the gate dividing the Olympeion from the rest of Athens, he inscribed the delightful contrast of present and mythological past: "This is the city of Theseus," on the side facing the Acropolis, and "This is the city of Hadrian, not of Theseus," on the new side. Hadrian's Athenian arched gate was one, perhaps the first, of many identical structures erected all over Greece and Asia Minor during his reign. The sanctuary of Demeter and Kore at Eleusis received two gates on the left and right of the area where the Greater Propylaea was soon to rise. The dedication to Hadrian the Panhellene suggests that these "triumphal arches" were not finished until after his death; there is nothing of Roman triumphal iconography here. The bases or socles of the engaged columns are enriched with crossed torches, an Eleusinian symbolism in vogue at the sanctuary long before the advent of Roman imperium.

The city of Isaura (Zengibar Kalesi) in Isauria was particularly rich in triumphal arches, as opposed to triumphal arched gates. The three single-arched monuments standing in various stages of ruin on the acropolis bore inscriptions to Hadrian, Marcus Aurelius, and Alexander

* In this and following chapters, where no specific citation is given, documentation, inscriptions and their sources, for a site can be found in Appendix B.

Severus, with private citizens (or local officials) and the Boule and Demos also mentioned in the various dedications. In no case does there seem to have been any enrichment on these arches, beyond the simplest of moldings. The sides or dromos walls of the gate to the acropolis had reliefs of weapons and emblems: a knotted dagger (?), a shield crossed behind by a sheathed short sword, a wreathed crown, a (Hellenistic) cuirass, and a helmet and greaves. The block with the shield and sheathed sword is still in place. Whether Hellenistic, as seems most likely, or Roman imperial in date, these decorative details are purely Hellenistic in concept, having echoes both of the Pergamene balustrades and of Hellenistic funerary reliefs, such as the orthostates of the small buildings still lining the roadway to the acropolis of Termessus Major in southwestern Pisidia. On the other hand, the triple-arched triumphal structure at Caesareia by Anazarbus in Cilicia has an elaborate entablature: enriched cornice, scrollwork frieze with hunting amorini and animals, and well-carved architrave. The keystones even have heads (Medusae?) in relief, and freestanding and engaged columns and pilasters were set to the left and right of the passages. There is no trace, however, of figured sculpture in the Western Roman sense. The arch is no earlier than the Antonine period and certainly no later than A.D. 230. The related inscriptions collected by the British expedition to study the site and its architecture bear out the Severan dating of the arch on stylistic evidence.

TEMPLES

In a vital sense the temples to the emperors throughout Asia Minor (and not Greece) are expressions of Eastern Roman state art. They also show the ultimate grandeur in the cult of the emperor as head of the state and, important to the patriotic Greek mind, as dispenser of financial aid to individual cities. Yet these temples do not seem at all offensive or even especially obtrusive in the framework of the Greek city. It took the excavators at Pergamon a great deal of effort, backed mainly by numismatic evidence, to prove the Trajaneum was a temple built by Hadrian to Zeus and his adoptive father. In the sense of personality, the Stoa of Attalus in Athens or the Arsinoeion at Samothrace with their monumental inscriptions naming the royal benefactors were every bit as conspicuous. On the other end of the spectrum, if the giant temple of Hadrian at Cyzicus featured a bust of the emperor in the tympanum (as some writers have indicated), there would have been no mistaking the building as something more than a grand manifestation of the ruler cult. The viewer, whatever his nationality, would have immediately considered it a vehicle of Roman triumphal art, although a patriotic Greek would have forgiven such a display as worthy of Hadrian the Philhellenic benefactor of Greek shrines and cities. In a like manner

architecturally speaking, Marcus Aurelius emerges from the colossal, foliate tondo of the Great Propylaea at Eleusis, a building and a setting combining gateway and temple pediment. It seems strange, an exception to the rule and to Marcus Aurelius' own rules about appearing in military costume, to find him here wearing an enriched ceremonial cuirass in this rare presentation as adjunct to monumental architecture (figure 12).

Roman state art might have appeared at its grandest in the temple to Domitian, put up in his lifetime in the thoroughly Roman city of Ephesus, but rededicated to the Gens Flavia (especially Vespasian) when the Senators rid themselves of the youngest Flavian in A.D. 96. The colossal statue within showed Domitian as a Hellenistic prince, no doubt clothed as Zeus or possibly in the heroic nude. From the turn of the head, as well as general size, it seems likely that the ruler was seated. The features were Flavian enough to be recognizable under the flashy Pergamene baroque overlay but not so veristic that the statue could not pass for Vespasian or Titus after the tyrant's death (figure 131). The temple had no other surviving inward or outward feature to differentiate it from any fairly small city-temple to a Hellenistic ruler or special hero. The altar in front might have given some Roman patron or artist a chance to go to extremes in emulation of the reliefs of a monument such as the Roman arch of Titus (as Philopappos did in the Trajanic period in Athens), but here too the specifically Roman themes are played in a low key. The front of the altar was enriched with elaborate shields, weapons, armor, and bow-cases, an impersonally military continuation of the Hellenistic tradition of Eumenes' balustrades in the shrine of Athena Polias at Pergamon. The surviving left end of Domitian's altar is only slightly more Roman: scene of a bull readied for sacrifice at an altar, shown below a garland supported by a bucranium. If any historical or state narration intruded it could only have been in the figures of a priest or *victimarius* on the other short side.

In temples, as in so many other categories of architecture in Greece and Asia Minor, sculpture and the placing of imperial statuary usurp the functions of building as symbolic of Roman imperium. Besides the many early imperial temples dedicated to Roma and the Genius Augusti (figure 3) and later temples dedicated directly to the imperator, older Greek temples were altered to accommodate imperial portraits. A late Julio-Claudian (Nero) had his likeness in armor against the cella wall of the temple of Zeus at Aigeria. The metroon at Olympia was invaded by a colossal statue of Augustus and by statues of other imperial notables down to Titus in armor and his daughter Julia (in civic dress) (figure 2).[1] Scanty evidence indicates that colossal statues of Antoninus Pius, Diva Faustina (the head preserved in good condition in London), and Marcus Aurelius (and perhaps others) may have filled or flanked the cella of

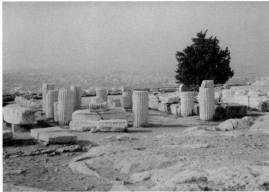

3. Temple of Roma and Augustus on the Acropolis at Athens

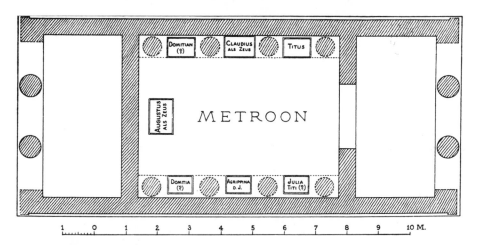

2. The Metroon at Olympia

the Artemision at Sardes.[2] The current American excavators have noted that the presence of these statues, together with the bestowal of a second neocorate, suggest that the temple was transformed into an imperial shrine.[3] After his death, the Olympeion at Athens was practically turned into a cult center of Hadrian by saturating the area with his statues.

THEATERS

The transformation of the Greek theater of the Hellenistic world into the grandiose affairs preserved at Aspendus, Athens, Ephesus, Vaison, and elsewhere is itself a landmark of Roman state art as well as Greco-Roman dramatic taste (figures 4, 5). In Greece and Asia Minor, Roman art intrudes in these theaters otherwise only in high-sounding dedicatory inscriptions (such as that to Antoninus Pius by Velia Procula at Patara in Lycia) or in statues on large bases. An unusual number of statues to Hadrian and his family blocked the spectators' views in the seats of

19

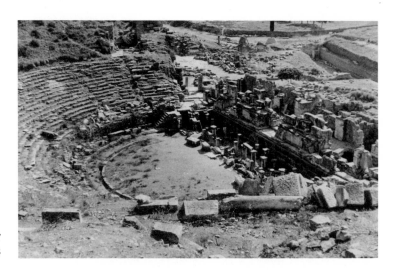

4. Great Theater
 at Ephesus

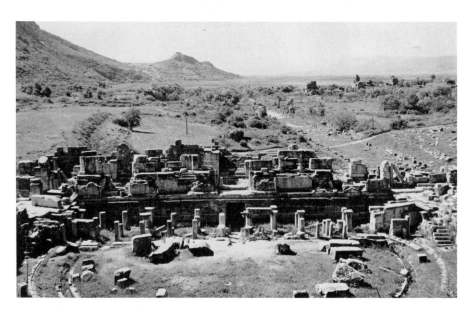

Dionysos' theater in Athens, this being the place where the Archon
Hadrian was honored with a statue during Trajan's lifetime. Sculptured
stage fronts or balustrades appear to have remained on the mythological
and Bacchic plane of the Antonine front in the Theater of Dionysos.
When they became more specific or commemorative, local worthies and
local heroes appear, like Theseus in Athens, to have been honored in the
somewhat timeless, allegorical manner of Hellenistic paintings and re-
liefs. The startling series of large frieze slabs discovered in 1956 at
Aphrodisias in Caria must come from the proscenium of the theater, and
here allegory and personification honor a local celebrity. Time (Honor)

20

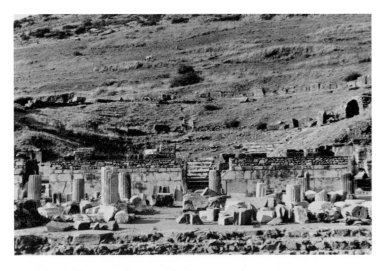

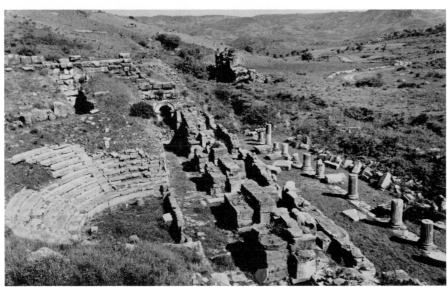

5. Odeon
at Ephesus

crowns Zoilos (a local poet or playwright) in the presence of (left to right
of the surviving slabs) a herm of Dionysos, Demos, Polis, Andreia
(Bravery) armed with a Gorgo shield, possibly Aphrodite herself, and
Aion seated looking at the scene from the right. This is almost the pic-
torial animation of the countless Greek imperial honorifics to emperors
and rich locals in which the Demos, the Polis, or the Boule take a lead-
ing part.[4] The style of this Aphrodisias frieze finds its closest parallels in
large Attic and East Greek grave stelai of the Roman period, for the fig-
ures are carved in low relief against considerable areas of neutral back-
ground.[5] In a world of such rarified intellect an emperor could have

2 1

been made to feel vulgar or crass if he saw himself in cuirassed marble in the places where Sophocles, Aeschylus, and their followers had trod. Small wonder sensible emperors — such as Tiberius, Caligula, and Trajan — curbed their Eastern subjects' enthusiasm by declining unlimited honorary statues! The opposite may be counted as one of Hadrian's few, unimportant faults concerning the politics of art.

CITY BUILDING AND CITY PLANNING

Without major exceptions Roman state art in Greece and Asia Minor forced itself upon an already determined Hellenistic architectural pattern, one imitated in Italy but unlike the ultimate achievements of the Latin West. The Greek agora, even in its Roman form, was very different from the Roman forum. Greek civic commemoration was oriented about the temple, its altar, and the surrounding precinct. Roman triumphal sculpture, by way of contrast, flourished in the setting of the imperial forum, the circus for chariot racing, or the arch (and arch and aqueduct) standing athwart a main street. Having a pattern of city planning and manner of honoring rulers already in hand, there was no reason why the Greeks of the Empire should commemorate the imperial family other than in the way they had been celebrating their own dignitaries and Hellenistic rulers for centuries with statues on inscribed bases, in the agora, theater, gymnasium, or temple precinct, and temples with altars and cult images for emperors to whom divine honors were all too readily accorded. Only in the age of the Tetrarchs and Constantine, in the generations from 290 to 330, do truly Roman cities emerge in the East, and by this time the emperors had achieved some (temporary) success at welding the arts into a cohesion of Latinity — witness the disappearance of the Greek imperial coinages in this period. Thus, Salonika in Macedonia foreshadows Constantinople in possessing the only triumphal arch in the Roman sense, that is, with historical reliefs, surviving in the pre-Constantinian East. It was one of a series put up by Diocletian and Galerius in the early years of the fourth century. Even this monument was somewhat Greek or Hellenistic, being a triple arch of which little more than two sections with their pillars survive (figures 171–176). Constantine the Great was wholly successful in making Byzantium the "New Rome," and the vista of fora, hippodromes, historical columns, triumphal arches, and basilicas which he and his successors lavished on the city is unparalleled anywhere in the East. The only partial rival in this sense, about which precise topographical details are too little known for the second to fourth centuries A.D., might have been Alexandria. Alexandria, as her Greek imperial coin types demonstrate, leaned very strongly toward Rome, befitting her position as the grain dispatcher of the main imperial province. Coins and other arts indicate this state of affairs was maintained in the fourth century.

However Roman in number of imperial monuments, Ephesus and Antioch were secondary during the Empire's last phase of Romanism.

FOUNTAINS AND RESERVOIRS

Anyone who has spent a day in Greece or Asia Minor knows how important access to running water was and is to the inhabitants. The architecture and decoration of the fountain provided the city or, especially, the local citizen with the perfect way to compliment the imperial family with inscriptions and statues. Conversely, the munificent emperor made artistic setting around the fountain the showpiece of a water system built, improved, or renovated at his orders. The clever emperor knew, as the clever sultan centuries later, that no act could win him greater glory in the East than to provide something useful which at the same time was not overwhelming (and prohibitively expensive) like the Baths of Caracalla or Diocletian in the imperial capital. Herodes Atticus, that prince among philanthropists, might be expected to have solved the symbolic function of the nymphaeum to perfection; and so he did at Olympia in the middle of the second century (figure 6). His nymphaeum was made the vehicle for a complex commemoration in statuary, with inscribed bases, of all the imperial family from Trajan to Marcus Aurelius and of his own family for several generations. The compliment

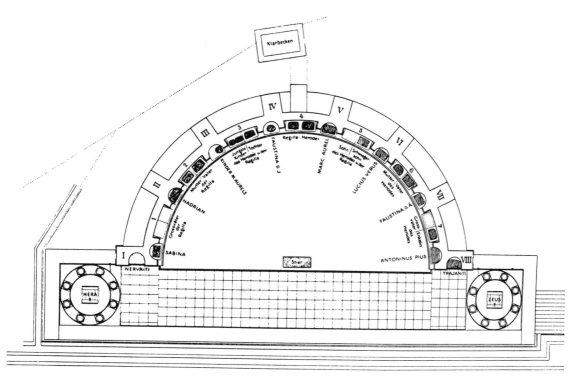

6. Nymphaeum of Herodes Atticus at Olympia

to imperium was complemented by the status to which the wealthy Athenian elevated himself by this munificence. If the excavators' placing of the bases in the rectangular and apsidal niches is correct, Herodes and Regilla dominated the center in the central niche. Their families occupied the large rectangles of the hemicycle, while the Antonines stood beneath the small apses. Trajan and Herodes' own prosperous male ancestor each filled a *tempietto* to the left and right of the main structure,[6] although some restorations show statues of Zeus and Hera in these prominent forward locations.

There is no question that it is the emperors who take credit (in Latin) for the Athenian reservoir and water channel on Lycabettus, started by Hadrian and completed in A.D. 140 by Antoninus Pius: AQUAEDUCTUM IN NOVIS ATHENIS COEPTUM A DIVO HADRIANO PATRE SUO CONSUMMAVIT DEDICAVITQUE.* This is preceded in the inscription by the full titles of Antoninus Pius.

At Ephesus the names of Augustus, Domitian, Diocletian, Maximianus, Constantius II, Constans, and Theodosius are associated with two fountain buildings and a large reservoir (figure 7). The earlier emperors received dedications from the city and rich locals; the later rulers had to initiate the expense of conservation and reconstruction. The large circular reservoir was built about 150 to 175, and two cuirassed statues, no doubt of Antoninus Pius and Marcus Aurelius or Aurelius and Lucius Verus, stood between the four columns of one of the side or flanking structures. When the complex was overhauled, the heads of the statues were removed and replaced by those of Constantius II and Constans (337–351).[7] The tradition of the fountain house as a vehicle of patronage and imperium goes back in pre-Hellenistic Greece at least to Peisistratos' structure at Megara.

TOMBS

Until Constantine the Great, all emperors whose memories and mortal remains were not consigned to infamy were buried in Rome. The problem of imperial tombs, therefore, was never confronted in the East. Trajan died at Selinus (renamed Trajanopolis) in Cilicia, but that city became merely his *heroon*, and the column in his vast forum at Rome received his ashes.†

Wealthy private citizens in the Greek East built tombs which reflected the art of their regions: elaborate, if usually lifeless, grave stelai in Athens, Attica, and the Peloponnesus; pillar sarcophagi and rock-cut façades in Lycia; temple-tombs in Ionia; temple-pyramids in Caria; and so forth.

* He finished and dedicated the aqueduct begun in new Athens by the deified Hadrian his father.
† Lovers of art well remember how Agrippina returned semi-triumphant from the East with the ashes of Germanicus, an event recorded by the American painter Benjamin West working in the tradition of the seventeenth-century French classicist Poussin.

24

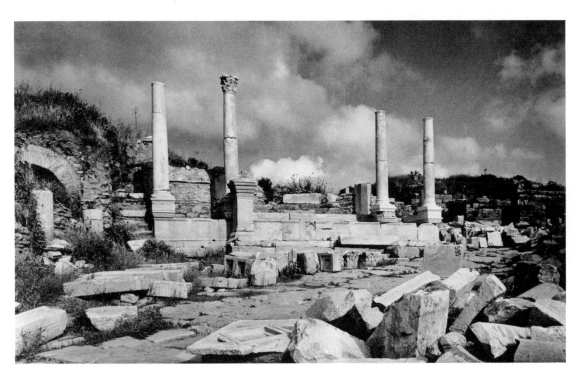

7. Fountain façade at Ephesus

The only possible exception is the obelisk of C. Cassius Philiscus at Nicaea, but this undoubtedly was considered nothing more than an imaginative grave stele. The obelisk per se did not enter Greece and Asia Minor until the fashions of old Rome were transferred to Constantine's city on the Bosporus in the fourth century. There was no counterpart to Cecilia Metella's circular mausoleum-fortress on the Appian Way, a building adorned with trophies and captives in the frieze. Greece and Asia Minor have left nothing as specific in funerary art as the tombs of Southern Gaul (with battle scenes in relief), the Rhineland structures with scenes of war and commerce in the commemorative reliefs, or even the frontier gravestones of prosperous centurions. The Tomb of the Baker beside the Porta Maggiore in Rome provides a bizarre Roman combination of Greek formalities (the relief of the deceased and his wife) and Roman earthiness (immortalization of the baker's oven in architecture) unimaginable in the Greek world. The pyramid of Caius Cestius, an imitation of the well-known Egyptian structures, carries this Roman taste to an extreme.

Greek sepulchral art, when dealing with portraits, rather than myths, allegories, or pure decoration, is grouped about a timeless interpretation of human activity. Human intellect as the prime endeavor leads the imperial men to appear invariably in the cloak (himation) and pose of

25

an orator or philosopher. The women stand or sit in the traditional veiled drapery of the early fourth-century Attic stelai, when they are not turned out in the fashionable garb of Demeter and Kore, Muses, or priestesses of Isis. These modes among men and women — Greek formal dress for funerary purposes — enjoyed considerable vogue in Italy in the late Republic to Julio-Claudian periods. The cuirassed officer occurs in Greek imperial funerary reliefs, on foot with his horse or occasionally on horseback, but the paraphernalia of war never is stressed as it is in Roman funerary art, in the legionary tombstones of the Rhine frontier or the British Isles. If arms and armor appear, they are treated little differently from symbolic athletic trophies.

The division between Eastern and Western imperial art is equally marked in sarcophagi, battle and biographical types belonging exclusively to the Latin West, with architectural and primarily decorative sarcophagi occurring mainly in the East. Although normally thought of as sculpture rather than architecture, sarcophagi in East and West reached the proportions of small temples.

The removal of the capital to Constantinople in 325 scarcely affected the character of triumphal mausolea, for by then the Empire was Christian, and the Church provided the setting and shelter for the imperial or imperatorial burial. But imperial sarcophagi in porphyry carried on the artistic unity from old Rome to the new capital. The sarcophagus of Constantina or Constantia, found in the mausoleum used by her after more important Constantinians had left for the East, is matched in its decoration of heavy acanthus scrolls and amorini by at least one imperial sarcophagus from Constantinople.[8] On the other hand, it is probably due to the mollifying influences of Christianity rather than chances of preservation that no Constantinopolitan sarcophagus survives with battles between Romans and barbarians to match the sarcophagus of Constantius (and Helena) from Tor Pignatara. The columns of Theodosius and Arcadius disprove any notions that artists could no longer produce or were no longer interested in carving coherent state or historical sculptures. Italy has yielded fragments of one or two other sarcophagi like the sarcophagus of Constantius, indicating that this great piece of carved porphyry was not an isolated phenomenon in the Latin West.[9]

UNUSUAL STRUCTURES

Greece in its Roman phase saw many imaginative products of late Hellenistic architectural planning. They fall in the first phase of Roman imperatorial constructions in the Greek world. Roman taste undoubtedly affected the form of these buildings to some degree, but there is almost nothing that can be called Roman in their decorative detail. The so-called Tower of the Winds, built by Andronicus Cyrrhestes about 45 B.C., was part of the early imperial private and public works program

in Athens which saw the completion of the Roman agora over two generations later (figure 8).* The major decorative feature of Andronicus' public clock-tower, sundial, and weathervane is the reliefs of the Winds represented as blowing from the direction faced by each slab of the octagon. Iconographically, the Winds are fascinating for they anticipate such creatures as the Seasons on Roman second- and third-century sarcophagi — witness Zephyrus flying along carrying his garment filled with spring flowers; stylistically, they bridge a gap between late Helle-

* The same patron set up a sundial and an exedra at the sanctuary of Poseidon on the island of Tenos.

8A. Tower of the Winds

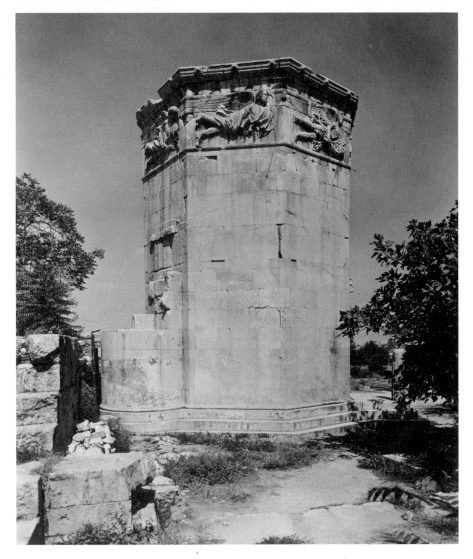

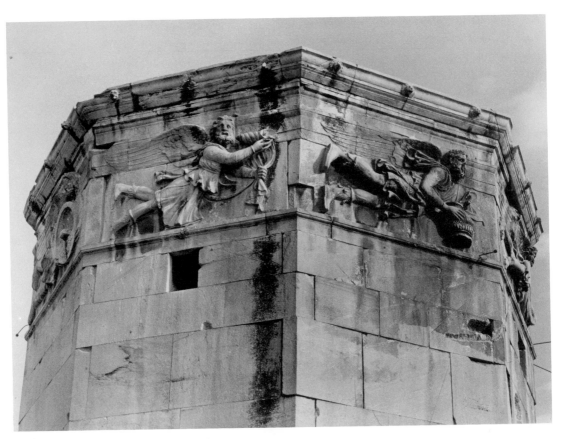

8B. Detail of Tower of the Winds

nistic decoration in the Pergamene tradition and the forceful Attic art, hardly to be termed Neo-Attic, which often emerges on Greek sarcophagi in the second century. The faces of the Winds look at home beside the Laocoon, but their bodies are (perhaps of necessity) almost frozen into a schema which is associated with later imperial work and which, since it is no longer Hellenistic Greek, actually should be called Roman. The Tower of the Winds had a bronze Triton on top of the weathervane. This contorted figure blowing on a shell must have been very Pergamene in concept and very like the marine creatures on the secondary sides of the Ahenobarbus base in details of pose and modeling.

About 50 B.C. Appius Claudius Pulcher paid for the small propylaea at Eleusis, a structure known to modern viewers as the Lesser Propylaea by way of contrast with the Greater Propylaea in front of it, a building of the Antonine period featuring the pedimental bust of Marcus Aurelius rising from a circular shield (figures 9–12). Appius Claudius Pulcher's munificence is commemorated by the unusual use of Latin for the inscription on the architrave of the pedimented gateway proper. The building is a symphony of precisely carved architectural symbolism, but

28

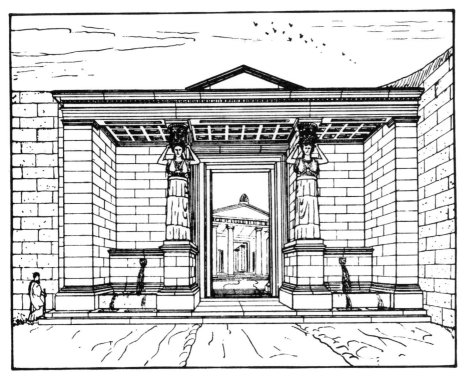

9. Inner Propylaea at Eleusis

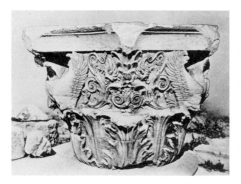

10. Capital and entablature
from Inner Propylaea

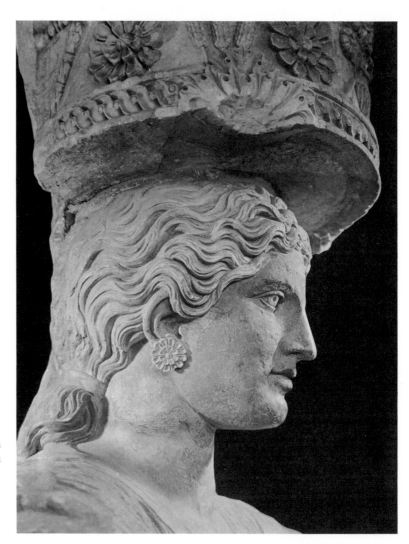

11. Caryatid from
the Inner Propylaea

no detail save the bucrania which replace bulls' heads of the metopes can be considered Roman, and, as befits the Eleusinian shrine in the first two centuries of imperium, evidences of a Roman state or triumphal art are completely lacking. The roof inside was supported by two colossal Caryatids, Eleusinian goddesses or maidens with elaborate cistae on their heads. These are almost without parallel in Greco-Roman art, although they harken back stylistically to the cult statues of Agorakritos and the immediate followers of Pheidias in Athens and around Attica. The mixed Doric and Ionic entablature, besides the bucrania, also displays cistae and wheat sheaves on the triglyphs (emblems of Demeter therefore) and rosettes alternating with the bucrania on the metopes. The capitals of this porched gateway are elaborately late Hellenistic Corinthian, with the unusual feature of winged animals (more Chimaeras than Pegasi) springing from the corners.[10] Roman example and initiative, therefore, produced two remarkably original works of late Hellenistic art in the crucial decades when the control of the ancient world was passing irrevocably from a republican oligarchy to the family of Julius Caesar.

12A. Great Propylaea at Eleusis

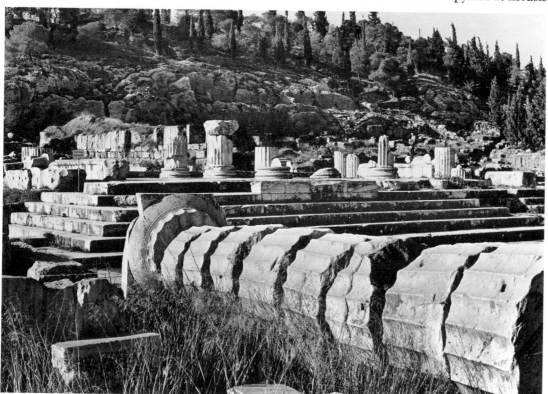

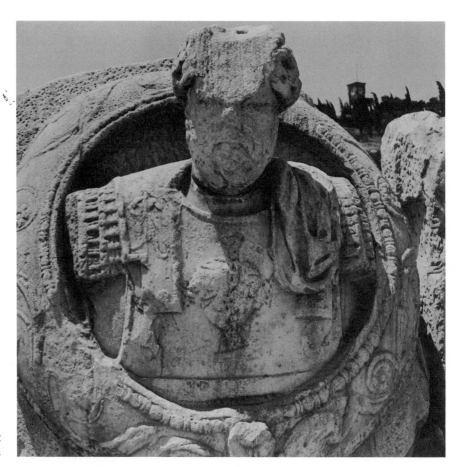

12B. Tondo bust
of Marcus Aurelius

ALTARS

Altars and their precincts bridge the gap between architecture and sculpture. This is seen in Asia Minor in the altar of Zeus Soter at Pergamon and in Rome in the Ara Pacis Augustae of 9 B.C. Both monuments, the latter derived in many ways from the former (which is dated about 175 B.C.), inspired imitations all over their respective areas, the Greek East and the Latin West. Aphrodisias, with perhaps three such altars based on that at Pergamon, is the principal Asiatic city in which the diffusion of these monuments can be traced. One of the structures at Aphrodisias (the Gigantomachy from the Gymnasium) is at least as late as the Antonine period, when Pergamene art was widely revived in Asia Minor and Italy in all media from sarcophagi to coin reverses. The sanctuary of Poseidon at Kionia on Tenos featured a small version of the altar at Pergamon, with a frieze of bulls' heads, garlands, and paterae and another frieze of Nereids and hippocamps (as the outer pre-

32

cinct balustrade or, technically, orthostate). They are executed in a style that was broad and bold but not deeply cut. In many respects, particularly in the style of the inner frieze and in the proportions of the precinct walls, the resemblance is closer to the Ara Pacis than to the Pergamene altar. In point of development, the altar on Tenos probably represents the intermediate monument, taking the form of the Ara Pacis and developing the type of garland panels to be used on it and the Ara Pietatis, without shifting from mythological generality to historical presentation. In this respect, so far as can be judged from the fragments gathered in the Tenos Museum, the altar had nothing approaching the mythological narration of the Telephos Frieze on the altar at Pergamon or even the allegorical and mythological plaques of the Ara Pacis. The altar at Tenos should be dated in the early Augustan period, not only on the grounds of style and suitability in commemorating various naval successes of the transition from Roman Republic to Empire, but because a head of Augustus of excellent quality was found nearby. What is extremely tantalizing is that this head is broken in such a way as to suggest it may have belonged to a high relief!

Like Kionia on Tenos, the sacred island of Delos had a large statue base or altar which in the artistic sense linked Pergamon and Rome. This altar was located at the south entrance of the Sanctuary of the Bulls. The major fragments indicate that the orthostate blocks were enriched with marine motifs: a Nereid rides to the left on a sea beast; there is the figure of a Triton; and crossed dolphins or small prows ornament other fragments. The design and execution are prototypes, on the heroic scale of Hellenistic sculpture in the Pergamene tradition, of the Ahenobarbus monument set up in Rome in the last years of the Republic.

The Ara Pacis Augustae, the great monument of allegorical and commemorative relief at the beginning of the Empire, was imitated a half-century later in Rome in the Ara Pietatis Augustae of Claudius, and the Roman provinces of Gaul and Spain seemed to have had their versions of the Augustan altar as late as Nero (the last of the Julio-Claudians) or the Flavians.[11] But there is some slight evidence that this legacy of the Hellenistic world to the Roman came back to Greece in its Roman form sometime in the Julio-Claudian period. On the rocky but flat, platformlike area in the shadow of the Athenian Acropolis, above the Odeon of Herodes Atticus and below the balustrade of the temple of Nike, cuttings for marble blocks suggest the outlines of two colonnaded precinct wings flanking the colonnaded (?) back wall of an altar. In the pile of marble sculptures nearby, arranged in a tidy rectangle in 1960 following the general touristic cleanup of the area, are small Ionic capitals, column-shafts, and other fragments which must have belonged to this Athenian version of the Roman altars.

The important clues to subject and dating lie in the fragment of a

33

relief with one column of the façade of a temple, similar to those so prominent in the Ara Pietatis reliefs, and in fragments of a garland and bucrania frieze that either adorned the altar itself or the inner wall of the precinct. This suggests a state or processional relief, and the bucrania instead of the bulls' heads of the Julio-Claudian period indicate Roman rather than Hellenistic taste. Claudius was much honored in Athens, and perhaps this altar commemorated his reign and the Claudian family, like its Roman counterpart. It is difficult in the light of what evidence survives to imagine panels with "historical" scenes (portraits) on a monument of this type in Athens around A.D. 50, but the chronological distance to the Philopappos monument of the Trajanic period is not so great, and at least one relief fragment of an imperial personage from Athens has survived. This is the relief with head of Augustus' son-in-law and admiral, Marcus Agrippa, now in the Museum of Fine Arts, Boston (figure 108).[12] Agrippa's own monument, a likeness of himself in a chariot and on the lofty pedestal which still survives, was almost a pendant at the entrance of the Acropolis to the area of the altar discussed here. The emperor Claudius, as his coins show, was very conscious of his forebears and may have taken the occasion of the construction of an altar such as this to commemorate a number of them, including Agrippa, in relief. But this is speculation of rather tenuous archaeological evidence! Agrippa also must have been commemorated elsewhere in Athens, in the Roman agora or in the Odeon which bore his name.

LIGHTHOUSES AND HARBORS

Buildings of such striking purpose and setting as lighthouses afforded Roman architects unlimited opportunities to combine triumphant imperialism with engineering. But from Ostia to Soli-Pompeiopolis, in the Latin West or the Greek East, the Romans were bound in a great degree to the model of the Ptolemaic Pharos at Alexandria. Towers of this type, adorned with statues and reliefs, were put up on the moles of Roman harbors from Sulla's time into the third and fourth centuries. Numerous Greek imperial coins illustrate the relation of these towers to their surroundings, and several Roman imperial bronzes from the mint of Rome document the pharos at Ostia and its counterpart in the octagonal harbor of the time of Trajan, known as the Portus.[13] On occasion the Roman pharos took the form of a statue with a torch (like the Statue of Liberty in New York harbor). Coins of the period of Marcus Aurelius from Corinth, for example, show the pharos in the form of a large cone surmounted by a statue, presumably of Poseidon. The summit of the Corinthian isthmus would have been the only suitable location for such a monument, to guide boats of all sizes toward the narrowing safety of

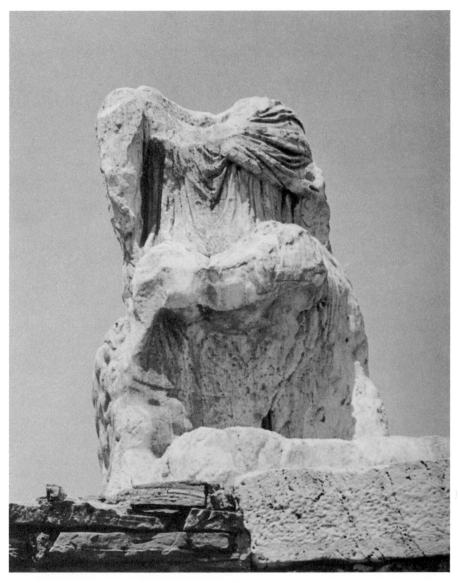

13. Colossal marble statue of Oikoumene

the two anchorages either side of the piece of land where small boats were dragged and where Nero tried to dig his canal.

The most impressive surviving statue which served as a lighthouse is the early Antonine marble colossus on the natural cone of the small island at the entrance to the harbor known as Porto Raphti on the coast of Attica across from and southeast of Athens (figure 13).[14] The ancient deme of Prasiae was on the shore nearby, and the modern name of the harbor stems from the resemblance in the statue to a tailor seated with "shears" in his raised right hand and cloth on his lap. A small bronze

35

replica found nearby shows that the statue was the female personification of Oikoumene or Orbis Terrarum, with ears of grain (the "shears") in her hand and her Pheidian himation about her lower limbs (figure 15). The beacon light was evidently formed from the large mural or Tyche crown on her head (figure 14).[15] A lighthouse keeper had to set the light each evening, just as in more orthodox structures. The notion of Oikoumene on an Attic hilltop, facing out toward the islands and Asia, was a truly Roman symbol of global domination and a useful piece of propaganda worthy of their practical natures.

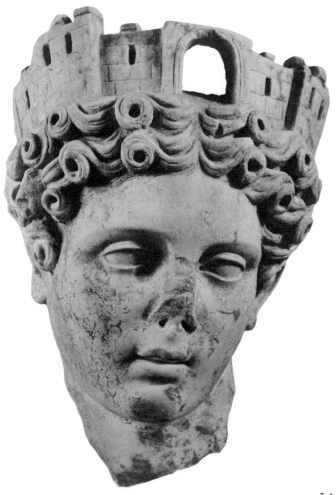

14. Marble head suitable for Oikoumene

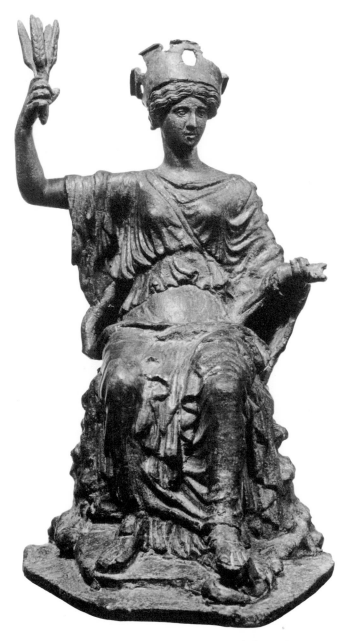

15. Bronze replica of the Oikoumene

The dominant themes of Roman architecture in the East are personal commemoration and sculptural adornment. Greeks seldom missed an opportunity to honor themselves, their rulers, and their divinities, usually through the same monument. Architecture was not only an opportunity to display statues or reliefs of gods and men but a sculptural expression in itself. Overriding considerations of personality could shape a building into human form. Lighthouses became standing Poseidons or seated Oikoumenes. Fountains thronged with emperors in armor and enlightened local benefactors in civic garb. The stages of theaters and gates of cities seemed to exist as much for populations in bronze and marble as for mortals living around them. Tombs, the world of the dead, were less concerned with honors to emperors but most involved in expressing cults of personality. Even a harbor, with its encircling colonnades and triumphal gates, its divinities and distinguished citizens in stone and metal and ships shaped like fish or dragons, could take on a sculptural aspect and a humanity unthinkable in the arts of most other civilizations.

Roman Imperatorial Sculpture

SCULPTURE HAS ALREADY been mentioned in a number of architectural connections, for in Roman art it is impossible to separate architectural sculpture from its decorative surroundings. In trying to define the nature of Roman sculpture in the East, honorary statues (portraits), historical or state reliefs, mythological or hero reliefs of Roman type, and sarcophagi all must be considered, for they represent the principal types of monumental carving in Greece and Asia Minor in this era. Before the artistic unity of the Empire under Diocletian and Constantine the Great, the only surviving, predominantly Roman, relief in Greece or Asia Minor is the frieze commemorating the rule of Trajan, Hadrian, and their successors (GLORIA IMPERII TRAIANI ET HADRIANI), found in the Library of Celsus at Ephesus.

Imperial portraits in the East have long been recognized as having a character of their own, developed out of Hellenistic traditions, but even the many cuirassed statues from the Greek world show no more (and, if anything, less) of the specifically Roman symbolism found in the Latin West. The sculptural symbolism of Roman imperium is subtly displayed in the East, in the traditions of triumphal iconography established by the Attalids at Pergamon. In Pergamene historical sculpture, the most specific type of surviving commemoration is the relief showing Mithradates as Herakles freeing Prometheus, the scene an allegory of Eupator's liberation of Greek Asia from the Romans. Geography (Asiatic) is represented in the person of the mountain god Kaukasos reclining and looking up at the scene from the lower left.[1] Only a person somewhat versed in history and mythology would realize what was taking place and what was intended. As a powerful portrayal of a rare myth the relief could not offend the Roman overlords, for Mithradates had flashed on the stage of history only briefly, was defeated despite his slaughter of Roman citizens, and possessed a portrait known chiefly to numismatists of the imperial period.

The Romans in the East let the impetus of commemoration center around honors to the emperor and originate with cities and individuals.

39

These groups knew only the heroic honorifics of the three centuries of Hellenistic kings. The Roman emperors built on a vaster scale than the Attalids or the Seleucids; they were honored by more and much broader sacral acreage and public works given theocratic focus. Temples in their names were larger, theaters or fountain-houses were more complex, but in hardly any instance did an example of purely Roman or Greco-Roman sculpture — statuary or relief — invade this world of Hellenistic or, at most, Greco-Roman architecture. In that imperial cuirassed statues are in general taste somewhat more Roman than Greek, they constitute the only major exception to this rule.

Among surviving imperial statues in the East, or fragments with certain identity, statues in cuirass and toga are in the majority, with the former far outweighing the latter. Only in one or two instances were Roman emperors represented in the Greek himation, unlike the many non-Hellenic Romans who chose this costume for their funerary monuments in the Latin West. Among the exceptions, the half-lifesized marble Marcus Aurelius from Antalya or Adalia (ancient Attaleia) in Pamphylia wears traveling costume (and has his cuirass as support by one leg) because of that emperor's strictures against appearing in military costume (figure 146).[2] Marcus Aurelius also wears a simple set of traveling clothes in his equestrian monument in Rome, for it was considered bad taste to be represented in military uniform in the capital.

Eastern statues of emperors in divine guise are no more frequent (as can be seen from surviving examples) nor any more unusual than those from Italy and elsewhere. The Gaius and Lucius Caesars from the Julian Basilica at Corinth are a common type, more heroic than specifically divine. Claudius appears as Zeus at Olympia, as he does in the Italian towns around Rome. All this art represents a copyistic taste dictated in Rome and executed by sculptors working in Athens, or by self-styled Athenians working in Italy. Statues portraying princes as Hermes and emperors as Zeus were shipped to countless shrines and marketplaces in the Latin West.

Judging from the surviving copies, the emperor Claudius as Apollo Patroos from Athens must have been more unusual than the typical Roman copy of a Greek fifth- or fourth-century cult image. Presentation of the emperor in the guise of a specific, unusual divinity was rare before the end of the second century A.D., when Commodus began tampering with the worship of Hercules and appearing in person and in art as the neo-Roman manifestation of that divinity. The colossal statue of Trajan as Zeus-Poseidon from the Roman complex in the acropolis or Castro at Tigani on Samos is a grander marble than any counterpart from Italy. Its nearest parallel, which is less complete, is a statue found at Seville in Spain. The emperor Balbinus and his co-ruler Pupienus (A.D. 238), discovered during modern dredging operations in the Piraeus,

carry this tradition of Jovian statuary in marble or in bronze almost to Late Antiquity, at least to the evensong of barbarian onslaughts in the Hellenistic world (figure 167).[3]

CUIRASSED STATUES

Surviving cuirassed statues are almost all in marble and represent Roman art throughout the empire. There were very few cuirassed statues before Augustus, and those which survive have a simple and direct Hellenistic character, in imitation of the field armor worn by Alexander the Great and his successors. Certainly the cuirass with shoulder straps, breastplate, and *pteryges* carved to simulate enriched metalwork belongs to the art of the Roman Empire.

The question now arises: do cuirassed statues in Greece, Asia Minor, and the East differ noticeably from those of the Latin West and Latin North Africa? The answer is partly yes and partly no. The Greek imperial East has produced no example of the historical-allegorical statue represented in the West by the Primaporta Augustus, the Vespasian or Titus at (Lepcis Magna) Sabratha, the Flavian emperor from Cypriote Salamis, the Fogg Trajan (which comes from Italy), the Cherchel Hadrian, and several other possible examples mostly too mutilated for precise classification. On the other hand, the splendidly Roman group of statues of Hadrian with Victoriae crowning Athena or Roma-Virtus on the breastplate belongs exclusively and extensively to Greece, Asia Minor, the Near East, the islands (especially Crete), and Greek North Africa (Cyrene). In this class, the Hadrian from Hierapytna in Crete is as "Roman" as one would wish to have a work of art, in the sense that Hadrian stands in all his military glory, crown, full cuirass, and heroic pantherskin boots, with his foot on the back of a prostrate Jewish captive (figure 138). The standard imperial field-ceremonial cuirass with two large griffins beneath a knotted cingulum, a class of statue popular in the second century in East and West alike, has its earliest surviving example in the headless Nero from Tralles, in Istanbul (figure 126).

The cuirassed statue thus represents one branch of Roman triumphal art which seems to have existed in both East and West, with similar types appearing in the areas concurrently. The reason for this may be that these statues best suited the Greek bent for commemoration only through dedication to an individual (or to the gods and heroes of various categories raised to the level of the gods). In the cuirassed statue the Greek world could absorb just what it needed of imperial artistic symbolism without having to alter the well-established Hellenistic structure of ruler-commemoration by building Roman arches and altars, putting up Roman trophies and columns, and defacing strongly traditional Hellenistic monuments of architecture with Roman historical reliefs.

But are cuirassed statues really as Roman in iconographic detail as

41

they are Greco-Roman in concept? The "historical" cuirassed statues are very few. The decorative detail of the majority, whether well-carved or stock copies, is drawn from a general Alexandrian or Ptolemaic Hellenistic (that is, Macedonian imperial or overseas) iconography known in other fields of decorative art and ranging from cinerary urns to silver plate to large carved cameos. Neo-Attic reliefs have influenced a major group of cuirasses made in Rome or Naples and found in the Latin West. In Greece, a class of imperial statues, including the signed Athenian example found with the Agrippa and other Julio-Claudians at Butrinto in Albania, is based very closely on Greek armor of the fourth century B.C., as known from countless Attic grave stelai. The large tombstone of Aristonautes in Athens provides the prime illustration.

In Late Antiquity, Hellenism rather than *Romanitas* triumphed throughout the ancient world. The so-called Greco-Roman detail, ornament of the breastplate and related parts (from shoulder straps to *pteryges*), was virtually suppressed in favor of the simple cuirass with cingulum and, when present, small semicircular tabs. Innovations, such as scaled mail (in the second quarter of the third century under the emperor Gordianus III) and chain mail (under Constantine and his successors in the fourth century), tend toward proto-medieval simplicity. In the East these developments were documented in the porphyry Tetrarchs of San Marco (from Egypt), the bronze Colossus in Barletta (probably from Constantinople and variously dated 370 to 465), and the fragments or drawings of the two destroyed imperial columns (Theodosius and Arcadius) in the new capital founded by Constantine on the Bosporus. Grave reliefs, Early Christian reliefs, paintings, or mosaics (of saints in armor), carved gems, and Byzantine coins carry the evidence of the re-Hellenization of the Roman imperial cuirass through the Middle Ages to the Italian Renaissance.

The form and iconographic detail of cuirassed statues, one of the most Roman of intrusions in the art of the Greek imperial East, begin in the late Hellenistic period with an art that is Greek and end in Late Antiquity with a return to the simple, direct components which had characterized Greco-Roman ceremonial and field armor in the Hellenistic period.

IMPERIAL PORTRAITS

The principal characteristics of imperial portraits in the East are not only those of style and type (of statues) but those of geographical distribution and specific placement in a city or shrine — a subject evident in speaking of cuirassed statues and of architectural settings. To know province by province and city by city the areas where imperial statues stood would give a vivid conspectus of Roman imperium in Greece and Asia Minor. Since many statue bases, few statues, and some-

what less than a few portrait heads survive, this is a study more for the epigrapher than the historian of art. Theodore Mommsen, A. H. M. Jones, and David Magie have given random but conclusive statistics in their classic histories of Roman polity in Greece and Asia Minor.

The emperor treated most completely from the standpoint of surviving literary, epigraphic, and artistic evidence is Claudius (A.D. 41–54), the subject of a thorough and perceptive monograph by Meriwether Stuart.[4] Stuart's statistics confirm in concise form the Greek world's penchant for honoring the emperors (and Greek imperial citizens of the grandeur of Herodes Atticus) with portrait inscriptions.* In the totals for Claudius, Italy, naturally, leads with twenty-seven portrait inscriptions, but Asia (because of its size) heads the provinces with twenty-two, Achaia second with sixteen, and Pisidia (with four) and Macedonia (two) not far down the list. In the realm of cities, Athens emerges in first place, with seven, to Rome's five. Veii (a Julio-Claudian cult center) and Delphi (where emperors seldom appear) have yielded three each, tying for third place!

The next step is to place the known portraits of Claudius from Greece and Asia Minor alongside these statistics to see how they coincide. Unfortunately, iconographers can never agree on basic lists of portraits of the Julio-Claudians (including Claudius) whose features were usually idealized and even generalized beyond the prime fact that they all looked alike. Stuart includes a cuirassed bust as the second Claudius from the Piraeus, but J. M. C. Toynbee seems correct in labeling this as a Neronian official, otherwise unknown.[5] The list of portraits identified to the present is suspiciously small for Greece and Asia Minor: Verria in Macedonia, Thasos (in Paris), Olympia (Claudius as Zeus, by Athenian artists and found in the metroon), Athens (Agora: the colossal, wreathed head possibly fitting the Apollo Patroos), Sparta Museum, Samos (Tigani, from the Roman *placa*), Smyrna (in Athens), Smyrna (once art market), and Priene (British Museum; found on the floor of the temple of Athena Polias). Brief as the documents of sculpture are, they do reflect the pattern set by the statue bases: Achaia and northern Greece providing examples outside of the Athens area, and three portraits hinting at the possibilities of identifications in Turkish provincial museums. The head found at Tigani may belong with a dedication to him from the Demos, and another inscription suggests that Claudius restored the temple of Dionysos after the earthquake of A.D. 47.

A general study of imperial portrait inscriptions and imperial portraits indicates that both follow parallel paths and that both measure

* Portrait inscriptions alone, rather than these inscriptions combined with surviving sculptures, form the best basis for adding up numbers because Italian collections have been thoroughly culled by the iconographers, while Asia Minor still has not been thoroughly explored by historians of Roman art and many unrecorded portraits lurk in provincial storerooms.

the personal popularity of emperors and the economic health of their subjects. Inevitably imperial portraits can be related to architectural undertakings initiated by Greek cities or their wealthy citizens. The identified, (often) dated, and located Greek imperial coins could provide the same information from the level of the minor arts. In the dark days from Gordianus III through Gallienus (roughly A.D. 240–270), however, many Asiatic cities produced an outburst of Greek imperial coinages at a time when the tide of monumental art ebbed rapidly. The reasons were economic in inverse ratio to the demands for statues: the inflation of the denarius and the bankruptcy of the imperial mints forced the issuance of local aes to meet the demands of regional trade.

With recovery under the Tetrarchs and Constantine, a sharp upturn in the number and quality of imperial portraits radiates from the New Rome on the Bosporus. Representative of the years preceding A.D. 323 are all the Tetrarch likenesses on the Arch of Galerius at Salonika, an arch which commemorated the Eastern wars of Diocletian and Galerius (A.D. 298) and had its counterpart in Rome. Besides the two sets of porphyry Tetrarchs from Egypt,* an overlifesized head of Diocletian, paralleled by earlier coin portraits, has been found at Nicomedia in Bithynia (figure 169). A head of Helena turned up in the same city, in the grounds of the Izmit Electric Plant which lie on top of the principal agora. After the initial generations of the family of Constantine the Great in Constantinople, at least four scattered contributions of the Theodosian Renaissance can be documented: a head of Theodosius I in Damascus; a bronze head of Gratianus in Krinides (Macedonia) from Philippi; the marble statue of Valentinianus II in Istanbul, from Carian Aphrodisias (figure 181); and the head of young Arcadius from Istanbul (figure 182).

Valentinian II was found in the Hadrianic Baths at Aphrodisias, flanking the antechamber and as pendant to a (lost) statue of Arcadius. Both bases were found near their original locations. In the placing of these two imperial statues the Greco-Romans of the late fourth century were as conscious of their Hellenic heritage as any citizens of the previous centuries. Valentinianus and Arcadius kept company in the East Gallery of the Baths with Trajanic or Hadrianic statues of ladies, and with two contemporary (late fourth century) municipal magistrates. New statues, therefore, were set up in traditional locations, amid the benefactors and worthies of the earlier, more peaceful days of Asia Minor.

* In 1966 parts of the sandal and plinth of a Venice Tetrarch were found at the Myrelaion in Istanbul. The statues were probably carried to Venice with other Crusader spoils in A.D. 1204. Their ultimate artistic origins remain in Egypt.

TWO MONUMENTAL SEVERAN STATUES

The overlifesized bronze statue of Septimius Severus found in a field at Kythrea (Chytri) in the northern central part of the island and now in the Cyprus Museum, Nicosia, is a rare masterpiece of Roman imperium in the East (figure 156). The statue of the emperor striding along in the heroic nude should be restored with a spear in the right hand and a small trophy in the left to create a likeness of Septimius Severus in the guise of the traditional Republican and Augustan cult figure of Mars Victor. Mars Victor is a familiar figure since he appears on Augustan and later coins, not to mention bronze arms and armor, gems, and several marble reliefs. He also occurs as a bronze statuette for military and household shrines. His connections with the emperors began when Augustus installed an older Republican-Hellenistic image in the small round temple built on the Capitol to house the standards recovered from Parthia in 19 B.C. Mars Victor or Mars Pater, then, is associated with imperial military successes in the East and particularly in Parthia.[6]

The Cypriote portrait of Septimius Severus as Mars Victor is executed in a restrained version of the earlier style of his reign, recalling portraits of his Antonine predecessors, especially Marcus Aurelius (Severus' self-styled "father"). On the evidence of the arch at Lepcis Magna and of the principal portrait on the Porta Argentariorum, the development of the later (or Sarapis) portrait-type of Septimius Severus has been dated to the period immediately preceding A.D. 204.[7] The Parthian wars were fought from 197 to 202. Considering the many conservative as well as local currents of Greek portraiture in the imperial period, there is no reason not to date the Nicosia statue as late as 202, in the period when Severus could point the parallel of Augustus' Parthian successes by having himself portrayed under the guise of a cult statue directly associated with the Parthian triumphs of 20 B.C. The use of Mars Victor (labeled as such) as a coin type in A.D. 71 by Vespasian both marks the ninetieth anniversary of the Parthian success and emphasizes the further parallel of Vespasian's own Jewish triumphs of the previous two years. The statue was evidently set up in a shrine that marked the beginning of the Severan aqueduct running across the plains from the mountains north of the Mesaoria to the Roman metropolis of Salamis on the east coast, one more illustration of the connection between imperial sculpture and a major undertaking of permanent civic benefit.

Another important iconographic monument of Severan activities in the East is the colossal marble and stucco head of Severus Alexander, found about 1950 at Memphis in Egypt and now in Boston (figure 166). The head was originally made as a likeness of one of the Ptolemies, most likely Ptolemy VI Philometor. The addition of four Sarapis locks over the forehead, a beard, and a more prominent nose, all in stucco, were

45

evidences of the means by which the Ptolemaic ruler became the last of the Severans. The statue probably portrayed Severus Alexander as the Greco-Egyptian Sarapis, after the seated Alexandrian cult image by Bryaxis, and was most likely made on the occasion of Alexander's progress to the Persian wars in A.D. 231. Many must have felt that this new ruler bearing the revered name of Alexander was a gift of the Greco-Roman gods to struggle successfully against the new Persian Empire.[8]

These two Severan statues, the overlifesized bronze and the colossal marble and stucco head, demonstrate how often imperial monuments in the East speak in messages of subtle (and even complex) symbolism. The votive or temple statue with interplay of autocratic and divine implications was much more suited to the Greek notion of an imperial art than were the triumphal arches of the type set up throughout Rome, by Trajan at Beneventum, by Galerius at Salonika, and ultimately by several emperors in the new metropolis on the Bosporus, where all other forms of Latin artistic splendor were brought from the old capital, to make Constantinople appear outwardly as like Rome as possible.

STATE RELIEFS

If the truly Roman historical or triumphal state reliefs in the East that antedated A.D. 300 can be counted on the fingers of one hand, certain borderline monuments cannot be discounted as mere continuations of Hellenistic art. The altars on Tenos and in Athens seem to have been produced in the tradition of the Pergamene altar of Zeus and as chronological parallels to the Ara Pacis and Ara Pietatis Augustae. The head of Agrippa from Athens, now in Boston, may well be the only surviving part of the "historical" portion of one of these altars (figure 108). The principal relief of the monument to C. Julius Antiochus Philopappos on the hill of the Muses in Athens shows an obvious dependence on the sculptures of the Arch of Titus and late Flavian illusionism in Rome.[9] The monument as an ensemble, however, is a continuation of Hellenistic heroons or exedrae, with the focus having been on the statues of the deceased Consul and his royal ancestors, above the relief panels. Even the sculptural effect of the reliefs, broken by the division into one principal and two narrow side panels (like certain Attic late fourth-century grave monuments), was further deemphasized or made more intellectual by the insertion of the deceased's titles and ancestry in Latin and Greek on the two Corinthian pilasters flanking the main relief.

HELLENISTIC COMMEMORATIVE MONUMENTS

Along with the various temple friezes and the Telephos frieze of the altar at Pergamon, certain reliefs indicate the types of monuments which formed the background to the state reliefs of the Greek imperial period. The Museo Arqueológico in Madrid preserves a small (0.70m. by 0.74m.),

46

early Hellenistic relief brought back from Troy by a Spanish traveler, who may have secured it from the Calvert collection. It may have adorned one of Alexander the Great's buildings at the refounded Ilium and shows a chlamys-clad spearbearer leading a mounted warrior in Greek cuirass to the left. Because of the costume and the impressiveness of the horse, it has been suggested that the scene portrayed Alexander on Bucephalus.[10] The relief is a reflection of the vigorous proto-Pergamene style of the Aristonautes stele of about 330 to 320 B.C. and the colossal grave relief of a horse and groom found over a decade ago in Athens and visible to all in the National Museum.[11] The concentration on the essence of a historical theme, Alexander (or one of his generals) riding to battle, is a characteristic encountered frequently in Greek art of the Roman Empire. Unity and brevity give the theme forceful appeal, recalling in another medium the central part of the Alexander mosaic after the fourth-century painting by Philoxenus of Eretria.

The less emotionally direct, more literary and didactic side of Hellenistic two-dimensional sculpture is summed up in the "Apotheosis of Homer" relief in the British Museum (figure 16). Small in scale and precious in content, with its mythological and allegorical figures carefully labeled, this work of Archelaos, son of Apollonios of Priene, has been dated on style in the second century B.C. and is the Hellenistic forerunner in miniature of the early Antonine theater balustrade from Aphrodisias.[12] Like the nearly contemporary Telephos frieze from Pergamon, the introduction of mountain landscape (here without continuous narration, however) adds a new dimension to Greek sculpture, one which Roman historical relief will employ more often than it will be used in monumental, official Greek imperial sculpture. The latter, as often as not, returns to the grandeur and emotional simplicity of the largest and latest Attic fourth-century grave stelai.

It is superfluous to describe the "Apotheosis of Homer" relief, when its details have been listed in every handbook of Greek sculpture. The mixture of rulers in allegorical guise (Ptolemy IV Philopator as Chronos and Arsinoë III as Oikoumene) and poet-dedicator (the final figure, as a statue) sets an artistic mode to be followed in other Hellenistic and, especially, Greek imperial statue groups or compositions in relief. The introduction of rulers in allegorical complexities appears at its simplest in the "Gemma Augustea" in Vienna, a scene of Augustus enthroned amid divinities, members of his family, and the subject people of the new empire, or in the other giant imperial sardonyx cameo, the "Grand Camée de France," and at its most complex in the Julio-Claudian cup, evidently of Western Asiatic Greek workmanship, in the British Museum, showing the drama of Julio-Claudian family relationships acted out in the guise of the adventures of Orestes, Pylades, and Iphigeneia after their departure from Tauri (figures 57–61). At least two of the

47

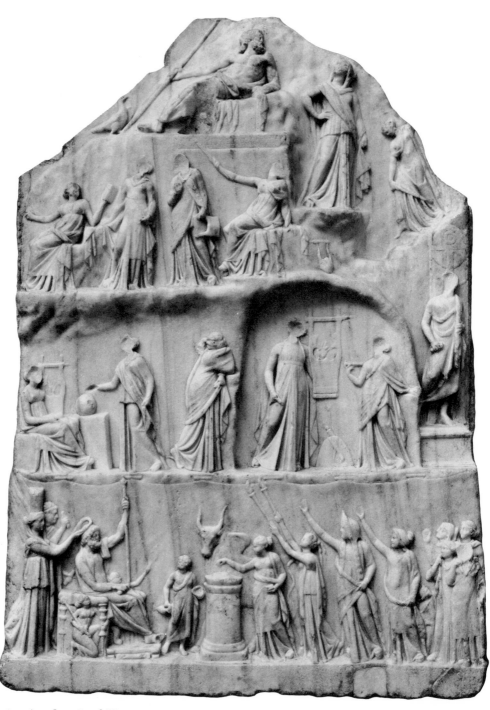

16. Apotheosis of Homer

heads on this cup are portraits — Germanicus, Drusus Junior, and possibly Livia — the cup having perhaps been made under Tiberius when the ill fortunes of the younger Julio-Claudians were "frontpage news" in the Greek East.

Comparisons for the figures, portraits, and arrangements of composition in the small, almost cameolike "Apotheosis of Homer" come mainly from the arts of small scale and precious materials. The large relief dedicated to the gods of Eleusis by Lakrateides in the first century B.C. and found in fragments in the Ploutonion of the sanctuary at Eleusis is a votive relief par excellence, with the gods and goddesses in the left three-quarters of the relief, the dedicator in the right rear, and two small members of his family gracing the left end (figure 17). Demeter, Kore, Pluto, the God, the Goddesses, and Eubuleus are seen in various seated and standing postures. The "Mission of Triptolemos" is shown in the left front, as the foremost of a series of four overlapping planes.[13]

The Eleusinian work sums up what late Hellenism could produce in the way of a monumental relief of commemorative purpose. The scene is god-oriented, with the votaries as accessories. Neutral space and areas suitable for inscriptions are important. Monumentality, contrasting place-

17. Relief dedicated by Lakrateides

ment of the figures, and variations from divine to human subject are never allowed to stray from the timelessness of classical representation. As a work of the first century B.C., the style leans strongly on Attic art of about 350 B.C. It is not far from a relief such as this to a quasi-historical imperial work where the emperor could replace or complement the donor and the honors be divided more equally between divinity and imperium.

Another type of Hellenistic relief, the frieze of trophies, arms, and armor, had special impact in the Greco-Roman world where Pergamene art and Pergamene iconography was one of the most beloved legacies of the last Attalid to the Roman intruders or conquerors who inherited the kingdom of Pergamon. The example of the balustrades of the stoa in the precinct of Athena at Pergamon comes to mind immediately. These reliefs — elaborate cuirasses and all manner of human and equestrian armor and weapons — were set in between the Ionic columns of the story above the ground, and thus just above the monumental inscription of the stoa part of the complex. Their warlike richness formed a very Greek contrast to the studied delicacy of the Ionic columns and the architectural carving.[14]

A more standard use of the frieze of trophies, arms, and armor occurred almost contemporaneously (circa 175–164 B.C.) in the frieze of the Propylon alongside the Bouleuterion at Miletus. An allusion to the recent victories over the Gauls in the presence of Celtic arms in the frieze has been seen, but this is as specifically historical as any of this class of decorative military sculpture ever becomes; witness the Gallic shields on coins of Ptolemy II (after 277 B.C.) or the snake-filled canister hurled by Nyx on the frieze of the Altar of Zeus at Pergamon.[15] The triglyphs and metopes of the Lesser Propylaea at Eleusis demonstrate how by the end of the Republic the tradition of decorative enrichment centering around military symbols could be converted to general symbolism of specific divinities, in this case the Eleusinian goddesses (figure 10).

The amazing relief of Mithradates VI Eupator freeing Greece and Asia from the Roman yoke, a subject represented in the guise of Herakles liberating Prometheus from the eagle with the mountain-god Kaukasos below, is the very essence of the Greek as opposed to the Roman method of presenting history. Whether or not the monument, as set up in the North Hall of the Sanctuary of Athena at Pergamon, had an identifying inscription, the secondary, political meaning of the scene is otherwise only evident if the face of Mithradates is identified. The first generation of excavators at Pergamon suspected Herakles was a Hellenistic portrait, but it was not until 1925 that the historical solution to the mythological scene was correctly published.[16]

Mithradates resided in Pergamon for three years from 88 B.C.; most

authorities agree that his likenesses as Herakles date from then. He was celebrated there as liberator of the Greeks, fit opportunity for patrons and sculptors to honor him through the vehicle of a Herculean myth. The royal diadem appears over Mithradates' thick, curly hair and beneath the lion's skin. This allegorical concept of Mithradates as liberator and savior of Asia is very different from the Roman imperial manner of presenting an historical event, even when the Romans take over allegory or mythological figures and introduce them into historically narrative concepts. The technical tricks of the Telephos frieze at Pergamon are used in setting the two antagonists, the eagle, and the geographical personification on various levels against a rocky landscape. This becomes a kind of direct, dramatic use of the type of setting encountered in more complex, more philosophical fashion in the "Apotheosis of Homer" relief. Of the various notions incorporated in the Mithradates relief, the Romans first and chiefly imitate the practice of combining a portrait head with an ideal or mythological statue, or else it is their Greek subjects and their Greek artists who honor the Romans thus.

Two more Hellenistic monuments measure the limitations of the Greek mind in mixing myth and reality, triumph and official commemoration. Unfortunately, these reliefs are too mutilated or too incomplete in themselves and in their contexts to be more than suggestive possibilities in a brief outline of the Hellenistic backgrounds of Greek imperial reliefs. In the Louvre, fragments of a large relief from Smyrna, dated on style of pose, drapery, and carving in the second century B.C. (on the label), are certainly work of this or the following century.[17] The fragments show a youthful Apollo (or, less likely, Dionysos) leaning against a tree before a dressed-stone wall, and a goddess (Artemis or Aphrodite) moving to the right before a similar section of wall (figure 18). The fragments are slightly larger than lifesized. This scene, a somewhat more animated and specifically located version of the Eleusis relief just discussed, is a further monumental example of Hellenistic sculpture's movement toward a detailed nature in which introduction of portraits on certain figures does not mean elimination of the divinities and personifications involved. Furthermore, the introduction of historical personages in no way forces an alteration of the way in which mythological or symbolic figures behave. On occasions they almost seem to ignore the presence of persons from the real world. This is very unlike Roman imperial historical or state reliefs, which absorb Greco-Roman divinities but, often as not, make them behave as if they were little more than mortal attendants of the emperor. The gods surrounding Domitian in the *Profectio* frieze from the Palazzo della Cancelleria almost lose their dignity in their efforts to hustle and wave the emperor off to his Germanic wars. The male figure of the sculpture found in the agora of Smyrna has been identified as Asklepios or Hephaistos and

18. Fragment of mythological relief

the female as Aphrodite, possibly with an apple. These fragments have been related to a number of others found in the agora which are certainly work of the Antonine period, after the rebuilding of Smyrna (A.D. 178), and are probably from a Dodekatheon related architecturally to the basilica. The fragments in the Louvre, however, belong to another, older set of reliefs. In both the Hellenistic slab and its Antonine counterparts, the stylistic sources lie in Attic work of the late fifth and fourth centuries B.C. A torso of a colossal statue of a goddess, from Rome and in Boston, is close in style to the Aphrodite of the Louvre fragment. The

former has been dated in the second century B.C., with recognition being taken of the fifth-century influence in the rendering of the diaphanous drapery.[18]

The high, almost freestanding relief of Nike carrying a trophy over her shoulder, from Apollonia in Epirus and probably dated about 320 to 200 B.C., must have formed part of a larger ensemble. It could be associated with one of Pyrrhus' adventures in the first half of the third century B.C. Perhaps his victory over Antigonus Gonatas at the beginning of the second quarter of the century furnished the occasion. The head of Nike is like those of ladies on Attic grave reliefs of about 340 B.C., and the relief gives a rare illustration of the formulation in Greece of an art which the Romans in the West later took over to such an extent that its Greek beginnings have been all but forgotten.[19]

In this respect, although associated with a Roman "liberator," the frieze of the monument to Aemilius Paullus at Delphi (circa 150 B.C.) is sculpture of a mainland Hellenistic simplicity, contrasting in its classic restraint with contemporary developments at Pergamon and elsewhere in Asia Minor. The frieze is technically unusual in its deep cutting and use of violent perspective, which developed out of Greek sarcophagi of the fourth century B.C. but which preserved a rationality not seen in the great baroque monuments of western Asia Minor.[20] So too, the stele at Kleitor in Arcadia, possibly one of those set up after 146 B.C. throughout the Peloponnesus in honor of the strategos-historian Polybius, is an ultraconservative Greek relief. Polybius is represented in the fashion of warriors on grave stelai from 400 B.C. on, standing in tunic and himation, with helmet at his feet and shield behind him at the left. The single, flat plane of the view is emphasized by the raised right arm and the strong profile of the head to the left.[21] In short, before 100 B.C. commemorative or state art developed somewhat separately in Greece and Asia Minor. In Greece it is harder to find what the mainland artists of the late Hellenistic period inherited in creating their contributions to Greek imperial art. The reliefs on the Athenian Tower of the Winds illustrate how mixed the sources of Athenian sculpture were by 50 B.C., the winds combining Pergamene baroque power with classicizing tendencies toward decorative patterns in the late Hellenistic period (figure 8).

FROM THE LATE HELLENISTIC WORLD TO THE EARLY EMPIRE

The vitality of Aphrodisias in Caria as a Greek imperial city has been defined repeatedly in recent years. The late Hadrianic early Antonine theater balustrade may now be added to the evidence of pre-1940 finds at Aphrodisias, to the schools of architectural sculpture working at Lepcis Magna, to the Aphrodisian artists' signatures from all over the Empire. A telling document of transition from Hellenistic Asia Minor to

Greek Imperial Asia Minor was excavated at Aphrodisias by the Italian Archaeological Mission in 1937.[22] This is the portico dedicated to Aphrodite, Divus Augustus, Tiberius, Livia, and "the People," and the Demes or outlying towns. One or more wealthy local citizens and the wife of one of them were evidently responsible for the complex. It is not the dedication that makes this large Ionic portico unusual, but the series of heads, protomes, which are spaced in the area of the frieze (figure 19). The mixture of gods, minor divinities, heroes, athletes, monsters, and the family of Augustus could only occur at a time when the notions of Roman artistic imperium in the East were partially formed. In the sections preserved there are heads of Augustus, Antonia or Agrippina Senior, and Livia, mixed with Herakles (old and young), Eros, the Gorgo, Roma or Virtus, satyrs, maenads, theatrical masks, Paris, Hera, diademed youths, and a host of other beings, many only recognizable to those who erected the structure. It must have been a curiously half-Greek, half-Asiatic mind which saw in this sculptured enrichment a suitable complement to the building's dedication to the first two emperors and Livia.[23]

19A. Ionic frieze from Aphrodisias

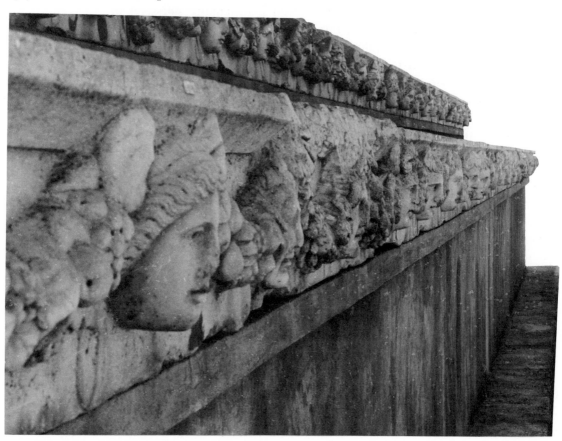

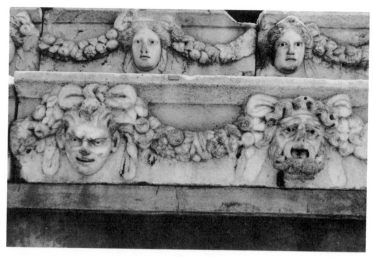

19B. Detail of Ionic frieze from Aphrodisias

At Aphrodisias the use of medallions with varying subjects to decorate buildings seems to have persisted into the Constantinian period. The evidence, destroyed in the tragedy of 1922, when the Greek quarter burned during Turkish occupation of the city, consisted of six medallions in the Museum of the Evangelical School at Smyrna. Four of these were photographed and published in the German corpus of sculpture known as the Einzelaufnahmen.[24] Technically and stylistically it is almost impossible to believe they were carved in the fourth century A.D., were it not for the subjects of two of the medallions and the obvious homogeneousness of the set. They speak of the persistence of classicism in the great centers of western Asia Minor, and they are technically as good as any sculptures produced in the Hellenistic or earlier imperial periods.

The likenesses in these medallions are careful replicas of contemporary and older sculptures. One goes back at least to the time of the "Great Ionic Portico" at Aphrodisias and perhaps even into Hellenistic times, being a Menander of the Marbury Hall type, with drapery corresponding to the Menander in the Museo Capitolino (figure 20). This head is a replica of the well-known series of portraits usually identified as Menander.[25] The second tondo bust is a philosopher of the type of the two statues in Paris, traditionally identified as Julian the Apostate (A.D. 361–363). The man of the tondo is probably not Julian, and the coincidence of resemblance stems from the fact that Julian tried to look like a Constantinian philosopher, probably a pagan from the Greek East (figure 21).[26] The third bust is that of a Constantinian youth, with flat, crisp drapery and a bulla around his neck. He may be an ideal portrait of one of the sons of Constantine; the most likely candidate, on the

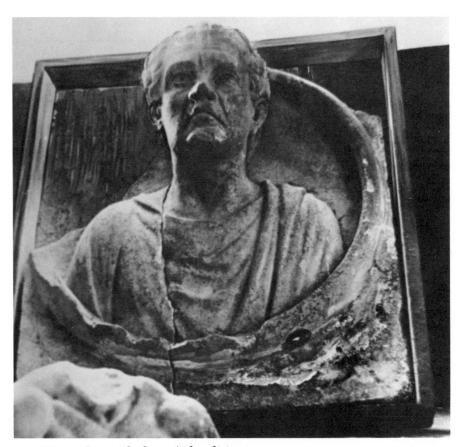

20. Menander tondo from Aphrodisias

basis of coins, would be Constantinus II.[27] Otherwise, he may be a member of the family who, in the good old East Greek tradition, paid for the building on which the plaques were set. Such persons naturally followed imperial iconographic fashions, trying to look as much like the ruling family as possible.

The next medallion, the best preserved of the group, is sculpturally the most classical of the series, being carved in crisp, hard fashion with touches of drill only in the hair. The bust is that of a city goddess or Tyche (figure 22). The Tyche of Aphrodisias is an obvious candidate, but the parallel to the Urbs Constantinopolis on Constantinian medallions celebrating the founding of the new capital in 325 also comes to mind.[28] Further suggestion for the inclusion of the imperial family in the series is based on the tenuous evidence of logical possibilities in a series such as this. The final two medallions were not photographed, and are listed merely as "Bust of a Child" and "Woman with a Diadem." The former presents several possibilities: Licinius II before the decline of his fortunes in 323, and a Caesar such as Delmatius or Hanniballianus, both of whom were put to death in 337. Hanniballianus was made King

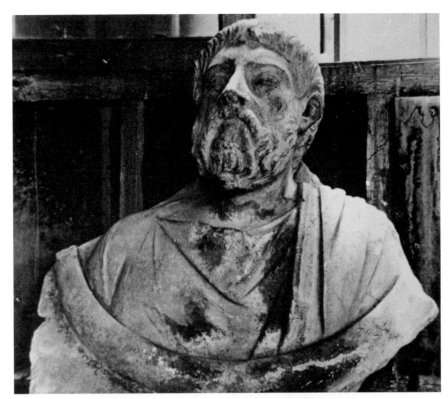

21. Eastern official, "Julian the Apostate"

22. City goddess or Tyche

of Pontus, Cappadocia, and Armenia by Constantine the Great, and he would have been a logical child to be commemorated by the cities of Asia Minor. The diademed woman could be any one of the oft-sculpted imperial ladies, from Helena to Constantia, daughter of Constantine the Great and wife of Licinius Pater. A head of Helena was discovered twenty-five years ago at Nicomedia in Bithynia, and Athens has yielded the magnificent portrait of Constantia now in the Art Institute, Chicago (figure 179).[29]

The Hellenistic imperial notion, exploited so successfully at Aphrodisias, of sets of rondels with ideal and portrait heads mixed carried over into Christian and Byzantine art. Four fifth-century examples are in Istanbul, where there is unfortunately no record of their provenance, although a strong tradition has it that they were found in the imperial capital. They show the Evangelists, each holding his Gospel book surmounted by a cross, and wearing the costumes of Hellenistic philosophers.[30] At this date theological and imperial iconography was mixed readily, and, if the set were larger than decoration conventional to the crossing of a church, it may have included imperial portraits as well.

SARCOPHAGI

Artists in antiquity lavished a disproportionate amount of effort on funerary sculptures, and those from the East are among the most unusual. Sarcophagi made in Greece and Asia Minor generally differ from those made in Italy; the former being architectural and decorative, the latter, vehicles of mythological or historical narration. The sarcophagi in question are those made from the time of Hadrian to well into the Christian or Byzantine era. Asia Minor, especially Lycia, had enjoyed a long tradition of sarcophagi going back to the sixth and fifth centuries B.C. The Lycian sarcophagi were characterized by their high, curved, pedimental roofs, a feature continued in Lycia and Pisidia into the late Hellenistic and early imperial periods. The popularity of Lycian sarcophagi, with reliefs influenced by Athenian optics of the late fifth century, is testified to by the famous example found in the royal necropolis at Sidon in Phoenicia.[31]

Roman official art influenced Greek sarcophagi of the imperial period. These sarcophagi differed from those of Italy and the Latin West because they avoided specific representation in favor of general decoration. Even complex mythological scenes are rare, although occasionally they are found on sarcophagi in Greece, and Amazon or ideal combat scenes were carved on sarcophagi found in Lycia and Pamphylia. When mythological scenes are found on sarcophagi in southwest Anatolia, these sarcophagi are often imports from Italy. Conversely, examples from these regions were shipped to the imperial capital. A certain union between sarcophagi in Italy and Asia Minor did not develop until the

columnar sarcophagi appeared in the third century A.D. On the other hand, Attic sarcophagi with mythological scenes or decorative motifs such as intoxicated Amorini were made and exported to Italy. Sarcophagi of the type associated with the province of Pamphylia in southern Asia Minor were also sent to the imperial capital and its environs. Greece or Asia Minor sent Italy no sarcophagi so thoroughly encyclopedic in mythological iconography as the countless examples produced in Italian workshops.

The Roman imperial contribution is more marked in Asiatic than in Greek mainland sarcophagi. The funerary motif of Victory over death is given the Roman triumphal twist of Victories carrying *vexilla*, parazonia, and wreaths, reminiscent of those in the spandrels of Roman triumphal arches. Portraits intrude into the design. A splendid example from Laodiceia Combusta in Lycaonia and now in Smyrna shows busts of a man looking like Antoninus Pius and a woman resembling Faustina I set between wreath-bearing Erotes, with triumphal Victoriae on the corners. The busts on the sarcophagi must have been based on similar, freestanding likenesses of the deceased made by an Ionian portraitist trained in Rome or able to work from the latest official models. The relation to the best Greek imperial portraits from Ephesus is startling.[32]

Sarcophagi from Side and Perge in Pamphylia present flying Victoriae holding wreaths between them. This design comes from Roman triumphal art of the first century A.D. and is found on second-century sarcophagi made in Rome. Also at Perge the triumphal motif undergoes the same decorative harmonization as on sarcophagi in Italy. In place of the Victoriae, twin Erotes with cloaks flying out behind support a shield with Gorgoneion in the center. The contrast is made all the more impressive by the fact that this design is on the reverse of a sarcophagus with Victoriae supporting a Gorgoneion shield.[33] None of the Roman sarcophagi with scenes of the life of a general or high official have been found in the Greek imperial part of the Roman world, and it can be presumed that no example in this extremely rare and thoroughly Roman class of Antonine and Severan court sepulchral art was manufactured east of Italy. Sarcophagi with the deceased reclining on the lid, such as those in Salonika, the great Sidamara sarcophagus in Istanbul, and the sarcophagus of Claudia Antonia Sabina from Sardes, carry the Romanization of sepulchral art as far as the Greeks cared to express it. The heroization of the dead is a traditional Greek concept, but the naturalistic presentation of man and wife reclining on a banquet couch came into Antonine Roman art from contact with Etruscan sarcophagi in central Italy.[34]

The sarcophagus depicting the departure of the Seven Against Thebes at Corinth has been recognized as an early Antonine work probably carved in Athens or Corinth itself (figure 23).[35] At first glance the cuirassed warriors of the departure appear very Greek in costume and

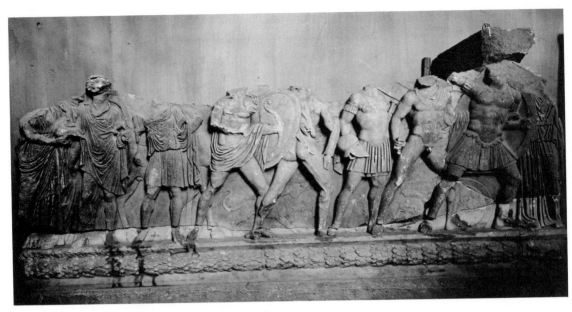

23. Sarcophagus with the Seven Against Thebes

style of carving, recalling grave stelai of about 330 B.C., the Aristonautes period. The Caryatids on the corners are reminiscent of those on the Erechtheum — which is not surprising in view of the popularity of the prototype in architecture as far west as Antonine Gaul. The background mixes details of armor with neutral space, as on a grave relief. Despite all this, the work may be classed among those Greek and Asiatic sarcophagi in which the strain of Roman official art is evident. The bunching of the figures in their "grave-stele" poses, the hardening of details in the cuirasses, and the mixture of frontal pose and action prove that the sculptor was not unaware of the experience through which major sculpture had passed between the Cancelleria frieze of about A.D. 93 in Rome and the so-called classicizing Hadrianic tondi of the Arch of Constantine.

The Asiatic or columnar sarcophagi, of which Claudia Sabina's is a late Antonine cornerstone, evince a return to the Greek feeling for statues in niches rather than a continuation of the Greco-Roman interest in narrative relief surfaces.[36] Generally speaking, Roman art in Asia Minor is expressed in terms of statues and architecture rather than relief sculpture. These Asiatic sarcophagi bring the Greek imperial as opposed to the Western Roman artistic tradition back into force in one of the most widespread fields of sculptural endeavor after A.D. 200. Muses, mythological heroes, hunting scenes, philosophers, Christ, Thetis arming Achilles, and bound Parthians indicate the diversity of subjects involved. Most of these subjects occur in the architectural decoration of triumphal imperium in Greece and Asia Minor from the second to fourth centuries. For instance, there is a splendid fragment in Oberlin (Ohio),

from Smyrna, of a bound Parthian in a niche; he is the worthy counterpart of the sculptures on the Severan triple arch or gate at Pisidian Antioch.[37] Morey has shown how the architectural details of these sarcophagi relate to those of the great stage-façades of western and southern Anatolia in the second century A.D., that of the theater at Aspendus being the classic example.[38]

The large, rich, and magnificent sarcophagus in the form of a temple in miniature, in Providence (Rhode Island), was found in Rome. Scholars who have studied this major monument in detail attribute it to a workshop which exported sarcophagi to southwest Anatolia, and it has even been classed as a Pamphylian sarcophagus (figure 24).[39] All indications point to the fact that the men who furnished this masterpiece worked in or came directly from Asia Minor; therefore, this sarcophagus may be considered a work of Greco-Roman art from Anatolia; a date at the end of the Antonine Period is generally accepted.

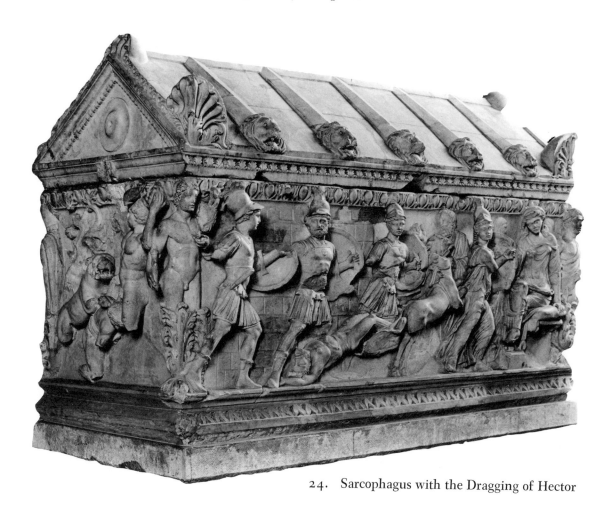

24. Sarcophagus with the Dragging of Hector

The florid decoration of the gabled lid and the moldings above and below the figures are Asiatic continuations of Hellenistic architectural enrichment and have parallels in Greek imperial public buildings. The two long and two short sides are divided by seasonal terms, springing from acanthus, into four scenes or sets of scenes. The principal side shows Achilles dragging the body of Hector around the walls of Troy. This scene is balanced on the other long side by monumental Erotes hunting a lion and a leopard, a scene reminiscent of those on "Sidamara" sarcophagi. The two short sides, characterized by the same large figures against rich backgrounds, show Hermes giving the lyre to Amphion, and a youth being slain by a lioness.

It is in the scene (or scenes) of Achilles and Hector that the Romanization of this mixture of mythology and hunting is most apparent. The cuirasses of the Greeks (and Hector, if he also appears at the left) are strongly influenced by Antonine imperial armor.[40] Andromache mourning at the right is a Greco-Roman matron, almost a cult image from an imperial temple. The walls of Troy fill the background in Roman imperial decorative fashion. In short, Hellenistic forms and an undoubtedly Hellenistic monumental treatment of the subject have been adapted to a major sculptural ensemble, one which marks a phase of Greek art filled with independence but not afraid to absorb Roman qualities of originality and excellence. The Romans, with their genius for such things, must have given impetus and organization to the manufacture and distribution of sarcophagi. They were certainly major clients throughout their empire. Recent researches indicate the problem is as commercially complex as the manufacture, distribution, and assembly of automobiles designed or marketed in Detroit, London, the Continent, and South America.[41]

The story of sarcophagi in the Greek imperial world concludes with Christ flanked by two disciples, the celebrated fragment in Berlin from Sulu Monastir (Constantinople).[42] The disciples, youthful and beardless but Roman rather than divine as is Christ, hold rotulus (right) and codex (left) and are probably apostles. They may equally well be symbols of the Old and New Testaments, figurative counterparts to the Iliad and Odyssey of older, Pagan sarcophagi. The work is variously dated between 300 and 400. I am inclined to place it around 350, on the similarity of the heads of the apostles to likenesses of the sons of Constantine. The monument is part of the tendency, stimulated by the founding of Constantinople, to bring official, pagan, and Christian art together on a lofty plane. This high level was reached by fusing diverse Greek imperial and certain Latin state formulas of artistic expression. Hellenistic feeling for vivid sculptural form lingers on in the virtual "statue" of Christ, and Roman verism in its post-Tetrarch development shows in the heads of the flanking figures. Imperial and private portraits of the

decades from 330 to 350 document this new verism, which is free or frozen depending on the proto-Byzantine tendencies of the sculptor.[43]

About twenty years earlier, that is, shortly after the founding of Constantinople, the great Victoria of the "Hunter's Gate" in Istanbul was carved (figure 25).[44] The work was very likely that of a group of sculptors brought from Rome to the new capital, men who had a few years previously executed the decorative ornament and imperial Victoriae of the Baths of Constantine and Helena on the Celian Hill in the Eternal City.[45] The giant relief in Istanbul no doubt survived because it was re-used as the angel of the Annunciation, a pendant figure (now lost) being taken for the enthroned Virgin of the Panaghia. The Victoria shows a stage in the Roman contribution to the artistic unification which led a Proconnesian or Lydian sculptor to create the Christ and apostles or attendants where otherwise a mythological or philosophic group would have been expected. Victoria is stiff, yet freely in motion; plastic, yet covered with strongly defined, linear drapery; and possessed of a face and drilled-out, topknot hair worthy of Hadrianic Aphrodisias. She is less roughly carved than her counterparts in Rome, and lacks the refinement of the Asiatic sarcophagus. Taken together, the triumphal relief and the sarcophagus were to lead to the great Roman sculptural "renaissance" of Theodosius and Arcadius in Constantinople.

Another monument, official or triumphal like the Victoria of Constantinople, links state work in Rome before 325 with that of the new capital created in the older city's image.[46] This relief, found in the city, shows an Eastern barbarian kneeling, hands tied behind him and with a small trophy at his back. The carving is high, and although there are no moldings, the slab was made for insertion in a larger complex. The barbarian is of princely class, for he wears a round cap with jeweled diadem over it. Date and style are not far from the *zoccoli* of the arch of Constantine in Rome, indicating that the work belongs soon after the construction of Constantinople. Little time was necessary for the erection of triumphal ensembles in the tradition practiced in the old capital in the previous decade.

Anatolia's reaction to the style formed in Rome and at Salonika and at Nicaea in the decades between 290 and 320 can be documented in a plaque from Philomelium in eastern Phrygia and now in Akşehir, the modern city.[47] The plaque shows two tiers, each of five soldiers with spears. A mounted officer stands to the right of either tier, and a trophy of helmet and cuirass has been set up on a pole in the upper background. The style is both an offshoot of that of the small friezes on the arch of Constantine and an early fourth-century culmination of Anatolian provincial tendencies. The figures answer all the canons of fourth-century art in Rome save that of the expressiveness seen in the Constantinian friezes and in many Early Christian sarcophagi. This Ana-

63

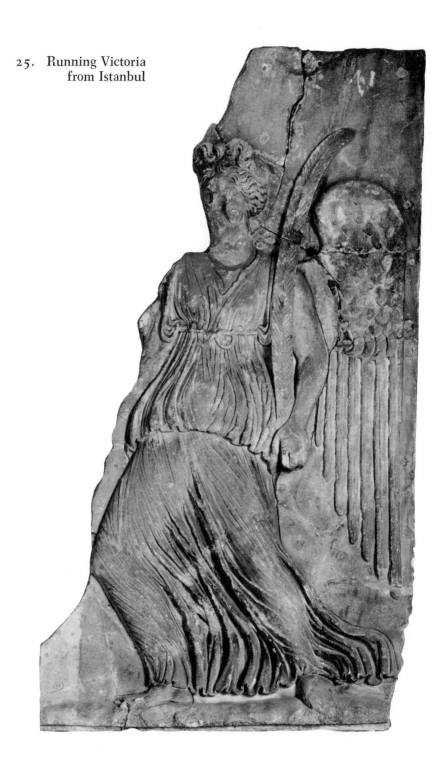

25. Running Victoria
from Istanbul

tolian urge to a pseudo-"triumphal" art in a votive plaque of secondary importance was no doubt brought about by the artistic unification of the Empire in the Tetrarch period. The sculptor of the relief from Philomelium was well aware of the local tradition in votive stelai, funerary monuments, and sarcophagi. He also understood what his more gifted colleagues in the imperial service were producing at Nicaea, Ephesus, and elsewhere.

These two monuments, minor in purpose but of a class major in influence, show some of the forces at work in the generations before the fragment with Christ and two disciples was created. From 350 to 420, the art of the Eastern Roman court became not only pan-imperial but elegant in the best Antonine tradition. A large, well-carved Christian triumphal sarcophagus in the Istanbul Museum represents a revival of good late Hadrianic to early Antonine sarcophagus carving. The work is of a type found mainly in Italy but also in western Asia Minor.[48] The short sides or ends have two apostles standing, as himation-clad philosophers, between a large cross. The principal face shows two Nikai, or angels, moving through the air sideways and supporting a Chi-Rho cross between them. The work is high in technical excellence and worthy of the splendid Antonine examples which feature Victoriae flying heraldically either side of a wreath or Gorgoneion shield. This Roman triumphal schema can therefore be followed from its Trajanic to Antonine development through its Constantinian modifications to the period of the Theodosian afterglow. "Afterglow" implies a strong flame, for what was produced around A.D. 400 was not merely a copy of Trajanic to Antonine art but a series of new creative forces. In one sense, these forces survived to the Italian Renaissance — in the elegant plasticity of Byzantine court painting (mosaics and illumination) and the minor arts (ivories and gems).

The emperor and his family could be represented as divinities, Apollo or Poseidon or Zeus for the men, and Aphrodite or Hera for the women. The ruler in civic garb, Roman toga and Greek himation, gave him the status of a paramount magistrate among the many officials of an Eastern metropolis or provincial town. Most favored was the statue in ceremonial cuirass, an effort to portray the princeps as guardian of the frontiers. State reliefs are few, and before the intense pan-Romanism of the Tetrarchs they are easily distinguished from their counterparts in the Latin West. Hellenistic mythological and allegorical reliefs developed a specific character of their own, even to the expression of contemporary events with portraits of rulers, before Roman administration fully grasped the Eastern possessions. These Hellenistic reliefs continued to be a dominant sculptural form in the East until well into the third century A.D. They are related to the strongly decorative, unspecific tendencies in East-

65

ern sarcophagi. With Constantinople's establishment in 325, Latin state narration and Hellenistic allegorical decoration were fused into a vibrant new expressiveness, partly under the aegis of the Eastern emperors and partly due to the impetus of Christianity.

IV

Epigraphic and Numismatic Evidence

THE NONSCULPTURAL, NONAESTHETIC TESTIMONY of Roman official art in Greece and Asia Minor falls into three categories: statue bases, altars or dedications, and inscribed architecture. Examples in all three may be considered works of art in themselves. A large statue base, with interesting moldings and well-carved letters, can be the very epitome of Roman imperial policy in uniting history and the visual arts (figure 165). The same applies to altars, which occasionally have the additional feature of carved decoration such as garlands and animals' heads, and symbols such as those of the sacrifice, the libation dish, the ewer, or the magistrate's staff.

Inscribed architecture is probably the most impressive feature of Roman art in the East, especially in areas from which no painting or sculpture and few coins of artistic merit survive. The stoa and its long architrave were the Greek imperial city's favorite place to honor the imperial family. The simple epigraphic dignity of the temple or stoa stems from the habits of Hellenistic rulers. A good example is the dedication of the temple of Athena Polias at Priene, about 334 B.C.; the name and titles of Alexander the Great appear on the face of a pier or anta of the building.[1] Alexander deemed himself unworthy to have his inscription on the Artemision at Ephesus. The Stoa of Attalus in Athens is a well-known example, although the inscription was neither included nor duplicated in the reconstruction of the building. The little circular temple of Roma and Augustus on the Athenian Acropolis just in front of the Parthenon has been cited frequently as a jewel of early imperial architecture and commemorative epigraphy, enhancing rather than cheapening its glorious setting.

The temple at Cyzicus, largest in the ancient world, must have been an impressive combination of elements, with its florid capitals and moldings, its inscription to Hadrian, and a bust of the deified emperor set in the pediment. Eleusis had the same combination of architecture, epigraphy, and sculpture. Perhaps to the emperor and his family, however,

the greatest honor was to see their names inscribed on a temple long famous in the annals of Greece. Nero's name and titles carved on the east façade of the Parthenon may now be regarded as the epitome of poor taste, but what can be said about the dedication to Livia by Claudius on the temple of Nemesis at Rhamnous?

Less fortuitous was the transformation of an older structure into a temple of the imperial family, either by placing their cult images inside or by surrounding the building with so many statues as to give the building such an appearance. There is ample justification for turning the temple of the Olympian Zeus at Athens into a glorification of Hadrian, the thirteenth Olympian, for he finished the building and made the city come to life again with his improvements, but the metroon at Olympia (Augustus) and possibly the Artemision at Sardes (Antoninus Pius or Marcus Aurelius) could only have been disfigured, or at least modernized in an unappealing way, by including statues of the imperial families in the structure or its portico. In the first instance they were placed in the cella and in the second probably under the colonnade of the building. One of the most successful and subtle imperial alterations to an older structure may have been the new temenos wall constructed under Augustus in 5 B.C. at the Ephesian Artemision. The inscription, repeated at least twice, also commemorated enclosure of the Augusteum within the same wall, marking indirectly the fact that the imperial cult was raised to the level of association with one of the oldest, most popular shrines in Asia.[2] For all that is said about Nero at Olympia, he did no harm to the sanctuary in adorning it with a triumphal-arch gate at its secondary entrance and with sundry peripheral buildings. Pausanias, ever ready to fault evil Romans, made no adverse comment on the four offerings of Nero (three crowns representing wild-olive leaves and one representing oak leaves) in the temple of Zeus at Olympia.[3]

The temple of Roma and Augustus at Ancyra in Galatia is an epigraphic and historical treasure-house. Besides the *Res Gestae* of the divine Augustus, which adorned the surfaces of the podium, the temple also exhibited the inscription of dedication to Augustus and Roma, and a longer text in which various local officials were mentioned for their activity in connection with the establishment of the cult. Here bilingual epigraphy made a pleasant visual contrast to the relatively rich Hellenistic carving of moldings and anta-capitals. Imperial letters to the provinces provided a wonderful excuse for visual commemoration in epigraphic form, however unimportant the text of the letter might be. The proscenium of the odeon at Ephesus contained at least two such documents. One, from Hadrian, stated only that private citizen so-and-so was known to the imperial authorities and should be afforded the courtesies of some one with imperial connections. The letter from Antoninus Pius told the good burghers of Ephesus to stop their petty squabbling with

Smyrna over styles and titles of address between the two cities. Smyrna received similar advice — "Be correct in your dealings with the Ephesians" — which no doubt also was inscribed in a prominent place in that city.

The temple of Zeus at Aezani in Phrygia must have resembled an imperial dispatch-box, the walls being littered with letters from Hadrian, imperial decrees, and records of local affairs. All this might seem little more than political or commercial convenience, when price-decrees and the like on the walls of the Roman agora in Athens are mentioned, but the majesty of styles, titles, and sentence structure in these imperial communications or commemorations made them a visual link with imperium in the cities of the provinces. Balbura in Lycia has yielded an inscribed letter, from Antoninus Pius in 158, which carried the practice too far: addressed to the Balburians, it concerns the treatment to be accorded to Meleagros, son of Castor, a victor in musical contests! Surely the Antonine *pax Romana* left the emperor better things to think about than a local lad of artistic leanings. At any rate, the Balburians were proud of the imperial notice achieved by their talented son.

Although the work of art they once supported has in most cases been lost, statue bases reveal much about Roman art in Greece and Asia Minor. The bases which held statues of the imperial family reveal a great deal about imperial or public art in these areas. A survey, employing the standard collections of Greek and Latin inscriptions, and the additions made by those who still tramp about with brush and squeeze-paper, shows that every city, however small, must have set up statues of at least a half-dozen members of the imperial families from Augustus through the fourth century to the house of Theodosius. The larger cities, of course, had statues of nearly every important emperor, and often possessed a number of statues of the same ruler, scattered throughout the city. Few cities aspired to exhibit the number of Hadrians seen by Pausanias in the precinct of the Athenian Olympeion, but several centers in Asia Minor could boast of a roughly comparable aesthetic experience.

The imperial statues of emperors probably were divided equally between those showing the subject in cuirass, those presenting him in the toga or himation, and those representing him in the heroic nude guise of a divinity or major hero.* From Asia Minor, in the first category there is the Nero from Tralles, in the second the bronze Hadrian from Adana, and in the third the marble Lucius Verus from the odeon at Ephesus (figure 5) or the bronze athlete remade as Trebonianus Gallus from Samsun. The great bronze Septimius Severus as Mars Pater from Cyprus is still another indication of a type of imperial art that must have been fairly common in the wealthy cities of Asia Minor (figure 156).

* As already suggested, imperial cuirassed statues seem most numerous, perhaps because they are readily identifiable even when headless or fragmentary.

There is little evidence concerning equestrian statues beyond the indications that Constantinople in Late Antiquity possessed such representations of Constantine the Great, Theodosius, or Justinianus. The marble statue of an Antonine general from Melos is unfortunately too ruined for identification. There are the bases of the statues of Tiberius and Agrippa in Athens, on which they were probably represented in quadrigas. Since the chariot groups were set on bases originally used for Attalus and Eumenes, the likenesses of Augustus' sons-in-law may have been achieved merely by altering the heads of older, Attalid statues.

In Asia Minor the distribution and frequency of statue bases, and therefore of statues, follow the pattern set by Greek imperial coins. Coin frequencies are an excellent yardstick since amount minted and amount surviving invariably are related. Where coins are plentiful and rulers represented in abundance, statues are numerous. There are, of course, exceptions. Deserted sites that have not been excavated, such as Aspendus or Sillyum in Pamphylia, have yielded few inscriptions in proportion to their size and prosperity. These sites, incidentally, yield few coins, although the former was one of the great coining-centers of antiquity. The excavations of the decade from 1945 at Perge and Side show how quickly the pick comes upon complexes of imperial commemoration in architecture, sculpture, and epigraphy. The biggest and most often and thoroughly excavated centers in Roman Anatolia, Ephesus, and Sardes, for instance, have produced the richest epigraphic harvests.

Considering her commercial prosperity and her coins, Smyrna ought to have produced more traces of imperial art; but the Greco-Roman city has enjoyed nearly continuous habitation through the Middle Ages to the present, and most ancient buildings disappeared long ago. Those resurrected by the excavations of the last few decades in the area of the Roman agora belong to the period of rebuilding after the earthquake of A.D. 177. The inscriptions, the marble triad of local divinities, and the head of Faustina II sculpted as ornament on the arch of an entrance to the agora give some slight indication of the imperial riches that must have once characterized Greco-Roman Smyrna. At the other end of the scale, Pisidian Termessus has yielded traces of at least six imperial statues, ranging from Augustus to Caracalla. This number for a city of its size is explained by the fact that the site has been deserted since Late Antiquity and very little has been carried away from its inaccessible heights in modern times for building material.

The Julio-Claudians and Hadrian dominate the art of statues and related commemorations in Greece. Save in Athens and at Olympia (there thanks to Herodes Atticus) prosperity economic and consequently artistic did not extend much beyond the Antonine period in Greece and the islands. Even before A.D. 200 the mainland had been subjected to disastrous Barbarian incursions, and more were to come with the Heru-

lians in the following century. The exception is, of course, the military center of Thessalonica with its burst of public and private stelai and sarcophagi, creativity leading up to the official monuments under the Tetrarchs. This city, however, was tied as much to Asia Minor, the northern defense routes, and Italy as it was to the central Mediterranean, that is, Greece. At many centers in Greece and the islands — Megara, Epidaurus, Delos, and Lesbos, for example — groups of Julio-Claudian statues are found arranged in or near the principal shrines. At Delos, the temple of Apollo was visually transformed by the presence of sculptured testimonials to Augustus, Livia, and their successors.

Hadrian revived a commemorative art that had lagged considerably under the Flavians and somewhat under Trajan. Attica's count of over one hundred surviving statues, altars, and dedications in the name of Hadrian is made up chiefly of the statues in the Athenian Olympeion, but even without these the number would be more than double that of the nearest imperial rival. Attica was busy producing statues of Trajan, but most were exported to the island of Samos, to Cos, to Olympia, to North Africa, and certainly to Asia Minor, where bases are not infrequent.

INSCRIPTIONS OF ILIUM

Ilium (Troy), for its size, was a place of special importance owing to the legend of Rome's founding by descendants of Aeneas. The Gens Julia, claiming the primacy of descent from Aphrodite's son Aeneas, were there early in the first century B.C., when a statue and dedicatory inscriptions were carved to L. Julius Caesar, consul in 90 B.C. In face of this competition, it is not surprising to find Pompey the Great being commemorated with a statue in 66 to 62 B.C., when he was imperator for the third time. The generals and important Romans in the provincial government of the Republic were honored by local cities and by their fellow Romans resident in Greece and Asia Minor. Their statues stood next to those of the successors of Alexander throughout the Greek world. They were often represented as Hellenistic rulers, a tradition going back to the gold stater of T. Quinctius Flamininus, the Roman general who defeated Philip V of Macedon at the battle of Cynoscephalae in 197 B.C. Flamininus has been made to look very like his regal rival Philip the Fifth.[4]

Augustus did a great deal for Ilium, and it is more than natural that he figured prominently in the city's commemorations. There were at least three dedications in his name, and these may have all been statues. Two of the dedications took the form of flowery tributes, and the third was a statue in the name of Melanippides Euthydikos (12–11 B.C.). The most glorious honor afforded the first emperor was a dedication in

letters of bronze on the temple of Athena Ilias. This temple was first built by Lysimachus, badly damaged about 85 B.C. by Fimbria, and renovated under Augustus. The inscription reads: "The emperor Caesar Augustus, son of the divine Julius, to Athena Ilias."

In addition to Augustus, there were naturally statues of Agrippa (18–13 B.C.), Gaius Caesar (1 B.C.), Antonia Augusta (A.D. 14–19) and Tiberius (A.D. 32–33). The site has also been rich in the number of Julio-Claudian statues that have survived along with their bases (figure 122). A stoa near the temple of Athena was furnished with dedications to Claudius and Agrippina the Younger, and an unusual series to the children of Claudius, including Nero, who, as an imperial youth, had pleaded Ilium's case for imperial aid in the courts of Rome. When the Flavians came to power, a shrine to the Gens Flavia was built, and the list of donors who gave the building has been preserved in an inscription. A triple statue base to Vespasian, Titus, and Domitian has also survived. The site has yielded the inevitable altar to Hadrian, and no doubt Ilium joined nearly every other Greek imperial city in honoring him with a statue. The final and latest imperial record is a dedication and honors paid Zeus and Minerva in the names of Diocletian and Maximian (A.D. 293–305).

THE ROMAN COINS OF ILIUM

The Greek imperial coinage of Ilium effectively begins about 19 B.C. with small bronzes bearing the cistophorus (imperial tetradrachm) or western Asiatic numismatic portrait of Augustus on the obverse and a series of simple reverses recalling the more glorious Hellenistic tetradrachms of the city.[5] A foreshadowing of the traditional themes which appeared in the reverse designs of the second century is seen in the boldly frontal design of Aeneas carrying Anchyses from the burning city. Throughout the remainder of the imperial series, the proportions, size, and quality of the coinage run true to the pattern encountered throughout Asia Minor. The Julio-Claudians, especially Caligula, issued dynastic types that emphasize their portraits and their relations with the divine Augustus. The Flavians continued this policy with the slight variation that they managed to crowd all three of their portraits and a statue of Athena on one small bronze. An anonymous issue of Titus or Domitian shows the bust of Ilium's Athena on the obverse and on the reverse presents the Anchyses motif again, in a forcefully Flavian style. Aside from these, die designers in the first century tended to be delicate, even timid.

Hadrian increased the choice of reverse types in a series of seven different small bronzes. Antoninus Pius produced only a crude semis with his portrait on one side and bust of Athena on the other. The advent of Marcus Aurelius to the imperium in A.D. 161, a rule shared for nearly

a decade with Lucius Verus, began a great age of Ilium's coinage, one that lasted for exactly a century until the mint was closed under Gallienus. The coins, still bronze or copper as in the earlier reigns, are impressive in size, corresponding to the Roman sestertius, dupondius, and as. Until Septimius Severus the quality of the dies was on a par with that of the Rome mint, and often the style was such as to suggest strong influence from the capital. After 200 the coins are no less impressive in size and variety of types, but the style begins to become that characteristic of Greek imperial coins of Asia Minor in the third century. The portraits are transformed into somewhat brutal caricatures of individual rulers until by Gallienus it is hard to tell whether the die cutter had him or Decius or Philip the Arab or even Caracalla in mind. Certainly the distribution of official portraits from Rome by way of Athens and Smyrna or Ephesus had broken down.

The most popular reverse type, striking in its sense of motion, is the scene of Hector galloping into battle in his biga. Gallienus used the design for an issue of large sestertii produced on the eve of the closing of the mint (figure 87). Commodus' reverse of Ganymede and the eagle, a composition from Hellenistic minor arts, is worthy of Antonine imperial medallions struck at Rome in the level of its design and execution. One of the more dramatic reverses belongs to a very large sestertius of Macrinus and shows Hector in the midst of combat over the body of Patroclus. The sense of crowded struggle is baroque indeed. Septimius Severus had presented a simpler version of this theme on a sestertius a few years earlier. Only Hector in armor and the fallen Patroclus are present, the former standing over and drawing his spear from the body of the latter. The later die designers of Ilium were men of ability. They took naturally to the broad flans and bold compositions of the Antonine baroque, carried its style into the third century, and were practicing a vigorous version of its expressionism at the very moment when non-artistic considerations (the economic crisis of 260) witnessed termination of the series.

FROM THE FLAVIANS TO THEODOSIUS

The Flavians, especially Domitian, concentrated on the selective establishment of their family cult in key cities of Greece and Asia Minor. They usually designated cities with firmly established Roman connections or with a substantial tradition of Roman monuments, as the temple of the Gens Flavia at Ilium, Domitian's temple at Ephesus, and the inclusion of Titus and his daughter Julia in the metroon at Olympia illustrate. Elsewhere the Flavians are characterized by useful works, such as the dedication to Vespasian and Titus (A.D. 77–78) in connection with a bridge across the Calycadnus near Seleuceia, or by single statues, such as that to Vespasian at Eresus on Lesbos or that to Titus

at Myra in Lycia. No doubt something of the scarcity of Flavian statues is due to the damnatio suffered by Domitian in 96. His family escaped, and thus Pinara or Combis in Lycia has yielded a double dedication, probably a statue base, to Julia daughter of Divus Titus and Domitia wife of Domitianus Augustus (81–91) from the Boule and Demos of Pinara.

In Asia Minor the Flavians coincided with a period between two great eras of prosperity. The cities were rich enough, and there were public buildings that are purely Flavian. Sextus Marcius Priscus, imperial legatus, erected the gate of the lower city and a statue to Vespasian at Xanthus, and in A.D. 80 the council and citizens of Aperlae, through the legatus Titus Aurelius Quietus, completed baths and a portico in the name of the emperor Titus. Heavy, Roman, and out of place though it is amid the Lycian funerary architecture of Xanthus, the Flavian gate was Hellenistic in its mixture of Greek architectural details, having triglyphs and metopes carved with busts of divinities such as Apollo and Artemis. Generally speaking, the Flavian era did not witness the wave of rabid building that went on between 120 and 170. Very little was done in Greece, and there are scarcely any traces of the Flavians in Athens or even at Corinth.

Nerva ruled for too short a time to leave any traces in Greece and Asia Minor. Cistophori from western Asia Minor and silver from the prolific mint of Caesareia in Cappadocia exist with his name and portrait, but otherwise his coins are few. He was honored by statues at Ephesus for example, but it is as a divus and the adoptive father of Trajan or grandfather of Hadrian. In the latter role, especially, his name is found throughout the East, as an opening phrase in imperial titles in which his name is linked with the official dynasty of Trajan and Hadrian.

Trajan, on the other hand, ruled for a generation and spent the last five years of his life directing affairs in Armenia, Mesopotamia, and Parthia. There were temples to him at Selinus-Trajanopolis where he died and at Iotape also in Cilicia. On a vaster scale there was the great Hadrianic shrine at Pergamon. In Greece he figured prominently in the Antonine nymphaeum of Herodes Atticus, as an official ancestor of Antoninus Pius (figure 6). The Roman agora at Samos possessed his heroic marble statue, representing him as ruler of the land and the sea. Aside from the scattering of statue bases throughout Anatolia, there is really nothing unusual to mark the effect of Trajan's Eastern policies, perhaps because the Parthian war ended rather disastrously, not only with a renouncement of Trajan's conquests but with the devastatingly widespread revolt of the Jews which upset Hadrian's first years of power.

Hadrian has appeared over and over again in these pages, and he is mentioned once more because no critic now can avoid the fact that his statues ornamented Greece and Asia Minor in a profusion barely imaginable even when all the statue bases and altars are counted. His own

temples count strongly in any study of Greek imperial art and architecture. In addition, he stood beside previous emperors in many older shrines or in buildings built by him for commemorative purposes, such as the Trajaneum at Pergamon. However small the city, if any emperor was represented it was bound to be Hadrian. Mytilene on Lesbos had no less than five altars to him as Olympian. Heretofore this city had been principally a cult center for Augustus and his family. Mysia, Apollonia, Miletopolis, and, of course, Cyzicus, where the greatest Hadrianeum stood, have produced dedications to him almost to the exclusion of all other rulers. Termessus Major in Pisidia had at least two statues: a dedication on a gate of the inner city, and an altar. The list can be scanned in this fashion from Macedonia to Cilicia, and the accumulations of Hadrians in all forms are monotonously repetitious. Yet all this must have been to a great extent the result of genuine gratitude for the peace Hadrian brought to the empire, for the prosperity which befell Asia Minor, and for the personal attention given by the emperor to the Hellenic world.

Antoninus Pius was the successor of Hadrian in many contrasting ways. He paid honors to the memory of the man who had made such a mark throughout the Greek world. The great altar at Ephesus was a sculptural tribute to his respect for the complex dynastic arrangements made by Hadrian. By way of personal preference, however, Antoninus Pius stayed in Italy through his nearly twenty-five years of rule and did not manifest the Philhellenism of his predecessor. The Greek world did not honor Antoninus Pius as lavishly as Hadrian, but he was not neglected. Statues existed in considerable numbers, as their bases testify, and patrons such as Herodes Atticus or the rich ladies of Lycia and Pamphylia honored the emperor in adorning their native cities with public buildings. The same balance of public and private commemorations of the imperial family was maintained in the reigns of Marcus Aurelius, Lucius Verus, and Commodus. The last-named was partly eclipsed by damnatio, but the Severan dynasty set up the old monuments to Commodus and encouraged new ones, for Septimius Severus regarded him as his imperial "brother" in an effort to circulate notions of dynastic continuity.

The century from Septimius Severus to Diocletian divides itself into three sections: the rule of Septimius and his family through Severus Alexander; the varied procession of emperors from Maximinus the Thracian through Valerian to his son Gallienus; and the recovery from extreme crisis in the generation from A.D. 267 to the formation of the Tetrarchy after 290. There was no diminution of imperial statues and dedications in the names of Septimius Severus, Caracalla, and Geta. Geta's name was systematically removed from everything after A.D. 212, but the many altars, milestones, and statue bases have survived. Caracalla

had a temple at Pergamon; on the epistyle was a dedication to "The Emperor from Pergamon, the City of the Third Neocorate." In the Antonine period Greek imperial coins were plentiful enough throughout the East, but under Severus and Caracalla the issues assumed a truly baroque grandeur. Such was the case with the coins of Ilium. Lots of big bronzes were struck, and reverse designs included vistas of cities and their temples, as well as the traditional gods and city symbols.

Severus Alexander did enough for the empire to be remembered by occasional statues and a number of milestones. He and his mother, Julia Mamaea, suffered a damnatio of sorts, but it did not affect his posthumous popularity as the last legitimate Severan. The next emperor to leave noteworthy traces in the Greek world was Gordianus III. At a time when any form of imperial monument was rare, his statues and milestones testify to an influence in the East beyond that normally accorded a boy emperor in a world where strong generals held sway. Thus, at Idebessus in Lycia several cities in alliance joined together to put up a monument to the young emperor, and at Akardja, formerly Cinna, in Galatia there was a dedication to him. Perge in Pamphylia had a pair of statues to Gordianus I and II from the Gerousia, and a statue of Gordianus III set up after A.D. 242 also in the name of the Gerousia and as a pendant to the previous two. Although short-lived in imperial power, the first two Gordians and the Senatorial emperors Balbinus and Pupienus were revered in the East as representatives of the aristocratic, para-military tradition of empire.

Statues of these martyrs were in demand, as the discovery of the colossal marble Balbinus as Zeus and fragments of a corresponding image of Pupienus in Piraeus harbor testifies (figure 167). Coins of Gordian the Third continue the grand Severan tradition in Asia Minor. One of the most beautiful or at least unusual issues is the large bronze commemorating the alliance between Side and Perge, the reverse showing the goddesses of the two cities shaking hands amid their attributes (figure 96). One of the most unusual issues belongs to Seleuceia in Cilicia and features busts of Gordian and his wife Tranquillina on the obverse, matched by busts of Apollo and the Tyche of the city on the reverse.

After Gordian the Third, coins continue to be struck by cities in Asia Minor to Claudius II (268–270), who rebuilt the walls of Nicaea, and Aurelianus (270–275), who brought Palmyra and its dependencies back into the empire. Statues, altars, milestones, and other commemorations are encountered infrequently, however, for the period was not one of creative activity. An exception occurs under Valerian (253–260) and his son Gallienus (253–268), emperors who faced the impossible task of checking the rising, rejuvenated Persian empire on the eastern frontier. Milestones testify to imperial efforts at keeping vital communications in

repair. New building of a nonmilitary nature is rarely recorded anywhere in an age which saw the fairest cities of Greece devastated by the Herulians. The period has yielded few sculptures that can be classed as works of art — the possible Trebonianus Gallus from Samsun on the Black Sea being one of the few exceptions.

The revival under the Tetrarchs (292–305) was marked. Many areas produced no important imperial monuments between the times of Caracalla and Diocletian. The utilitarian nature of Tetrarch and Constantinian art is stressed in the great number of milestones. From Constantine the Great the line can be traced in a steady level of revived imperial activity to the house of Theodosius and thence into the fifth century. The types of inscriptions remain the same, those on statues and milestones; altars, of course, disappeared with the suppression of the pagan traditionalist Licinius in 325. A great gap exists in which there were no longer any Greek imperial coins, only Eastern mints producing designs and styles often indistinguishable from those of the mints to the west. Latin was the universal language of coins and the chief script of inscriptions in the fourth and early fifth century, although the empire was to emerge as Hellenistic again by A.D. 500.

Coins and inscriptions from the Greek imperial world go together and are singularly revealing, more so than in the Latin lands of the empire. The Greeks loved to inscribe tributes to persons and events, just as they enjoyed making speeches. Since every city, large or small, had a partly autonomous coinage, these coins reveal much more about local affairs than the uniform, Rome-oriented issues of Italy, Gaul, Britain, Spain, and western North Africa. Intensive study of coins and inscribed altars, bases, and architecture from a single city, Ilium in the Troad, shows how closely numismatic and epigraphic documents are allied. The Greek imperial coinage did not survive the monetary crises under Gallienus and Aurelian. The Tetrarchs instituted a Latin coinage at all the major mints of the empire, and this system was continued until after the fall of the Western Augusti in 476. Styles varied from region to region, but Eastern imperial coins were no longer a prime source of history, religion, architecture, and iconography. From Augustus to the house of Theodosius epigraphic monuments reflected the fortunes of empire with a predictable fidelity. Strength and prosperity has left many traces, but civil war and frontier disaster has usually marked a reign in which little creative was accomplished. An exception might be in the matter of milestones. Some of the evilest or, at least, most unfortunate emperors did the most for Asia Minor's network of roads, if only to secure their own precarious claims to the purple.

V

Single Monuments and Important Men

CERTAIN WORKS OF ARCHITECTURE and sculpture in the East are unusual if not unique. Other monuments are worthy of individual attention because of their striking originality and their permanent influence on later works of art and architecture in the Greek world or in both the East and the Latin West. All help to define the character of imperial Roman art in the Greek world.

TRIPLE ARCHES AND GATEWAYS AT PISIDIAN ANTIOCH

The function and importance of the triple gateway in the Greek imperial cities of Asia Minor can be emphasized by analysis of two examples, one Augustan and one Severan, at Antioch-toward-Pisidia or Colonia Caesareia, as the city was called when it became a Roman colony under Augustus. To an area already enhanced by a triple arch to Augustus, patron of the revitalized city, and an Augustan propylaea, a Severan triple city gate was added two centuries after the original constructions. The Augustan colony in Pisidia offers a splendid demonstration of the artistic relation of two triple-arched architectural complexes, standing within a relatively short distance of each other. The sculptural enrichment of the two triple arches and the propylaea is Hellenistic or, more especially, Greek imperial, but motifs on the Severan gate, with inscription of G(aius) Jul(ius) Asp(er), Consul in A.D. 212, have come to assume a character specifically Roman imperial rather than simply vestigal Hellenistic.[1]

On the triple arch of Augustus, the spandrels of the north and south arches were enriched with winged Victories or Genii holding festoons of fruits and flowers and trailing fillets or ribbons. This is a typically late Hellenistic design repeated under the impact of Roman triumphal art and developed into a standard repertory of the imperial East. The central spandrels were occupied by nude and draped Pisidians with hands bound behind their backs, a wreath and a flaming torch in the field beside each. The captive Pisidians are treated as rough versions of Per-

gamene giants, or the Gauls of post-Pergamene decorative sculpture. Wreaths and flaming torches are standard devices for filling space in Hellenistic architectural relief, examples occurring in all periods at Eleusis (where the torch was most appropriate) and in Asia Minor (on gates, statue bases, and balustrades). The frieze of the Propylaea is filled with marine motifs, an old Hellenistic decorative notion which can be connected in Augustan art with the crucial sea victory at Actium in 31 B.C.

The Severan gate moves toward something closer to the stream of Roman imperial commemorative art, whether in Asia Minor or Rome and whether on the reverses of coins or in monumental relief. Its principal iconographic motif refers to the Severan victory at Ctesiphon in A.D. 198, where Septimius Severus sought to repeat the military glories of Trajan and the diplomatic successes of Augustus over the Parthians. The central spandrels are occupied by a pair of kneeling Parthians, the one on the left holding a *vexillum* and his counterpart on the right offering a standard. The frequent Greek imperial design of garland-bearing Victories (and Genii) has been postulated in the restoration for the spandrels of the side arches. These kneeling Parthians and the enrichment of the Augustan arch at Pisidian Antioch may go back iconographically and architecturally to the triple arch of Augustus in the Roman Forum. The design of the Parthian kneeling to return a Roman standard is found on Augustan denarii struck in Rome in 18 B.C., and the way the figures are arranged on the coins points to derivation from a major architectural composition.[2] While connections with the arch of Augustus near the temple of Divus Iulius in Rome cannot be proven, the Augustan coins demonstrate that the principal design of Asper's arched gate at Pisidian Antioch was common to the Roman imperial repertory exactly two centuries before its first documented appearance in monumental architecture in the imperial East. The coin design, in addition, may have originated in Asia Minor or Syrian Antioch, and too much emphasis can be placed on this one motif as a step in the Romanization of the Severan gate at Pisidian Antioch in terms of triumphal art in Rome, even though the gate was built in the fourth century of Roman imperium in the East.[3] There is no reason why Asper's gate could not have had older prototypes in Asia Minor or Syria. The kneeling barbarian was a popular figure in many phases of imperial art.

THE SEVERAN PROPYLAEA AT CYRENE

The city of Cyrene and its environs along the African coast west of Egypt could be included in this book, for Cyrene was tied to the Greek world from the era of Greek colonization. The prosperity of the Cyrenaic pentapolis in classical and Hellenistic times is well attested. Cyrene became a Roman province in 74 B.C., and was joined with Crete seven

years later. By the time of Septimius Severus, the city was still being rebuilt following the violent Jewish uprisings in the last months of Trajan's reign. The great temple of Zeus had a late Antonine cult image modeled in respect to size and details on the Pheidian Zeus at Olympia, a city with which Cyrene had long enjoyed ties.[4]

The Severan propylaea are typical in message and decorative detail of such structures throughout the Greek East.[5] The inscription in Greek on the architrave gives the imperial titles and dedication. The scene of combat on the frieze above is a traditionally Hellenistic type carried late into the Roman Empire. It is a timeless, not very elegantly carved view of Greeks fighting Persians or Parthians. Hellenistic motifs abound, stock poses from sculptured or painted struggles going back through the frieze of the Artemision at Magnesia to the Mausoleum at Halicarnassus in the fourth century. There are trophies and bound barbarians, a Roman triumphal touch amid the strife, and some of the protagonists are nude. The architecture is in essence an entablature on columns, serving as a curtained gate, a type of structure common at Corinth and in Asia Minor.

The style of the frieze is very good, and the figures are round, plastic, and (in the ideal heads) thoughtfully modeled, with drilled channels evident only in accessories such as costume and, occasionally, hair. The drill is boldly used, but only to strengthen lines and not to create broken-up areas or effects of liquid shadow. The figures stand out confidently from the background, and several heads protrude remarkably. There is, however, a tendency toward crudeness in the faces, enlargement of heads, and general dumpiness. In many motifs and details this aspect of style looks back to the Column of Marcus Aurelius in Rome, but it also anticipates the Late Antique Hellenistic qualities of the Arch of Galerius at Salonika or the plain primitivism in Roman imperial terms of the little friezes in the Arch of Constantine in Rome. Comparable Severan reliefs are those on the Arch of Septimius Severus in the Roman Forum, but the reliefs of the propylaea at Cyrene are much more Hellenistic in subject, composition, and sculptural emphasis. This frieze marks a merging of Italian or Germanic and Hellenistic imperial tendencies in Roman triumphal art at Cyrene.

THE MONUMENT OF PHILOPAPPOS IN ATHENS

What remains of this striking monument on Mouseion Hill (figure 26) is the ornamental façade of a large quadrangular mausoleum, only a few connecting and foundation blocks of which have survived. Dating in the last four years of the emperor Trajan (more precisely, from 114–116), this commemorative ensemble glorifying the Commagene and Seleucid houses has a mixture of Hellenistic and Roman features which is both progressive and retrospective. The feeling for architectural and sculp-

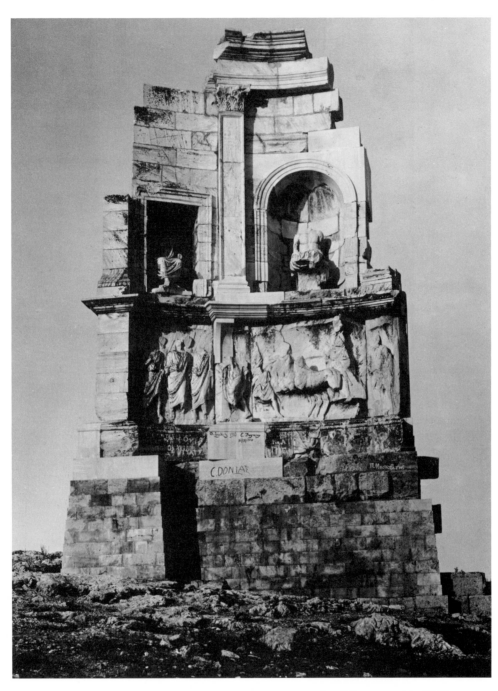

26. Monument to Philopappos

tural form in the concave façade with its niches, entablatures, and pilasters anticipates Hadrianic work in Rome and certain civic structures in Asia Minor and Syria in the third century. As a piece of architecture in Greece the Philopappos monument must have been a rare structure. There were certainly other monumental tombs on the road to Athens, for Pausanias speaks of several. The façade of Philopappos and his ancestors, however, is more of a nymphaeum without water than a funerary structure in the Greco-Roman sense.

The sculptured reliefs of the monument are as striking as its architecture. The relation of the *processus consularis* panels to the scenes on the Arch of Titus in Rome, whether by coincidence or because sculptors from the same atelier worked on both monuments, has long been recognized as one of the few positive, visual links between Eastern and Western Roman triumphal art.[6] The so-called Flavian illusionism of the Arch of Titus has been toned down in what remains of the Philopappos reliefs. The sense of a crowd scene appears in the group of lictors at the left, but here Greek desire for orderly frontality and even arrangement in two rows has left its influence. The central scene, divided into three slabs, has much of the constructional sense of a large Attic grave stele in triptych form, two isolated figures on the sides and the consular quadriga with one attendant at the head of the horses in the center. The technical details of carving are typically second-century Athenian, and the use of drill and claw chisel, incisive lines and smoothed surfaces, some slightly roughened to receive paint, can be paralleled precisely in Attic grave reliefs of this decade.

The remainder of the monument is a true document of imperial Hellenism in the Greek East. The inscriptions honor Philopappos, his grandfather King Antiochus of the Commagene, and their ancestor Seleucus I Nicator, general in the armies of Alexander the Great and founder of the Seleucid dynasty. One inscription, in Latin, spells out the Roman career of Philopappos and pays the compliment of power to the emperor Trajan. This mixture of genealogies, titles, and compliments to the real ruling power is characteristic, over and over again, of the Greek approach to state or state-triumphal art under the Roman rule. There is no loss of Greek dignity; in fact, the Hellenes almost appear to be continuing rulers, with the Romans as a form of political appendage to their glory.

In the ultimate detail of the monument, unfortunately less than two-thirds preserved, the Greek or Hellenistic element reigns supreme. This detail is the series of three statues of Antiochus, Philopappos, and Seleucus, the last having vanished completely. Philopappos is in the half-draped, heroic, seated pose of a divinity or a heroized philosopher. King Antiochus is seated in the costume of an Athenian magistrate or important citizen, with chiton covered on the left shoulder and around

the lower limbs by an ample himation. It is, after all, to Athens, intellectual capital of the Hellenistic and Roman imperial worlds that Philopappos came to be buried and commemorated. As a Hellenistic ruler, or the descendant of same, he was only doing what Antiochus the Great had done at the Olympeion and the Pergamenes had carried through around the Acropolis in offering material homage to the city of Socrates, Plato, and the playwrights. In this sense, as he sits in the pose and costume of the gods on the Parthenon's East Frieze, he seems hardly affected by the Roman world about him. The Romans had deprived his family of real power, given him some extra titles, and allowed him to prosper in peace. Philopappos made slight concessions artistically and epigraphically to the Romans in commissioning his monument; otherwise they might never have existed. This approach is a basis of Greek art in the imperial East, of imperial art in Greece and Asia Minor.

THE FAÇADE OF THE COLOSSAL FIGURES AT CORINTH

The façade with colossal figures was a form of stoa, which has been reconstructed as serving mainly to ornament and complete the north boundary of the agora at Corinth.[7] The structure had eight colossal male and female figures on bases; they served as supports for the pedimental center and flanking roof of the upper story. The two principal surviving figures are male Eastern barbarians, in Phrygian caps, tunics, cloaks with brooches, and trousers (figures 27, 28); one is a mirror image of the other, the head, arms, and upper part of the torso being in matching, opposite poses. The reliefs of the two bases are carved with scenes generally symbolic of Parthian or Armenian triumph. The first presents Victoria crowning a trophy, with a bound Eastern prisoner standing at the left (figure 30). The second is somewhat more complex, showing a mourning female, a child captive, a pile of shields with a helmet on top, and, at the right, a standing barbarian (figure 29). These two scenes are conventionally Roman in their arrangement of "barbarian" motifs, an expression of what occurs on Roman cuirasses and decorative work in the minor arts. It is as if the Greek sculptor had been ordered to carve "Roman" scenes with only a work in the minor arts as model and means of contact with what his cousins were producing in the imperial capital. The figures are like little statues poised against neutral backgrounds, with no Hellenistic or Roman feeling for relief. If the sculptor of the bases worked elsewhere, he was probably at home carving grave reliefs in the Attic tradition such as the stele of the imperial knight Timokles at Epidaurus and its few Severan successors.

On style the sculptures can be dated in the early third century. Students of sculpture and architecture have suggested a date of about A.D. 150, but the carving of the reliefs parallels Severan compression of proportions in the scenes on the Arch of Septimius Severus in Rome. An

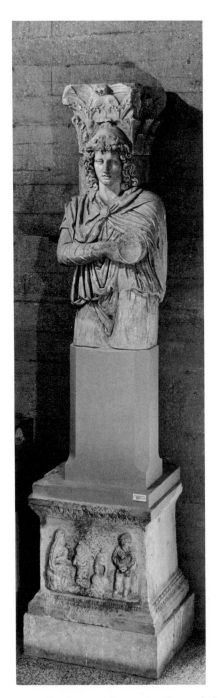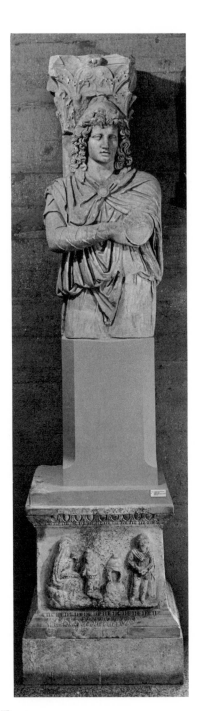

27. Sculptures from the Stoa of the Colossal Figures

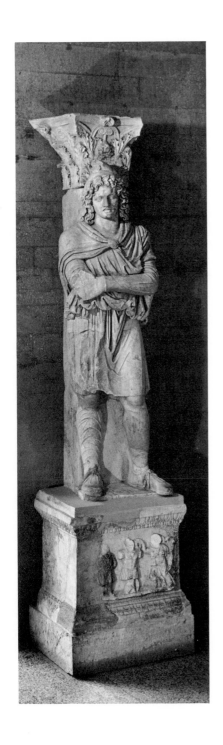

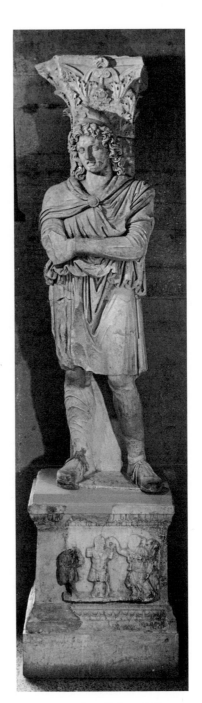

28. Colossal Figure

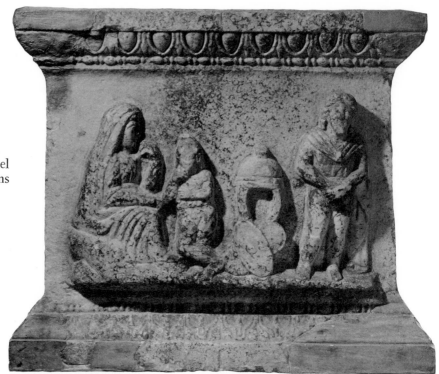

29. Panel
with captive barbarians

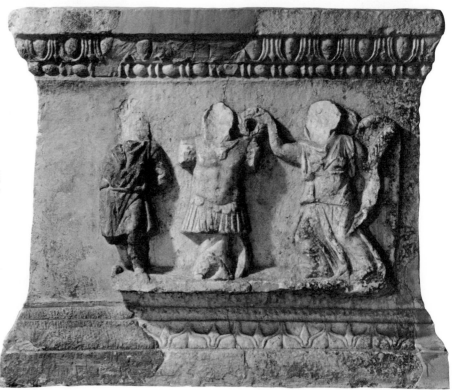

30. Panel
with Nike crowning trophy

Antonine date would mean that reference to Eastern triumph must be general, with memories of Trajanic-Hadrianic wars in Parthia and Judaea and Antoninus Pius' intervention in the affairs of Armenia uppermost in the minds of the designers. There is of course the possibility that the captives commemorate the triumph of Lucius Verus over the Parthians in 165, but this event was attended by calamities, such as a great plague, which left little time for rejoicing in Greece and Asia Minor. A date in the first years of the third century, however, would bind the Façade of the Captives to commemoration of the Parthian victories of Septimius Severus. These decisive military actions were remembered all around the Mediterranean, most notably by the arch in the Roman Forum (A.D. 202 or 203) and the arch at Lepcis Magna in Tripolitania (probably 203). In other, less topical and purely decorative contexts, such as the Odeon in the Athenian Agora or the Theater of Dionysos in Athens, these architectural figures could just as easily be Tritons or Silens. The type of colossal "Parthian" used at Corinth parallels and is reflected in western Asiatic or Lydian sarcophagi in the third century, as a fragment of exceptional quality in Oberlin (Ohio) from the region of Smyrna shows.[8]

A surviving ceiling slab of the lower order of the façade has busts of Helios and Selene in inset coffering, designs similar to those found in more broken-up, undercut form in the Antonine constructions at Baalbek. The Selene, with her crescent behind her shoulders, is very reminiscent of a small bronze steelyard weight blown up to large scale. The school of architectural sculptors that carved this slab worked in a style that is less crisp and Attic, more drilled and Hellenistic than the statues or their bases. Of the other monumental figures, only two heads of females survive. Mixing prototypes of the fifth and fourth centuries, they are faithful copies of Hellenistic works in the tradition of Agorakritos, with upswept hair recalling the "Themis" of Rhamnous.[9]

The whole monument reflects an Attic version of the Antonine baroque, based on Pergamene models carried into the Severan period and thus going back again to Athens of the fifth and fourth centuries, the hundred years from Pheidias to Lysippos. So far as technique goes, the colossal figures show the force of Attic classicism at a late date in its imperial history. The tradition of Hadrianic and Antonine Attic sarcophagi is followed, and the violent, broken-up undercutting or drilling found in so much decorative or funerary sculpture in Rome, thanks to the Flavian revival, or in Asia Minor, thanks to Syrian optic influences, has been avoided in a monumental way. Despite the attempt of the statues to fit into the scheme of Roman imperial triumphal iconography, they recall Pheidian Athens in the same sterile way, and to a degree only slightly less traceable, than the sea-gods of the Odeon in the Athenian Agora recall the Poseidon of the Parthenon's West Pedi-

87

ment.[10] They are too filled with the sense of their architectural purpose and too mindful of Hellenic tradition to represent Roman art in Greece. Since many would say the captives at Corinth cannot be removed from the repertory of Rome's triumphal art in Greek lands, they further illustrate how Greek this art usually is.

CAPTIVE BARBARIAN FROM ALEXANDRIA

The fragment of a bearded, kneeling figure in the British Museum is said to come "from the so-called Palace of Trajan at Ramleh."[11] He appears to have been part of a large ensemble in high relief, one not unlike the "Trofei di Mario" on the Capitoline balustrade in Rome. The right-hand of two barbarians represented as cowering with their hands tied behind them beneath a trophy, he was looking upwards to the left, toward the trophy; a small piece of the cloak of the latter remains at the left. The barbarian's long hair flows out around his Phrygian cap, and the pupils of his eyes are incised (figure 31).

The carving is of exceptionally high quality, in Parian marble, and the monument seems to have been much more Roman in its message than the façade at Corinth. A definite date is difficult, but the monument must be part of the commemoration of Eastern victories which went on in general terms in the Hadrianic and early Antonine periods. A date not far from the Ephesus altar, that is, around A.D. 140, is in accord with the style of the barbarian's face. The Greek imperial coinage reveals how closely the official art of Alexandria was tied to Rome, rather than the Greek world, and this relief reflects these close-knit influences from the capital.

A TONDO BUST OF APOLLO

The date of the unusual bust of Apollo, Roman work in high relief, is circa A.D. 150 to 175.[12] The tondo is said to have been found in central Italy and is now in the Museum at Hamburg in Germany (figure 32). Apollo is identified not only by his long, curly locks and chlamys pinned with a brooch above the right shoulder but by the quiver (only slightly visible) behind his head and neck. This is a far cry from Goethe's admired Apollo Belvedere, yet it owes the general form of the hair and face, and the softened anatomy, to a Greek original of the fourth century B.C. This tondo bust, with its expressionistic face and fleshy forms, is a Roman imperial concept of the god Apollo that could only have originated in Asia Minor in the second century of the Christian era. André Malraux has been widely quoted as saying that the world of classical statues, being a world without sight, was also a world without a soul. Hamburg's Apollo is full of large-eyed, eager sight and must therefore possess the Neoplatonic soul of the later Roman world.

This tondo has the emotional expression and formal emptiness, almost

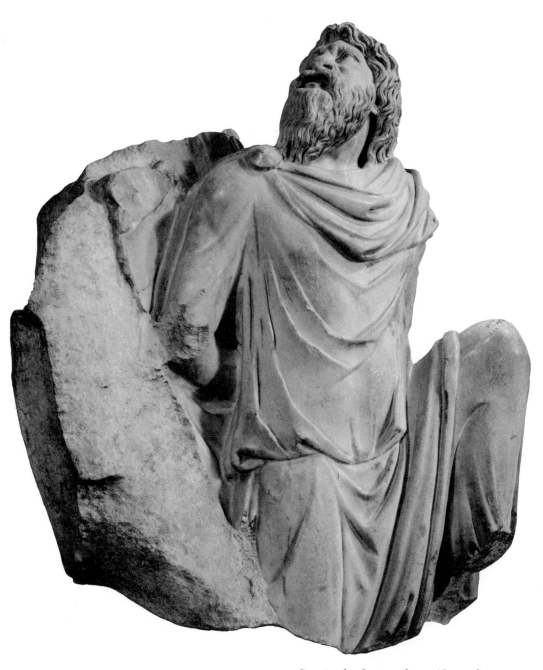

31. Captive barbarian from Alexandria

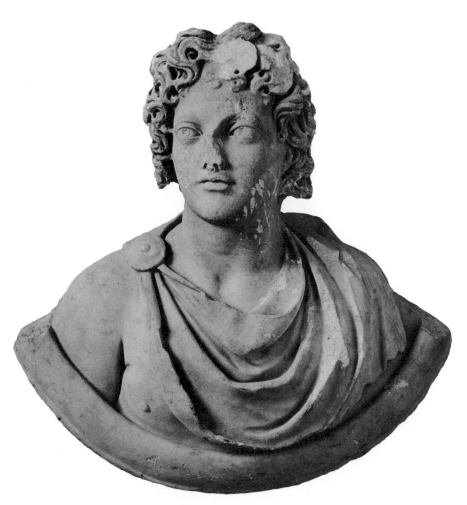

32. Apollo, architectural tondo

to a haunting degree, of Antonine sculpture from a southwest Asiatic site such as Aphrodisias in Caria. Given the number of Aphrodisian works found in Rome, it seems very likely that it was one of a set (the principal divinities?) carved at Aphrodisias and exported in antiquity to adorn the agora or stoa (forum or basilica) of some Italic town. The forerunners of this relief lie in the heads carved at Aphrodisias in the reign of Tiberius (A.D. 14–37) for the frieze of the long Ionic portico,[13] and less exuberant decorative carving contemporary with Apollo is visible in enrichment for the agora of Smyrna, rebuilt after the great earthquake of A.D. 178.[14] The mainland Greek counterparts to this tondo are, even when carved a generation or two later, more substantive in classical form and less emotional in gaze, as, for instance, the barbarians from the Stoa of the Colossal Figures at Corinth (figures 27, 28). Such

90

sets of tondi not only included busts of the gods but also could comprise busts of the imperial family and famous local citizens. Hamburg's Apollo would have been balanced by a bust of Diana, wearing her own quiver and perhaps rising from a crescent. The strongly classical marble tondi of the early fourth century, found at Aphrodisias and preserved in the Evangelical School at Smyrna until the tragic fire of 1922 in the Greco-Turkish War, provide a parallel.[15] They show the wide range of subjects possible in a single series of marble medallions. The playwright Menander was included with a city-Tyche, one of the young princes of the Constantinian period, and a local philosopher or official who looked like Julian the Apostate (figures 20–22).

Many will find this Apollo an ugly work of art if they judge it by classic Hellenic standards of beauty. It is, however, a rare and wonderful document of dying paganism which looks ahead from the ancient world to the Middle Ages. The staring eyes, open mouth, and drilled-out hair are Roman imperial expressions of Hellenistic illusionism. Used here to turn a major divinity into a decorative tour de force, they show one of antiquity's last efforts to immortalize its gods on a meaningful monumental scale.

ROMAN ART AT BAALBEK

It is very hard to speak of anything but a Romanized version of Hellenistic architectural ornament in the various monuments of the sacred precinct at Baalbek. All the motifs and decorative techniques of the most elaborate Hellenistic ornament are there: bull or lion protomes alternating as the frieze of the large temple, peopled scrolls, relieving panels enriched with garland-bearing genii, and eagle designs as keystones. Surfaces wherever possible are carved with figured and foliate decoration. The water basins have balustrades running around them. Their orthostate blocks are enriched with ideal heads in relief. The standard motifs of garland-bearing genii with Gorgoneia above the swath fill the flat surfaces between.[16]

The hemicycle or concave reliefs are carved with Roman second-century versions of Hellenistic marine designs, sea griffins, Tritons, and Nereids on sea creatures. These Nereids on Tritons are very baroque in action as well as style of carving; they wave their cloaks like dishtowels behind their heads. Others among this marine clan are more rococo in concept and accessories. These Nereids are seen half-draped and from the back while riding on the Tritons and in the company of Erotes. A Greek sarcophaguslike design of Erotes or genii with garlands suspended beneath busts or protomes also appeared between the capitals of the pilasters in the hall of the Propylaea. These reliefs all must have been carved by Lycian or Pamphylian Greeks, for they employ motifs and whole designs occurring on these classes of Asiatic sarcophagi in the

second century A.D. It is easy to imagine an atelier of decorative sculptors coming to work in Syria for a number of years.

To the right of the door to the so-called Temple of Bacchus is a relief, set in the wall just slightly higher than eye level, which presents a scene of sacrifice in partly Hellenistic, partly Roman terms. The procession marches from right to left, and the abrupt termination of the scene in its processional force at the molding on the left suggests that it continued in the pendant slab to the left of the door. The figures have been defaced, perhaps first by Christian and later by Islamic zealots. Victoria, with palm over her right shoulder, conducts a bull to sacrifice at a small altar; attendants carrying a sack and a basket follow; and a ram is being led along in the center. A youthful divinity (?) and another Victoria stand at the right, the latter crowning a Tyche who stands in front of her. The scene is Dionysiac in general spirit, but the sacrifice may be going on in the presence of a Roman official. The destruction is too great to be certain of the divinities involved. The Greek sense of allegory and timelessness is tempered by a Roman multiplication of details. In general, however, the work is Greek in spirit and tradition, and the Roman element is minimal. The excavators compared this scene to the reliefs of the great Antonine altar at Ephesus, but sculptures from Ephesus have a much stronger element of Roman specifics in their Pergamene baroque Hellenism.

The reliefs on the left and right bases of the Adyton or baldachino of the inner shrine show satyrs and maenads in exaggerated forms of the Neo-Attic revel. They can be classed as Antonine in style with some degree of certainty, and they provide some slight evidence for speaking of the temple as having been dedicated to Bacchus. The excavators, however, seem to prefer a statue of Zeus Heliopolitanus flanked by bulls in their reconstructions.

The last detail that might be termed Roman is the relief over the door of the so-called Round Temple. It is almost a speaking symbol of the coexistence of Romanism and Hellenism in the Greek East. The Roman eagle holds the kerykeion in his talons (perhaps indicating that the temple was dedicated to Hermes) and in his beak a rich, flowery garland which is shouldered by Erotes at the extremities of the relief.

The multiplication of sculptured busts, of gods, goddesses, and Tychai, in the ceilings of all buildings is an intensification of the idea behind the late Hellenistic decorative heads on the great Ionic portal (of Tiberius) at Aphrodisias. The Antonine baroque trend toward optic play in architectural sculpture, paintings, and mosaics, coupled with Syrian love of richness, has naturally transferred these busts to ceiling coffering amid carpetlike arrangement and cutting of foliate design. The Roman ancestor of this decoration is the relief of Titus carried heavenward on an eagle in the coffered barrel vault of his arch on the Velia.

Since Roman official art in the East is a random and often personal thing, appearing in certain areas and not in others according to activities of imperial or local officials, single monuments and their authors can provide a general view. At the Augustan colony of Antioch in Pisidia, a city priding itself on Latin coinage, triumphal gates of the time of Augustus and Septimius Severus were Roman in concept and figured decoration, Hellenistic in secondary details. The same mingling of Roman and Hellenistic designs occurs in the Severan Propylaea at Cyrene and the Trajanic monument of Philopappos in Athens, the latter having in its consular procession one of the few narrative scenes east of Italy. At Corinth, at Alexandria, or at Baalbek in Syria, although there are Roman symbols of captives, trophies, or eagles, Hellenistic timeless decoration predominates. In essence this decoration survives until the advent of official Christianity.

Greek individuality was responsible for the singularity of monuments east of Italy. Coincidences of survival and fortunes of excavation may explain the diversity of arches at Pisidian Antioch, but their decoration must have been typical of Eastern cities, particularly Roman colonies, in the period from Augustus through the Severans. The Severan march eastward and family connections with Syria no doubt dictated an increase in Eastern triumphal monuments after A.D. 200. The propylaea at Cyrene was an anticipation of Greek and Roman styles that were to fuse in the historical registers of the Arch of Galerius at Salonika. The façade with colossal figures at Corinth was a late expression of architectural humanism traceable back to the Caryatids of the Erechtheum in Athens. Among other single monuments, the mausoleum of Philopappos in Athens provided a unique, thoroughly Greek answer to the creative challenge of Roman triumphal art.

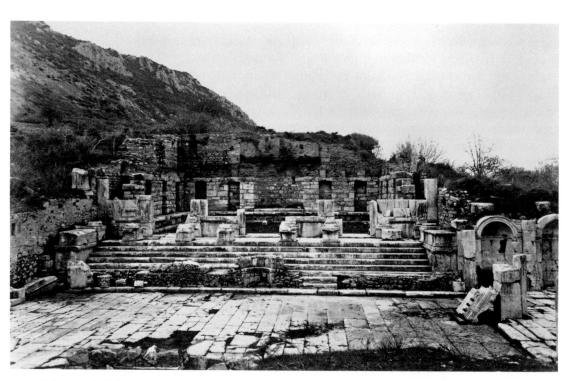

33. Library of Celsus

The Great Antonine
Altar at Ephesus

THE GREATEST MONUMENT of Roman art in Asia Minor, if not in the whole Greek imperial world, still offers problems of purpose, arrangement, iconographic interpretation, and possibly even date. Early in the present century Austrian excavators found a number of slabs carved in relief with fragments of related reliefs roughly two meters in height and preserved in various fragments to a total length of about thirty-one meters. These reliefs were discovered near the Hadrianic Library of Celsus, which is not where they were set up in the second century A.D. (figure 33). There is every indication that the monument which they originally adorned was not far away, but the reliefs had been taken apart and placed at the Library in Christian times as fronts for the water fountain inserted in the older building. The order of the slabs had been altered when they were shifted in antiquity, and some were arranged around the Library purely as ornament. The frieze could not possibly have been set up around this water fountain in the order in which it was intended to be seen in the second century.[1]

The problem of determining the correct order of the reliefs is an extremely difficult one. The missing sections and the slabs existing in cut-down state make a definitive solution impossible.[2] The three sets of lettering — on the fronts of the bottom-strips, on the background of the relief surface (Slab Φ) and on the upper moldings — indicate that the reliefs were set up and then shifted about at least twice in the Late Antique history of the city. While the precise order of slabs and fragments may always be open to question, it seems to me that the form of the original monument, its date and purpose, and the general, thematic order of the sides or groups of slabs can be reconstructed.[3]

The reliefs were actually found in five separate places, indicating partial dispersal in Late Antiquity or the Middle Ages. Part of one slab, a Roman in a cuirass, was found as late as 1926 and is at present in the town of Selçuk (figure 34). The principal slabs and fragments are in the Kunsthistorisches Museum, Vienna (figures 35–52). The marble

is from the vicinity of Ephesus. The order of the slabs is determined not only by subject and style but by the fact that when originally set up, or when first disassembled, they were given guide letters which run the course of the Greek alphabet from A to X. The majority of these letters are now lost, but the three sets of letters still visible on the lower (and upper) parts of the slabs are as good guides to modern reconstruction of the whole composition as they were in antiquity.

DATE

The date of the frieze has been disputed. Older scholars associated the reliefs with the Eastern victories of Lucius Verus and therefore dated the whole monument in the sixties of the second century. Closer scrutiny of the surviving heads of the principal scene (attendance at a sacrifice) has led recent critics to push the date back a generation; this would suggest that the series of reliefs glorifies Hadrian and his family by adoption and was executed just before or not long after his death in the summer of A.D. 138. Faustina I appears and, although she died and was deified in 141, her costume as Demeter of the Cherchel type is only a partial suggestion that the reliefs could have been planned after her death and apotheosis. A compromise that seems difficult to accept was proposed by A. Giuliano. He has seen the relief in question as the scene of adoption of the Antonines by Hadrian on 25 February 138; he has suggested that the reliefs are from a monument in honor of Lucius Verus, datable after his death (169), with his apotheosis on one of the other panels. He has focused attention on the seven-year-old Lucius Verus "che occupa la parte centrale come colui al quale il monumento era dedicato." [4]

All of the reliefs fit perfectly into the art of the Roman Empire at the outset of the Antonine period. There is nothing in style or subject that cannot be explained against the background of Hadrian's dynastic succession on the eve of his death, and the portraits (present and missing) can only fit the year just before or those shortly following Hadrian's death. In glorifying Hadrian and the Antonine house, the reliefs mix the imperial family from Trajan through the infant Lucius Verus with divinities, sacrifices, attendants, geographical and other personifications, and scenes of Roman combat symbolic of the troubles which marked periods of Trajan's and Hadrian's reign, especially the last few years of the latter. The political emphasis of the series of complex scenes stands out from the series of religious and allegorical formulas, and this emphasis is on the grouping of Marcus Aurelius (aged eighteen), Antoninus Pius (aged fifty-three), Lucius Verus (aged eight), and Hadrian, in his sixty-third and final year. It has been suggested by Giuliano that the youthful figure behind and to the right of Hadrian is the genius of Aelius Verus father of Lucius (died 138), but this figure seems to be female

and is very likely Faustina II, daughter of Antoninus Pius and Faustina I and designated empress of Marcus Aurelius. This seems, however slight, another reason for dating the relief about A.D. 140, when the memory of Aelius had been replaced by the hopes of the Antonine clan, to whom the recently deceased Hadrian remained the link with a great past and insurance of a secure future.

TYPE OF STRUCTURE

The Great Antonine Frieze at Ephesus once belonged to the outer walls of an altar building or platform modeled very closely on the Great Altar of Zeus Soter at nearby Pergamon (plan 1).[5] The altar at Pergamon had inspired other Hellenistic altars, and these too contributed to the conception of their Antonine neighbor in western Asia Minor. The two chief surviving examples both belong in the period about 150 B.C. or later and have been identified with the architect Hermogenes. They are the altar in front of the temple of Artemis Leucophryene at Magnesia

A ROUGH ELEVATION OF THE ANTONINE ALTAR AT EPHESUS

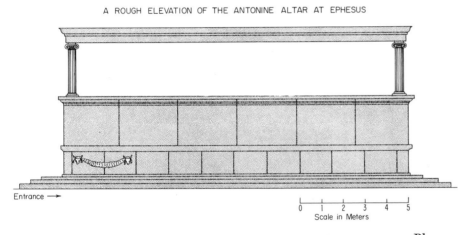

Entrance →

0 1 2 3 4 5
Scale in Meters

Plan 1

on the Maeander and the altar east of the temple of Athena at Priene. The former must have been about the same size as the Antonine monument at Ephesus, for its dimensions of 23.15 m. by 15.80 give a total surface to the base of about 60.00 m. if a width of 4.00 is allowed for each slab flanking the staircase on the front.[6] Like the altar at Pergamon, the altar at Priene had a gigantomachy represented in relief on the podium.[7]

The altar at Magnesia had bulls' heads with garlands in the frieze of the entablature above the Ionic columns. This provides another link with the Antonine altar, with the motif probably used on the blocks below the frieze of the latter. Both Magnesia and Priene placed sculpture

97

in the colonnade on the top of the podium. At the first altar there were figures in high relief on the walls extending out over the antae and beneath the double colonnade of the wings. At the second altar statues, probably of priestesses, stood in the area between and behind the Ionic columns. It is not difficult to speculate that the Antonine structure at Ephesus had statues of the imperial family and prominent private citizens, Roman and local, on the area above the figured frieze (elevation).

THE BASE BLOCKS

Along with the slabs in Vienna are two blocks carved with bulls' heads supporting garlands of oak-leaves and acorns (figures 51, 52). These blocks are about 1.20 meters high and 1.50 long. They are quite thick, being 0.35 to the frieze surface. The two blocks in Vienna each contain one bovine head and part of the garland on either side. One slab is lettered ΛΒ–ΛΓ and the other ΛΓ–ΛΔ. These two blocks and more from the set, in Izmir, certainly belong to the Antonine monument which I propose to reconstruct as an altar of Hellenistic type. The total of lettered blocks gives a length of about 60 meters. It is tempting to think that these are the facing or orthostate blocks from the podium of the altar. They would have run around the monument below the figured frieze. The area between would have included a set of cornice moldings, and the slabs with the bulls' heads would have been raised from the steps or base by a series of moldings approximately 0.20 to 0.30 meters in height. All this would have placed the bottom of the figured frieze at a height of at least 1.50 minimum to about 1.80 from the top of the stylobate. Now this means a modern person of above-average height would have had to look up to see the frieze, and, even at the minimum measure, to most viewers the lowest parts of the figures would have been above normal eye level. This seems to be confirmed by a detail in Slab T of my arrangement (figure 48). The underside of the fish grasped in the lowered left hand of the reclining water divinity projects over the bottom of the slab and is carefully carved to be seen from below. Thus, the figured frieze was set at a monumental height, one which allowed easy viewing and comprehension of details.

The blocks with bulls' heads and garlands seem to solve one problem. One of the sets of Greek letters on the figured frieze must have been either for installation or for reference at the time the monument was first dismantled. Either purpose would have been equally valid for an ancient reconstruction, thus such letters can be used to put the monument together on paper in modern times. These letters must be the ones on the lower fillet or ground of the frieze. The installation (or reinstallation) letters on the bulls'-head blocks are of a good style. In having served a similar purpose, they confirm either that the original planners and sculptors used the letters to install the monument or that, when the

building was taken apart, reinstallation was contemplated, or even carried out, with little alteration and after a short interval.

The garlands show some signs of drillwork, but there is no hasty or impressionistic or even "baroque" carving either here or in the bulls' heads. This carving looks late Hadrianic to early Antonine, but such close dating on stylistic grounds in the realm of decoration traditional to western Asia Minor is impossible. The motifs give little clue to the purpose of the building. If they were bucrania rather than bulls' heads, it would be tempting on analogies in Rome to speak of the funerary character of the structure. The converse does not hold true, however, for the decorative design of the monumental bull's head belongs in all aspects of Greek island and Asiatic decoration, funerary and otherwise, from early Hellenistic times onwards. The oak-wreath garlands are certainly imperial, stemming from the *corona civica* motif of Augustan commemorative sculpture in Italy.[8] A traditionally Greco-Roman motif, one used for friezes on buildings, altars, bases, and sarcophagi, may have imperial connotations in one aspect of its detail, but this motif provides no absolute clues to the dating and therefore to the specific interpretation of the Antonine altar at Ephesus.

The Hellenistic altars related to the Antonine altar's prototype contain either one frieze (Pergamon), a few plaques in the base (Priene), or a plain base (Magnesia). It remains to show the Hellenistic and Roman link with any reconstruction based on the observation that the blocks with bulls' heads and garlands may belong to the Ephesian monument. The altar east of the metroon in the Athenian agora was evidently set on its steps in the late fourth century B.C. Homer Thompson has suggested that the ensemble was originally located on the Pnyx. In late Hellenistic or early imperial times it was probably moved to its present location and provided with an orthostate characterized by rich upper and lower moldings.[9] These moldings give a clue to the appearance of comparable features, carved on separate blocks of the structure at Ephesus. Like the Ephesian reliefs, blocks of the steps of the altar in Athens bear reassembly letters, but, unlike the letters on the base fillet of the Ephesian reliefs and the letters on the Ephesian orthostate blocks, they are roughly sketched. They are obviously temporary guides and not the well-cut letters which at Ephesus have been identified with the original carving or a careful disassembly in a good period of Roman art. The blocks from the choregic monument of Nikias (319 B.C.), partly reused in the so-called Beulé gate of the Acropolis in the period of the fortification of Athens against the Herulians, are marked with letters for reassembly.[10] These letters are well designed and cut with consideration for the impression they would make on the casual observer of the monument in its disassembled state or when reerected.

The so-called "heroon" or cenotaph in the courtyard of the Bouleu-

terion at Miletus has been dated variously in the late second century B.C. and in the period of Trajan or Hadrian.[11] The combination of base blocks enriched with bucrania, paterae, and garlands below a low colonnade backed by a wall of sculptured relief in the florid Hellenistic style could suit either date. The figured reliefs, myths of Apollo and Artemis connected with the city, give every indication of being Hellenistic, in the tradition of the frieze of the temple at Magnesia, but the carving of the orthostates speaks for a date in the period from 100 to 130. With its elaborately enriched orthostate above a three-stepped stylobate, the "heroon" probably represents the latest major Greco-Roman link with the magnificent conception of the Antonine altar at Ephesus.

THE RELIEFS

The diagram shows the location of the reliefs, starting on the end of the right wing, running down the right side, across the long (rear) façade, back up the left side and ending on the short face of the left wing (plan 2). The sides have been named according to their principal contents. Like the Hellenistic prototype at Pergamon, the reliefs have all the rhythmical action of a well-constructed symphony or opera. The control

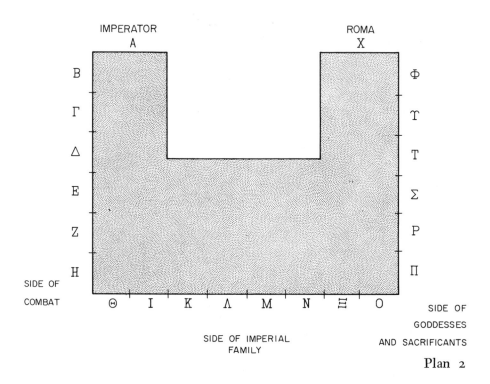

ALTAR AT EPHESUS

Plan 2

of themes and staging is even tighter than that of the more monumental Altar of Zeus. The story begins with a cuirassed general (Hadrian or a donor such as Celsus) as spectator, runs through a side of various emotions of combat, turns to the long façade which contains the principals honored by the monument and the rites of the state religion, returns along a side in which the secondary spectators are massed, and concludes with the goddess Roma Aeterna as witness to the whole series of scenes. Each of the three long sides has its share of important figures, and scenes of violent motion are skillfully juxtaposed with scenes of noble repose or static pose.

The whole monument seems to be relatively complete; few crucial parts of the frieze can be considered to be missing. There are, however, annoying gaps where parts of slabs have disappeared or remain unidentified. In no instances do these lacunae seem to affect an understanding of the composition, although they naturally influence its definitive arrangement. Certain of the surviving slabs (Σ for instance) were trimmed down in later times. Where slabs may be completely lost, it seems they can be fitted into the system of lettering on the molding of the bottom of the figured frieze, the system of lettering followed in this reconstruction.

THE RIGHT END: *"Imperator"*

[A] A cuirassed general stands facing to the right; he may have had his left hand on a barbarian crouching at his side. The Wolf and Twins appear in the rocky landscape behind. The cuirass is carved in a particularly naturalistic fashion and is close to the freestanding example in the Guelma Museum,[12] which has been placed in the circle of the statue from Ephesus, a statue generally taken to represent Celsus.[13] The presence of the Wolf and Twins suggest an emperor, rather than a donor such as Celsus, and it is tempting to think that Hadrian, as principal recipient of honors in the frieze as a whole, is portrayed once here in quasi-military role and once as chief figure in the assembly of Antonine notables. This slab (figure 34) of the frieze is based stylistically and compositionally on the Herakles and Telephos slab of the inner frieze at Pergamon.[14] (Dimensions: 1.35 by 0.89.)

THE RIGHT SIDE: *"The Side of Combat"*

As in the pendant (left) side of the monument, the scenes are arranged in a balance of arrest and motion: combat on foot, a cavalry charge, more combat on foot, another cavalry charge, Romans proclaiming victory and barbarians fleeing or dying, and the final Roman charge through the suiciding ranks of barbarians.

[B] A barbarian kneels, and a Roman auxiliary (?) swipes at him with a

101

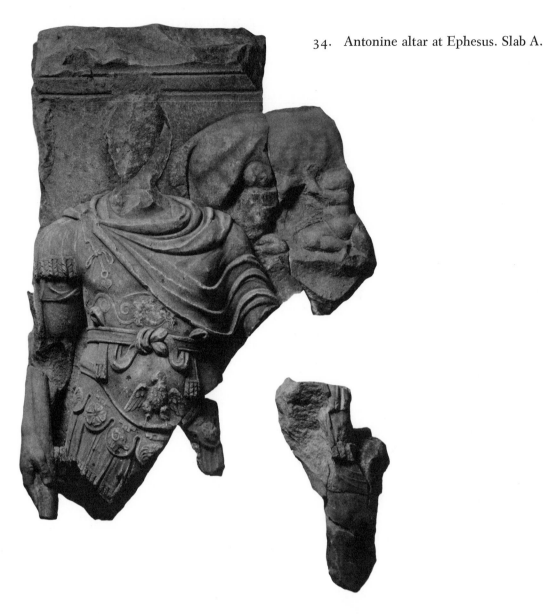

sword; a horse rears in the background (figure 35). The transition to Γ is marked by a Roman officer and a cavalryman riding into a melee. (Dimension: 1.44 wide.)

[Γ] The scene continues (figure 36), with the transition marked by the right leg of a fallen Eastern barbarian. The Roman cavalryman turns inward and lunges at a young Eastern barbarian fleeing to the right. A barbarian has fallen from his dying horse in the middle plane. At the right, a Roman auxiliary reaches with his left hand well into Δ to grasp the hair of a fallen adversary whose right leg extends back into Γ. (Dimensions of Γ and Δ: 2.05 by 2.95.)

102

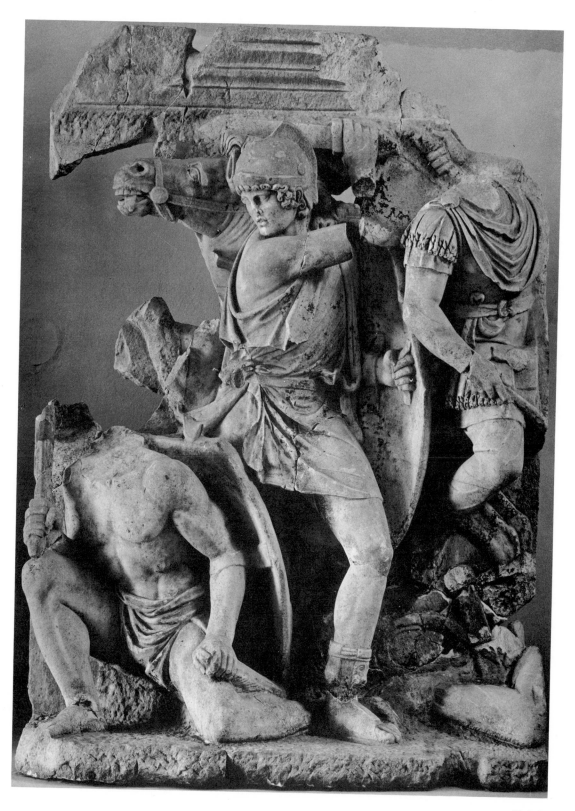

35. Slab B

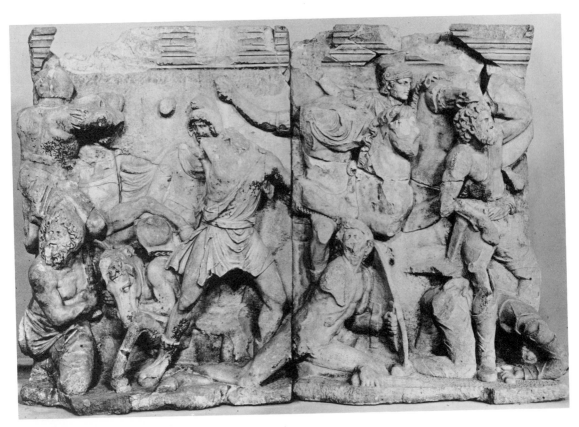

36. Slab Γ, Δ

[Δ] From Γ to Δ a transition in the upper register is made by the raised right arm of a Roman officer or cavalryman who rides to the right, with another cavalryman in similar attitude behind and ahead of him. The adversary in the foreground, whose leg reaches back to Γ, crouches on his left knee and uses his shield as support. With his right hand he is picking up his knife or dagger which lies on the ground. The horsemen are charging an older, bearded barbarian from behind. He is looking to the right, with horror at the scenes to follow. Between his legs, a Persian (fully clad) doubles over in agony on the ground, right hand gripping his sword and left holding his shield on his back, in a last protective effort against the horses' hoofs.

[E] This slab (figure 37) provides an interlude between the dramatic motion (to the right) of Δ and Z, H. Two Roman legionaries advance to the right, in a reversal of the "Tyrannicide" pose.[15] One holds his shield up behind a Parthian prince, on horseback, slumped over his bow (?) and animal-skin saddle. The position assumed by this legionary also resembles that of the "Borghese Warrior," a statue which is, after all,

104

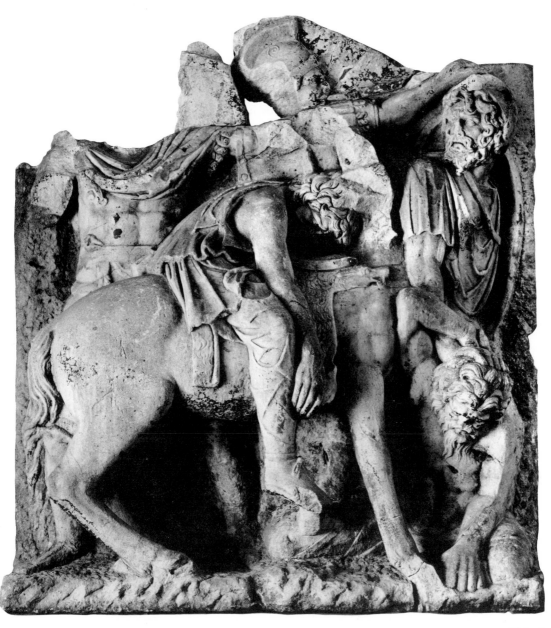

37. Slab E

signed by a sculptor from Ephesus.[16] The second Roman legionary blows
a *tubicen* behind an elderly (that is, bearded) Parthian who moves to
the right, fleeing with his shield on his left shoulder and his right hand
on the head of a half-nude shaggy barbarian kneeling frontally and
trying to pull an arrow from his back. (Dimensions: 2.07 by 1.70.)

[Z] A Pan-faced, Phrygian-capped, scraggy-bearded barbarian is being cut down by a satyr-faced auxiliary in the background (figure 38). A pair (or biga) of horses spring through the center of the scene, moving to the right. Beneath their legs, [H] a dying barbarian with Phrygian cap draws a spear (?) from his side. Another barbarian uses his short sword on his shield to commit suicide by plunging it into his heart. The first barbarian may have just finished doing likewise. Between them is the protome of a dying horse. Like the death of Decebalus on the column of Trajan,[17] this forms a fitting conclusion to the scenes of the "Side of Combat."

38. Slab Z, H

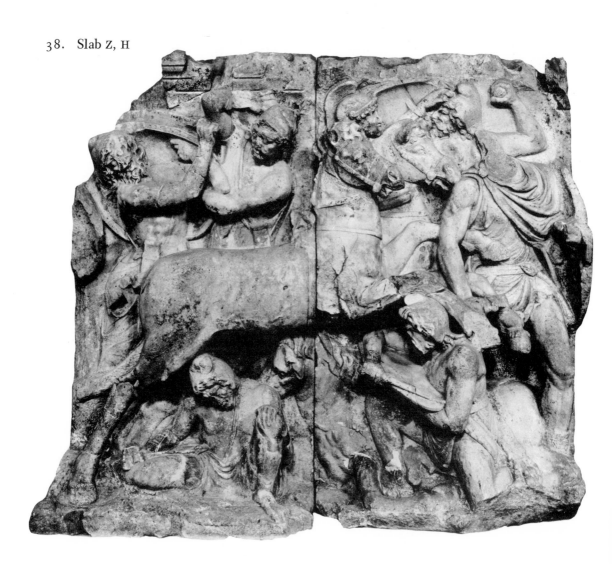

The transition around the corner, however, is made in the second and third layers of the upper half of H. A Roman and a Phrygian-capped, bearded barbarian duel in the background, the former raising his shield and the latter desperately holding up a rock in his right hand. At the right, ahead of the two galloping horses, an auxiliary (sword in right hand, shield on left shoulder) strides manfully to the right, and to the corner. Traces of a shield at the left edge indicate that the slab was, except at the base, wider than at present; the dimensions also support this. (Dimensions of Z and H: 2.05 by 2.35.)

THE LONG SIDE: *"The Side of the Imperial Family"*

Here the composition is very harmonious: "Ephesus" and Isis on the left and Sabina, Faustina I, on the right. The Profectio of Divus Traianus (occupying two slabs) balances the (three) slabs of the imperial family and sacrifice. The attendants, looking both ways, provide the slabs of the middle point.

[Θ] This slab is badly damaged, with only two figures (and there may not have been more), both female, surviving (figure 39). The first is a regional personification, perhaps Ephesus herself. She wears a long chiton and a tunic, pinned with a brooch on the right shoulder. The *vexillum,* held aloft in her (missing) right hand, is embroidered with a four-pointed star above a crescent. Both forearms are also missing.[18] The second figure is clad in a fringed chiton and a himation knotted in Isiac fashion. Her hair is arranged in Isiac ("Ptolemaic") ringlets. In her raised hand she holds an olla or offering jar; the (lowered) right arm is missing. Her headgear consists of a cap with rolled-fillet brim. This second female is either a priestess, like the group of women in the slab Λ, or, more likely from her location on the frieze, also a regional personification. From the Egyptian garb, Alexandria comes to mind, and the notion of Ephesus joined by her sister metropolis in the East is a plausible one. A parallel, possibly Alexandria, but with the olla restored turns up among the provinces on the podium of the Hadrianeum in Rome.[19] Here the cap is called a circle of rosettes.

[I, K] These are the slabs with the scene which is now generally, and surely correctly, termed the *Profectio of Divus Traianus*[20] (figure 40). The cuirassed imperator mounts the quadriga of torch-bearing Helios who, with parazonium-bearing Virtus, leads the procession. Nike helps the imperator to mount. Tellus, accompanied by a child with cloak of fruits, reclines beneath; she holds her characteristic cornucopia. The details and style of the imperatorial cuirass fit perfectly in the years between 138 and 140. The broad cingulum with two large griffins beneath,

39 Slab Θ

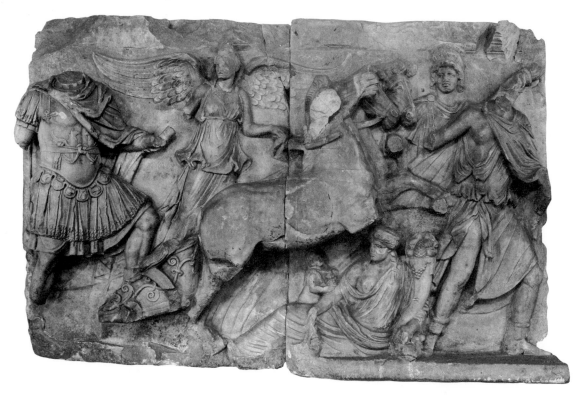

40. Slab I, K

combined with paludamentum and details of the *pteryges*, mark the transition from the late Hadrianic to the standard Antonine cuirass.[21] (Dimensions: 2.07 by 3.10.)

[Λ] The two figures in Θ point to this slab (figure 41), and Virtus in K leads into the scene. Seven young priestesses wear heavy wreaths in their hair and long tresses below the shoulders. (The "lady" in the left front may possibly be a youth.) The lady in the left background holds an oinochoe in her lowered right hand. They wear chitons and ample himations in various fashions. With the exception of the lady with the jar and the girl in full profile to the right, beside her, all other heads are mutilated. All the figures (save the ladies with heads) present strong aspect of frontality. For stylistic comparison there is the city-goddesses relief in the Louvre, from Diocletian's Arcus Novus and thence from a late Hadrianic arch in Rome.[22] (Dimension: 1.17 wide.)

[M, N] This is the relief of the imperial succession, Hadrian and the Antonine rulers (figure 42). From left to right stand Marcus Aurelius and Antoninus Pius, the latter clutching little Lucius Verus to him and

41. Slab Λ

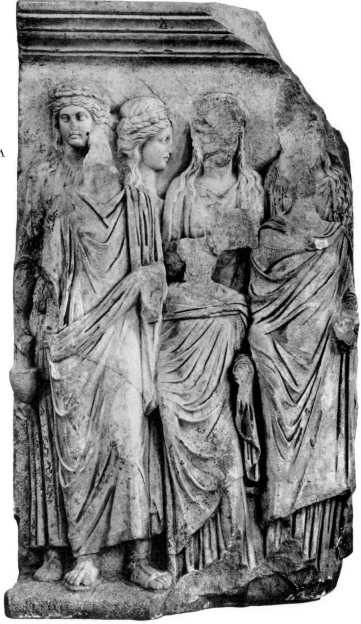

holding a scepter-staff in the crook of his left arm. Hadrian has his right hand extended, palm up; he and Antoninus are veiled. The lady behind him and at the right is very likely Faustina II, daughter of Antoninus Pius and future empress of Marcus Aurelius. (Dimensions: 2.05 by 1.50.) For Faustina II see also below, ADDITIONAL FRAGMENTS.

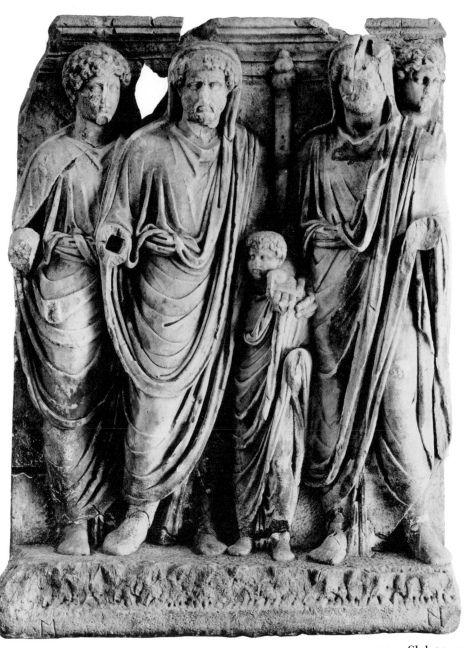

42. Slab M, N

[Ξ] This Scene of Sacrifice (figure 43) is probably the *Nuncupatio Votorum* for the new reign.[23] At the beginning of the slab, that is, at the upper left and below the moldings, a youthful head of the Spinario or Antinous type gazes back at the emperors presiding over the sacrifice. Although Antoninus Pius and Hadrian are looking straight ahead, the figures around them link them with the attendants and the ox to be sacrificed. Two *victimarii*, a double-flute player (between), and a trumpet player (at the right) fill out the scene as it is now. The *victimarii* wear the Greek *exomis* and lead an Eastern humped ox toward the spectator. No other figures, even the Romans and barbarians in combat on the right side, show the body and muscle of the attendants in this slab. The *victimarius* on the left was holding the axe, while he on the right was leading the beast. This slab may have been carved by one or more Athenian artists. The master of this slab, so different from its neighbors, is an individual, who employs a boldness of undercutting and a combination of Attic freshness with second-century technical tricks and details. He uses an Attic style of proportions and drapery. The folds of the drapery of the *victimarius* at the left recall those of Philopappos in relief in his chariot and the funerary relief of a Damascene in the American School at Athens.[24] The drilling and cutting of the hair is a mixture of the dry, the hard, and the baroque. Presentation of the scene of sacrifice in two parts, the group around Antoninus Pius and the attendants, has been identified as a thoroughly Roman development leading to tendencies in Severan art. (Dimensions: 2.05 by 1.25.)

[O] This slab (figure 44) seems to portray two empresses as goddesses, perhaps Sabina as Hera and Faustina I as Demeter. The portrait identifies Faustina, but all of "Sabina" above the middle of the thighs is missing. The earthly status of these senior imperial ladies is not clear. Sabina died in 136/7 and was raised to divine rank by Hadrian; Faustina I died in 141 and was accorded similar honors by Antoninus Pius. If the Antonine monument at Ephesus was planned before Hadrian died, or just after, then Sabina was a Diva and Faustina I was still living. If the ensemble was designed, or this slab finished, in or after 141, then Faustina I would have also been enrolled among the Divae. Costumes and attributes are no guarantee, for it was common to find Roman empresses represented as goddesses during their lifetimes. "Sabina" wore a long chiton and a full cloak extending to the legs just above the ankles. Faustina I, with the headdress characteristic of her coins and portraits in marble, is veiled for sacrifice and holds a large cornucopia in her left hand. Her costume approximates that of the Demeter of Cherchel. She is frontal, but her legs bend like a Pheidian statue.[25] (Dimensions: 2.10 by 1.08.)

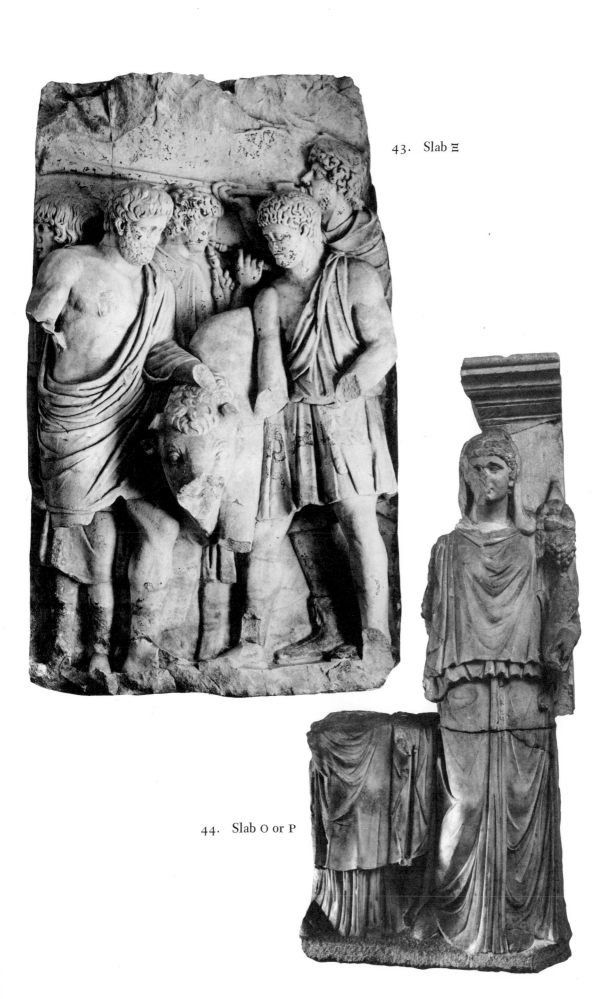

43. Slab Ξ

44. Slab O or P

THE LEFT SIDE: *"Side of the Goddesses and Sacrificiants"*

This side provides a gradual conclusion to the whole series of scenes: the seated goddess who invites us to look around the corner at the long side; the group of goddesses or attendants; Demeter or Persephone; the goddesses of the modius and "Poseidon" looking to the left; and finally the two-slab-in-one scene of Artemis — Selene stepping off into the heavens ("Apotheosis of Diva Plotina"). At the right end of this scene of apotheosis, Nyx looks around the end to Roma on the Left End.

[Π] The principal figure of this slab (figure 45) is a goddess or personification seated on a hill (the local mountain) or a pile of rocks. At the left appears the leg of a draped figure who was standing or seated close to her. The principal goddess-personification has a Hellenistic topknot, high-girt and sleeveless, slightly slipped chiton, and himation fallen off her shoulders. She is looking to the left and down slightly. At her feet the form of a reclining watergod is barely discernible. He rests his left arm on a flowing urn, which faces the viewer. His right hand held an attribute, which was probably navigational — a paddle or rudder. Another woman stands at the right, wearing a Doric chiton with long overfold. She recalls an Athena of the period around 380 B.C. (the Athena Ince, for example).[26] Her missing right hand was extended to the seated goddess. (Dimensions: 1.78 by 1.43.)

[P] Only the lower half of the slab survives, showing the mutilated remains of four figures (figure 46). The figure at the extreme left and the one at the extreme right are facing to the right, toward the additional goddesses and personifications and the second scene of apotheosis. From left to right the figures seem to be: a male philosopher or priest with sandals; a female (?); a female facing (who is perhaps a goddess); and an imperial official in toga and what appear to be boots. (He may, however, be wearing a himation, and it is possible that he is the Boule of Ephesus — equivalent to the Roman Genius Senatus — or a god such as the Greco-Egyptian Sarapis.[27]) (Dimensions: 1.17 by 1.46.)

[Σ] The lady, apparently a goddess and probably Persephone (figure 47), held a scepter-staff (or torch) in her right hand; her left hand is missing. She has long, loose tresses that fall on her shoulders, and her costume consists of a long chiton with woolen tunic falling to an uneven line just below the waist. A short mantle is draped over her left arm and shoulder, around the back, and over the right arm.[28] (Dimensions: 2.08 by 0.90.)

[T] Two goddesses or personifications and a reclining watergod (of the shaggy barbarian type) look toward the other goddesses and personifica-

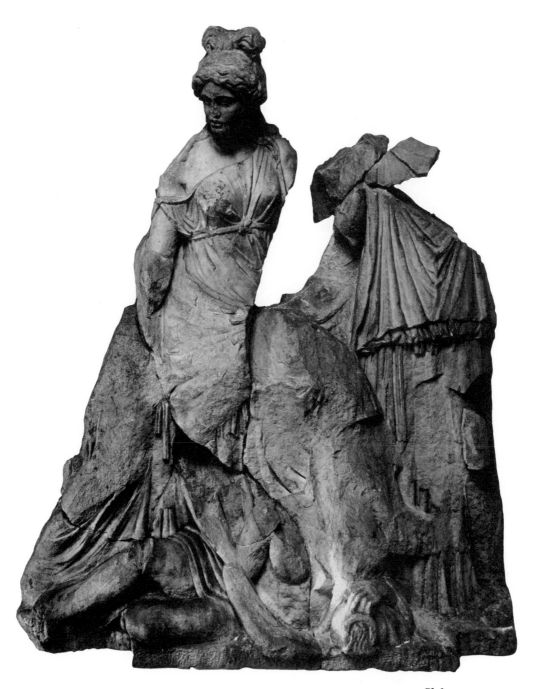

45. Slab II

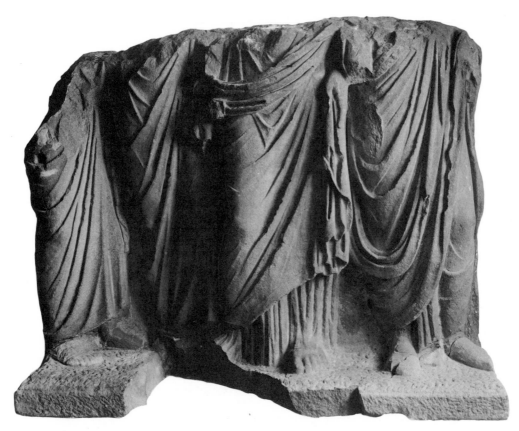

46. Slab P or O

tions of Π, P, and Σ and beyond to the long side of the altar. The goddess on the left holds an ornament in the form of a ship's prow (an akrostolion) or a wave (an aphlaston) in the crook of her left arm. The attributes of the second female are missing. In the upper background, behind the two goddesses, appears a long modius stuffed with ears of grain. The watergod has a scaly body and squeezes a fish in his left hand.[29] The carving is flat and stringy, a distinct contrast to the solidity and corporeal delineation of the panel with the scene of sacrifice (with the sacrificial animal). This effect is aided partly by the weathered, abraded condition of the slab (figure 48). (Dimensions: 2.08 by 1.40.)

[Υ, Φ] This (figure 49) is the scene of apotheosis of an empress as Selene ("Apotheosis or Profectio of Diva Plotina"). The empress as Artemis-Selene, in short hunting garb, steps into a chariot drawn by two stags. She is conducted by Hesperos who flies at her left, in the background. At the right and beneath the biga, Oceana (Thalassa) reclines to the left, with a rudder in her left arm. She leans on a marine monster, who

116

47. Slab Σ

swims to the right. In front of the stags, Nyx (cloak billowing around her
as symbol of the enveloping vapors) strides to the right, her gaze directed
into space. There are traces of a crescent moon behind Selene's left
shoulder, and Hesperos evidently held a torch in front of him. The style
of the relief is good, in the best Roman sense. As the scenes are now
preserved, the two strongest passages are in the draperies of "Artemis"

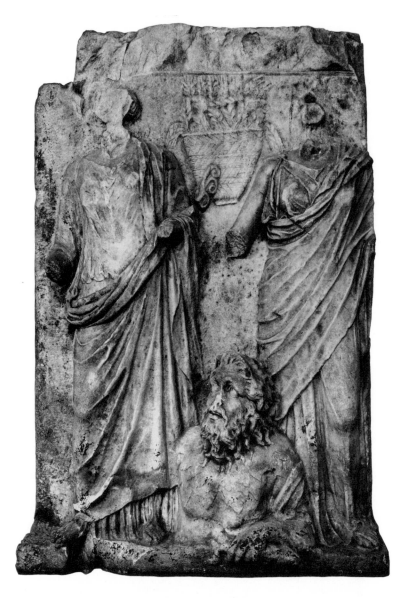

48. Slab T

and Nyx. The fragment of the head shows that in style the latter was closely related, although more Romanized, to the Nyx on the Pergamene altar. The rosette and tendril decoration of the biga is, in simplified form, the enrichment of the celebrated marble chariot in the Sala della Biga of the Vatican.[30] (Dimensions: 1.85 by 2.90.)

THE LEFT END: *"Dea Roma"*
The firm gesture of Roma's right hand closes the composition.
[X] Roma (figure 50) sits to the left, her right hand raised in witness to the events human and divine. She is the Athena or semi-Amazon Roma

118

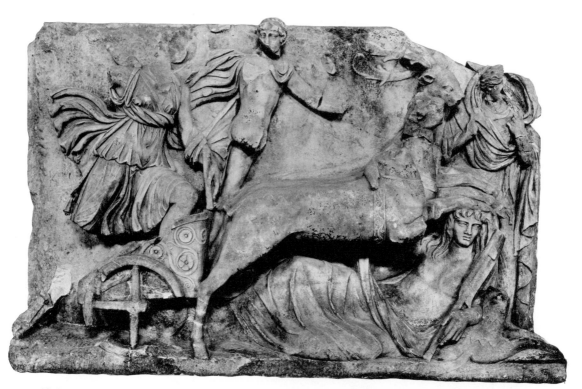

49. Slab Y, Φ

50. Slab X

type, with long, belted chiton and very ample himation. She is poised on a cuirass and has a shield beside her. There appear to be traces of another female, standing in the background to Roma's right and partly in front of her. In gesture Roma anticipates the Roma of the Antonine column base in the Giardino della Pigna. In iconographic type she is the Roma-Minerva of a unique silver medallion of Domitian, probably from the mint of Rome but perhaps struck in the East.[31] She is also like the Hadrianic cult statue of the great double temple near the Coliseum in Rome.[32] (Dimensions: 1.44 by 0.99.)

ADDITIONAL FRAGMENTS

In Vienna there are five fragments and two heads which have not been included in the descriptions of the frieze because of their uncertain positions in any, even tentative, reconstruction. One head is that of a

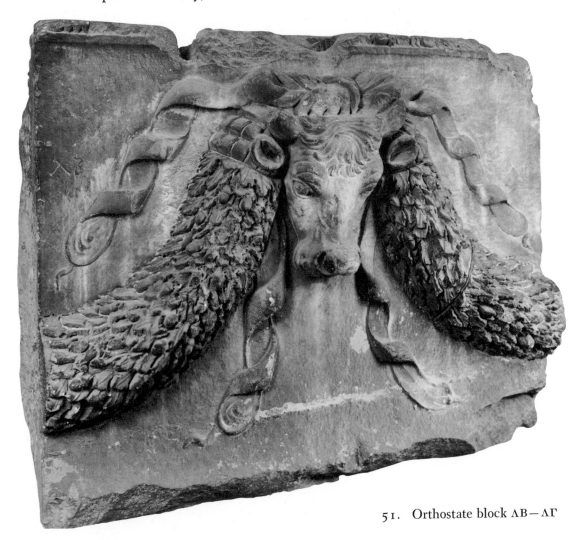

51. Orthostate block ΛΒ—ΛΓ

young man who may be an attendant or magistrate; it may belong to one of the figures assembled in Slab P. The head may even be that of the figure identified as "Demos" and assigned to the second slab of P, or PB. The other head is perhaps that of Sabina, and may have been part of the mutilated figure beside Faustina the Elder in Slab O. Her hair is arranged in straightforward, Junoesque coiffure, and she looks up to her right. This simplicity of hairdress and slight animation of pose provides a perfect foil for Faustina I, who wears her characteristic elaborate knot of false braids and looks straight ahead. Alternatively, this head may be that of Faustina the daughter of Antoninus and Faustina I; her place on the monument has not been determined with certainty. As daughter of Antoninus Pius and consort or consort-designate of Marcus Aurelius, she would scarcely have been omitted.

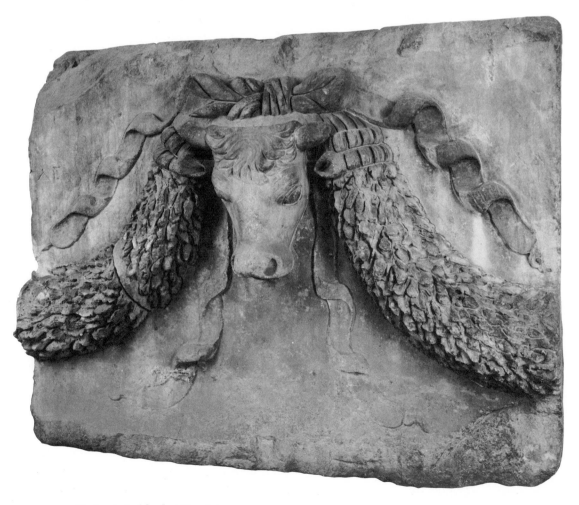

52. Orthostate block ΛΓ — ΛΔ

The first "floating" fragment (0.86 by 1.40) has two personifications, a figure perhaps male and a putto reclining with two fish at his feet. The standing figure wears a form of traveling costume consisting of a cloak hanging in a broad, rectangular fold down the front, trousers tied at the ankles, and boots. There are certain parallels, none exact, among the "provinces" of the Hadrianeum in Rome, especially the lady in the Conservatori who holds a large *vexillum* in her right hand.[33] Cappadocia as a Hadrianic and Antonine coin reverse is also close to the figure suggested by the fragment.[34] This province, however, would probably not be represented beside Ephesus-Ionia and Alexandria-Aegyptus on a crucial slab at Ephesus. In this connection, it is tempting to think these two figures, the personification and the putto, complete the right part of Slab Θ. In the case of the marine putto, it seems unlikely that all the slabs with water divinities were grouped along the left side of the monument. The putto with fish is a natural filling motif, which from its position would help to point back around the corner to the scenes of combat on the right side. Identification of the personification must await further evidence or remain permanently in doubt. Usually cities are of the Tyche type, draped in long himation over a full chiton, but the Puteoli Basis in Naples shows how variable the iconography of cities or their goddesses can be. Ephesus appears here, quite rightly, as the Berlin-New York Amazon wearing a Tyche crown.[35]

The second set of fragments have been fitted together on paper by Fritz Eichler. The first part, on the left (1.04 by 0.50), presents a lady in goddesslike costume; she wears a chiton and over it a himation wrapped around her left shoulder and under her right breast. Joining this fragment on its right is a slab with a torso coming up out of the ground and turned to the left, back toward the "goddess" (1.04 by 0.49). The effect achieved by this figure, obviously a local divinity or geographical personification, is that produced by Mother Earth (Ge) rising up amid the combat on the section of the Pergamene frieze showing Athena killing a giant.[36] These two fragments continue the composition of Slab Λ, the crucial scene of priestesses between the slabs with imperial apotheosis and the slab (M, N) with the Antonine succession. These fragments must have been part of a second slab (ΛB), and another fragment in Vienna can be proposed as its right end or corner. This piece shows merely the middle and lower part of a standing woman in chiton and himation (1.36 by 0.49).

There remains a fragment with the lower half of a man clad in the heroic costume of divinities and personifications. He wears no chiton; his stomach is exposed; and his ample himation is swung across his abdomen in a large fold (0.87 by 0.54). I would like to call him a personification of Demos, the Greek counterpart in all respects of Genius Populi Romani, and place him beyond the Boule of Ephesus on the right

end of Slab P. Since this slab is complete enough, the Demos may have formed part of a narrower, supplemental slab (PB). Demos is an extremely popular figure on Greek imperial coins in western Asia Minor, and he is usually represented as a young Genius.[37] On the theater balustrade from Aphrodisias, however, he is a bearded elder in the garb of Demosthenes, to note a play on words which might have caught the eye of the early Antonine sculptor.[38] In 1911 a seated statue of the Demos of Ephesus was transported to the Istanbul Museum. Found in the middle of the skene of the theater and identified from an inscribed base, he was draped from the thighs downward and was also bearded.[39] The figure assigned here to Slab PB may thus have been bearded also. If this figure is not that of Demos, he can be another candidate for a geographical personification and finds his exact counterpart in the youthful Temnos of the Puteoli Basis.[40]

ARTISTIC MAGNIFICENCE

No photograph or drawing can begin to convey the splendor of these reliefs. On the basis of the examples from Rome, Antonine state sculptures are usually thought of as impressive rather than moving experiences. The reliefs from Ephesus are as great from the purely artistic standpoint as those of the altar of Zeus from Pergamon. The quality of carving apparent throughout is enhanced by the yellow patina which the western Asiatic marble has acquired. The drill is not used as a steady prop, nor as a resort to conceal technical inabilities; it is employed to give the maximum technical assistance to a high degree of carving made intelligent by the inherent power of the composition under execution. The reliefs from Ephesus share the breathtaking qualities of the Pergamene altar. They tell a story of imperial glory, earthly and divine, in terms that represented a perfect fusion of Hellenistic drama with Roman sense of historical purpose. In this they are the apogee of Roman art in the Hellenistic world.

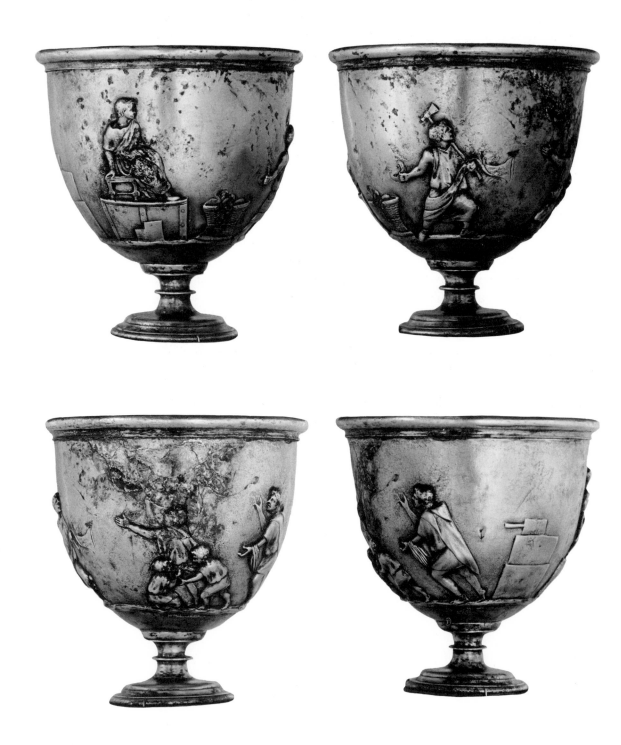

VII

Imperial Metalwork

TWO GILDED SILVER commemorative cups of the Julio-Claudian period illustrate the general symbolism of imperial art in the Greek East. One, the so-called Judgment of Bocchoris cup in Boston, was found in a royal tomb at Meroe in the Sudan (figures 53–56).[1] The second, a cup with scenes from the Orestes cycle, is in the British Museum and undoubtedly comes from Western Asia or an adjacent area (figures 57–61).[2] The outward presentation of legend and myth is apparent in both, and the dependence of one on an illustrated storybook and of the other on an illustration for a play can be reasonably postulated from parallels in Roman painting and the minor arts. The fact that both cups have portraits of the Julio-Claudians among the principals of their scenes is important in an assessment of Roman court art in the East.[3]

The king on the Bocchoris (Egyptian Bakenrenef) cup has the features of Augustus (figures 53, 68). The scene has never been interpreted in a completely satisfactory way. It has been interpreted as a version of the Judgment of Solomon. Proceeding from left to right around the cup, the figures are the king (Solomon–Bocchoris–Augustus), a basket, a gesturing executioner with his axe, two children clutching at the knees of an excited woman, a gesticulating man, and a chopping block beyond. Whatever the specific details of the story, the king is about to pardon or spare the distraught female and the children. The man at the right may or may not be pleased by this decision.

The excavators are correct in thinking the cup was made in Alexandria. Other finds in tombs of the period are also imports from this great Hellenistic center. The presence of Augustus as Solomon–Bocchoris may be only a conscious bit of meaningless self-amusement on the part of the metalworker; it is dangerous to read too much into such works of decorative art. On the other hand, the scene on the cup may copy a monumental work (a painting?) with political implications and embodying the type of flattery so expected in the arts of the Hellenistic and imperial East. In 23 B.C. the Augustan general Petronius invaded ex-

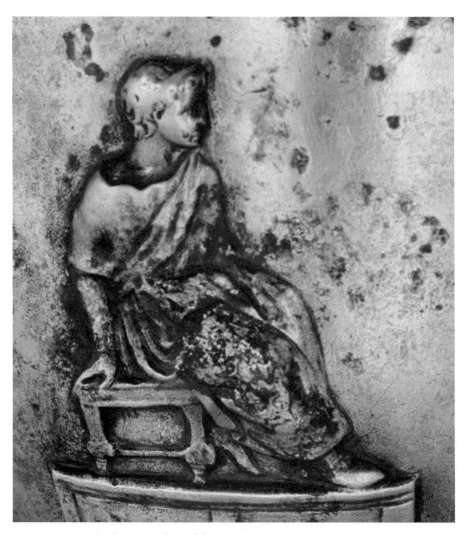

56A. Detail of silver cup from Meroe

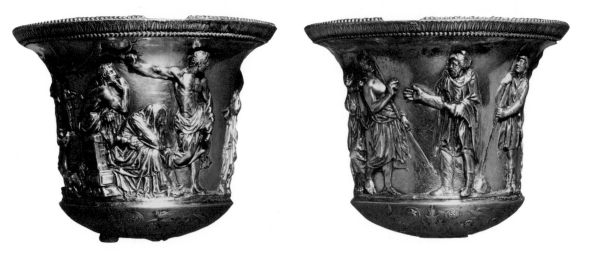

57–58. Silver cup from Asia Minor: Julio-Claudian princes in Orestes cycle

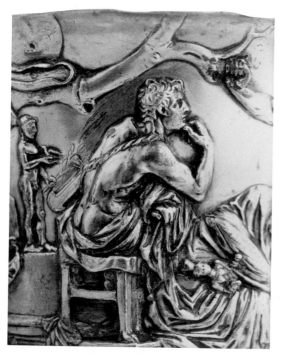

59. Drusus Junior

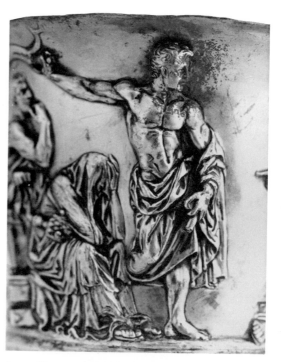

60. Germanicus

Details of cup with Orestes cycle scenes

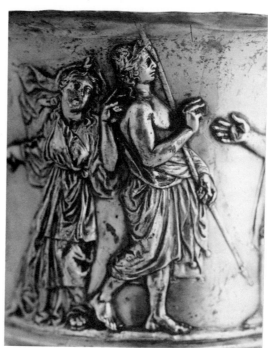

61. Claudius

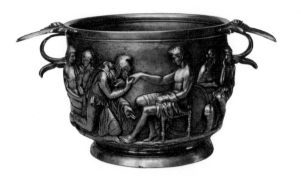

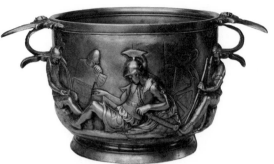

62. Silver cup from Hoby:
Priam before Achilles-Tiberius

63. Reverse:
Sleeping heroes and soldiers

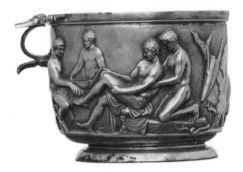

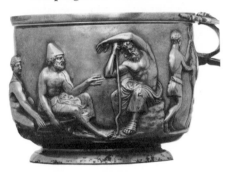

64. Second cup from Hoby:
Philoctetes on Lemnos

65. Reverse:
Odysseus addressing Philoctetes

treme Upper Egypt and the Sudan to settle affairs there. The result was that, by the end of the first decade of Augustus' sole stewardship of the Greco-Roman world, the affairs of Upper and Lower Egypt had been successfully and peacefully resolved. Could not the distraught woman symbolize Egypt, with the upper and lower provinces represented by her children? Since Augustus appears as Bocchoris, the scene assumes the significance of the new Pharaoh (Augustus) who brings happiness to the country of Egypt. This would be a typical manifestation of the sophisticated artistic thinking in the major workshops of the Greek imperial East.

The Orestes cup is one of three silver chalices acquired by the British Museum in 1959. The other two also have *repoussé* decoration whose floral scrolls with delicate traces of gilding recall the lower outside panels of the Ara Pacis Augustae. The find included at least two other items in silver with traces of gilding: a cup with Dionysiac motifs (figures 72–72c), and a ladle.[4] The Dionysiac cup is paralleled in arrangement of details, but not in delicacy of design, by a kantharos in the great cache of silver objects found at Berthouville in 1830. The Berthouville Treasure is, however, work of the second century A.D.,[5] and a closer qualitative parallel exists in the Hildesheim treasure.[6] The ladle has a panther-

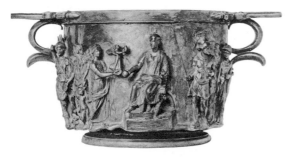

66A. Silver cup from Boscoreale:
Allegorical homage to Augustus

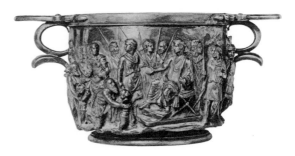

66B. Reverse:
Barbarian submission to Augustus

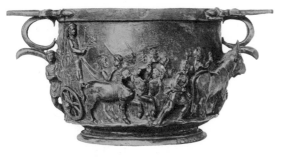

67A. Second cup from Boscoreale:
Triumph of Tiberius

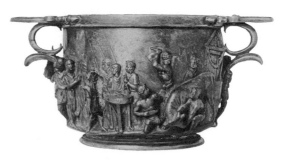

67B. Reverse:
Sacrifice before the Capitol

headed terminal to the handle and a separately cast bowl whose outside takes the form of an acanthus calyx like that of the giant Augustan or Julio-Claudian marble bowl in the Palazzo dei Conservatori.[7]

The subject of the Orestes cup, in size as well as design the masterpiece of the group, is a recondite piece of adaptation from the world of literature and the theater. The scene was recognized in the initial publication as a unique representation in art of a legend which is believed to have been the subject of the *Chryses*, a lost play by Sophocles, and perhaps of another, also so entitled, by Pacuvius. It is known, though only in confused outline, from the *Fabulae* of Hyginus, a mythological handbook of the second century A.D.

The story, in brief, is that Chryseis was restored by Agamemnon to her father Chryses, priest of Apollo at Sminthe. She was with child, as she asserted, by Apollo; a son, also named Chryses, was born. About twenty years pass, and one day Orestes and Iphigeneia sought sanctuary at Sminthe. They and Pylades were fleeing from Thoas, king of Tauri, with the image of Artemis which they had stolen. The younger Chryses was about to surrender them to the king of Tauri when the elder Chryses tells the younger that Agamemnon was his father. He and his half-brother, Orestes, then kill Thoas.

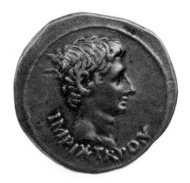

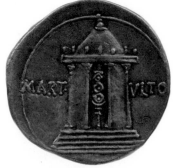

68. Cistophorus of Augustus

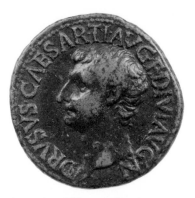

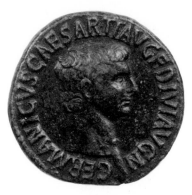

69. As of Drusus Junior

70. As of Germanicus

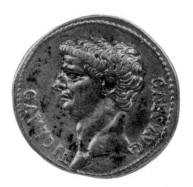

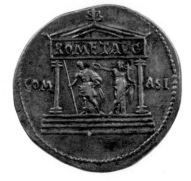

71. Cistophorus of Claudius

In the scene on the cup the elder Chryses has vanished, and it seems to be Chryseis who, more logically, tells of the relationship between the young men (and with Iphigeneia). Proceeding in a counterclockwise direction, the salient details comprise a tree with armor, the cult statue of Apollo Smintheus, and the triad of Pylades, Iphigeneia, and Orestes (clutching a tree). Orestes listens to the young Chryses who parleys with

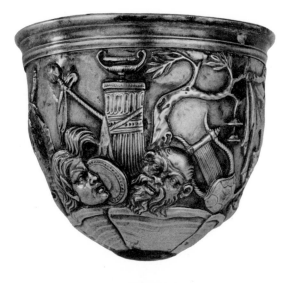

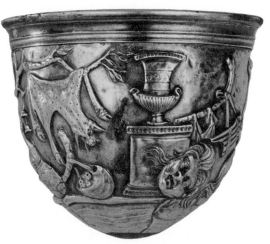

72. Cup with Dionysiac devices

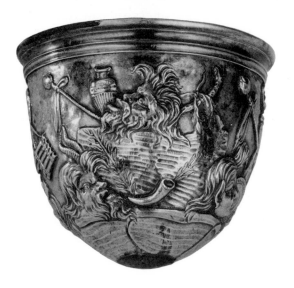

Thoas and an armed attendant. Between them is Chryseis, touching her son Chryses on the shoulder and pointing dramatically to the group of refugees at the shrine of Apollo Smintheus.

The consideration essential to understanding imperial art in the East lies in the simple statement that Orestes and Pylades are portraits of Julio-Claudian princes. Chryseis is, albeit distraught, a female member of the Julio-Claudian house. In the subtle and complex family struggles of the Julio-Claudians a solution to the political symbolism of this scene cannot be too difficult. A woman interceding with a (younger) man turns emotionally to two young men and a woman who are companions (that is family relations) in an important adventure. Several combinations are possible, if it is allowed that the family relationships of these Agamemnotes cannot be exactly paralleled. Orestes seems to be a portrait of Germanicus. Given this, the scene could show Livia interceding with Augustus on behalf of (her grandsons) Germanicus and Drusus Junior. Iphigeneia in this case would be Agrippina, the widely traveled and faithful wife of Germanicus. On the other hand, all the Greco-Roman world knew how Livia, through her second husband Augustus, advanced the fortunes of her own children Tiberius (Orestes) and Nero Drusus. Iphigeneia in such a case could be none other than Antonia, the virtuous wife of Nero Drusus and daughter of Mark Anthony. The family resemblances in Julio-Claudian portraiture could allow other combinations of persons, but these examples make the dynastic message of the cup clear enough (figures 59–61, 68–71).

In the two sets of combinations suggested here the principals (Germanicus–Orestes and Tiberius–Orestes) both had strong connections with Asia Minor. Tiberius was there as a high official under Augustus and again as a private citizen during his self-imposed exile on Rhodes. The last years of Germanicus and his untimely death in A.D. 17 were part of the story of the Greek East under Roman rule. It is important, therefore, that this particular Orestes myth should be the one that brings the triad to the shores of western Asia Minor. A clue as to where the cup was made lies in the fact that the image of Artemis clutched by Iphigeneia is nothing else than a miniature of the great Artemis of Ephesus. At this time Ephesus was the chief center for production of imperial portrait cistophori, the largest silver coin in circulation in the Roman Empire. The so-called Apollo Smintheus may be the cult statue of that shrine, but he also resembles a late Archaic to Transitional statue associated with Miletus or the sanctuary at neighboring Didyma. In short, this cup was packed with the literary, theatrical or dramatic, political, geographical, and religious subleties which delighted a learned man, whether Greek or Roman, in the Greek East of the Julio-Claudian period.

BOSCOREALE AND HILDESHEIM SILVER

A comparison between the silver treasure that included the Orestes cup and the two principal cups in the Boscoreale find demonstrates a basic difference between major Greek and Roman imperial silverwork.[8] Although Alexandrine designs exist in a number of Boscoreale cups and plates, I am convinced that the whole group was manufactured in Italy, that is, in Naples or Rome. The Boscoreale cups are so much heavier, so much deader (in the sense of liveliness), than the cups in the new find. The silver is of an Italian rather than an Asiatic quality. Such comparisons are self-evident when one looks at great numbers of denarii from the Rome mint as opposed to cistophori from the mint of Ephesus. It goes without saying that the Berthouville silver is Italian or, more likely, Gallic in manufacture.

Few Greek, Asiatic, or Egyptian finds of silver plate have survived in proportion to the obvious amount of output; much must have gone into the melting pot from Islamic to Turkish to recent times. Although I have never seen the pieces, I would say that the Hildesheim silver is also Asiatic in manufacture. Many have said that this treasure belonged to Varus, who died in the ambush at Teutoberger Wald in A.D. 9. Before taking command in Germany, Varus was Legate in Syria and spent considerable time in the East. One plate in the group contains a bust of Cybele in relief, and another exhibits a bust of the very Anatolian god Men-Attis, with his characteristic attributes of Phrygian cap, torque, and, especially, the crescent moon behind his shoulders. The find also includes a shallow kylixlike cup with a *rinceaux* enrichment like the comparable details of the ladle in the treasure to which the Orestes cup in London belonged. The masterpiece of the Hildesheim treasure, the plate with Athena seated in a rocky landscape that includes her owl in the upper left of the tondo, is familiar to all from countless photographs and reproductions in electrotype. This composition and its execution too are very Hellenistic in flavor and detail. Athena with her triple-crested helmet, aegis, shield, and ample drapery recalls the richly modern seated Athena of Hellenistic coins, notably the type widely circulated by Lysimachus after the death of Alexander the Great. Athena and her owl were very popular devices in the circular coin-designs of many western Asiatic cities in the Hellenistic period (Pergamon, Priene, and Heracleia on the Latmos, to cite at random), and a metalworker who grew up in the world of these coins has produced the interior design of this plate.

In the Boscoreale silver, the two principal cups are two generations in advance of their time in presenting subjects worthy of Claudian or later state reliefs. The first cup shows a homage to Augustus on the part of Virtus (or Roma), the Genius Populi Romani, Venus–Livia (with Victoriola), and Mars leading the provinces (figure 66). On the other side

133

of the same cup barbarians come to do obeisance to Augustus, who is enthroned amid his lictors and military guard (figure 66b). The Roman general who presents the barbarians has been identified as Nero Drusus, who died in 9 B.C. The other cup shows Tiberius in triumphal (or, less likely, consular) procession on one side, and a sacrifice before the Capitol on the other (figures 67, 67b). These scenes were first connected with the consulship of 13 B.C. and the sacrifice of A.D. 10 on the eve of Tiberius' departure to the Pannonian front. This spread of dates seems too great, and the Pannonian triumph of A.D. 12 is perhaps the most likely event represented in both scenes. The persuasive suggestion has been put forth that the scenes of this (and perhaps the other?) cup copy reliefs on the Arch of Tiberius erected on the Capitol in A.D. 16. This would place the date of both cups early in the reign of Tiberius. The treatment of figures in depth and perspective, the groupings within the scenes, and the iconographic details are forerunners of what we think was introduced to Roman art in Flavian state relief.

The Bocchoris cup and the Orestes cup refer to Julio-Claudian events by the subtlest uses of allegory and myth, and for this reason are truly Greek imperial in concept. The Boscoreale cups present the deeds of Augustus and Tiberius with some allegory, concentrated in the scene of symbolic homage to the first emperor. The basic orientation of these scenes, especially those on the cup to Tiberius, is historical and ritualistic. In this respect these cups are monuments in the development of Roman rather than Greek imperial art. These comparisons point up the different paths of development in the art of the two halves of the Empire through the reigns of Tiberius (14–37) and Caligula (37–41). Caligula is mentioned because he was assiduous in commemorating the older members of the Julio-Claudian house, and the Orestes cup may conceivably have been made as part of this commemoration, or at least a reflection of it on the part of a private person of intellect, whether patron or master craftsman.

THE HOBY CUPS

Some light on the artists of these mythological-historical cups comes from a discovery made in 1920 in a Nordic chieftain's grave at the village of Hoby on the island of Laaland in Denmark. A pair of gilded silver cups of the usual skyphos type and of very superior workmanship are among the most important Mediterranean imports heretofore discovered on the extreme northern frontiers of the European continent. They are both engraved — one in Greek letters and the other in Latin letters — with the name of their Greek artist. The Latin signature reads CHEIRISO-PHOS EPOI. The principal subject of one cup is Priam kneeling before Achilles (figures 62, 63). The second cup presents the legend of Philoctetes on Lemnos (figures 64, 65). They are now ornaments of the Na-

tional Museum in Copenhagen, where they have attracted perhaps more attention on the part of students of Roman civilization in Scandinavia than from historians of Hellenistic and Roman art. They have been correctly dated in the Augustan period,[9] and I suggest that the subject matter indicates a date after 19 B.C., the date of the artistically as well as politically all-important Parthian Settlement.

Each cup has a graffito indicating weight and the Latin name SILIUS on its bottom. These have been taken to be the mark and name of the owner. In the years 14 to 21 a certain Caius Silius governed Germania Superior and led a diplomatic expedition into the area of the Low Countries and Denmark. Although Silius is not a rare Roman name, there is considerable likelihood that the cups were given by him to a local princeling, or, less probably, were deposited by him in a place where they could have passed into the commerce of barbarian plunder.

Connecting Silius with the artist Cheirisophos, if only by reason of the bilingual signature of the Greek artist, most authorities have given Central to Southern Italy as the place where the cups were created. The *Cambridge Ancient History* even narrows this down to "made in Capua." There need be no immediate connection between the owner's marks and those of the manufacturer. The signature in Latin would be not out of place in Greece, or especially in western Asia Minor, where Roman officials represented a class of wealthy patrons and where Greek imperial coins, obviously by Greek die designers, bore Latin inscriptions. And if the cups passed directly from the workshop of Cheirisophos to the silver collection of Silius, the Greek could have very easily put the weight and the new owner's name on his handiwork in the form requested by the patron. Without belaboring the point, I see no reason why these cups were not produced in the Greek East, in Asia Minor or Egypt. The presentation of Roman history in the guise of Greek myth involved in the more important of the cups is very in keeping with the class of gilded silver vessels which have been assigned to Greek imperial workshops in these pages.

The cup showing Philoctetes on Lemnos divides the scene into the unhappy beginning and the happier near-conclusion of the hero's decade of torment. The source of artistic suggestion seems to have been the lost tragedy of Euripides. On the first side, the young Philoctetes, a veritable Polykleitan youth of the age of the Doryphoros, is having his snakebite attended to by two companions who are also Polykleitan in concept (figure 64). On the principal side, Philoctetes, now a bearded elder of a well-known Hellenistic rococo type, is being addressed by Odysseus, who brings Diomedes in his train (figure 65). The bearded Philoctetes is seated, leaning on his bow in a manner which has suggested him as the subject of the Belvedere Torso. In no face on this cup is there the suggestion of a portrait, even given the tendency of Greco-Roman artists

in the Augustan Age to liken heroes in myth and drama to princes, old and young, of the Julio-Claudian house.

The back of the second cup, the cup of Priam and Achilles, presents a Hellenic form of forerunner to late Medieval scenes of soldiers asleep at the Resurrection (figure 63). Three Greek warriors, including Odysseus like a trophy under his Phrygian bonnet in the center, recline in slumber. A biga at the right is attended by the elderly charioteer of Priam. On the side which gives the quintessence of the arguments proposed here, two young Greek warriors crouch at the left, and two women of the Greek camp kneel at the right. In the center, Priam, aged and in Greco-Roman barbarian costume, kneels to kiss the hand of the young hero Achilles (figure 62). This is a famous motif, and its presence in Arretine ware indicates it once adorned other metal cups.

The head of Achilles is an unmistakable portrait of Tiberius. The two Greek youths on the left are also Julio-Claudians in heroic or semi-ideal form, he on the left being the popular general Germanicus and he on the right being Tiberius' son Drusus. Germanicus was son to Drusus the Elder, and Drusus the Elder was younger brother to Tiberius. Therefore Germanicus and Drusus Junior were first cousins who stood in relations of power and heredity to the man whom Augustus (or Livia) picked to be second emperor in the line established by Julius Caesar's dictatorship. The important Julio-Claudian women of the last years of Augustus and the early years of Tiberius as emperor are not neglected. The Greek woman closest to Achilles–Tiberius is Agrippina the Elder, daughter of Augustus' admiral Agrippa and wife of Germanicus. The older lady at the right is Livia, wife (or widow) of Augustus and mother of Tiberius.

Priam in homage to Achilles–Tiberius, therefore, becomes a symbol of something beyond mere insertion of an imperial portrait in a scene from the Iliad. In garb and behavior he symbolizes the Asiatic barbarian world paying homage to the power of Rome. Tiberius took the return of the standards captured over thirty years before from Crassus by the Parthians in 19 B.C. This event became a never-ceasing theme in Augustan artistic policy.[10] Here it echoes in the minor arts, as it did elsewhere, and here a Greek artisan has again paid a skillful compliment to the political world in which he worked by using Greek mythology as the vehicle for suggesting Roman glory in the Greek world, amid the members of the ruling dynasty and to the benefit of the *Pax Romana* under which Greek civilization from 30 B.C. thrived and continued to grow.

THE INGOLSTADT CUP

Augustus is the principal in another Homeric scene, on the silver bowl in Munich. This piece, much worn from having been polished in antiquity, appears to have been found at Ingolstadt in Bavaria.[11] The work is Hadrianic or Antonine, after a model created in the early decades

of Augustus' reign. The emperor appears as Achilles or Neoptolemus, depending on whether the prisoners being slaughtered (or spared at the last moment) are those at the funeral of Patroclus or those taken at the sack of Troy. The reverse of the cup is mainly occupied with mourning women. Motifs relating to Roman triumphal art are evident, and the authorities in Munich have noted that the group of commanders with bound "barbarians" is repeated on an Antonine sarcophagus in the Museo delle Terme in Rome.[12] It is not strange to have this taste for Augustan court scenes carried on as late as the middle of the second century, for Hadrian initiated a strong revival of Augustan designs in the minor arts. A parallel in our own times is offered by the fashion for revivals of Napoleonic designs and objects, and during the first quarter of the twentieth century United States medals, coins, and other work in metal were designed after compositions initiated in the Italian Renaissance.

The evidence of a plaster model suggests that the Munich cup or its immediate prototype may have been made in Alexandria. If so, Augustan court art owed more than we realize of its development in metalwork to the thriving industries of the Egyptian city with its long tradition of a Hellenistic royal iconography. A famous painting may lie behind the scenes on the Munich cup or bowl, but there is no reason to assume this painting was in Alexandria. Models could travel in all directions, and the Alexandrian metalworker could have worked from a sketch, just as his contemporaries and successors made imperial coin-types from the mint of Rome part of their productive repertory.

HELLENISTIC SILVERWARE

The transition from Ptolemaic Alexandrian to pan-imperial apotheosis in metalwork has now been recognized and documented in detail in the silver dish from Aquileia in Vienna.[13] Triptolemos stands between his snake-drawn biga and an altar where three children congregate; Demeter is enthroned at the upper right, and all are set amid divinities or personifications and snatches of landscape. The design speaks much of Alexandrian official art in the last moments of the Ptolemies, before the new stimulus and imaginative breadth of the Augustan age and Roman imperium. Triptolemos, unnaturally aged and heroic, is a portrait of Mark Anthony, while Cleopatra is hinted at in Demeter, and the children at the left are presumably theirs. The protagonists in divine guise are stiff and self-conscious, as is the whole composition with its set pieces and unrelated series of excerpts or stock iconographic poses.

The Bocchoris and Orestes cups are much more successful as positive expressions of strong compositions because their figures, mythological or real, are engaged in actions, not simply set about in symbolic poses. So, too, the Boscoreale cups impart none of the formal pretentiousness

of the plate from Aquileia because they are busily and outwardly concerned with glorification of the Roman state. In short, the Ptolemaic symbolism of the Aquileia plate was the last breath of a bankrupt power, a symbolism no longer needed for its own sake but in 30 B.C. ready to hand over its tools and its traditions of craft to the house of Augustus.

There is another aspect, no less Greek, in the artistic message of this Asiatic and Egyptian imperial court silver. It is the possible message of political mockery or satire conveyed in some of these elegant scenes from literature, in which the principals are evidently Julio-Claudians. The Bocchoris and Orestes cups may fall in this category. The Hoby cup of Priam before Achilles is a straightforward historical compliment under the guise of the Trojan tales. The two principal Boscoreale cups are devoted, on one hand, to pure historical allegory and, on the other, to pure history. There is no touch of humor or satire, or concealed ridicule, in the scenes of homage to Augustus and of Tiberius sacrificing and riding in triumph.

The notion of Augustus as a Jewish king or an Egyptian pharaoh presiding over the squabbles of two women about one or more children may have been humorous to the Greek who made the cup or to the client who bought it, whether the latter was Roman, Greek, Jewish, Egyptian, or Nubian. By 20 B.C. the delights of an Alexandrine education and the world of courtly intellect to which it gave access had long been open to the upper classes of non-Greek origin, as witnessed in the tastes of Herod the Great and by the Hellenistic statuette of a negro boy-orator, posed like Hermarchus of Mytilene, in Boston.[14] Presentation of Augustus, pacifier of Egypt, in this amusingly non-Roman legend could have appealed to any number of educated persons, Roman officials and otherwise, in touch with the Ptolemaic court jewelers and silversmiths working on in Alexandria after the deaths of Anthony and Cleopatra. It is not surprising, therefore, that the Bocchoris cup found its way into a royal tomb at Meroe, into a necropolis which has yielded in the bronze bust in London one of the most striking portraits of Augustus as a young emperor.

There is more bitterness, more satire to the message of the Orestes cup. It is well to have spoken of the subtle plays on intellect implicit in Julio-Claudian family foibles presented as the *Chryses* of Sophocles or Pacuvius, but the screaming intervention of Livia on the cup can also be taken as an acid commentary on the way she upset the succession of Augustus by intrigue and even murder. In this case, if Livia is the distraught Chryseis, then Asiatic court silversmiths or their patrons would have no difficulty in identifying Augustus with Apollo, his patron divinity. It was, after all, in claiming union with Apollo that Chryseis caused all the confusion and the near-tragedy of the legend. It was in securing for her children by a member of the Claudian family what Augustus should have given his own daughter and grandsons by his faithful

admiral Agrippa or the descendants of his sister Octavia and Mark Anthony that Livia brought grief to so many innocent persons of all ages. The artist of the Orestes cup was resorting to the traditional vehicle of the Greek stage to scold the Julio-Claudians for their weaknesses in such a way that the artist would be safe to create more such masterpieces and the purchaser would be safe to display them in the luxury of his *triclinium*. Many a late Hellenistic artist must have heard what happened to Pheidias when he dared to place too bold a likeness of himself and Perikles among the Greeks fighting Amazons on the shield of the Athena Parthenos. The subtleties of silver and gold cups were safer.

This notion of history and historical scandal clothed under the guise of myth or impossible beliefs no doubt found expression in paintings now lost to us. It was current in cameos or cameo reliefs and their counterparts in glass. The Portland vase with its telling of the Atia tale is one illustration in the latter medium.[15] Apollo is said to have appeared to Atia in the form of a snake, and in this form to have become the father of Augustus. If, by chance, both the seated and the walking hero on the vase were portraits of Augustus, as well they may be, more biting satire is possible in the two scenes. In one, Dionysos–Augustus contemplates Ariadne–Livia asleep on the island of Naxos. In the other Peleus–Augustus courts Thetis–Livia, who goes through her transformation into various serpents and monsters before he wins her. Neither comparison is particularly flattering to Livia.

BERTHOUVILLE SKYPHOI

Two skyphoi from the treasure found near Berthouville in Normandy, on the site of an ancient federal assembly-place, are no doubt fine Roman copies of the first or second centuries A.D. after Hellenistic designs. They show famous philosophers, prophets, and writers in various acts of instruction or meditation.[16] Aratus of Soli faces his Muse (Urania) of astronomy, and Lycophron of Chalcis listens to the inspiring words of the tragic prophetess *Alexandra* or Cassandra about whom he wrote. Lycophron's master Menedemus of Eretria is read to from a rotulus by an unidentified Muse, and her sister Thalia lectures a very ideal Theocritus of Syracuse in a poetic landscape. Aratus is identifiable from his portraits in marble and on coins of Soli, but with present knowledge the others are scholarly conjectures. Since all lived in the age of portraiture, the ancients no doubt knew their faces more precisely. Through other mediums, these compositions can be related to the art of Hellenistic courts from Macedonia in the third century B.C. to southeast Anatolia or Syria or Alexandria.

After the Roman victories at Cynoscephalae in 197 B.C. and Pydna in 168, the precious metal vessels of the Macedonian kingdom were carried in grand processions through Rome. Several writers report that there

were chastened vases of exquisite art, silver kraters, rhyta, cups, kylikes, and other breathtaking creations. Vases featuring philosophers must have served as models for metalworkers in Italy for generations to come.[17] From what we have seen of Hellenistic art in the East, it is doubtful whether rulers were represented except as divinities or in scenes of the most general allegory, the metallic counterparts to the Ptolemies in the "Apotheosis of Homer" relief. The Pergamene relief of Mithradates–Herakles freeing Prometheus is one of the first Hellenistic mythological scenes containing political sharpness, even venom.

It remained for metalworkers of the Augustan age in the East to take the major step of turning this medium of expression into something official and triumphal or, more immediately and directly, an art based on literary tradition and satire. Vases of the type from Berthouville, with recognizable philosophers as subjects, provided the beginnings of an art that culminated in the Orestes and Bocchoris cups, with identifiable emperors as actors in myths or literary dramas. The fact-bound triumph and sacrifice of the Boscoreale cup featuring Tiberius was an Italic rather than an Eastern innovation, but there must have been many intermediate stages both in the Hellenistic cities and in Italy. The Boscoreale cup with the real and allegorical homages to Augustus, for example, lies just on the Italic side of the transition from myth to reality.

DIONYSIAC DECORATION

Beyond myth and reality at all times, Hellenistic and Roman, lay the handsome series of cups in which religious, mythological, or floral motifs and designs had no visible relation to narration. The art of the silver-smith in the Hellenistic kingdoms and the Roman Empire was primarily a decorative one. A cup could present a masterful display of Dionysiac devices in an ensemble that included vessels of the allegorical or quasi-historical class.

The focal point of the single cup with Dionysiac scenes in the find that included the three British Museum cups and the gilded ladle is the altar or baetylus between the satyr and the Silenus head lying on the edge of the tortoise-shell kylix which forms the bottom of the cup (figure 72). On top of the altar is a high-handled skyphos or a kantharos, and a filleted thyrsos is wrapped around the shaft. Beside the head of the young satyr at the left appears a tambourine, and a gnarled tree rises behind the Silenus at the right. Beyond him and beneath the tree is a large tortoise-shell lyre, and cymbals hang from a branch directly above. Going to the right, the farther reaches of the branches display a goat's skin, while below, a basket of fruits or flowers is hung from a pedum so as to rest on the ground.

On a circular altar or base, a large metallic krater rises nearly to the upper molding, and another young satyr's or maenad's head lies in the

foreground, rolled to the right and facing (figure 72b). With open mouth and incised pupils, the head produces quite a terrifying effect. The next scene grows out of the round base and consists of Pan-pipes suspended from a filleted pedum, which rises up to the right. The last vignette leads out of the Pan-pipes (figure 72c). It centers on a rocky landscape on which an old satyr's head appears, with thyrsos, oinochoe, and tasseled pedum behind. A head of Pan is at the left, in front of the rock, and a rhyton with branches of laurel(?) rising up the rock left and right forms the frontispiece of this section of the design. Beyond, the rock disappears behind the head of the young satyr to the left of the altar. The series of decorative details has run its full circle.

The designs are both bold and delicate. The art is that of accomplished late Hellenistic decoration. The facing Silenus mask partakes of the ideal naturalism accorded portraits of Socrates and Homer. The details of furniture and nature are not veristic to the point of being fussy. The design as a whole is not really cluttered. Cups like this that show Bacchic symbols rather than Bacchic myths or processions give a great opportunity to the artist to mix objects and nature in imaginative juxtaposition. Above all the craftsmanship is superb. The outside skin of the cup, the cast and hammered metal of the reliefs, is thin and precisely worked in the touches which have made the difference between a masterpiece and just a good piece of silverware.

Greek ways of expressing artistic individuality found a happy outlet in silver plate during the Hellenistic age. With the advent of Roman politicians and Roman patronage, this creative urge turned to inclusion of emperors and their relatives in traditional narrations of myth or allegory and in quasi-historical scenes. From there it was a small step to the full-fledged historical presentations of the Boscoreale cups. At all times the decorative nature of medium and shapes were borne in mind, and a reversion to impersonal symbolism and pure vegetation as a theme accompanied every stage of creative progress from Hellenistic artistry to Roman history. Centers of Hellenistic creativity in a Roman political and commercial world existed in western Asia Minor and in Alexandria. Since silver from these areas was exported all over the Latin West, in many respects this form of art propagated the Greek spirit amid an imperial political world more readily and perhaps more thoroughly than architecture and large-scale statues. Court silver made its message felt among the rich and ruling classes, but for better or worse these were the people who shaped the course of empire.

141

VIII

Numismatic Art

ANY STUDY OF Roman official art in Greece and Asia Minor must consider the wealth of coins struck in the name of the emperors by the Greek cities and Roman colonies. The series extends from the reign of Augustus until the reforms of Diocletian in A.D. 296. The obverses usually present the imperial portrait and titles, but the reverses are as rich as the imaginations of individual cities could make them. Thus, Greek imperial coins can be fairly precisely dated and located within Greece and Anatolia. They are as typical of the Greek approach to Roman imperium as the buildings, statues, and inscriptions character- istic of Hellenic reaction to Roman polity. In their individuality of de- sign and style, they are a perfect foil to the subjective and stylistic unity of products from the imperial mint of Rome and its branches.[1]

The Greek imperial series is much richer in Asia Minor than in Greece proper. From the time of Augustus to that of Hadrian most Greek cities did not possess the right to coin. Imperial centers such as Corinth and Patras produced feeble series in comparison with their economic and artistic potentials. Hadrian's interest in Greece redressed the balance somewhat, and cities such as Olympia were allowed to issue commemora- tive medallions (in honor of Antinous) and coins glorifying their antiqui- ties.

The most fruitful Greek cities were the Roman military encampments and colonies of Macedonia and Thrace, cities such as Thessalonica and Byzantium being numismatic landmarks on the high road to Anatolia. It is almost impossible to comprehend the wealth and diversity of Greek imperial numismatic activity in Asia Minor in the first three centuries of the empire. Major centers such as Pergamon and Ephesus produced majestic issues, medallic in size and rich in historical or artistic signifi- cance. Cities favored by Rome for religious or emotional reasons, such as Ilium, left magnificent numismatic records. The coins of Troy were designed to glorify the mythical lineage of the Romans. The total wealth of Greek imperial coinage in Anatolia is not measured solely by the

output of great cities from Smyrna to Caesareia in Cappadocia and An-
tioch, across the geographical border in Syria; it is also computed by the
issues of countless small cities in the hinterlands of Lydia, Phrygia,
Pisidia, Cilicia, and other provinces — cities that would be little more
than names in early Christian church lists or questionable sites were it
not for the testimony of the coinage.

Chronologically, the Greek imperial issues fall into three great groups.
The first extends from the reign of Augustus through the rule of Trajan
(27 B.C.–A.D. 117). The second embraces the Hadrianic, Antonine, and
Severan periods (117–235). The final division spans the tumultuous
decades from the advent of Maximinus the Thracian to the elimination
of the Greek imperial series with the closing of the mint at Alexandria
in Egypt under Diocletian (235–300). These groups, defined in terms
of approach to a homogeneous yet individual presentation of the com-
mon denominator of imperial commemoration, are subjective and stylis-
tic.

Numismatically, the Greek imperial world fell heir to a vast tradition
of Hellenistic royal coinage, ranging from the Macedonian series through
the regal issues of Bithynia to the widespread output of the Seleucid
and Ptolemaic mints. In addition, Roman intervention in Asia in the
second century B.C. freed a number of cities to resume the rich coinage
interrupted by the period of Macedonian domination. Cities such as
Smyrna, Heracleia on the Latmos, and Miletus struck handsome tetra-
drachms in the broad, flat, precise style of post-Pergamene Hellenistic
classicism. Finally, the Greek world was conditioned by intrusion of
Roman Republican coins to grasp what the Roman ruler expected in
terms of numismatic commemoration. The great hoard of imperatorial
portrait gold discovered at Pisidian Antioch in 1961 bears ample wit-
ness to this. Most of the coins therein are double-portrait aurei, com-
binations on opposite sides of such as Julius Caesar and Octavius, Octa-
vius and Mark Anthony, Mark Anthony and Octavia, and Mark Anthony
and Antonius Filius. An arresting example of the more orthodox late
Republican type is the aureus of Ahenobarbus, with his plump face on
one side and a temple in perspective on the reverse. With issues such as
these, the Greek imperial world was set to embark on its own program
of local mintages.

Most Greek imperial issues are characterized by obverse and reverse
legends in Greek. Roman colonies such as Corinth and Pisidian Antioch,
however, felt obliged for reasons of prestige more than convenience to
cut their dies with legends in Latin. This did not necessarily mean that
the style of the coinage was like that of the mint at Rome; there is no
rule about stylistic relationship to the imperial issues in the Latin West.
In the time of Philip I (A.D. 244–249), Zeugma in the Commagene was
producing sestertii with Greek legends, which in every other respect

143

were just like the sestertii of Roman imperial type struck in Italy and at Syrian Antioch. Most Greek imperial coins were made of bronze or copper. Roman coins supplied the need for silver. Cistophori (tetradrachms) and four-denarius pieces were exceptions, as were the drachmas of Caesareia in Cappadocia and the progressively baser tetradrachms of Antioch. The cistophori, struck at Ephesus or Smyrna or Pergamon, belong mainly to the coinages with Latin legends. They were rich and plentiful in the periods of Augustus, Claudius, and especially Hadrian. The Flavians and Trajan are well represented by various types, but during these periods the quality of design is irregular.

The glorious years of Greek imperial coinage — the period from Septimius Severus to Diocletian — are precisely those years when monumental imperial art is hardest to trace in Greece and Asia Minor. Emperors such as Severus Alexander, Gordianus III, Philippus I, Decius, Valerian, and Gallienus lent their portraits and titles to issues of many cities, coins with reverses covering the widest range of imperial and local thought. Cities in alliance with each other, like Perge and Side under Gordian III, issued joint bronzes to commemorate their "Omonoia." (The reverse of Perge and Side's alliance coinage shows the Athena of Side greeting the Artemis of Perge over an altar; Side's pomegranate floats like a hand grenade above the scene.) When no alliance was openly proclaimed, cities near each other often used the same mintmasters, sharing not only die cutters but even specific dies. In the third century Sagalassus and Termessus in Pisidia work together in a curious "stringy" style of portraits, reverse designs, and lettering. A more elegant, more Roman style is manifest in the best issues of Antalya, Perge, and Side. Their common issues, that is, their smaller, everyday coins, belonged to the average level of numismatic art practiced throughout Anatolia in the second and third centuries.

In terms of style and content, the period from Augustus through Trajan was one of formative development for Greek imperial coins. It took this length of time to shake off the Hellenistic Greek notions of timeless uniformity and develop an imaginative formula for representing the emperor on the obverse and commemorating the region or city on the reverse. Early Greek imperial coins were not very successful artistically because they were neither Greek in beautiful timelessness nor Roman in control of orderly specifics. To a lesser degree, Roman imperial coinage centering around the mint of Rome was having the same problem in casting off Greek notions of coin design in favor of Roman. Roman imperial issues did not realize their artistic potential, their capacity for combining beauty and commemoration, until the aes coinage of Nero.

After Hadrian, Greek imperial issues blossomed forth to enjoy a century and a half of economic and artistic prosperity. Flans became big

and bold, and designs ranged from the grandly decorative to the mythologically or historically imaginative. The reign of Antoninus Pius (138–161) saw a revival of antiquarianism throughout the ancient world, and cities hastened to use their coinages to immortalize their oldest cults, their greatest building, and their important myths. Hadrian's bestowal of numismatic freedom on Greece coincided with this rise in antiquarian interests and led to Greek imperial bronzes serving as the illustrations for Pausanias' literary tour of the cities of old Greece.

In a sense it is fortunate the Greek imperial series ends so abruptly. Its great years are not followed by a long period of decline. The series was doomed to give way to the panimperial uniformity imposed on Greek and Latin worlds by Diocletian. When the cities themselves lost many of their remaining freedoms, their coinages lost the spirit as well as the reason to exist. By the time imperial coinage again became Greek in language and design, many centuries had passed, and the Roman world had been transformed into that of the Byzantine Empire. The vocabulary of the coinage was now that of medievalism and Christianity.

REPRESENTATIVE COIN TYPES

The cistophori of Augustus struck in the years immediately after the Parthian Settlement of 19 B.C. reflect thoughts and artistic events current in Rome and in Ephesus or Pergamon, where the coins were minted. The portraits of Augustus depend on official models of the decade after Actium, but western Asiatic die cutters have given the hair and eyes of the first ruler an ever-so-slight touch of Alexander the Great. One reverse shows the circular shrine of Mars Ultor or Pater on the Capitol in Rome. This was the small temple in which the Parthian standards were placed on their arrival in the capital, before the giant temple of Mars Ultor in the Forum of Augustus was completed (figure 68). The feeling for circular structure is combined with minute detail, as the standard is portrayed above the stylobate and below the antefixes. Another reverse gives a vista of a triumphal arch, one which could be in Rome or in Ephesus (figure 73). Imperial titles and a reference to the diplomatic success of the returned standards cover the arch below the quadriga and fill the open space within. The best Greek imperial die designers worked on cistophori, and their products influenced both the development of Roman denarii in Rome and Greek imperial coinages in the East.

73. Cistophorus of Augustus

THE MEDALLION OF HERACLEIA-PERINTHUS WITH ZEUS RULER OF THE COSMOS (figure 74).

One of the grandest medallic productions of the ancient world belongs to the Greek imperial series, to the rule of Severus Alexander (222–235). It is without parallel in the Greek East or in the Roman imperial

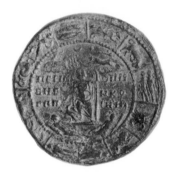

74. Heracleia-Perinthus: Severus Alexander

West. The obverse presents a mighty portrait of the young emperor, a deep bust clad in a rich cuirass and paludamentum, the latter draped on the left shoulder. On top of the cuirass, as if in imitation of a statue, is the aegis with Medusa's head in the center. This seems to be a conception of the die designer, for on a specimen in the British Museum the aegis only covers the left shoulder (like a paludamentum) and the Gorgoneion is directly on the breastplate, as in so many cuirassed statues. Bold and metallic though this obverse is, it has rivals in the large aes of Caracalla and Elagabalus for Perinthus, and it is surpassed in elegance (if not in forcefulness) by the half-figure Severus Alexander on a Roman imperial gold medallion or eight-aurei piece found at Tarsus.

The reverse is unique. The Capitoline Zeus is enthroned in the center, with patera in his right hand and scepter-staff vertically in his left. In the tondo field above him are Helios and Selene, one moving to the right in a quadriga and the other to the left, holding a torch and riding in a biga of bulls. Selene's crescent appears above Helios, and his star is in ascent over the moon-goddess. In the area beneath the groundline supporting Zeus, Ge or Gaia reclines to the right (holding a cornucopia) and Thalassa is squeezed in to the left, a rudder in her left hand and a minute prow at her feet. The tondo, between inner circle and outer border, is formed by the twelve signs of the zodiac. This maplike picture of Zeus presiding over air, land, the seas, and the cycle of the months is a Roman imperial concept with parallels from Rome itself. It is surprising to find that its sole venture on the numismatic level is in the

146

Greek East. The place where people, especially artists, of the Empire saw and remembered the theme of Zeus enthroned between the rising sun and the waning moon was in the pediment of the temple of Jupiter Capitolinus above the Forum Romanum. Sarcophagi of the late Antonine and Severan periods borrowed these details of the pediment, especially for the rectangular areas of the lids. The god or goddess between Gaia and Thalassa occurs on several imperial cuirassed statues, as the central design of the breastplate. The popularity of all these designs and motifs stemmed from the rebuilding of the temple of Jupiter Capitolinus under Domitian and the celebration of Rome's nine-hundredth birthday in the middle of the reign of Antoninus Pius. Finally, still within the Roman imperial orbit, a smallish marble group in the Villa Torlonia-Albani (although much restored) seems to show Zeus enthroned in a zodiacal circle, as on this coin. It is a characteristic of Greek (rather than Roman) imperial medallions to essay crowded reverses, but few carry it to the successful extremes of this composition. Greek imperial medallic reverses often seem to depend on paintings for their compositions, and such could conceivably be the case here.

JULIO-CLAUDIAN COLONIAL COINAGE: DUPONDIUS OF NERO STRUCK AT PATRAE (figure 75).

The coinage of this Augustan colony on the Gulf of Corinth is typical of the lack of spirit in Greek imperial issues from Greece proper and the Peloponnesus. In fact this is a coin more Roman than Greek, a provincial borrowing of dupondii being struck in Rome around the year A.D. 60. About the only changes from contemporary Roman imperial models are the alteration of the reverse legend to suggest Patrae as a Neronian colony and a general falling off in quality from the Roman model.

75. Patras: Nero

The imperial series of Patrae cannot stand comparison with that of Corinth as a Roman colony, for the latter was many times larger and richer. Corinth, however, never approached what could have been its artistic potential in Greek imperial times, so far as coins were concerned. A bronze of Geta as Caesar, minted at Patrae, presents the city's imperial coinage in more favorable light (figure 76). The half-figure bust, clad in chlamys, is not without charm. It recalls medallic portraits of

Antinous in the reign of Hadrian. The reverse shows an excellent bird's-eye view of the port, with temple, colonnade, mole, and two ships in the harbor. Within the pedimented temple-front, a statue of Poseidon is visible; it is the type created by Lysippos, the god holding out a dolphin and resting his right foot on a prow. As an introduction to the topographical possibilities of Greek imperial coins, this reverse die can be counted a great success.

76. Patras: Geta

MAJOR DIVINITIES IN THE PROVINCES

Average Greek imperial reverse types of the second and third centuries in Asia Minor provide an insight into types of divinities and their presentation in the arts. Apollonia Mordiaeum, a major city of the border area between southeast Phrygia and Pisidia, produced a sestertius under Marcus Aurelius (161–180) with Zeus enthroned on the reverse (figure 77). A local cult image may have been behind the type, with patera in extended right hand and scepter-staff vertically in the left. This Zeus of good Antonine style turns up elsewhere in Anatolian coinage, and perhaps there may have been no such major image of Zeus in this city of Apollo. The invocation may have existed on no higher material level than the minor arts, a small bronze statuette for instance; or, the design could have been the invention of the die designer. A large alliance medallion of Pergamon and Ephesus, struck under Commodus (180–192), presents firmer evidence in speaking of cult images as symbols of cities

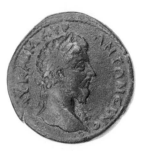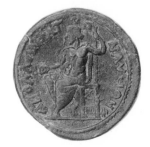

77. Apollonia Mordiaeum: Marcus Aurelius

148

(figure 78). Nike flies forward at the top, both arms extended with wreaths, in a frontal pose anticipating the hieraticism of Constantinian coin reverses, paintings, and mosaics. She is crowning the cult statue of the Asklepeion at Pergamon and that of the Artemision at Ephesus. Both statues, here given a certain lifelike animation, are familiar to Hellenistic and Roman art from a number of other media, including large statues. The composition as a whole sums up the symbolism of metropolitan alliance in a perfect shorthand.

MAJOR AND MINOR DIVINITIES COMBINED

Under Antoninus Pius a symbolic alliance between Miletus and Smyrna is celebrated by an unusual congregation of divine figures (figure 79). The Apollo of Didyma, with his patera and bow, stands at the left, looking out at the beholder in the stiff unconcern of a late archaic to transitional-style image, something like the Omphalos Apollo or the Apollo named after the French collector Choiseul-Gouffier. His companions are also cult statues, the two Nemeses of Smyrna, ladies who wear costumes of the century after Perikles and Pheidias, who face each other in a kind of mirror image, and who spit into the upheld folds of their garments! The effect is surely one of religious familiarity and antiquarian curiosity combined.

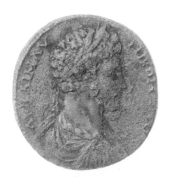
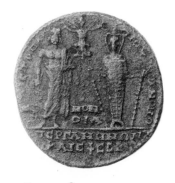

78. Pergamon-Ephesus: Commodus

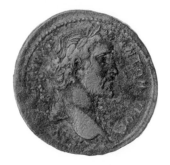
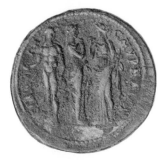

79. Miletus-Smyrna: Antoninus Pius

CURIOUS MYTHS

At Tarsus in Cilicia under Gordianus III (238–244) an unexplained meeting between Perseus, local hero of the city, and a fisherman is represented (figure 80). The former holds up the archaic cult statue of Apollo Lykeios (or Tarseios) in his left hand and an object like a torch in the right. The latter dangles his fish. The style is slightly crude but fairly forceful. As with all these later large aes of Tarsus, the reverse is crowded with the name of the city as a metropolis and with various magistrates' or control letters.

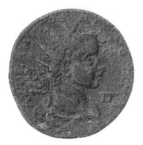
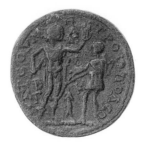

80. Tarsus: Gordianus III

IMPERIAL ACTS

At Amaseia in the hinterlands of Pontus, the northern tier of Anatolia, a sestertius was struck in the name of Marcus Aurelius in the year 162. This coin takes its affirmation of imperial harmony and indeed much of its style from a sestertius of the Rome mint (figure 81). After all, the die designers of remote Amaseia could only observe most imperial acts from afar, through the easily transmittible medium of imperial coinages brought from Rome. A togate Marcus Aurelius clasps the hand of his co-emperor Lucius Verus, who is about to take his delayed departure to secure the Anatolian frontier by dealing roughly with Parthia, especially as regards the ever-touchy question of Armenia. The

81. Amaseia: Marcus Aurelius

motif can be traced in Roman numismatics to sestertii of Vespasian, Titus, and Domitian; in Roman painting it was as old as the early Republic when Romans met their Latin adversaries or allies.

IMPERIAL TEMPLES

Hadrian's well-designed sestertii for the League of Bithynian cities show an octostyle temple, which (with variously sculptured pediment and frieze) appears too grand to be one of the earlier temples (Roma and Augustus) in the province (figure 82). Hadrian's efforts at architectural grandeur are well known from his temple at Cyzicus on the Propontus opposite Constantinople, the largest pedimented post-and-lintel structure in the ancient world. The simple fact of a large, even giant, temple seen on this sestertius with inscription of the Bithynian League must be a recording of some famous landmark in Nicomedia, Nicaea, or Bithynium-Claudiopolis, perhaps the last, which was honored with a major shrine for having given Antinous to the imperial world. Like Olympian Zeus in Athens, the temple on Hadrian's coin is traditionally Hellenistic in exterior design.

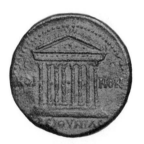

82. Bithynian League: Hadrian

CIVIC OR FUNCTIONAL ARCHITECTURE

Unfortunately, few Greek imperial coins record bouleuteria or councilhouses, baths, gymnasia, and marketplaces. As in the case of Patrae, ports (a fascination for ships and sea-gods) do command some attention, but Greek love of symbolism, using the god of the local senate instead of his building, kept architectural specifics to a minimum. There are exceptions. At Antioch on the Maeander in Caria, a sestertius of Gallienus shows a major bridge over this major river (figure 83). The bridge is a large Roman affair of a type still used or visible in ruins at numerous points where the Roman roads of Anatolia meet natural hurdles. There are the arches and piers of the span, the side walls and a large, triplearched tower at one end, forming a triumphal enframement for the masterpiece of engineering and a refuge for guards or customs officials. The artist has presented everything in tumbling but essentially correct

perspective and in that stringy, slightly disjointed style which marks the coin-dies of many Anatolian cities, especially in Pisidia and Pamphylia, in the last two decades of Greek imperial coins. The detail of water rushing beneath the arches is particularly charming. Lest everything seem prosaically real, the god of the river has been poised like a statue (the Father Nile or Tiber motif) on the center of the span. Statues no doubt did decorate the bridge, like the Hadrianic Pons Aelius in Rome.

83. Antioch on the Maeander: Gallienus

CURIOUS BUILDINGS

Strange religious practices were perpetuated in Asia Minor from Hittite, Phrygian, Carian, or Lycian civilizations, and as late as the middle of the third century A.D. coins show these reminiscences of the Anatolian world before Alexander the Great. At Lyrbe in Cilicia under Gordian the Third, a shrine of obvious local importance was commemorated (figure 84). It consists, not of a Pheidian god in a columned temple, but of a tree growing in or behind a conical stone of omphalos shape, flanked by two small structures of naiskos type, columns and lintels or altar-tables beneath which something akin to plants or bushes is visible. The conical stone brings to mind the similar object which Elagabalus (218–222) brought to Rome from his native Emesa in Syria and installed in shocking fashion in a temple on the Palatine. It also calls to memory, for comparative purposes, the neo-Hittite or archaic

84. Lyrbe: Gordianus III

Greek lotus-bud altar of dark stone which was discovered in the ruins of Roman Side. Lyrbe and Side were not far apart, and the former commemorated the latter's gods on other coins.

ARTEMIS ELEUTHERA ON AES OF MYRA IN LYCIA

The imperial coins of Lycia are few and rare, despite the number of magistrates and cities which had undoubtedly issued silver in the fifth and fourth centuries B.C. The Lycians were proud, independent, and poor in the Roman period, a fact which is reflected in their lack of major coins. A fine example, however (figure 85), comes from Myra (modern Demre) on the coast shortly before Cape Gelidonia and the curve northward to Pisidia and Pamphylia. The city, a rich site in a large plain with a major freshwater lake nearby, is perhaps best remembered for its church and cult of Saint Nicholas, for its large theater and for a splendid cliffside of Lycian rock-cut tombs. The obverse of this sestertius presents a bust of Gordianus III equal in style and careful cutting to the best products of the Roman imperial mints in Rome or at Syrian Antioch. Young Gordian wears cuirass and cloak, the latter thrown loosely over his shoulders. On the reverse Artemis Eleuthera, mammiferous cult image of pseudo-Archaic type, faces the viewer in a distyle temple with Tuscan columns and akroteria. A small, circular object, perhaps a cista for her protecting snake, is beside her at the left. Everything is clear, simple, and very Anatolian. However modern the cult image may have been, it represented a notion going back as early as or earlier than the years around 500 B.C., when Greek sculptors were busy on funerary reliefs in Lycia. Another sestertius of Gordian, practically the only emperor to have coins at Myra, shows the goddess in a tree, protected by snakes and attacked by men with double axes. A reference to interference from overseas in the Bronze Age seems possible.

85. Myra: Gordianus III

MEDALLION OF BYZANTIUM

Numismatics give one of the few datable insights into the art of imperial Byzantium before the founding of Constantinople in 325. After the siege and sack by Septimius Severus in 196, the victor over Pescennius

Niger transformed the city into an imperial outpost, with a new hippo-
drome, gymnasium, and other signs of Severan favor. At this time, almost
in anticipation of what was to happen under Constantine the Great,
Byzantium became a collecting place for works of art, originals and
copies, from elsewhere in the Greek world. A series of large aes, medal-
lions or perhaps double sestertii, commemorate the family of Septimius
Severus, especially his son Caracalla. A splendid example (figure 86)
was struck in the early years of his sole rule (212 or 213) and presents the
emperor in military costume, wearing a radiate crown, on the obverse.
The reverse seems to speak of an equestrian statue, or of the emperor's
passage into Asia Minor on his way toward the East. He is seen on
horseback, in traveling costume and carrying his lance reversed (that is,
with the point upwards to the rear). The name of the magistrate in
charge of the coinage surrounds the group, and the city's name is below
the groundline. Obverse and reverse are very Roman in imperial theme
and style. The equestrian Caracalla could be a transcription of Marcus
Aurelius on horseback in Rome or the lost equestrian statue of Septimius
Severus (the "Regisole") at Ticinum or modern Pavia. The obverse die
is like that of a Roman imperial Antoninianus enlarged. In terms of
quality Byzantium has nothing to be ashamed of in its Severan phase.
Byzantine literary appreciations of the pre-Constantinian works of art
in the city confirm this.

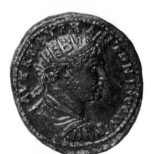

86. Byzantium: Caracalla

HOMERIC MEDALLION OF ILIUM (TROY)

At the very end of its fruitful numismatic history, in the sole reign of
Gallienus (260–268), Ilium issued a small group of large bronzes of
crude, forcefully baroque style. They seem like desperate luxuries in an
age when Greek imperial issues were dying. One of these coins (figure
87) presents a scene reminiscent of Roman sarcophagi in the late second
century, a vignette from the cycle older than Greek art itself. Hector
(suitably labeled) gallops to the left, spear and shield on his left arm. Seen

partly from the back, he wears only a large, crested helmet. In honoring Hector the citizens of Ilium paid tribute to a purely Trojan hero (as opposed to Greek Achilles, for instance) and also reminded the Romans that Hector was numbered among their common ancestors. The portrait of Gallienus on the obverse, despite its naturalism, is not an accurate likeness. The die designer, for lack of better information in these years of chaos, took his model from some older coin, perhaps aes of Maximinus (235–238) or Philip the Arab (244–249). The reverse too is a revival in cruder terms, of a design used at Ilium in the reign of Septimius Severus. Many designs in Antonine and Severan Greek or Roman imperial sarcophagi can be related to famous paintings, and, as with the medallion of Perinthus, it seems not unlikely that the die designer at Ilium has turned to a painting for his composition. Whether or not the original was at Ilium, the city no doubt possessed a good copy, just as in the case of royal portraits in England under Charles the Second or George the Third.

87. Ilium (Troy): Gallienus

MEDALLION OF CYZICUS

A giant medallion of Cyzicus on the Propontis (figure 88), worn though this unique piece is, shows the high level of die cutting reached in the best of these imperial bronzes. It is as fine as any comparable product from the mint at Rome. The obverse is taken up, in usual fashion, by a bust of Commodus in laurel-wreath, cloak, and cuirass, surrounded by his full name and titles in Greek. The reverse, a product of Commodus' last years on the throne, hails Cyzicus as the city of the Roman Herakles, who is of course Commodus. The word NEOKOROS (Temple-Guardian) suggests that there may have been a cult of Commodus–Herakles there; as stated, Hadrian and his temple were the focuses of imperial cult in that city. Anyway, in the high, round relief of the Antonine baroque, Herakles (with the features of Commodus) stands with club and lion-skin, and looks at the Tyche of Cyzicus who threatens to crown him

155

with a large wreath. Such equation of the ruler and Herakles had been standard practice in Greece and Asia Minor since Alexander the Great, but in Rome it was (along with other factors) to contribute to the assassination of Commodus in 192.

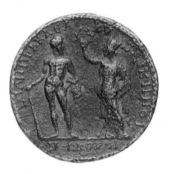

88. Cyzicus: Commodus

MEDALLION OF PERGAMON

Another big medallion (figure 89), struck under Caracalla at Pergamon during his sojourn in western Asia Minor (most likely in 213), at a time when the city dedicated a temple to him, is less Roman and more Greek imperial in flavor. An anticipation of Byzantine styles can almost be caught in the strongly profiled imperial head with its careful curls and in the flattened, truncated cuirass with Gorgoneion in the center. The dies and flan of this piece are flat and crowded with regular lettering, like a medallion of Constantius II (337–361) or the house of Theodosius. Greek imperial die designers played a major part in shaping Late Antique styles, and perhaps the germ of their work is visible here in the early third century. The reverse of Caracalla's medallion is taken up with the

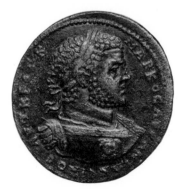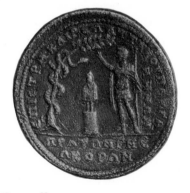

89. Pergamon: Caracalla

156

favorite imperial cult of Pergamon. The emperor in armor salutes the serpent of Asklepios, which is coiled around a tree (like the well-known reptile in the Garden of Eden), and between them Telesphoros, the little companion of Asklepios, stands in his hood and cloak on a small, circular altar. The composition is difficult, even bizarre, and it cannot be said that the die designer made a great success of it. There is an element of folk-art stiffness in the figure of Caracalla.

IMPERIAL PORTRAITS

The dated sestertius of Amaseia, already described, affords a good opportunity to look at the features of Marcus Aurelius, early in his reign, on a Greek imperial bronze. The curly mass of hair and beard, the long profile, and the conventions of laurel-wreath and draped and cuirassed shoulders are familiar from products of the Rome mint. This is an only-slightly-provincial version of a portrait circulated from the imperial capital, as in the marble or bronze likeness of the philosopher-emperor, which turns up in slightly varying forms throughout the Empire. The similarly attired bust of Septimius Severus on a sestertius struck at Smyrna provides a stylistic midpoint between the concept of Marcus Aurelius on the aes of Amaseia and the broad, linear Caracalla on the medallion of Pergamon (figure 90). As self-styled son of Marcus Aurelius and brother of Commodus, Severus looks like an Antonine, but his North African features show slightly in his squared head.

It is instructive to compare these two numismatic portrayals with monumental portraits in marble. The Marcus Aurelius is a colossal head, probably a posthumous likeness of the reign of Commodus or even of Septimius Severus, when the greatest of the Antonines was officially revered for dynastic or political reasons (figure 149B). It is now in the Indiana University Museum at Bloomington and, although reputedly from Ostia, may have been carved in western Asia Minor. Its qualities of hairy rectilinearness make it a better comparison with the coin-portraits of Severus from Smyrna or Caracalla from Pergamon than Marcus Aurelius from Amaseia. The Septimius Severus also has been

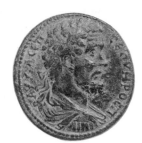 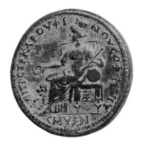

90. Smyrna: Septimius Severus

157

identified with Ostia and shows the Antonine-Severan baroque on a subtle level (figure 157B). In the face of Severus, beneath his locks arranged like those of the Greco-Egyptian god Sarapis, are seen the beginnings of the disturbed, pathological style in portraiture, the dreamy other-worldliness which has been identified with the chaos and new philosophies of the middle of the third century. In their emphasis on the sitter's eyes, as in the sestertius from Smyrna, coin-portraits give some intimation of trends to come.

THE TRIUMPH OF DIONYSOS IN LYDIA

No design more Roman in its details, more magnificent in its transferral of a monumental painting to a coin-die exists than the reverse of a large bronze struck for Traianus Decius (251–253) by an archon at Maeonia (figure 91). Dionysos spent his first days in Lydia and many cities in these valleys so congenial to the grape honored the god of wine. This reverse recalls the most elaborate late Hellenistic or imperial painting, especially in the form such compositions were preserved on Roman sarcophagi of the Antonine and Severan periods. Within the inscription, Dionysos is enthroned holding his thyrsos and kantharos; he is being drawn along in his two-wheeled cart by two panthers. Beyond, a maenad (or Ariadne) runs with the procession, carrying a vine laden with grapes. She and the panther closer to her look back at the god. Like the famous black-figured kylix by Exekias in Munich, Dionysos finds congenial enframement for his tondo in the vine that curls toward him and the leaves hanging down behind the maenad. Perhaps the archon Aurelius Appianus and/or the die cutter were Christians, for the PX of APXA appears at the top of the scene as ☧, a surprising coincidence in a famous reign of persecutions.

On the obverse, Decius is as lean and fierce an old emperor as any Christian would wish to avoid. His face is wrinkled and sunken, with an unusually prominent nose; his hair and beard are bristling amid incised lines. A rare sestertius of Cremna, a Roman colony in Pisidia, presents the whole family of ill-fated Decius (figure 92). The obverse shows Etruscilla his wife, the sweet face of her Roman aes now endowed with demi-primitive ferocity; she is diademed and in full costume, with the lunar crescent behind her shoulders. The reverse is filled by a bust of Decius flanked by those of his sons Hostilianus and Herennius, all above a large imperial eagle of apotheosis. None of the portraits is very accurate or fierce and it is even tempting to switch that identified as Decius to the right and that of the elder son who fell with him against the Goths in Moesia to the center, as focus of the abortive dynastic exercises presented by the obverse and reverse of this coin. Still, the total effect of the obverse and reverse is stunning. The only rivals to this wealth of imperial portraiture in the Roman imperial series are certain

aurei or denarii showing Septimius Severus and his family or the several third-century medallions in which busts of two emperors, or an emperor and empress, share one die.

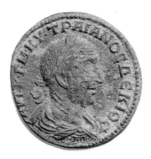
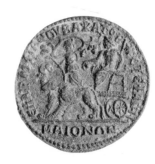

91. Maeonia: Traianus Decius

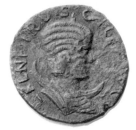
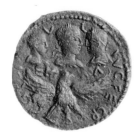

92. Cremna: Etruscilla, Decius, and sons

CYBELE AND HEKATE OR ARTEMIS PHOSPHOROS

The reverse of the Severan sestertius from Smyrna presents a very grand, very neo-Pheidian cult image of the Asiatic mother-goddess which must go back to a colossal statue of the Pergamene period if not earlier. Turreted Cybele is turned sideways on a high-backed throne, a conventional representation, a method of visualization which the die designer at Smyrna has derived from Roman imperial issues. She is holding tympanum and scepter beneath the elbow or in her left hand and a libation dish in her extended right. The lion is visible just beyond. By contrast to this full-bodied, very classical image, Hekate–Artemis on a Severan medallion of Stratoniceia in Caria is a flat, slender, linear, and almost schematic affair (figure 93). Her attribute is the torch and her companion a dog. If the obverse of Caracalla's Pergamene medallion has been cited as anticipating Byzantine styles in the Greek imperial art of Asia Minor, then this reverse of the Carian Hekate can be said to manifest the same tendencies in even more pronounced fashion. The tendency toward bodily frontality in the later Greek imperial reverses, in the figures and architecture alike, is manifest here. The obverse of the medallion from

159

93. Stratoniceia: Septimius Severus and Julia Domna

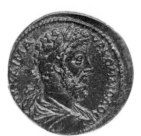
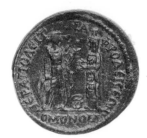

94. Hierapolis-Aphrodisias: Commodus

Stratoniceia combines busts of Septimius Severus and Julia Domna, forceful and elegant products of Anatolian provincialism in a delicate, almost fussy style, with two later countermarks — a helmeted head of Athena, and the pertinent word THEOU. This die contrasts sharply with the elegant, very Roman portrait of Commodus (looking like Marcus Aurelius his father) on an alliance sestertius of Hierapolis in Phrygia and Aphrodisias in Caria (figure 94). The double portrait (Severus and Domna) occurs on some Antonine and Severan medallions or aurei from the Roman imperial mint, but it becomes at this time a fairly popular tour de force in Greek imperial issues from Moesia Inferior, Thrace, and Asia Minor.

CULTS, ALLIANCES, AND FAMOUS MYTHS

The reverse of the alliance sestertius of Phrygian Hierapolis and Carian Aphrodisias presents one of the most charming confrontations of cult images in imperial art. Apollo of Hierapolis is a Kithareodos or lyre-player in full costume, of the type identified with a statue probably by Skopas in the fourth century. He is engaged in a *sacra conversazione* with the Aphrodite of Aphrodisias, known from innumerable statues to have been an image like the Ephesian Artemis, with a rich display of symbolic reliefs on Dedalic body. Since Aphrodisian artisans worked throughout the Empire, many small marble replicas of their patron goddess have enabled archaeologists to reconstruct her with some degree

of accuracy. She is seen here in a view from the left side, as she holds out her hands to the god of the friendly Phrygian city. An object comes between them on the ground, perhaps a small altar topped by a dish for offerings. By contrast, Valerian's (double) sestertius of Temenothyrae (Flaviopolis) in north-central Phrygia, not far from the Lydian border, presents a reverse definitely dependent on a famous and monumental composition in painting or relief, most likely the former (figure 95). The scene is familiar: Herakles stands with his attributes in the garden of the golden apples, the latter guarded by the serpent coiled around the tree; at the right three Hesperides huddle in fear, excitement, or anticipation. Titianos, First Archon and Pontiff of the city, was responsible for this coin; the painting may have stood in his temple. Despite the Hellenistic or early imperial origin of the composition, the die designer turned his whole reverse into something dry and decorative, flat and patterned. The border of dots has as much meaning as the golden apples on the tree!

 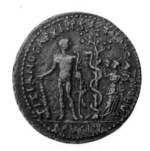

95. Temenothyrae (Flaviopolis): Valerian

LATE PORTRAITS

The obverse of the large coin of Temenothyrae has all this decorative dryness. It also has a rather brutal, almost-cubistic (in the Tetrarch sense) rendering of the noble features of patrician Valerian, the emperor (253–260) destined to die a prisoner of Shapur the Persian king. Die designers in Asiatic cities such as Temenothyrae in this age of chaos probably had a longer wait than in decades past for the official images of new rulers. Hence, rather than a faithful, naturalistic portrait of Valerian, this is an ikon, the die cutter's synthesis of a number of older experiences or observations drawn from earlier coins still in circulation. The radiate Valerian has the square face, tightly curled hair, and short beard of Caracalla, an emperor still much remembered for his generosity in Asia Minor. There is also something of Severus Alexander (222–235) or Philip the Arab in this likeness. By contrast, Gordian the Third is still very much himself on the alliance medallion of Perge and Side

(figure 96). As a young emperor with powerful family connections (in-laws) in Asia Minor, as a man whose legates did a great deal of rebuilding and repairing, he was very popular in the Greek imperial coinage as well as in inscriptions (mostly, as might be expected, milestones). His likeness survives in the Greek world in a marble head from the sanctuary at Kionia and now in the Museum at Tenos. It was in his reign that some of the last datable Greco-Roman copies of famous Greek statues were made for decorative purposes, for the façade of the nymphaeum at Miletus.

After several varieties of the alliance motif, the reverse of Gordian's special issue at Side provides a slight touch of comedy. Careful perusal of the die shows a summary, restless treatment of a composition that is outwardly fraught with traditional iconography and Athenian fifth- or fourth-century sculptural types. Yet the hurried meeting of hands over the altar and the "bomb bursting in air" deprive the scene of its desired nobility. It is more like a bargain over a barrel of corn in the agora at Side than a meeting of divine patronesses. Technically, there is an interesting parallel to Late Antique or Gnostic gems here, for the die cutter has used a wheel to produce the lines of his design.

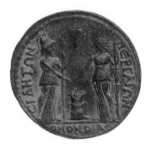

96. Side-Perge: Gordianus III

QUASI-AUTONOMOUS COINAGE

One of the most unusual, "barbarous" bronzes of the Anatolian series was minted by the mountain stronghold of Termessus Major, northwest of Attaleia (figure 97). Unconquered by Alexander the Great, this city never acknowledged the supremacy of Rome to the point of striking coins with the imperial portrait, although it did put up honorary gateways and statues to the Augusti. The citizens could proclaim their security and individuality from Mount Solymus above the Pamphylian plain, where splendid architecture thrust skyward on green mountains ringed with clouds. This coin is not datable beyond the fact that stylistic resemblance to the bronze of Antioch on the Maeander under Gallienus (253–268) suggests a similar period late in the annals of Greek imperial autonomy. Herakles is easily recognized on the coin's reverse, a rougher

version of the figure in the Garden of the Hesperides on the coin of Phrygian Temenothyrae. The inscription TON MEIZONON (The Greater) is a reference to the importance of the city as compared with its Lycian colony of the same name. The obverse is even more arresting. The words "Termessus the Autonomous" ring a wreathed head of Zeus patron of Mount Solymus that is as wild as the fiercest mountaineers who defended the passes and caravan routes leading from Phrygia through this part of Pisidia to the coast. This coin, perhaps a double sestertius, represents the Pamphylian "stringy style" at its forceful best.

Other, less individual cities produced quasi-autonomous bronzes, often concurrently with issues in the name of an emperor. One such bronze (figure 98) was coined at Colossae in southwest Phrygia, on the great highway from Ephesus up the Maeander to Laodiceia and thence fifteen miles southeast before swinging up to Apameia. The obverse type is one of several regularly chosen for coins of this class. The Demos, or Genius of the People of Colossae, is represented as a young man, laureate and with features derived vaguely from those of Helios or Alexander the Great. The fact that Demos on this second bronze also looks a bit like the young Commodus or Caracalla suggests that it can be dated in the late Antonine or Severan periods.

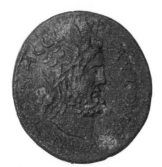

97. Termessus Major: quasi-autonomous, third century

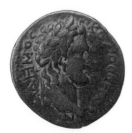 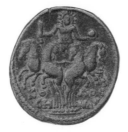

98. Colossae: quasi-autonomous, about A.D. 200

ANTICLASSICAL DESIGNS AND STYLES

The reverse of Colossae's quasi-autonomous bronze is another departure from anything encountered previously. It is one of the most startling compositions of all Greek numismatics, one about which students of orientalism and proto-medievalism regarding the laws of frontality in Roman art have written chapters. As with the reverse of Herakles in the Garden of the Hesperides, a monumental painting must have given the engraver his source for the scene. The four-horsed chariot of Helios or Sol rises up in full frontal view, above the letters of the city's name. The horses splay out in pairs in either direction, their legs forming a series of arcs. The god, radiate and holding orb and whip or torch, is spread in balanced pattern against the background. The composition is like some medieval relief of Alexander the Great's apotheosis, or else it recalls the glorification of some Sassanian ruler on a gold-inlaid silver plate. This die is one further piece of evidence that notions later in force after the decline of classicism were circulating around Anatolia and Syria at the height of the imperial period.

Under Philip the Arab, Tripolis in southeastern Lydia and Laodiceia, thirty miles farther on the roads south and east, struck an alliance medallion of traditional type (figure 99). Tripolis is represented by Leto running along with the infant Apollo and Artemis in her arms (the city was once named Apollonia), while majestic, fully clothed Zeus Laodikeos stands for his city in this scene of "Omonoia." Zeus Laodikeos is a well-known cult image, and Leto seems to reflect some fourth-century figure such as those used for daughters of Niobe in the group of sculptures attributed sometimes to Skopas and alternatively to Praxiteles. Proto-Byzantine flatness and stiffness, especially in the supposedly running figure of Leto, invite comparison with monumental relief of the period shortly after Constantine the Great founded his new capital at Byzantium on the European shores of the Bosporus. The running Victoria in the Archaeological Museum of Istanbul, removed from above one of the gates of the city, derives iconographically from the long series of tri-

99. Tripolis-Laodiceia: Philippus I

umphal Victoriae in Rome, but in pose and style the figure owes much to the same currents which influenced the die cutter at Lydian Tripolis nearly a century earlier (figure 25).

THE PHRYGIAN MOON-GOD MEN

The town of Siblia has been located by modern topographers in the plain of the upper Maeander, halfway between Apameia and Eumeneia in Phrygia. Men, widely worshiped in Phrygia and eastern Lydia, was particularly revered here, and he, rather than Selene, seems to appear on a bronze of Caracalla. The coin (which is one of the few surviving specimens) may have been struck at the instigation of a priest-magistrate named Menodotos, a man whose name appears on certain coins of Caracalla and Geta (figure 100). The obverse presents a characteristic likeness of Caracalla as a boy-emperor, a laureate, draped, and cuirassed portrait copied from a Roman imperial coin of the early part of the third century. The local die cutter has done very well, especially in the up-turned or heaven-gazing eye of his subject.

On the reverse, amid the city's name, the young god stands in chiton and ample himation, a spear in his right hand, a bovine head under his left foot, and a small image of Nike on his outstretched left palm. Distinguishing attributes, besides the animal's head, are the Phrygian cap and the crescent behind the shoulders. Men's pose of foot raised in the traditional stance of a Lysippic statue and principal attribute of Nike equate him with Zeus or with some Hellenistic ruler like Seleucus Nicator, not to mention Roman emperors from the Flavians on. This particular design was a popular one and, since it occurs on Greek imperial coins at Phrygian Sebaste, in Pisidia (Antioch), and Pamphylia (Sillyum), inspiration on the level of the die designers must have been fortified by knowledge of a cult image somewhere in these parts of Anatolia. There is something painterly about the way Men is flattened out in all directions in the coin's circular design, and a small painting or terra-cotta relief may have provided means of circulating the composition into the mints. Once in the coinage of one city, it was easy for a traveling die cutter to carry it about Phrygia, Pisidia, and to the one city in Pam-

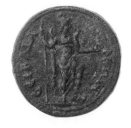

100. Siblia: Caracalla

phylia where Men was a staple of the coinage. The die cutters at Pisidian Antioch varied the pose of the small Nike from left to right and substituted a trophy for the wreath. This city has also produced the best evidence that the ultimate model was a cult statue, for Ramsay's excavations of 1912 yielded a headless marble statuette which Mendel, in his publication of the sculptures in Istanbul, compared with the coin-types mentioned here.[2]

THE PROVINCE OF GALATIA

The coins of Galatia, vast interior province of Anatolia centering on the ancient metropolis and modern Turkish capital of Ancyra (Ankara), were just as Roman and just as individual in quality and style as those of the more populous, prosperous regions to the west and south. A sestertius of Vespasian (A.D. 69–79) struck at Tavium, on the road eastward from Ancyra to Sebasteia (Sivas), and a similar coin of Ancyra itself, minted under Caracalla, illustrate this. In style, the coin of Vespasian is unusually elegant and Hellenic, almost recalling issues of the later Hellenistic rulers (figure 101). In orderly design, it is very Roman, worthy of comparison with the best sestertii from the Western imperial mints. Caracalla is bold and forceful, having a height of relief and a compactness of design not present even in his huge medallions from Pergamon. The hole in Vespasian's cheek is a centering mark, indicating that the mintmaster used a raised point to secure accurate strikings from his dies.

The reverse, which hails Tavium as imperial city of the eastern Galatian tribe, provides a vivid portrayal of the Zeus for which the city was famous. Strabo describes the statue as being colossal and in stone (that is, marble). Artistically, the image depends on one of those Hellenistic (Seleucid) restylings of the Pheidian Zeus at Olympia, which are familiar from tetradrachms struck at Syrian Antioch or in western Asia Minor. The same Hellenistic sources were used by the Romans about 80 B.C. when a new image of Jupiter Capitolinus was created by Apollonios of Athens for Sulla's rebuilding of the Empire's foremost temple in Rome. At Tavium, Zeus's high-backed throne is like a baldachino, and his eagle is perched on the seat. Caracalla's reverse at Ancyra is concerned with the Isopythia, one of the sets of games for which the city was famous (figure 102). An athlete crowns himself, a

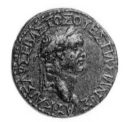 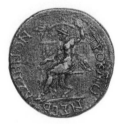 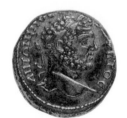 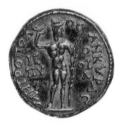

101. Tavium: Vespasian 102. Ancyra: Caracalla

motif with antecedents in Greek art of the fourth century B.C. Just such a marble statue, a copy of the Antonine period, was found in the Baths of Faustina at Miletus. The superabundance of overblown muscle crowded into the die cutter's tiny figure calls to mind the Farnese Hercules from the Baths of Caracalla in Rome or the mosaics of athletes and gladiators from the floors of the same and later imperial baths.

SILLYUM AND TARSUS: CITIES ON THE ROAD TOWARD SYRIA

The magnificent site of Sillyum, between Perge and Aspendus in Pamphylia, has ruins as large as those of Pergamon on and below an equally breathtaking acropolis. Since as yet no excavation has disturbed or revealed the splendor of ruined baths, basilicas, theaters, stoas, temples, hippodromes, gates, fountains, and what lies beneath, the city can only be judged from afar by its adequate but not-excessive imperial coinage. A medallion of Marcus Aurelius is bronze, but the piece was once completely silvered (figure 103). The portrait, a half-length bust with wreath and cloak on which there may be an aegis, is in the best tradition of Roman imperial medallions. Again, it makes a contrast of elegance with the rather brutal portrait of young Gordian the Third seen on the sestertius or bronze drachma of Tarsus in Cilicia. Gordian, radiate and in armor, is carrying a spear and shield, a type of representation destined to become very popular in the Roman imperial coinage under the military emperors, like Claudius II, Aurelian, or Probus, who followed Gallienus on the throne.

The reverses of the medallion of Marcus Aurelius from Sillyum and the aes of Gordian from Tarsus form a fitting conclusion to this chapter. They glorify divinities who are only partly Greco-Roman, who are much older than either the Greeks or certainly the Romans in Anatolia. At Sillyum the Anatolian moon-god Men, sometimes associated with Zeus Sabazios or Cybele and already encountered in Phrygia, rides along on horseback. His Phrygian cap indicates he is the religious reminiscence of some prehistoric or little-known migration out of the hinterlands southeast past Termessus Major into the Pamphylian plain, where Sillyum's long, high hill made a natural citadel. Mostly he is found in small statues, in reliefs, and on coins from western Phrygia, eastern Lydia, or Bithynia, as the example from Phrygian Siblia demonstrates. Sandan in his baldachino, amid magistrates' marks, on the coin of Tarsus is a manifestation of Herakles peculiar to that city (figure 104). He sports a polos or kalathos (grain-measure) on his head, holds a large wreath, raises his hand in salutation, and stands on a long-horned bull. Bow and quiver are visible on his back. The style and exotic flavor of this reverse recall the great series of imperial aes struck at Alexandria in Egypt. This Sandan reaches from the realm of Greek imperial numismatics in Asia Minor to the Syrian frontier and away from the Hellenic traditions into those of the ancient Near East.

103. Sillyum: Marcus Aurelius

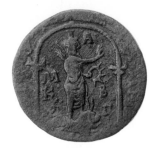

104. Tarsus: Gordianus III

No arts are better served by numismatic evidence than the architecture, sculpture, painting, and minor crafts of imperial Greece and Asia Minor. No civilization before or since has offered the vista of a thousand cities and towns from Albania to Syria striking dozens of different coins during the reigns of fifty emperors from Augustus to the last quarter of the third century A.D. Many of these coins are small, routine examples of numismatic activity, but many are large, medallic tondo surfaces on which buildings, local divinities, excerpts from famous myths, or athletic contests have been recorded in an art appropriate to time and place. Since every coin can be precisely dated and located, any piece of artistic significance can contribute as much as careful excavation to comprehension of major styles and their sources.

Augustus and
the Julio-Claudians

AUGUSTUS FORMED A new political system in Greece and Asia Minor. To a certain extent he directed the course of a new art in these areas. So far as Roman influence was concerned, it was an art of focus on the ruler and his family, a concentration of all the attention lavished habitually by the Greeks on the Hellenistic rulers and famous nonregal citizens. The house of Augustus reciprocated in the tradition of the Attalid and Seleucid monarchs. In Athens especially they financed construction of buildings which served as memorials to imperial success in the midst of honors paid to worthies in ages past. The gate of the Roman agora and the Odeon of Agrippa are landmarks of this policy. At Olympia, on the other hand, the metroon was turned into a shrine to Augustus, his cult statue displacing that of the Mother of the Gods. Athens honored Augustus and Rome in erecting the circular temple in front of the Parthenon. Nero was to receive an even greater honor in having his name and titles inscribed on the eastern architrave of the building. Agrippa had his quadriga on the formerly Attalid pillar to the left of the entrance to the Acropolis, and a similarly impressive Attalid monument in front of the Stoa of Attalus was rededicated to Tiberius. On Delos, statues of Augustus, his daughter Julia, and her husband Agrippa were set up in or beside the cella of the temple of Apollo.

Otherwise, Greece was generally too poor to do more than put up statues to the family of Augustus. This was done liberally, but naturally not on the scale in which Hadrian and Antoninus Pius were honored in the following century. Asia Minor, too, was slow in grasping the potential grandeur of the imperial cult. Aphrodisias produced a portal which honored Tiberius but which mixed portraits of the imperial family with gods, heroes, personifications, and satyrs — perhaps not the compliment a Roman ruler would have desired. Pisidian Antioch, because of its military connections with Augustus and its position as a Roman fortress, had a triple-arched triumphal gate recalling the Parthian arch of Augustus in the Roman Forum. Augustus lent his name to the wall which enlarged

the temenos of the Ephesian Artemision. Otherwise, the custom of statues in the tradition of Hellenistic rulers gave imperial character to the Asiatic cities.

The character of Roman art in Greece and Asia Minor can be measured by surveying the evidences of activity of an imperial nature in each region and city. Since a statue base is an indication of art which now probably no longer exists, inscriptions must be considered as well as the actual remains of statues. Fragments of inscribed architecture point out the presence of buildings and therefore of imperial art of an architectural nature. In surveying Augustan and Julio-Claudian art in the Greek East, I do not propose to make a corpus of imperial inscriptions. Such work has been done more competently in epigraphic publications. A sampling of epigraphic evidence, however, can demonstrate why, where, and how works of imperial art were set up. The best way to analyze imperial artistic activity is to proceed roughly clockwise around the Greek world, city by city, from Thrace and Macedonia. This is the system perfected by B. V. Head for Greek and Greek imperial coins and perpetuated in all publications since his encyclopedic handbook *Historia Numorum* and the first British Museum catalogues.

AUGUSTAN AND JULIO-CLAUDIAN ART IN THE GREEK WORLD

Augustan imperial art in the Greek world is more concerned or identified with and concentrated in specific cities than the art of the succeeding imperial epochs. This is because Augustus tried to compensate for the destructions of the civil wars by rebuilding on a large scale in certain areas. In addition, statues of Augustus and his immediate family, and even larger public monuments, were set up throughout the Hellenistic world. The favored cities included the sites of the great Julian victories, Philippi and Nicopolis, as well as those refounded or developed as Roman commercial and military centers, Patras, Corinth, and Pisidian Antioch. Finally, cultural centers such as Athens and Hellenistic religious-commercial crossroads such as Ephesus could hardly be overlooked in the Augustan program of developing the Roman world by artistic as well as political, religious, and commercial activity.

The Greek world gave the Roman imperium magnificent sites in which to receive their commemorations. These sites might not be large or rich, but they were unsurpassed in breath-taking scenery. The agora of Thera, perched on a cliff overlooking the sea, provides an excellent example. Statues of the Julio-Claudians and their successors stood on circular bases and looked out over the sea toward Ios from the shadow of the Doric porticoes. Emperors were honored (and suffered damnatio) at this location as late as Severus Alexander in the third century A.D. Part of the grandeur of the commemorations lies in speculation as to how these

statues were brought from the coast below to the Hellenistic terraces far above the sea. The small theater, as at so many Greek sites, hung on a cliff's edge with its stage almost suspended above the void. A rectangular base testifies that Agrippina the Elder was honored by her son Caligula as Hestia Boule. A pendant statue of her husband Germanicus was also set up, and over thirty years later a statue of Vespasian was placed nearby.

Sometimes glimpses of Julio-Claudian sculpture suggest the rich potentials of what has been destroyed or what, more tangibly, remains to be unearthed. On Rhodes there is an overlifesized torso of a Julio-Claudian ruler as Hermes-imperator. Cuirassed and wearing baldric and paludamentum, the ruler held a large caduceus in his left hand, against the left shoulder. Coins and gems indicate the identification of Augustus with the cult of Hermes, and probably this beautifully carved torso is the remainder of a dedication to the first emperor as Hermes.[1]

The whole attitude of the Greek world to the Julio-Claudian family can be summed up in Tacitus' account of Germanicus' progress to the East in A.D. 18: "Then he visited Athens, contenting himself with one official attendant, out of regard for our treaty of alliance with that ancient city. The Greeks received him with highly elaborate compliments, and flattery all the more impressive for their emphasis on the bygone deeds and words of their own compatriots" (*Annals*, book II, ch. LIII). The elaborate compliments paid to Germanicus and his family throughout Greece and Asia Minor took the form of inscribed buildings and statues with bases containing complex dedications. Flattery was implicit also in the fact that the inscribed buildings often had a glorious Hellenistic or older history and the statues were placed among those of Greeks renowned in literary, political, and military endeavors.

PORTRAITS

Portraits and inscribed bases, the latter taken in random sampling, give a picture of early imperial art in the Greek world. Augustus is individual enough and his portraits are thoroughly enough recorded to make the list reasonably complete. Notwithstanding, there are problems of identification among surviving sculptures which have been labeled as likenesses of the first emperor. The famous bust of a man in the Athenian agora, originally considered Augustus, has been removed from the list of his likenesses. A head on Thera proposed as Augustus (or Julius Caesar) seems to be an imperator of the generation of Brutus and Cassius. Otherwise, problems connected with portraits of Augustus devolve into two categories: the degree of Hellenism in certain marble heads or busts and the date of prototype and replica. The so-called Primaporta type, diffusion of a Roman original of 19 B.C. or later, is found all over the Greek

world. As the colossal head from Myra (Demre) indicates, this type was given additional lines to indicate the emperor's increased years and went on being carved for posthumous likenesses in the Julio-Claudian and later periods.

Difficulties connected with identifying Greek imperial portraits of Augustus are nothing in comparison with the problems of recognizing the portraits of his family. There were a great many Julio-Claudian princes and princesses, and they all looked alike. In many cases the third and fourth generations after Augustus' daughter Julia were multiple cousins through dynastic inbreeding. This did not encourage individuality of features. In addition, the idealizing tendencies of Augustan and Julio-Claudian art suppressed these differences of physiognomy. Tiberius is usually recognized by his prominent nose, but Nero Drusus his brother, Drusus Junior his son, and Germanicus his nephew were enough like him to compound the problem of classifying a slightly unorthodox or provincial likeness. The himation-clad statue from Magnesia ad Sipylum, in Istanbul, has a youthful head with the rolled-fillet headdress of a ruler or man of intellectual authority. The slender face and prominent nose are probably the characteristics of Tiberius, but they may belong to a likeness of Germanicus produced in a workshop dependent on western Asiatic rather than Roman models. Roman prototypes circulated widely in Greece and Asia Minor, as many portraits show, but the area also possessed a tradition of Hellenistic portraiture which had been vital since the lifetime of Alexander the Great.

If there are problems involved in identifying male Julio-Claudians, they are nothing compared to those of sorting out the women, whose features were made even more ideal in sculpture. The Julio-Claudian women usually take their hair styles (and features) from Livia Augusta, until the time of Claudius when Messalina introduced a new, more elaborate coiffure. The body types continue to be those favored by important Hellenistic women. These various draped poses include replicas of statues of Demeter and Kore going back to the fourth century B.C., when the atelier of Lysippos created the "Large" and the "Small" Ladies of Herculaneum. There are not many "radical" statues of women in the Julio-Claudian period, and none of these are in the Greek East. That is to say, there are no statues of empresses as nude Aphrodites, as Omphale with the attributes of Herakles (to recall the Severan empress in the Vatican), or even as the Venus Genetrix so popular in Italy. Such statues belong to Italy and the Latin West, and began to become popular in the Flavian period.

Roman official art in the East in the century from 30 B.C. to A.D. 70 is represented, therefore, by a large number of evidently imperial portraits which are difficult to identify. The lists here attempt to show the distribution of surviving portraits, while fully recognizing that scholars

will argue indefinitely over specific identifications. The inscriptions (architectural members, statue bases, and, to a much lesser extent, altars) give a random idea of where and how Julio-Claudians were commemorated in official art. Statue bases are almost a more reliable guide than portraits of disputed identity, but, naturally, a portrait of doubtful attribution can say more for Greek imperial *art* than many empty statue bases.

AUGUSTUS

Scholars have long recognized that the majority of portraits of Augustus found east of Italy depend on the so-called Primaporta type. This marble statue of Augustus presents him in the pose of Polykleitos' Doryphoros and wearing a breastplate with a scene and personifications referring to the Parthian Settlement of 19 B.C. The prototype of this marble statue may be as late as the decade 10 to 1 B.C., and the Primaporta statue itself may have been carved anywhere up to two decades after its model in metal. The original of the Primaporta statue was not necessarily the first example of this particularly sober, classicizing portrait of Augustus. Certain critics have tried to show that heads of the so-called Primaporta type found in the East depend on a model or models circulated before that type was conceived. In any case, Greece and Asia Minor took happily to the general circle of the Primaporta Augustus as a yardstick for portraying the emperor. Artists were quick to vary the model, to give it Hellenistic and local characteristics, and to add indications of advancing age. These last may have received fresh inspiration from new models exported from Rome or Corinth.

All through the history of Augustan portraiture there is an element of nondependence on the Primaporta type (figures 105, 107). This is especially marked in Octavius-Augustus' younger days, when he was much in the East and when Roman iconographic canons had not crystallized. The Hellenistic ruler portraits, the Seleucid or Attalid continuations of the Alexander type, are the inspirations from which sculptors worked when they were not looking to some version of the Primaporta head.

Surviving Augustan portraiture is relatively rich in that it includes a heroic statue, a togate statue, and two bronze heads which still possess their inset eyes. The *togatus* from Corinth also reveals traces of red on the visible part of the hair (figure 106). The list given at the end of this book omits the dubious identifications, although the head from Thera is retained because a negative verdict is too difficult to reach.

AGRIPPA

Marcus Vipsanius Agrippa (62–12 B.C.) made his mark in the East as the victor of Actium. His later career as Augustus' minister and son-in-

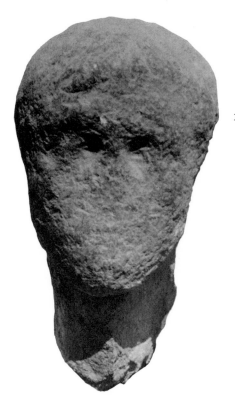

105. Augustus, Tower of the Winds

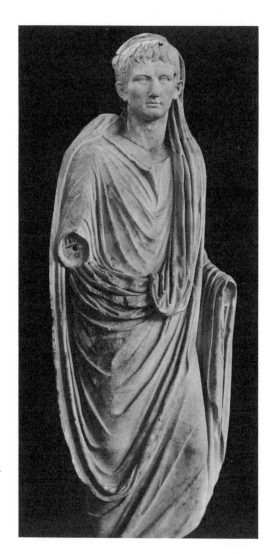

106. Augustus, Corinth

law, and his benefactions to cities such as Athens, insured him a place among the Augustans honored in Greece and Asia Minor. His face is distinctive enough, with its heavy brow and thick jaw, to be recognized in a group of early portraits produced in Italy and the East around 30 B.C. and in an official portrait circulated from Rome in the years just before and after his death. The later group of portraits, all found in Italy but copied in the relief from Athens, are anticipated by the head found in a niche of the *scenae frons* of the theater at Butrinto (ancient Buthrotum) opposite Corfu (Corcyra) in Albania.

The bronze head in the Metropolitan Museum, New York, from Susa, is the Italian version of the early Agrippa, which is dated and paralleled by the portrait on denarii and quinarii of the years after 18 B.C.[2] In the East an Agrippa of this type was discovered in the Hall of the Prytaneion at Magnesia-on-the-Maeander; there the statue was set up amid those of local citizens, and another head found nearby has been called variously Agrippa Postumus or Lucius Caesar. Being both in Berlin, these heads have attracted considerable attention.[3]

The Albanian Agrippa is a forcefully dry portrait, with hair worked in broad, flat groups of locks and is probably the product of an atelier of copyists in Corinth.[4] It has much in common with the portraits from the Julian Basilica there. The cuirassed statue found in another niche

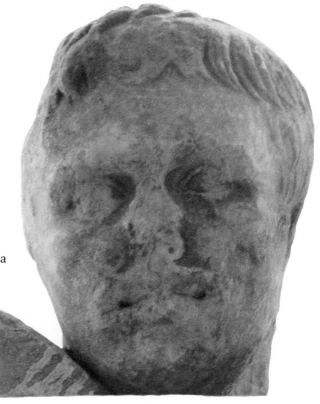

107. Augustus, from Myra

of the theater at Butrinto and signed by Sosikles, son of Sosikles, an Athenian, has a replica in Patras, from Achaia, indicating an export trade through the Gulf of Corinth and up the west coast past Corfu.[5] Corfu, scarcely five miles across the water from Butrinto, has yielded a statue base of Agrippa, with a Greek inscription speaking of him as patron and savior. All this activity was the result of Actium and the founding of Nicopolis not far to the South. Finally, close to the head of Agrippa in the theater of Butrinto, was found a head of the youngish Augustus, a precise, dry copy of Brendel's Type B. This type is best represented in the Greek world by the head of Augustus in the Museum at Vathy on Samos. The Augustus excavated at Butrinto was produced in the same workshop as the Agrippa and can likewise be dated in the fifteen years after 30 B.C.

In Attica, the Amphiareion has yielded fragments of a splendid cuirassed statue that must represent Agrippa and belong with an inscribed base set among those of Hellenistic and Roman Republican generals along the main avenue of the sanctuary. What remains of the scene on the statue's breastplate symbolizes a military-naval success such as Actium. Jupiter and Venus Victrix float above the sea, and the former extends a parazonium toward a scene of Herakles wrestling with the Nemean lion. The workmanship is above average, being fine Attic decorative work in Parian marble.[6] The Greek marble relief with head of Agrippa in profile to the right, found in Athens and now in Boston, shows summary yet incisive handling of the chisel (figure 108). The portrait depends on the fully developed, frowning type produced in Italy

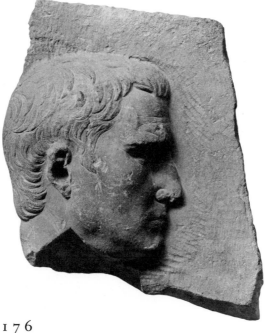

108. Agrippa, from Athens

176

in the years when the Primaporta Augustus was being widely circulated. The neutral background, with chiseled grooves forming a kind of mandorla before the face, gives no clue as to the setting of the fragment, but it must have belonged to a Greek version of a Roman state relief. Agrippa may have appeared amidst Athenian gods and heroes, or with other members of the imperial family.[7]

LIVIA

There are only about seven or eight portraits of Augustus' famous wife from the Greek world, although her name appears on a number of statue bases. She was married to Octavius in 38 B.C. and lived well beyond him to A.D. 29. Two of her Eastern portraits are in the Ny Carlsberg Glyptotek in Copenhagen. The first, a youthful portrait bust, was found with busts of Augustus and Tiberius in the amphitheater of Arsinoë in the Fayoum; the three busts were evidently not a set, for they are of varying sizes. The Livia is a portrait of excellent quality, carved in a dry, precise style which suggests imitation of basalt in marble; it may have been exported from Italy.[8] The second Livia in Copenhagen comes only from the art market in Istanbul and shows a slightly older likeness. This bust is rather crudely finished.[9]

A young, really dry Livia was discovered at Butrinto in Albania. Such sensitivity as the head may possess perhaps comes from wear to the surfaces; this portrait, like the Agrippa and the Augustus from Butrinto, was probably carved from an Italian model in Corinth or Athens.[10] The Livia of the *Salus Augusta* coins is to be recognized in the head from a statue, found in the agora at Gortyna and now in Heraklion. This likeness shows signs of her advancing years and probably belongs in the reign of Tiberius, unless the whole group of portraits was made at one time, in the reign of Caligula who is prominent among the four (figure 109).[11]

OCTAVIA

Livia and Augustus' sister are often confused by modern students of iconography. The latter lived from 66 to 11 B.C., having survived her unhappy marriage to Mark Anthony. The only possible portrait of Octavia from the East was found on Crete and is now in the National Museum, Athens. It is a harsh likeness, a product of her later years and carved with no particular feeling; the hair has even been made like the strings of a mop. Octavia seems to have worn the severe late Republican coiffure until the end of her days.[12] In this head, however, she was veiled, with the bun showing behind; the back is not completely finished, and the ears were pierced for rosette plugs. This portrait, in island marble, comes from the same workshop as the Troy Agrippina and has the same dry, tentative quality of the Livia from Gortyna.

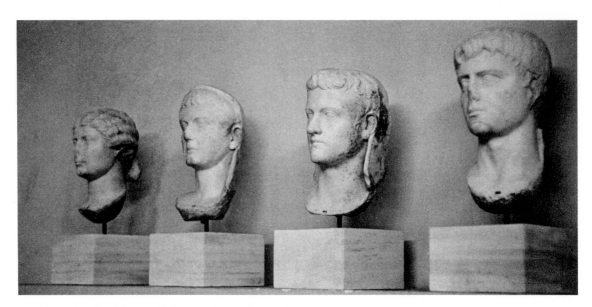

109A. Heads of Livia, Tiberius, Caligula, and
Germanicus — from Gortyna

109B. Livia, from Gortyna

JULIA, DAUGHTER OF AUGUSTUS

It is surprising no portraits of this famous lady have been identified, particularly in the Greek world. C. Hanson and F. P. Johnson have collected thirteen portrait inscriptions, all from the eastern part of the empire.[13] Aside from one statue as a girl of twelve or younger, the bulk belong to the years of her marriage to Agrippa (21–12 B.C.) and probably to the years 16 to 13, when Agrippa commanded in the East. Her age then was twenty-four to twenty-seven. Honors thus appear to have come to her because of her first husband's position. The lack of reliable numismatic iconography no doubt explains the failure to identify Julia in marble heads.[14]

A somewhat overlifesized head in northern island marble was found in the temple beneath the cathedral of Saint Achillios on the acropolis of Larissa in Thessaly. It has been identified with reservations as Livia, Octavia, or Julia and is certainly one of the early imperial ladies.[15] The clear, smooth face seems on the youngish side, and the lack of strong features suggests Julia rather than one of the older women. The quality is good, with fluffy, imaginative hair.

GAIUS AND LUCIUS CAESARS

Augustus first pinned his dynastic hopes on his two grandsons, Gaius Caesar and Lucius Caesar. They were children of his daughter Julia and his lieutenant Agrippa, and Augustus adopted both brothers in 17 B.C. Gaius was born in 20 B.C. and died in A.D. 4, while governor of Asia, as a result of a wound received interfering in the Armenian succession. Lucius lived from 17 B.C. to A.D. 2, dying from an illness gained at Marsailles while on his way to Spain. From the standpoint of primacy, life span, and activity in the East, it would seem natural to find more Greek portraits of Gaius than of Lucius. The fact that they were widely represented in pairs has increased the number of potential likenesses of Lucius in relation to those of his older brother.

The basis for the iconography of the two brothers is the pair of statues from the Julian Basilica at Corinth (figures 110, 111). Here they flanked a togate statue of Augustus (figure 106). The brothers were sculpted in the heroic guise of divinities or demigods, such as Hermes and Achilles. On the basis of this combination with a togate Augustus veiled for sacrificing according to the Roman rite, modern critics have suggested the statues were set up in A.D. 4 or 5, just after the death of Gaius. The two princes look very much alike, but it is now agreed that the statue surviving only from the waist up is Gaius while the complete figure is his younger brother Lucius. Gaius has a thin and rather thoughtful face; Lucius is made to look like a youthful copy of the Primaporta

110. Gaius Caesar, Corinth

Augustus. Both portraits are rather dry and academic; Gaius has even been termed stodgy.

With the two portraits at Corinth as guides, six heads of Gaius Caesar have been identified. His brother Lucius has been recognized in a like number of heads and possibly in a bronze statue showing him in extreme youth (figure 112). Assos is the only definite provenience in Asia Minor for a possible head of Gaius, although two others seem to come from the area of modern Turkey. Lucius, likewise, is less well represented in Asia Minor than in Greece or the islands, with a possible head in Berlin said to come from east of the Aegean.

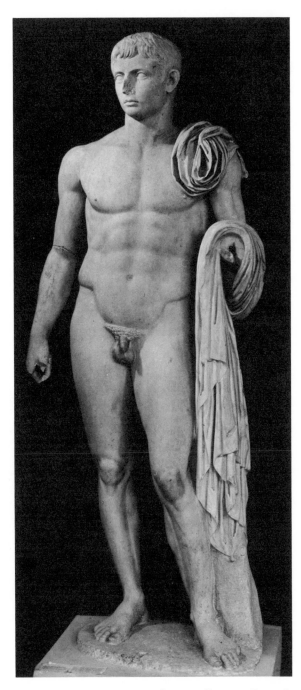

111. Lucius Caesar, Corinth

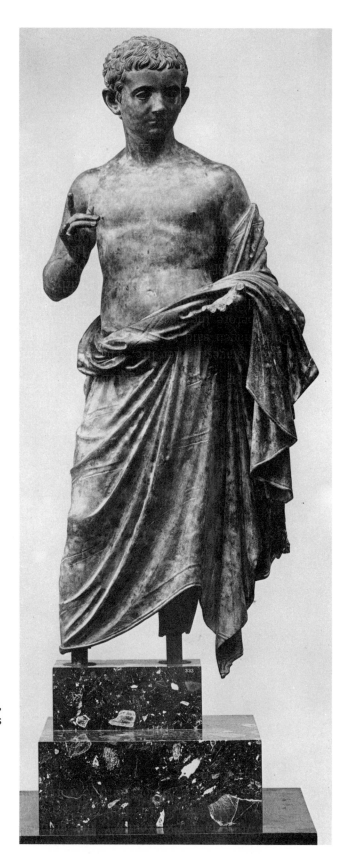

112. Lucius Caesar,
perhaps from Rhodes

TIBERIUS

In his advanced years Tiberius is one of the easiest Claudians to recognize. His aquiline nose, his flappy ears, and his pointed chin set him apart from the younger Julio-Claudians (figures 113–115). He lived a long time and endured a long rule, being born in 42 B.C. and dying in A.D. 37. He was active and important in the East, militarily in connection with the Parthian Settlement of 19 B.C., politically because of his gifts to the cities of Asia after the earthquake of A.D. 17, and intellectually as a result of his retirement to Rhodes under Augustus. Mommsen wrote, "for Tiberius, the small number of statues erected to him may perhaps be recorded among his titles to honour." He politely declined divine honors in an inscription at the city of Gythium in Laconia. Cities such as Athens, however, went ahead on their own in setting up statues and other testimonials to Tiberius. Since twenty of his portraits in marble have been recorded from all parts of the Greek world, the prohibitions against setting up his image must have been relaxed at intervals throughout his long career. Despite the fact that he died when his popularity with the aristocracy and the people was at a low point, some statues were dedicated after his death, particularly by his successor Caligula. The veiled head from the agora at Gortyna in Crete was carved to fit a series of Julio-Claudians commissioned under Caligula.

In general his surviving portraits span his entire public career, the earlier ones often found alongside heads of Augustus. The head in Berlin from Troy is one of these. The bust from the amphitheater at Arsinoë in the Fayoum was found with busts of Augustus and Livia; it belongs to the period leading to A.D. 4, when Tiberius was adopted because Augustus had lost his cherished grandsons Gaius and Lucius Caesars. Two other heads from Egypt show the first and second stage of removal from an official portrait of the earlier part of Tiberius' career. The first portrait, a head and neck worked for insertion in a statue, is based on a model sent from an imperial atelier; the sculptor has afforded his subject considerable animation so often lacking in works of this type. The second portrait is a local copy of the first, with hair and lines of the face simplified to conform with tendencies found in Greek funerary sculpture.

NERO DRUSUS

Nero Drusus' brilliant military career took place entirely between the years 15 and 9 B.C., when he died of a fall from a horse. He was not yet thirty years of age and had campaigned exclusively on the Germanic frontiers. All the Roman coins of Nero Drusus belong to the reign of his son Claudius, and some of his statues would be expected to have been set up in these years (A.D. 41–54).

113. Tiberius as a Roman priest

114. Tiberius, from Gortyna

115. Tiberius, from Knossos

Only three portraits have been identified as his, the first in Paris and probably from Attica, the second at Olympia, and the third in Berlin, said to come from the Greek islands. This seems strange considering the fact that coin portraits of Nero Drusus are quite distinctive, but his long neck and small, pointed chin were inherited, in exaggerated fashion, by Claudius, and it is possible that portraits identified as the young Claudius really represent his father.

Louvre no. 3515 is a typically Attic imperial portrait, the lines of the eyes, nose, and lips being heavily defined and the hair left in partly blocked-out state; this head has a certain striking individuality, although the Roman model is easily recognizable in the proportions and general details. The likeness belongs to the period of Claudius.[16] The head at Olympia comes from a statue, perhaps a *togatus* from the manner in which the neck is worked for insertion. The type is Roman, but one of the Athenian portraitists who sign so copiously at Olympia has given the marble deep-set eyes and forcefully blocked-out hair. The face has more life in its surfaces and less a feeling of cut marble than the Louvre head. The head was found near the metroon.[17] Epigraphic evidence indicates that there were two quadrigas on bases in the Altis, in front of the temple of Zeus. In one stood Tiberius and his brother Nero Drusus; in the other Germanicus and Drusus the Younger. This head might be connected with these groups, but they were more likely carved in bronze than in marble. The bust in Berlin is also Attic work, but it strays farther from the Roman model. Its prototype was created during Nero Drusus' lifetime, and this Greek version is also a contemporary likeness, giving Hellenistic emphasis to the plastic quality of the hair.[18] In workmanship and especially in cast of features, this portrait can be grouped stylistically with a head in the Athenian agora, a portrait of a private person which has sometimes been identified as Augustus.[19]

Finally, L. Curtius noted that a head in the Vatican, set centuries ago on an alien togate statue with a bulla on the chest, had a Hellenized replica formerly in the Calvert collection at Çanakkale (Dardanelles) and now seemingly lost. Both heads were made to be inserted in draped, probably togate statues. Curtius suggested that they represented Nero Drusus at about the age of ten.[20] A Roman of importance is no doubt involved, but who he can be is anyone's guess!

ANTONIA

The daughter of Mark Anthony and Augustus' sister Octavia maintained a position of importance after her husband's death in 9 B.C. After the death of her son Germanicus in A.D. 19, she protected her grandson Caligula from the suspicions of Tiberius and his lieutenants. Caligula is said to have repaid her good efforts and advice by having her poisoned in A.D. 39, when she was nearly eighty years of age. Roman

portraits show her at all stages of her life. The first portrait included here, the bust in Copenhagen said to come from Tralles, probably belongs to the years just before the death of her husband Nero Drusus (figure 116). The second, a fragment of a head found in the Athenian agora, was carved in the last years of Augustus or early in the reign of Tiberius. It is the remains of a type which is repeated in a head in Berlin, said to come from Samos. Another possible likeness, on Cos, has been identified here as Agrippina the Younger, her granddaughter. A head in the Archaeological Museum at Istanbul, no. 4503, may also be an Antonia; the provenience is Asia Minor, but the workshop may have been Attic or Ionian imitating Attic.

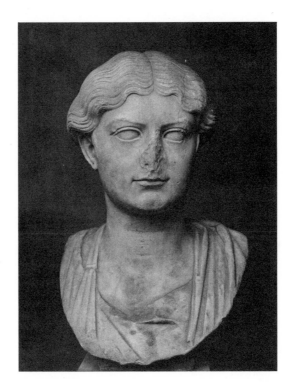

116. Antonia Minor, reputedly from Tralles

GERMANICUS

Son of Nero Drusus and Antonia, nephew of Tiberius, father of Caligula, and brother of Claudius, Germanicus had ample reason to be commemorated in the East. Born in 15 B.C., he was Rome's most popular general from A.D. 10 (the year of his Dalmatian triumph) until his death under mysterious circumstances at Epidaphne near Antioch in A.D. 19. Germanicus spent the last three years of his life in Greece, Asia Minor, Syria, and Egypt, and this must have been a stimulus for the

erection of locally produced statues and busts. Most of the Roman coins of Germanicus were struck under Caligula and Claudius; this indicates that many of his sculptured portraits must have been executed in the reigns of those who sought to remove the cloud of Tiberius' jealousy from his memory.

The iconography of Germanicus is as elusive as that of any Julio-Claudian. His coins indicate no prominent, distinguishing characteristics such as the aquiline noses of Tiberius and his son Drusus Junior. Germanicus had regular, slightly squarish features which, given a touch of idealization, could be made to look like the ideal of any Julio-Claudian. Germanicus has been difficult enough to recognize in the mechanical regularity of portraits in Italy, and he is even more elusive among the freely rendered Asiatic portraits of the imperial family.[21] Four portraits have already been considered in connection with other young Julio-Claudians as possible likenesses of Germanicus. They have been assigned elsewhere, however, and the fact that Germanicus is a second choice measures the degree of uncertainty about his iconography. The four are Gaius Caesar no. 6 (Assos), Lucius Caesar no. 4 (Thera), and Tiberius nos. 12 (Istanbul, from Pergamon) and 13 (Istanbul, from Magnesia ad Sipylum). The last is the only statue so far brought into consideration in connection with Germanicus. Another possible Germanicus has been identified as a bust of his son Caligula (no. 3).

There remain only five or six portraits which can be linked with Germanicus out of the vast numbers which must have stood in Asia Minor and in Greece. A head in the Tigani Museum, from the Heraion on Samos, was identified by Curtius as the youthful Germanicus.[22] The likeness is a romantization in Hellenistic terms of a Roman model of the period of Augustus, of the years shortly after Germanicus' rise to prominence in A.D. 9. The head is turned slightly to its own right and is characterized by copious hair arranged in dry fashion, in irregular strands to imitate bronze over the forehead. Curtius, and Hafner following him, made the mistake of publishing the front view of the young Nero from Tigani with the profile of Germanicus.[23] V. Poulsen had already caught the error, had indicated where the front view of Germanicus was published,[24] and had illustrated the correct profile for the young Nero.[25] This error causes some confusion in Hafner's otherwise splendid stylistic analyses.[26] The second head identified here as Germanicus is in Hamburg and is said to have come from Epidaurus, where it adorned a statue with a back support or a very high relief (figure 117). It is a dry Athenian or Corinthian version of the Roman portraits of Germanicus which give him strong resemblance to Augustus.[27] Augustus favored Germanicus considerably in the years from 10 to his death in 14; he arranged for Tiberius to adopt the young prince as son and future heir to the Empire. The third head of Germanicus, once on a statue in the

agora at Gortyna and now in Heraklion (no. 66), is not unlike the Tigani portrait, but the hair is more undercut and the eyes bigger to match the sense of movement in the face. The head was partly covered by a veil, made separately. It is a good provincial Greek likeness, in a different style from the other three portraits from the agora at Gortyna (figure 119).[28]

A slightly overlifesized marble head in the Syros Museum (no. 110), from Minoa on Amorgos, has been carved to be let into a draped statue set in a niche or against a wall (figure 118). That the person is a Julio-Claudian is evident from the cast of the face, with its pile of hair styled in the manner of a Hermes of the fourth century B.C. Germanicus would appear to be the logical candidate from the profile and age of the forceful subject, and this identification seems confirmed by the fact that the head of a lady found at the same time is clearly Agrippina the Elder

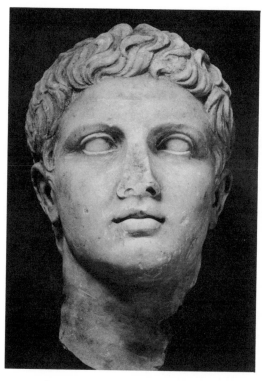

117. Germanicus, perhaps from Epidaurus

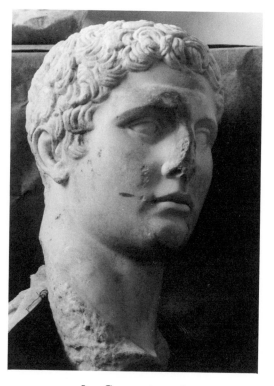

118. Germanicus, from Amorgos

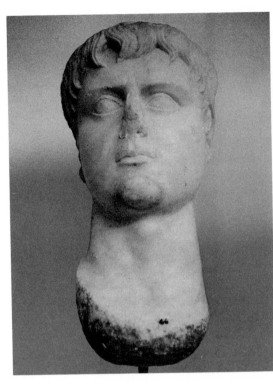

119. Germanicus,
from Gortyna

(figure 121). There was a statue of Caligula at Aegiale and one of
Claudius at Minoa; Germanicus and Agrippina would have been appro-
priate company at either place.[29]

Finally, there is an overlifesized portrait, patently of a Julio-Claudian
prince, in the Sikyon Museum (no. 318). It is a sober, almost somber,
work in mainland marble, which must have formed part of a major
commemorative statue. Although Greek in its free, original casting of
the sitter's features, there is every reason to think this is Germanicus,
who was certainly in Sikyon and Corinth on his tours from west to east
near the close of his career.[30]

Outside of Greece and Asia Minor, there is a twice-lifesized head of
Germanicus in the Royal Ontario Museum, Toronto. It comes from
Lower Egypt and is a good local version of a Roman model of his last
years (figure 120). A large square dowel-hole in the back of the head
indicates that his separately made toga was drawn up in the back of
the head. The famous sightseeing tour of the Nile Valley was the occa-
sion for this bland but characteristic and slightly individual likeness.[31]

AGRIPPINA SENIOR

Portraits of Germanicus' distinguished wife are distinctive in every sense
save that they can be confused with those of her infamous daughter,
the wife of Claudius and the mother of Nero. Agrippina Junior tried

to look like her mother, but the coins indicate that her features were harder and more pointed. Agrippina Senior commanded great respect in the East because of her husband's activities there and as a result of her loyalty to his memory during difficult times; Agrippina Junior was honored there because of the numerous dedications to her husband Claudius and because her son Nero devoted so much attention to the Greek world.

The four or five portraits of Agrippina the Elder from Greece and Asia Minor are related in their common dependence on well-known Roman models. They were probably carved in the years before her exile by Tiberius in A.D. 30 or after her son Caligula became emperor in 37. Caligula caused coins to be struck with her likeness and decreed other honors to her memory. Claudius also honored the lady who was his sister-in-law and, posthumously, his mother-in-law.

Of the portraits the Agrippina Senior in Paris from Athens is strikingly similar to the coins and must be a work commissioned in the reign of Caligula. The head from Amorgos is the product of a sculptor who had seen good models in Athens but who lacked the ability to copy them with finesse or feeling (figure 121). All three heads from Asia Minor copy Roman or Attic models with varying degrees of faithfulness and

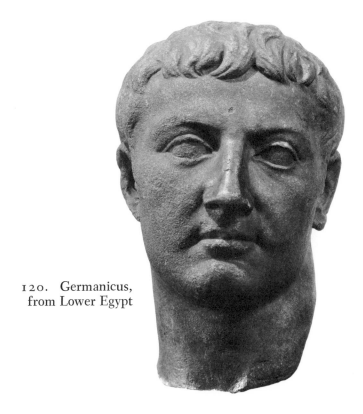

120. Germanicus,
from Lower Egypt

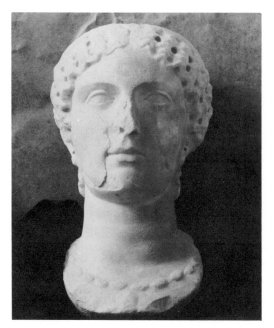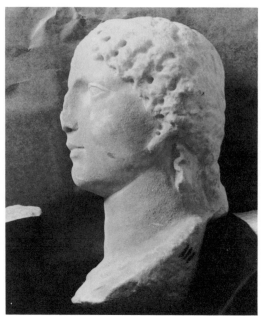

121. Agrippina the Elder, from Amorgos

feeling. Like other portraits of the virtuous wife of Germanicus, they
were made for insertion in draped statues. The example from Troy is
a dry but faithful derivation of a good Roman prototype (figure 122);
Pergamon and Trabzon's contributions are freer, livelier, more idealized,
and therefore more typical of Greek, probably Athenian, rather than
Roman sources.

It seems plausible to identify Agrippina Senior as the subject of the
statue in pose of prayer, that is, the Pietas or *orans* pose with hands
raised and palms open, found in the metroon at Olympia. This repeti-
tion of a draped statue that goes back to the fourth century B.C. is signed
by the Athenian sculptor Dionysios. The hair is more elaborately curled
than in the other portraits, save perhaps in the likeness from Troy which
shares with the statue at Olympia the characteristic of showing Agrip-
pina as she was in her last years of prominence. The Agrippina at Olym-
pia was probably set up in the reign of Claudius, being of the same
mechanical yet moving quality as the Claudius at Olympia.[32] V. Poulsen,
however, implies that this is a statue of Agrippina the Younger, pointing
up the difficulties of complete agreement among those who have spent
years trying to separate one Julio-Claudian from another.[33]

AGRIPPINA JUNIOR

The younger Agrippina, Caligula's sister and Claudius' wife, appears
here because her characteristics have been discussed in connection with
those of her mother. She was born in A.D. 16, married Claudius in 49,

192

and was killed at the instigation of her son Nero in 59. Since she was much favored by Caligula, her youthful portraits could belong to the years 37 to 40.

The Julio-Claudians lavished so many sculptures on Troy that it is natural a likeness of the younger Agrippina was found alongside that of her mother. This youthful, ideal portrait, of western Asiatic style, probably belonged to a statue set up under Caligula; the head is now in Berlin.[34] In the museum at Cos there is the upper part of a colossal, veiled and diademed head. This splendid work, the remains of a cult statue, presented Agrippina the Younger (or possibly Antonia) as Demeter Karpophoros or Rhea.[35] Agrippina, if indeed this be she, is made to look very like her mother. As the wife of one emperor and the mother of his successor, she attained greater power than Agrippina Senior or Antonia, and it seems most likely to identify her with this magnificent fragment.[36] Last of all, a diademed head at Olympia must be a pendant to the statue of Agrippina the Elder. It was found in a late wall in the gymnasium. Agrippina appears as she must have looked just after her marriage to Claudius.[37]

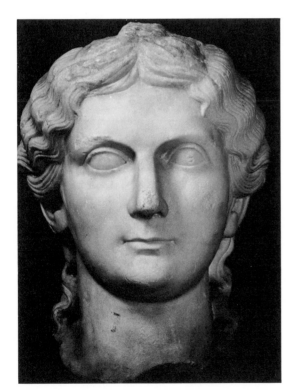

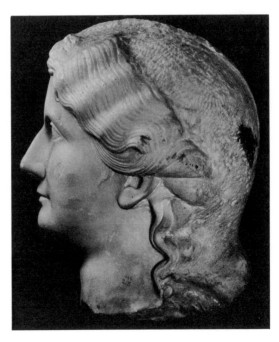

122. Agrippina the Elder, from Troy

NERO OR DRUSUS CAESAR

A number of strong arguments have been put forth for identifying the handsome veiled head with beard of mourning, in Corinth, as Nero, elder of the first two sons of Germanicus (figure 123). This is an official portrait, following the Roman model very closely. The death of Livia in A.D. 29, when Nero was twenty-three or twenty-four, has been suggested as the reason for the slight beard.[38] There is no doubt that this head represents a Julio-Claudian, and the names of Nero or Drusus (several years younger) have been arrived at more by process of elimination than any positive parallels. The ripple in the nose and the flapping ears have led to identifications as Tiberius, Drusus son of Tiberius, or Caligula. Something of Agrippa's chin is present in the profile view, and this might make Agrippa Postumus his son a candidate.

CALIGULA

The details of Caius Caesar's short reign (A.D. 37–41) are all too familiar. But what we tend to forget is that his irrational acts followed a bout of brain fever; at the outset of his rule he was quite systematic in spending the funds accumulated by Tiberius on public works that would resound to the glories of the Julio-Claudian house. The great historian Mommsen has noted that the emperor Caius declined, in his letter to the Diet of

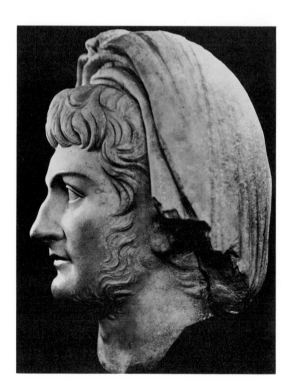

123. Julio-Claudian prince,
Corinth

194

Achaia, the "great number" of statues adjudged to him, and contented himself with the four of Olympia, Nemea, Delphi, and the Isthmus near Corinth. Still, Roman imperial coins and numerous inscriptions from the Greek world testify to the fact that Caligula or his ministers instituted a systematic program of honoring his illustrious Julio-Claudian forebears. To emphasize the purpose of such statues, Caligula's own image was included in the commemoration. The classic surviving illustration is in the agora at Gortyna, where a statue of the young emperor stood with those of Livia, Tiberius, Germanicus, and perhaps others.

A type of portrait created for Caligula in Rome and existing in a number of marbles is easy to recognize from numismatic evidence. The second of the three Eastern portraits mentioned here and listed in the Appendix follows this model; this is the well-sculptured head in Copenhagen from Istanbul. The other two likenesses are Eastern creations; the first, the veiled head from the agora at Gortyna, is dependent ultimately on Rome, and the third, the cuirassed bust from Nicomedia, can be described best as an independent Asiatic work (figure 124).

CLAUDIUS

The statistics of Claudian portraits in the East have been given, and it remains only to list and describe the marble likenesses discovered east of Italy. The life of Claudius has been crowned by two volumes from the

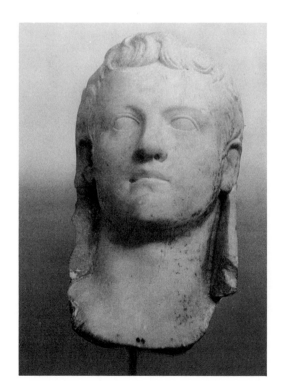

124. Caligula, from Gortyna

195

pen of Robert Graves. They emphasize that Claudius stayed alive to rule because he stayed out of Julio-Claudian family quarrels and jealousies. Since Claudius was not very highly regarded before the soldiers dragged him into the purple, nearly all surviving portraits belong to the fourteen years of his rule (41–54) (figure 125).[39]

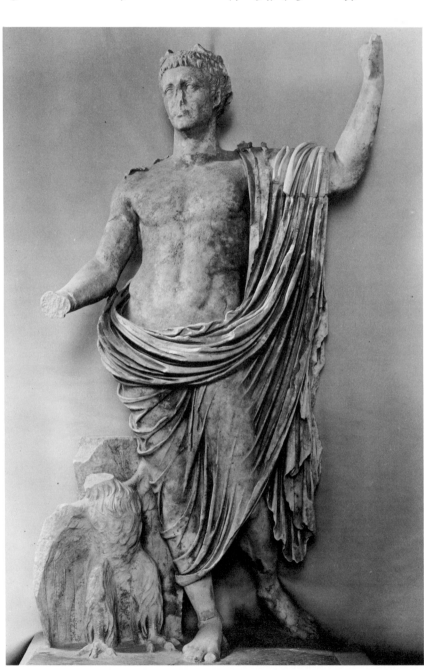

125. Claudius as Zeus, Olympia

NERO

The son of Agrippina the Younger was adopted by her new husband, Claudius, in A.D. 50, became *princeps iuventutis* or heir apparent in 51, and emperor in 54, at the age of eighteen. Of the Eastern portraits discussed here and in the Appendix, only one appears to have shown Nero when he became fat and took to wearing his hair combed upwards from the forehead to create an image of Hellenistic apotheosis. This cuirassed statue is, unfortunately, now headless (figure 126). It is easy to see why no portraits of Nero at the height, or depth, of his career have survived.

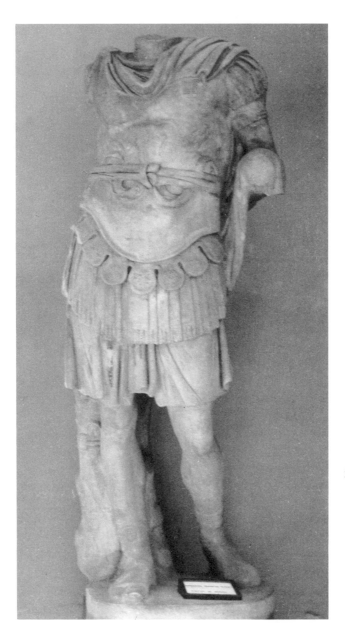

126. Nero, from Tralles

These were precisely the heads which would have been smashed when word of his death in 68 reached the East. Since many inscriptions to Nero have survived, not all his statues were taken down, and no doubt one or two of his later portraits remain to be discovered above or below ground.

Togate statues of the young Nero, the monumental counterparts of his image on silver cistophori or four-drachma pieces from Eastern mints, have been found at Eleusis and on Samos. The former must have been connected with initiation at the sanctuary, while the latter stood in the agora on the acropolis of the ancient city near the Heraion. Another statue of the young Nero was set up elsewhere on the island. At Olympia there were several monuments connected with Nero as patron of games and festivals, but the youthful heir to Claudius or newly created emperor was honored well before the Nero-as-artist phase with a statue either in the metroon or in the Heraion. The former was converted to a shrine of the imperial family under Augustus, and the latter received imperial statues during the first century of the Empire. Nero's own second wife, Poppaea, was honored in this fashion there.

The other two likenesses of the young Nero from the East were found on Cos and at Stratoniceia in Caria. The first is an overlifesized head of the years 52 to 54 that precisely parallels the likeness on cistophori struck at Ephesus. The face was deliberately mutilated in antiquity. The head from Caria, now in Izmir, fitted in a draped statue or bust and is also large in scale. Like all the other Eastern portraits, this work dates from the period when Nero became emperor.

OCTAVIA

Daughter of Claudius and Messalina, this unhappy princess was married to Nero in A.D. 52, when she was no more than ten years of age. Ten years later Nero forced her to commit suicide after having twice sent her into exile. Her portraits must belong in the years from her childhood to about A.D. 60, when Nero turned his full attentions to Poppaea.

F. Poulsen correctly identified a head in Tigani (Samos) as Octavia. Mutilated though it is, this companion to the other Julio-Claudians from the agora shows Octavia in the years when she was empress. She had already assumed the headdress characterized by two rows of archaistic curls over the forehead, a hair style more evident in numismatic portraits of Poppaea.[40] The head, like so many others on Samos, is an Ionian variant of a portrait made in Rome and shipped as a model to Greece. V. Poulsen has gone on to suggest that the head in Tigani is a portrait which belongs to a group commissioned on the occasion of or shortly after Octavia's marriage.[41]

In a Late Antique wall of the Gymnasium, the original excavators of Olympia found the head of a long-faced Julio-Claudian princess wearing

the diadem of Hera and having an ideal cast produced by an inclination of the face to her own right. Despite the idealization, V. Poulsen has identified this lady as Octavia, on the occasion of Nero's accession in A.D. 54; he has characterized the head as a typically Greek version of a portrait known in two more-severe replicas from Rome.[42] The Octavia from Olympia must have been made as a pendant to the young Nero from near the Heraion.

POPPAEA

Poppaea Sabina ruled Nero and reigned as empress from A.D. 62 (twelve days after Octavia's death) until Nero kicked her into eternity in 65. Nero regretted his action and erected a temple to his wife, a fact which would allow for statues in the four years before Nero's own unhappy end. Her only generally accepted statue is in the Olympia Museum and comes from the cella of the Heraion, where she stood between the columns next to the niche for the so-called Hermes of Praxiteles. Poppaea is clad in long chiton and himation draped in a popular Hellenistic fashion. Her hair is done in elaborate archaistic style, foreshadowing the honeycomb wigs of the Flavian period. The rather bland face, its pouting lips, and the corkscrew curls go very well with Poppaea's portrait on Alexandrine coins. The head is the work of one mediocre Athenian, the body of a slightly more gifted colleague, either Eros, or Eleusinios who sign identical statues from the pronaos of the Heraion.[43]

GALBA

A head and part of the neck toward the right shoulder of a bust or statue was found buried beneath the exact center of the orchestra in the theater at Corinth. It is now in the Corinth Museum (no. 15) and has been labeled a portrait of the stern old soldier who tried to govern the Roman Empire without success in the years 68 to 69, during the first part of the turmoil following the death of Nero (figure 127).[44] The identification stems from coins and is a possible one, although the break across the nose increases its aquiline effect. The head definitely belongs at the end of the Julio-Claudian period, when severe, republican-looking men like Galba emerged in likenesses that tempered the natural verism of the subject with the humanity and technical virtuosity of the sculptor. The excavators noted that a portrait of Galba would have been popular at Corinth after Nero's murder, but that it could have been buried as obsolete when the new floor was laid in the Antonine period, the time of Herodes Atticus. This head is a local work of good, free quality, which may account for lack of conviction that this really is Galba. Corinth, and to a much lesser extent the neighboring Roman colony of Patras, were the chief cities between Italy and Syrian Antioch to strike coins for Galba; several of their types hail his "victories" in the Civil Wars.

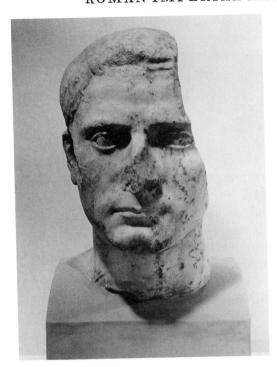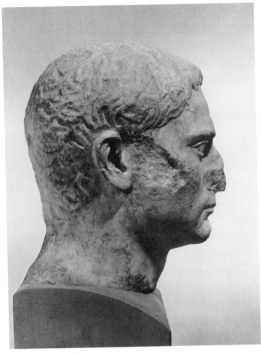

127. Galba, Corinth

The bronze coins struck for Galba at Corinth by L. Can. Agrippa as Duumvir or high magistrate of the colony often show a profile remarkably like this portrait in marble.[45]

CONCLUSION

The lists of Julio-Claudian portraits in the East show that in each decade the official images from Rome were awaited with eagerness. These portraits were sent to Athens or Corinth (the local sculptors still signing as "Athenians"). In workshops in these cities the master image from Rome was copied mechanically and faithfully by some and with various degrees of creative freedom by others. Often the master images were merely faces, accounting for the variations in hair. In most instances something indelibly Greek was stamped on these likenesses. The Greek creations were then dispatched throughout Greece, to the islands, and to Asia Minor. At the same time Roman workshops bypassed Athens and exported portraits directly to islands such as Crete, to centers such as Byzantium, and especially to the imperial province of Egypt.

The Athenian portraits were used as the basis for groups of portraits in the third stage from the Roman model. Most important of these groups were the heads modeled and carved in the great cities of western Asia Minor — at Smyrna, at Ephesus, or at Miletus. They were circulated among islands close to the coast (Samos), among the cities from Assos

to Antalya, and in the Anatolian interior. Western Asiatic portraits in the third stage from Roman prototypes usually contain a greater degree of emotional Hellenism than any other coherent collection of imperial likenesses. The Alexandrian, the Rhodian, or the Pergamene sculptural experiences of the Hellenistic period were too gripping and too fresh in the repertory of Asiatic Greek sculptors to be ignored in the representation of rulers to whom Asia paid divine honors in the Macedonian Hellenistic tradition.

In all phases of Julio-Claudian portraiture there were some local productions only vaguely related or not related at all to Roman or Athenian models. Asia Minor produced some of the most striking. A number belong to the periods after an emperor mounted the throne or a relative sprang into prominence and before an official image could be produced and circulated to cities where artistic prosperity and commercial zeal had no desire to await the word from the capital.

X

Augustan and Julio-Claudian Commemorations

GEOGRAPHICAL STUDY OF inscriptions, enriched bases, and monuments of architecture executed in the century from 27 B.C. to A.D. 70 begins in the Greek islands. In many respects these islands have been a unit independent from their surroundings since the Bronze Age. In Roman times they were places of rest or exile for the imperial family and way stations between Italy, Asia Minor, and Syria or Egypt. These factors often gave them unusual claims on the arts.

THE GREEK ISLANDS

On the island of Thasos, there was a statue of Augustus on the acropolis of the city. An altar in his name was found near the odeon, and a further inscription gives evidence for the cult of Roma and Augustus. His family was no less honored. In or near the agora, in a shrine of the first emperor, there were three statues of imperial ladies: Livia, Augustus' daughter Julia, and her daughter of the same name. There was also a dedication to Lucius Caesar, put up in the years A.D. 2 to 4. The agora has yielded a dedication to Claudius by Paranomos, and one of its buildings was evidently rededicated to the same emperor, with an inscription on the architrave.

Although the island of Thera has been relatively rich in imperial portraits in marble, early imperial epigraphic evidence has been relatively meager. There is an altar to Augustus, as Octavius Caesar between 31 and 27 B.C., of the usual circular Hellenistic type with garlands and bulls' heads. Augustus in these years was also given a statue (30 B.C.). Tiberius is mentioned as having been patron of the gymnasium of the ephebes, receiving an altar or cylindrical base similar to that accorded Augustus. Portrait-inscriptions of Germanicus and Agrippina, as Caligula's parents, stood in a group that later included Vespasian. Delos, with its famed sanctuary of Apollo, presents a richer epigraphic picture, although proportionately less sculpture has survived. Mithradates was honored with a cuirassed statue in the sanctuary of the gods of Samo-

thrace, in 102–101 B.C., the period when Romans still had to compete with Hellenistic kings for public favor in the cities of the East. About 100 B.C. Midas, son of Zenon of Heracleia, known benefactor of the Italian colony of Delos, set up against a wall of the portico of Antigone a statue of C. Billienus C. F., a propraetor. He has a ship's prow as support at his right foot. After Archelaos, Mithradates' lieutenant, sacked Delos in 88 B.C., a Roman citizen (A. Attiolenus A. F. Velina) restored the statue and had this fact recorded in Latin above the original Greek inscription.

The Agora of the Italians at Delos has proven an important source for Greek art in its earlier phases of contact with the Romans. In one of its niches was found the Polykleitan-Praxitelean nude statue of C. Ofellius, by Dionysios and Timarchides of Athens. The artists' signatures appear on the base, and an inscription records the thanks of the Italians to the gentleman in question. The niches of this marketplace were generally adorned with statues of rich merchants or of Roman administrators. Niche number sixty-eight contained a statue by Agasias son of Menophilos of Ephesus, and number twenty-five reads Q. POMPEIVS. Q. F. RVF. COS. At the northeast angle of the Roman agora was found the beautiful statue of a general on horseback, only the cuirassed torso surviving; the work must be dated around 100 B.C., rather than in the early Antonine period, where most of these strongly Hellenistic cuirassed statues are usually placed. The base inscribed in Latin to L. Cornelius Sulla, monumental in its simplicity, must belong to the period after the First Mithradatic War, 84 B.C.

Delos has yielded seven inscriptions to Julio-Claudians, three of them definitely for statues and a same number (including one statue) found in or near the temple of Apollo. As with so many other sacred sites, the Julio-Claudians and those who paid homage to them felt it the supreme honor to have images in or near the principal shrine; these statues were often dedicated to the patron divinities, in this instance Apollo, Leto, and Artemis. In 48 B.C. Julius Caesar received a statue as savior and benefactor of the Hellenes (of Greece). The inhabitants of the island put up a statue of Octavian, and Augustus' physician made a dedication to his employer. Augustus also had an image in the cella of the temple of Apollo. His daughter Julia, wife of Agrippa, was honored near the temple by the Athenian Demos and local inhabitants, and there was a round base to Augustus' admiral and son-in-law in the temple. The final Julio-Claudian dedication was to their child, Augustus' grandson Gaius Caesar.

To continue in the Aegean islands, the Demos of Andros set up a statue of Julia as wife of Agrippa. A big epistyle block with three fasciae seems to have belonged to a stoa in the agora on the acropolis of Seriphos; the building was dedicated to Augustus. Cycladic Amorgos has yielded a

dedication to Caligula at Aegiale, and the mountain site of Minoa appears to have included a statue of Claudius from the Demos. The remains of several *palliati* and *togati* at this walled city overlooking the pleasant principal bay of the island testify to the sculptural wealth of its agora in Roman times. To shift southeastward into the Dodekanese, Astypalaea possessed an altar to Augustus Caesar, and also a curious document of the migration of inscriptions in antiquity. This consists of a stone with a letter from Augustus to the Cnidians. The marble was brought to Astypalaea and reused for a letter of Hadrian to the Astypalaeans. The island of Calymnos (Calymna) has produced a statue base or dedication to Caligula, probably in the years just before Tiberius died, when the aged emperor had made it seem to the world at large that Caligula would be his successor. The inscription was found at the temple of the Delian Apollo and is now in the British Museum. The Demos also set up a statue of Claudius.

Cos enjoyed considerable prosperity in antiquity owing to its shrines of Asklepios, to its agricultural activities, and to its proximity to Caria. Its several towns possessed a number of artistic monuments to the Julio-Claudians. Tiberius wrote the islanders a letter in the year A.D. 15, the second of his rule, and the epistle was commemorated in stone. The principal city, bearing the name of the island as a whole, had a statue of Augustus and an altar dedicated to him. There also appears to have been a statue of Nero's mother, Agrippina the Younger, at Cos. At Hippia there was a statue of Nero Caesar, the last of the Julio-Claudians, erected by the people of the town; the base has suffered the defacements of a damnatio. Halasarna was rich in Julio-Claudian commemorations, with an altar to Augustus (A.D. 1–4), a statue of his daughter Julia (17–13 B.C., when she was in Asia), an altar to the Tyche of Tiberius, a statue of Caligula's sister Drusilla, a statue of Claudius, and a similar monument to Nero. The last has suffered epigraphic erasures. At Antimachia there was a dedication to Caligula, and a suburb of the town possessed a statue of his successor Claudius.

From Cos this survey jumps north along the Ionian coast to the island of Lesbos (Mytilene). This island, and particularly its city of Mytilene, has produced the largest number of Julio-Claudian altars or dedications of any site in the Greek imperial world. The name of the emperor, or similar distinguished person, in the dative case indicates, as with dedications to the gods, that the altar was a monument set up to the imperial person. This implied the existence of a local cult of the man or woman so honored. It would be superfluous to note all mention of members of the Julio-Claudian house in inscriptions, particularly because a local custom led to groups of dedications in compartments on a single stone. Mytilene had its statue of Augustus, among the five altars to him which have been found there. A statue of his daughter Julia was matched by

at least six dedications, most of them multiple, to Julia's husband Agrippa and their children (Gaius, Lucius Caesar, and Agrippa Postumus). Tiberius was honored with two statues, and Antonia Augusta, widow of his brother Nero Drusus, also received a statue as benefactress of the city.

The Lesbians honored the family of Germanicus and Agrippina with statues because the imperial couple visited there in A.D. 18. It was at Mytilene that Agrippina delivered herself of her third child, Julia Livilla. Agrippina was much honored in connection with the gymnasium, and a number of testimonia have been found in the baths of Artemis north of the modern village. There was a statue of Nero Drusus, the son of Germanicus and Agrippina who died in 31; Germanicus is hailed as *theos* here. Between the years 20 and 33 a double dedication, possibly with statues, was set up to Nero and Drusus Caesars. There was a dedication to Caligula, and he also had a statue. In Rome and the East (Antioch, for instance) Caligula was industrious in honoring his ancestors and immediate family, a policy reflected in the monumental commemorative art of Mytilene. In the first year of his reign his name was connected with a dedication to Agrippa, to Nero and Drusus, to Agrippina, and to Drusilla as Nea Aphrodite. There was also a dedication by Caligula with compartments inscribed in the names of Pompey the Great, Julius Caesar, Augustus, Agrippa, Gaius and Lucius Caesars, and Agrippa Postumus. Another grouped Pompey (filius?), Julius Caesar, and Gaius and his brother Lucius. The last Julio-Claudian work of art at Lesbian Mytilene was a statue of Agrippina the Younger, set up in A.D. 50. This was the period near the beginning of her liaison with her uncle Claudius.

At Plakados near Mytilene there was a statue of Julia as Nea Aphrodite, a work of the years 15 to 13 B.C., and at Thermis there was a dedication to Agrippina Karpoporus. Eresus was second to Mytilene as the Lesbian city offering honors to the first imperial dynasty. In the years 15 to 12 B.C., a letter from Augustus was immortalized in marble, and the town also displayed a dedication to the divine Augustus. A bilingual dedication, possibly including a statue, linked Julia Augustus' daughter and Venus Genetrix the family divinity. It was set up before Octavius Caesar became Augustus in 27 B.C. Eresus had a statue of Tiberius, dated in the years A.D. 16 to 18, and in the years 18 to 19 the city put up a statue of Germanicus, who was then in their midst. The name of Tiberius in the inscription was rubbed out, either in the general anger resulting from the supposed poisoning of Germanicus or after the death of the second emperor nearly a decade later. An inscription by priests of Claudius and "the other Sebastoi" describes Claudius as "savior of the oikoumene," but there is no evidence concerning the emperor's specific benefactions. Claudius was also honored by a statue.

From Lesbos or Mytilene (the ancient city giving its name to the modern island as a whole), it is natural to move south again along the Ionian coast, stopping first at Chios off the Gulf of Smyrna. The traditional fertility and prosperity of the island was reflected in at least three statues of the period discussed here. In 48 B.C. the Boule and the people honored Julius Caesar; he was commemorated again during the brief period of his second dictatorship. The people then honored Drusus the son of Tiberius with a statue, in the decade from his father's accession as emperor; he is styled as "Drusus Caesar the son of the Augustus."

Samos honored Augustus and his family frequently. The first emperor resided in the island on more than one occasion, and the Julio-Claudians were naturally attracted by the fame and importance of the Heraion. It has already been shown how rich the city and the shrine of Hera have been in portraits of Augustus and his successors. In 67 B.C., to look backward for an instance, the city of Samos set up a statue of Pompey the Great, after the pirate wars. A pedestal to Augustus records a decree after his visit of 19 B.C., during the Parthian troubles, and an altar from Samos is dedicated to Augustus as Zeus Polieus and to Tiberius under the same guise. Samos had a shrine of the emperors, the gods of the city (Zeus) and Augustus. After the earthquake of 47 the Demos set up a statue in honor of their benefactor Claudius, in the area of the agora or modern Castro.

The Heraion in the seaside plain along the coast to the south of the city was particularly rich in Julio-Claudian commemorations. About 19 B.C. Julia Augusta Filia dedicated a statue to Hera, and there was also a statue of her youngest son, Agrippa Postumus. Drusilla, sister of Caligula, was represented by a statue, and in the years A.D. 54 to 62 a similar monument was put up to her cousin Octavia, the daughter of Claudius and the wife of Nero. Under Claudius there appear to have been set up statues of Livia, her mother, and her father; Claudius, it is remembered, rescued Livia's memory from the official neglect it suffered under Caligula and the aging Tiberius, and he arranged for her elevation to the divine rank of her husband.

Evidences of Julio-Claudian official art on Samos may belong to the Heraion, to the city nearby, or to other sites on the island. The inscriptions in question were moved about in the Dark Ages or were imprecisely recorded. There was a dedication to Dea Roma and Augustus, probably of the years 21 to 19 B.C., when the emperor was on the island, although he had been there earlier. With this can be counted at least three further dedications to Augustus, the last in the name of a number of local worthies. Probably during the crucial year A.D. 18, when Germanicus was in the East, the islanders put up a brace of statues to him and to Agrippina his wife. Tiberius' son Drusus Junior also received a statue, at some time between the year A.D. 4 and the year of

his death, 23. The last bit of Julio-Claudian epigraphic evidence on the island is a dedication to Caligula.

From Samos, it is natural to skip south and west to Crete, before swinging eastward to Rhodes and Cyprus. The city of Polyrhenium dedicated a statue to Augustus. At Assi or Axi a statue of Tiberius as son of Augustus appears to have been set up in the years shortly before he mounted the throne as second emperor. Gortyna has been richer in actual portraits than in inscriptions suggesting the same. The group of Julio-Claudians from the agora (Tiberius, Livia, Germanicus, and Caligula) is supplemented by the large dedicatory inscription to Augustus, dated between 2 B.C. and A.D. 7. Lyttus was a great center for commemoration of Trajan and his family, but prior to that time there is only the evidence of a dedication to Claudius, and another to Divus Titus. At Oloi there was an altar to Tiberius, and Hierapytna has yielded two dedications to Claudius.

The people of Rhodes set up a statue of Poppaea Sabina, wife of Nero, in A.D. 63 to 65. This famous city has provided Julio-Claudian portrait sculpture but little else of direct testimony to the amount of early imperial activity that went on in the island where Tiberius spent his years in retreat. At Lindos a statue of the second emperor stood near the temple of Athena. His wife, Julia, daughter of Augustus, and his brother, Nero Drusus, were also represented. On the acropolis there was a statue of Claudius and, presumably as its pendant, a likeness of his first imperial consort, Messalina, whose fall and death occurred in 48. Neomaras also boasted a statue of Nero's second wife, Poppaea.

Among the inscriptions found on Cyprus, there is the evidence that T. Apicatus Sabinus erected statues of Gaius and Lucius Caesars at Amargetti, north of Kouklia. There may have been a shrine here, for the formula "sacred building and statues" was used. The two princes were also honored at Salamis, and Gaius appears alone at Old Paphos. This site has produced epigraphic evidence for a statue of Julia, daughter of Augustus. In the temple of Aphrodite, the showplace of the area, there were dedications to Tiberius; his statue also stood there. Further documents from Salamis comprise a statue of Livia, set up during the lifetime of Augustus, and two dedications to Nero, the first in the year 59 and the second in A.D. 60.

Statues and inscriptions from the Greek islands cannot really be turned into a cohesive whole because they are as scattered as the islands themselves. The Julio-Claudians were naturally present at religious centers such as Delos and Samos. They are surprisingly frequent on Lesbos because the island discovered from the beginning, on a grand scale, that honors to the imperial family brought material returns. Lesbos, Samos, and Rhodes shared the extra prosperity of being places where the first emperor and his family spent time in residence. These islands

and Chios basked in the proximity of Asia Minor's economic boom. They were prosperous in themselves, but the fact that they were stepping-stones to the continent from mainland Greece and Italy meant that they were ever liable to be active instruments of Roman imperial policy. The ratio of surviving bronze and marble sculpture to inscriptions is particularly large in the Greek islands, perhaps owing to the fact that this area did not share Greece's and especially Anatolia's long periods of Byzantine architectural prosperity. The imperial sites were allowed to fall into ruin without extensive rearrangement and quarrying. Augustus founded his empire on naval victories; he and his family recognized the eastern Greek islands as keys to the control of Anatolia and Syria. Accordingly, the islands of Lesbos, Chios, Samos, Rhodes, and, to a surprisingly lesser extent, Cyprus were important in the military and thus in the commemorative policies of the Julio-Claudians.

THE GREEK MAINLAND

To begin with Nicopolis (Actium) in a survey of Julio-Claudian commemorations in Greece is to begin at the very focal point of Augustan power. Suetonius wrote: "He [Augustus] founded the city of Nicopolis at Actium, and, besides enlarging the ancient temple to Apollo, he dedicated to Neptune and Mars the site of the camp, which he had used and which was now adorned with naval spoils." * Finds on the site go back to the eighteenth century. For example, W. M. Leake reported in 1839 that a bronze ship's prow from Actium was found off Preveza. The principal commemorative monument was constructed by Augustus on the hill behind the harbor of battle (Mikalitzi), at the point where Augustus' (or Octavian's) tent overlooked his camp and the enemy action. A statue of Apollo stood above the captured prows. A circular trophylike structure was set in the porticoed temenos, and there was a monumental commemorative inscription on the trophy.

At Mesembria in Thrace an undated inscription marks the dedication of statues of Claudius, Hermes, and Herakles by Gnaeus, son of Gnaeus, while serving as gymnasiarch and agonothetes. The combination indicates that the monuments were put up in a gymnasium. Lebadeia (modern Livadia) on the road from Thebes to Delphi in Boeotia had a statue of Drusus the Younger, dated between A.D. 14 and 23 in the reign of his father Tiberius; the base was reused for another statue in Late Antiquity. At Tanagra a round base to Augustus has been recorded; there was a statue of Octavius set up at Thespiae in the years 30 to 27 B.C., and another of Tiberius dated just before the death of Augustus. The cities of central Greece commissioned a statue of Claudius which

* " . . . urbem Nicopolim apud Actium condidit . . . et ampliato vetere Apollinis templo, locum castrorum, quibus fuerat usus, exornatum navalibus spoliis, Neptuno ac Marti consecravit" (*Aug.* 18).

stood at Coroneia. At Delphi the base, perhaps from a portrait herm, is evidence that the sacred city was the cult center for the worship of Augustus in Greece; it was dedicated from the Athenian Demos and *all the Greeks* after 12 B.C.

Because of Athens, Attica has proven a rich source for evidences of imperial commemorative art. A brief conspectus of inscriptions reveals the following statistics: eighteen for Augustus, two for Livia, one each of Julia and Drusus Senior, twelve in the name of Drusus the Younger, three for Antonia, one for Gaius Caesar, two for his brother Lucius, eleven for Tiberius, and three for Germanicus. The single inscription in the name of Caligula has suffered erasure of the praenomen, Gaius (Caesar). Claudius had sixteen, including his bronze statue as Apollo Patroos in the Athenian agora and the altar in his name at Rhamnous. The last ruler is of course Nero, whose two include one which has suffered damnatio. The other was inserted in letters of bronze in perhaps the most artistically advantageous spot in all Greece, on the architrave of the eastern end or principal entrance of the Parthenon.

Augustus left his mark on Athens in several successful ways. The Roman agora is one of these. The western portico with its Doric entablature and pediment has an inscription on the architrave saying that the gate was erected by the people out of gifts made to them by Julius Caesar and the emperor Augustus and dedicated to Athena Archegetis. The base remains of a statue of Lucius Caesar, set up before his death in A.D. 2; the monument formerly stood above the pediment as an acroterion. All this in effect gave the aspect of a Kaisareion to the Roman agora, especially to anyone coming from the direction of the Stoa of Attalus and the old agora. Nearby, Stuart and Revett recorded a quadrangular base which formerly supported a statue of Julia Augusta (Livia, Augustus' widow) in the character of Providentia. The statue was put up in the name of the magistrates, the council of the Areopagus, and the people, at the expense of Dionysius the Marathonian who was one of the prefects of the market. Lucius Caesar's brother Gaius seems to have been honored as the "new Ares" on the evidence of a statue base seen by Cyriac of Ancona in the neighborhood of the Theater of Dionysos.

From the lower city of Athens it is logical to proceed to the Acropolis. On the lofty pillar still prominent at the entrance, the people of Athens set up a statue of Agrippa, probably in a chariot group of bronze. Agrippa's head, or the whole group, may have been substituted for an earlier dedication to one of the Attalids, probably Eumenes II. A similar monument stood in front of the Stoa of Attalus and was no doubt first dedicated to Attalus; the rededication to Tiberius at the beginning of his reign included the epithet "Theos," showing that the Athenians were quick to offer divine honors to the second emperor. Tiberius was commemorated in Athens by at least five statues before his adoption, and

after this event his statue appeared west of the Parthenon, alongside other Julio-Claudians. Remarkable among rededications at the gates to the Acropolis was the pair of equestrian statues by Myron. These were transformed into commemorations of Germanicus and another prince, probably Drusus, the son of Tiberius. It is remembered that these two were adopted by Tiberius as his successors, according to the will of Augustus, and that they were hailed as the "new Dioskouroi" because they were said to get on so well together.

The most important early imperial monument on the Acropolis was the little round Ionic temple of Roma and Augustus in front of the principal entrance to the Parthenon. Dedicated after 27 B.C., its nine slender columns rested ultimately on a square base. The inscription on the architrave was simple and direct. The whole building, modeled in its details on the Erechtheum, was as tasteful an expression of the imperial cult as could be found in an area so crowded with famous monuments.[1] Claudius was not only honored by a statue west of the Parthenon but appears to have had another in the Theater of Dionysos.

At Rhamnous in Attica, Claudius was responsible for the dedicatory inscription on the east epistyle of the fifth-century temple. It was to the empress Livia, deified by Claudius, in A.D. 42, with mention of the priest of the goddess Roma and of Augustus Caesar. In Athens her name appears on a seat of the theater, "priestess of Hestia on the Acropolis and of Livia and Julia." At the Attic Amphiareion there is a statue base to Agrippa, and the remains of a handsome marble cuirassed statue featuring Augustan marine motifs on the breastplate must have belonged with the inscription. Agrippa was in the exalted company of Lysimachus and a number of Roman Republican generals who felt a kinship to the early Greek hero. A statue of a man clad in heroic himation, the drapery around the lower limbs only, is in the Amphiareion Museum and must also belong to one of these dedications.

Eleusis had a high priest of Tiberius Caesar Augustus, and the togate statue of the young Tiberius in the Eleusis Museum is witness to his long-standing connection with the sanctuary. A large statue base to Tiberius was also found on the site. The surviving statue of the successor to Augustus is complemented by the similarly togate statue of the young Nero. Despite its relative lack of importance in the Roman period, Megara has produced a richer harvest of evidence for Julio-Claudian works of official art than many a larger city. There was a statue of Octavius Caesar, and another likeness presented the first emperor as Apollo. The bronze head of Octavius in Copenhagen, from a statue showing the young imperator in military dress, may have formed part of the statue at Megara. A double dedication honored Agrippa and Livia, and after Augustus' death the latter received a statue. Tiberius had a statue. In A.D. 47 the Megarians set up a large inscription honoring

Claudius, and a base of black marble speaks of a statue to Nero, then the adopted son of Claudius.

Despite the paucity of early imperial monuments at Corinth, the Julian Basilica did yield the splendid statue of Augustus flanked by the princely grandsons Gaius and Lucius Caesars. Above the marketplace Pausanias saw a temple of Octavia, Augustus' sister. Nero's abortive effort to dig the canal across the Corinthian isthmus seems to have been commemorated by a relief carved in the rock of the cut at the western end. Colossal statues of Nero and Dionysos probably stood on the bases (and blocked the view) in the orchestra of the theater at Isthmia. Marble copies of Nero's famous speech at Isthmia in the year 67, his "gift of freedom" to the Greek cities, were set up throughout Greece. One of these, from Akraiphnion in Boeotia, is in the Thebes Museum.

Epidaurus appears to have possessed an Augustan and Julio-Claudian cult center, focusing on a statue of Asklepios. The group included a marble stele of Germanicus in armor, another of Livia as Hygeia, and at least one other imperial prince in a cuirass. A base for a statue of Livia, from the people of Epidaurus, was found in the theater; the block was used twice, for there was an inscription to a private citizen on the other side. A statue of Lucius Caesar, the work of one Ektoridas, was removed from its base, and the pedestal was reused. There were two dedications to Drusus the Elder, one being a statue from the city of Epidaurus. Tiberius was honored with two statues. Among other commemorations, the names of Diva Drusilla (died in A.D. 38), Claudius, Messalina (to 48), Agrippina the Younger as wife of Claudius (A.D. 49–54), and Claudius with Agrippina are mentioned in inscriptions.

Messene has yielded an altar to Augustus and Tiberius in the years A.D. 4 to 14, and two major dedications or statue bases to Nero. One of these statues was in bronze. Gythium had a statue of Augustus, placed against the wall of the theater. At Pherae in Messenia there was a big dedication to Divus Augustus, Tiberius and his family, dating in the year A.D. 30. Corone in Messenia received a statue of Agrippina, wife of Germanicus, set up after A.D. 37 in the name of Caligula. Asine matched this with the pendant statue of Germanicus. Tegea had a statue of Augustus and an altar to Livia. Sparta appears to have possessed a statue of Nero. Excavations in the theater produced the bases and fragments of overlifesized statues of Gaius and Lucius Caesars; the statues, not dated, were set in place near the west end of the stage. These random samplings are completed by the statue of Claudius or Nero which stood in or at the temple of Despina at Lycosura.

The remaining concentration of Julio-Claudian dedications in mainland Greece and the Peloponnesus was at the great shrine of Olympia. This site appealed to the Romans as a center for dedications, no doubt because of their worship of Zeus and because of the healthy connotation

of athletics. Nero's name is, of course, linked with Olympia in a rather unsavory way. He performed there and stole works of art from the shrine, but he did contribute certain architectural embellishments. The roof of the temple of Zeus had an inscription honoring Julius Caesar. The metroon appears to have been restored under Augustus and dedicated to him by the Eleans, according to the inscription on the architrave. The remains of the cult statue of Augustus, seated in Jovian guise, were found within.

The Achaean League put up a statue of Augustus at the east front of the temple of Zeus. A large base or altar honored Tiberius, Nero Drusus, Drusus Junior, and Germanicus. This and another large base, also in front of the temple of Zeus, were part of the evidence that a pair of quadriga groups contained statues of Tiberius and his brother Nero Drusus on one hand and their two sons Drusus Junior and Germanicus on the other. Tiberius was represented elsewhere in the sanctuary by statues at various stages in his career. Finally, there was a monument to Nero as PRINCEPS IUVENTUTIS (50–54), and the Olympians had the pleasure of gazing on his statue as emperor. All this epigraphic evidence at Olympia has been in Greek, but the Latin language produced two documents. A pavonazetto or Phrygian marble plaque commemorated repairs to the temple of Zeus under Marcus Agrippa in 27 B.C., and an inscription to Nero in the next to last year of his reign (A.D. 67) came from a commemorative structure with a fountain basin.

ASIA MINOR

The transition from Greece and the islands to Anatolia is made by detouring to the northern coast of the Black Sea and stopping at Olbia in Sarmatia. This region, seemingly so remote from the Mediterranean world and not more than an affiliate of the Julio-Claudian empire, possessed at least one public building, a stoa, dedicated between A.D. 4 and 14 in the names of Augustus and Tiberius. At Panticapaeum farther to the east in the same general region, Cotys, the son of Aspurgus, king of the Bosporus, set up a dedication to Nero, with the emperor's full titles brought into play. Cotys appears in his family's self-styled, traditional role as "friend of the emperor" and "friend of the Romans." Phanagoria was in no way behind Panticapaeum. The energetic queen Dynamis, wife of Asandrus, commissioned a statue to Augustus.

Across the Black Sea in Anatolia proper, a statue to Agrippina the Elder was dedicated from the people of Sinope. One of the most unusual monuments of Roman imperium in Asia Minor was set up to Claudius by a group of imperial officials, along the road through the mountains half way between the seaport of Amastris (Amasra) and Parthenium (Bartin), ten miles inland from the Black Sea and almost on the Pontus-Bithynian border. It was undoubtedly a by-product of re-

building that road. There was a small aedicula in which a palliate statue (now headless) probably of Claudius was set. The base for the statue was circular and bore the inscription. There was seemingly also a Tuscan column which was surmounted by a statue of an eagle holding an olive branch. Such a motif, common to early imperial art, appears on coins of Amastris and other cities of the Pontus-Paphlagonia regions. This rustic shrine, with its combination of a traditionally Greek statue of the emperor and a Hellenistic to imperial city-emblem, is one more example of how imperial art in the Greek world is so often connected with rural setting and natural grandeur. Alexander's Egyptian successors began the idea with the Pharos at Alexandria; the colossus of Rhodes or the altar of Zeus at Pergamon continued this combination of the artificial and the natural; and, as might be expected, dramatic setting became a part of the repertory of imperial dedications.

In Bithynia, on the eastern shore of Lake Ascanius, there were two big bilingual inscriptions cut in the rock to Nero in A.D. 58 and 59 for the repair of the road from Nicaea to Apameia. The work was carried out by the procurator C. Julius Aquila. At Gueul Bazar, not far from Nicaea (Iznik), stood a dedication to Nero in the years 62 to 63. Like Nicaea, Nicomedia has suffered too much from later rebuildings to leave much trace of its Julio-Claudian or earlier city. The cuirassed bust in Istanbul, here identified as Caligula, is evidence that the city must have had at least one shrine or some kind of commemoration, if only on a private and personal level, of the Julio-Claudians.

Cyzicus, in Mysia and across the Propontis from Byzantium, presents a more fruitful provenience for Julio-Claudian monuments than Bithynia. One Aristander Eumenis dedicated a statue of Augustus, and in the period after A.D. 23 the city received a statue of Tiberius. A major monument documents the Cyzicenes' concern with how their Julio-Claudian rulers felt about them. It consisted of a large pedestal, presumably for statues, and possibly a triumphal arch from the Roman residents and Cyzicenes in honor of Augustus, Tiberius, and Claudius, perhaps finished in 51 to 52. The people of Cyzicus included Augustus and Tiberius for motives beyond mere commemoration of Claudius' British victories. The Cyzicenes had lost their freedom in 20 B.C. for violence done to Roman citizens. Under Tiberius in A.D. 25 they again lost their freedom on charges of neglecting the worship of Augustus and violence to Roman citizens. Relations became more cordial under Caligula, and the Cyzicenes therefore saw opportunities to "atone" for their past failures! Needless to say, at least half the inscriptions of the monument were in Latin. At the town of Hodja-Bunar a dedication to Drusus Junior has been found; this may have been the base of a statue, which stood in Cyzicus.

The city had a history of triumphal commemorations which bridges

the crucial time from the last generations of the Roman Republic into the Julio-Claudian period. In Istanbul there is a large fragment from a rectangular base, which has been said to come from a monument set up by the Cyzicenes after the retreat of Mithradates, the victory of Lucullus, and the deliverance of the city in 73 to 72 B.C. from a major siege. The relief comprises trophies at the left and right, a cuirass and a *vexillum* in the center, a helmet and greaves at the lower right, and round or rectangular shields above, with various swords and lances filling the remaining area. The presence of the *vexillum* denotes a commemoration involving Romans. The influence of the composition is that of Attalid Pergamon, but the design is Roman in its specific details. The monument shows that there was really more Roman art in Greece and Asia Minor in the last decades of the Republic than in any period before the beginning of the fourth century after Christ. The impact of Roman habits of trade, conquest, and government was still fresh enough that Roman artistic expression had not lost its novelty and become clouded with the Hellenistic formulas of abstract, personified drama punctuated by theatrical phrases in art.

In the years between A.D. 14 and her death in 29, the Gerousia of Lampsacus set up a statue and inscribed base to Julia Augusta. She is hailed as the new Demeter, a title which recalls those awarded to Julio-Claudians in the dedications on Lesbos. Pergamon offers the first really rich harvest of Julio-Claudian official art from Anatolia. Rome not only inherited the Pergamene state, but the Romans received an important legacy of imperial triumphal art and how to arrange it in its proper settings. The Attalids had developed the symbolic expressions of state art to a high point: trophy monuments, balustrades with reliefs, enriched pilasters, monumental altars, and symbolic bases. The prototype of the Roman Ara Pacis Augustae was seen not only in the Great Altar of Zeus Soter but in the small complex around a circular basis or altar of the type dedicated by Eumenes II. The front panels to the left and right bore foliate tendrils and stems with leaves and berries at the left and right of a central calyx-shaft. The short sides of these plaques carried caduceuses and torches. The sculptural wealth of Pergamon can almost be symbolized by the fact that the head of Augustus in Istanbul was found in a cistern near the temenos of Demeter, with two other Julio-Claudian portraits, a head of Hermes, and a head of Eros.

Julius Caesar was much honored at Pergamon. He received a statue as early as 63 B.C. There were three other statues, one set up in the gymnasium in 48 B.C. and another in the temple of Athena after Pharsalia. There was a second dedication after the same battle, and the remaining monument also comprised a dedication. There was a temple cult to Augustus in the city. One statue was set up after 29 B.C.; a second statue, in the temple of Athena, belonged to the years of the Par-

thian Settlement (20–19 B.C.); a third statue stood in the gymnasium; a fourth statue came from the people of Pergamon; and a fifth was presented by the Roman citizens of the free and allied city of Amisus. The city has also yielded two other dedications, one in the temple of Athena.

The gods of the gymnasium, Hermes and Herakles, were joined by Augustus and Livia as recipients of another dedication. Tiberius received at least two statues before his adoption by Augustus in A.D. 4, and one as a Caesar during the next decade. Among the other Julio-Claudians, Octavia Maior, Drusus Junior, Julia the sister of Caligula, Julia the daughter of Drusus Caesar, Germanicus (twice), and Claudius (possibly twice) were also honored with statues. Caligula's sister was titled "new Nikephora," and one of the likenesses of Germanicus was signed by the sculptor Glaukon, in A.D. 18 or 19.

Troy or Novum Ilium held a special spot in the affections of all Romans because of the Homeric tales and a particular spot in the thinking of those Romans who saw themselves as descendants of the refugees from the burning city. As early as 68 B.C. in the funeral oration for his aunt, the wife of Marius, Julius Caesar had stressed to all Romans the relation between Troy and Rome. After the battle of Pharsalia, Caesar visited the ancestral site, finding it still suffering from the destruction of Fimbria; he confirmed the city's privileges and declared it a *civitas libera et immunis*. Among the later benefactors were the Julio-Claudians, who perpetuated for obvious political purposes the tradition that the family of Caesar was descended from Venus through her Trojan son, Aeneas. In the imperial period the Trojans were not slow in capitalizing on this genealogical link with the greatest city on earth. For a city so small, Ilium has yielded an important number of imperial works of art. Surviving Julio-Claudian portraits have already been considered. The tradition goes back further than the Roman Republic, for Alexander the Great began his conquest of the Persian empire at Troy and his successor Lysimachus gave the city its Hellenistic temple of Athena Ilias. Lysimachus was also probably responsible for the splendid early Hellenistic relief, now in Madrid, showing Alexander the Great riding into battle on Bucephalus, a soldier leading the way on foot. Under Augustus two stoas, the propylaea at the south side of the sanctuary of Athena, and a small circular shrine (Roma and Augustus?) in front of the temple's east façade were built. An inscription on the architrave provides evidence that the temple of Athena was rededicated under Augustus. A third (west) stoa was added under Claudius.

To the second century A.D., the Antonine period when the same subject appears on coins, belongs a tondo medallion, on a square plaque, from the Julio-Claudian theater. The central scene is the oft-repeated motif of the Lupa Romana; above the Wolf and Twins are two deer in foliage, and a further touch of Hellenistic landscape is added by Pan

in a grotto below the main scene. The relief was Ilium's commemoration of the Roman event which marked an intermediate stage in linking the two cities.[2]

The epigraphic evidence for the Julio-Claudians at Ilium begins with statues or other honorifics to L. Julius Caesar who was Consul in 90 B.C. and who was killed in 87. In 66 to 62 the people set up a statue of Pompey the Great, who was at that time imperator for the third time. There were at least three statues of Augustus, two accompanied by flowery tributes from the city of Ilium for which he did so much and the third (12–11 B.C.) dedicated in the name of Melanippides Euthydikos. Marcus Agrippa received his statue in the years 18 to 13; Gaius Caesar, as son of Augustus, Governor of Asia and patron benefactor of Ilium, received a similar honor about 1 B.C. Antonia Augusta was commemorated in the first five years of Tiberius' principate, and a statue base to the second emperor survives from the years A.D. 32 to 33. There were the dedications to Claudius and Agrippina Junior, and others to their children or to the children of Claudius, including Nero! In A.D. 53 a wealthy burgher, Tiberius Claudius Kleophanes, put up a stoa in the precinct of the early Hellenistic temple to Athena to hold statues of the imperial family, the Senate, and the Demos of Ilium. Only one of the three surviving marble portraits from Troy can be linked to any of these inscriptions: the head of Augustus, of the Primaporta type, in Berlin. Even this connection is tenuous, for the marble portrait looks posthumous and the statue bases belong in the first emperor's lifetime. The young Tiberius found with it can hardly be placed on a statue set up in the last five years of his reign, and no inscriptions are recorded for the Agrippina Senior in Philadelphia, Pennsylvania (figure 122).

Across the Troad south from Ilium lies the ancient market town of Assos. As the American investigations of the last century revealed, the greater part of the lower town was built during the tranquillity produced by Roman domination. Augustus was honored by a stoa with an epistyle or frieze inscription, as one early traveler mentioned, "written bold and brave on blocks of the architrave": "The priest of the god Caesar Augustus, himself likewise hereditary king, priest of Zeus Homonoos, and gymnasiarch, Quintus Lollius Philetairos, has dedicated the Stoa to the god Caesar Augustus and the people." With this inscription belongs another on a large marble plaque, once set in the wall of the bath and now in Boston: "Lollia Antiochis, wife of Quintus Lollius Philetairos, first of women, who was queen in accordance with ancestral customs, dedicated this Bath and its belongings to Julia Aphrodite and the people." Julia Aphrodite must refer to Livia the wife rather than to the daughter of Augustus. The epistyle inscription of this bath gave much the same information, adding that Lollia Antiochis was wife of Quintus Lollius Philetairos, priest for the life of Divus Caesar Augustus.

Livia as a goddess, "the new Juno, the wife of the god Augustus," also had a statue, and Roman merchants set up a statue of Gaius Caesar in the years 1 to 4 after Christ, the head perhaps still surviving in Istanbul. Below the Bouleuterion the excavators found a bronze tablet congratulating Caligula on his accession, according to a decree of 37. Assos has produced no more evidences of imperial art until the early third century.

At Aegae in Aeolis there was a lengthy inscription in Greek and in Latin on the epistyle of a long stoa or porticus in or near the agora and dedicated in the name of Tiberius. The inscription, which has been recorded in similar form at Magnesia ad Sipylum and elsewhere, honored the emperor for his help given to twelve cities at one time, after the earthquake of A.D. 17. At Aegae, as elsewhere, Tiberius appears to have restored the principal temple as well as stoas or porticoes. Aside from these remains of an early imperial building, Aegae seems to have yielded only a dedication to Claudius from local citizens.

The next city is Myrina, famed for the terra-cotta figurines from its Hellenistic tombs, on the coast just west of Aegae. A dedication to Augustus and to Pax may belong to the period 9 B.C., when the Ara Pacis in Rome was completed. Between Cyme and Myrina the base of a statue to Nero, the son of Germanicus, has been recorded; the monument may have been put up posthumously, in the time of the prince's brother Caligula. Besides the stoa to Tiberius, already mentioned, Magnesia ad Sipylum on the Hermos River had an altar to Claudius, dedicated between A.D. 43 and 46. At Tyanollus to the northeast, on the road to Hierocaesareia and Thyateira, there was a statue of the same emperor. At the site known in later times as Mostene, a dedication to Tiberius in A.D. 31 and the base of a statue of Claudius or Nero have been found.

Imperial Sardes was the city of Augustus, having yielded at least twenty-one inscriptions in which he is mentioned or honored. One of the dedications to Tiberius consisted of a statue set up after the earthquake of A.D. 17. Agrippa and his consort, Augustus' daughter Julia, were each honored once. Eight inscriptions spoke of Gaius Caesar, the grandson of Augustus. Germanicus appeared once, and there was a statue of his son Drusus. Antonia was also represented by a single inscription, as was her grandson Caligula. The last Julio-Claudian to appear is Claudius, who was mentioned at least four times. The most important of his connections with Sardes was the aqueduct which he completed by a gift and which had a bilingual inscription of the years 53 to 54, stating (in part): AQUAM CIVITATI SARDIANORUM A FONTE . . . ADDUXIT, INSTANTE TI. CLAUDIO DEMETRI F. QUENNA APOLLOPHANE.

Apollonis lay slightly to the west of the road from Sardes to Thyateira. The principal imperial inscription from this site offers the problem of being either a statue base to Livia after her deification in 42 or a similar

monument to Julia Domna, as Thea Iulia. Although rich in inscriptions of the period from Domitian on, the metropolis of Thyateira has yielded only one testimonial for the Julio-Claudian era, a dedication to Augustus. The modern town of Monghla, however, has produced the base of a statue from the Demos to Tiberius as emperor. Kula, in eastern Lydia, although a medieval city, became a gathering place for ancient monuments. One of these, now in Trieste, is a rare example of imperial folk art from this area, a relief dedicated to Caligula and Germania. Caligula, richly cuirassed and on horseback, rides toward a woman labeled as Germania. This somewhat primitive creation was intended as a local recognition of Caligula's German expedition, an adventure so ridiculed by later imperial court historians. Finally, Blaundus has provided evidence among its extensive ruins (including a monumental city gate) for a building, possibly a temple in connection with a stoa, dedicated by wealthy local Romans to Claudius. Unfortunately, the epistyle blocks are too damaged to give precise readings; the temple had Ionic columns and a maeander ornament in the frieze.

From the Lydian hinterlands it is a natural descent back into the Ionian basin of Smyrna. While every form of evidence has testified to the Hellenistic and early imperial prosperity of this city, frequent earthquakes have meant that most remains belong to the late Antonine period or later. Among the few traces of the Julio-Claudian city, there was a statue base from the people to Tiberius in the decade (A.D. 4–14) when he was heir apparent to Augustus. There appears also to have been a temple to Tiberius, Livia, and the Senate, perhaps near the stadium and probably overthrown in the major earthquake of 178. After an earthquake in his reign, Claudius may have rebuilt or renovated the theater. This is a poor record of survival for a rich period of so great a city.

In the sanctuary of Apollo at Claros the excavators have found a statue base of Augustus with titles that antedate his being named Sebastos. Mention is made on it of his "quasi-divine exploits" and his "benefactions to the Panhellenes." The statue could have been one of those that show him as Apollo.

The ruins of Ephesus present, on larger scale, the same problems as those of Smyrna. Save at the site of the Artemision, there was so much rebuilding and later building that the Hellenistic, late Republican, and early imperial buildings were often obliterated or remain to be discovered. Yet the silver cistophori and many other evidences testify to the prosperity of the city in the days from Pompey to Nero. Two examples of the bilingual inscription of 5 B.C. on the peribolos wall of the Artemision survive, one in London and the other (from the northern corner) in Berlin. The letters are handsome, those in Latin being slightly superior to the Greek. The name of the Proconsul, Gaius Asinius

Gallus, husband of Vipsania, has been rubbed out in such a way as to be still visible.

IMP. CAESAR DIVI — F. AVG — COS. XII. TR. POT. XVIII. PONTIFEX. MAXI
MVS. EX. REDITV. DIANAE. FANVM. ET. AVGVSTEVM. MVRO. MVNIENDVM
CVRAVIT. [C. ASINIO. GALLO. PRO. COS] — CVRATORE. SEX. LARTIDIO
LEG

The sanctuary or small temple of Roma and Augustus seen on Ephesian cistophori stood within the precinct of the Artemision. The cult group comprised the cuirassed Augustus (probably a replica of the Primaporta portrait) crowned by a Roma of the Hellenistic city-Tyche type. Another Augustan monument at Ephesus was the double-winged, triple-arched gate leading from the agora to the Library of Celsus (figure 128). The structure was dedicated by two freedmen of Agrippa, Mazaeus and Mithridates, in 4 or 3 B.C. to Augustus, Agrippa, Livia, and Julia. The architrave of the building had a foliate-scrolled frieze, and the attic was crowned with statues of the imperial family. The inscriptions of the frieze area were in Latin on the left and right, that is, on the wings, and in Greek on the inset central arched area.

128. Gateway of Mazaeus and Mithridates at Ephesus

At Priene the two principal monuments, the temple and the altar attributed to Hermogenes in the late second century B.C., were rededicated to Athena Polias *and* the emperor Augustus. As in the case of the Parthenon in Athens or the temple of Nemesis at Rhamnous, these inscriptions were carved on the architrave of the temple and on the abbreviated entablature of the altar. The temple also had a later frieze, a gigantomachy and an Amazonomachy, which may have stood in the building and which may be an Augustan continuation of the Pergamene tradition. On the other hand, the slabs, scattered between Berlin, Constantinople, and London, are finished in the facile, drilled style which is often taken to be Antonine work, when Pergamene art was even more widely revived.

Miletus has yielded surprisingly few Julio-Claudian monuments. On the wall of the north hall of the Bouleuterion there was an honorary

inscription for Augustus. A like inscription existed in the theater of the same building. At the Delphinion there was inscribed the text of a letter in A.D. 48 from Claudius to those responsible for work in connection with the cult of Dionysos. The inscription stood not far from a bronze statue of Seleucus I or Apollo, dedicated in the name of the people of Miletus to Apollo. Pompey the Great was honored, perhaps posthumously, in the South Market area as patron and benefactor of the city. So also Marcella Minor, who married Paullus Aemilius Lepidus in or after 16 B.C., appears to have received a statue. At neighboring Didyma, Dio Cassius reported that Caligula built himself a temple in the name of the province of Asia. An inscription from the site goes into the matter in great detail. In the area of the Maeander Valley farther inland one of the few definite Julio-Claudian monuments encountered is the thirty-first milestone on the Roman road from Ephesus to Tralles. It appears to have been set up in the name of Tiberius.

Phrygia is the next major region to be considered. With Mysia, Lydia, Ionia, and Caria it can be lumped under the Province of Asia, the largest Roman imperial administrative unit of the sub-continent. Phrygia, traditional or administrative, as the large and populous land mass of western Anatolia is difficult to traverse geographically in a study such as this. The simplest method, that of the numismatists, would be to list and discuss all the cities by the letters of the alphabet. This solution does well enough for coins but does not allow for monuments, such as milestones, which link one city with another. The best plan is to wander about in Phrygia, moving roughly from north to south, in order to be able to travel westward into Caria. Phrygia also has Lycia on its southern borders and Pisidia to the southeast. These regions, the first a Roman province in its own right and the second technically part of Galatia in the administrative sense, will be considered in this order after Phrygia.

A strong cult of Augustus and Livia existed at Phrygian Ancyra near the headwaters of the Macestus and on the road from Thyateira to Aezani. Two inscriptions describe the local arrangements, which included wooden tablets set up on the doors of the shrine. Golis, identified from a statue base to Hadrian the Olympian, set up a statue of Tiberius Claudius Caesar Augustus Germanicus imperator, dedicated by a local official named Diodoros Kleandros. Aezani is remembered for the excellent remains of its temple of Zeus, a work abounding in epigraphic evidence to supplement its architectural tribute to Hadrianic and Antonine Hellenism in Phrygia. The city lay east of Ancyra on a minor road which forked right to Dorylaeum and left to Bithynian Prusa. A statue of Claudius was accompanied by an altar in connection with it. There were also games in honor of Claudius, and all this activity led to a neocorus Claudii et Britannici, the city being declared a guardian of the imperial cult. On the other hand, in the year A.D. 50 a letter was

recorded in marble, consisting of a panegyric in honor of Nero and Agrippina.

In nearly every direction from Aezani, especially toward the south and east, one encounters the great cities of Phrygia so well known from ancient authors, from coins, and from inscriptions discovered within the last century. Many of these cities enjoyed such prosperity in the period from the Flavians into the fourth century that the imperial monuments of the Julio-Claudian period have disappeared. Monuments that no doubt survived the later rebuildings perished in the disasters of the Middle Ages. Thus, Dorylaeum, Nacoleia, Laodiceia Combusta in eastern Phrygia or Lycaonia, Hierapolis, Laodiceia ad Lycum in southwest Phrygia, and Colossae slightly to the east in the upper Maeander Valley have produced imperial monuments only from the period of Vespasian or later. Splendid though the architectural remains often are, and despite the possibility that certain buildings are older than the inscriptions found with them, all must be discussed in connection with the emperors whose names appear on them.

Trapezopolis (modern Bolı) lies just off the ancient highway running from Apameia through Colossae and Laodiceia down the Maeander Valley toward Tralles and Ephesus. The evidence for imperial art in the city consists chiefly of a marble pedestal found in a field at the south end of the plateau; it relates that one Titus Flavius Maximus Lysias dedicated a statue to Hadrian. There is another, a rather unique monument of Roman official art in its influence on the funerary sculpture of Anatolia during the first century of the empire. In the wall of a hut, in the Maarifdairesi at Denizli in 1934, an Anglo-American team searching for inscriptions recorded a relief from Trapezopolis. The marble panel has a molding above and a tenonlike projection below. On the left side is a large eagle with head turned to the right and wings displayed. On the right side stands a woman who once held attributes such as wreaths or a wreath and palm. The inscription gives the name of Apollonios the son of Menekratos from Phocaea. The eagle is large and Roman in the Hellenistic funerary sense; the woman is either Victoria (if the traces of wings are assured) or, less likely, a personification. The relief is part of the enrichment of a funerary building and shows in its iconography and style a curious mixture of Hellenistic architectural (temple) decoration and Roman triumphal motifs.

Southwest of Trapezopolis, about ten miles in the direction of Alabanda, and about fifteen miles northeast of Aphrodisias, lay Attouda (modern Hisarköy). A marble slab, recorded in a house wall, came from a monument erected in the lifetime of Augustus, between A.D. 3 and 10. It was dedicated to the divine Livia, wife of the divine Augustus, by Tatius Aristonos or Aristonomos. At Heracleia Salbace to the southeast, on the border between Caria and Phrygia, there was a statue of Lucius

Caesar, the grandson of Augustus. Apollonia, on the road running due south and then west toward Tabae, had a cult of Nero even during the lifetime of Claudius. L. Robert photographed the base of the accompanying statue, to Nero (erased) Claudius Drusus Caesar Germanicus; the name of Artemidoros son of Artemidoros, priest of the cult, is also given. At Tabae itself there was a monument in honor of Tiberius as Augustus.

Acmonia lay in the center of western Phrygia, on the great highway from Philadelphia to Dorylaeum, the old royal road of the Achemenian empire. It was the focal point of a wealthy, populous district, and it had a copious coinage in imperial times. The town put up an altar to Tiberius Claudius Caesar Britannicus, one of the rare commemorations of that unfortunate prince in Anatolia. Much more impressive was the dynastic monument, perhaps a tomb complex with porticoes and other public structures, built by Julia Severa, continued by her son Servenius Cornutus, and completed by her granddaughter Servenia Cornuta. The complex was dedicated in at least two places to the emperor Nero, father of his country and of the cosmos, in the name of the Roman people. At Eumeneia, almost directly to the south and on the next major highway into the interior, there was a dedication to Germanicus by a group of local officials, very likely a souvenir of the year A.D. 18 when the prince was on his Eastern mission.

The Julio-Claudians are much more in evidence at Cibyra, the southernmost city of Phrygia, being in the section that points down to Lycia with Caria on one side and Pisidia on the other. Britannicus, son of Claudius, was mentioned in at least two inscriptions, one seemingly a statue base or the remains of a building dedication while the other comes from an altar. The theater has a long inscription recording worthy acts done in and around it by a local benefactor in the reigns of Tiberius, Caligula, and especially Claudius. About this time Q. Veranius, legatus of Claudius in Asia in the first few years of his reign, undertook public works at Cibyra in the emperor's name and was honored by the city folk. Northeast again, at the Sagalassian territory near the southwestern end of Lake Ascania, an inscription has been recorded commemorating a dedication by various Roman magistrates to Nero and his family.

Back to western Phrygia and to the Philadelphia-to-Dorylaeum highway, the two cities of Blaundus and Naus or Naïs are situated close to the Lydian border. The base of a statue of Tiberius has been discovered at the former city; Naus had a propylaea with a stoa dedicated to Nero (whose name was effaced) and the people of the city by one Macer; unfortunately, much of the inscription is missing. At Dionysopolis, which appears to have been located to the southeast about thirty miles from Blaundus, there stood a stele in honor of the emperor Augustus.

Phrygia's last major monument of the Augustan and Julio-Claudian

periods is one of the most interesting in Asia Minor. It was set up in the years A.D. 14 to 19 at the city of Apollonia-Sozopolis in southeastern Phrygia, on the borders of Pisidia and not far from Galatia. The monument was an altar or group of altars evidently with portrait statues on a large pedestal. The front of the pedestal was inscribed with a Greek copy of the *Res Gestae Divi Augusti,* the autobiography of the first emperor, and the statues were those of Augustus, Livia, Tiberius, Germanicus, and Drusus Junior. The presence of the deceased Augustus and Germanicus gives the range of date. Augustus stood in the center, with Tiberius and Germanicus on his right and Livia and Drusus on his left. This combination of a crucial imperial document displayed in easily readable form beneath imperial statues and with altars in front of the main pedestal formed the perfect Greek imperial documentary and artistic tribute to the Julio-Claudian house. Otherwise, at Apollonia there appears to have been a major cult of the imperial family. They were worshiped in a temenos, an inscription mentioning the shrine of Roma (antedating the imperial cult) and three equestrian statues. These were of Tiberius with the crown princes Germanicus and Drusus. There was also a statue of Claudius, with inscription in Latin, and yet another similar monument to Tiberius.

The first city well within Caria is Mylasa, inland and just to the south of where the Milesian peninsula becomes part of the mainland. Here the local senate made a dedication to Claudius "out of reverence" during the priesthood of Tiberius Claudius Meneitas, a man no doubt connected with the imperial family through freedman status. He may well have paid for the monument involved. Halicarnassus on the southern side of the next peninsula to the south has produced a dedication to Augustus, as savior of the world and mankind. Tentative evidence suggests that in Roman times the peribolus of the Mausoleum may have been adorned with figures of captive barbarians; a similar set of sculptures may have formed part of a monument, a set of trophies, at Myndus on the coast at the end of the peninsula. A head from one of these wore a Phrygian cap. In the wall between the central towers of the castle of St. Peter at Bodrum (Halicarnassus) there is an oblong architectural block adorned with a round shield, baldric, and sheathed sword or parazonium below. The shield bears a dedication to Claudius and the Delian Artemis from the people, presumably of Halicarnassus where Artemis was a favored divinity. Several similar blocks with shields in relief are scattered about the modern town of Bodrum, but they appear to have belonged to a private tomb. Each has a vine-wreathed skyphos below the shield.

So far as early imperial monuments in Caria are concerned the great center was Aphrodisias, just above the headwaters of the Marsynus River in the Maeander Valley. The great Ionic portal of Tiberius and

223

Livia has already been discussed in detail, in connection with imperial honors amid displays of sculptural virtuosity. The city benefited from an asylum decree of Mark Anthony, and Caligula renewed the privileges in another decree. A portrait of Claudius was erected jointly by the people and Menander, the priest of Claudius and Dionysos. Livia at this time was commemorated as the divine Julia, the new Demeter. Priests or priestesses of the following are mentioned: Augusti, the emperor Claudius, the god Titus, the god Nerva, and Livia (rather than Julia Domna) as just indicated. The temple of the Sebasti appears to have been outside the city.

The town of Termessus Minor is situated in Lycia, not far over the border from the Carian-Phrygian triangle around Cibyra and on the road running north and south through the heart of southern Phrygia and Lycia to the sea. Here an important inscription, published by Dessau and discussed again by Robert, throws light on the custom of displaying gold, silver, and gilded bronze images of the emperors in provincial cities. Those at Termessus Minor appear to have been carried in procession to and from the imperial temple on important state occasions, such as the accession of a new Augustus. The specific emperor mentioned is Valerian, in the third quarter of the third century. In connection with these ceremonials, the city had sebastophoroi, who were numbered among the ephebes as at Athens and Tanagra.

Tlos lay well inland, southeast of Telmessus and about twenty-five miles directly north of Xanthus. The city produced some federal coins in the period from 168 B.C. to the reign of Claudius, and there are imperial coins of the third century, notably of Gordian III. A statue of Augustus is the only imperial monument before A.D. 85, when P. Vaivius Italicus as Legate and Propraetor presided over an altar to Domitian. The statue of the first emperor was set up to "the founder and the savior of the people" in the name of the imperial Gerousia.

There are also federal coins for Sidyma, on the coast between Telmessus and Patara, but few if any imperial issues have been recorded. The same holds true for Apollonia, on the old road near the coast east of Antiphellus and northwest from Aperlae by a very few miles. From Sidyma there is the wonderful testimonium of a "local lad" who made good at the imperial court and who returned to his home town to honor the emperor under whom he had prospered. A large statue and a separate dedication to Claudius were set up and laid out by Tiberius Claudius Epagathus, the freedman, doctor, and *accensus* of Claudius, and by another Sidymanian of similar background, Tiberius Claudius Livianus. The dedicatory inscription was actually carved on the stoa which the two men likewise dedicated to "their benefactor." Apollonia has yielded a double statue base, to Augustus and to Tiberius, after the

adoption of the latter in the last decade of the first emperor's rule. Both inscriptions record the works as being from the people of Apollonia.

The principal Greco-Roman city on the south-to-southeastern coast of Lycia was Myra (modern Demre), in the center of a fertile plain with the principal road into Phrygia about ten miles to the east. Myra's contribution to Roman imperial sculpture in the form of the colossal head from a posthumous statue of Augustus has already been mentioned. Myra's seaport of Andriaca contains one of the best-preserved monuments of imperial efficiency in Asia Minor. It is a long rectangular building, complete save for its roof, which served as a combination granary and shipsheds. The façade has niches for busts of Trajan and Hadrian, and this indicates the date. Aside from this, there is epigraphic evidence that the building became or also served as a commercial cult center for the imperial family, the Julio-Claudians in particular. It may be that the structure was merely rebuilt by Hadrian, like Agrippa's Pantheon in Rome, or that the Julio-Claudian statue bases were brought there long after Hadrian's time for utilitarian purposes. It seems most likely, however, that the Demos of Myra (whose name is mentioned several times) collected a number of their imperial monuments on the spot, both at the granary and in a small temple nearby.

A double inscription or statue base from the Demos honored Augustus the savior and Agrippa the benefactor and savior of the "state of Myra." Livia received a statue, after A.D. 14, as Julia Augusta and mother of Tiberius. The second emperor was similarly honored. Other commemorations from Andriaca, not necessarily in the granary building, include a statue of Germanicus, son of Tiberius, as savior and benefactor, from the Demos of Myra. A pendant statue of Agrippina Senior can also be dated A.D. 17 to 18. A statue of Nero Claudius Drusus as patron and benefactor probably refers to Drusus the son of Tiberius rather than Drusus the son of Germanicus. Finally, the site of Myra itself has produced one or more dedications to the god Caesar Augustus, as savior of the world, and one of any to Augustus from the city or its port may well be connected with the overlifesized marble head now in the Antalya Museum (figure 107).

The other coastal cities of Lycia have proven rich in monuments to Hadrian, especially the series of dedications at Phaselis (modern Tekirova) on the occasion of his visit in 129 or 130, and the Flavians have left considerable traces. Hadrianic prosperity continued into the reigns of Antoninus Pius and Marcus Aurelius. There are, however, no more Augustan and Julio-Claudian monuments to record.

Most monuments of Roman imperium in Pisidia belong to the time of Hadrian or the Antonines, but several cities had statues and other evidences that they honored the Julio-Claudians. Going from north to

south on the secondary road from Phrygia to the Pamphylian coast, the first stop in this connection is Seleuceia Sidera midway between Lake Limnae and Lake Ascania. The city acquired the title Claudio-Seleuceia when Claudius reorganized the province of Lycia-Pamphylia in the year 43. The quasi-autonomous and imperial bronzes run from the reign of Hadrian to Claudius II. To the period of the renaming of the city must belong a statue base of Claudius, hailing him as the "manifest god."

Sagalassus, about twenty-five miles to the south of Seleuceia Sidera, was the major city of the region, having a copious imperial coinage stretching from Augustus to Claudius II. The coins of Seleuceia Sidera were evidently modeled on those of the larger city, where ruins of a large temple of Antoninus Pius and his official family still can be seen. Sagalassus had a dedication in Latin and Greek to Claudius, and another such inscription in Greek honored Nero as the "New Sun." In this choice of titles, it is worth speculating whether the locals had heard of the great statue of Nero as Helios placed in Rome near the later location of the Flavian amphitheater, the statue which gave the name "colosseum" to that building. The third Pisidian city to have early imperial monuments is Termessus Major, the Hellenistic mountain city about twenty-five miles northwest of Attaleia (Antalya). A statue of Augustus hailed him as savior and benefactor; it was set up in the name of the people of Termessus.

Lanckoroński recorded an important work of late Roman Republican or early imperial sculpture in the temple of Zeus Solymeus at Termessus. It was an altar or statue base, circular in shape, with a scene of sacrifice. The rite is typically Roman with victim, *victimarius*, and two flute players. Although certainly the work of a Hellenistic sculptor, the monument can be connected with the circular bases in Rome and vicinity which belong to the years 50 B.C. to A.D. 50 and which present comparable scenes in simple compositional groupings and strung-out profile.

Attaleia was a major port for Pamphylia. It has continued to the present day with name and topography little altered and is the center of archaeological activity from Xanthus to Anemurium in Cilicia. Works of art and inscriptions in its museums come from a number of different Lycian, Pisidian, and Pamphylian sites. Among the monuments from Antalya itself, there is record of a statue base to Claudius or Nero. In publishing the various inscriptions collected in the Antalya Archaeological Museum, G. E. Bean has spoken again of the common Anatolian imperial practice to provide by will for construction of a statue of the emperor. Under Claudius, in A.D. 50, the roads of Attaleia received the attention of the Procurator M. Arruntius Aquila (*vias refecit*), by whom a large bilingual milestone was set up.

Despite its extensive Hellenistic and Roman ruins, Perge has pro-

duced only two Julio-Claudian statue bases, one to Caligula and one to Claudius as *pater patriae*. A principal building, probably a gymnasium, was dedicated by C. Julius Cornutus with his wife and his freedmen to the emperor Claudius and perhaps also to Nero. The building bore the dedication both in Greek and Latin. At Side, on the coast to the southeast, there was also a building honoring one or the other of these emperors; a fragment of the inscription was found in the agora.

The very heart of Anatolia was occupied by the area and province of Galatia, and the center of Galatia was Ancyra. Here stood the temple of Augustus and Roma on which was inscribed the *Res Gestae* of the first emperor, in Latin and Greek. A dedicatory inscription stated that the federation of Galatia worshiped the deified Augustus and the goddess Roma. The names of Tiberius and Livia were also included. On the south pilaster the same inscription was repeated, substituting the people of Galatia for their federal organization.

Midway between Ancyra and the Cilician coast at Anemurium stands Iconium (Konya), a center for traffic moving east and west through Anatolia. This Lycaonian metropolis has given evidence of having had Julio-Claudian monuments. Besides a dedication to Augustus, an inscription in the walls of the Medieval castle states that the city's people honored Lucius Pupius (whose offices and titles followed), Proconsul of Claudius and Nero in Galatia, benefactor and restorer of the city. At Isaura Vetus, the center of Isauria south of Iconium, the imperial monuments all belong to the age of Hadrian or later, but the late Hellenistic gate to the acropolis is typical of monumental state decoration in the years before Roman art made its influence felt in this region. There are reliefs with weapons and military emblems: shields, swords, knotted daggers, parazonia, wreathed crowns, helmets, greaves and a Hellenistic-type cuirass. They were on the individual big blocks of masonry along the "dromos" or passage wall of the road to the top of the citadel. In choice of a general military symbolism, these reliefs are paralleled by those of the funerary structures and propylaea along the road leading to the mountain stronghold of Termessus Major in Pisidia (figure 1).

Cilicia covered coastal Anatolia from Pamphylia to Syria, and an important group of early imperial monuments has been recorded here. Olba, inland from Seleuceia on the Kalykadnos River, had a columned street with statues of the imperial family on consoles of this ensemble. The inscription for a statue of Tiberius has survived, honoring him as founder and savior of the city. At the great imperial port of Soli-Pompeiopolis, where most of the visible remains belong to the second or third centuries A.D., a statue base to Octavius Caesar from the Demos has been noted; a dedication to his grandson Lucius Caesar probably can be dated to the year 2 after Christ. At Tarsus, also a city with a long pre-Roman history, there was a statue of Augustus dedicated by

the Demos. The major imperial benefactor of this famous city was, strangely enough, Severus Alexander, who ruled over two centuries after the death of Augustus.

The Armenian campaign of Nero's famous general Corbulo has left its mark in the arts. At Ziata (Harput) in Armenia Major, three dedications, seemingly the bases of statues, with inscriptions to Nero in Latin (about A.D. 61) have been found. They are military in character, and the officer immediately responsible was Aurelius Fulvus, grandfather of the emperor Antoninus Pius.

Of the ages of imperial art in the East none was as important for portrait sculpture as the Augustan and Julio-Claudian. In the century from 30 B.C. to A.D. 70 the habit and rules of official commemoration in the arts were formed, the public works that produced statues, reliefs, and monumental epigraphy initiated. New colonies like Corinth or Pisidian Antioch vied with Hellenic cities like Athens or Ephesus in honoring Augustus, his family, and his successors. During the reign of Tiberius, one of Asia's great earthquakes led a group of cities to execute an extensive program of rebuilding under imperial auspices. Claudius lent his titles to a number of public works, and Nero's traces are more extensive than his bizarre personal life might indicate. His name was set on the architrave of the Parthenon in Athens and in dedications made in Armenia, far off on the Eastern frontier.

The Flavian Dynasty

THE PAUCITY OF likenesses of Vespasian, Titus, and Domitian from Greece and Asia Minor is more than compensated for by the quality of these portraits and their excellent state of preservation, whether heads, parts of statues, or the complete cuirassed Titus at Olympia. Considering that the Flavian imperial fortunes began in the East and considering the extensive coinages in Asia Minor and Syria in the years A.D. 69 to 85, it is not surprising to find these emperors represented by monumental marbles in Olympia, Athens, Pergamon, and Ephesus — the four areas particularly patronized by the imperial families from Augustus to the Antonines. It is not without reason that Domitian, the emperor who had the least physical contact with the Greek imperial world, is the Flavian most honored in these regions. Domitian's notions of Hellenistic epiphany led to greater material emphasis on the ruler cult than had been encouraged under his brother or father. The temple at Ephesus is the chief example of this.

EASTERN PORTRAITS

VESPASIAN

A colossal head in the Walters Art Gallery, Baltimore, is Vespasian (A.D. 69–79), and the cuttings of the neck indicate that it was fitted into a statue draped in the Greek manner. The head appeared in the sale of the Lambros Collection in Paris (1912), and the provenience was given as Pergamon (figure 129).[1] This seems to suit a head which is pendant to the likeness of Domitian found at Pergamon. Although also recalling the Domitian from Ephesus, he is more Roman in his crispness, without being as "Republican" as the Naples head.[2] His hair covers forehead and is idealized by straight combing on the sides. Vespasian was about as un-Greek a subject as a Hellenic portraitist could have been expected to represent.

A headless cuirassed statue found in the 1960 excavations of the theater at Salamis on Cyprus may add one more monument to the

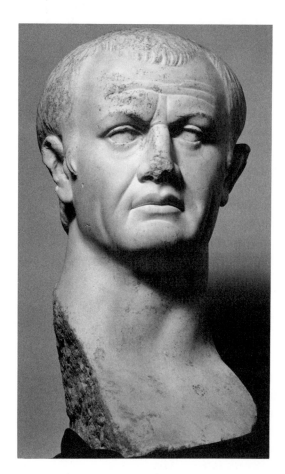

129. Vespasian,
from Pergamon

meager list of sculptures commemorating the Jewish campaigns of Vespasian and Titus. The statue seems to relate stylistically to the headless Flavian emperor, probably Vespasian, excavated in the basilica at Sabratha in Tripolitania. The monument may have honored Vespasian during his lifetime, or Titus Caesar as the general responsible for the victory at Jerusalem. The scene on the breastplate is unique in the repertory of imperial cuirassed statues: Caelus, reminiscent of the comparable figure on the Primaporta Augustus, presides over Virtus in her usual frontal pose. Virtus is flanked by two torch-bearing priestesses, who burn offerings to her in the same manner Pax often burns the spoils of war. Below, Tellus and Oceanus recline, holding up their cloaks as billowy symbols of the earthly and marine vapors. The statue probably came out of a workshop located on mainland Greece, at Athens, or at the Roman commercial center of Corinth. Another cuirassed statue from the theater at Salamis may have portrayed Trajan, at the end of his career or at the time of the Parthian wars. If this were true, the theater must have been a veritable shrine to the imperial ambitions of Rome on the mainland to the east.[3]

Egypt has produced one orthodox and very impressionistic Alexandrine portrait of Vespasian and possibly a curiosity in the Egyptian tradition. The marble and stucco head in Alexandria, from the Delta, is overlifesized and in every respect the Hellenistic Egyptian counterpart of the Vespasian in Baltimore, from Pergamon. The likeness belongs in the last five years of the emperor's reign and catches the imperial Roman profile, familiar from coins, in terms of Alexandrian-Hellenistic mobility, plasticity, and a latent touch of divine emotion. The top and back of the head were evidently finished in the more perishable media.[4]

In Cairo, the portrait depicting Vespasian as a sphinx is a clumsy likeness, for the Sabine farmer's broad face has been made too flabby, too rubberlike at the hands of a sculptor trying to emulate the verism of the Middle Kingdom. The identification, not absolutely certain, is based on or paralleled by portraits of Vespasian on tetradrachms of Alexandria. This head, which must once have had inlaid eyes, is another in the series of Romano-Egyptian imperial statues, monuments starting in the time of Augustus and culminating in several noteworthy portraits of Caracalla as a Pharaoh.[5] Vespasian visited Egypt at the outset of his reign, and the Roman imperial coinage testifies to his interest in the Greco-Egyptian cults and their temples in the Campus Martius in Rome.

TITUS

The cuirassed statue of Titus (A.D. 69–81) at Olympia stood in the cella of the metroon, next to the statue of Claudius as Zeus and probably faced by his daughter Julia. The metroon had been converted into a Julio-Claudian cult center, dominated by a heroic statue of Augustus. Titus wears a crown of oak leaves on his brow, and gazes sightlessly upward in a form of Hellenistic apotheosis. The statue is the principal example of a Flavian group of emperors or high officials in armor. Most others made in the same studio or from the same patterns come from Italy. One torso in Venice, however, appears to have the Peloponnesus as provenience. It is difficult to say whether the statue originated in a Greek or Roman workshop, although the latter seems more likely. As regards Flavian style, the artist is up-to-date. The figure has a restless plasticity in the high-relief Nereids of the breastplate and the details of the *pteryges*; the leather straps are particularly windblown.[6] Meager evidence from Dodona and Olympia indicates that bronze counterparts to the statues of this group existed in the Greek world.[7]

An excellent head of Titus in the Ashmolean Museum of Oxford is East Greek work, evidently brought to England from the islands or Asia Minor with the Arundel Marbles. The third Eastern likeness of Titus is a head recognized in a New York private collection, known to come from Egypt or Judaea, and now in the Museum of Archaeology at the

University of Missouri. The work is provincial, and the head with its indented beard and clumsy neck belonged to a statue set up while Titus was campaigning in the East, or shortly thereafter in honor of his victories (figure 130).[8]

DOMITIAN

The four portraits of the Flavian emperor (A.D. 81–96) whose memory was condemned include a head in the National Museum in Athens.[9] This likeness is close to the often-published head in the Museo Nazionale in Naples; the emperor has his hair arranged in the Neronian coiffure, and a large wreath in another material probably enframed the brow. It can be considered a work of the years A.D. 90 to 96.

The colossal marble head and arm in the Izmir Museum from the Flavian temple at Ephesus is one of the grandest ensembles in the East.[10] The portrait is youthfully inspired in the Hellenistic tradition of baroque optic effects. The sculptor must have been unaccustomed to carving on such a large scale, for he had difficulty matching a precise face and studied hair with massive neck muscles. After Domitian's death the temple was converted into a memorial for Vespasian, and the statue survived with very little alteration, no doubt because all the Flavians looked enough alike to make the substitution an easy matter for a Greek artist in a western Asiatic city. Indeed, the portrait is almost general enough in the Hellenistic idiom of distorted proportions and twisted muscles to pass for Vespasian, Titus, or Domitian merely by changing the dedicatory inscription on or in the building. Thus, it is a matter for speculation whether or not this colossal statue was first executed as a Domitian. It may have begun as a Vespasian or a Titus, been appropriated for the cult of Domitian, and then converted back into a likeness of the father after A.D. 96 (figure 131).

The head once in the Pergamon Museum but now lost belongs to the type put in circulation after A.D. 84; the provenience was not noted precisely, but it must come from the city or thereabouts.[11] Domitian's face is turned downward to its own right and, although carved in a dry and precise manner, has a pensive cast. The head may be a pendant to the Vespasian from Pergamon and now in Baltimore, for it is well over lifesized, being twenty inches in height. Finally, a heroic statue in the Cairo Museum (no. 42 891), despite damage to the face, may be a portrait of the imperial years. Here the emperor is clad only in a paludamentum or officer's cloak over one shoulder.

GENERAL CHARACTERISTICS

The artists of the Greek world took great comfort in the challenges of Flavian portraiture. The temper of the age demanded a more emotional, less academic art than that sponsored under the Julio-Claudians,

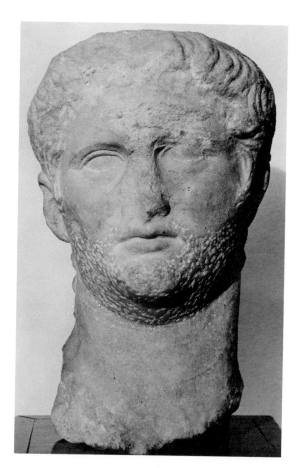

130. Young Titus,
 from Egypt

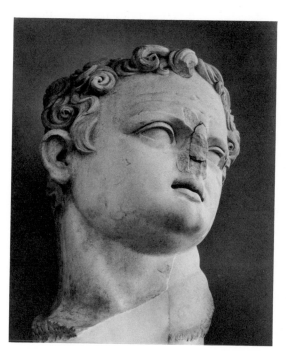

131. Domitian,
from Ephesus

and Pergamene dynamism offered the traditional Hellenistic formula for antithesis to Neo-Atticism or dry precision in portraiture. In addition, the Flavian rulers were a more earthy race than the inbred Julio-Claudians. Their broad, plump faces offered new dimensions of expansiveness combined with vigor. Within the Flavian period, Domitian's tastes for Hellenistic divinity — tastes which led to his downfall — provided a slight artistic respite to Flavian flesh and shadow.

Greek sculptors, more than their relatives or counterparts in Italy, rose to the challenges of fleshy surfaces, undercut curls, and slightly distorted faces. It was as if the divergent individuality of Hellenistic rulers had come alive again after the suppressing influence of Augustus and his uniformly ideal family. The colossal Flavian head from the family temple at Ephesus sums this up nicely. In cuirassed statues, the breastplates afforded ample opportunity to break away from the rather dull Julio-Claudian products, both in iconography and style. Allusions to the Jewish wars and the peace that followed never reached the level of the Primaporta Augustus, a document unique in political and allegorical commemoration; but Flavian cuirasses referring to the civil wars and the settlement in Judaea were a refreshing change from the endless griffins or Nikai flanking candelabra that characterized late Julio-Claudian ateliers producing cuirassed statues. The Titus at Olympia shows with what success a cuirass could be carved when the breastplate was bold and shadowed, the tabs imaginatively enriched, and the straps imbued with life.

As more Flavian imperial portraits are identified in the East, particularly in Asia Minor, regionalisms in the general Flavian style may emerge. There are now all too few identified portraits for the amount of activity that went on in these provinces and client kingdoms.

NERVA

A presumably posthumous statue of Nerva (A.D. 96–98) in himation was believed to have been located in the complex of the nymphaeum of the Emperor Trajan beside the main street at Ephesus. In 1957 the statue was reerected on a pedestal at the left side of the principal semicircle. It has since been determined, however, that the head, statue, and base do not belong together. The statue is that of an important Greek of the middle Hellenistic period, probably a man of letters. Imperial and other statues, copies of Hellenistic Aphrodites, water nymphs, satyrs, and the like were lined up on the structure's two middle terraces. The building was constructed by Trajan's successors to commemorate the savior of Asia in the Dacian and, particularly, the Parthian wars. Works of art were placed around to balance the twice-lifesized imperial statues. To the east of the nymphaeum is the Propylon of a larger building; the inscription on the architrave also honors Trajan, and the structure was put up in his age, in the years 114 to 116.[12]

234

FLAVIAN COMMEMORATIONS

The pattern of Flavian commemorations was centered in Lycia, Antioch, Caesareia (Palestine), and Commagene during the reign of Vespasian. Titus as emperor had little time to make his influence felt in the provinces. Domitian allowed the Hellenistic ruler cult to honor him with a temple at Ephesus and saw a city named in his honor in Asia Minor (Domitianopolis in Lydia), but his death by assassination and subsequent damnatio undid many of the commemorations marking his long reign. Nerva inherited Domitian's unfinished building schemes in the capital, and, if he has left any traces in Greece and Asia Minor, it is because monuments were rededicated to him during his brief reign. The Flavians had good cause to remember the East, for their rule began amid the acclaim of the armies here and the "settlement" of the Jewish question.

GREECE AND THE ISLANDS

At Salonika there was a gate with architectural decoration and reliefs, which may be attributed to the reign of Vespasian. The frieze consists of garlands and broad fillets, with rosettes under the cornice. On the socles, left and right, are reliefs of horsemen standing beside their horses, which are held by attendants. Traces of the inscription above the entablature give the letters vio and suggest FLAVIO. The Dioskouroi on the socles could therefore be equated with Vespasian and Titus, or Titus and Domitian. On the base a list (in Greek) of the officials putting up the arch includes the name of T. Flavius Sabinus, the brother of Vespasian.

Heracleia-Perinthus lay in Thrace, on the northern shore of the Propontis, about sixty miles along the road west from Byzantium to Aenus and Trajanopolis. A dedication to Domitian has been recorded there, for the years 88 to 90. The city of Thebes in Boeotia honored Domitian as Caesar with a statue, and near it stood a statue of Divus Titus, set up after his death. The next Grecian harvest of Flavian monuments is in Attica itself. There two dedications to Vespasian have been published, one as THEOS. Domitian appears once with his father and twice alone. In one of the latter he is hailed as Zeus Eleutherios. Nerva, on the other hand, has been recorded in five inscriptions as THEOS NERVAS, but this seeming popularity and deification in so short a reign stems from the fact that Trajan honored him as an official father and Hadrian as a grandfather. At Corinth there seems to have been an important building dedicated in the name of Vespasian in A.D. 78, memorial of his contribution toward reconstruction after a major earthquake. The frequency of earthquakes in the eastern Mediterranean world tried the generosity of the imperial purse on many occasions, the most notable being the catastrophe under Tiberius about A.D. 17 and the leveling of Smyrna late in the reign of

Marcus Aurelius. Each disaster afforded opportunities for the arts at the service of the one man who could underwrite rebuilding in several cities. The statues of Titus and Julia in the metroon at Olympia have been cited as evidences of Flavian continuity in a Julio-Claudian cult center. The sanctuary also had a plaque to Vespasian and another to Domitian. Such economical dedications were used not only because the Flavian Olympians were not rich but also because the Altis or sacred precinct was overcrowded with older monuments and there was little room for new statues until Herodes Atticus built his nymphaeum-exedra in the middle of the following century.

There are few Flavian monuments in the Aegean. Domitian, with the titles of imperator, Caesar, Augustus, and Germanicus, had a statue at Iulis on Ceos. Nerva was probably honored in the small sanctuary south of the temple at Kionia on Tenos. The whole complex was dedicated to Poseidon and Amphitrite. In Hadrian's time cuirassed statues of the emperor, of Trajan, of Nerva, of Aelius, and of Antoninus Pius, with the Lapith and centaur motif on the breastplates, were evidently commissioned and installed here. The five cuirassed torsos and an inscription to Trajan and Hadrian have been found; the cuirasses are Hadrianic revivals of Hellenistic design, with the reliefs being carried out in the Neo-Attic style. Delos had a statue of Titus as emperor, one of the few non-Julio-Claudian monuments recorded on the island, which declined greatly as a cult center in the second century A.D. Vespasian's image was added to those of Caligula and his parents on a long base in the theater at Thera. The town of Isthmus on the island of Cos received a statue of Vespasian in 74, and Eresus on the western shore of Lesbos also had a statue of the first Flavian. At Chios an imperial epistle from Domitian, dated A.D. 93, survived into modern times. Lyttus, a city in the southwestern corner of Crete, set up a statue of Domitia, wife of Domitian, in 84; the town was a cult center to the family of Trajan. At Brykos near the northern tip of Karpathos the local citizens and the citizens of Rhodes (who controlled the island) installed a statue of Domitian and another to his wife. On Rhodes, in Ialysos, a monument with a big base and a statue to Vespasian was dedicated by the city. Cyprus had several Flavian commemorations: a massive cylindrical bomos to Domitian at Old Paphos in the southwest; a statue of Domitian in the temple; and two dedications in his name. The Polis of Citium in the southeast set up a statue of Nerva in the year 96 or 97.

ASIA MINOR

Outside of Flavian Anatolia, a dedication to Vespasian is encountered at Phanagoria on the northeast shore of the Black Sea. A statue was commissioned by Tiberius Julius Rhescuporis in the years A.D. 77 to 79, for he was king from 77 to 92 and Vespasian died in 79.

The inscriptions indicating new gates at Nicaea in Bithynia about the year 71 have been mentioned. Nicomedia, to the north, had a shrine and sanctuary to Vespasian, constructed in 70 to 71 through the initiative of the procurator M. Plancius Varus. There is some evidence that Cius at the southeastern edge of the Propontis had a cult of Domitian. At Cyzicus in Mysia, according to a scholion on Aristeides, Vespasian was responsible for an imperial hall, presumably a stoa paid for and dedicated in the name of the emperor. Domitian had a statue here, dedicated by the archons of 84. As Caesar he had received a statue in the first year of his father's reign at Mysian Apollonia, from the Archon Damostratos Olympa. In A.D. 75 Elaea, at the junction of two major roads near the coast southwest of Pergamon, had a milestone to Vespasian. It is strange that Pergamon has produced no traces of the Flavians other than the large head of Vespasian in Baltimore and its pendant in the museum on the site. The family did try to continue the Julio-Claudian connection with Ilium in the Troad. A list of donors who contributed toward the construction of a temple of the Gens Flavia survives, as does a triple statue base to Vespasian and his sons, with Domitian's name badly mutilated.

At Caesareia Trocetta in Lydia Keil and von Premerstein discovered a fragment of an inscription from a building, probably a stoa, dedicated to divinities and (bilingual) to . . . [VESPA]SIANO A[VGVSTO . . ./ Οὐεσπασι[ανῶ] Σε[βαστῶ]. . . . The same site has yielded a stele with handsome moldings, dated A.D. 86, which mentions Domitian (with damnatio) as COS XII with Servius Cornelius Dolabella Petronianus. Its form suggests a grave monument, but it is rare to have an emperor and his fellow consul named in this connection. There were no other details save the architectural moldings below the pediment. Vespasian is mentioned once, Titus once, and Domitian not at all in the harvest of inscriptions from Sardes. Nerva enjoys the brief credit of a bilingual milestone dated A.D. 97 at Thyateira in northern Lydia; the stone was used five years earlier for the same purpose under Domitian. The road construction in this region under Vespasian in 75 is reflected in a bilingual milestone, and a dedication to Domitian has been recorded at Julia Gordus, about twenty-five miles east of Thyateira.

Tenuous evidence — a fragment of a pilaster relief in Berlin — indicates Flavian decorative work at Smyrna. A head of Domitian or Nerva appears in an acanthus scroll; the terms of treatment are directly reminiscent of work identified with Aphrodisias. Otherwise the Flavians are found in two more milestones from Vespasian's activity in 75, both along the road southeast to Ephesus. A bronze statue of Domitian was set up in a grove close to the little river Meles at Smyrna, for Apollonios addressed considerable venom to the image. Perhaps two dedications from Smyrna belong with a statue or statues such as this: one to Titus

in 80, the other to Domitian in 83. Teos, the coastal terminus of the road southwest from Smyrna, displayed a statue of Titus as son of Divus Vespasianus.

Details of Domitian's Ephesian temple have been given already, in connection with the cult statue forming its focal point and the altar with a scene of sacrifice and various weapons in relief. The nymphaeum of Domitian stood in the square with his temple. It was erected between A.D. 4 and 14 in honor of Sextilius Pollio, who built the aqueduct over the Dervendere, and enlarged by Domitian's lieutenants. The sculptures on the upper rim of the apsidal water-basin, scenes of Greeks and Amazons, may belong to his reign. In the north hall of the North Market at Miletus stood a Hellenistic circular base reused by the family of G. Julius Antiochus for an altar to Domitian. There also may have been a statue in connection with the dedication.

In the upper gymnasium at Priene, a courtyard shrine appears to have been dedicated to Domitian, for the base of a statue set up to him was found there. The last monument of the period was at Tralles (modern Aydın) in the Lydian part of the Maeander Valley. It is a dedication to Nerva from one Onesimus who seems to have risen high in the imperial service and to have adorned Tralles with a temple, bath, gymnasium, and statues of his patron and himself. The inscription depends partly on restoration:

IMPERATORI NERVAE CAESARI
AVGVSTO PATRI PATRIAE
ONESIMVS — AVGVSTI LIBERTVS PROCVRATOR
LAPICAEDINARVM CELLAM
CALIDARIAM GYMNASII IN
VSVM TRALLIANORVM
EXORNATAM AD [IECTIS SIMVLACRIS] DVOBVS DEDICAVIT.

Titus (or Antoninus Pius) was commemorated in a large building, perhaps a stoa, with monumental inscription in Greek on the architrave at Dorylaeum in Phrygia. A similar structure, dedicated with certainty to Titus as emperor, existed at Pessinus in Galatia.

Laodiceia ad Lycum in southwest Phrygia was an extensive city, much enriched under the Flavians. Its ruins were visited, drawn, and described by early travelers. The Greek inscription on the moldings of the stadium ran: "To the Emperor Titus Caesar Augustus Vespasian(us), Seven Times Consul, Son of the Deified Emperor Vespasian; and to the People. Nicostratus the Younger, Son of Lycias, Son of Nicostratus, Dedicated . . . at his own expense; Nicostratus . . . his heir having completed what remained of the work, and Marcus Ulpius Traianus the Proconsul having consecrated it." The date is late in the year 79. Another inscription, a pedestal by another ruin, shows that the family actually contracted the stadium, turning it into an amphitheater for Roman gladi-

atorial shows. Marcus Ulpius Traianus was the emperor's father and an enlightened governor of Asia under Titus and Domitian.

On the southeast side of the city hill ten limestone blocks, with triglyphs and moldings, from the top of a three-arched gateway, were visible until recent years. The inscription in the first line is a dedication in Latin to Domitian by a Proconsul, perhaps Sextus Julius Frontinus (A.D. 88–90). This and Domitian's name in the next two lines, in Greek, have suffered a damnatio. The two lines of Greek continue Domitian's titles and tell how the arches are identified with the gates and towers of Tiberius' rebuildings after the earthquakes of A.D. 17 to 19. The site has also yielded a statue base dedicated in A.D. 79 to Titus, son of Divus Vespasianus, by Nicostratus Theogenes, evidently first cousin to the Nicostratus who rebuilt the stadium. Nicostratus, the son of Lycias, also put up a votive to Titus in 79.

At Apameia, near the headwaters of the Maeander and a major road junction of south-central Phrygia, a statue of Vespasian was set up between the years 65 and 69. Acmonia (Ahat) in western Phrygia, the Roman province of Asia, had a monumental gateway which probably served the agora. The inscription was bilingual and mentioned Divis Caesaribus Vespasiano et Tito | Imperatori Caesari Domitiano Augusto Germanico. The responsible person was M. Clodius Postumus, perhaps an Acmonian citizen, probably a Roman official, and quite likely the son or grandson of the man of the same name who governed Thebaid under Augustus. Another imperial building has been documented, but the inscription is too fragmentary for further identification. Sebaste, about twenty miles south of Acmonia on the back road to Eumeneia and Apameia, had a dedication to Domitian from the Roman traders in the city; the monument was commissioned in 88 or 89 and suffered damnatio eight years later.

Less than ten miles west of Acmonia, on the main road from Laodiceia ad Lycum north or on the great highway from Smyrna to Dorylaeum, lay Keramon or Geramon Agora. Two imperial inscriptions recorded there concern the Flavians: one, although mutilated, appears to honor Vespasian; the other is a dedication to Titus and Domitian Caesars. In a modern village not far to the south (on the west side of Banaz-Ova), Ramsay found an altar or similar monument to Domitian, among other imperial inscriptions. Naus, to the southwest and on the great highway about ten miles northeast of Blaundus, had a dedication to Domitian in the name of Lucius Minucius Rufus. At Dionysopolis southwest of Eumeneia a pedimented stele of about A.D. 90 bears the name of Domitia Augusta, wife of Domitian. This form of monument has been encountered at Caesareia Trocetta in Lydia in connection with Domitian. Stectorium, halfway between Eumeneia and Metropolis going eastward, had a statue base to Nerva in 97, its inscription written in bad Latin.

Aphrodisias in Caria had priests for the cults of Divus Titus and Divus Nerva which suggests the existence of shrines and statues. The other monument of Flavian Caria was a large decree stele or a commemorative aedicula at Thera, northwest of Idyma and southwest of modern Muğla. The inscription is to the Emperor Vespasian from the Theran federation.

Balbura in northern Lycia received a long dedication to Vespasian, Titus, and Domitian in A.D. 84 or 85. The presence of the two *divi* in the inscription may have saved Domitian's name from damnatio, although his monuments were never as systematically attacked and mutilated as were those of Geta after 212. At Cadyanda, in southwestern Lycia, Vespasian was honored in the inscription of and may have been partly responsible for the baths and a large Doric temple. A statue was evidently set up on this occasion. Tlos, where Augustus was honored, also received (A.D. 85) an altar to Domitian, through P. Vaivius Italicus who was Legate and Propraetor. The Boule and Demos of Pinara dedicated a double statue base to Julia, daughter of Divus Titus, and to Domitia, wife of the Augustus Domitian; a date of 81 to 91 can be determined by the year of Julia's death.

To the side of the modern road and athwart the ancient highway from Patara northwest into the city of Xanthus stands a triumphal arch or gate with an inscription of the time of Vespasian. What remains states only that "the People, through Sextus Marcius Priscus, his legate, who superintended the work." A portion of the "frieze" of this gate was brought by Charles Fellows to the British Museum and consists of triglyphs and metopes with a bust of Apollo and a bust of Artemis, both with quivers over their shoulders. Apollo once had a metal laurel wreath, and Artemis wore a diadem. This enrichment, elaborate busts of divinities looking out from architectural enframement, was the Flavian forerunner of the coffering in the skene building of the theater at Side and of other such examples of architectural richness in the wave of prosperity that swept Antonine Lycia, Pamphylia, and Pisidia. That the emperor whose name is missing in the gate's inscription was Vespasian is confirmed by a statue base which once stood nearby, "The Emperor Caesar Vespasianus, Augustus, the protector and benefactor of the world, the Council and the People of the Xanthians honor him through Sextus Marcius Priscus, his Legate and Propraetor."

The baths at Patara on the southern Lycian coast below Xanthus were built by the same legate of the emperor, Sextus Marcius Priscus, with funds from the Lycian Federation and from the city of Patara, according to the building inscription set over the door into the second chamber. Limyra in southeastern Lycia had a stoa built and dedicated to Domitian, thanks evidently to his handling of the city's finances. Between Patara and Limyra, on the coastal road, lay Aperlae, which

had Flavian baths and a portico close to the sea. The inscription stated that the building, which has only one period of construction, was completed in honor of Titus Vespasianus, son of Divus Vespasianus, and to honor certain legates (including Titus Aurelius Quietus, Consul Suffectus in 82 and Legatus-Propraetor, and one local, not to mention an erased name) by the senate and people of the city and the people of their republic who "constructed this bath and entrance portico from foundation to top." At Myra to the east there was a statue of Titus and a similar monument to one of his legates. Phaselis on the eastern shore near the Pamphylian border had a statue of Vespasian (after A.D. 73) and one of Domitian (93–94); the latter suffered damnatio.

The kale (fortifications) of Antalya, Attaleia in Pamphylia, has yielded a statue base to Vespasian, from the Gerousia of the city. The Gerousia or Board of Elders, the Council of the Citizens, and the People of Attaleia were very active in providing imperial statues, the first occasionally setting up sculptured testimonials simultaneously with the latter two. Sir William Ramsay has pointed out in connections like this that it was common practice to provide by will for construction of a statue of the emperor. Lyrboton Kome (near Bazar-Ghediyi Örenlik or Barsak village) in the hinterlands behind the Attaleia-Side coast was visited before the First World War by H. A. Ormerod and E. S. G. Robinson. They studied a small tower containing inscriptions. It was built in the reign of Domitian by a local family, who added further testimonies to their activity and a dedication in the reign of Hadrian. A series of complex family relationships may be reconstructed, in addition to the epigraphic mention of right of asylum in the temple of Artemis Pergensis. At Side local citizens seem to have been responsible for a monument to Vespasian in the year 71. It consisted of a pedimented niche for a statue, with an inscription on the architrave, flanked by two pedimented projections or wings supported by Corinthian columns, in which statues of donors, one in a himation, evidently stood. The ensemble was on a podium and two-stepped stylobate. The monument was apparently moved to its present location near the theater, and in Late Antiquity (the fourth century A.D.) it was incorporated into a massive wall. Vespasian may have been shown in armor, but his statue has not been identified.

The Roman colony of Cremna in Pisidia, a city that struck Latin coins throughout its imperial history, has been little disturbed over the centuries, save by earthquakes. It is not surprising, therefore, to find several imperial building-inscriptions recorded from the site (Girme). The earliest of these appears to be an epistyle to Nerva. Among the imperial inscriptions in the region of Galatian Ancyra, a dedication to Titus has been recovered at Sivri-Hissar, between Germa Colonia and Palia Iustinianopolis, southwest of Gordion on the Galatia-Phrygia border. There is no indication from which of these cities it may have

come. At Caesareia by Anazarbus in northeast Cilicia (Anavarza), the aqueduct was of the time of Domitian, according to an inscription. Finally, it is recorded that Vespasian contributed to the restoration and enlargement of the harbor at Seleuceia on the Kalykadnos, just inland opposite Cyprus on the principal stretch of the imperial Cilician coast. A dedication to Vespasian and Titus in the year 77–78 was set up in connection with a new or renovated bridge across the river Kalykadnos.

One Flavian dedication, a large one, really falls outside the limits of imperial Asia Minor. It was set up by Mithradates in A.D. 75 at Harmozicae in Armenia Major and included Vespasian, Titus, and Domitian.

Like the Julio-Claudians, the Flavians left their mark in Greece and Asia Minor. There were dynastic statues, as at Olympia or Pergamon, and dynastic temples, as at Ephesus. There were numerous public monuments, either gates such as the enriched structure at Salonika, or commemorative constructions such as the pedimented building for statues at Side. Baths, city entrances, imperial halls, and stadiums bore the names of Vespasian, Titus, or Domitian. Where all other forms of honors might have been lacking, as at Caesareia Trocetta in Lydia or Dionysopolis in Phrygia, a stele was erected bearing the names and titles of Flavians or their female connections. Imperial officials and local magistrates were responsible for these activities, and the sudden death of Domitian did not produce a widespread mutilation of his monuments. Under Vespasian and his sons a final consolidation of provinces in Asia Minor took place, and the transition from Hellenistic kingdoms to imperial polities, provinces, and cities, was brought near completion.

Trajan and Hadrian

THE AGE OF Trajan (A.D. 98–117) is always cited as the period of Rome's greatest physical extent. In Greece and Asia Minor, Trajan's rule saw a continuation of public works instituted under the Flavians, although more had been done in the reigns of Vespasian, Titus, and Domitian and exciting improvements would take place with the advent of the Philhellene traveler Hadrian. Trajan's military affairs kept him close to Asia Minor during the last five years of his career, but imperial finances were funneled toward necessities of the army rather than civic improvements.

TRAJAN AND HIS WORKS

Despite Trajan's influence there, portraits of the greatest of the military emperors are found in the East perhaps less frequently than those of his successors, because he frequently refused to allow himself to be honored by the erection of statues (Pliny, *Epis. ad Traianum*, 9). A number of statues of Trajan, the majority of those recorded in the East, belong to the reign of Hadrian, who was careful to secure his own position by commemorating his "father." Thus, the only other inscribed imperial statue base among the half-dozen surviving Hadrians in the Athenian Olympeion bears the name and titles of Trajan. At Perge, a statue of Divus Traianus was included in the imperial family group of the monumental gateway. Iotape in Cilicia had a small temple to Trajan, the altar of which was found *in situ*, and at Selinus in the same province Trajan appears as the seated cult figure on coins of Septimius and Alexander Severus. This is appropriate, for Trajan died here, and the city was renamed Traianopolis, a name also given to the Greek city of Doriscus near Aenus in Thrace.

The Egyptian-style reliefs of Trajan at Philae, Dendera, and Esneh are valid expressions of Trajanic art, but they have no place in an appraisal of the Greek imperial heritage. Like the statues of Caracalla in the guise of an Egyptian Pharaoh, they are more curiosities of the

243

survival of Egyptian art than documents of Roman state commemoration in the East. They do fall in line with the imperial policy of assimilation with the gods and religions of subject peoples, but it is doubtful that it was politically necessary for Trajan or any other emperor to appear under the guise of Rameses II in an age that was nearly a century and a half after the death of Julius Caesar and the battle of Actium.[1]

There are several interesting portraits of Trajan from the Greek world. The heroic statue of the emperor as divine ruler of the world that has lain in pieces for nearly two generations in the apotheke of the Castro on Samos is one. Another is the head of the cult statue from the Trajaneum at Pergamon, a large-scale representation of Trajan as Zeus which had as its mate in the cella of the temple a cuirassed statue of Hadrian. Last of all, the aged Trajan in bronze from the Bouleuterion at Ankara in Galatia, a wreathed bust in civic garb set in an *imago clypeata*, indicates that local artists could create masterful portraits that did not depend on prototypes sent out from Rome, Athens, or Ephesus (figure 132).

THE EMPRESS PLOTINA

The date of the monumental gateway and court of Plancia Magna at Perge depends on the fact that Trajan was elevated to the ranks of the gods while his wife or widow (died A.D. 121 or 122) was still Plotina Augusta on the bases of the statues set up beyond the arch. Although she no doubt existed in the nymphaeum of Herodes Atticus at Olympia, her surviving sculptured likenesses come from Crete and Cyme in Aeolis. Plotina was also much honored by Hadrian, for she was supposed to have had a major hand in his "adoption" by Trajan.[2]

Of the three portraits of Plotina identified so far, one of the two heads from Crete is colossal in scale and very idealized, suggesting that Trajan's wife or widow was represented as a goddess, perhaps as a draped Aphrodite. The other head from Crete is an average work, a competent copy of a Roman model that faces the beholder with a look of coldness and possibly dullness (figure 133). Certainly there is nothing in the Roman histories to indicate that before and after Trajan's death Plotina was anything but a calculating character who knew her way through imperial politics and palace intrigue. The head from Cyme in Aeolis, which apparently belonged to its draped statue, is a good version of a portrait circulated in Rome and then shipped in some form or other to the coast of Asia Minor.

FURTHER TRAJANIC COMMEMORATIONS

GREECE AND THE ISLANDS

There are surprisingly few Trajanic commemorations and no really important testimonia in the art of Greece and the islands. Heracleia-Perinthus on the Thracian shore of the Propontis dedicated a statue,

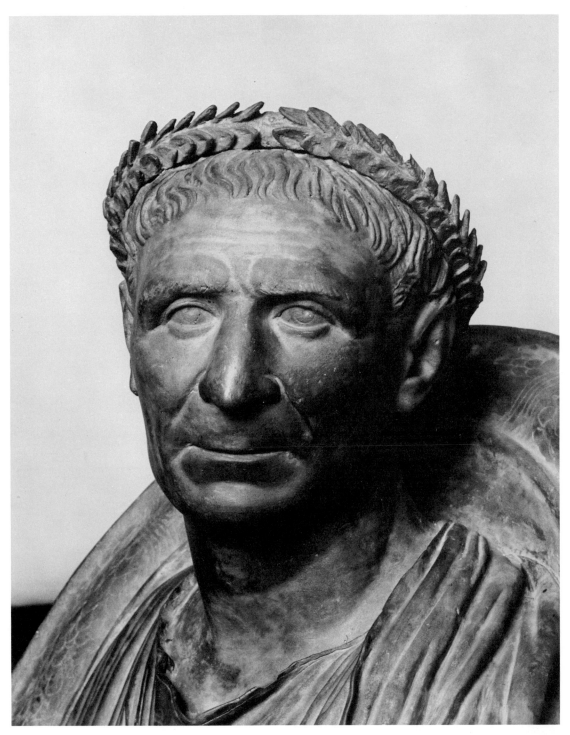

132. Trajan, Ankara

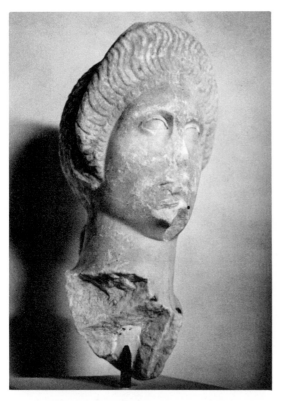

133. Plotina, Heraklion

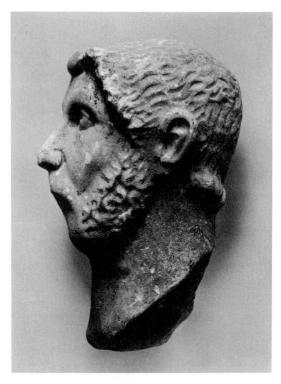

134. Hadrian, Corinth

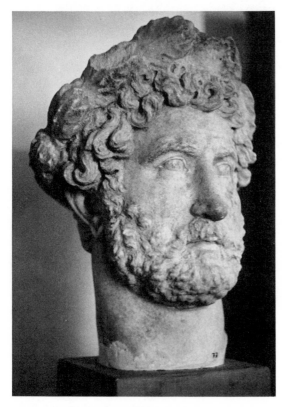

135. Hadrian, from Dictynnaion

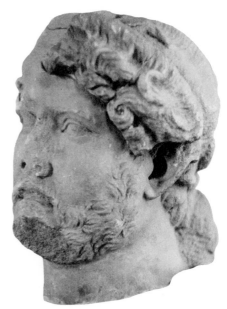

136. Hadrian,
from Dictynnaion

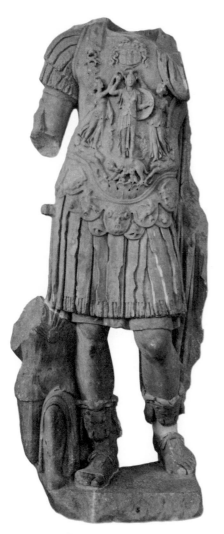

137. Hadrian, from Gortyna

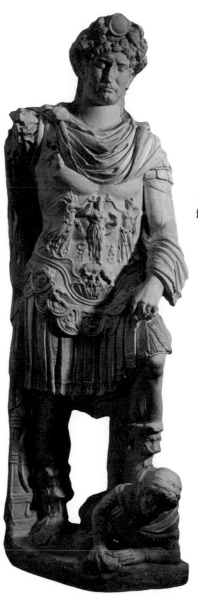

138. Hadrian,
from Hierapytna

139. Hadrian, at Thasos

140. Hadrian, at Perge

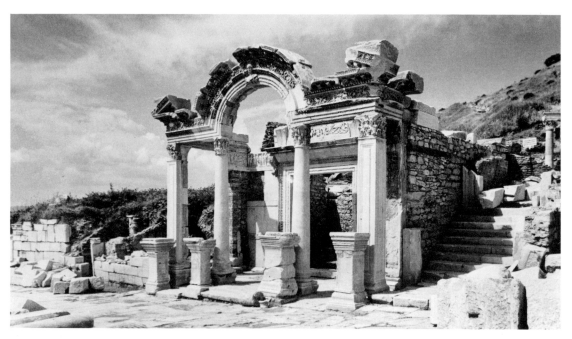

141. Temple of Hadrian, at Ephesus

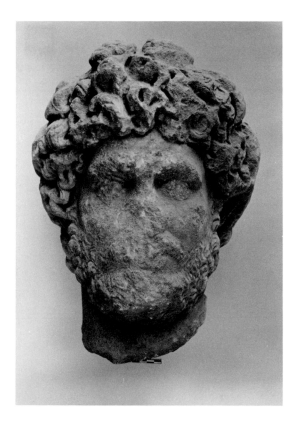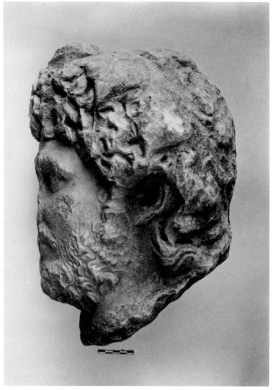

142. Aelius Caesar, Corinth

from the Boule and Demos, to Trajan's niece Matidia. The emperor appears to have been named in an inscription at Philippopolis in Thrace. Lebadeia (modern Livadia) in Boeotia dedicated a statue to Trajan between A.D. 98 and 102. He was honored at least once on the Acropolis in Athens, and Attica as a whole can boast over fifteen epigraphic testimonia to the Optimus Princeps. Thanks to the generosity of a private individual, Trajan's title appears by formulaic courtesy in the dedication of a library built on the edge of the Greek agora during his reign. The inscription of the Library of Pantainos reports in a manner worthy of the great private undertakings in Anatolia in the second century of the Roman Empire: "To Athena Polias and to the Emperor and to the city of the Athenians, the priest of the Muses who love wisdom T. Flavius Pantainos, son of Flavius Menander, head of the school, dedicated (the whole complex) from his own resources along with his children Flavius Menander and Flavia Secundilla." Besides the statue transported to the exedra of Herodes Atticus, Olympia could boast a plaque to Trajan among the other such imperial dedications in the Altis.

Inscriptions at Kionia on Tenos, together with the evidence of the group of cuirassed torsos discovered in this sanctuary of Poseidon, suggest that Nerva and Trajan were among those honored. Cyriac of Ancona reported a statue base to Trajan (dated after 103) on Mykonos. This presumably came from Delos and was the work of one Titus Flavius Demetrius. A similarly dated statue base was found on the latter island by the French excavators. At Mytilene on Lesbos there was an altar to Trajan; otherwise, the island has yielded only one indication of comparable sculpture, a statue base at Eresus. Chios has been somewhat more productive, with a dedication to Trajan as "savior of the universe" and a statue base from the Gerousia. A dedication to Hera and Trajan turned up at Chora on Samos; it was evidently placed in a shrine of Asklepios and Hygeia by Quintus Nerius Carpus and his wife Fausta.

Crete, Rhodes, and Cyprus present a picture of more activity, something brought out in the surviving sculpture at Heraklion and in the museum at Cos, although Samos still holds the prize throughout Greece for the little-publicized heroic statue at Tigani. From west to east on Crete, a statue of Trajan was set up at the beginning of his reign in the city of Kantanos, southeast of Polyrhenium. Chersonesus on the coast east of Knossos dedicated an altar to the emperor in or after 102. The great Trajanic cult center on Crete was the city of Lyttus where there were seven altars and four statues to the emperor. The altars cover most years from 105 to 113, and the statues were dedicated in 106, 112, 113, and 114. There were three statues of Plotina (112, 113, and 114), two of Diva Marciana (112), and three of Matidia (107, 112, and 113 or 114). The activity must have continued under Hadrian, for he received statues in three successive years from 123, and his sister Paulina was

thus honored in 125. The people of Karpathos and their Rhodian connections dedicated a statue of Trajan as savior and benefactor at Potidaeum on the former island, and a statue of Plotina stood on the acropolis at Rhodian Lindos. At least three Trajanic monuments have been identified on Cyprus. At Carpasia near the northeast tip an emperor, possibly Trajan, erected a gymnasium or similar public building. A statue or dedication to the Optimus Princeps was set up at the temple of Apollo Hylatis, and Cypriote Salamis gave him a statue in the second year of his reign. They also managed to set up another dedication, probably an altar.

ASIA MINOR

Evidence for Trajanic monuments and the works of art they produced in Anatolia begins with a dedication to Trajan during the years 102 to 116 at Nicaea in Bithynia. Another dedication, for the years 102 to 110, has been recorded at a place called Gueul-Bazar, southeast of Nicaea; the region as a whole was rich in ancient sites. Cius, on the Propontis west of Nicaea, had a similar monument to the emperor, donated by a group of six local citizens. The city was to progress to even greater imperial glory, for a cult of Hadrian with an appropriate statue was ordered about the time of his famous Bithynian visit of 124. Trajan's own statue was evidently set up at Cyzicus in Mysia by Bittius Proculus, proconsul of Asia in 115 to 116, for the base was recorded at nearby Aidindjik.

The Trajaneum at Pergamon formed the focus of that emperor's cult in Asia Minor. To house the new divus, a great building rose on the summit of the city's acropolis. All the Roman world rendered commemorations, as one inscription has put it, IN HONOREM TEMPLI IOVIS AMICALIS ET [IMP. CAES. DIVI NERVAE FIL. NER] VAE TRAIANI AUGUSTI GERMANICI DACICI. There were two statues of Trajan in or near the temple of Athena, both works belonging to the years 114 to 116, when the Parthian war at one point seemed settled, only to flare up anew. Early in the emperor's reign a dedication was set up in the temple of Asklepios, and the inscription from a major statue of Trajan was found between the theater and the Trajaneum. In the temple itself there were also letters from Trajan and Hadrian, and similar records were installed in permanent form in the gymnasium.

At Magnesia on Hermos, not far distant in Lydia, a statue base of Trajan has been reused in the Tschessingir-Djami; Quintus Julius Manelleinos was responsible for the monument. Further up the river, at Sardes, the great harvest of imperial inscriptions has included over twenty of Augustus, six of Septimius Severus, and three of Caracalla, but not a single example for Trajan, who insured the peace of Asia Minor by his Mesopotamian ventures. Trajan's statue, however, stood at

Julia Gordus in northern Lydia, and construction was carried out in the emperor's name in the eastern part of the region, at Uludjak near Kula.

Between 102 and 112 the proconsul L. Baebius Tullus repaired the aqueduct finished by Trajan's father at Smyrna in A.D. 79–80; several copies of the dedicatory inscription have been found. The Roman agora of Smyrna had a shrine with a statue of Trajan; a fragment of sima molding from the aedicula gives a date late in the year 114 and indicates a monument connected with the Parthian wars. The nymphaeum and gateway put up at Ephesus in memory of Trajan have been mentioned in connection with the commemoration of Divus Nerva. A twice-lifesized statue of Trajan was placed over the water-channel of the nymphaeum; a portion of the partly nude figure and the inscribed plinth survive. The names of those responsible are given. Coming a generation after the temple and rebuilt fountain building of Domitian, these buildings completed the second stage of imperial transformations at Ephesus. The next phase was to be carried out by private wealth late in the reign of Hadrian and during the rule of Antoninus Pius. The first phase had been brought to completion in the reigns of Augustus and Tiberius, especially the former.

The people of Notium, on the coast northwest of Ephesus, put up a statue of Trajan; and Teira, south of the Cayster River on the secondary road from Ephesus to Philadelphia, counted a dedication to the emperor. Teira was to receive dedications to Hadrian the Olympian and Marcus Aurelius at later dates in the city's history. At Miletus a statue base of the Optimus Princeps was found in the late city wall near the Bouleuterion; the statue was set in its original location after 102. Four bases of the same date, in the names of Roman and local officials, were discovered in the vicinity of the South Market. A dedication to Trajan was set up in the year 100, in connection with the replanning of the city. Although rebuilt and probably heightened in 241 to 244 under Gordian III, the Great Nymphaeum at Miletus was originally a memorial to Trajan's father, Proconsul of Asia in 79 to 80; it was built and equipped with statues of father and son in the latter's reign by the local men of wealth. The Latin inscription on the architrave also mentioned Vespasian and Titus as having been elevated to the ranks of the gods.

The Asiatic hinterland's testimonials to Trajan are often incoherently scattered. Votives to the emperor as Augustus have turned up at Colossae near the slope of Mt. Kadmos in southwest Phrygia. Ilyas had the emperor's statue, with full titles, the offering of one Flavia Tatia. Heracleia Salbace in the same general area has produced a monument to Trajan, probably on the occasion of his passage to the Parthian wars in autumn of 113. The statue involved was erected by the emperor's physician, T. Statilius Criton, as a bequest. Heracleia also seems to have boasted a temple with porticoes or a stoa, dedicated to the Fortune of Trajan and

of Hadrian. Trajan was listed in the Greek inscription as a divus. A Trajanic cult group existed at Apameia in south-central Phrygia. Statue bases have been found to Marciana, Trajan's sister, and her daughter Matidia. The first monument was set up before 115 and the second between 107 and 117; if dedicated together the range of time would have been from 107 to 115. A rare mention is made of Trajan's wife Plotina in these circumstances; at some time after 108 a monument to her was dedicated by the city's bursar, Marcus Attalus, in the name of the council and people. Bennisoa, just northeast of Appia, had a dedication in Trajan's name, in the altar-shrine of the local divinity, Zeus Bennius.

At Apollonia in eastern Phrygia or western Galatia, a city rich in imperial associations, a statue base to Trajan has been recorded. It was bequeathed to the people by a testator whose name is lost. At Sebastopolis, over the southwestern border of Phrygia in Caria, the local worthy P. Statius Hermas chose the last two years of Trajan's reign to set up a statue of Nike and possibly a statue of the emperor (a group?) on the occasion of the Parthian victory. The commemorative inscription survives. The monument must have resembled those statues of Nikai standing on arms and armor which were reused in Late Antiquity in one of the main gates at Side.

In Lycia several Trajanic monuments have been recorded. The Boule and the people of Pinara dedicated an imperial statue after 102, and at Sidyma to the south the same combination honored Diva Plotina, who died in 122. Letoon, between Xanthus and Pydna, received a statue of Trajan in 102, from the city and from the combined cities of the Lycians. The Hadrianic granary and shipsheds at Andriaca, seaport for Myra, have been discussed in relation to the former's role as a sort of shrine to the Julio-Claudians. The façade of the building had niches for busts of Trajan and Hadrian, and a commemorative inscription in Latin.[3] Pisidian Termessus (Major) contained Trajan's statue, as well as one of Hadrian, and the Boule of Sagalassus joined with the people in a similar monument.

Iotape's temple of Trajan, already noted, included not only the altar found at the entrance to the cella but also mention of a statue, cult or otherwise, in the inscription. The date was 115 to 117, probably at the time of the emperor's death. Diocaesareia, likewise in Cilicia, possessed a monumental gateway or similar structure with dedication to Trajan by the city; a crucial section of the inscribed architrave survives, walled-up on the south side of the city. In the parts of the province to the east, Tarsus and Mopsuestia on the Mesopotamian highway both set up statues of the emperor, the latter city as early as the year 99. Cappadocian Cocusos, a center for milestones because of its location at the juncture of great highways to Armenia and Mesopotamia, had an imperial dedi-

cation for the years 105 to 106. The gateway and forecourt at Perge in Pamphylia included Trajan's family because they were Hadrian's official forebears. Their statues increase Trajan's statistics, but they reflect the commemorative impulses of his successor's rule.

All this adds up to too little in the way of artistic representation in Greece and Asia Minor for an emperor whose name in Italy is synonymous with a great phase of imperial art. So often Trajan's monuments are inevitably part of the honors paid to Trajan after his death, when the Greek world fell in step with Hadrian's carefully cultivated program of emphasizing the continuity from Trajan's reign to his own.

HADRIAN

WORKS (figures 134–141)

The first major group of sculptured commemorations of this much-traveled, much-honored emperor (A.D. 117–138) is the set of cuirassed statues of the Athenian agora-Olympia type. Fourteen examples — in Greece, Crete (figure 137), Syria, and North Africa — were given in the 1959 catalogue of surviving cuirassed statues of all types produced between 200 B.C. and A.D. 500. The list of Hadrians continues to grow, with additions being made at Prusias ad Hypium (probably erected in 126), Attaleia, and Cyrene. Four of the best statues, including the masterpiece with head preserved and left foot resting on the back of a barbarian youth (Hierapytna), come from Crete (figure 138). The usual breastplate shows Athena standing on the Lupa Romana and being crowned by Victoriae; the statue at Knossos substitutes Roma or Virtus, giving the scene a no less imperial and only slightly more Roman flavor.[4] Fairly late in Hadrian's reign a cuirassed statue with plain breastplate of Greek fourth-century type was set up in an apsidal room of a portico in the agora of Thasos. The work is crisp, dry, and very businesslike in its Hellenic way (figure 139).

Hadrian must have enjoyed being commemorated by the Greeks as much as some emperors disliked having statues of themselves installed in public places.* No Greek or Asiatic site is without its bases for statues of the great philhellene. The Olympeion in Athens teemed with material commemorations paid for by the cities of the Greek world; a half-dozen of their bases are still visible on the site. The Diet of Achaia resolved to set up a statue to Hadrian in each of its towns, of which the base of that

* Altars and statue bases to Hadrian in Greece and Asia Minor are collected in exhaustive detail in an admirable article by A. S. Benjamin: "The Altars of Hadrian in Athens and Hadrian's Panhellenic Program," *Hesperia* 32 (1963) 57–86. Her maps can be used to compare the proveniences of surviving statues, heads, and cuirassed bodies with the concentrations of inscriptions. Hadrian is both the easiest and most elusive emperor for such an experiment because he occurs nearly everywhere in some form.

commissioned for Abea in Messenia has been preserved. Since imperial authorization for such erections was required from the start,[5] Hadrian must have been well aware of what was taking place.

Publius Vedius Antoninus was responsible for building the temple of Hadrian at Ephesus, a structure with a triumphal-gate front recalling Hadrian's Gate at Athens (figure 141). Ephesus also possessed a free-standing gate similar to that at Athens. Vedius' temple was probably put up after Hadrian's death, but, at Pergamon, Flavia Melitine's statue of Hadrian in the heroic nude has been identified with his visit of A.D. 123, although the pedestal is inscribed ΘΕΟΝ ΑΔΡΙΑΝΟΝ. Hadrian appeared in Diomedes pose, with parazonium in the crook of his left arm, cuirass on treetrunk as support beside his leg, and cloak on the left shoulder. It would seem strange indeed if this statue were set up under an imperial authorization issued in advance; the statue stood in the central niche of the east wall of the library in the Asklepeion, a library noted for its collection of classical authors.

The complex, temple and monumental gateway, at Ephesus had its counterpart in the heart of Bithynium-Claudiopolis (modern Bolu), where part of an architrave block was found. Sabina as well as Antinous, Bithynia's native son, were probably also honored here. A foliate frieze between honeysuckle moldings ran above the area of the inscription. A statue base to Hadrian, dedicated by the Phyle Apollonis in 134, may be connected with this structure.

Other structures of Hadrianic type became focal points for commemoration of the emperor and his family. The two-tiered triple gateway similar to the gates at Athens, Eleusis, Ephesus, and elsewhere still stands at Adalia or Attaleia in Pamphylia. It also had engaged columns and a simple entablature, with vine-scroll frieze above. The major dedication to Hadrian has been identified from early descriptions and from surviving bronze letters. Other related dedications found in the area include the base of a statue of Hadrian, the base of a statue of Paulina (Hadrian's sister) offered by Julia Sancta, and a basis to Antoninus Pius. Julia Sancta also built a tower nearby, and another tower was probably dedicated either to Antoninus Pius or Titus.

The city gate, court, and colonnade at Perge, a remarkable series of statues and architectural surroundings paid for by Plancia Magna, belong in the first five years of Hadrianus Augustus. His statue appeared with those of his wife, Trajan's family, Divus Nerva, the Genius Civitatis, and Diana Pergensis (figure 140). The statues of Plancia and her family were set with the patron divinities and legendary founders of the city.

Since statues to Hadrian existed nearly everywhere, the architectural monuments in his honor or memory perhaps form a better index of Greek enthusiasm on behalf of the emperor cult in the generations of

Pax Romana. The following give a further general sampling. The small sanctuary south of the temple at the shrine of Poseidon and Amphitrite on Tenos (at Kionia) was probably dedicated to Antoninus Pius and his official forebears. Four cuirassed torsos in Parian marble with the Lapith and Centaur motif on the breastplate were found here; another, now lost, was noted in the eighteenth century. An inscription discovered to the east of the temple mentions Trajan and Hadrian; this accords well with the date of the statues, which probably represented Nerva, Trajan, Hadrian, Aelius, and Antoninus Pius.[6]

At Nicaea (Iznik) in Bithynia new city gates or triumphal portals were built under the Flavians. The east gate was restored by Hadrian, who also added markets, piazzas, and walls, as at Nicomedia. Here he was honored in an inscription put up by the Demos. The west gate, on the road to Constantinople, was likewise put in order at this time and received an inscription to Hadrian. These gateways were rich in statues and reliefs, of which a few traces survive from later times. In 269 the north and south gates were rebuilt, and their inscription is recorded by Sir Charles Fellows: "The very splendid and large and good city of the Nicaeans [erects] this wall for the autocrat Caesar, Marcus Aurelius Claudius, the pious, the fortunate, august of Tribunitial authority, second time Proconsul, Father of his Country, and for the Sacred Senate and the People of the Romans, in the time of the illustrious Velleius Macrinus, formerly Consul, Legate, and Lieutenant of the august Caesar Antoninus, the splendid orator." The city had been sacked by the Goths the previous year.[7]

In 123 the city of Cyzicus suffered a severe earthquake. Hadrian appeared on the scene the following year and initiated public works projects by way of relief. His chief contribution was akin to that embodied in the temple of the Olympian Zeus at Athens: he undertook to complete a great temple, the largest in the Greco-Roman world. This project was not brought to conclusion until the year after Hadrian's death. The Byzantine chronicler John Malalas wrote that "Hadrian . . . set up for himself the marble stele of a great bust, right there in the roof of the temple," and Bernard Ashmole has noted the comparison with the tondo portrait of Marcus Aurelius in the pediment of the Great Propylaea at Eleusis. Gorgon motifs on the capitals and elsewhere indicated that the building was finished as a Hadrianeum, with Hadrian assimilated to Jupiter. The frieze, in keeping with these notions, seems to have shown the Olympians in various actions.[8] Finally, F. W. Hasluck has pointed out that the interior of the temple may have had niches between the columns for statues of the Twelve Olympians.[9] Hadrian would have then been portrayed as the thirteenth member of the ruling council of heaven, and nine dedications to Hadrian have been found in the region of Cyzicus in which he is hailed as "Olympian, Founder of the Colony."

The central feature of the sanctuary at Claros was the hexastyle Doric temple of Apollo with its oracle or prophet's well under the cella. The building, with such singularly un-Ionic architecture designed to recall Delphi, was begun in the third century B.C. and finished by Hadrian. The colossal cult statue of Apollo, mainly of marble, was flanked by similar statues of Artemis and Leto. Hadrian's interest in this Panhellenic shrine was nobly recorded in an inscription on the architrave of the temple. The titles indicate that the dedication does not antedate December 135 and therefore belongs to the final period of his rule. In the second century the shrine was frequented by delegations from cities in the nearby islands (principally Chios), Ionia, Pontus, Phrygia, Pisidia, and elsewhere in the provinces toured with such diligence by Hadrian. Thus, the temple of Apollo at Claros joins the Athenian Olympeion as an example of Hadrian's interest in gaining popularity for the imperial cult in the Greek world by finishing a centuries-old monument of the Olympian religion. The building also joins the Parthenon, the temple of Nemesis at Rhamnous, and other classic structures in which the imperial name or dedication was introduced by way of an inscription on the architrave.

There was also a sanctuary of Hadrian at Thyateira in Lydia, and a small altar of the years 128 to 138 hails Hadrian as one of the Olympians. Among the ruins of the large theater at Laodiceia in Southwest Phrygia is a block dedicated to Aelius Caesar (136–137) and Hadrian; the latter visited this city in 129, as a votive to the emperor and Sabina recalls. At Heracleia (Vakif) not far distant, an inscribed entablature block from a stoa or temple to the Fortune of Divus Traianus and Hadrian has survived. A monument had been erected to Trajan, probably on the occasion of his passage to the Parthian wars in the autumn of 113, and a statue of Hadrian the Olympian was set up in 129. Recent excavations have revealed that the inscription on the colonnade around the temple of Aphrodite at Carian Aphrodisias mentions Hadrian.

In the province of Pisidia, the city of Termessus had a propylaion with dedication to Hadrian on the architrave; it was a modest, unpretentious little building. A certain Longus erected a basilica, forum, and exedra in the Roman colony of Cremna, dedicating them to the emperor Hadrian and to the colony of Cremna. One copy of the Latin inscription ran in two lines along the outer face of a forum wall, and the second apparently occupied the architrave of the forum colonnades.

At Isaura in the Roman province of Isauria or Cilicia, a number of imperial triumphal arches lined or spanned the principal street on the acropolis. They appear to have been plain, solid structures with only elaborate imperial titles and simple moldings as decoration. The oldest survivor is dedicated to Hadrian; it had a barrel vaulted arch and inscription on the architrave. Slender evidence, mostly stylistic, suggests

257

that there may have been a Hadrianeum at Seleuceia on the Kalykadnos (Selefke). The frieze blocks of the Corinthian temple show flying Victoriae supporting heavy garlands surmounted by rosettes; these Victoriae wear Antonine topknots, and their schematic style recalls Victoriae on Antonine coins. An early Antonine date for the temple seems most likely. The torso of a statue of an emperor as Diomedes, found nearby, may be Hadrian, and the cuirassed statue transported to the Adana Museum could be that of Antoninus Pius set up when the temple was dedicated.[10]

PORTRAITS

Aside from the cuirassed statues produced in Athens for export in the East, portraits of Hadrian have been found in nearly every area of the Empire.[11] Some of the isolated heads rediscovered in museum stores may well belong to these cuirassed statues; two are connected with Crete, where such statues were almost plentiful. The examples from the Athenian Olympeion and at Eleusis, as well as Louvre no. MA 3131 from Crete, show the increased popularity of the draped, heroic, or cuirassed bust as a form of commemoration serving as an alternative to a complete statue in a temple or shrine. In addition to the statues already mentioned, the most interesting is the complete cuirassed statue found in 1913 in the Dictynnaion on Crete and mostly destroyed in a fire within the next generation; the cuirass can be dated to the reign of Antoninus Pius, and the statue was without doubt a posthumous dedication (figures 135, 136).

The "splendid" bust from the Olympeion poses an iconographic question. Is it Hadrian or is it a person of importance whom the portraitist endowed with a strong suggestion of the imperial features, a form of flattery common in Roman portraiture of the Empire? Most critics agree that, if this long-faced man with very curly hair and large eyes is Hadrian, the bust was carved in the Antonine period. The portrait is probably as late as the reign of Marcus Aurelius or the early years of Commodus. It may be Hadrian, and, if so, it is one of the few posthumous portraits which really breaks with the traditions of representation disseminated in his own lifetime. It gives him something of the dreamy, slightly sensuous look which Commodus inherited from Marcus Aurelius.[12]

Despite doubts expressed by Wegner and others, the bronze statue in Istanbul from Kadirli in the Vilayet of Adana (Inv. no. 5311) is certainly an Anatolian portrait of Hadrian. It is work of the highest quality and of great individuality, conforming neither to a common western Asiatic Hellenistic pattern nor to standards set for export in the workshops of Rome. Hadrian stands in an ample himation and long chiton, his hands gesturing as if he were making a public oration, the right lowered and extended and the left held against the major folds of the

himation. The fingers of the right hand were once wrapped around a rotulus. A double wreath of laurel with a ruler's medallion in the center crowns the brow.

The face is stern and forceful, almost too much so for Hadrian. This is part of the brooding but not barbaric style of the Anatolian Greek artist. The ample, rolled locks have become curls and are more tightly controlled than in most surviving marbles. This, coupled with the overwhelming force of the eyes and knitted brow, led scholars to question the identification. The tondo portrait of Trajan from Ankara and the face of Antoninus Pius from Adyamian show how far from the Roman norm a good Anatolian imperial portrait could depart. The artist was thinking of some late Hellenistic ruler of Cappadocia or Cilicia when he conceived his image. His training led directly back to the bronze "philosopher" of the Antikythera wreck, a veristic work of the third century B.C. However, he had studied portraits of Hadrian enough to make an unmistakable likeness. The work should be dated between 120 and 130, when Hadrian was touring the innermost cities of Greece and Asia Minor.

New discoveries in Hadrianic portraiture are made almost every year. The colossal head and fragment of the breastplate of a cuirassed statue found along the ancient waterfront of the Piraeus may have been part of a monument set up there or may have been waiting for export when beset by some calamity; incrustation indicates that it spent some time in the sea. The cuirassed Hadrian from the agora at Thasos proves that all such statues of the emperor did not conform to the Greek or western Asiatic export models (figure 139). At Perge in Pamphylia a standard cuirassed Hadrian, a statue similar to the Nero from Tralles in arrangement of griffins on the breastplate, was placed in a niche of the remodeled Hellenistic and Roman gateway between A.D. 117 and 122 (figure 140). A statue of Sabina as Demeter stood nearby. The colossal head of Hadrian that turned up in a Lucerne sale in 1959 is tantalizing because it obviously came from Asia Minor, the islands, or Syria in recent years. It may have belonged to a statue set up after the emperor's death, perhaps one that showed him in the heroic, half-draped guise of a divinity.

The problem of portraits of Hadrian created many years after his death arises in the East. A head in Beirut from Antioch may be a commemorative sculpture of the third century A.D., and a battered but crudely forceful head from Corinth seems to represent Hadrian seen through the eyes of an artist of the Constantinian period or later (figure 134). The large number of heads and statues of Hadrian yielded by Crete alone suggests what extensive excavation will produce in the undug metropolises and lesser cities of Asia Minor.

HADRIAN AND GREEK IMPERIAL ART

The attitude of Hadrian and the works of his reign mark a high point in the imperial culture of Greece and Asia Minor. Aside from the imperial travels, the Panhellenism, and the general prosperity, a generation that opened with Parthian and Jewish wars and closed with the final destruction of Solomon's Temple in Jerusalem was bound to leave extensive traces in the Eastern provinces. Study of specific monuments shows that Hadrian was surrounded by philanthropists ever ready to ornament Greek cities in his name and theirs. The emperor's concern with the Bithynian youth Antinous was one of the chief factors leading to imperial and private commissions in art and architecture in many cities of Greece and Asia Minor.

The doctrine that the emperor himself molded the architectural and artistic forces of his reign is now thoroughly accepted. Attic neoclassicism has been recognized as having considerable influence and stimulus in Hadrianic sculpture and painting. Hadrian's intervention in the arts is directly manifest in the planning of many sections of the villa at Tivoli and in the dome of the Pantheon. To a major extent the art and architecture of the Greek East was brought to the Latin West under his patronage. Hadrian's tastes not only stimulated the Atticism of reliefs and sarcophagi, and particularly academic copies of famous Greek statues, but these tastes resulted in the introduction to the Latin West of a more varied repertory of Greek imperial art.

These developments represented no sudden reversal of a previous policy. The Hellenistic city of Damascus in Syria had given Rome the architect Apollodorus to plan the Forum of Trajan, the bridge over the Danube, and other vast undertakings. Apollodorus, however, was a conservative, trained in Roman or Romano-Hellenistic ways. He was famous because he could do on a grander scale and more boldly for Trajan what other architects had done for the Flavians. Apollodorus' fall was the culmination of disagreements with Hadrian over a number of years. The ultimate rift grew out of his conservative reaction to Hadrian's radical ideas in dome and cella construction.[13]

Hadrian not only found architects to carry out his ideas, he also developed schools of architectural decorators to carve and mold in his particular Greek imperial style throughout the Empire. For example, a school of sculptors of pilaster capitals and moldings on typically Hadrianic gates and façades was employed on the arch of Hadrian in Athens. The same guild (if such be the term) worked at Eleusis and Olympia, and by about A.D. 125 was engaged in carving decorative details for the architecture of the Tiburtine Villa Hadriana.[14] Hadrian surely started the vogue for Roman versions of the Erechtheum South Porch in the Latin West. The famous Caryatids occurred as a façade alongside the

canal of the "Canopus" at Tivoli; they adorned the Roman theater at
Vaison; and Herodes Atticus followed his mentor in patronage by using
the Erechtheum maidens as a porch of the tomb of his wife Regilla on
the Via Appia Pignatelli (the Chapel of S. Urbano).[15]

An artistic and political development of Hadrian's reign was antici-
pated in the first century A.D. When Tiberius aided the Asiatic cities
stricken in the earthquake of A.D. 17, the cities expressed their gratitude
by setting up statues of themselves (the personifications of their regions)
around a statue of Tiberius seated, in the Forum of Caesar. The ensemble
must have perished in the fire of A.D. 80. At least there is an echo of
the personifications in the base from Puteoli, and the statue of Tiberius
(seated in a toga, holding a scepter, and extending a patera toward an
altar) appears on sestertii struck at the Rome mint in commemoration of
the restoration of the cities.[16] The examples under Hadrian confirm how
typically Greek imperial was the notion of surrounding the ruler with
a forest of statues, or of setting up a number of statues of one ruler in
one spot. The commemoration of Tiberius' generosity to the cities of
Asia was the first evidence of this type of ensemble in Rome.

Hadrian tolerated such multiple dedications at a number of sites in
the Greek world. The most obvious place is at the Olympeion in Athens,
where numerous Greek cities honored the emperor in his lifetime or
after his death with statues of himself and perhaps of themselves. The
same phenomenon is encountered on a smaller scale in the Athenian
Theater of Dionysos. About A.D. 240 a group of cities paid tribute to a
private citizen of Dorylaeum in Phrygia in the same fashion — with a
group of bronze statues of the man in question or, less likely, of them-
selves personified.

Centuries of plundering rather than systematic excavation has meant
that all too little is known about how the statues were set out in Hadrian's
Villa at Tivoli. There were groves and exedrae, as well as the niches of
the domed structures and porticoes, devoted to different types of sculp-
ture. Gavin Hamilton's sketchy description of his finds in the Pantanello
marsh indicate that the nearby grove commemorated Romans of the late
Republic or early Empire whom Hadrian admired, as well as Zeus and
Antinous. Caesar, Cicero, and Augustus were among these.[17] In the
best fashion of a Greco-Roman museum, the exedra of the Canopus was
devoted to copies of statues by great artists of the generation after 450
B.C. Pheidias was represented by the Mattei Amazon, and Polykleitos
was commemorated in the Amazon of the Lansdowne type. Alkamenes
and Kresilas may have been the sculptors of two other statues in the
group, a helmeted warrior resembling Ares and a Hermes.[18]

There is evidence that the Greek imperial theme of the ruler sur-
rounded by geographical personifications were represented in an area at
Villa Hadriana. To begin, there is the well-known statue of a province,

most likely Cappadocia, now in the Ince Blundell collection at Liverpool.[19] And in the Casino Fede, the storehouse of the recent finds, part of the torso of a personification in the Amazon chiton of Virtus or Roma, among the uncatalogued fragments,[20] suggests a typically Greek imperial hemicycle or colonnade in which statues of the provinces visited during the imperial travels were placed. Coins give an idea how imaginative just such a layout could be. In keeping with the taste for sculpture in these forms of architectural settings, the great temple built by Antoninus Pius to Divus Hadrianus, the Roman Hadrianeum, had statues of provinces represented in relief on the podium.

In the Greek East Hadrian's patronage hastened, though unconsciously, the policy of artistic uniformity which was to culminate in the Romanization of sculptured relief and coin types under Diocletian, the period when the last Greek imperial mint was converted to the production of Diocletian's reformed Latin currency. The statues of Antinous were the beginning of the end of Greek creativity in the classical and Hellenistic (as opposed to the Late Antique) sense. This means not classicism of design, which was perpetuated from the fourth century A.D. into the Middle Ages, but a combination of the timeless ideal with monumental scale. These statues represent one of the last displays of technical virtuosity in the restrained sense in Greek art. Within their ideal they are very imaginative. It took some thought on a planner's part to dream up all the divine attributes with which Antinous was displayed.[21]

More characteristic of the Greek imperial ideal than the various essays in Pheidian and Praxitelean classicism embodied in the statues of Antinous were the group of cuirassed statues centering around the Hadrian from Hierapytna and the class of cuirassed busts represented best by the Hadrian in Copenhagen and a headless example (Hadrian) at Eleusis. The fact that the cuirassed busts occur all over the ancient world is no doubt due to the enterprise of one or two Athenian and Roman workshops copying imperial archetypes. The shoulder straps enriched with snake-legged giants indicate the neo-Atticism of the design. This design continues at least to Marcus Aurelius, where it occurs on a grand scale in the imperial *imago clypeata* of the Greater Propylaea at Eleusis (figure 12).[22]

Only imperial impetus, however, could have spread the cuirassed statues with Athena or Roma-Virtus on the breastplate so widely throughout Greece, Asia Minor, Crete, Syria, and North Africa. The theme of Athena or Roma-Virtus flanked by Victoriae with wreaths and standing on the Lupa Romana is the very epilogue of Hadrian's Hellenistic imperialism.[23] The barbarians at the legs of several statues in the group vary enough to indicate references to the several disturbances and the multinational triumph ushering in Hadrian's reign (figure 137).

TRAJAN AND HADRIAN

The proveniences of the statues bespeak enterprise on a level above casual city dedications to the imperial family. Two statues are on the Athenian Acropolis, one lying between the Parthenon and the Propylaea; another was found at Olympia. But the most peculiar location is provided by the example set up near the Palace of Minos at Knossos; this is one of the two Roma-Virtus types, the other being the fragment at Prusias ad Hypium (Üskübü) in Bithynia, where the base of a statue of Hadrian is preserved with it. At least two North African cities — one Greek (Cyrene) and one not (Haïdra, in Tunisia) — have yielded examples. And the cuirassed Hadrian found in the middle of the Athenian agora may well be one of the statues mentioned by Pausanias on his trip through the area. In conclusion, the Eastern end of the Mediterranean is represented by the torso now in the Beirut Museum.

THE EMPRESS SABINA

Hadrian's wife (died A.D. 135) was honored in Italy, and she must be the person of whom only the lower half remains, standing in high relief, next to Faustina I on Slab O from the altar at Ephesus. An overlifesized head of Sabina in the National Museum at Athens (no. 449), dated before A.D. 130, combines breadth, force, and sympathy in one portrait. The eyes are treated with great delicacy, irises slightly engraved and pupils hollowed. She wears her hair wrapped around her crown, in the series of coiled braids seen on her coins. The drilling of the hair is sublimated to broad strokes in the outer curls, and there was polish on the surfaces of the face. The neck has an Aphroditelike turn, so that Sabina looks and leans slightly to her right.

At Perge, Sabina appeared as the type of the Demeter from Herculaneum in a statue set up near a cuirassed Hadrian in the forecourt of the ceremonial gate to the city.

AELIUS CAESAR

An almost colossal head in the Athenian agora has been identified, from its relation to portraits of Lucius Verus, as the survivor of a statue perhaps set up in 162 or 163 when Aelius' son Lucius visited Athens.[24] It is a powerful statement of the Antonine baroque carved in the best Hellenistic tradition of ample hair and carefully combed beard worked out with fine precision. The portrait has an immediacy stemming from the fact that the eyes convey intent and directness, and have not become large and dreamy. This is a very Greek portrait, representing the finest of Attic craftsmanship.

Aelius Caesar (died A.D. 137) also is to be seen in a head in the Corinth Museum, which came not from the American School excavations in and around the ancient city, but was a chance find brought in from the nearby village of Solomos in 1938 (figure 142). This battered head is

263

crowned with a Dionysiac wreath of vine leaves. Comparison with the large head of Aelius in the Athenian agora, and with heads of Hadrian like that of the statue from Hierapytna (figure 138) or that in the Louvre (no. 1187), indicates that this is a portrait of Aelius Caesar.[25] It is a local replica of a Roman prototype and lacks the force of the head in Athens; the drilling of the hair suggests that it might date in the reigns of Antoninus Pius or Marcus Aurelius and, therefore, might have belonged to a group of statues representing members of the house of Hadrian, as they appear on the Antonine altar at Ephesus or in the exedra at Olympia. From its resemblance to portraits of Hadrian, it is evident that the prototype for the head at Corinth was created in the last months of his reign, when Aelius was adopted by Hadrian and designated Caesar only to die shortly before the emperor. In this copy Aelius may have been represented deified as Neos Dionysos, a title frequently bestowed on Lucius Verus or Commodus in Asia Minor.

The reigns of Trajan and Hadrian were not the highest points of material activity in Greece and Asia Minor. The latter period may have been surpassed by public works undertaken in the name of Hadrian's successor Antoninus Pius. Under Trajan and early in Hadrian's rule, parts of the East suffered a setback of sorts in the amount of destruction wrought in the Jewish and other disturbances that were an aftermath of the Parthian wars.

Hadrian is everywhere in quantity, and a certain number of Trajanic commemorations owe their existence to Hadrian's adoption by Trajan's inner circle. The great temple and the related statues at Pergamon are prime examples. As works of art the statues of Trajan and Hadrian are capable but not spectacular commodities. Sculptors under Hadrian did produce the splendid series of cuirassed statues that occur all over the Greek world, and his ministers at Ephesus may have planned the Great Antonine Altar. The portraits of Flavians are more interesting, certainly for their rarity but also for their restless qualities as creations in marble. Portraits of Antoninus Pius and Marcus Aurelius demonstrate greater variety, ranging from the sober tradition of Greek philosophers to the dramatic illusionism embodied in the term Antonine baroque.

Hadrian made a massive artistic contribution to the Greek world, one that lasted through the reign of Caracalla, in increasing the number and variety of imperial monuments and commemorations in each municipality. With his visits to Greece and Asia Minor imperial art touched every city however small and however remote. Hadrian's name is associated with major architectural additions to Athens, but only the gate in front of the shrine of the Olympian Zeus can be attributed completely to his rule. The aqueduct or reservoir, for example, was finished by Antoninus Pius, and the contributions of Herodes Atticus also fall mainly in the

Antonine age. Olympia, Cyzicus, and Ephesus are among other cities where monuments associated with Hadrian were actually built or at least completed under the Antonines. In terms of statues and dedications, however, Hadrian far outdistances his rivals among the Antonine and Severan emperors.

XIII

Antonine Art

THE ARCHITECTURAL CONNECTIONS of Antoninus Pius and his suc-
cessors with the Greek imperial world were more epigraphic than in
previous periods of prosperity. The rush to honor the imperial family by
construction of public buildings in which names and titles of emperors
and donors were emblazoned across the façades was especially marked
in the decades between A.D. 140 and 190. Certain structures, such as
the reservoir in Athens, were carried out under imperial supervision and
were, therefore, gifts of the imperium to the region rather than local
benefactions. Although Antoninus Pius stayed close to home, he bene-
fited greatly by being successor to the widely traveled, divine Hadrian.
Hadrian initiated a number of works which he did not live to complete
and for which his successor was given partial credit. The Athenian
reservoir falls within this category; the temple at Cyzicus must have
been the grandest example; and perhaps the great altar at Ephesus was
carried out in this fashion.

If Antoninus Pius did little by physical presence to encourage build-
ing in his own name in the East, the general prosperity of the period
has given him the greatest number of public structures. His successors
Marcus Aurelius and Lucius Verus were present for wars and an insur-
rection in the East, and his daughter Faustina died there. Several struc-
tures are connected with the imperial progress in 162 and 163 to the
Parthian wars, and others can be linked with Marcus' tragic mission in
175. Nature took a hand, for at this time it was necessary to rebuild
the earthquake-ravaged city of Smyrna. Marcus contributed heavily
toward this undertaking, and, naturally, his deified wife was honored
in the architecture of the agora there.

Commodus, like his grandfather, turned his back on Greece and
Asia so far as travels were concerned, but the East honored him as son
of one conqueror and brother-in-law of another. There was a slight hiatus
in building activity, but this may have been partly due to the fact that
so much had gone on in the previous decades rather than to any external

disturbances. Although murdered and cast in the role of a second Nero, Commodus was speedily rehabilitated under Septimius Severus.

ARCHITECTURAL COMMEMORATION

GREECE AND THE ISLANDS

In a geographical tour around Greece and Asia Minor according to Head's system for *Historia Numorum*, the first Antonine monument is at the Roman colony of Philippi in Macedon. At the corners of the forum there were twin temples, and since one inscription mentions *divo Antonino* they must belong to the period around 161. If the pendant structure does not honor Faustina the Elder, it could well commemorate Lucius Verus, who died in 169. Nearby the Via Egnatia was spanned by a simple triumphal arch of Anatolian type; this colonial arch lay just outside the pomerium, to the west. It very likely can be dated in the Antonine period. A bilingual inscription to Marcus Aurelius at Philippopolis in Thrace suggests a monumental architectural dedication, such as the frieze of a stoa.

The next monumental Antonine undertaking is in Athens and is the façade of the reservoir on the slope of Mt. Lycabettus. F. da San Gallo's drawing, based on Cyriac of Ancona's lost notebook, shows the left half of the entablature standing on its Roman Ionic columns. It also depicts the broken arch of the adjoining arcuated entablature forming the gateway to the reservoir, and the right half of the inscribed frieze and architrave which were beyond, lying on the ground. By 1675, when Spon and Wheler visited Athens, the portions on the ground had disappeared. In 1794 Stuart and Revett published a handsome plate of the left third of the monument still standing against the background of Lycabettus and with bucolic scenes beneath, but these remains had been pulled down fifteen years previously.

Dodwell writes in his *Views of Greece* (1819), in connection with a plate titled "Entrance to Athens": "This entrance to the city of Athens is in the eastern wall near the Gate of Hadrian, and conducts to the villages in that part of the plain called Messogia, to Cephissia, Mount Pentelikon, and Marathon. It is constructed of three masses of marble belonging to an ancient aqueduct. The beginning of one of the archivolts is seen at the end of the frieze, upon which and the architrave are the remains of an inscription. . . .

"The walls surrounding the lower modern city are about ten feet in height, and not two in thickness. They were constructed about 1780, as a defence against the piratical attacks of the Arnauts, who occasionally entered the town at night, and threatened at times to pillage it. They were completed in seventy-five days, no intermission to the labour of all hands taking place during the intervening nights; but as this service

was compulsory, the cost was small. Every variety of materials which could be collected were employed in their construction; they consequently exhibit frequently marbles and fragments of inscriptions torn from ancient buildings. The bridge of Hadrian over the Ilissus on this occasion shared the fate of other perhaps more beautiful remains."

When Athens' "Albanian wall" gave way to the forerunner of the modern city, the frieze, top fascia of the architrave, and adjoining section of arched molding — all comprising one large block — were moved to the Royal Gardens where it can be found today amid the shrubbery of a tiny rock-garden "retreat." The inscription, as completed from Cyriac, is one of the most impressive recorded documents of Antonine imperium in the Greek world. It was in Latin, although some lost portion of the complex may have had the corresponding text in Greek. The letters are spaced so that the name of Antoninus appeared in large letters in the frieze, while everything else was secondary to it on the two fasciae of the architrave. In this respect it is the forerunner of the inscription on the façade of St. Peter's in Rome, where the Prince of the Apostles plays epigraphic second fiddle to Paul V Borghese!

IMP CAESAR T AELIVS ANTONINVS
AVG PIVS COS III TRIB POT II PP AQVAEDVCTVM IN NOVIS ATHENIS
COEPTVM A DIVO HADRIANO PATRE SVO
CONSVMMAVIT DEDICAVITQVE

The monument thus was arresting, not because of its relatively small size in terms of Roman architecture but because of its inscription, its setting, and its arched entablature. The last feature must have been a striking innovation in Athens in 143 and 144, for this is an architectural form associated with Asia Minor or Syria in the second century and Rome in the third.

There were other Antonine buildings in Athens. One of these, dedicated to Antoninus Pius, was the small building of the Agoranomion in the Roman agora. Beside the path in the section of the National Gardens where the blocks from the façade of Hadrian's reservoir are placed, there are columns and entablature from a tiny building, perhaps a stoa, which bore the titles of an emperor in Greek. The ninth Tribunician Power is referred to, and this can only be Antoninus Pius in the year 145, for no other second-century emperor held that office so many times. When Marcus Aurelius reached this number in the office, in 154, he was still only Caesar under Antoninus Pius. Some of the architectural scraps of this building lie further to the southeast, toward the bird ponds of the small zoo, and it is tempting to connect these fragments with the remains of a stoa noted in that area by Judeich in his

plan of the antiquities in the gardens. Otherwise, they might conceivably have something to do with later work on the reservoir complex.

The architectural direction of the Great Propylaea at Eleusis has already been discussed in connection with the colossal bust of Marcus Aurelius in the tympanum. The gateway as a whole was also dedicated to the memory of Antoninus Pius, for a statue base to him as divus still stands in the immediate area. The whole Antonine house came in for a share of these honors, bases to Diva Sabina and Diva Faustina dedicated by Faustina the Younger as the "daughter of Antoninus." These dedications would be the conjugal counterparts of Marcus' connection with the gate itself.

On the west terrace of the Lower Agora at Corinth two temples included the titles of the Emperor Commodus in their dedications. Both were evidently paid for by Cornelia Baebia, member of two prominent Corinthian families. One, dedicated to Poseidon, has been dated 185; the second, of uncertain dedication, was erected five years later.

The Antonine connections with the nymphaeum at Olympia rebuilt by Herodes Atticus just before the middle of the century have been described in detail in discussing the statues of various members of the imperial family from Trajan through the young Lucius Verus set up in its architectural complex. The nymphaeum was by no means the grandest but has become one of the most famous of the private dedications in which the donor's family basked in the reflected glory of the imperial family by being juxtaposed in the statuary or inscriptions of the architecture. A separate building inscription to Antoninus Pius was also found at Olympia.

About 149 one Flavius Kleitosthenes carried out a similar program on more modest scale by restoring the Stoa Basilike in the agora at Thera. There are inscriptions to Antoninus Pius, Marcus Aurelius, Lucius Verus, and Faustina I, and the heads from the statues of the last two may be among those found on the site. Lucius Verus was still an adolescent at the time, and Faustina had been a goddess for eight years. At Minoa, in the mountain behind the principal bay of Amorgos, there was a dedication to the god Dionysos and to Commodus, dating from 188 to 192, in a shrine with a statue of Tyche. For the populace of such an architectural and sculptural complex, there are the parallels of the colossal Tyche in Istanbul from Tralles and the head of Commodus as Dionysos, from the same site, in Canterbury.

ASIA MINOR

An epistyle fragment in the walls of Sinope gives a dedication to Marcus Aurelius and Commodus as Caesar; their full titles are used, and the date is A.D. 176. Dio mentioned a temple of (or to) Commodus at Nico-

269

media in Bithynia. The great temple to Hadrian at Cyzicus is said to have been finished by Antoninus Pius in 139 or under Marcus Aurelius as late as 167. It is certain that work was done on the building under the Antonines, and it may have taken to the later date to finish the details of decoration and furnishing.

At Pergamon a temple to Diva Faustina Mater, at the extreme north corner of the Acropolis and beyond the Trajaneum, was also dedicated to Faustina II, who followed Marcus Aurelius to Asia Minor and died there.

The city of Julia Gordus in Lydia was prosperous enough to need a new market colonnade in the agora. The structure was dedicated (and presumably paid for) by the family of Poplius Aelius Prontonianus or Frontonianus. Although begun under Marcus Aurelius and Commodus (177–180), the architrave inscription belongs to the period of Commodus as sole emperor. It was a stoa and portico complex, dedicated to the gods and Commodus. Remains of the columns and epistyle were found. Stratoniceia-Hadrianopolis to the northwest had a construction dedicated to Antoninus Pius.

The temple of Artemis and Zeus, the major temple at Sardes, must have been altered under the Antonines to acquire colossal statues of Antoninus Pius, Faustina the Elder, and perhaps Marcus Aurelius. The building was perhaps turned into an imperial shrine. This was at the time the city received its second neocorate. Heads from colossal statues of the Antonines were excavated on the site, suggesting some such important cult activity early in the reign of Marcus Aurelius. There may have been architectural work carried out under Lucius Verus, or at least on the occasion of his visit in 165. On a raised platform of the apse in the gymnasium, the 1959 excavators discovered a statue base of Lucius Verus, inscribed: "The city of Sardes twice honored with imperial cult (neocorate) the Emperor Caesar Aurelius Antoninus Verus Augustus. Claudius Antonius Lepidus, Chief Priest of Asia, First Treasurer, who from the beginning took care of the administration of the gymnasium, dedicated [the statue]." An aedicula of Commodus at Philadelphia was replete with his portrait and secondary decorative carving of Erotes.

At Smyrna it fell to Marcus Aurelius in the last three years of his rule to begin the reconstructions necessitated by the great earthquake. The damage centered around the Greco-Roman agora, and everywhere evidence shows that what the Antonines did not complete Septimius Severus and his family continued and received epigraphic credit for. One monument honored the whole Severan family, and the entrance of the west colonnade or stoa carried a large inscription to one or other imperial family on its architrave. Not enough has been found to be certain, since both used the names Marcus Aurelius Antoninus. Antoninus

Pius' reign may have been an occasion for engineering work connected with drainage near the mouth of the Hermos, according to a dedication to the river and to that emperor jointly.

The Gymnasium of Publius Vedius Antoninus at Ephesus was dedicated to Antoninus Pius; Vedius also honored the Tyche of his native city and the goddess Artemis. His statue, standing wrapped in a himation like the well-known Lateran Sophocles, was uncovered in the building. The imperial cult chamber was an inset porch within the courtyard of the east front where a statue of Antoninus Pius and an altar once stood. Publius Vedius Antoninus and his wife Flavia were also responsible for the odeon, where the remains of a statue of Lucius Verus in the heroic nude were found at various times. The lower part is in London; the trunk was lost in a shipwreck; and the head perished when the Evangelical School at Smyrna was sacked in 1922. The proscenium of the odeon bore the text of a letter from Antoninus Pius to the Boule and Demos in the years 140 to 144; this inscription, now in the British Museum, is a good guide for dating the structure.

Another public building of considerable size can be linked to the imperial court, but, as is the case of the uncertain names at Smyrna, it is difficult to say whether the stoa at Dorylaeum in Phrygia honored Titus or Antoninus Pius. The letters to and from Antoninus Pius inscribed on the walls of the temple of Zeus at Aezani to the southwest should be counted among works connected with architecture. The environs of this temple were rich in Antonine statues and dedications; the important local M. Ulpius Appuleius Eurykleus set up statues of Marcus Aurelius and Lucius Verus on their accession in 161, and there was a dedication to Commodus. A substantial structure was dedicated to Titus at Pessinus, but at Dorylaeum only one large block with molding above and the letters AWT. T. survives. At Miletus the large baths linked with the name of Faustina have proven to be an abundant source of Hellenistic statuary. They were started late in Hadrian's reign and dedicated under Antoninus Pius. The museion of the baths contained among various sculptures pendant statues of Marcus Aurelius in a cuirass and Faustina II. Setting of imperial statues amid divine symbols of learning, such as statues of the Muses, probably occurred in a number of Roman buildings in Asia Minor, the gymnasium at Sardes, for example.

The Gerontikon at Nysa on the Maeander was a typical civic council chamber in an average Hellenistic and Roman city of Asia Minor. Against the walls facing the semicircular seats were statues on bases, forming a commemoration of local heroes and a shrine to Antoninus Pius, Marcus Aurelius, Lucius Verus, and Faustina II. The inscriptions give a date of 146. A man named Iulius Antoninus Pythodorus sponsored the dedications. The statue of Antoninus Pius showed him clothed in a ceremonial cuirass. The architectural decoration of the building was

similar to that of the Bouleuterion at Miletus, including a frieze with bulls' heads, garlands, and rosettes or paterae.

At Shohut Kasaba, a town which contains a number of inscribed fragments from Synnada in the eastern part of the province of Asia, slabs from a building with inscription in Latin, have been restored to read as follows: CAESARI NOSTRO T. AEL. HADR. ANTONINO AVGVSTO PIO ET DOMO EIVS T. AEL. AVG. LIB VERNA PROCVRATOR. At Hierapolis, to the southwest, a bilingual inscription on a portico speaks of a gate and towers dedicated to an emperor whose name is missing but whose titles can fit only Commodus, Septimius, or Caracalla. Motella's exedra and stoa, begun in 136 or 137, may well have been finished in the Antonine period. It was in the name of Hadrian and Aelius Caesar in conjunction with Zeus Soter, being primarily from the people of the city through Attalus, son of Attalus, Zenon.

In his *Account of Discoveries in Lycia*, published in 1840, Fellows gives a translation of one of the grandest and most illuminating imperial inscriptions in all Anatolia. It is (or, more correctly, in the last century was) inscribed in large, well-formed letters over the east end of the proscenium of the theater at Patara, upon the screen wall connecting the stage with the cavea. The inscription, which disappeared when this part of the theater was robbed for building materials, reads, in Fellows' translation:

"To the Emperor Caesar, the son of the god Hadrianus, the grandson of the god Traianus, the Parthic, the great grandson of the god Nerva, Titus Aelius Hadrianus Antoninus Pius, Augustus, Pontifex Maximus, in the tenth year of his tribunitial power, having been Consul four times, the father of the fatherland, and to the Gods, the Augusti and the Penates, and to her dearest native city, Patara, the metropolis of the Lycian nation, Velia Procula, daughter of Q. Velius Titianus, a woman of Patara, has given this, and has consecrated the proscenium, which her father, Q. Velius Titianus, built from the foundations, and the ornament upon it and the things belonging to it, and the erection of statues and sculptures, and the building of the Logeion and the incrustation with marble of it, which things she provided herself; but the eleventh step of the second diazoma, and the awnings of the theatre, which were provided by her father and herself, were already dedicated and delivered over according to the decree of the excellent Council."

An inscription such as this not only reveals local pride, civic activity, and tribute to imperium but indicates how carefully documented the urban activities of imperial Asia Minor were. Many now-anonymous structures must have been very intelligible in imperial times thanks to such testimonia. Other building activity went on at Patara under Antoninus Pius, as mutilated architectural inscriptions testify. The small city of Aralissus in eastern Lycia was granted a neocorate under Com-

modus; the statue commissioned by the grateful citizens may have stood in a newly built or rededicated temple to that ruler. Lycia suffered from a bad earthquake in the reign of Antoninus Pius, and the emperor paid for much of the rebuilding through his local officials. Cyaneae, near the southern coast, put up a statue commemorating this generosity; its citizens also recorded in marble an imperial letter of 143 to all the Lycian communities.

Sagalassus in Pisidia had a temple to Antoninus Pius on one side of the city. Of a scale comparable to the Trajaneum at Pergamon, it was enclosed by a temenos wall with propylaion. There were honorary columns and triumphal arches within the precinct, a blending of the Roman with the Greek. Statues of emperors stood to the west of the building, and Antoninus Pius inhabited the temple with images of his deified ancestors and his imperial successors. An elaborately worded inscription spelled out in detail the honors to him. Trajan, Aelius, Commodus, and the Severan house were honored elsewhere in the city. Milyas or Melli, also in Pisidia, seems to have possessed a building dedicated to Antoninus Pius, amid its early Hellenistic walls and theater. Nearby were statues dedicated to the Antonine and Severan families.

Amid many imperial statues, the evidence of a slab from Attaleia and in the Antalya Museum indicates a building to Antoninus Pius in that city. The dedications in Greek and Latin over either door of the theater at Aspendus were to Antonine emperors, probably Marcus Aurelius and Lucius Verus. Conceivably a temple may have been dedicated to Divus Marcus Aurelius at Ancyra in Galatia, for the sextumvir Aelius Lycinus recorded himself in a Latin inscription found in the cemetery as *devotissimus numini eius*. The last site, moving toward Syria, is Isaura in Isauria or Cilicia, where an arch of Hadrian has been mentioned. A similarly simple arch to Marcus Aurelius was put up along the main street in 166 to 169 by M. Marius and a group of officials. The inscriptions listing participants were quite lengthy. A statue of the emperor stood nearby.

SURVIVING PORTRAITS

The Eastern portraits of the Antonines are arranged in *Historia Numorum* fashion from Greece to Egypt according to provenience and, if this is unknown, to regional museum when presence in such a collection is indication of discovery within a reasonable distance. These portraits belong to the period when Asia Minor reached its greatest prosperity under the Romans, and, despite the methodical investigations of M. Wegner as part of the German Archaeological Institute's corpus, many additional portraits of the principal Antonines must await identification and connection with the numerous surviving bases.[1]

ANTONINUS PIUS

The principal monuments of Roman imperium connected with this emperor (A.D. 138–161) in the East are the inscribed façade of Hadrian's reservoir on the slope of Mt. Lycabettus in Athens, a now-lost structure in honor of Antoninus Pius at Salonika, and the center of the great series of reliefs at Ephesus, where he appears as successor to Hadrian and patron of the dynasty destined to end with the murder of Commodus in A.D. 192. This period, as Gibbon so cogently pointed out, coincided not only with the era of greatest material wealth in the East but with the last period of unbroken peace before civil wars and troubles from the northeastern and eastern frontiers. The events of Antoninus Pius' reign were not particularly moving, in terms of copy for history books. He continued Hadrian's policies of favor to individual provinces, but his principal artistic efforts centered around commemoration of things Italo-Roman. The completion of Hadrian's great temple to Venus Felix and Roma Aeterna, the program honoring the apotheosis of Diva Faustina in A.D. 141, and the celebration of Rome's nine-hundredth birthday in 148 afforded stimuli for artistic production on all scales from large paintings and sculptures to new coin types. The dedication of the temple of Divus Hadrianus, the Hadrianeum in Rome, in 150–151 brought to conclusion another cycle of commissions, the principal survivors being the reliefs of personified provinces amid panels of banners and arms on the walls of the podium. Recent study has shown that an increasing number of monuments, formerly dated to other reigns, belonged to the rule of Antoninus Pius.

From the point of view of iconography, Antoninus Pius is as dull as his reign was quietly prosperous. Little is known of his portrait before his adoption by Hadrian. His appearance in the late Hadrianic tondi on the Arch of Constantine introduces him to official art; shortly thereafter he is honored with the Hadrianic succession on the Great Antonine Altar at Ephesus. His square, open face with its kindly eyes and neatly full beard does not change throughout the nearly quarter-century of his rule. Some of his Greek imperial portraits — the head in Olympia for instance — endow Antoninus Pius with a brooding, Jovian unruliness not found in the preciseness of portraits from Roman workshops, but portraits such as this are exceptional tributes to imaginative sculptors rather than testimonies to the inspiration radiating from the subject.

One workshop, in Athens or Corinth, produced marble heads of colossal scale, designed for statues, which convey this Jovian *terribilità* not only through massive modeling of the hair and beard but through the device of eyes made in alien material and inset. One of these large Jovian heads which once had inlaid eyes and a metal wreath on the brow was found in the Stoa of Zeus below the Hephaisteion in the

Athenian agora. Another such overlifesized head comes from Corinth and has a strong feeling of the Pergamene baroque tradition in handling of beard, wreath with medallion carved in the hair, and rippling structure of the face. By contrast, a small marble head at Eleusis, broken from a statue, must be a portrait carved early in his reign, before a variety of Roman models reached the Greek market. The sculptor has taken his inspiration in part from late portraits of Hadrian. If the colossal seated statue found in the amphitheater at Gortyna is Antoninus Pius, then the head now in the Heraklion Museum is a crude portrait with a square face, topping a local work which presented the emperor in Greek dress. Another provincial creation is the head in Rhodes, perhaps a work of about 155, based on a model made at Ephesus or Smyrna. Other early portraits are in Cos and Istanbul; the latter, an Asiatic version of a likeness created in Rome, was found in the precinct of the temple of Apollo at Alabanda in Caria and must date about 140.

Asia Minor has produced several unusual portraits of the benign successor to Hadrian. Fragments seem to remain of a colossal head which was part of a statue set up in the temple at Sardes. (The head of Faustina the Elder, from the same dedication, survives in good condition in the British Museum.) A fragment of the head of a bronze statue in Ankara comes from Adyamian near the site of Arsameia-on-the-Nymphaios in southeast Asia Minor; since the mask of the face is preserved, it is enough to indicate an early portrait based on Italian models. The quality of work is good, with a sideways cast of the eyes that could only be found in an imperial portrait molded in Anatolia (figure 143). Dispute exists as to whether or not an overlifesized head in Adana from Seleuceia-on-the-Kalykadnos is Antoninus Pius; if the identification is tenable, the likeness belongs in the group of baroque, Jovian portraits from Athens and Corinth. The head could be a copy made in Cilicia or it could have been shipped around the coast from western Asia Minor.

The sole portrait documented in Egypt, a head in Cairo from Ashmunein, is a forceful creation produced in Alexandria after a Roman model. Against the over-all dullness of these portraits, whether official or provincial, must be weighed the fact that the iconography of the good emperor Antoninus Pius was to exert a strong influence in the classicistic revivals of the period of Septimius Severus, the period from Gallienus to the Tetrarchs, and the rule of Julian the Apostate, in 361 to 363. When baroque plasticity and the elevating image of a bearded ruler of godlike ideals were sought, sculptors returned time and again to the last emperor who ruled when the ancient world enjoyed a secure peace and a healthy economy.

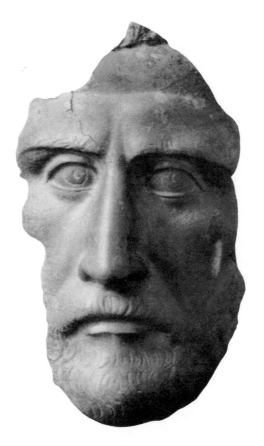
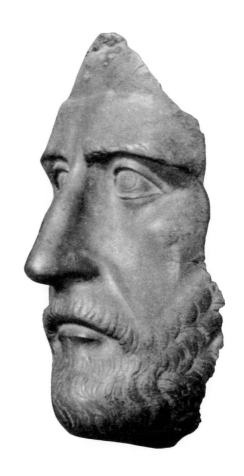

143. Antoninus Pius, from Adyamian

FAUSTINA I

If Antoninus Pius may be termed a routine subject for imperial portraits, his wife was even more so. She died in A.D. 141 after four years of her husband's imperium and received the honors of consecration, complete with a temple in the Forum Romanum. Most of her coin portraits present her as a diva, and, presumably, her monumental likenesses belong mainly in this category. She appears in the guise of the "Demeter of Cherchel" with Diva Sabina(?) in Slab O of the Antonine ensemble at Ephesus.

Four other portraits of the consort of Antoninus Pius have been identified from the Greek world. The most beautiful is the head in Athens, found in Syntagma Square, and the most breathtaking is the colossal head from an akrolithic statue, discovered in the ruins of the Artemision at Sardes (figure 144). At Olympia, Diva Faustina was naturally included among the statuary compliments paid the Antonine succession by Herodes Atticus in the exedra and *tempiettos* of his nymphaeum.

276

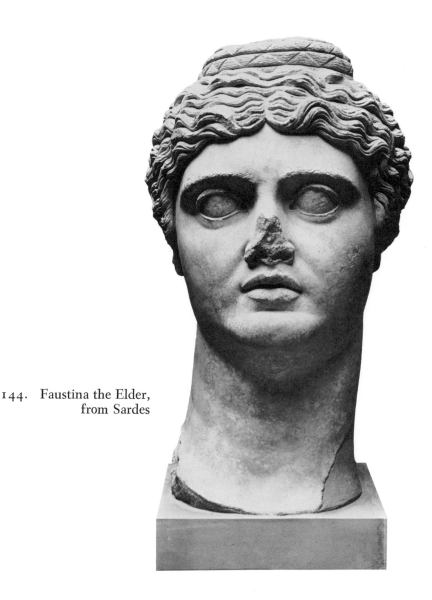

144. Faustina the Elder,
from Sardes

MARCUS AURELIUS

Unlike Antoninus Pius, Marcus Aurelius was a very young man (eighteen) when he became the constant subject of imperial portraits. His term as Caesar ran from 140 to 161, and he was emperor for a generation (161–180). Antoninus Pius' portraits are, to a certain extent, a continuation of the artistic tradition established in the last decade of Hadrian's reign. Those of Marcus Aurelius, especially in the last decade of his Caesarship and in the years of his rule, reflect the full development of the "Antonine Baroque." Marcus, with his rich, curly locks and his luxuriant philosopher's beard, was a fit subject for portraiture which sought part of its basis in Hellenistic art of the third and second centuries B.C. When faced with commissions for likenesses of the emperor, Greek

portraitists of intellect tried to capture all the facial suggestions of court philosophy, the imperial role as a Stoic and the imperial preoccupation with Greek religious thought in its best sense (figures 145–149). Marcus, at the outset of his career, holds a prominent position at the left in the imperial group on the monument at Ephesus; even at this early date the viewer can sense how sculptors will be drawn to the optic effects inherent in the Caesar's rich hair in contrast to his open but thoughtful face (figure 42).

The other appearance of Marcus Aurelius in sculptured relief in the Greek imperial world is as the *imago clypeata* of the tympanum over the Great Propylaea serving as the decorative entrance to the sacred precinct at Eleusis (figure 12). This structure, an imitation of a Doric temple and thus a reflection of the entrance to the Acropolis at Athens, has always been dated on the assumption that the emperor Antoninus referred to in inscriptions in connection with the triumphal arches nearby was Antoninus Pius and therefore that he was responsible for the Great Propylaea. For a long time the tympanum bust was labeled Antoninus Pius, although the inscription on the large epistyle of the inner façade mentions Marcus Aurelius. Some have concluded, therefore, that the building was erected after Aurelius received the title of Caesar.[2]

The bust is that of the elderly, full-bearded Marcus Aurelius, who does resemble his adoptive father in a number of portraits made after he ascended the throne in 161. Antoninus Pius, or those governing Greece in his name and their wealthy colleagues like Herodes Atticus, may have taken credit for the triumphal arches copied after the Arch of Hadrian in Athens, but the tympanum tondo confirms a later date for the outer propylaea. It is difficult to be more specific. Marcus Aurelius did not visit the East in his capacity as emperor until the revolt of Avidius Cassius in 175. Although the emperor spoke out against the wearing of military dress and although Eleusis is hardly the setting for an emperor in armor, the fact that Marcus wears an elaborate ceremonial cuirass with Gorgoneion emblem and a giant on the shoulder strap suggests connection with the disturbances threatening the eastern and northern frontiers in the last five years of his rule. In 170, it is well to remember, the Costoboci broke through the Danube, across Macedonia, and into the heart of Greece, where they plundered and damaged the Periclean temple of the Mysteries at Eleusis.

This tympanum *imago clypeata* of Marcus Aurelius reflects a design popular in Asia Minor but found in Roman funerary art at least as early as the Haterii relief. The carving was done, naturally enough, by sculptors from Athens. The bust relates to the one from the group of three found by Fauvel in the eighteenth century on the estate of Herodes Atticus at Probalinthos near Marathon in Attica. They are: Marcus Aurelius, with giant on the shoulder strap of his cuirassed bust (Paris,

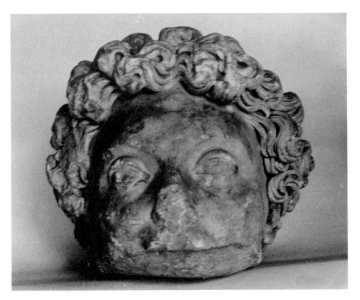

145. Marcus Aurelius Caesar, from Byzantium

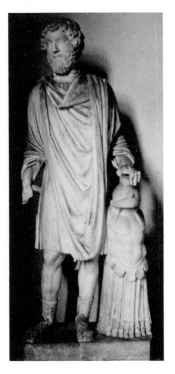

146. Marcus Aurelius, from Antalya

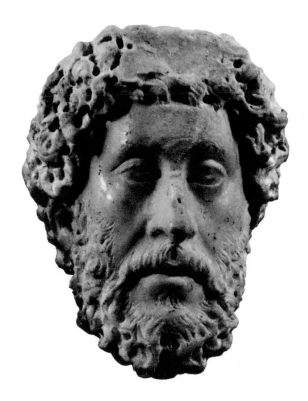

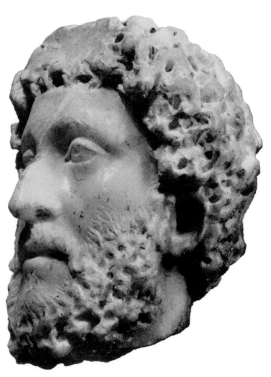

147. Marcus Aurelius, Nicosia

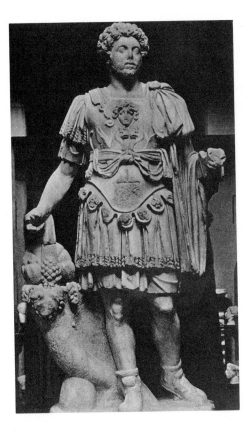

148. Marcus Aurelius Caesar, from Alexandria

Louvre); a similarly cuirassed and draped bust of Lucius Verus (Oxford, Ashmolean), and a head of Herodes Atticus (Louvre, no. 1164). All three are characterized by their high quality of carving in (yellowed) Pentelic marble. They represent one of many Greek and Asiatic Greek examples of a wealthy private citizen complimenting the imperial house and himself by setting up an ensemble of statues or busts. On the other hand, at Kephissia herms of Herodes and Polydeukes were set up side by side. Herodes Atticus rivaled Hadrian's commemoration of Antinous in his own dedications of likenesses of Polydeukes, and possibly of the African Memnon.

At least one head of Marcus Aurelius was found in Athens, a late portrait that is an uninspired creation characterized by a thin face and a massive mop of hair. The head in Preveza from Kamarina is a crude, local portrait in the iconographic traditions of likenesses of Alexander the Great. Although based on a model from Rome, the cuirassed bust in Corfu emerges as a timid product of the emperor's later years, relating to a head in Athens that may have been carved as late as 185. Byzantium, or perhaps its fourth-century successor Constantinople, had an over-lifesized statue of Marcus Aurelius executed about 160 when he was still heir to Antoninus Pius (figure 145). The same type of head tops a

280

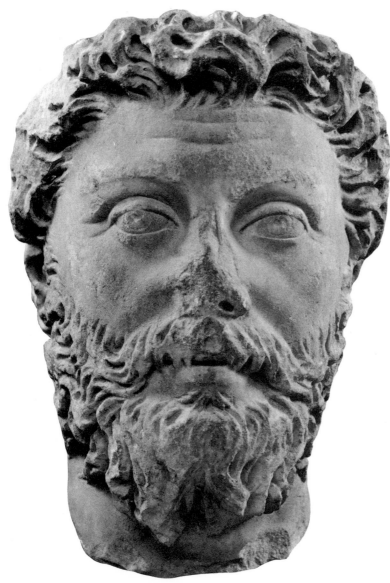

149B. Marcus Aurelius, from Ostia

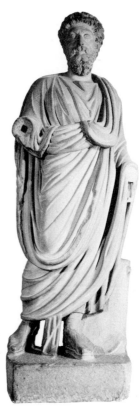

149A. Marcus Aurelius, from Alexandria

cuirassed statue found in Alexandria (figure 148). Another head, based in a general way on a Roman portrait of the emperor's younger to middle years, was fished from the sea at Ayvalık, the harbor that gave access to the hillside city of Pergamon. One of the most orthodox portraits of the height of Marcus Aurelius' imperial career is the head found with a likeness of Faustina the Younger at Kandilli Köyü or Bozhöyük.

The statue of about A.D. 175 in Istanbul from Antalya or Adalia has been termed a portrait of a private person resembling the emperor. It seems, however, that the likeness must be imperial, and the civilian traveling costume reflects the emperor's aversion to wearing military uniform except when actually face to face with an enemy. The small statue must have been made when the emperor was on his way to the East to settle the revolt of his trusted lieutenant Avidius Cassius (figure 146). An argument for designating the statue that of a private citizen might lie in the likeness of a certain Diogenes found at Aphrodisias in Caria in 1964; this official in himation wears a high crown adorned with ten or twelve small busts. Were it not for the inscription it would not be difficult to identify Diogenes as Marcus Aurelius or, more likely, Lucius Verus. A further indication that the statue from Antalya is Marcus Aurelius lies in the presence of a similar head, also less than lifesized, in a private collection on Cyprus (figure 147).

Marcus Aurelius must have been popular in Egypt, or at least his reign and its aftermath coincided with exceptional artistic prosperity in that imperial province. Besides the cuirassed statue of about 160 from Alexandria, there is a togate statue from the same city, a routine creation probably made about 200 as dynastic foil for a cuirassed image of Septimius Severus (figure 149). The museums of Alexandria, Cairo, and Stuttgart contain heads and a cuirassed bust of Marcus Aurelius. The bust is an import to the Egyptian Delta from Rome, and the two heads are good provincial restylings of official portraits dating from the height of his career.

FAUSTINA II

Faustina the Younger (died A.D. 175 or 176), daughter of Antoninus Pius and Faustina I, wife of Marcus Aurelius, and mother of Commodus, played an important part in Greek imperial art. She appears in the principal panel on the long side of the Great Antonine Altar at Ephesus, at the right and behind Hadrian (figure 42). The arts received considerable stimulus nearly two generations later from the fact that Faustina died in Asia Minor, during her husband's expedition from the northern frontier to the East to settle the disturbance of Avidius Cassius' revolt. The town in which she died, Halala in southwest Cappadocia, close to Cilicia, was renamed Faustinopolis, and the empress soon joined the ranks of the Divae. Her portrait, as a draped bust in high relief, adorns

the keystone of an arch of a portico in the agora at Smyrna. Iconographically, the type as translated into architecural decoration is one circulated in the decade from 165 and best known from a bust in Paris. In 178 Smyrna was almost completely destroyed by an earthquake and was reconstructed with funds donated by Marcus Aurelius, through the intercession of the orator Aelius Aristides. The keystone, as unusual a compliment to Faustina as that paid to Marcus Aurelius on the Outer Propylaea at Eleusis, was certainly part of this rebuilding. The sense of architecture is very strong, for the three curved fasciae of the architrave run as unbroken moldings behind her head and shoulders. The face is a troubled, sensitive one.

Otherwise, freestanding portraits of Faustina II, where documented, seem to be found most often in pairs or groups with Marcus Aurelius and other prominent Antonines. Such is the case with heads from Marathon in Attica, Olympia (figure 150), Kamarina near Preveza, Corcyra, Kandilli, and Perge. One of the more unusual portraits is the small statue from Aetolia in which the young empress or princess is presented as a much reduced copy of the striding Artemis Colonna of the fourth century B.C. The two problem portraits are the large, very ideal heads with hair arranged in the Hellenistic topknot of Aphrodite, both in Copenhagen (figure 151). One seems to come from Carian Aphrodisias and the other from Tarsus. Their degree of simplification is such that, in the sculptors' efforts to make princess look like a goddess, they can be either Faustina the Younger or her daughter Lucilla. They are placed among portraits of the former chiefly because there is so little epigraphic evidence for portraits of Lucilla in Asia Minor. The head from Tarsus, having a plumper face, is very likely Faustina either shortly before her death in 175 or 176 or as a goddess following the sudden tragedy in Cappadocia during the emperor's return from Syria.

Most freestanding portraits of Faustina II in Greece and Asia Minor are routine copies of models created in Rome or Athens shortly before Marcus Aurelius became emperor in 161 or in the five years thereafter. The three heads in the National Museum in Athens show how basic official types can vary. There is also a standard portrait that looks like the empress on coins of about 170. Heads in the Thebes Museum, in Preveza from Kamarina, in the Corfu Museum, and in Istanbul from Kandilli belong to this group, with allowances for local styles and chronological variances. A head in the Antalya Museum seems to be a copy of an official likeness made during her last year in the East or at the time of her death.

LUCIUS VERUS

As a child of eight the future emperor Lucius Verus (A.D. 161–169), son of the recently deceased Aelius Verus, appears on the focal slab on the

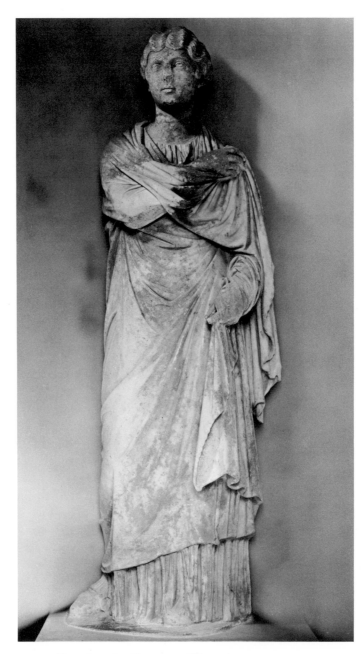

150. Faustina the Younger, Olympia

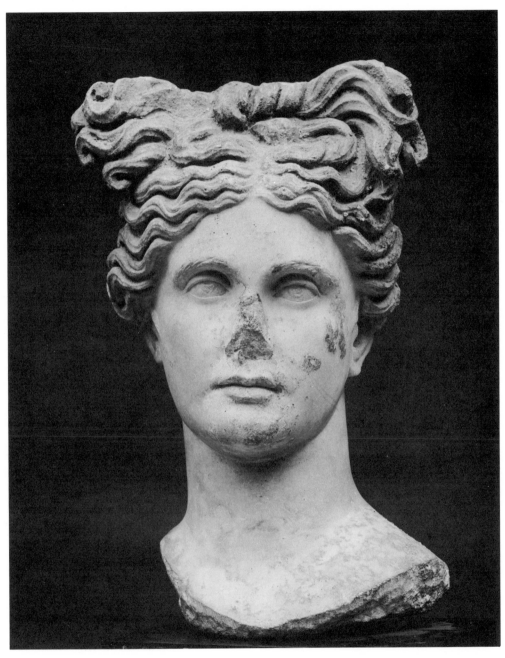

151. Faustina the Younger, from Aphrodisias

long rear side of the Great Antonine Altar at Ephesus (figure 42). His future is assured by the paternal attention he is receiving from Hadrian and Antoninus Pius, the former holding an outstretched palm over him and the latter clasping him to his side. His arrival at manhood is also documented in Greek imperial sculpture, for he was represented as a youth of seventeen to nineteen (147–149) in the exedra of the nymphaeum of Herodes Atticus at Olympia (figure 6). The young, beardless head found there may belong to a fine, headless, cuirassed statue. Another statue of Lucius Verus, dated before 161, was set up near the main entrance of the odeon at Ephesus; it showed him as a youthful divinity in the heroic nude, perhaps as Apollo or a Dioskouros. This is the statue that suffered the fate of being divided into three parts, the head and part of the body being now lost. The inscription on the base mentions Lucius Verus as well as Publius Vedius Antoninus, the Ephesian of wealth and influence who did so much for his native city. A similar inscription was excavated at Olympia.

At Antioch in Pisidia, Lucius Verus was grouped with local worthies, his head having been discovered with a statue of Cornelia Antonia and a young man of the time of his joint rule with Marcus Aurelius. As one of the coemperors, he was associated with Herodes Atticus on the latter's estate at Probalinthos near Marathon in Attica. Verus was in the East during the Parthian campaigns, and his presence in cities such as Athens must have encouraged the arts. At least two of his portraits have been found in the city itself. The colossal head of his father, Aelius Verus, one of the most moving portraits found in the pre-Roman agora, must have been executed and set up as a memorial during one of these visits. To this period also must belong the large-scale likeness of Lucius Verus from a statue evidently dedicated in or near the Theater of Dionysos. The sculptor of this powerful, brooding head was a genius, using deftness of chisel on Pentelic marble to turn the dissipated young aristocrat into a veritable Neos Dionysos. His portrait invited comparison with the fully draped, bearded cult image of the god of wine and drama by Alkamenes in the temple beside the theater against the southeast slope of the Acropolis.

Lucius Verus was very handsome in a refined way, and his delicate face challenged sculptors to produce a high level of portraiture. Because of his dynastic position in the Antonine house, he was elevated to the ranks of the gods on his death, and without doubt portraits were made throughout the reigns of Marcus Aurelius and of Commodus. One of these posthumous likenesses is the unworldly, extremely baroque head in Cleveland, from Alexandria or the Nile Delta (figure 152). It can be compared with an overlifesized Commodus, also from the Delta, a head carved about 186 as an Egyptian version of a portrait created in Rome. The Lucius Verus in Cleveland trades the elegance of heads carved in

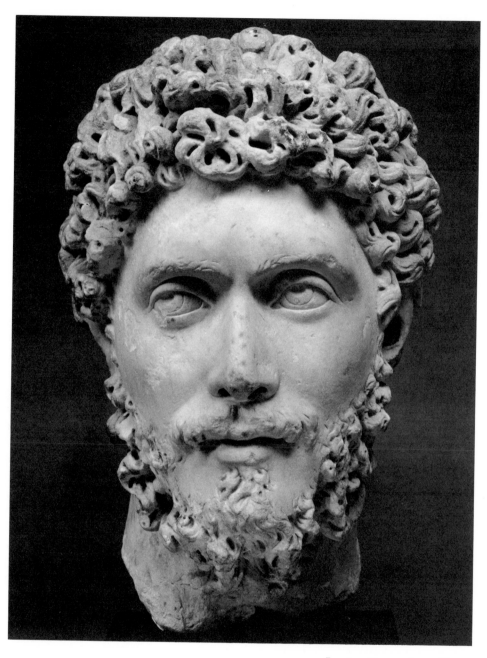

152. Lucius Verus, from Egypt

Athens during the subject's lifetime for a hairy, heaven-gazing countenance that has lost all touch with reality and with the inherently handsome features of the emperor; it is a masterpiece of sculptural virtuosity if not of penetration into the character of the subject.

LUCILLA

On coins and elsewhere Lucilla (died A.D. 183) looks very like her mother, Faustina II. Actually, some portraits identified as Faustina may be the daughter. The colossal head of an empress as Aphrodite in Copenhagen and from Smyrna or Carian Aphrodisias cannot be singled out with certainty as mother or daughter because of its ideal qualities, and this may also be true of the similar head in Copenhagen from Tarsus. Lucilla must have appeared in the architectural decoration of the rebuilt agora at Smyrna, but because she died in disfavor with her brother, Commodus, some of her portraits may have been destroyed in antiquity.

A head from the agora at Smyrna has been proposed as a standard imperial portrait of Lucilla. She has also been seen in an unusual head from Perge and in a head in Iznik (Nicaea). The last has been identified on the basis of the head from Perge. A head in Istanbul, found at Ephesus in 1895, seems so ideal in its approach to divine types that it is impossible to say whether an Antonine empress, a private person, or a goddess is represented. Lucilla's wedding to Lucius Verus was celebrated at Ephesus in 164, when she was fifteen years of age. Faustina the Younger's deification was also commemorated there in the presence of Marcus Aurelius in 176.

COMMODUS

Although Commodus (A.D. 177–192) was murdered by his palace followers, his memory was never clouded by damnatio and he received divine honors from Septimius Severus, who linked his family officially with the Antonine house. Statues of Commodus, therefore, were undoubtedly set up in the generation after he died. His appearance in monumental art can be documented from coins of the period when Marcus Aurelius made him Augustus or joint emperor, at the age of sixteen. About this time his bust was carved in relief in the gable of a shrine or small temple, which was seen years ago at Alaşehir (ancient Philadelphia) in Lydia. Commodus is styled *Autokrator* in the inscription to his Tyche by twenty-one local citizens. Iconographically, the portrait is very like those of the young Marcus Aurelius; in quality the monument is similar to an East Greek grave stele or architectural carving of the imperial period. It seems to be a characteristic of imperial art in Greece and Asia Minor to place portraits of the emperors and their families in the pediments of temples or gates and the gables of shrines or monumental inscribed shafts. Examples of various sizes from Eleusis, Cyzicus,

Smyrna, and Aphrodisias all belong in the period from Hadrian to Septimius Severus. Other instances can be deduced from minute study of imperial coins of the second century A.D.

Most surviving marble heads of Commodus are replicas of portraits sent out from Rome in the last five years of his rule. Thus, the copies known nowadays may well belong to the age of Septimius Severus, for that ruler, who styled himself the "brother" of Commodus, wished to see mature, bearded portraits of the last Antonine emperor, likenesses which stressed a courtly similarity to heads of their "father," Marcus Aurelius, and to Severus' own early official portraits. The two likenesses of Commodus in the National Museum in Athens conform to these requirements, both being copies of late creations. The first example gives every stylistic indication of having been carved after the emperor's death. The second was once a splendid version of a model created between 185 and 188. Save for a young head on Samos, all portraits are late or copy types belonging to the emperor's last years. A head in Smyrna is so like Marcus Aurelius as to confuse experts as to whether father or son is represented. A head from Ephesus was found on the fourth floor of a Roman luxury apartment, where it must have been treasured as an heirloom long after the emperor's shoddy but romantic assassination. It may have been carved under the Severans.

Perhaps the two most exciting portraits of Commodus are the old head crowned with the vine-wreath of Dionysos, in the Canterbury Museum, from in front of the Great Gate at Tralles (figure 153), and the large head, adorned with a weighty oak-wreath, that appeared in the art market in Beirut (figure 154). The portrait from Syria or the Phoenician coast, perhaps from Berytus itself, and also a creation of the years around 190, has the dramatic "soul-inspired" qualities of the head from Tralles but lacks the strength and Asiatic individuality of the Commodus as Neos Dionysos. The Commodus from Beirut was made to fit a cuirassed statue, and the complete figure, almost colossal in size, may have been carved in an Athenian atelier and exported to the eastern end of the Mediterranean.

CRISPINA

Only one portrait of Crispina, wife of Commodus, has been identified, although one or two may exist among those named Faustina II or Lucilla. Jale Inan and E. Rosenbaum propose Crispina in a diademed head with curious hair style in Konya.[3] The head may come from Antioch in Pisidia, but it is not identical with a portrait found over forty years ago by the American expedition to that site.[4]

CONCLUSIONS

The universal artistic quality of Antonine imperial portraits in Greece and Asia Minor is striking. There are few inferior works from the

289

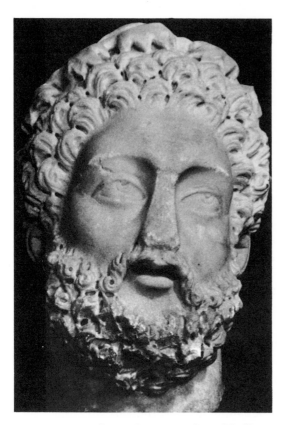

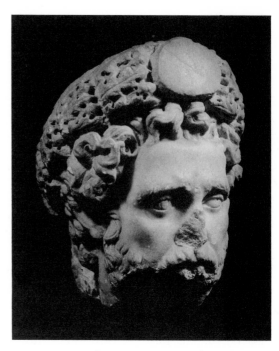

154. Commodus as Imperator, from Beirut

153. Commodus as Dionysos, from Tralles

sculptor's chisel. The only surviving monumental bronze, the head of Antoninus Pius in Ankara, is remarkable because the expression, eyes looking sideways in nervous apprehension, foreshadows the Late Antique. There are few dull, merely showy marbles, such as those found in some number in North Africa. The quality of the marble often appears to raise the level of workmanship, but Greek sculptors had a long tradition of good carving behind them. Many of the models came from Rome, or were similar to those used in Roman workshops, but Eastern variations took the form of infused emotion and imaginative freshness. If there are any pedestrian portraits in the East, they are copies of Roman models made in Asiatic marbles in the workshops of newly rich cities in the lesser Asian hinterlands.

No precise type, heroic, cuirassed, or draped, dominates the iconography of the Greek provinces. There is no group as organized and diffused as the cuirassed Hadrians found in Greece, Asia Minor, Syria, Crete, and North Africa. The Marcus Aurelius from Attaleia is the only statue sensitive to a specific political event: the emperor's order to discard the cuirass in favor of the sagum. The Commodus as Dionysos from Tralles, a head lost in divine or autocratic transfiguration, gives a glimpse of what Hellenistic iconography could become in the late Antonine

baroque. The Faustina II or Lucilla as Aphrodite from the region of Smyrna, evidently from Aphrodisias, forms the female parallel.

STATUE BASES AND OTHER ANTONINE EPIGRAPHIC EVIDENCE

Many inscribed evidences for works of art have been dealt with in the pages on architecture, and enough portrait sculptures survive to give a good idea of this art in Greece, the islands, and Asia Minor from A.D. 140 to 190. Certain Antonine inscriptions are important here for their texts and their settings. They can be considered representative not only from the art historical but from the geographical standpoint. Antonine monuments are as numerous and widely distributed as those of Hadrian. They cover the Greek world from northwestern Thrace, to Crete, to the Pontus, to Cyprus, and into the Commagene. Their numbers are not unduly swelled by milestones; statue bases and altars in appropriate settings provide solid statistics. Like portrait sculptures, totals are increased by the fact that Septimius Severus nursed the official fiction that he was son of Marcus Aurelius and brother to Commodus. The latter was rehabilitated under Severus and Caracalla, and new statues of the Antonines were created to serve dynastic or "family" monuments of the Severans, such as, for example, those at Augusta Trajana in Thrace and Sagalassus in Pisidia.

GREECE AND THE ISLANDS

In Thrace, Philippopolis was a center of Antonine commemoration, with monuments, including statues, to all the emperors. The activity continued well into the third century, to the time of Gordianus III. Serdica had a statue of Marcus Aurelius. Statistics for Attica show at least seventeen inscriptions to Antoninus Pius, four to Marcus Aurelius and Lucius Verus jointly, two to the former after the latter's death, and seven to Commodus. This last count includes one damnatio and two as Theos Commodus. Eleusis had, besides the colossal bust of Marcus Aurelius in the tympanum of the Great Propylaea, statues of Diva Faustina, Diva Sabina, and Divus Antoninus nearby. Otherwise, it is amazing how, excepting Corinth and Olympia, Greece, especially the Peloponnesus, declined in terms of imperial statues and altars after the Julio-Claudian period. Even the ubiquitous Hadrian fared poorly in these areas.

The city of Tegea put up a statue of Antoninus Pius as savior and restorer of the universe. He received another from the city's Boule, but this could not have stood for long (or ever have been set up), for the base was reused upside down in a private dedication to an important priest and official of the third century. The man may have been a priest of Caracalla and Geta, and perhaps even the statue of the emperor (if completed) was reused also. Between 161 and 164 the city of Tegea managed a statue of Marcus Aurelius; Mantineia to the north paid

similar honors to Lucius Verus between 165 and 169. In Laconia, Sparta gave Antoninus Pius a statue in 147, and a round altar to Marcus Aurelius and Lucius Verus hails them as the New Dioskouroi! The city of Caenepolis, or the shrine of Poseidon at Taenaron on the southernmost promontory of Laconia and all Greece, seems to have had a statue of Marcus Aurelius, for there is a rectangular base dating between 166 and 169. A round altar appears to have accompanied it, and a pendant statue to Lucius Verus belongs to the months immediately after his death in 169. Over the border in Messenia, Pherae recorded an epistle from Marcus Aurelius and Commodus, with the latter's name erased, in 177 or 178 concerning a dispute with Sparta. At Messene itself, an official of the Achaean League, whose career can be traced, dedicated a bronze statue of Marcus Aurelius during the years he was Caesar.

Besides the other Antonine monuments, Thera had two statues of Marcus Aurelius. The town of Peparethos on the island of the same name in the northern Sporades had a statue of Antoninus Pius. The town of Tenos was similarly honored. Pendant statues of Marcus Aurelius and Lucius Verus, dating between 164 and 166, stood on Astypalaea. At Mytilene on Lesbos it is a contrast to note only one Antonine monument, a dedication to Antoninus Pius in the years 151 to 152, after at least five altars to Hadrian the Olympian. On Chios, the First Strategos Pompeius Latrius was in charge of setting up a statue of Lucius Verus in 162, and between 178 and 182 a similar monument was dedicated by the Demos to Crispina. The only Antonine monument documented on Samos is a statue base to Antoninus Pius, found at Chora and dedicated by the local authorities.

Aside from a dedication to Antoninus Pius at Lyttus, the principal Antonine monuments on Crete were a pair of statues to Marcus Aurelius and Lucius Verus at Hierapytna, where the famous statue of Hadrian in Istanbul was found (figure 138). The date was the period of the Parthian wars, 163 to 165, and the official involved was Lucius Flavius Sulpicianus Dorion. Both emperors are hailed as "lord of the universe" ($\kappa\acute{\upsilon}\rho\iota o\varsigma$ $\tau\hat{\eta}\varsigma$ $\dot{o}\iota\kappa o\upsilon\mu\acute{e}\nu\eta\varsigma$), titles used also in Lycia and Pamphylia, and the type of compliment to the emperor which Greek minds in the second century A.D. regarded as the ultimate in successful political policy. On Cyprus there was a statue of Antoninus Pius at Soli, and between 175 and 180 dedications to Marcus Aurelius and Commodus were put up in the temple at Old Paphos. Salamis had a handsome round base to Commodus, a monument taken down after his fall from grace but evidently set up again at a later date.

ASIA MINOR

In the far reaches and peripheral areas of Asia Minor, the periods when emperors were honored often reflect the reigns when Roman influence

for one reason or another was strongest beyond the imperial frontiers. In Sarmatia and the farther Bosporus-Pontus regions Augustus, Trajan, Hadrian, and the Severans receive the majority of monuments. The Antonines are scarcely represented, due no doubt to Hadrian's retrenchment policies and later to disturbances under Marcus Aurelius. A dedication to Antoninus Pius does appear at Heracleia in the Pontus, and Amastris records a long dedication to Marcus Aurelius and Lucius Verus for the year 165.

Near Prusa in Bithynia the base of a statue to Antoninus Pius has been found, dedicated in 139 in the name of the strategos Attinas Glaukon. In Mysia, Cyzicus has yielded two dedications to Antoninus Pius. In 137, Attinas Glaukon as Praetor was responsible for a statue of Aelius Caesar, who died shortly before his opportunity to succeed Hadrian as emperor came to pass; the statue, appropriately enough, was at Hadriani, near the Rhyndacus river on the northeast border of Mysia and Bithynia. Marcus Aurelius was honored by a group of local officials with a statue at Antandrus on the Gulf of Adramyttium and on the road from Assos and Gargara to the east. Pergamon is surprisingly bare of Antonine monuments, efforts having been spent under Hadrian in completing the Trajaneum and by consequence in honoring Hadrian for his efforts. The Trajaneum and its surroundings had one dedication in the name of Antoninus Pius and two letters from the emperor.

In Lydia a dedication to Antoninus Pius stood at Caesareia Trocetta, southwest of Sardes, in the direction of Smyrna and the coast. Out near the end of the Ionian peninsula to the west, Erythrae could boast of twin statues to Marcus Aurelius and Lucius Verus. Nearly all the Antonines were honored at Sardes, and ten inscriptions add weight to the already massive evidence of the colossal heads of Antoninus Pius and Faustina the Elder from the temple of Artemis and Zeus. Thyateira had an unusual Antonine monument, in the form of a statue of M. Annius Verus, the infant son of Marcus Aurelius and Faustina (166–169). There was a large statue base to Commodus as a Divus, either a commemoration early in his reign (180–182), or possibly one by Septimius Severus after his death. At Maeonia, on a northeastern triangle between Sardes and Philadelphia, Lucius Verus was hailed on a statue base as Neos Dionysos in a dedication by two local citizens during the years 163 to 166, when he was en route to or from the Parthian wars. This city was noted for coin types which were extravagant in the honors paid to Dionysos.

Besides the monuments of architecture already mentioned, Smyrna has preserved epigraphic texts of letters from Antoninus Pius (on honors for Hadrian the Olympian) and Marcus Aurelius or Lucius Verus (on the city's *collegia*). Teos to the southwest had a dedication to Antoninus Pius, and between 162 to 166 Colophon set up a statue of Lucius Verus. Teira, south of the Cayster River and on the back road from Philadelphia

to Ephesus, recognized Marcus Aurelius with a dedication between 170 and 175. In front of the temple of Artemis Leucophryene at Magnesia on the Maeander there were pendant imperial statues beside the Hellenistic altar. In 98 the chief priest, Titus Flavius Demochares, commissioned a statue of Nerva, and a statue of Marcus Aurelius was the offering of a group of priests. The area of the South Market at Miletus was full of Trajanic, Hadrianic, and Antonine imperial statues. There were two to Antoninus Pius, the one of 154 to 155 having a pendant Marcus Aurelius. He, in turn, had three other statues as sole emperor. Commodus was honored once, before 183.

Many Antonine monuments in Phrygia have already been cited because of their links with architecture. At Nacoleia the freedman T. Aelius Aurelius Niger made a dedication to Antoninus Pius, and a bomus, dedicated on the city's behalf by one Craterus, honored Commodus in elaborate Latin terminology more important or appropriate to a Roman than a Greek imperial city. Orcistus, north of Amorium and south of the Sangarius in eastern Phrygia, had possibly two statues of Marcus Aurelius and one of Theos Commodus, all in the names of local administrative bodies or officials. In southwest Phrygia, Lunda's statue of Antoninus Pius was set up by Apollodotus Diodorus, who also struck coins. Apollonia to the southwest had a statue of Commodus, dated after 185, with a long inscription on the base.

Apameia was represented by an altar probably to Marcus and Commodus from 176 to 180. Sebaste could display pendant statues of Marcus Aurelius and Lucius Verus, and Synaus had a statue of Antoninus Pius installed in the name of the Boule and the Demos by the archon Menandros Asklepides. Another pair of the series of statues to Marcus and Lucius put up throughout Asia Minor in 166 or 167 was at Trajanopolis. Another set stood to the southeast, on the west side of Banaz-Ova; and south of Lake Ascania on the trail to Sagalassus the two emperors were honored with a dedication. In this region there were big imperial estates belonging to the descendants of Marcus Aurelius' sister; the family controlled them well into or past the middle of the third century. At Blaundus, far to the northwest, the family of Antoninus Pius was honored with a dedication by Flavia Magna, and Tymandus, to the west of Lake Limnae, could speak of a large pedestal for a statue of Antoninus Pius dated in the year 140.

Commodus figured in the dedication of a local building complex at Iasus in Caria, on the southern coast of the peninsula which ends in Didyma and Miletus. A pair of exedrae with a double row of porticoes between were dedicated to Artemis Astiadis and the emperor by one Diocles. The inscription records how he built most of the structure at his own expense, as a memorial to his deceased son who had reached the dignity of stephanophorus. In Lycia, Oenoanda, on the road from Cibyra

to the sea, had a statue of Antoninus Pius, hailing him as savior and benefactor of the city. A statue at Araxa, about ten miles to the south-west, contained a simple dedication from the Boule and Demos. Cadyanda, about the same distance toward Telmessus, honored Marcus Aurelius or Caracalla as Marcus Aurelius with a statue. There exists some confusion as to which emperor, if not perhaps both, enjoyed the commemoration. Faustina II, as Augusta, before her death in 175, received a statue at the Letoon; and the city of Idebessus, inland on the Limyra-Phaselis triangle, put up a statue of Divus Commodus as "savior and rejuvenator of the universe." Aralissus, a few miles southeast, celebrated a neocorate with a statue of Commodus, but the citizens later treated the last Antonine to a damnatio.

Besides its Antonine theater and varied other imperial monuments, Patara could boast several important dedications to the family of Antoninus Pius. The family responsible for the theater joined with the daughter of Tiberius Claudius Flavianus Titianus, Proconsul of Cyprus, in dedicating three statues of prominent Antonines. The statues were undoubtedly in marble, as the beginnings of two of the inscriptions (Faustina the Younger and Lucius Verus) were carved on the respective plinths. The three stood on separate bases which were in turn set on a common podium: Faustina was on the left, Marcus Aurelius in the middle, and Lucius Verus on the right. Patara also dedicated an altar to Lucius Verus, as savior. Rhodiapolis, near the Chimaera and Olympus, set up a statue of Antoninus Pius from the Boule and Demos; and at Corydalla, barely over five miles to the south, the same local bodies honored Marcus Aurelius in similar fashion. Olympus itself, as a cult center with a long tradition, may have had a temple dedicated to Marcus Aurelius. There was certainly an imperial shrine, and, at a "temple on a grand scale," Fellows copied the inscription of a pedestal standing in the doorway; it stated that the Council and People of the Olympians commemorated Marcus Aurelius (with his titles given), "in consequence of his kind gifts twice."

In Pisidia, Termessus Major had a statue of Commodus from the Boule and the Demos. The multifold architectural activity at Sagalassus included statues of the Antonine emperors wherever buildings arose under their patronage. Thus, there were perhaps three statues of Commodus in or near the Macellum, which was repaired or rebuilt in his name. In the suburbs of the city a statue of Marcus Aurelius has been recorded; and on the path southwest to Colbasa there was a dedication from the city of Sagalassus to Marcus Aurelius and Lucius Verus. Selge, almost due north of Pamphylian Sillyum but across the Pisidian border, had a statue of Commodus. The Antonine dedications at Milyas have already been mentioned in connection with the building in honor of Antoninus Pius and the attendant monuments. Specifically, there were

inscriptions to Antoninus, Marcus, Lucius, probably Commodus, and Septimius Severus and Caracalla. Pisidian Hadriani boasted of a large statue (base) from the Boule and Demos to Lucius Verus.

Attaleia (or Antalya) in Pamphylia offered a variety of statues, altars, and dedications. Lucius Verus received statues in his lifetime and after death. Commodus was thus honored twice in the years just before his father died; the Gerousia was responsible on one occasion, and the Boule and Demos shouldered the expense on another. In the first year of his reign, that is in A.D. 138, the city put up an altar to Antoninus Pius. Amid its wealth of other second- and third-century monuments, Side had a statue of Antoninus Pius. In Galatia, a similar monument appears to have stood in Ancyra, and that city had a dedication to the emperor with nearly one hundred names recorded as taking part in the celebrations.

Besides its temple to Trajan, Iotape in Cilicia had a statue of Antoninus Pius, from the Boule and the Demos. He was hailed as "lord of the universe," a title encountered in other Antonine statue bases. Olba was the site of a dedication to Marcus Aurelius and Lucius Verus, and a statue of Commodus was placed on the horseshoe mole or under the colonnade of the main street at Soli-Pompeiopolis. Tarsus contributes a statue of Faustina II, who was in the area and who died in this part of the world during her husband's efforts to avoid civil war in the East. Mopsuestia has reported a statue of Antoninus Pius, dating in the year 140.

Far to the north, in Pontus Galaticus, the crossroads city of Amaseia had a dedication to Marcus Aurelius. Not far to the southeast Comana could claim a similar monument to Marcus Aurelius and Lucius Verus. Somewhat to the south, Sebastopolis set up monuments to Antoninus Pius and Marcus Aurelius. This was the area where a dedication to Hadrian in the last year of his reign had been recorded in the name of the legate Flavius Arrianus, the historian.

The age of the Antonines was one of giant prosperity in Asia Minor and, partly as a result, a time of numerous artistic commissions in Greece. Many of these were for export to Crete, Asia Minor, Syria, or Africa. There are perhaps more Antonine portraits, more buildings, more temples or shrines, more coins, and more inscribed public works than for any other dynasty or group of rulers. The pattern of honors differs little from what went before or what followed under the Severans, but somehow the concentration of power in imperial hands is sensed in the systematic penetration of art involving the emperors into the programs of cities ranging from remote parts of Thrace to the Asiatic hinterlands. Antonine baroque portraits found perfect settings in the complex theaters, elaborate market façades, and dazzling waterworks put up as material

evidences of the Roman peace. Thanks mainly to Herodes Atticus, Greece received a fair but far from matching proportion of these buildings. Athens, Corinth, and Olympia were enriched, but many another famous old city or shrine was lucky if it received the standard set of statues of Antoninus Pius, Marcus Aurelius, Lucius Verus, and Faustina the Younger. Although the peace was soon to give way to civil war and barbarian inroads, such dire thoughts were far from the minds of public and private investors or builders in the reigns of Antoninus Pius, Marcus Aurelius, and even Commodus.

XIV

Severan and Later Portraits and Public Commemorations

GREECE AND ASIA MINOR witnessed little transition from portraits of the Antonines to those of Septimius Severus and his sons, Caracalla and Geta. Portraits of Septimius Severus follow naturally on those of Marcus Aurelius and Commodus grown to bearded manhood. The Severans, especially the father, maintained the dynastic fiction that they were related to the Antonines, Marcus Aurelius being the "father" and Commodus the "brother" of Septimius. Pertinax, intervening for a few tragic months following the extermination of Commodus, was taken as a species of "uncle," being the contemporary in all respects of Marcus Aurelius. If the break between late Antonine and Severan portraits seems greater where women are concerned, it is because Julia Domna introduced a new hair fashion as she grew to middle age. Characteristic portraits belong to the latter years of her career and can be called "late Severan," a term for the portraits of Severans after the interregnum of Macrinus and Diadumenianus.

EASTERN PORTRAITS

SEPTIMIUS SEVERUS

Innovations in the iconography of this African ruler (A.D. 193–211) center around portraits created in Rome or, shortly after A.D. 200, in his home province of Tripolitania, perhaps by way of Alexandria. The "Sarapis" type was doubtless a result of the imperial sojourn in Alexandria at the turn of the third century. The cuirassed statue found in that city, however, belongs in the conservative Antonine tradition, and all examples of the "Sarapis" type come from Italy or North Africa. Toward the end of his career this "inspired" portrait was abandoned for a patriarchal likeness recalling numismatic and posthumously sculptural heads of Pertinax.[1] The two revelations in early Severan portraiture in the East are the bronze statue of Septimius as Mars Pater found on Cyprus (figure 156) and the painted tondo of the Severan family (with

Geta eradicated) in Berlin from Egypt.[2] The former superimposed a subtle Roman iconography in the Hellenistic tradition on the Greek world; the latter gives only a faint glimpse of what imperial paintings were lost in the destruction of ancient civilization.

The commonplace portraits of Septimius Severus in Greece and Asia Minor are not easy to single out and classify, for Greek artists often made his round, Afro-Roman face into the ideal image of a patriarch from an Attic grave stele of about 340 B.C. Artists no doubt were ordered to make Severus look like Pertinax, whose champion he claimed to be, or Marcus Aurelius, considered his father in the formal imperial genealogies. The results were often too successful in relating Severus to Pertinax, and sometimes, as in the case of a head from the acropolis of Pergamon, it cannot be said for sure whether the portrait is Septimius Severus or a retrospective, somewhat freely rendered Pertinax. Heads in Salonika, Verria in Macedonia, and Istanbul — the last from Nicomedia — are early portraits in which the sculptors have carried the process of idealization far in the traditional Greek sense. Perhaps they had not yet received official models from Rome, and these likenesses were probably produced in the first years of the emperor's rule, when he was wresting the East from the grasp of his rival, Pescennius Niger.

In contrast, the architectural bust from near Aphrodisias is a work of the years before 200 in which an official model has been observed to the extent that there is no questioning the emperor's identity (figure 155). A second head in Istanbul, probably from Beirut, gives one of the few portraits of Septimius Severus in the East that falls in the second half of his reign, when he was occupied in Rome or in the northwest provinces such as Britain (figure 157). In short, the Greek world showed its gratitude to the conqueror of Pescennius Niger and the husband of Julia Domna from Syria early in his reign, then was content to rest to a large extent on the accumulation of good works.

JULIA DOMNA, CARACALLA, AND GETA

Despite the survival of many inscriptions, three-dimensional portraits of the Syrian Julia (died A.D. 217) have been discovered only in Athens and at Salimiyeh near Hama in her native Syria. The former is a late miniature in marble, and the latter the bronze bust of strong local style at Harvard (figure 158). Her older son, Caracalla (A.D. 198–217), is fairly well represented from Philippi in Macedonia, to the Athenian Acropolis, to Mysia or Pisidia, and finally to Koptos and Oxyrhynchus in Egypt. In the last two places his statues are among the last from Antiquity in which a ruler is portrayed with the iconographic trappings of an Egyptian Pharaoh. Caracalla is found as often as the boy emperor of the years 198 to 209 as the savage sole emperor from 212 to 217 (figures 159–163). What few of his portraits were overthrown by partisans of

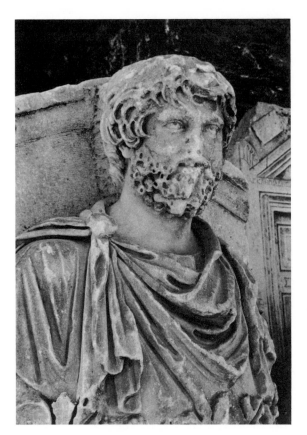

155. Septimius Severus,
from near Aphrodisias

Macrinus in 217 or 218 were undoubtedly reconstituted under Elagab-
alus (218–222) or Severus Alexander (222–235), both of whom were
honored to be his official progeny and actual relatives.

The masterpiece among Eastern Caracallas is the bronze head from
Pisidia, a portrait of about 205, which gives every indication of belonging
to a statue of the type of Alexander with the Lance, now in the Houston
Museum of Fine Arts (figures 163, 164). Such a statue would have
been the perfect parallel to the Septimius Severus as Mars Pater from
the shrine at the head of the aqueduct running eastward across the plain
to Salamis on Cyprus (figure 156). Images of Caracalla are found
throughout the East (figure 165). Caracalla murdered his younger
brother Geta in 212, and Geta's images were systematically thrown
down. Only one portrait of this poor prince (A.D. 209–212) has been
identified, a miniature bust in the museum at Konya. The legion of
erased inscriptions in Greece and Asia Minor reveal, like the arch in the
Roman Forum or the painted tondo in Berlin, how effective was the
campaign to eradicate Geta from the arts. It is a wonder that so many
of his coins have survived.

300

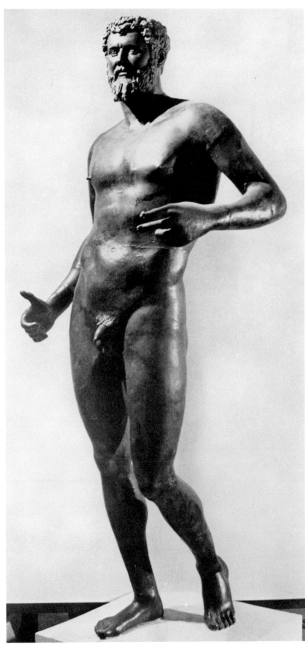

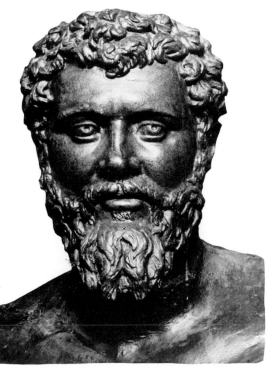

156. Septimius Severus as Mars Pater, from the Salamis aqueduct

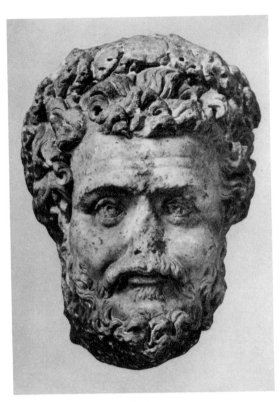

157A. Septimius Severus, from Beirut

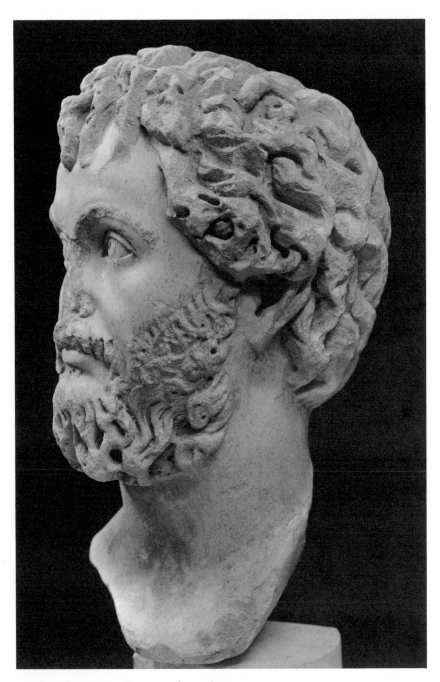

157B. Septimius Severus, from Ostia

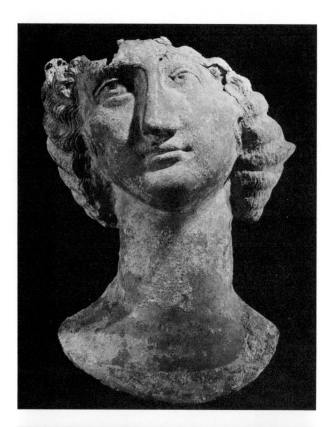

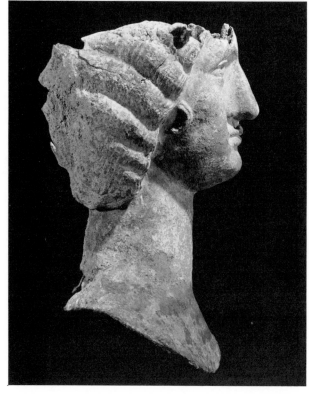

158. Julia Domna,
from Syria

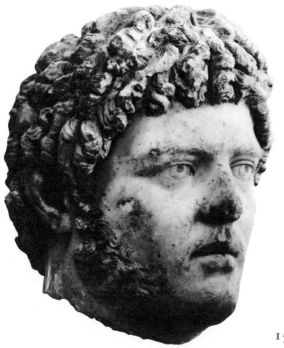 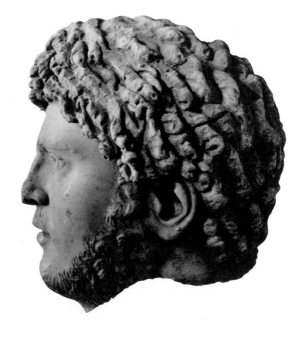

159. The youthful Caracalla, from Corinth

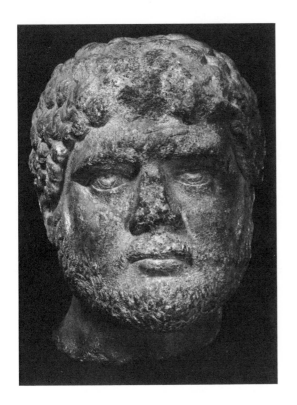 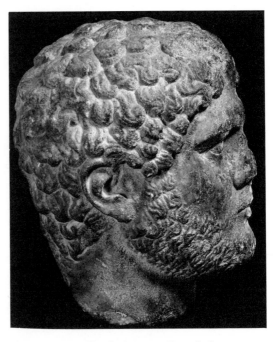

160. Caracalla, from near Istanbul

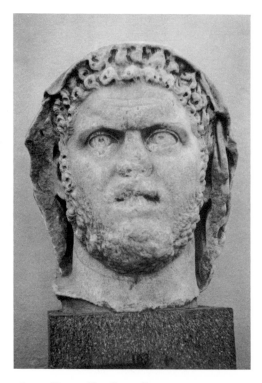
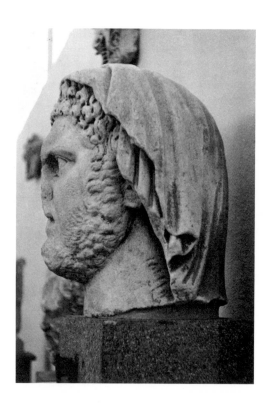

161. Caracalla, from Pergamon

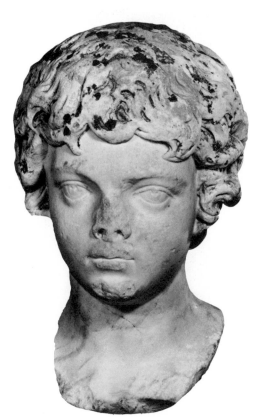

162. The young Caracalla, from Kula

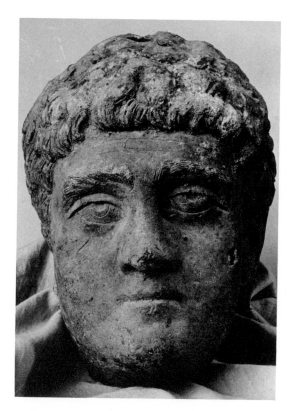

163. Young Caracalla,
from southern Asia Minor

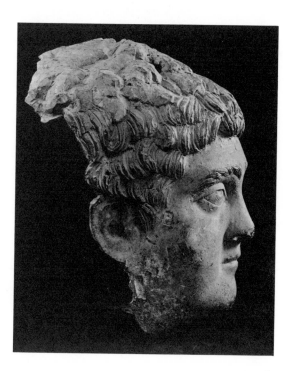

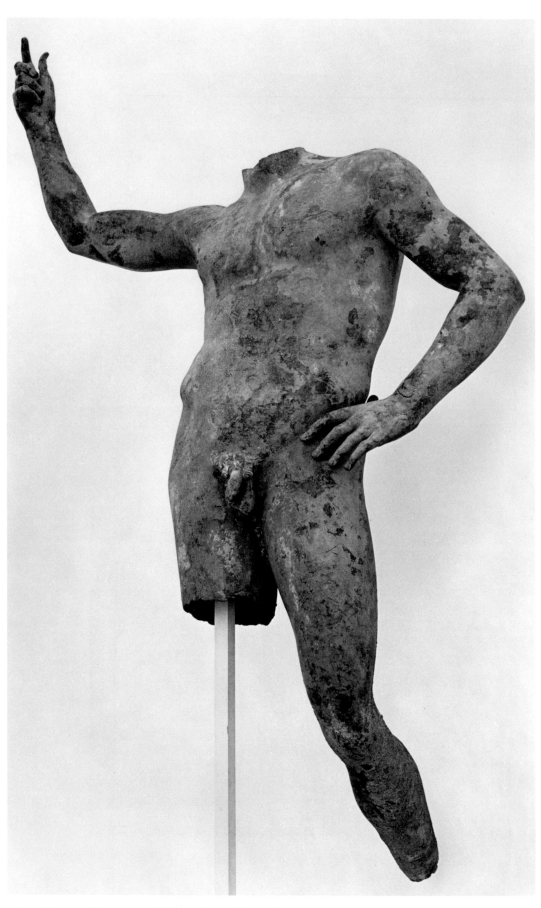

164. Statue of the type of Alexander with the lance

165. Base of a statue
of Caracalla, Sardes

SEVERUS ALEXANDER THROUGH THE SUCCESSORS OF GALLIENUS

The general decline of the arts under military emperors and the particular suffering brought to the Greek world in the period of Valerian and Gallienus explain why these portraits are so few. No glyptic portraits of Macrinus (217–218) or Elagabalus (218–222) have been identified, although inscriptions and coins indicate they could exist. Even if new monuments were set up under Severus Alexander, Gordian the Third, and Philip the Arab, many were bundled into hastily constructed defenses in the era of the Herulian barbarians or the Sassanian Persians. Since statues made in the first and second centuries were frequently rechristened with new heads, it is difficult to assign more than a few headless marble cuirassed statues to the period after Caracalla. Some statue bases and other evidences of monumental imperial art survive, but such was the nature of the times that the major monument of imperial art in Asia Minor became the milestone, marking repairs to roads vital to the defense of Eastern frontiers.

The two candidates for identification as Severus Alexander, last of the dynasty of Septimius Severus, come from Egypt, where the young emperor visited in 231 during an inconclusive war against the Sassanian or neo-Persian kingdom. One portrait is based on a model sent from Rome, but the second appears to have been remade from a monumental likeness of a Hellenistic ruler (figure 166). The emperor's domineering mother, Julia Mamaea, who was murdered with him by the troops on

309

166. Ptolemaic portrait
remade as Severus Alexander,
from Memphis

the German frontier in 235, is better represented in Greece and Asia
Minor. A head in Nauplia and two heads from Ephesus match her
portrait on Roman imperial coins. A bronze statue found in 1964 on the
acropolis of Sparta has been termed Julia Mamaea. Although the
epigraphic odds favor Julia Mamaea, restoration of the face may reveal
one of the wives or other female connections of Elagabalus, or merely an
important private lady of the late Severan period.

After Severus Alexander and before the advent of Diocletian in 284,
the two really important portraits are the large Jovian statue of Balbinus
(A.D. 238) in the Piraeus Museum and its counterpart, his coemperor
Pupienus, surviving only in fragments (figure 167). Dredged from the
harbor, these clumsy marbles must have been produced in greater Athens
for export to some shrine or public area. Since both emperors ruled so
briefly and since they were well remembered for their abortive efforts to
restore sane government to imperial Rome, it is likely that the two statues
were ordered under Gordian the Third, between 238 and 244. If these
sculptures belonged to the few months that the two emperors reigned, it
might have been the imperial overthrow in 238 that sent the statues
from the docks to the bottom of the harbor. Maximinus the Thracian
and his son Maximus (235–238), objects of the revolts that brought

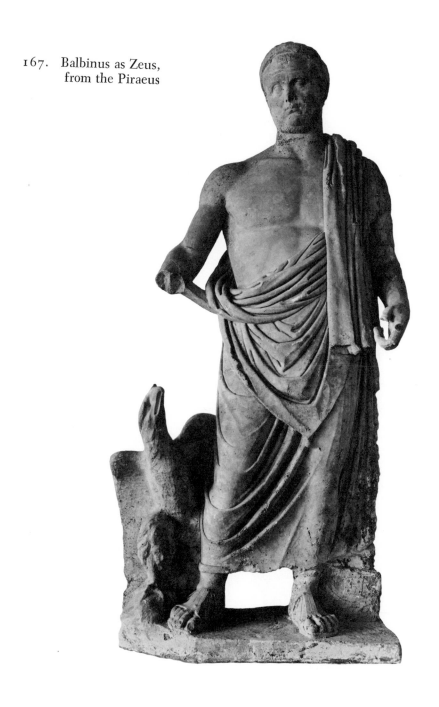

167. Balbinus as Zeus,
from the Piraeus

Balbinus and Pupienus to power, seem to exist in a bronze head from the Egyptian Delta and a cuirassed statue from the chief imperial administrative building at Side in Pamphylia. The head of Maximus appears to have been set on or reworked from the portrait already on an Antonine military statue.

Gordian the Third is well recorded in inscriptions, including statue bases from Greece and Asia Minor, but the sole sculptured portrait recognized so far is a marble head from the shrine of Poseidon and Amphitrite at Kionia on Tenos. The head of Philip the Arab (244–249) in Athens and the bronze statue of Trebonianus Gallus in Istanbul from Amisus (Samsun) are very dubious identifications. Beyond these, there is chiefly a marble head which may be Volusianus, son of Trebonianus Gallus (251–253), a portrait first made known from an old photograph taken at Eskişehir (Dorylaeum) in northwest Phrygia many years ago. A splendid pair of overlifesized heads, Valerian and Gallienus, were undoubtedly carved for a city of western Asia Minor, but their precise provenance has not been determined. They date before 260, and, although the models stemmed from Italy, the execution belonged to an atelier influenced by Flavian and Julio-Claudian styles found at Smyrna or Pergamon (figure 168).

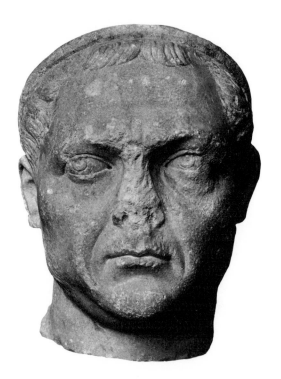
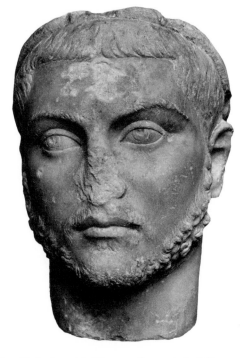

168. Valerian, Gallienus, from Asia Minor

SEVERAN DYNASTY AND LATER COMMEMORATIONS

MAINLAND GREECE

Evidences for Severan art in the Greek mainland begin in northwestern Macedonia, at Heracleia ad Lynkestis (modern Bitola in Yugoslavia). The city, "Septimia Aurelia Heraklea," was probably where Septimius Severus stopped on his way back to Rome from the east in 202. His statue stood in the agora, and there may have been also a monumental arch with an inscription in Latin. The marble statue of a magistrate or man of letters found and set up again on a base at the site belongs to the second century and perhaps to the Severan period. He wears the pallium or himation, holds a rotulus on his left knee, and has a scrinium as support at his left foot. His beard and hair are worn in a fashion recalling portraits of Plato, but he is definitely a man of the Antonine or Severan periods. A Greek artist carved the statue. Near him stands a (headless) young lady. Her garb is that used for statues of Persephone, and she is the three-dimensional counterpart of the princess as Persephone, probably Faustina the Younger, in Slab Σ of the Great Antonine Altar at Ephesus (figure 47).

The colossal head of Caracalla from Drama in Macedonia confirms that the region was fixing up monuments to that ruler in 217, in preparation for his return from the Parthian wars. Such a visit never took place; assassination prevented the emperor from following in the triumphal footsteps of his father across Thrace and Macedonia. The strong Severan commemorative and epigraphic activity in Macedonia and Thrace is reflected in the number of private monuments and portraits of the period assembled in the museum at Salonika. A portrait of a young girl with hair gathered in a large, crownlike circular braid on the back of the head is the qualitative rival of the famous little girl from the Palatine in the Museo Nazionale Romano. Both portraits make a transition from the late Antonine to Severan periods in courtly sculpture of a nonofficial category.

Neapolis (modern Cavalla in Macedon) possessed a milestone in Latin to Septimius Severus and Caracalla, dating between 198 and 201. Both rulers were hailed with their full titles. Further commemorative activity along the Via Egnatia, where Severus had to travel to defeat Pescennius Niger, consisted of a column at Amphipolis in Macedon (near Provista) dedicated by the city in 209 in the names of the Augusti Severus, Caracalla, and Geta. Philippi had a small base honoring the Victoriae Germanicae of Caracalla; the last months of that emperor's reign produced at least three milestones found along this part of the Via Egnatia. Philippi offers the first post-Severan commemoration, in the form of a large altar to the emperor Carinus, Diocletian's predecessor in the years 282 to 284. Near Aenus, the important Greek town in southeast Thrace, a mutilated

inscription to the whole Severan family, including Plautilla, has been found. Gordian the Third's wife Tranquillina, who appears surprisingly often in Greece and Anatolia, is named in another inscription from the site. The city of Hadrianopolis, one of the many foundations named for that emperor, dedicated a milestone to Severus Alexander and his mother Julia Mamaea. Selymbria, on the road between Heracleia-Perinthus and Byzantium had an altar to Gordianus III; an inscribed rescript from the same emperor was set up in the portico of the Trajanic baths.

The inland Thracian city of Augusta Trajana produced Greek imperial, or municipal, coins from Marcus Aurelius through the Severans and then very rarely to Gallienus. On the other hand, the immediate area has been rich in major monuments from Septimius Severus through Gallienus. A milestone, the eighteenth on the road from the city, mentions Severus, Caracalla, and Geta in the years 199 to 210. Six other dedications honor Septimius or his family, in various combinations. A monument to Commodus may also belong to the reign of his self-styled "brother," Severus. Severus Alexander was represented by a statue base and another dedication. Inscriptions to Maximinus I, Gordianus III, Philippus I, Philippus II with his father, and Gallienus survive also.

Several imperial monuments adorned the public squares and buildings at Heracleia-Perinthus on the shores of the Propontis. Septimius Severus is mentioned once alone and once with Caracalla. Traianus Decius, fated to fall fighting the Goths in Moesia to the northwest, received a statue in the three years of his rule (from A.D. 249). North and back into the Balkans, Philippopolis struck a rare variety of imperial coins, with legends in Latin on the obverse and in Greek on the reverse. Four inscriptions honored Septimius Severus; two spoke of Caracalla; and a lavish text combined Caracalla with Julia Domna. Severus Alexander appeared twice, and, unusual though it may seem, Balbinus (A.D. 238) was commemorated in a lengthy series of names and titles. Although ruler for a matter of months only, he and his colleague Pupienus were well remembered as emperors of the Senate, and their colossal statues in Jovian guise were carved to be set up in the Piraeus or exported from an Attic workshop. Philippopolis has produced three epigraphic mentions of Gordianus III, once with his wife Tranquillina. At the great late imperial center of Serdica (modern Sophia in Bulgaria), Elagabalus, Severus Alexander, Gordianus III, Gallienus, and his wife Salonina were cited in inscriptions. The head of Caracalla from Rumeli Hisar may have belonged to an imperial monument put up at the outset of the emperor's sole rule, when he was embarking on a period of Anatolian patronage (figure 160).

The pattern changes abruptly in the heartland of Greece. The impoverishment of the central and southern areas, classical Greece, compared to the militarily vigorous north, is reflected in the disappearance or

lack of imperial monuments for the Severan and later periods. There are a few exceptions. In Phocis the Boule and Demos of Elateia in the north dedicated a statue of Caracalla, and Ambrysus almost due south across the peninsula paid like honors to Severus Alexander. At Delphi Cyriac saw, of all things, the base of a statue of Carus from the sacred city; this must have been set up in connection with the eastern campaigns on the eve of Diocletian's accession. Chaeroneia at the northeastern border of Boeotia dedicated a statue to Macrinus (217–218), a rare honoring of this unfortunate monarch. Thespiae had an altar to Septimius Severus, and Thebes dedicated a splendid statue of Caracalla in which his full titles were set forth. The city also honored Claudius II (268–270) in similar fashion, no doubt in connection with his defeat of the Goths. Saloninus the son of Gallienus appears to have received one of his few honors in the Greek world in the form of a statue at Lebadeia, on the road south from Chaeroneia toward Coroneia and Thespiae.

Attica was not completely barren of monuments in this century, having five to Septimius Severus, including one with Caracalla and another mentioning both his sons. Geta appeared alone in an inscription afflicted with damnatio. The Athenians honored Julia Domna with a golden statue in the Parthenon. Elagabalus is recorded once, and Maximinus I with his son Maximus Caesar is named in a single commemoration. There was an altar to Septimius Severus at Eleusis, where Hadrian and the Antonines had been given so much in the way of architectural honors at a site normally associated with pre-Roman Greece.

In the Peloponnesus it is surprising to find *two* inscriptions to Tranquillina at the Asklepian center of Epidaurus, a site which otherwise has yielded no other imperial monuments later than a statue of Caracalla reused for Severus Alexander. The agora at Cleonae appears to have had a small exedra with statues of the Severi. The Nauplia Museum contains a head, found at nearby Petri, which may represent Julia Mamaea in the years 230 to 235. This possible likeness of Alexander Severus' mother belongs to a statue and is somewhat battered. During the lifetime of Septimius Severus, a statue of Julia Domna was set up at the east front of the temple of Zeus at Olympia. This is the last and latest recorded connection between this famous sanctuary and the Roman emperors.

THE GREEK ISLANDS

Near the Herakleion at Thasos stood a monumental arch of the years 213 to 217, dedicated to Caracalla, Julia Domna, and the deified Septimius Severus. A cuirassed torso found there has been identified as possibly Caracalla, but the breastplate, with scene of Victoria crowning a Palladium, is carved in the style of the Hadrianic period; perhaps the statue was reused in the Severan period, or perhaps an earlier imperial statue was installed near the arch. Little Skiathos in the northern Spora-

des had two altars to Septimius Severus, one from the Boule and Demos. The island of Thera is the first area in the central Aegean giving Severan commemorations in any number. Two statues of Septimius Severus, one apparently of Caracalla, and one of Alexander Severus have been found here. This is a contrast to the scarcity of such items in Greece itself. Andros has yielded a dedication to Severina, wife of Aurelian (270–275). The Tenos Museum contains a battered head of Gordianus III, from the sanctuary of Kionia; coins from the area around the altar to Poseidon and Amphitrite indicate that activity continued into the fourth century. A marble plaque with a simple name-dedication to Trebonianus Gallus (251–253) has been found at Koumaros in the south center of the island, inland from Tenos.

At the mountain site of Minoa, above the principal harbor of Amorgos, several Severan monuments were placed amid earlier and later works of imperial art. Some time after the year 201, the Boule and private donors set up two statues of Caracalla; Hermokratous Aristion had charge of one, and several names are mentioned in connection with the other. There was also an inscribed letter from Septimius Severus and Caracalla, containing congratulations on sacrifices for the British expedition of 208. The island of Astypalaea, rather than the town of the same name on Cos, also appears to have had a statue of Caracalla, and another of Gordianus III. At the city of Cos, there were pendant statues of Caracalla and Geta, belonging to the years 211 or 212, when both ruled after their father's death. Another statue of Geta, with name later erased on the pedestal, stood at the town of Isthmus. At the principal town of the island of Nisyros, directly south of Cos, there was a monument, probably a statue, to Caracalla.

Mytilene, principal city of Lesbos and directly across from Pergamon, set up a statue of Septimius Severus as early as 193, and Caracalla was honored in the same fashion in or after 201. The successes of the Parthian campaigns and the assumption of new imperial titles on these occasions were reflected in waves of new imperial monuments in the Aegean and Anatolia. Epigraphic evidence from Samos in general comprises the base of a statue to Caracalla in the years 210 to 217, and a statue to Julia Domna at the Heraion, commissioned between 198 and 211.

On Crete there were a number of Severan monuments. Gortyna set up its statue to Septimius Severus in 210 or 211. There was also a monument to P. Septimius Geta, *brother* of Septimius Severus, and after 213 a statue of Caracalla appeared in the temple of Apollo Pythius. Lyttus had a statue of the same emperor, and Itanus possessed a double statue base to Severus and Caracalla (201–210), with one inscription at the right and the second on the left. On Cyprus, the Severan monuments occur along the southern coast. Nea Paphos had a statue of Septimius.

In 198 a huge bilingual milestone, number XV, was placed in his name on the road from Curium to Paphos. At Citium Julia Domna was honored by an image with dedication in Greek as "Mother of the Camp," a title which she received shortly before 200.

ASIA MINOR

Severan monuments in Asia Minor begin with those on the periphery of the Black Sea. Sarmatian Olbia had monuments to Septimius Severus and Caracalla, to Caracalla and Geta (198–209), and to Severus Alexander. At Panticapaeum the ruler T. Julius Sauromatis II set up a dedication to Caracalla about 201. On the Pontic coast of Asia Minor, the road from Amastris had at least one milestone to Septimius Severus, Caracalla, and Geta as Caesar; their names and titles appeared together on each stone shaft. Not far away to the northeast, along the coastal road, the city of Abonuteichus, later called Ionopolis, ordered a statue of Septimius Severus in the year 210. In the years 211 to 217 the town added a monument to Caracalla.

Nicomedia in Bithynia enjoyed Severan favor as a result of the destruction of Byzantium. Caracalla gave his name to baths there, and these were enlarged under Diocletian. Nicomedia and Synnada, in eastern-central Phrygia, had statue bases with identical inscriptions honoring Caracalla in 202, after the capture of Ctesiphon. Another statue honored him as son of Septimius Severus in 212. The city hailed Julia Domna as Mater Castrorum, with a statue and a flowery stele. Prusias ad Hypium, slightly north of the main road east from Nicomedia and about twenty-five miles south of the Black Sea, also devoted some attention to the Severans, in this case to the last of the family. The base of a statue of Severus Alexander set forth his full titles and family relationships descending from Caracalla and Septimius Severus. A similar monument which gave even fuller titles was afflicted with the damnatio so unjustly suffered after this emperor's murder. Two of the emperors under whom so much was done for Asia Minor, Severus Alexander and Gordian the Third, suffered damnatio on a local basis throughout Anatolia after their assassinations by trusted generals.

Dacibyza lay on the road along the Propontis from Calchedon to Nicomedia, about equidistant between the two cities. The sole imperial monument recorded on the site is an altar to Caracalla in the years 206 to 207. At Apameia Myrleia, like Cius the terminus of a road from Prusa to the coast, the city set up a statue in the years 261 to 262 to the emperor Macrianus Junior, who with his father and brother was one of those products of the disturbed decade following the capture of Valerian by the Sassanian monarch Shapur. Bithynium-Claudiopolis, on the eastern road from Nicomedia, received much favor from Hadrian, as the city where his favorite Antinous was born. That the highway was important

in the middle of the third century and that it was given attention in the form of repairs or resurfacing is testified to by a milestone of Traianus Decius.

At Assos, according to an inscription found in the agora, the senate and the people erected a statue of Julia Domna Augusta, Mother of the Camp. The base was reused for another dedication by covering the inscription with a bronze plaque. Pergamon boasted a temple of Caracalla, having a frieze enriched with bulls' heads and eagles supporting garlands, paterae above. The inscription spoke of Caracalla as founder of the new temple, a fact which connects with numismatic evidence: "To the Emperor [Caracalla] from Pergamon, the City of the Third Neocorate" appeared on the epistyle. The decorative motif of the frieze is a Roman version of a Hellenistic design encountered elsewhere in Anatolia in divine or funerary connections. There was also a separate, inscribed dedication to the emperor, and one of his edicts was set up as a stele in the Trajaneum. Elaea, at the junction of the roads from Assos and Pergamon to Smyrna, had a monument, probably a suburban milestone, to Gordianus III. Aegae in the heart of Aeolis, one of the cities restored after the great earthquake under Tiberius, had a dedication to Septimius Severus, and another to Gordianus III existed at Myrina on the coast.

Lydia is rich in Severan and later imperial monuments. A statue of Septimius Severus stood in the Ionian coastal city of Phocaea, southwest of Aegae and terminus of the road through Smyrna to Sardes and Philadelphia. At Magnesia on the Hermos, at the foot of Mt. Sipylus in western Lydia, a total of three bases for statues honoring Septimius Severus have been reported, and Hyrcanis to the northeast has been thought to have set up a statue of Caracalla probably during the winter of 214–215, when the emperor lingered at Thyateira. Septimius Severus appeared in no less than six inscriptions at Sardes. Building "B" at Sardes has an imposing entrance façade to its central room which is dedicated to the Severan family, with Julia Domna as Mater Castrorum and Geta's name erased. The name of the proconsul Asiae has also been removed. Since a palaestra was on one side, the whole thing looks like a complex on the order of the so-called Baths of Caracalla in Rome. Otherwise at Sardes, Caracalla was mentioned twice (figure 165) and Severus Alexander once.

The road from Pergamon to Thyateira to Sardes has yielded milestones of Elagabalus, Gordianus III, and Tacitus, something noted here because works of art connected with emperors after Caracalla and before Diocletian are rare everywhere. Acrasus, halfway point on the section of the road between Pergamon and Thyateira, had a monument with a Latin dedication to Septimius Severus. On the left there was an inscription in Greek to the emperor Tacitus, from the Boule and Demos; the

connection with road repairs seems evident. A small base, a plaquelike fragment, to Septimius Severus was found at Hierocaesareia in Lydia, and Thyateira has a Severan agon, a base to Herakles of the time of Severus Alexander. Other Severan monuments at Thyateira include a statue of Julia Domna, whose inscription leaves some doubt as to whether or not Livia was intended; several enterprising locals were involved. There were two statues of Caracalla commissioned about the time of his visit; an altar with possibly a statue to Severus Alexander has part of his name rubbed out. A milestone set up by the city of Thyateira in the reigns of Carus and Carinus (282–283), with inscription in Greek, has also turned up in the vicinity of Hierocaesareia (Bey Oba). One of the towns lying between the two cities put up an inscribed stele to Elagabalus, who improved the region's roads.

There was a colossal statue of Septimius Severus, with an honorary inscription styling him as "Germanicus," at Hermocapelia, near Jaja Keui, also in Lydia; the base has been recorded. The city seems also to have been author of a statue of Tranquillina, through the offices of an archon named Aurelius Attalus. Apollonis, southwest of Thyateira, has been mentioned in Chapter X as having an inscription to the deified Julia, which could either refer to Livia after A.D. 42 or to Julia Domna who visited Thyateira with her son Caracalla. At Philadelphia the neocorate granted the city in 213 was marked by a stele with pedimented top; on the body the imperial letter granting the honor appeared, and there was a dedication to Caracalla on the epistyle.

The excavations in the Roman agora at Smyrna in Ionia produced a section of soffited architrave, without fasciae. The complete inscription (in Greek) probably honored Septimius Severus, Julia Domna, Caracalla, and Geta, although all that survives is the section mentioning Julia as Augusta and Mater Castrorum, and the dedication by the city of Smyrna. The building must have been contemporary with the Severan bath or gymnasium at Sardes. The passage forming an entrance to the west hall in the agora shows that either Marcus Aurelius and Commodus or Septimius Severus and Caracalla were commemorated again at Smyrna; five blocks of this monumental, fasciaed architrave have not provided enough letters to make the identification more certain. The agora continued to be enlarged, rebuilt, or repaired later in the third century. The excavators found the curved section of an archivolt, with adjoining section of wall, and the inscription indicates the arch came from a building dedicated to Gordianus III.

The sixth milestone in the road from Smyrna east to Sardes was unusual in naming the emperor Aurelianus and his wife Severina (270–275); aside from occasional coins, the leader in the revitalization of the Empire is not much remembered in Anatolia. Since so much of imperial Smyrna has vanished amid earthquakes, fires, and imperial reconstruc-

tions, the monuments on the city's outskirts become a barometer of activity that must have embellished the metropolis. Milestones are poor indexes of imperial activity because they represent immediate work of a mobile sort. Their information is often recorded more than once; in contrast, their epigraphic formulas are frequently indispensable, telling what titles an emperor held during periods of motion and impact, consequent or not, on the broad regions in which clusters of such milestones are found. Thus, the milestone to Aurelian and his wife appears to have been reported in enough varying suburbs of Smyrna to indicate more than one such stones survived. Near Smyrna, on the road to the east, a pillar recorded a monument constructed to Trebonianus Gallus and Volusianus by the "City of the Hyrcanians." In contrast to these road records, Smyrna has yielded two inscribed imperial letters: one from Severus and Caracalla on the Sophists; the other addressed from Valerian and his son Gallienus in the years 253 to 260. And at the modern town of Kassaba, to the east, there was a statue of Septimius Severus, or at least a base for such a statue has been observed. The inscription gives only the three important titles and the name of the emperor.

Perhaps because Septimius Severus was so busy in Africa, Ephesus seems not to have accorded him the architectural honors bestowed on the Antonines. Also, the city had just enjoyed such a prosperity of building that perhaps the need for public structures had been satisfied. There is some evidence that Ephesus had an altar complex to the Severans, perhaps a smaller version of the Great Antonine altar. There was a dedication to Caracalla and Geta in the theater. In any case, a rival metropolis such as Sardes seems to have enjoyed more imperial attention. And Hierapolis, near the headwaters of the river Maeander in Phrygia, had a porticus with bilingual inscription to one of the Severans, most likely Severus Alexander, since the title Persicus appears. This would date the structure, located near the city gate and the agora, at 232.

Dorylaeum in northern Phrygia has produced a curious, nonimperial manifestation of the Greek method of honoring important persons during the Roman period. This commemoration recalls the way the cities of the Greek world paid tribute to Hadrian at the temple of the Olympian Zeus in Athens. Between 212 and 253 ten or twelve bronze statues on inscribed bases 2.50 m. high were set up by various city tribes to the Equestrian Q. Aelius Voconius Stratonicus (Acamantius). The statues were removed and the bases bundled without ceremony into the city walls between 253 and 270, a low point in the fortunes of imperial Asia Minor.

A marble *miliarium* in the names (in Latin) of Septimius Severus, Caracalla, and Geta — the last-named chiseled away — has been recorded at Nacoleia (Seyit Gazi) in north-central Phrygia. Much work

was done on the roads in this area under the Severans. Nacoleia also had a marble base or bomos honoring the emperor T. Flavius Julius Quietus, a flowery dedication to this rarely remembered member of the "Thirty Tyrants" of A.D. 260 to 261. Asia is said (Zonaras, xii, 24) to have welcomed the rule of Macrianus and his two sons, Quietus and Macrianus the Younger. Macrianus Junior was also honored at Apameia in Bithynia, and perhaps Nacoleia's bomos is the remains of a dedication in which the whole family was honored with statues. The same might be said of the inscription at Apameia. To the southwest, near Synaus or Cadi, there was a monument to Philip the Arab and his son; it was a petition (in Greek) from the Proconsul Marcus Aurelius Eglectus and the imperial reply (in Latin) in connection with public works.

Laodiceia Combusta in Lycaonia (Ladik or Yorghan Ladik) had a statue to Julia Mamaea with inscription in Latin, set up by the liberti of the imperial estates. A round column with inscription to Marcus Aurelius Probus in Greek and Latin probably served as a milestone, but a similar dedication to Carus, Carinus, and Numerianus was more likely an honorary column. This was the period in which vigorous generalship did so much to repair the devastation of previous decades in Anatolia and on the eastern frontier. At the other Laodiceia in the upper Maeander Valley, Laodiceia ad Lycum (Λαοδίκεια ἡ πρὸς τῷ Λύκῳ), the Phrygian city of great ruins admired by the eighteenth-century travelers, there was a building with inscription to Iulia Domna Augusta, according to a preserved section of the architrave; she probably had a statue in conjunction with this monument. Another dedication honored Septimius Severus.

Apameia in southwest Phrygia (Dinar) yields all too rare mention in Asiatic honorific inscriptions of Salonina Augusta and the young Cornelius Saloninus Valerianus Caesar. Both sons of Gallienus are mentioned as being Augusti, a fact which dates the monuments involved between the years 257 and 259; in the first year the younger son became Augustus, and in the second the elder was killed. Roman Lunda, due west, had a statue of Septimius Severus, and the fourth milestone on the road to Peltae was dedicated to Traianus Decius and his whole family in 249. At Acmonia there was an altar to Dionysos and the emperor Marcus Aurelius Severus Alexander. Septimius Severus was named in an honorific inscription commissioned by the city of Diocleia, a few miles to the east. This city also had a statue of the emperor, put up late in his reign by local officials who had served earlier in various capacities. Trajanopolis, about twenty miles west of Acmonia on secondary roads, displayed a statue of Trebonianus Gallus, paid for by local officials and accorded damnatio after 253. On the stretch of the great highway from Appia to Acmonia a milestone was set up between 209

and 211 in the name of Septimius Severus, Caracalla, Geta, and Julia Domna. Geta's name was later rubbed out and so was the title Sebastos after the official names of Caracalla.

The great nymphaeum façade at Miletus poses certain problems. The building seems to have been enlarged or rebuilt under Gordianus III, and a number of statues must have been made for its adornment. It has been rightly observed that these statues are among the few sculptures in the round of the period, and although mostly copied from works of classical and Hellenistic times they reach a good technical level of work. The upper architrave was inscribed in Greek to the emperor, in the years 241 to 244. The lower part of the building, that is, the lower architrave, has been discussed in connection with Trajan and his father who was Proconsul of Asia in A.D. 79 and 80. No doubt a number of the statues used in the building as enlarged under Gordian belonged to the Trajanic structure, but there must have been new commissions necessitated by the size of the building as finally completed. The statues varied in subject and style: a Muse, a nymph, a Silen, a copy of the Pasitelean "Electra," a nude hero or a ruler in heroic guise, a Nike of the type close to representations of Artemis, a fountain nymph of the usual type, Venus Genetrix, and other representations. Elsewhere at Miletus there appears to have been an altar to Julia Domna in the Bouleuterion. In the South Market a statue of Severus was put up by the city which regarded itself as first in the Ionian confederacy.

Among its many dedications to and records of Hadrian and the Antonines, Aezani in northwest Phrygia exhibited a letter from Septimius Severus, circa 196, with the emperor's full "genealogy" from all the Antonines; the document was a solicitation of good relations at the time of his campaign against Pescennius Niger. At Meiros, about thirty miles to the east, there seems to have been an imperial shrine to Gallienus and his wife Salonina. The city set up an altar to Salonina, and the two larger road centers of Nacoleia to the northeast and Prymnessus to the south offered a dedication to Gallienus.

Eastward in the Phrygian hinterland, at Apollonia in east Asia or western Galatia, traces from the Severan period are few, despite the importance of the imperial cult in the time of Tiberius. A statue of Septimius Severus, probably dedicated in 198, did exist, the gift of a prominent local citizen, and a milestone in the name of Septimius Severus and Caracalla is recorded for the years 199 to 208. Another monument to Caracalla, probably a statue, was dedicated by the Boule and Demos. The neighboring area of Docimium, Prymnessus, and Acroenus has produced a milestone of Septimius Severus (at Afion), a base to Julia Domna (at Seulun), and a base to Caracalla (also Seulun). The base to Julia Domna was for a statue from the Procurator Asiae and the imperial Legatus; the same two gentlemen, Q. Tineius Sacerdos and Domi-

tius Aristaeus Arabianus, also paid for a similar statue at Synnada. Synnada also had a statue of Septimius Severus dated after 195, and another of unknown date. The first is evidently the one ordered by Aurelius Sanctus and Plautia Agrippina. The statue of Severus at Docimium was put up during the last decade of his reign, with flowery titles in the dedication from the city. An altar to Zeus Pandemos (at Şoğut) was dedicated in the names of Septimius Severus, Caracalla, and Geta by two men who dedicated various other things and seem to have been responsible for a building with an inscribed entablature, that is, a gateway or stoa. At Metropolis the prominent local citizen G. Aurelius Sosthenes or Zosimus dedicated a statue of Septimius Severus in 197, the base being recorded in the cemetery at Horu.

Sebaste put up a dedication to Septimius Severus, through its board of magistrates, and a statue of Caracalla. Its vicus or suburb Dioscoma dedicated a monument to Philippus I and the imperial cult in 245 or 246. At Eumeneia in 196 Septimius Severus received epigraphic credit because Vitellianus, Procurator of Asia, came to the aid of the city, then a garrison town, and restored the Praesidium of the Camp which had "collapsed" in an earthquake. Ilyas to the southeast had statues of Severus and Julia Domna, perhaps on a double pedestal. She was saluted as Mater Castrorum. The dedication was by M. Aemilius Longus, who also founded athletic festivals. In the years 202 and 203 the city of Tacina, southwest of Lake Ascania on the road to Cibyra, erected baths in the name of the Severan family. Julia appeared as Nea Hera; Geta's name was erased from the inscription. There were many milestones of Severus and his family in the region of Lake Ascania, dating repairs to the road system to the year 205. At least six of these, not previously mentioned, have been recorded. The small city of Bruzus or Brouzi, northeast of Eumeneia, dedicated a statue to Severus; another was presented to the emperor from the people of Pisa or Pisea on the Lycaonian border through one of their important citizens, Philaios Marionos Eumenes.

At Aphrodisias in Caria there may have been priestesses of the cult of Julia Domna, who was styled the New Ceres, although the Thea Ioulia referred to has been identified as the deified Livia. Otherwise, there was a statue of Caracalla, executed with proceeds from the bequest of Flavius Attalus. The recently excavated Bouleuterion had an inscription to Septimius Severus. In connection with a statue of Severus Alexander at Sebastopolis in Caria, the *curator reipublicae,* P. A. Antiochus, is mentioned; after Alexander's murder the inscription suffered partial damnatio. There was also a statue of Julia Domna or Mamaea, the base made of local red marble; it was in the name of the Boule and Demos, from local archons who were epimeletes for erection of the statue. Cidramus, about fifteen miles to the southwest, set up a statue

to the emperor Valerian (253–260); the base was taken from an older monument, perhaps a dedication to Otacilia Severa, who suffered a form of damnatio in 249.

In Lycia, Balbura commissioned a dedication to Septimius Severus and Caracalla. Termessus Minor, on the main road to the south, has yielded a very important inscription in connection with images of the emperors in the provinces. In the time of Valerian they were carried in regular processions to and from the temple of the imperial cult. They were made of gold, silver, and gilded bronze. At Oenoanda, to the south a very few miles, stood an altar to Septimius Severus. The coastal road from Telmessus to Caunus in Caria must have been repaired at this time, for a milestone to Septimius and Caracalla has been found near Cadyanda. Combis, to the southeast, has provided further evidence for Valerian's popularity in the area; in 256 the Boule and Demos put up a statue of that ill-fated ruler. At Arycanda, farther to the east and on the main road to Phrygia, a dedication from the Boule and Demos to the family of Valerian and Gallienus appeared in 258. Idebessus, to the north, raised funds for a statue of Caracalla, and several cities in alliance picked the site to honor Gordianus III with a dedication. The coastal road and the Phrygia road met just south of Limyra; the Severans made some repairs there in 198 to 199 and were credited on a milestone. Corydalla, just to the east and on the coast looking toward Pamphylia, had a statue of Septimius Severus, set up in the last year of his reign.

Sagalassus in Pisidia made much of the Severan house, there being an honorary arch or column to Septimius within the temenos of the temple of Antoninus Pius and dedications to the other Severans elsewhere. The total includes two statues of Septimius, two of Caracalla, and a dedication to Severus Alexander by a priest of the emperor. A six-sided statue base to Septimius was found under the propylaea northwest of the temple of Apollo Klarios; the inscription spares no praise in its glorification of the emperor. After the Severans, there is an imperial silence until a dedication to Gallienus and Salonina. Conana, to the north and northeast of Lake Ascania, set up a statue of Septimius Severus, from the Boule, the Demos, and the "Roman inhabitants." South of Sagalassus, at a place now called El-Majiik, the base of a statue of Julia Domna as Mater Castrorum, from the Boule and Demos, has been found. At Milyas, in south-central Pisidia, Septimius Severus had a statue among the Antonine family, into which he had "adopted" himself. This statue stood with at least five others, one being Caracalla, at a building dedicated to Antoninus Pius. Southwest, Termessus Major put up a statue to Septimius and another to Caracalla. Hadriani, an old site refounded in the reign of the great traveler, has produced a large statue base of Caracalla, dedicated by the Boule and the Demos.

Moulassa had a statue of Septimius as "savior of the universe," from

the Demos. Cremna, the great Roman colony roughly between Sagalassus and Termessus Major, set up a statue to Caracalla; an epistyle was inscribed in Latin with a dedication from the priests of the colony in 196 or 197 to Septimius Severus, Julia Domna, Caracalla as Caesar, and Julia Maesa. The last, Julia Domna's sister, was to appear in a larger role on the imperial stage when partisans of the Severan dynasty placed first Elagabalus and then Severus Alexander on the throne. Both cousins were grandsons of Maesa. Pogla, to the west near the Phrygian border, honored Caracalla and Julia Domna with an inscription, dating about 213 or to the period when they were resident in Phrygia. Adada, northeast of Milyas, produced another of the inscriptions referring to imperial images, a statue base recording that a man of the third century offered sacrifices to them and made celebrations in their honor. This benefactor's statue stood along a street just north of the temple of the emperors.

Attaleia in Pamphylia is rich in evidences of imperial statues put up during the years from 193 to 284, the Severan age and its disturbed aftermath. Statues were set up simultaneously by the Gerousia, and the Council and the People, to Julia Domna in her role as Mater Castrorum. A votive to Elagabalus and his cult has been partly erased, and a statue on a round base was commissioned in 244 to celebrate the accession of Philip the Arab. In or after 242 the Gerousia of Perge set up statues to all three Gordians, Gordianus I and II having perished in 238. At Side a dedication to Julia Domna also mentioned Caracalla.

Hadrianopolis lies far to the north on the border between Bithynia and Paphlagonia, not far from Bithynium-Claudiopolis and Creteia-Flaviopolis. A statue of Septimius Severus was found at Tchukur-Keuï, a modern site near Hadrianopolis, and a dedication to the same emperor has been observed where the ruins are. At Ancyra in Galatia records have been made of an altar in the name of Severus, Caracalla, and Geta (Caesar), with the latter's name erased, and of another dedication to Caracalla. Cinna, near Pessinus and southwest of Gordion toward the headwaters of the Sangarius River, had a dedication to Gordianus III.

Cilician Isaura's several triumphal arches on the acropolis included a plain, solid structure, with elaborate titlature, from the Boule and Demos to Severus Alexander. This monument is an excellent demonstration of the fact that the Greek world combined the elaborate inscription with practical or relatively austere architecture in its honoring of Romans. Sculpture was brought into prominence in connection with individual statues or statues on decorative façades. A statue of Septimius Severus has also been recorded on the site.

Charadus lay on the Cilician coast, opposite western Cyprus and midway between Selinus and Anemurium. Between 199 and 210 one Antonius Balbus set up a statue of Septimius Severus there, hailing the emperor as ruler of the universe. An inscription to Septimius and Cara-

calla at Claudiopolis, well inland on the road from Seleuceia to Laranda, may come from a building. At Olba, inland from Seleuceia and Corycus, a dedication honored the whole family of Septimius Severus (with damnatio reserved for Geta). Corycus' share of Severan monuments include an altar to Septimius and a statue to Julia Domna as the new Hera and Mother of the Camp. In the temple of Zeus, the religious center of the region, a dedication to the brotherly love of Caracalla and Geta was put up between 211 and 212; when Caracalla murdered his brother, the latter's name was erased. Severus Alexander was a major benefactor of Tarsus, and one long inscription to him occurs on the base of his statue. At the Cilician Gates a large, lengthy inscription in Latin saluted M. Aurelius Antoninus Pius Felix Invictus Augustus (Caracalla) and another emperor (Alexander?), who restored the road and bridges all the way to Alexandria.

The triumphal arch at Caesareia by Anazarbus in eastern Cilicia appears to belong to the Severan period, a dating arrived at chiefly by the style of the ornamental carving. It may have been a triple arch; the easternmost entrance has an elaborate entablature, with enriched cornice, scrollwork frieze, and a well-carved architrave. The entablature is broken to the left and right of the arch, for freestanding columns. The keystone has a head in relief, and in the scroll of the frieze are animals and an Amorino aiming his spear at a bull. A milestone of the reign of Alexander Severus suggests that this arch might have been recent enough work to call forth the following lofty adjectives, "Two miles from Anazarbus, the First, Greatest and Most Beautiful; the Glorious Metropolis of the Three Provinces — Adorned with Roman Trophies, honoured with the Greatest and Choicest Privileges." Along the coast again, there was a dedication to Septimius at Aegeae on the northwestern side of the Gulf of Issus.

At the great city of Comana in the heart of Cappadocia, northwest of Cocusos, there was a dedication or statue to Publius Licinius Cornelius Valerianus, older son of Gallienus, who perished in 259. Other statues honored Gallienus in the years 253 to 268 and Probus in 276 to 282. The roads radiating from Cocusos have produced many milestones, including examples for the Severans, Gordianus III, Philippus I, and Trebonianus Gallus. Various legates were in charge of repairing this important system of communications between Anatolia and Armenia or Mesopotamia.

The Roman colony of Faustinopolis, created out of the town of Halala where Faustina wife of Marcus Aurelius died in 175 or 176, is now identified as having been located at the village of Başmakçı southeast of Tyana; a Latin dedication to Gordianus III, styled Invictus Augustus and dated A.D. 239, has recently come to light there. The stone seems to be the base of a statue set up by the magistrates and people of the colony.

The final area of Severan imperial commemoration is at Pajas and Alexandria (Iskenderûn), the former being over four hours north of the latter by the old methods of travel. A statue base to Septimius Severus was found at Pajas, and a triumphal arch between Pajas and Iskenderûn, a few minutes south of Merkes-Kalesi, has a single gate. The structure has been dated to the reign of Septimius Severus, and it has been suggested that the monument commemorated his defeat of Pescennius Niger at Issus in the winter of 193–194. Another statue base to Septimius seems to have been recorded near Alexandria.

Side, back along the coast to Pamphylia, effectively demonstrates why there are not more monuments of Roman art in Greece and Asia Minor in the generations between 220 and 280. The area was so hard hit by barbarian and Sassanian invasions that there were few funds and talents for undertaking new enterprises. When sculptures were not being melted down or reused in hastily erected city walls, they were being employed over again for new dedications to new emperors or officials. Building "B" was evidently the Capitolium or praetorium at Side. The monumental niches of this Antonine structure held statues of gods, imperators, and citizens (male and female) mixed together. One of these statues was a likeness of an Antonine imperator in a cuirass. The head had been sliced off and replaced by a portrait of Maximus Caesar (235–238). The excavator has suggested that the new head is a likeness of Licinius, early in the fourth century. The identification is not extremely important; what is worthy of consideration is the fact that the statue was altered at least once after its creation. The emperor originally represented may have been someone like Pescennius Niger who was defeated; more likely, the statue was decapitated and refurbished with another head merely because the sculptors of Side could no longer readily turn out, or the local plutocrats could no longer import, a new cuirassed statue worthy to stand in the city hall.

The third century began with seeming artistic continuity after the unfortunate interlude of civil wars. New public buildings and new statues were erected or installed, but by degrees more commemorative effort seems to have gone into utilitarian, dull, unartistic milestones. After Alexander Severus there was a brief round of activity under Gordianus III, but Romans and the Greeks who honored them were too busy building defenses against each other or common foes such as Huns or Sassanian Persians to order many new portraits or new ensembles in which to set them. It was the age of the soldier or civil defender not the bronze-caster or architectural carver. Where new statues and inscriptions existed, they often represented the reuse of older works of art or carved stones. In contrast, the coinage of the years 250 to 270 is rich and varied, with many new designs struck on large surfaces.

XV

*The Tetrarchs
in Greece and Anatolia*

THE PERIOD OF Diocletian, Maximianus, Galerius, and Constantius
Chlorus is relatively short in terms of the Antonine dynasty or the Sev-
erans and their military successors. The years from A.D. 284 to 307,
however, mark a turning point in the renewed fortunes of Greece and,
especially, Asia Minor. For a brief time the Greek world became Roman.
The flame of *Romanitas* burned brightest in the East before the eastern
part of the empire became culturally subordinated to a late classical
Hellenism in the tradition of Ptolemy Soter or Hadrian. Greek imperial
coins disappeared, save at the mint of Alexandria in Egypt, and after
296 a uniform mintage with standard types and Latin inscriptions char-
acterized the Greco-Roman world from Antioch in Syria to the mint
of London. With the exception of imperial palaces in the garrison cities,
there was not so much renewed activity in building as systematic desire
to glorify the Tetrarchs. The Hellenistic world was made to realize that
these four emperors, Illyrian soldiers of partly Roman stock and guard-
ians of the virtues of power, were restorers of imperial tradition and
divine purveyors of the material benefits of a Roman peace.

Considerable attention was devoted to walls and roads, the geographic
fortifications of empire. The Tetrarchs are most often honored by in-
scriptions suggesting the completion of defenses started in the previous
generations or by milestones which measure in literal fashion imperial
leadership in rearranging vast areas of the Anatolian highlands. Tetrarch
civic and military inscriptions are usually found on major Antonine (and
earlier) monuments or on small, showy creations of their own times,
such as stelai and milestones. They testify as to the power induced by
four emperors whose force ranged over a civilized world and was but-
tressed entirely by the armies. The legions were temporarily purged of
their desire to overthrow the new order of government.

ART AND INSCRIPTIONS

The rulers of the new government continued the process of recon-
struction, and the Greek world documented their efforts with suitably

effusive inscriptions. In several places they built great monuments of art as well as architecture. Their triumphal arches at Salonika and Nicaea are examples of a Roman form of art introduced into areas which had known few such historical monuments. Roughly half of the Arch of Galerius at Salonika has survived, but only random reliefs from the arch at Nicaea remain, reused in the city walls and gates.

At traditional centers of Roman art, such as Ephesus, the Tetrarchs rebuilt Flavian or later sites and made these older ensembles into commemorations of themselves. They received their share of statues, chiefly at cities such as Nicaea and Nicomedia, centers of power in the new era. These rulers did little for the classic Greek centers of religion and culture such as Olympia, Athens, or Delphi; two of these areas had been ruined by barbarian invasions, and Athens was struggling back from partial devastation in the previous generation. The Tetrarchs were men of action, and perhaps it was enough for the Greek world to be relieved of external dangers in an era which did not produce rulers like Hadrian. It remained for Constantine the Great and his family, one and two generations removed from the original Tetrarchs, to make the East a new center of intellect as well as of political security.

In Greece, fragments of a heroic bronze statue of Licinius I have recently come to light in Thessaly, and the face of a lifesized likeness of Galerius may be identified among the marbles in the Nauplia Museum (as no. 13287), found in 1956 at Titani. Half of the back of the head and most of the chin are missing.[1] Diocletian has been seen in a lifesized head of unknown provenance in the Athens National Museum.[2] The sculptor tried to fit Hellenistic plasticity into a cubic frame. He has succeeded quite well, in that the head combines strong modeling of forehead, eyes, and beard with the austere profiles of the Tetrarchs as seen on their coins. This is not the splendid type of the head from Nicomedia but the forceful portrait of the Arch of Galerius period. The head probably derives from a statue of Diocletian dressed in himation or toga; the back of the head was summarily worked.

Besides these fragments of statues, there are a few epigraphic indications that art flourished elsewhere on the Greek side of the Aegean than at Salonika. Strictly speaking, Heracleia-Perinthus west of Byzantium belongs in the Anatolian world. The city had a group of statues of the four rulers of the First Tetrarchy. Attica had a total of four inscriptions to Diocletian and Maximianus, and one to their junior colleagues Constantius and Galerius. Corinth set up dedications, on revetment-plaques, to Diocletian and Galerius Caesar, in the region of the northwest stoa. At Sparta there was an honorary column to Constantius Chlorus; Asopus also set up a dedication to him. Near Thuria in Messenia, the eleventh milestone bore the names of Diocletian and Maximian (286–305). Tegea commissioned a statue of Diocletian.

329

On the island of Thasos, a statue of Constantius Chlorus stood, probably in the agora. It dates in the years (293–305) when he was Caesar, and since his monuments are never found alone in the East the statue must have been accompanied by one of Galerius and perhaps others of Diocletian and Maximian. Among the other Greek islands there are a few monuments of the Tetrarch period, isolated souvenirs of imperial passages between Italy or the Balkans and Asia Minor. They form somewhat of a contrast to the poverty of monuments in Greece itself. In a ruined chapel on Samothrace the Austrian expedition of the period shortly before 1880 found a statue base to a member of the family of Constantine the Great, work of the years between 317 and 337. It had been recut over an honorary inscription to Severus and Galerius or Maximinus Daza, that is the period of struggle in the so-called Second Tetrarchy. At Amarynthus, near Eretria on Euboea, there was a dedication to Diocletian and his four colleagues, for the years 292 to 305; the name of Maximianus was later erased.

Near the Pythium, at Gortyna on Crete, the excavators uncovered pendant statue bases to Maximianus and Galerius, from a monument set up between 292 and 305; Constantius, junior colleague in the West, and Diocletian, senior colleague in the East, also must have been present. In the Heraklion Museum (no. 191) there is a superb marble head, wearing a lion's skin. It is a Greek version of the cubist style, with Hellenistic eyes. It is certainly a Tetrarch and most likely Maximianus Herculeus (figure 170). Milestone VII on the road from Cypriote Curium to Paphos was used by three rulers over the span of a century: a Greek dedication to Aurelian (270–275) was followed by Latin inscriptions to the Tetrarchs and to Jovianus (363–364).

Commemorations for the Tetrarchs begin on an extensive scale in northwest Asia Minor, at Nicaea and Nicomedia. One of the most splendid surviving heads of Diocletian was unearthed at the latter city. He is crowned with a large oak-wreath, part of the equation with Jove found so often in inscriptions and on coins (figure 169).[3] Diocletian had enlarged the baths of Caracalla and given the city a basilica, a circus, a palace, a mint, and an arms factory. Evidence of concern with the imperial highways comes from Bithynium–Claudiopolis, where a milestone of the years 293 to 305 has been recorded. A dedication to the four rulers was observed in the vicinity of Coryphantis, on the road from Adramyteum to Smyrna. The only imperial monuments later than an altar to Hadrian to be discovered at Troy are a dedication and record of honors paid Zeus and Minerva in the names of Diocletian and Maximian, in the years between 293 and 305, and a statue of Constantinus II, probably in 324.

Larissa in southern Aeolis put up a statue to one of the three rulers struggling for control of the Roman world, A.D. 311 to 313. The dedi-

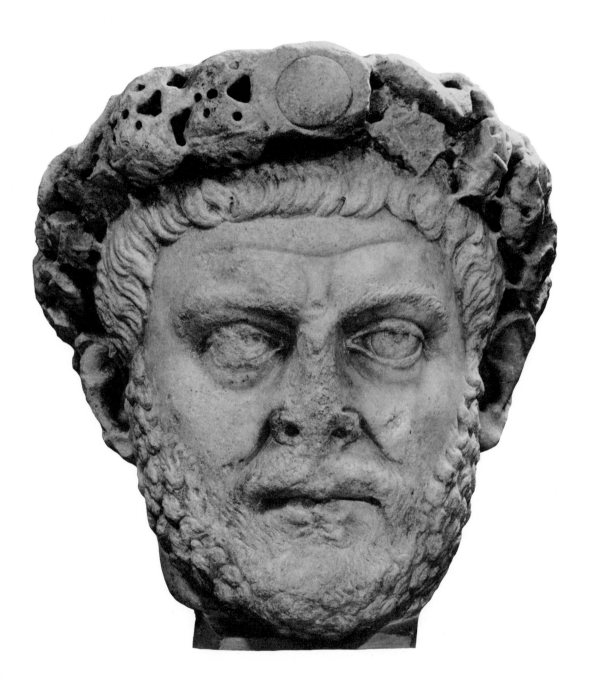

169. Diocletian, from Nicomedia

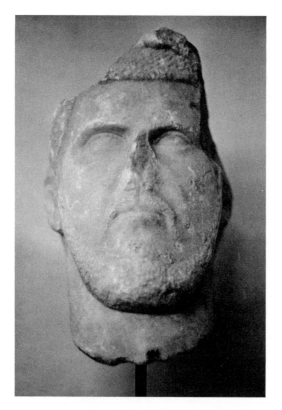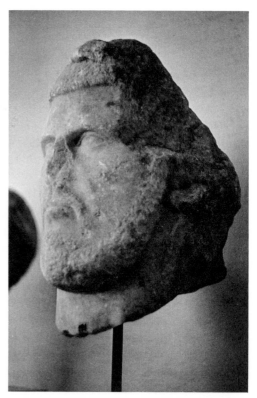

170. Maximianus Herculeus, from Gortyna

cation is to Galerius Maximianus or, more likely, Maximinus Daza (readings vary), Constantine the Great, and Licinius Senior, but the base was large enough for only one statue. Probably there were other bases with similar inscriptions and with statues of the other rulers. A Tetrarch milestone stood on the road from Pergamon to Myrina, on the coast to the northeast. In Lydia, Sardes honored the four original Tetrarchs with a single inscription, the first such imperial commemoration (among those recorded) since Severus Alexander.

A milestone at Thyateira in Lydia was used twice: at its creation during the First Tetrarchy (292–305), and by the three sons of Constantine the Great (337–340). In each case the inscription was recorded in Greek only. The road from Pergamon to Sardes via Thyateira appears to have been repaired under Diocletian. A similar use or reuse of a marble column was made in the region of Kula, a medieval city in eastern Lydia: there a Greek inscription (299–302) speaks of the Tetrarchs, while a Latin inscription (323–326) honors the family of Constantine the Great. Extensive overhaul of the roads radiating from Smyrna is reflected by at least seven milestones for the twelve years

following 293. They have been found at Metropolis, Lebedus, and Temnus, to cite three centers in the wide radius of Smyrna.

After Salonika, Nicaea, and Nicomedia, Ephesus is the first city which offers traces of the art of the Tetrarchy commensurate with what was put up in the Latin West, at Milan or Trier and, especially, in Rome itself. A monument of the Tetrarchs was set up by Diocletian "for the good of the imperium" before Hadrian's temple on the main street of Ephesus (figure 141). The inscriptions were in Latin, and the Proconsul Iunius Tiberianus was the responsible official. There were bronze statues of Diocletian and Galerius and of Maximianus and Constantius Chlorus on columns. The effect must have been identical to that created by the statues on columns placed in back of the Rostra of the Forum Romanum to commemorate the first decade of the Tetrarchy. One of the sculptured bases from this group in the Roman Forum survives, and a view of the whole ensemble appears in the background of the *Oratio* relief on the Arch of Constantine, a relief carved ten years after the columns were set up.[4] The columns and statues at Ephesus were certainly put up on the main street in front of Hadrian's temple on account of the powers of association with a "good" emperor who did so much for Asia Minor, just as Hadrianic reliefs were used on the Arch of Constantine in Rome. A statue of Theodosius, father of the Emperor Theodosius I (375–392), was also placed in front of the temple of Hadrian, and the frieze of the building was rebuilt to include a relief honoring the Ephesian Artemis, the heroized deceased, and Theodosius I.

At the same time that the statues of Tetrarchs were set up in front of the temple of Hadrian, a statue of Diocletian was erected in front of the northern basin of the nymphaeum on the east side of the Street of the Kouretes. A statue of Maximianus was placed in front of the southern counterpart of this basin. The nymphaeum was originally Augustan and was probably restored under Geta; the fountain building was restored again in the time of Theodosius. Another fountain building, erected about A.D. 10 in honor of Sextilius Pollio, was enlarged under Domitian and stood on the square with his temple. Diocletian, like earlier rulers, was clever to realize that water control in the arid East was a most important way to win respect as a benefactor or recipient of commemorative inscriptions. Diocletian was also honored with a dedication in Latin in the theater. It has been suggested that either Diocletian or Constantine the Great was responsible for rebuilding the gymnasium at Nysa on the Maeander, east of Tralles. The base for a colossal statue was found inside, and this statue may have represented the imperial donor.

Diocletian was active in repairing the roads leading south of Dorylaeum in Phrygia, and a miliarium of the First Tetrarchy in that city

(Eskişehir) survives as witness to this work. At Aezani, to the southwest, Aurelius Eumenos Merogenos dedicated an altar to Diocletian. Hierapolis, well across Phrygia to the southeast, produced an interesting milestone with multiple imperial inscriptions. The road was first repaired under Probus, whose name was erased. Diocletian's titles were added in the years 284 to 286, when he was sole ruler. Between 286 and 292 Diocletian and Maximian were immortalized on the stone in Latin. In the last year or thereafter the Caesars Constantius Chlorus and Galerius Maximianus joined the list, by way of an inscription in Greek.

Laodiceia Combusta in Lycaonia had an altar to Maximinus Daza, to Constantine the Great, and to Licinius, a dedication of the years between 308 and 313. These three rulers controlled East and West after the death of Galerius in 311 and the defeat of Maxentius in the following year. Daza was defeated by Licinius and died in 313. These altars, like the comparable statue bases, came in groups according to the number of rulers involved. Laodiceia Combusta produced another altar or bomos to the same triumvirate, perhaps connected with the first monument.

At Colossae, in southwest Phrygia, a pedestal seen in the nearby town of Honaz gives a Latin dedication of the years 305 to 306 to the junior pair of the first Tetrarchy as Augusti. The name of Galerius (who died in 313) has been erased, perhaps because of his activities against the Christians. Heracleia Salbace's collection of milestones includes a bilingual to the First Tetrarchs and a shaft used by four sets of emperors in the years from 300 into the fifth century. The original inscription honors the Caesars Constantius Chlorus and Galerius Maximianus (probably along with their Augusti), and above or over it the sons of Constantine as Caesars, Arcadius and Honorius, and, finally, Theodosius II and Valentinianus III have left records of their power. Docimium made a dedication to the Tetrarchs, and the city used the memorial to pay homage to Constantine, Licinius, and Constantine the Second in the years from 317 to 323.

Apameia in south-central Phrygia (Dinar) seems to have had statues of Maximianus Augustus and Galeria Valeria Augusta, his wife. Near Tacina to the south, on the road toward Cibyra at the modern village of Karajuk Bazar, several nineteenth-century travelers recorded a milestone to the Tetrarchs, with the usual titles and compliments. Synnada, northeast of Apameia, had a statue to Constantius Chlorus as Caesar put up by a procurator, and a milestone at nearby Altı Hisar honored the First Tetrarchs and, later, Constantine and Licinius with Greek inscriptions. The stretch of the great eastern highway that passed from Acmonia to Appia had Tetrarch milestones at the sixth and thirteenth miles from Appia. Several milestones testify to the activity of Diocletian's engineers on the roads leading from Lake Ascania and Cibyra

into Pisidia and Pamphylia; others were on the principal roads to the immediate northwest.

In A.D. 286, authorities under Diocletian and Maximian used the southeast wall of the theater at Aphrodisias in Caria to tell the local populace that for divine and political reasons they should "rejoice at the establishment of our reign" and "offer due sacrifices and prayers." "Hope for the future" was held out under the rights granted by the Romans. This use of a major monument for purely propagandistic commemoration rather than as a testament of construction carried out is characteristic of Tetrarch efforts to make the Greco-Roman world seem to live again as it had in the *res gestae* of Augustus and Hadrian. This is illustrated by the fact that Diocletian's price edict was carved in Latin on the walls of a temple at Stratoniceia in the center of western Caria; elsewhere in Caria fragments of one or more copies have been found at Mylasa.

The southern coast of Anatolia has not produced many works of art of the Tetrarch period, but there are certain traces of activity, mostly functional. A milestone to the Tetrarchs has been found between Pydnae and Xanthus on the southwest coast of Lycia. Farther along the coast to the east, the city of Aperlae dedicated a large inscription as well as statues to the Tetrarchs in the years between 292 and 305. This suggests that the harbor town may have been one of the few in the region to boast an imperial Kaisareion at this date relatively late in the history of Roman Asia Minor. On the borders of Sagalassus, far to the north in Pisidia, a dedication to the Tetrarchs was recorded on the site now called Deir or Düver, whence the inscription was taken.

Between 292 to 305 the Boule and Demos of Hadrianopolis in western Paphlagonia, on the border of Bithynia and south of the Euxine at Amastris, set up a statue of Constantius Chlorus. As the Western Caesar, he could hardly have stood alone, and there must have been comparable monuments to his Western overlord Maximian and their two Eastern counterparts. Along the southern coast in Cilicia, at Corycus, the city at the mouth of the Kalykadnos, a Greek milestone on the side of the main street gives the names of Constantinus Caesar and Valerius Maximinus Daza and is thus datable 306 and 307; Daza's name has been partly erased. In Cappadocia, the triangle of roads from Comana to Cocusos to Arabissus held the key to highway travel from Anatolia to Armenia and Mesopotamia. Recognizing this, the Tetrarchs carried out considerable works of maintenance, and these are reflected in at least eight milestones. Often the inscriptions were carved on older milestones, and those most frequently rededicated belonged to the era of road repair under Septimius Severus. Markers set up under Philippus I by his faithful legate M. Antonius Memmius Hiero, and even those bearing the name of Elagabalus, were pressed into service.

THE ARCH OF GALERIUS

THE SETTING OF THE RELIEFS

As a monument of Roman historical art in Greece, the Arch of Galerius (figures 171–176) is both a great document and a great disappointment. It is the former because so much is preserved, particularly of the figured sculpture of the pillars; it is the latter because, tragically, somewhat less than two pillars of a tetrapod arch with flanking arched passageways survive. The admirable publication prepared by K.-F. Kinch in 1889 has long enabled students to trace the events of Eastern campaigns in the last decade of the First Tetrarchy. These campaigns are represented on the areas between the base-moldings and the arches above the two surviving pillars. Kinch's reconstruction of the upper part of the central passageway of the arch was put forth in modest, tentative fashion, but it seems perfectly in accord with more complete, less interesting arches standing elsewhere in the Eastern Empire.[5]

The focus of the design was the four statues in the four niches (the lower parts of two remain) to the left and right above the pillars of the central passageway. The two statues on the northwest, the preserved side, no doubt represented Maximianus Herculeus and Constantius Chlorus, while the statues facing southwest completed the Tetrarchy, Diocletian the Augustus and Galerius, the principal hero of the monument. In keeping with the overtly military themes of the surviving sculptures, these statues would have presented the rulers in military dress. A second, less likely, quartet for these niches could have been Hercules and Mars on the west and Jupiter and perhaps Virtus on the eastern façade. These statues would have honored the leading divinities of the Tetrarchy, including Virtus, who figures very prominently with Galerius in the sculptures of the surviving pillars. A slight modification of the suggested pediment of Kinch's reconstruction would have left room for two more general personifications in the Greek tradition, perhaps Oikoumene on one side and the Tyche of Salonika on the other. This suggestion should not be emphasized, for the Greek residue is subjective rather than objective and personifications of this type appear in the schemes of the pillar-panels.

In his analysis of the scenes, Kinch deduced that the right-hand pillar (the southwest, along the Via Egnatia from west to east) commemorated the war in Armenia and the left-hand (northeast) pillar honored the victories achieved in Adiabene or the area of ancient Assyria. This would have left the Median campaign in the Persian heartland and one other for the two totally destroyed pillars; one of these, however, may have held reliefs which gave a general summation of the glories of the Tetrarchy. Not only the location of the wars but the arrangement of

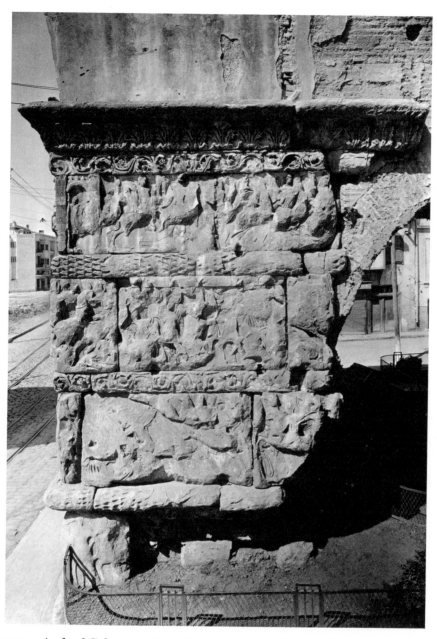

171. Arch of Galerius at Salonika: northeast pillar, southeast face

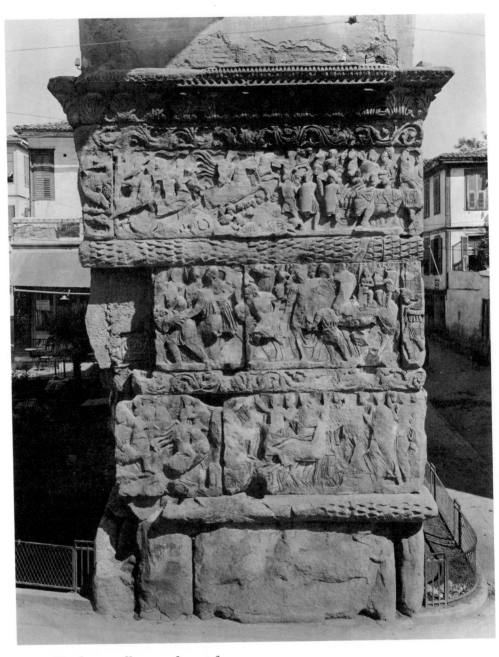

172. Northeast pillar, southwest face

338

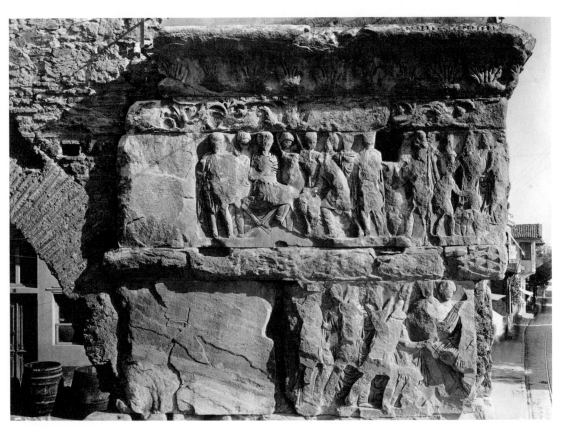

173. Northeast pillar, northwest face

339

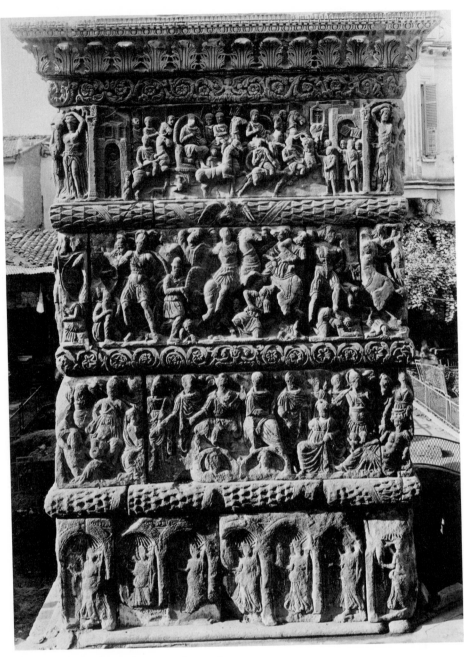

174A. Southwest pillar, northeast face

174B. Southwest pillar, northeast face, restored

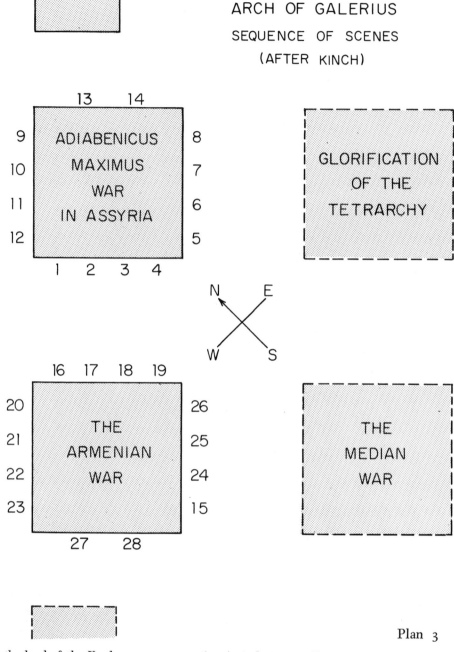

ARCH OF GALERIUS

SEQUENCE OF SCENES

(AFTER KINCH)

ADIABENICUS MAXIMUS WAR IN ASSYRIA

GLORIFICATION OF THE TETRARCHY

THE ARMENIAN WAR

THE MEDIAN WAR

N E
W S

Plan 3

1. Battle in the land of the Kurds
2. Prisoners carried from an Assyrian city
3. Emperor peacefully received in enemy country
4. Procession of beasts (r. to l.)
5. Cavalry combat in Mesopotamia
6. Romans surprise male and female orientals
7. Persians flee across Tigris
8. Woman leading horse to left (rest mutilated)
9. *Clementia Caesaris*
10. Reversed (l. to r.)
11. Ladies: personifications or noble captives
12. (Completely destroyed)
13. ("Two reliefs
14. completely destroyed")
15. Galerius' *Adlocutio* at a Danubian city

16. Arrival in an Eastern city, possibly in Armenia
17. Battle
18. *Pietas Augustorum* (Tetrarchs)
19. Seven Victoriae in shell-niches
20. *Victori Orientis*
21. The combat renewed
22. "Harem of Persian king taken"
23. Niches: Roma-Virtus, four Victoriae
24. Galerius receives a Persian embassy
25. Diocletian and Galerius sacrificing
26. Persian mission brings presents to the Emperor
27. Victoriae with shield on cippus; Mars, Virtus with prisoners
28. "Figures in niches"

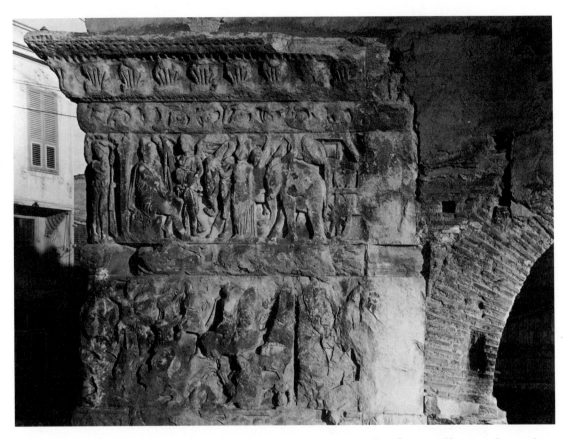

175. Southwest pillar, northwest face

343

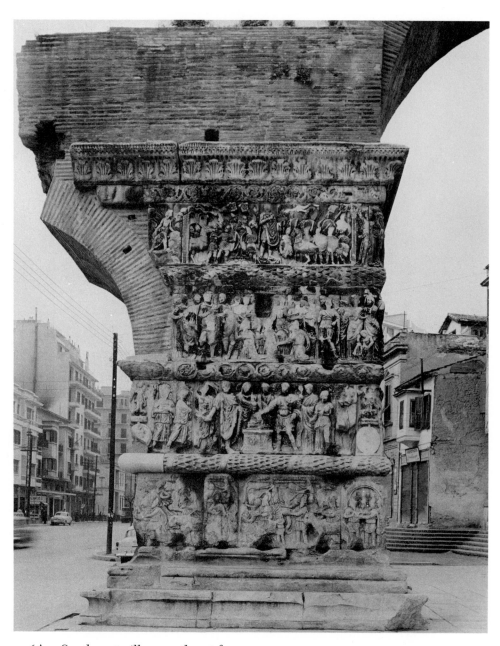

176A. Southwest pillar, southeast face

344

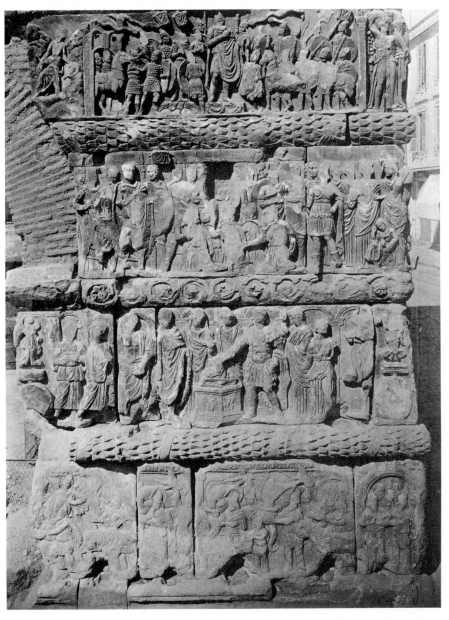

176B. Detail of southwest pillar, southeast face

345

the reliefs on the surviving pillars make it clear that the southeast front of the tetrapod was the principal façade of the monument. Therefore the two destroyed pillars, especially their southeast faces, contained the panels thought by the planners to be the most important in the ensemble.

If the pillars adhered to any thematic order, it was one based on strategic location of important events rather than chronology. They ran clockwise in order of importance. Coming from Asia Minor and Constantinople-Byzantium, the first pillar on the right probably contained the glorification of the Tetrarchy; the pillar on the left showed the Median campaign, that which retaliated on the Sassanids for their incursions as far as the Cilician Gates in the generation of Valerian; the pillar in the left rear presented the war in Armenia; and the final or right rear pillar was reserved for the secondary campaign or punitive expedition in Assyria. Literary evidence indicates that the Armenian campaign occurred first, followed by those in Media (Atropatene, or the western part) and the northern part of Assyria (Adiabene). Why, then, were the positions of the Median and Armenian pillars reversed? Or why did the master planner not run the pillars counterclockwise, starting on the southeastern side, at the southern corner? The answer is partially that the Romans demanded the right side for the principal scenes of a monument, and, as indicated, the eastern side called for the two major pillars. Coming from Europe to Asia, therefore, the traveler saw important scenes of the Armenian War on the right and scenes from the campaign in Assyria on the left. The panels presented subjects not as important historically as those on other surfaces, but the themes and scenes of the northwest side were important symbolically and very effective as decorative enrichment viewed from a distance. A great number of female personifications and noble female prisoners in these panels added to their visual effectiveness. The top scene on the right was symbolic of victory in the East, with Victoria crowning the seated emperor while another Victoria leads an elephant quadriga toward him. The theme of the panel at the upper left is *Clementia Caesaris*, shown in the traditional way with prisoners begging for mercy at the emperor's feet.

The subtleties of inner organization in the panels of this tetrapod arch can be only partly understood because two pillars are lost. In a tetrapod structure, obviously, the interior surfaces of pillars are nearly as important to the viewers as the exteriors. Thus, the southeast faces of the two surviving pillars, viewed from the east, both reenforced the scenes of the outer pillars and offered a secondary paraphrase of the entire war from start to finish. The right-hand surface was devoted to combats in Mesopotamia, climaxed by the Persians fleeing across the Tigris River; the surface of the pillar on the left contained the very

beginnings of the series of campaigns, in the form of Galerius' *Adlocutio* at a city in the Balkans (the Danube region), and two reliefs honoring the imperial victors, Galerius receiving a Persian embassy and Diocletian joining Galerius in a scene of *nuncupatio votorum* at an altar to Jupiter and Hercules. The lowest panel of each face, from left to right, had the unifying theme of a continuous procession of Persians bringing presents to the emperors.

The reliefs flanking the central passageway of the rear half of the tetrapod and those on the opposite sides of each pillar, on the outsides or on one side of the secondary passageways running either side of the principal means of thoroughfare, remain to be mentioned. The two sets of reliefs in the lesser passageways are decorative tailpieces of the cycles on each pillar and consist of two panels apiece instead of the usual four. The panels of the Adiabeneiac pillar are completely obliterated. Those of the Armenian pillar indicate the general triumphal theme of the decorations. In the upper register Victoriae support a shield on a cippus, a motif frequently found in late Tetrarch coins; they are flanked by trees, hung with Persian weapons and with captives beneath. Beyond in either direction Mars and Virtus supervise the prisoners. The lower register corresponded to the lower registers of the opposite side and the northwest face of the same pillar, niches with figures who were probably Victoriae.

The reliefs of the central passageway present a variety of experiences, generally in rhythmic alternation between the turmoil of battle and the set piece of an imperial *adventus* or ceremonial enthronement. Thus, from top to bottom on the right are found a battle in the land of the Kurds, prisoners being transported from an Assyrian city, the emperor peacefully received at a town in the enemy country, and (on the bottom) a procession of beasts. This last, a procession of beasts, tribute, or booty seems to have been the theme of the bottom registers of this "Assyrian" pillar, although two of the four lowest registers have been completely destroyed. On the left, from top to bottom, the Caesar Galerius' *adventus* in an Armenian city is celebrated, a battle takes place, the four Tetrarchs receive the homage of the divine and real worlds, and seven Victoriae in shell-niches provide the unifying decoration of the lowest register. In a further sense the two sets of reliefs complement each other through the way in which the eye can leap across the gap to see:

adventus	battle
battle	prisoners
gloria imperii	emperor peacefully received
Victoriae	procession of spoils.

The same subtle relations and crosscurrents, found throughout the surviving portions of the arch, make it a masterpiece of complex thematic planning within the framework of Roman imperial triumphal iconog-

raphy. A strong Hellenistic Greek tradition abounds in the layout and enframement of the reliefs, as well as in their content.

THE ART OF THE RELIEFS

The first question that might be asked about the art of the arch at Salonika is why the artist chose the type and manner of display for the reliefs. A tetrapod arch is admirably suited to commemorative uses at a location near the entrance to a city, where the arch can serve as a control point and functional focus for various types of traffic. The excavations of 1939 confirmed that the Palace of Galerius with its hippodrome was immediately south of the arch and the Via Egnatia. North of the arch was a sacral or temenos area, including a round temple (now the church of Agios Georgios), high walls, and an approach to a double colonnade leading from the arch in perpendicular orientation to the palace. A great covered vestibule also ran from the arch, on the side of the palace. All this made the Arch of Galerius a focal part of a vast *palatium* complex which must have been not unlike the colonnades, vestibules, mausoleum, palace, and arcuated gateways of the Palace of Diocletian at Spalato. The reliefs on the arch at Salonika must be judged as sculptural backgrounds to this larger, complex architectural creation most of which no longer survives.[6]

In an ensemble such as the Arch of Galerius there are two ways of carving slabs for the lower (or visible) surfaces, the pillars: one consists of designing slabs with single, large-figured scenes, one subject and secondary decoration for each surface; the second consists of preparing the reliefs in registers, as actually carried out in the monument. The latter is much more satisfactory, especially when it is remembered that the attic and possibly the pediment of the arch contained large statues to fill out the decoration and give the monument as a whole a sense of historical or triumphal focus when approached from either direction.

The reliefs in their sets of four or two registers are not difficult to see, thanks to the strong, simple modeling and deep cutting of the figures. In fact, the separate scenes and details therein show up from a much greater distance than might be expected. The choice of registers rather than of single large panels was also dictated by one of the two strong traditions in the mainstream of Roman state relief, that of small, highly narrative friezes. That the taste for large single panels was not dead in the Tetrarchy is seen in the surviving base of one of the four columns set up to honor the Tetrarchs in the Forum Romanum in A.D. 303 and in the *zoccoli* reliefs of the Arch of Constantine, a decade later. Small narrative friezes go back to late Republican, early imperial funerary monuments (Tomb of the Baker), occur on Augustan temples (Apollo Sosianus), and appear on the Arch of Titus late in the first century A.D. Among surviving monuments the immediate Roman ancestors of the

reliefs on the Arch of Galerius at Salonika are the principal scenes of the Arch of Septimius Severus in Rome. Here the groups of small figures are "frozen" in a series of seemingly landscaped panels, in reality vehicles of hieratic arrangement. The friezes of the arch at Salonika have banished this last, stilted breath of Roman illusionism in favor of set strips carefully defined by architectural and decorative moldings.

By arranging the friezes in a series of complex relationships the "master" of the Arch of Galerius invoked, perhaps unknowingly, another great Roman narrative tradition, that of the reliefs on the Columns of Trajan and Marcus Aurelius. Although set out in continuous spirals, these reliefs are no less a series of "set pieces" than the panels at Salonika. All three monuments rejoice in the use and reuse of compositions and isolated motifs inherited by Roman state art from Hellenistic painting, the combats between charging cavalry and hapless barbarian infantry, the grouping of divinities and geographical personifications as participants in or attendants at a scene, the introduction of reclining river gods in their native locales, or the multiplication of Nikai against architectural settings of theatrical and nymphaeum nature, to cite random examples — the last being present only at Salonika. All three monuments provide many instances of scenes, motifs, and figures which are Roman in the fullest sense of what can be termed Roman art. The emperor addresses auxiliaries; the enthroned Tetrarchs receive the homage or submission of Armenia and Mesopotamia, or a part thereof, personified by the usual Hellenistic Tychai; Diocletian and Galerius sacrifice in front of the arcuated architecture of a city such as Antioch; and other cities in the East are represented with details specific enough to allow at least identification of the region involved.

The Arch of Galerius marks the point in the history of Roman art in the East at which the art becomes one with that of the Roman Empire as a whole. This sweep to a unified art, as much Eastern as Western, has been documented in the precision of dated and located coins. The year A.D. 296 is crucial, for this was the year in which Greek imperial coinage ceased, and a coinage with Latin lettering and designs prepared in the mint at Rome became standard from Anatolia to Scotland.[7] The Arch of Galerius is a Roman triumphal monument in the fullest sense, but certain details keep it firmly in the imperial tradition of the Greek East. The undercut, heavily enriched, peopled and vegetable scroll of the upper and third moldings would not occur in this position on a Roman triumphal monument in the West. The giant filleted wreaths or crowns of the second and fourth divisions between the panels are also Hellenistic or Greek imperial rather than Roman when employed on this scale and in this location. The Greek desire to organize the reliefs into an architectural unity very carefully circumscribed by personified decoration shows up where it would not in Rome. Thus, the relief of imperial

349

arrival in an Armenian city (the northeast face of the southwest pillar) is set off on the left and right by scalloped architectural niches in which stand pendant Hellenistic Victoriae holding large cornucopiae.

Perhaps the most Greek contribution to all the reliefs is the strongly Hellenistic sense of plasticity which permeates all the reliefs at a time when the Hellenistic residue was being minimized in Rome by the extensive use of all types of drills and a penchant for cutout relief. This sense of depth, by modeling and undercutting of the figures and foliate decoration, can be best judged by comparison with the four reliefs of the Decennial base in the Roman Forum. The reliefs in Rome are flatter and more silhouetted in outline than in the Hellenistic play of light in depth. To be sure Constantine's triumphal arch of a decade later exhibits in its contemporary narrative reliefs extensive displays of depth coupled with a sense of statuesque individuality in many of the figures, but these figures are frozen in a uniform surface plane which negates their sense of modeling. They are also expressed in a series of unclassical proportions, undefined bodies, and large heads, which cancel out the Hellenistic element implicit in the similarity of subjects to those on the Arch of Galerius. The reliefs on the Arch of Galerius still exude a Hellenistic, even a Pheidian grace and sense of classic nobility which has vanished in the more disturbing reliefs of the Arch of Constantine.

THE RELIEFS AT NICAEA

While Rome was moving from the uninspired sculpture of the Tetrarch base in the Forum to the impoverishment of the Arch of Constantine, Asia Minor was sharing with Greece a traditional Romanism given new direction as the third century moved into the fourth. For approximately a hundred years thereafter the traditions of Roman state art were kept alive in centers near Constantinople. In the new capital of the Roman world, columns and arches were built and decorated with reliefs in a fashion recalling second-century Rome. Rome, itself, and the Latin West, had long since abandoned the pretense of undertaking monuments such as these.

Since the seventeenth century, travelers to northwest Anatolia have observed and commented on the relief with scene of combat, walled up in the complex of city gates and defenses for which this site is famous. The relief is badly mutilated, but there is no doubt that it belongs to the period of the Arch of Galerius in Salonika, and is one of the few surviving documents of the penetration of Roman state art in Asia Minor in the artistically crucial decades of the Tetrarchs. In the relief Romans and Persians or "Parthians" are in combat, the former riding in traditional closed formation from left to right to meet the latter who are disorganized on horseback, on foot, and falling to the ground.[8]

The formulas involved, like those in comparable scenes at Salonika,

are Hellenistic in origin, but they are the Roman versions of these formulas. The left center, as in the Trajanic reliefs on the Arch of Constantine in Rome, is dominated by the Roman officer who rides over a fallen foe, and elsewhere the action is conducted on the three planes traditional to Roman official scenes since the Flavian period. The principals are in the center and either side close to the surface plane; the background is filled by two layers of moving combatants on horseback; and the lower part of the relief is given over to those fallen in battle.

Three other reliefs from the same monument are built into the Byzantine or later walls at Nicaea. The monument was triumphal and certainly contemporary with the arch at Salonika. The presence of these reliefs in the fortifications of Nicaea has been attributed to the same late Byzantine urge to decorate walls which led to the reuse of reliefs in the masonry near the gates of Constantinople. The original structure appears to have been a tetrapod arch like the building at Salonika. Its foundations have been identified at Maltepe near the Lefke or eastern gate of the city. The arch probably succumbed to the universal medieval need for building materials, only a few of the reliefs being preserved.[9]

The most important of the other reliefs is the scene of an imperial *Clementia* before a walled city and in the presence of standard-bearing legionaries. A figure, who may be a personification, kneels before a cuirassed emperor. He has just dismounted and stands on a small podium with his horse behind him. A bastion of the wall above the suppliant bears the carefully lettered Latin inscription ALAMANIA. This has led to the suggestion that the monument commemorated the war against the Alamanni under Constantius Chlorus in 298. Nicaea had been sacked by the Goths in 268, an event which produced the great effort to enlarge the city walls under Claudius II in the months immediately following. Thirty years later the city had completely recovered and had taken its place as an imperial center in northwest Asia Minor. It was fitting indeed that Nicaea should lead imperial art into the century of Constantine the Great by having a monument to rival that of Galerius at Salonika. In honoring Constantius Chlorus and the victories on the northeastern frontiers, the city recognized the balance of power among the Tetrarchs and took notice that pressure had been removed from the frontier most dangerous to its security.

The two remaining reliefs, mutilated as they are, confirm that the sculptural style of this monument was very like that of Galerius at Salonika. One relief appears to show barbarians and their possessions being led into captivity or resettlement, and the other presents a group of soldiers, infantry and cavalry, drawn up in close formation on the field of battle to listen to an imperial harangue, an *adlocutio*. The imperator at the left is missing, but the foreground of the battlefield is strewn with fallen barbarians. If anything, stylistically the figures in

351

these reliefs are more elongated, more Hellenistic and less Late Antique in concept than those at Salonika. The difference is slight, however, and both monuments represent the preservation of Hellenistic-Roman optic, spatial, and proportional principles on the eve of Byzantine art.

In general, the political and military reforms undertaken by Diocletian had a good effect on the arts. The Arch of Galerius and the reliefs at Nicaea are measures of renewed interest in historical sculpture; these reliefs exceed anything of this nature produced in Greece or Asia Minor since the Great Antonine Altar at Ephesus, and they are more Roman in their presentation of narration rather than allegory or symbolic combat. The sculptures at Salonika and Nicaea belonged to monuments that were accompanied by new buildings, in the first instance a vast palace complex. Elsewhere, particularly at Nicomedia where Diocletian had his capital, architecture led the other arts. There are portraits of the Tetrarchs, and amid all the milestones enough statue bases survive to indicate that there were many more likenesses, although doubtlessly some were new heads set on older bodies. Few private statues or reliefs can be dated in the era of the Tetrarchs, for the emperors and their lieutenants had to take most of the artistic as well as military and economic initiative in reviving a sagging Empire.

XVI

Constantinus Magnus Augustus and His Successors

THE STORY OF Constantine the Great and his immediate successors is the saga of a unified official Greek and Roman imperial art and of the establishment of a center for that art in Constantinople, the old city of Byzantium on the Bosporus. The growth of official and popular Byzantine art out of the ingredients in Constantinian art is part of the emerging heritage of the Middle Ages. After A.D. 325 a giant effort was lavished on making Constantinople artistically as well as politically the New Rome, and both the eastern and western halves of the Roman Empire contributed their talents and styles in creation of the new capital. The apogee of this officially sponsored effort came fifty to seventy-five years later in the columns of Theodosius and Arcadius, helical friezes which symbolized the artistic grandeur of the old capital absorbed into the new. Diocletian and his colleagues had forced an official unity of Greco-Roman art which lasted about a century. By 400 the characteristics of official art of the Theodosian dynasty were beginning to develop into what was to become Byzantine art in the time of Justinian, a century and a quarter later. Byzantine art owed its origins not only to the state painting, sculpture, mosaics, and minor arts of fourth-century Constantinople but to a host of unofficial styles in Anatolia, Syria, Egypt, and, not the least, Italy itself.

Outside of the new capital, the artistic activity of Constantine and his immediate successors in Greece and Anatolia did not differ remarkably from what had gone on under the Tetrarchs; it was not until the latter part of the fourth century that Christian iconography became a factor to reckon with. The age of Constantine the Great was still characterized by repair or construction of the traditional types of public buildings and the setting up of the same commemorative monuments. Inscriptions on theater walls, honorary statues from the city or its administrative bodies, and milestones marking road repairs continued to provide the measurements of Roman art in the Hellenic world. By 500 these measurements had changed so radically — if only because they became Christian and

353

Byzantine — that the conclusion of this investigation can be said to have been reached and passed.

PORTRAITS UP TO A.D. 500

CONSTANTINE AND HIS FAMILY

As might be expected, the most important portrait identified as Constantine the Great from the East appears to have been found in Istanbul and is in the Archaeological Museum there (figure 177). It is twice the size of life and may have come from a cuirassed statue. The type is late (after 325) and was probably disseminated widely throughout the East. The identification is not certain, but the youthful appearance of the head has led to the suggestion it might be Constantius II as Caesar, probably in the last years of his father's reign.[1]

A head in Vienna, from Ephesus, was identified as Constantine about 306, when he was still Caesar rather than Augustus, but the face seems too thin and sensitive to be anything but a Constantinian private person. He might even be one of the Greek officials of Ephesus. A portrait in marble, found in Constantine's forum in the new imperial capital, has been termed a Constantinian copy of a portrait of a Julio-Claudian prince, but it may be a likeness of Constantine himself, carried out in the very classical, traditional, Julio-Claudian idiom made popular by the emperor who moved the center of empire from the Tiber to the Bosporus.[2] The problem of Julio-Claudian and Constantinian iconography also arises in a Pentelic marble head in the Heraklion Museum from Gortyna. It looks like a portrait of Augustus recut to make a likeness of Constantine as Caesar, that is, in the years 305 to 306 (figure 178). His characteristic jutting forehead and slightly aquiline nose are visible, and the light beard, seemingly cut out of the surface of the Julio-Claudian head, is like that found on certain coins struck in the lifetime of Constantius Chlorus, or in the first years of his rule as Augustus after 25 July 306.

Helena, the sainted mother of Constantine, can be recognized in an overlifesized head found a generation ago in the grounds of the electric plant at Nicomedia.[3] The basis for comparison is the head set in Antiquity or in the Renaissance on the Pheidian body of the so-called Agrippina in the Museo Capitolino.[4] A diademed head in a private collection in Istanbul has been a candidate for Constans, and his brother Constantius II, despite his long reign, has been documented only on three silver *largitio* plates from Kertch (Panticapaeum), now in Leningrad. A marble head from Aleppo has been proposed as a Syrian portrait of Constantius II, perhaps of the years 335 to 337 when he lived as Caesar in Antioch, but the elongations of face, the narrow eyes, and the pointed chin seem to be as much peculiarities of the sitter as of the por-

177. Constantinus Magnus,
Istanbul

178. Constantinus I,
from Gortyna

traitist.[5] All three portraits on the silver dishes recall those of the large gold medallions awarded to barbarian allies, including the portrait of the scene showing Victoria leading the emperor on horseback in an "Adventus Augusti." [6] Finally, the portrait of a young princess, found in Athens and now in Chicago, has been identified by me as Constantia and will be discussed separately (figure 179). Constantia was daughter of Theodora by Constantius I, half-sister of Constantine the Great, and wife of the ill-starred Licinius I from 313 to 324.

CONSTANTINE'S SUCCESSORS

It is not surprising that there should be three or more candidates for identification as Julian the Apostate (361–363) among portraits in the East (figure 180). The philosopher and soldier, who was the last reigning pagan and the last member of Constantine's family to wear the purple, lent himself to portraiture, if only because of his distinctive beard that recalled men of the arts in the fifth and fourth century B.C. Pagan ideas suggest patronage of painting and sculpture. The coins are evidence that in his brief reign Julian thought in terms of revived designs and styles going back to the second and third centuries of the empire. These official Roman coin designs borrowed from Greek imperial as well as traditional

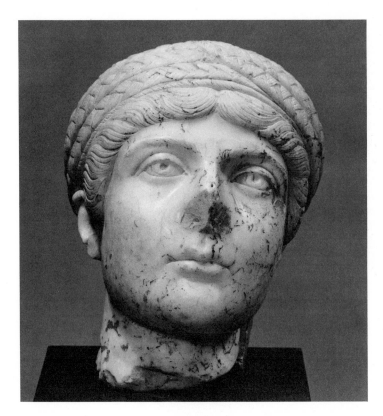

179. Constantia, from Athens

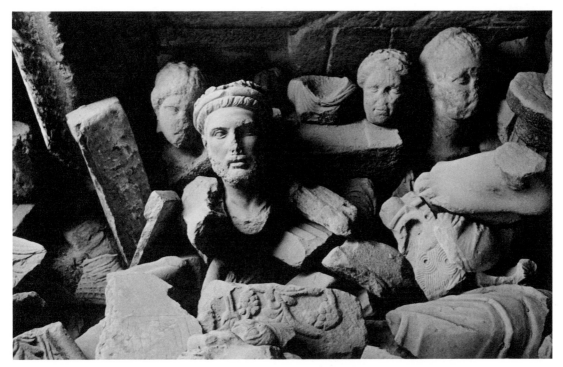

180. Julian the Apostate and other sculptures in the Tower of the Winds

Roman designs. An official portrait created in Rome, known from the two statues now in Paris, was circulated in the East. Survivors include the "turbaned" head from the agora at Thasos, and a diademed, wreathed head excavated at Ephesus. The *polos*-crowned head found near Hadrian's Library in Athens is related to these portraits but more individual in its recollection of archaic Greek types used for Zeus. If this head is indeed Julian, it is further evidence that sculptors in Late Antique Athens had not lost their creative touch. Portraits of Antoninus Pius influenced the individual details, and this is logical from the political standpoint, for Antoninus Pius was one of the last gentle, peaceful, and thoroughly admirable pagan emperors to wear the type of beard Julian cultivated.

After Julian, identifications are made difficult by the lack of reliability, that is, accuracy, in portraits on coins. In the period of Valentinian I (364–375), when several emperors ruled at once, die designers occasionally used the same image for Gratianus, Valentinian II, or Valens. The bronze colossus at Barletta in southern Italy surely comes from the East, probably from Constantinople, but the debate as to which of a half a dozen possible emperors is portrayed has raged for fifty years to the true satisfaction of few. Here the bronze is identified as Valentinian I because until well into the fifth century coin-portraits of this emperor are more reliable than those of most of his successors. There is one

357

comfort in the late fourth and fifth centuries. Imperial portraits are usually easily distinguishable from those of private citizens by the presence of the imperial diadem. Furthermore, to the general detriment of the arts, there are far fewer portraits of magistrates, philosophers, soldiers, athletes, or their wives than in the days before Constantine the Great. Private portraits turn up mainly in the great commercial centers of western Asia Minor, such as Ephesus, Aphrodisias, or Sardes, and in Athens.

Gratianus (367–383) seems to be the subject of a small, diademed head from the agora at Philippi in Macedonia, and the oft-published marble statue in Istanbul from the Hadrianic baths at Aphrodisias must be Valentinian II (371–392) rather than Valens, who fell at Hadrianopolis in Thrace in 378 (figure 181). The best place to study the iconography of Theodosius I (379–395) and his family is from the several imperial scenes in relief on the base of the obelisk of about 390 in the Hippodrome of Constantinople. Theodosius the Great appears here with Valentinian II, Arcadius, and the very young Caesar Honorius. A splendid conclusion to the range of imperial portraits in the East is offered by the marble head of Arcadius (395–408), found near a wall of the Forum Tauri in Constantinople (figure 182). This frozen yet sympathetic portrayal of fragile youth thrust into awesome power belongs to the first five years of the unfortunate prince's reign as first true emperor of the East.

CONSTANTINIAN AND LATER ART OUTSIDE OF CONSTANTINOPLE

Constantinian and later commemorations west of Anatolia are scanty indeed. There was a Latin inscription to Constantine the Great, a dedication, at the famous site of Philippi in Macedonia. Delphi had two statues of Constantine, one of Constans (337–340), and a large pedestal for bronze statues of Valentinian and Valens. They appear to have stood close together, perhaps in the fraternal embrace of the porphyry Tetrarchs in Venice. There may have been a statue of Theodosius, dedicated in the name of the Polis, at Aedepsus at the northern end of Euboea. This city also put up a monument to the divinity of Constantinus Augustus. At Amarynthus, east of Eretria, Constantinus Magnus and his sons as Caesars seem to have been honored with a column or stele, not a milestone. The former was cut on a base originally used for a statue of Hadrian the Thirteenth Olympian from the Boule and Demos of Istiaia, and the latter was fashioned on a monument, mentioned previously, dedicated to Diocletian and his three colleagues in the First Tetrarchy. Perhaps in the first instance the statue of Hadrian was reused, although the base (and statue) may have been employed once by the city of Istiaia in the interval between A.D. 130 and 325. Aside from the

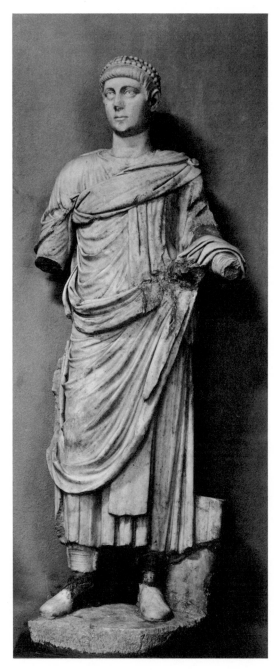

181. Valentinianus II, from Aphrodisias

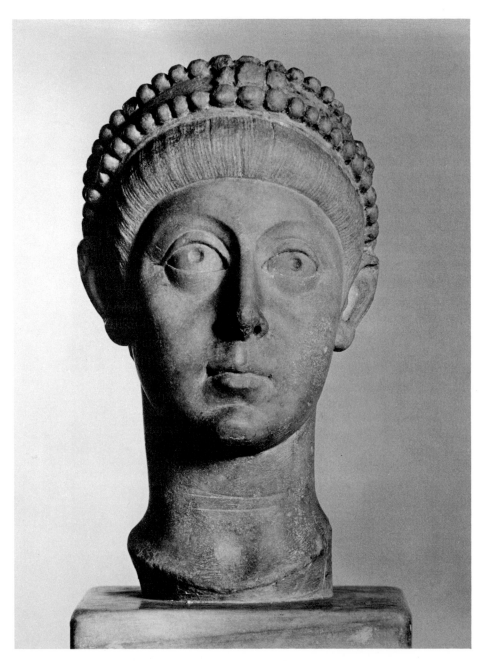

182. Arcadius, from Istanbul

portrait of Constantia, Attica is represented by a rectangular column at Daphne. The surfaces were used three times: once for an emperor whose name was completely erased in damnatio; once for Valentinian and Valens; and on a third occasion (405–407) for the emperors Arcadius and Honorius, the sons of Theodosius under whom the division of empire between east and west became permanent. This last inscription was in Latin. One other inscription to the family of Theodosius has been recorded for the region around Athens.

A flowery dedication to Theodosius, with Arcadius and Honorius as Augusti, was set up at Corinth between 393 and 395; the letters are particularly well cut, being works of art in themselves. The praises must have seemed empty to the citizens of a city soon to be sacked by Alaric. The agora at Tegea apparently was transformed into a kind of Kaisareion of the Constantinian house. Remains of statues of Constantine the Great and Constantius Caesar (323–337) were found on a double base. There was also a set of statues of Constantius Chlorus and Constantine the Great, set up in the crucial years between 305 and 307: the first was erected when the former was still a junior Tetrarch, and the second when the latter was not yet styled Augustus. Constans as Augustus received a statue in the years 337 to 350. The officials of the city were not always sure of the correct imperial names and titles, a fact which causes some confusion in identification and chronology. The Constantinian and later inscriptions on Samothrace and Cyprus have been mentioned in connection with the Tetrarch monuments to which they were added.

Caelius Montius was an important Roman magistrate who was murdered by Gallus Caesar in 353. On a pier in the agora at Assos in the years after 340 he commemorated an official act, which failed to save his life a decade later: "Caelius Montius, the most illustrious Proconsul of Asia [has erected this statue of] Flavius Julius Constantius, the founder of the city, the greatest conqueror and trophy-bearer, forever Augustus. By decree of the Senate and the People." The main street of the agora at Assos also had a statue of Constantinus II as Augustus, thus dated 337 to 340. A milestone of the years 383 to 385, remade from an altar, mentions Valentinian, Theodosius, and Arcadius. The inscription, with the addition of Gratianus, is paralleled by one Ramsay copied in the fountain on the pass of Belcaive near Sardes.

Caelius Montius' inscription at Assos is a good example of the fourth century's tendency to use flowery imperial titles and adjectives. Another illustration of this is a statue base from the vicinity of the great church at Philadelphia (Alaşehir) in Lydia; the emperor is Constantinus Magnus, and the statue was set up after the defeat of Licinius in 323, ἡ λαμπρὰ φιλαδελφέων πόλις. Between Thyateira and Hierocaesareia, this important road from Pergamon to Sardes has yielded a milestone to

Licinius I and II (317–324) and another, on the road between Tekeli and Mermere, to Constantine and Licinius (313–317). At Hermocapelia in Lydia a base was dedicated to Constantinus I and his three sons in the years 333 to 337; it was reused under Honorius (393–423) with only slight changes in what had become a very rudely carved inscription.

The activity of Theodosius in restoring the public buildings at Ephesus has been indicated in Chapter XV. His hand is evident in the Trajanic nymphaeum, the temple and gate of Hadrian, and the northern of the two fountains on the east side of the Street of the Kouretes. Constantius II and Constans in the fifteen years of their joint rule were responsible for rebuilding the large circular reservoir. Their portraits were inserted in two cuirassed statues dating from the original construction of the buildings and waterworks under Antoninus Pius. The statues stood between the columns of one of the structures flanking the pool; the building was tetrastyle, a point which emphasized the placement of the imperial portraits on their bodies presented in Antonine Hellenistic armor. L. Caelius Montius, the Proconsul so active at Assos, put up a statue of Constantinus Magnus in the agora. Caelius Montius was also responsible for a monument at Clazomenae on the Gulf of Smyrna.

Julian the Apostate was not without honor in the East during his three-year rule. A dedication in Latin has been recorded at Nacoleia in Phrygia, and a milestone in eastern Phrygia marks the activity brought about in preparation for the Persian campaign of 363, the expedition on which the emperor lost his life. This marker, recut on an earlier inscription, was placed on the road from Amorium to Laodiceia Combusta and Iconium. Flavius Claudius Iulianus is hailed even in this simple column as victor, triumphator, and perpetuus Augustus. And as late as the decade after 395, Heracleia Salbace in the border region between Caria and Phrygia was able to boast a marble *miliarium* to Arcadius. Another milestone at the same city was used three times in the upper registers and once in the lower. The lower part belonged to the Caesars Constantius and Galerius in the First Tetrarchy; the sons of Constantine (337–340), the brothers Arcadius and Honorius (395–408), and the emperors Theodosius II and Valentinian III (435–450) all shared the upper part of this crowded stone. At Apollonia, less than ten miles to the south, stood a statue of Constantine the Great, the simple inscription of which was recorded by L. and J. Robert on the base at the mosque of Garipköy.

Iovianus Augustus, the well-meaning but uninspired successor of Julian, was honored by a dedication at Apameia — logically enough since his was the task to lead the Roman armies in a great retreat across Anatolia from Mesopotamia. The inscription was in Latin, and the monument, matched by a companion on the road across Phrygia from Philadelphia, must have also been a milestone. At Acmonia to the north

Ramsay noted another set of dedications that look very much like road markers. The inscription to Constantine and Licinius is in Latin, but the same stone bears a Greek tribute to Crispus, Licinius II, and Constantinus II, in the years 317 to 323.

In the hinterlands of western Asia Minor, the area of east Asia and west Galatia was sufficiently looked after by Constantine and his family to have a milestone with their name, the inscriptions being both in Greek and Latin. The twentieth milestone on the road from Apollonia to Antioch in Pisidia was carved in limestone with a Latin inscription to Constantinus Magnus, the two Licinii, Crispus, Constantinus II, and Constantius II. It stood near Tymandus, west of Lake Limnae. Another milestone of Constantine and his family, with bilingual inscription, was studied on the main highway passing through Docimium on the road from Prymnessus to Amorium, where the route met important passages to the east and south. The Severans had undertaken much road maintenance and improvement in this region.

An inscription over the west gateway at Aphrodisias in Greek is recorded, which despite its pretensions indicates repairs rather than new construction, an apt commentary on the state of things by the seventh decade of the fourth century. It states, in essence, that "Fl. Quintus Eros Monaxius, the governor, has erected it at his own expense, and lavishly dedicated it for the good health, and the safety, and the honors, and the victory, and perpetual welfare of our lords . . ." The rulers appear to have been Constantius II and Julian, although erasure, no doubt by followers of Christ, has created the point of doubt. The inscription probably belongs in the years 358 to 361, for a destructive earthquake ravished the city in the first of these years.

About 390 the marble statue, now in Istanbul, identified as Valentinianus II was set up in the Hadrianic baths. It was in the east entrance, north of the door leading to the antechamber; the base was recorded, as was that of the pendant statue of Arcadius. Valentinianus II at this time was between nineteen and twenty-four years old. He is represented in Roman civic costume, about to give the signal for the beginning of games. The statue was found with two second-century Trajanic or Hadrianic statues of ladies and with two municipal magistrates of the late fourth century (figure 181).

In the fourth century, and especially on the southern coast of Asia Minor, hexagonal bases are extremely rare. One, seen on the east side of the market at Sagalassus in Pisidia, was designed as a commemoration of either Constantine the Great or his imperial son of the same name. Diocaesareia in Cilicia had a pair of statues to Arcadius and Honorius, set up after 395; the north front of the town gate contained a lengthy inscription to these two rulers, a text indicating that the *hieron* of Olba probably received the name of Diocaesareia in the reign of Vespasian.

At the harbor city of Corasium, to the south, Captain Beaufort found the extensive ruins of a walled town with temples, arcades, aqueducts, and tombs; on a tablet over the eastern gate, he saw and recorded a flowery dedication in Greek to Valentinian, Valens, and Gratianus, probably commemorating a thorough renovation of the fortifications.

It would be improper to end a survey of imperial art from Constantine to the sons of Theodosius without mentioning that Olba, inland from Seleuceia and close to Diocaesareia in Cilicia, gives epigraphic evidence that imperial works in Anatolia do not stop at A.D. 400. In the town of Ören Köy near the site of Olba an inscription mentions that under Justinus II (565–578) and Sophia the aqueduct of Olba was repaired.

ATHENIAN PORTRAITURE IN THE FOURTH CENTURY: CONSTANTIA

On the threshold of the Middle Ages, Athens was a city steeped in a glorious past, on the one hand, and on the other shaken to the core by the ravages of Herulian Huns less than two generations in the past. To a still-vital Athens in the early fourth century, Constantia came as a bride, thrice-blessed in her connections with imperial power. She was the daughter of one emperor, the sister of another, and the bride of a third. Fortune's wheel spun very rapidly for Constantia's husband, the Emperor Licinius. They were married at Milan in March 313. The following month Licinius secured control of the Roman Empire in the East, but in October 314 his rival, Constantine the Great, twice defeated his armies and reduced his brother-in-law's share of the Empire to Thrace, Asia Minor, Syria, and Egypt. Athens, therefore, was lost to Licinius after scarcely a year and a half. The aftermath does not make an attractive story of family affection. Constantine the Great wished to be sole ruler; after less than a decade he hounded Licinius from battlefield to battlefield, and ultimately to execution in 324. Constantia, sister to the victor and wife to the vanquished, lived on in goodly esteem until her death in 330.

The likeness of Constantia in the Art Institute of Chicago (figure 179) could only have been carved in those few months when Licinius ruled Athens. It seems to have been found years ago in the Roman agora, where Constantia's likeness was placed among those of philosophers (perhaps the Seven Sages).[7] The identification derives from commemorative coins struck after her death. A date of A.D. 313–314 suits the style of the portrait and the age of the sitter. She was then, admittedly, fifteen years older, but portrait head and numismatic profile speak of the same person.[8] The precisely carved marble head, probably originally designed for a statue, presents a lady of about eighteen to twenty-five years of age. Her large eyes and delicately determined mouth are set off by the severe but elaborate arrangement of her hair. This is arranged

in symmetrical groups of strands around her forehead and is held in place by a rolled fillet and triple headband tucked under at the top of the head. The effect must have been something of long, elaborate braids wrapped around the head, ends carefully hidden for the sake of neatness.

Portraits of the Roman period, whether from Italy, Greece, or Asia Minor, are often difficult to date because older fashions of representation were always being revived. This is especially true in portraits of women, where fashions of wearing the hair could also revive long-forgotten styles. Many analogies for this exist in ladies' fashions of the nineteen-sixties, which can bring back both Empire dresses and skirts from the nineteen-twenties within a span of one or two years. During the rule of Constantine the Great (306–337), the spirit of revival was strong in portrait sculpture, and the head of Constantia is no exception to this trend. The whole concept, from hair style to the manner of drilling and incising the pupils of the eyes, goes back to Greco-Roman portraiture of the early Antonine period, the two decades from A.D. 135. There were political undertones in this "revival," for Constantine the Great was bent on restoring the peace and prosperity of the Roman Empire of the second century A.D. It is natural that his ambitious ideals should be reflected in some measure in this court portrait of his half-sister.

A POSSIBLE LIKENESS OF SAINT PAUL

The relative of a Greek who found it "in a well" on his land brought this overlifesized head in Pentelic marble to the United States years ago (figure 183). The place of discovery was given as "Agea Paraskevi near Athens in Attica." [9] This is easily recognizable as a phonetic sounding of Agia Paraskevi ("St. Friday" or the Preparer), and there are several towns of that name near Athens. Two lie northwest of Marathon, in the middle of the peninsula, but they are well beyond range of the term "near Athens." The most likely candidate, confirmed by further investigations, is a village, now swallowed by urban expansion, on the road leading out of Athens, to the west of the junction of the roads to the eastern coast of Attica and to Sounion or Porto Raphti, going through the center of Attica beyond Athens and south of Kifissia. There are remains of early churches and at least one major Early Christian basilica not far from this crossroads. There may be Early Christian remains actually where the modern suburb of Agia Paraskevi has sprung up. At Brauron, site of the sanctuary of Artemis, somewhat farther beyond the crossroads ("Stavros") in the direction of the coast, there were important Early Christian and Byzantine churches.[10]

The region, a plain known as the Misogea and rich in Byzantine times, was fought over and depopulated once the Eastern Empire's grip began to slacken. Slavs and Saracens appeared there in the seventh and eighth

365

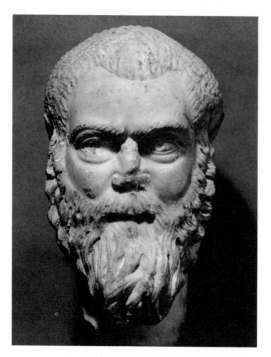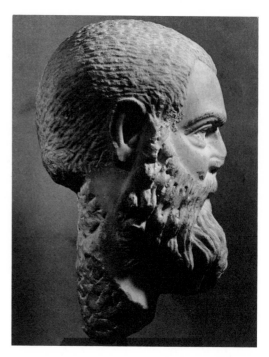

183. Saint Paul, from near Athens

centuries. In the seventeenth and eighteenth centuries, for instance, Turks, Albanians, and Greeks, not to mention miscellaneous pirates from all over the Aegean, struggled for tenure of this once-and-now-again fertile area. About 1780, Athens was even reduced to pulling down a host of ancient monuments, including Hadrian's reservoir façade, to throw up a hasty wall against marauding Albanians.[11] The National Gardens of Athens, behind the old Royal Palace, are still full of ancient blocks and carvings left when this wall was taken down after the war of independence. Therefore, the consignment of a major Early Christian statue to the building blocks and subsequently as fill in a disused well would not be out of place in outlying Attica in any century from the eighth through the eighteenth. Greek wells have from ancient times to the present served as repositories for every conceivable type of discarded object. The stratification often becomes confused, classical artifacts rising to the surface and automobile parts working their way to the neolithic levels.

This man of powerful beard, piercing eyes, and large cranium is every inch a Greek philosopher or patriarch. He is a man of intellect and action. His face has the magnificent restlessness of a Neoplatonist and the immobility of Julian the Apostate. Everything is concentrated in the eyes, the sides of the beard, and the shape of the skull beneath roughed-out hair. The sides of the neck are as immobile as a telephone-pole.

366

From this mold the Greeks and Latins of the fourth century created an iconography for the Apostles and Old Testament heroes who surrounded Christ in His acts or in His majestic enthronement.

Saint Peter and Saint Paul most resemble the man of this large head. On the sarcophagus of Rome's Prefect Junius Bassus, a work dated A.D. 359, Peter being led to prison or Paul being conducted to execution (scenes separated in time and space) are stylistic parallels for the head from Agia Paraskevi. Allowance must be made for technical differences inherent in likenesses a few inches high and a marble of almost-colossal proportions.[12] Besides association with the sarcophagus from the Vatican necropolis and still in the crypt of St. Peter's, there are other Early Christian sculptures and paintings which make a persuasive case for identifying this head as one of the princely Apostles of the early Church. Iconography and situation dictate a choice between Peter and Paul. Earlier and later than the sarcophagus of Bassus there is a strong, almost-unwavering tradition, especially in the *traditio legis* scenes on catacomb-plaques and sarcophagi and in wall paintings, of showing Peter as fully bearded with white curly locks arranged like those of Nero or Domitian in careful bridges over the forehead. By contrast, Paul is invariably more slender, with a more pointed beard and much less hair on a large skull.[13] His most constant iconographic type corresponds fairly closely to this head from Attica. Peter had little reason to be represented in Greece, while Paul preached on the Athenian Areopagus and made an enduring impression in the churches of Greece as the Apostle who fashioned from Judaic Hellenism his particular form of active, rational Christianity. This head could be Saint Paul. No other Apostle deserved such recognition in early Byzantine Greece, and, for those with justified doubts, no mere magistrate or imperial lieutenant would have been represented in such a patriarchal ikon.

The head and neck were carved to be let into a statue showing the subject draped in a tunic and pallium or himation. This costume, the Greek equivalent of the Roman toga, featured a fold in the outer garment which rose up above the back of the neck. Such a fold may account for the rectangular chiseling of the back of the neck, although this is so drastic as to suggest the head was reused as building material at some time in the Dark Ages, when the building in which the statue stood was destroyed.

Athens was badly damaged, the old agora devastated during the invasion by Herulian barbarians in 267. Still, the city recovered sufficiently to be an important university town in the fourth and even the fifth century. A few portraits were produced, likenesses of rulers, magistrates, and holy men, and among them was this head, one of the last monumental Greek sculptures in the classical tradition of Roman portraiture. As a possible likeness of a saint, it can be considered a major expression

367

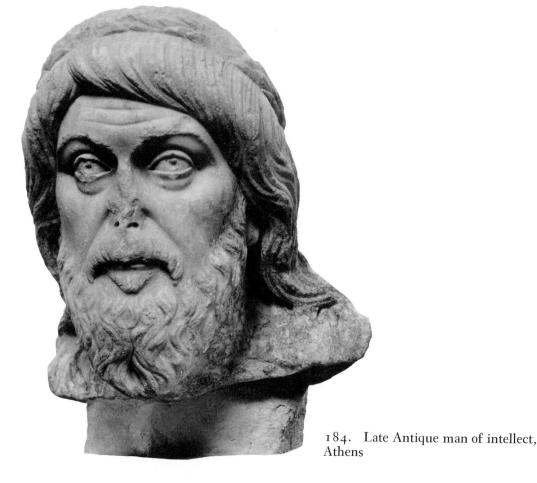

184. Late Antique man of intellect,
Athens

of Early Christian art whether from the Greek East or the Latin West.
The total number of portraits from this period, the so-called Theodosian
renaissance of the last quarter of the fourth century and the first quarter
of the fifth, makes a startling comparison with the masses of portraits
cast or carved in the second and third centuries.[14] Theodosian and later
portraits have been found at Aphrodisias in Caria, at Ionian Ephesus,
at Sardes,[15] in Constantinople, in Athens (three or four), and in Rome.
With some exceptions, they present a dry, schematized view of humanity,
whether the human is conceived in the image of a Greek philosopher or
a Roman imperator.

The head from Agia Paraskevi shows what has often been stated —
and occasionally denied because the evidence has heretofore been so
scanty — that the Athenians of A.D. 400 were capable of producing a
portrait as filled with knowledge of technical effects and surface plas-
ticity as they had been two hundred years earlier.[16] Its best parallel
is the head of a man of intellect or holiness found on the Athenian Acro-
polis and now an ornament of its museum (figure 184).[17]

368

Roman imperial art in the East was still vital and creative as the fifth century turned into the sixth. While future Byzantine designs and styles were being perfected in the art of the Christian Church, imperial secular iconography was continuing along traditional paths, with many imaginative concessions to changing areas, peoples, and religion. The imperial artistic repertory had already given the Church a host of representations that still play a part in the religious art of the East. The year 500 is just over a generation after the fall of the Empire in the West. Since, in the main, Roman art and the East are synonymous, the definition of Eastern imperial art constitutes a main part of the history of art itself.

XVII

Conclusion

ROMAN IMPERIAL ART flourished in Greece and Asia Minor in accord with a multitude of predictable rules. The Hellenistic influence was strong as late as the end of the fourth century, but Byzantine art owed as much to popular traditions in the East as did Romanesque art to corresponding developments in the Latin West. The history of popular or folk art in Greece and Anatolia under the Roman Empire remains to be written, but even superficial glances at votive and funerary reliefs of the second and third centuries show to what degree these sculptures determined courtly styles of carving in the centuries after Constantine the Great. The relaxation or distortion of the classical ethos in painting and sculpture leads to either the elongation or the compression of the human form, and both tendencies occur in forceful purity or in mixed degrees in the formative years of the Eastern Roman Empire. A lack of monumental sculpture may characterize the last millennium of Roman creativity in the East, the ages from Justinian to Constantine Palaeologus, but it did not hinder a pouring of imperial iconography, styles, and types of decoration into paintings, mosaics, and the minor arts. Greek response to Roman artistic polity produced habits of expression in Greece and Asia Minor that were as valid in the Church of the Holy Wisdom in Constantinople as they had been in the Antonine market place at Miletus.

If Roman imperial art in the Greek East left any legacy, it is the whole vast heritage of official Byzantine art. This inheritance did not die with the fall of Byzantium in 1453; it continued in many realms, chiefly in the art of the Eastern Churches, until after the advent of the Industrial Revolution. The ikons of Saint Constantine in his robes of state or of Saint Theodore in the outfit of a Roman cavalry commander preserve the imperial imagery present in monumental marble on statue bases in countless municipal structures from the principate of Augustus to the reign of Arcadius. Greek artistry and technical skill recognized how the imperial ideal should live in the land of Perikles or Alexander,

370

and the forms of expression perpetuated were original, lasting manifestations in a comprehensive view of the Roman and Byzantine Empires.

Romans entered the artistic horizons of Greece about 165 B.C. and of Asia Minor about 125. They were in both areas as cultural forces until late into the sixth century, when the Eastern Empire began to take on its final Byzantine Greek form. Seven hundred and fifty years of art is no fleeting moment in the history of western civilization. The over-all importance of the Greek world to later ages is unquestioned, and therefore the long period during which Rome played a major part in the affairs of the Greek East has long needed the attention heretofore devoted almost exclusively to Hellenistic art from Homer to the successors of Alexander the Great. In the evolution of Roman art in the East no battles were fought and no victories were won. Rome made many contributions. Greece maintained her identity and her integrity. The synthesis that emerged, Greek in spirit and Roman in motivating forms, added significantly to the sum of man's heritage east to Japan and west to Ireland.

ABBREVIATIONS

APPENDIXES

NOTES

INDEXES

Abbreviations

(Abbreviations of journals follow generally the system used by the *American Journal of Archaeology*, 69 [1965] 201ff.)

AA	Archäologischer Anzeiger
AbhBerl	Abhandlungen Berlin (Academy)
ABSA	Annual of the British School at Athens
AJA	American Journal of Archaeology
AM	Mitteilungen des Deutschen Archäologischen Instituts, Athenische Abteilung
AnatSt	Anatolian Studies
Annuario	Annuario della (R.) Scuola Archeologica di Atene
ArchEph	Archaiologike Ephemeris
ArtB	Art Bulletin
BCH	Bulletin de correspondance hellénique
Belleten	Belleten Türk Tarih Kurumu
BMC	British Museum Catalogue
BMFA	Bulletin of the Museum of Fine Arts, Boston
BMQ	British Museum Quarterly
BullMusImp	Bullettino del Museo dell'Impero Romano
BurlMag	The Burlington Magazine
BWPr	Winckelmannsprogramm der Archäologischen Gesellschaft zu Berlin
BZ	Byzantinische Zeitschrift
CAH	Cambridge Ancient History
CJ	Classical Journal
FastiA	Fasti Archaeologici
GBA	Gazette des beaux-arts
HSCP	Harvard Studies in Classical Philology
IG	Inscriptiones Graecae
ILN	The Illustrated London News
JARCE	Journal of the American Research Center in Egypt
JdI	Jahrbuch des (k.) deutschen archäologischen Instituts
JHS	Journal of Hellenic Studies
JIAN	Journal international d'archéologie numismatique
JOAI	Jahreshefte des öesterreichischen archäologischen Instituts
JRS	Journal of Roman Studies
MAAR	Memoirs of the American Academy in Rome
MdI	Mitteilungen des deutschen archäologischen Instituts
Meddelelser	Meddelelser fra Ny Carlsberg Glyptotek
MemConnAc	Memoirs of the Connecticut Academy
MemPontAcc	Atti della Pontificia Accademia Romana di Archeologia, Memorie
MonAnt	Monumenti Antichi
MonPiot	Monuments et mémoires, Fondation E. Piot
NdS	Notizie degli Scavi di Antichità
NumChron	Numismatic Chronicle
OpusRom	Opuscula Romana
PAPS	Proceedings of the American Philosophical Society
PBSR	Papers of the British School at Rome
ProcBritAc	Proceedings of the British Academy
REA	Revue des études anciennes
RivIstArch	Rivista del (R.) Istituto d'Archeologia e Storia dell'Arte
RM	Mitteilungen des deutschen archäologischen Instituts, Römische Abteilung

(Frequently cited books and articles)

Anat. Stud. Buckler	*Anatolian Studies Presented to William Hepburn Buckler*, Manchester, 1939.
Bean, Mitford, "Journeys in Rough	G. E. Bean and T. B. Mitford, "Journeys in Rough Cilicia in 1962 and 1963," Österreichische Akademie der Wissenschaften, Denkschriften 85 (1965).
Bieber, *Sculpture of the Hellenistic Age*	M. Bieber, *The Sculpture of the Hellenistic Age*, 2nd ed., New York, 1961.

Blümel · C. Blümel, Staatliche Museen zu Berlin, *Römische Bildnisse*, Berlin, 1933.

Bodnar, *Cyriacus* · E. Bodnar, *Cyriacus of Ancona and Athens*, Collection Latomus, vol. XLIII, Brussels (Berchem), 1960.

Boehringer, *Neue Deutsche Ausgrabungen* · E. Boehringer, *Neue Deutsche Ausgrabungen*, Berlin, 1959.

Caskey, *Catalogue* · L. D. Caskey, *Catalogue of Greek and Roman Sculpture in the Museum of Fine Arts, Boston*, Cambridge, Mass., 1925.

Chamoux, *MonPiot* 44 (1950) · F. Chamoux, "Un Portrait de Thasos: Lucius Caesar," *MonPiot* 44 (1950).

CIG · *Corpus Inscriptionum Graecarum*, Berlin, 1828–1877.

CIL · *Corpus Inscriptionum Latinarum*, Berlin, 1863– (especially volume III).

Collart, *Philippes* · P. Collart, *Philippes, ville de Macédoine, depuis ses origines jusqu'à la fin de l'époque romaine*, École Français d'Athènes, Travaux et Mémoires, fascicule V, Paris, 1937.

Delbrueck, *Spätantike Kaiserporträts* · R. Delbrueck, *Spätantike Kaiserporträts*, Berlin and Leipzig, 1933.

Devambez, *Grands bronzes du Musée de Stamboul* · P. Devambez, *Grands bronzes du Musée de Stamboul*, Paris, 1937.

Dörner, *Istanbuler Forschungen* 14 (1941) · F. K. Dörner, "Inschriften und Denkmäler aus Bithynien," *Istanbuler Forschungen* 14 (1941).

Einzelaufnahmen · P. Arndt and W. Amelung, *Photographische Einzelaufnahmen antiker Sculpturen*, Munich, 1893–1940.

Essays in Memory of Karl Lehmann · *Essays in Memory of Karl Lehmann*, New York, 1964.

Fabbrini, *BdA* 4 (1964) · L. Fabbrini, "Il ritratto giovanile di Tiberio e la iconografia di Druso Maggiore," *BdA* 4 (1964).

Felletti Maj, *Iconografia* · B. M. Felletti Maj, *Iconografia romana imperiale*, Rome, 1958.

Fellows, *Lycia* · C. Fellows, *An Account of Discoveries in Lycia*, London, 1841.

Fellows, *Asia Minor* · C. Fellows, *Travels and Researches in Asia Minor*, London, 1852.

Festschrift für Friedrich Matz · *Festschrift für Friedrich Matz*, Mainz, 1962.

Giuliano · A. Giuliano, "La ritrattistica dell' Asia Minore dall' 89 A.C. al 211 D.C.," *RivIstArch* 8 (1959).

Giuliano, *Annuario* 37–38 (1959–1960) · A. Giuliano, "Rilievo da Aphrodisias in onore di ΖΩΙΛΟΣ," *Annuario* 37–38 (1959–1960).

Graindor, *Bustes et statues-portraits* · P. Graindor, *Bustes et statues-portraits d'Égypte romaine*, Cairo, 1937.

Greek and Roman Portraits · *Greek and Roman Portraits, 470 B.C.–A.D. 500*, Boston, Museum of Fine Arts, 1959.

Greek Etruscan & Roman Art · *Greek Etruscan & Roman Art, The Classical Collections of the Museum of Fine Arts*, Boston, 1963.

Gregorovius, *Hadrian* · F. Gregorovius, *The Emperor Hadrian*, London, 1898.

Gross · W. O. Gross, *Bildnisse Traians, Das Römische Herrscherbild*, II, 2, Berlin, 1940.

Hafner · G. Hafner, *Späthellenistische Bildnisplastik*, Berlin, 1954.

Hanfmann, *Roman Art* · G. M. A. Hanfmann, *Roman Art, A Modern Survey of the Art of Imperial Rome*, Greenwich, Conn., 1964.

Harrison · E. B. Harrison, *The Athenian Agora, I, Portrait Sculpture*, Princeton, 1953.

Head · B. V. Head, *Historia Numorum*, Oxford, 1911.

Heberdey, Wilhelm, *Reisen* · R. Heberdey and A. Wilhelm, *Reisen in Kilikien*, Denkschriften der Kaiserlichen Akademie der Wissenschaften in Wien, phil.-hist. Klasse, 44, 6 (1896).

Hill, *Athens* · A. T. Hill, *The Ancient City of Athens*, Cambridge, Mass., 1953.

Hill, *History of Cyprus* · G. F. Hill, *A History of Cyprus*, Cambridge, 1940.

ABBREVIATIONS

Hoffmann, Hewicker, *Kunst des Altertums* H. Hoffmann and F. Hewicker, *Kunst des Altertums*, Mainz, 1961.

IC M. Guarducci, *Inscriptiones Creticae*, Rome, 1935–1950.

IGRR *Inscriptiones Graecae ad Res Romanas Pertinentes*, Paris 1901– .

Inan-Rosenbaum Jale Inan and Elisabeth Rosenbaum, *Roman And Early Byzantine Portrait Sculpture in Asia Minor*, London (The British Academy), 1966.

Ingholt, *JARCE* 2 (1963) H. Ingholt, "A Colossal Head from Memphis, Severan or Augustan?," *JARCE* 2 (1963).

Johnson, *Corinth* IX F. P. Johnson, *Corinth* IX, *The Sculpture 1896–1923*, Cambridge, Mass., 1931.

Jucker, *Bildnis* H. Jucker, *Das Bildnis im Blätterkelch*, Lausanne, 1961.

Keil, von Premerstein, I, II J. Keil and A. von Premerstein, *Bericht über eine (zweite) Reise in Lydien*, Denkschriften der kaiserlichen Akademie der Wissenschaften in Wien, phil.-hist. Klasse, 53, 2 (1910); 54, 2 (1911).

Kourouniotes, *Eleusis* K. Kourouniotes, *Eleusis, A Guide to the Excavations and the Museum*, Athens, 1934.

Lanckoroński K. Lanckoroński, *Städte Pamphyliens und Pisidiens*, I–II, Vienna, 1890–1892.

Laurenzi, *Annuario* 33–34 (1955–56) L. Laurenzi, "Sculture inedite del Museo di Coo," *Annuario* 33–34 (1955–56).

Le Bas, Waddington P. Le Bas and W. H. Waddington, *Voyage archéologique, Inscriptions*, III, Paris, 1870.

Lippold, *Handbuch* G. Lippold, *Handbuch der Archäologie*, III, 1, Munich, 1950.

Luce, *Catalogue* S. B. Luce, *Catalogue of the Mediterranean Section*, The University Museum, Philadelphia, 1921.

Magie D. Magie, *Roman Rule in Asia Minor*, Princeton, 1950, Volume II: Notes.

MAMA *Monumenta Asiae Minoris Antiqua*, Manchester, 1928–1962.

Mansel, Akarca A. M. Mansel and A. Akarca, *Excavations and Researches at Perge*, Ankara, 1949 (Türk Tarih Kurumu Yayınlarından V. Seri — No. 8).

Mariani, *AJA* 1 (1897) L. Mariani, "Some Roman Busts in the Museum of the Syllogos of Candia," *AJA* 1 (1897).

Mendel, *BCH* 33 (1909) G. Mendel, "Catalogue des Monuments Grecs, Romains et Byzantins du Musée Impérial Ottoman de Brousse," *BCH* 33 (1909).

Mendel, *Catalogue* G. Mendel, *Musées Impériaux Ottomans, Catalogue des sculptures grecques, romains, et byzantines*, Constantinople, 1912–1914.

Morey, *Early Christian Art* C. R. Morey, *Early Christian Art*, Princeton, 1942.

Morey, *Sardis* V, 1 C. R. Morey, "The Sarcophagus of Claudia Antonia Sabina and the Asiatic Sarcophagi," *Sardis* V, 1, Princeton, 1924.

Olympia III G. Treu, *Die Bildwerke von Olympia in Stein und Thon, Olympia, Text*, Berlin, 1897, III.

L'Orange, *Apotheosis* H. P. L'Orange, *Apotheosis in Ancient Portraiture*, Cambridge, Mass., 1947.

L'Orange, *Spätantiken Porträts* H. P. L'Orange, *Studien zur Geschichte des Spätantiken Porträts*, Oslo, 1933.

Picard, *MonPiot* 44 (1950) Ch. Picard, "Un Cénacle littéraire hellenistique sur deux Vases d'argent du Trésor de Berthouville-Bernay," *MonPiot* 44 (1950).

Picard, *Les trophées romains* G.-Ch. Picard, *Les trophées romains*, Paris, 1957.

Poulsen F. Poulsen, *Catalogue of Ancient Sculpture in the Ny Carlsberg Glyptotek*, Copenhagen, 1951.

V. Poulsen V. Poulsen, *Les portraits romains*, I, *Republique et dynastie julienne*, Ny Carlsberg Glyptotek, Copenhagen, 1962.

V. Poulsen, *Meddelelser* 14 (1957) V. Poulsen, "Caligulas Billede," *Meddelelser* 14 (1957).

V. Poulsen, *OpusRom* 4 (1962) V. Poulsen, "Portraits of Claudia Octavia," *OpusRom* 4 (1962).

377

Ramsay, Church — W. M. Ramsay, *The Church in the Roman Empire Before A.D. 170*, London, 1892.

Ramsay, Cities — W. M. Ramsay, *The Cities and Bishoprics of Phrygia*, Oxford, 1895–1897.

Ramsay, Studies — W. M. Ramsay, *Studies in the History and Art of the Eastern Provinces of the Roman Empire*, London, 1906.

Raubitschek, JRS 44 (1954) — A. E. Raubitschek, "Epigraphical Notes on Julius Caesar," *JRS* 44 (1954).

Reinach, Rép. rel. — S. Reinach, *Répertoire de reliefs grecs et romains*, vols. I–III, Paris, 1909–1912.

Reinach, Rép. stat. — S. Reinach, *Répertoire de la statuaire grecque et romaine*, vols. I–VI, Paris, 1897–1930.

Richter, Ancient Italy — G. M. A. Richter, *Ancient Italy*, Ann Arbor, 1955.

Robert, Carie — L. and J. Robert, *La Carie; histoire et géographie historique avec le recueil des inscriptions antiques*, Paris, 1954.

Robinson Studies, I, II — *Studies Presented to D. M. Robinson*, I, St. Louis, 1951; II, St. Louis, 1953.

Roman Portraits, Worcester — M. Milkovich, *Roman Portraits, A Loan Exhibition of Roman Sculpture and Coins from the First Century B.C. through the Fourth Century A.D., Worcester Art Museum, April 6–May 14, 1961*, Worcester, 1961.

Ryberg, MAAR 22 (1955) — I. S. Ryberg, "Rites of the State Religion in Roman Art," *MAAR* 22 (1955).

Schede, AM 37 (1912) — M. Schede, "Mitteilungen aus Samos," *AM* 37 (1912).

Schefold, Bildnisse — K. Schefold, *Die Bildnisse der antiken Dichter Redner und Denker*, Basel, 1943.

SEG — *Supplementum Epigraphicum Graecum.*

SIG — Dittenberger, *Sylloge Inscriptionum Graecarum*, 3rd ed., Leipzig, 1915.

Smith, Catalogue II — A. H. Smith, *A Catalogue of Sculpture in the Department of Greek and Roman Antiquities II*, London, 1900.

Smith, Catalogue — A. H. Smith, *A Catalogue of Sculpture in the Department of* III *Greek and Roman Antiquities III*, London, 1904.

Squarciapino, La scuola di Afrodisia — M. F. Squarciapino, *La scuola di Afrodisia*, Museo dell' Impero Romano, Rome, 1943.

Stark, Alexander's path — F. Stark, *Alexander's path, from Caria to Cilicia*, London, 1958.

Stark, Lycian shore — F. Stark, *The Lycian shore*, New York, 1956.

Strong, Art in Ancient Rome — E. S. Strong, *Art in Ancient Rome*, II, New York, 1928.

Stuart, Claudius — M. Stuart, *Portraiture of Claudius*, New York, 1938.

Suhr, AJA 59 (1955) — E. Suhr, "A Portrait of Claudius," *AJA* 59 (1955).

Texier, Asie Mineure — C. Texier, *Asie Mineure*, Paris, 1862.

Texier, Description — C. Texier, *Description de l'Asie Mineure*, Paris, 1838–1849.

Toynbee, ABSA 53–54 (1958–59) — J. M. C. Toynbee, "Four Roman Portraits in the Piraeus Museum," *ABSA* 53–54 (1958–59).

Toynbee, Art of the Romans — J. M. C. Toynbee, *The Art of the Romans*, London, 1965.

Toynbee, Hadrianic School — J. M. C. Toynbee, *The Hadrianic School, A Chapter in the History of Greek Art*, Cambridge, 1934.

Toynbee, JRS 37 (1947) — J. M. C. Toynbee, "Roma and Constantinopolis in Late-Antique Art from 312 to 365," *JRS* 37 (1947).

Vermeule, AJA 59 (1955) — C. Vermeule, "Notes on a New Edition of Michaelis," *AJA* 59 (1955).

Vermeule, AJA 68 (1964) — C. Vermeule, "Greek, Etruscan, and Roman Sculptures in the Museum of Fine Arts, Boston," *AJA* 68 (1964).

Vermeule, Berytus 13 — C. Vermeule, "Hellenistic and Roman Cuirassed Statues," *Berytus* XIII (1959).

Vermeule, Berytus 15 and 16 — C. Vermeule, "Hellenistic and Roman Cuirassed Statues: A Supplement," *Berytus* XV (1964); *Berytus* XVI (1966).

Vermeule, BMFA 58 (1960) — C. Vermeule, "A Hellenistic Portrait," *BMFA* 58 (1960).

Vermeule, Goddess Roma — C. Vermeule, *The Goddess Roma in the Art of the Roman Empire*, Cambridge, Mass., 1959.

Vermeule, *PAPS* 108 (1964) — C. Vermeule, "Greek and Roman Portraits in North American Collections Open to the Public," *PAPS* 108 (1964).

Vermeule, *PAPS* 109 (1965) — C. Vermeule, "A Greek Theme and Its Survivals: The Ruler's Shield (Tondo Image) in Tomb and Temple," *PAPS* 109 (1965).

Vermeule, Quarterly 54 — C. Vermeule, "Two Masterpieces of Athenian Sculpture," *The Art Institute of Chicago Quarterly* 54 (1960).

Vermeule, D. von Bothmer, *AJA* 60 (1956) — C. Vermeule and D. von Bothmer, "Notes on a New Edition of Michaelis: Ancient Marbles in Great Britain Part Two," *AJA* 60 (1956).

Vessberg, *OpusRom* 1 (1954) — O. Vessberg, "Roman Portrait Art in Cyprus," *OpusRom* 1 (1954).

Volbach, Hirmer, Early Christian Art — W. F. Volbach and M. Hirmer, *Early Christian Art*, New York, 1961.

Wegner, *Die Flavier* — G. Daltrop, U. Hausmann, and M. Wegner, *Die Flavier. Vespasian, Titus, Domitian, Nerva, Julia Titi, Domitilla, Domitia, Das Römische Herrscherbild*, II, 1, Berlin, 1966.

Wegner, Hadrian — M. Wegner, *Hadrian, Plotina, Marciana, Matidia, Sabina, Das Römische Herrscherbild*, II, 3, Berlin, 1956.

Wegner, Herrscherbildnisse — M. Wegner, *Die Herrscherbildnisse in Antoninischer Zeit, Das Römische Herrscherbild*, II, 4, Berlin, 1939.

West — R. West, *Römische Porträt-Plastik*, 2 vols., Munich, 1933–1941.

Appendix A

IMPERIAL PORTRAITS FROM GREECE, ASIA MINOR, SYRIA, AND EGYPT

(The rulers follow chronological order, and portraits of each are arranged geographically.)

AUGUSTUS, Emperor
27 B.C. to A.D. 14

1. Salonika, Museum, no. 1065, found near the Sarapion: heroic statue in Thasian marble, made in five pieces; the head is a mechanical version of the Primaporta type (O. Walter, "Archäologische Funde in Griechenland von Frühjahr 1939 bis Frühjahr 1940," *AA* 1940, cols. 261ff., figs. 70–73; BCH 78 [1954] 137ff., fig. 36).

2. Chalcis, Museum. A lifesized head (H.: 0.25m.) is characterized by a thin face and hair arranged in the manner of the Augustus from Primaporta (cf. Hafner, p. 43, MK 24).

3. Athens, National Museum, no. 3758, from the Roman agora. This slightly overlifesized head is of the ordinary Primaporta type, but possesses enough of the cubistic heaviness to provide a prototype for the Pisidian Antioch and Cairo heads (A. Hekler, "Neue Porträtforschungen in Athen," *AA* 1935, cols. 399f., figs. 3f.; Hafner, A 29). Strong drillwork is evident, and there is stucco on the top and back of the head, as if it had been veiled. The marble is from the Greek islands.

4. Athens, Tower of the Winds, presumably from the Roman agora. This very battered head is like the Tigani (Samos) version of the Primaporta type but is turned to its own left instead of the right (figure 105).

5. Athens, Acropolis Museum: a head which is individual and quite Greek in style (information from G. Daltrop).

6. Megara, now in Copenhagen: bronze head, from a cuirassed statue. This appears to be an Athenian portrait of the young Augustus (Oc-tavius) in the 30's B.C., a work falling into no other iconographic classification (Hafner, pp. 76f., A 27; Vermeule, *Berytus* 13 [1959] 4f., note 3; G. M. A. Hanfmann, *Göttingische Gelehrte Anzeigen* 218 [1966] 28; V. Poulsen, pp. 79ff., no. 43, where identification as L. Domitius Ahenobarbus is suggested).

7. Corinth, Museum, from the Julian Basilica: statue in tunic and toga, a rather simplified version of the Via Labicana togatus in the Museo Nazionale Romano; the sculptor has almost turned the toga, drawn over the head for the Roman rite of *sacrificium*, into a himation by eliminating the folds over the legs (Harrison, pl. 43; Johnson, *Corinth*, IX, no. 134, pp. 70 ff.) (figure 106).

8. Tenos, Museum, from the sanctuary of Poseidon: fragment, perhaps from a high relief. This head is the Primaporta type, in its sober Corinthian or Athenian form.

9. Siphnos, Museum: E. B. Harrison observed a battered head which appears to be Augustus.

10. Thera, Museum, from the Basilike Stoa: bust, which may be an Eastern version of Augustus in his later years; otherwise this thin, rather ailing man is an imperator of the period 45 to 30 B.C. (F. Hiller von Gaertringen, *Thera*, I [Berlin, 1899], 224, pl. 17).

11. Delos, Museum: colossal head with inset eyes, a portrait of great individuality; damage and abrasion of surfaces prevent detailed discussion of this non-Primaporta type. Hafner has suggested linking this head with an inscription of 27 B.C., thus placing it a decade before the Roman type (Hafner, p. 77, A 28; C. Michalowski, *Les Portraits Hellénistiques et Romaines, Délos* 13 [Paris, 1932], pl. 20).

380

12. Samos, Vathy Museum, of unknown provenance: this head has been identified as a youthful portrait, possibly Brendel's Type B (30–15 B.C.), and also as an official type influenced by the Pergamene baroque (Th. Wiegand, "Antike Sculpturen in Samos," *AM* 25 [1900] 166f., no. 37; Giuliano, p. 162, no. 4; Hafner, p. 37, MK 11).

13. Samos, Tigani, from the Heraion: a very Hellenistic version of the Primaporta type, the set of the eyes and the elongated neck giving the likeness an affinity to the Menander-Virgil portraits (Harrison, pl. 43 g; Hafner, p. 37, no. MK 12; Giuliano, p. 163, no. 6, figs. 11f.).

14. Cos, Museum: a head of the Primaporta type, which according to Giuliano shows local characteristics of Rhodian sculpture (L. Laurenzi, *Clara Rhodos* 9 [Bergamo, 1938] 63, fig. 41; Giuliano, p. 162, no. 3). It is extremely battered, but the treatment does seem to be rather general.

15. Cos, now in Paris, Louvre: mask of a marble head, which Hafner sees as the Primaporta type grown old and which Giuliano identifies as an imposition of Rhodian elements on the Roman type (Hafner, p. 18, R. 13; Giuliano, p. 162, no. 2). This portrait may have been carved after the first emperor's death.

16. Rhodes, Museum, from a building in the city: head and neck, lifesized. This portrait appears to be a free version of a Hellenistic type. In most respects it lies somewhere between the bust on Thera and the head on Delos. The excavators suggested Augustus, but it may be a youthful Tiberius; the nose, an important clue, is missing (*Ergon* 1958, p. 173, fig. 180; *BCH* 83 [1959] 731, fig. 11; Fabbrini, *BdA* 4 [1964] 312, 316, fig. 16, as Drusus Senior).

17. Troy, now in Berlin. This head is a Julio-Claudian transformation of the Primaporta type and probably belonged to a statue set up in Augustus' last years or just after his death. A youthful Tiberius was found with it (no. 11) (Blümel, p. 7, R 13, pl. 8; Hafner, p. 43, MK 24; Giuliano, p. 165, no. 14; Inan-Rosenbaum, p. 57, no. 2). There is a head of Augustus in the museum at Çanakkale, but the precise provenance is not known. This is an average product of a nearby atelier, perhaps one at Cyzicus (Inan-Rosenbaum, p. 57, no. 3).

18. Hadrianotherae (near Balıkesir), now in Boston, Museum of Fine Arts, 64.701: small terra-cotta tondo with head of Augustus, taken from a portrait made in the last decade of his reign. This plaque, 0.145m. in diameter, was found in a tomb with five similar heads on circular backgrounds showing Sarapis and minor Dionysiac or theatrical figures (Vermeule, *PAPS* 109 [1965] 363ff., figs. 4–6).

19. Pergamon, now in Istanbul and found below the shrine of Demeter: a Pergamene copy of the Primaporta type (*BCH* 70 [1946] pl. 20; Mendel, *Catalogue*, II, no. 556; Hafner, p. 49, NK 4; Giuliano, p. 162, no. 5; Inan-Rosenbaum, pp. 57f., no. 4).

20. Sardes(?), now Copenhagen, Glyptotek no. 611: a variant of the Primaporta type, datable ca. 10 to 1 B.C. and showing middle Augustan classicism (Poulsen, pp. 424f.; Hafner, pp. 38f., MK 15, and appendix no. 1; Giuliano, p. 167, no. 23; V. Poulsen, pp. 64f., no. 33).

21. Cyme, now in Istanbul. This veiled head, definitely Augustus, has been termed by Giuliano, "an urban type, perhaps copied from a terra-cotta bozzetto." It has something of the heaviness of features mentioned in connection with the Athenian portrait (no. 2); the surfaces, however, are soft, almost to the point of delicacy (Mendel, *Catalogue*, II, 90, no. 333; Giuliano, p. 157, no. 5; Inan-Rosenbaum, p. 57, no. 1).

22. Ephesus, once in the Selçuk Museum(?), from the fill of the nymphaeum. This head, an Ephesian Hellenistic type, has been badly broken; it has the broad, blank Skopasian face of the colossal Domitian of ca. A.D. 90 and may be a posthumous likeness (Heberdey, "XI. Vorlaüfiger Bericht über die Grabungen in Ephesos 1913," *JOAI* 18 [1915] Beiblatt, col. 87, fig. 32; Giuliano, p. 157, no. 6, "La scultura non presenta alcuna originalità iconografica e stilistica"; Inan-Rosenbaum, p. 58, no. 5). In 1963, however, I did see a battered head which I took to be Augustus and a wonderful portrait with well-polished face in the Selçuk Museum, both portraits were of or close to the Primaporta type. The former is probably the head published by Inan-Rosenbaum (p. 63, no. 15) as Tiberius, at the outset of his reign. The latter, taken also by H. Jucker as a possible Augustus, is listed by Inan-Rosenbaum as a member of the Julio-Claudian family (p. 65, no. 21). A lifesized head of Augustus, with an overlifesized Germanicus and Agrippina the Elder, was found in the basilica on the north side of the city's market. See *Österreichisches*

AUGUSTUS (continued)

Archäologisches Institut, Grabungen 1965 (Vienna, 1966), p. 8. Parts of the torsos of the two larger statues were found; the ensemble must have resembled the portraits in the Julian Basilica at Corinth.

23. Pisidian Antioch (Yalvaç), now in Istanbul, found (as an heirloom?) in a Byzantine house near the Augustan temple and propylaea. This head is a large, heavy, cubistic version of the Primaporta type; no doubt an Asiatic sculptor tried to copy a version made in Athens or along the Ionian coast (Inv. no. 4026; D. M. Robinson, "Two New Heads of Augustus," *AJA* 30 [1926] 125ff.; Inan-Rosenbaum, p. 59, no. 8).

24. Myra (Demre), now in Antalya, Museum (Inv. no. 906): colossal head, a posthumous version of the Primaporta type, with wrinkles and side-whiskers added to indicate greater age than the archetypes (Inan-Rosenbaum, p. 58, no. 6) (figure 107).

25. Side, Museum: head, from a draped statue and a fine, original work from an atelier in Asia Minor (Inan-Rosenbaum, pp. 58f., no. 7).

26. Konya, Museum: identified by Inan-Rosenbaum as a provincial version of a bust in the Museo Capitolino (p. 59, no. 9) (from Pisidian Antioch?: Robinson, "Roman Sculptures from Colonia Caesarea (Pisidian Antioch)," *ArtB* 9 [1926] 69, fig. 127 is another head, which has not been seen in recent years).

27. Fayoum, now Copenhagen, Glyptotek no. 610, found in the amphitheater of Arsinoë: bust, a type of ca. 10 B.C., related to the Primaporta group but showing the emperor's greater age; F. Poulsen considered it Roman work exported to Egypt (*Catalogue*, pp. 423f.; V. Poulsen, pp. 63f., no. 32). The portrait was found with busts of Livia and Tiberius.

Of late the authenticity of this discovery has been questioned (G. M. A. Hanfmann, *Göttingische Gelehrte Anzeigen* 218 [1966] 26, 33), partly on the grounds that a dealer was involved and partly because the find included a marble statue of Victory holding a bronze statuette "representing the suicide of Cleopatra," with only the snake surviving. The group was surely Victory holding Pax-Salus-Nemesis, an excellent Julio-Claudian concept and one beyond the comprehension of a Levantine steeped in folk tales from Alexandrian guidebooks. The type appears on coins of Claudius, "she is winged, she holds a *caduceus*, she bends an arm upwards to draw a part of her robe up across her face, and in front of her there is a snake" (M. Grant, *NumChron* 1949, p. 24). Thus, if only the base of the statuette on Victory's hand were preserved, the snake easily could have been the chief surviving part, unintelligible save in terms of the Cleopatra legend. In short, there is scant reason to question the tale that the three busts were found together.

28. Cairo, now in Berlin: this head is basically the Primaporta type, but it is solidly constructed, in the manner of the first head from Pisidian Antioch (Blümel, p. 7, R 12, pl. 8).

29. Meroe, in London, found in a pocket of clean sand before the entrance to one of the palace's principal buildings and perhaps deliberately buried: this heroic bronze head with inlaid eyes stands in roughly the same relation to the Primaporta type as does the marble head in Tigani, Samos; it is drier, with less of the "pathetic" qualities of the head from the Samian Heraion (West, I, pl. XXIX, no. 120).

30. Egypt (Memphis ?), now Cranbrook Academy, near Detroit (Michigan). Strongly Hellenistic head in marble, with hair made separately in plaster. There are traces of paint in the eyes. Harald Ingholt has compared this portrait to the colossal Hellenistic head in Boston, from Memphis, a head remade as Severus Alexander; he even suggests, probably rightly, that the two might have been produced in the same workshop (see below, Severus Alexander, no. 2; and Ingholt, *JARCE* 2 [1963] 136ff., pl. 37).

31. Cairo, recorded in the art market. This colossal head in crystalline white marble is said to come from Athribis; the complete statue was four times natural size. The head, an ideal and Hellenistic presentation of the first emperor, has been compared to the Hadrianic Augustus (in Boston) from Ariccia near Rome, and therefore it may be a posthumous portrait, perhaps one made as late as the reign of Hadrian. Its general aspects are similar to the head in Boston remade as Severus Alexander (see above, under no. 30), characteristics that seem to be common to large-scale cult statues of Roman emperors made in Egypt. Like the Severus Alexander, this Augustus has traces of red ground-color in the eyes (Graindor, *Bustes et statues-portraits*, pp. 44f., no. 3, pl. III).

GAIUS CAESAR, died A.D. 4,
and
LUCIUS CAESAR, died A.D. 2

Gaius is recognized in the following marble portraits:

1. Athens, National Museum, no. 3665, from Athens: only the left side of this head is preserved. This is a careful but very uninspired portrait, like the head of the statue at Corinth (Hafner, p. 80, no. A 35). The man who carved this head was normally employed in carving large sepulchral monuments of the Augustan period. Only the hair over the forehead is really worked. The marble seems to be medium-grade Pentelic.

2. Philippi: this head is another mechanical work like the Corinth head; it may have been carved in and shipped from Athens or Corinth (Hafner, pp. 50f., NK 6; Collart, *Philippes*, pp. 353ff., pl. 74, 4).

3. Corinth, Museum, from the Julian Basilica: upper half of a statue, nude and with large cloak on the left shoulder (Johnson, *Corinth*, IX, 72, no. 136; Chamoux, *MonPiot* 44 [1950] 83ff.) (figure 110).

4. Corinth, Museum, Workrooms: top of the head of another replica of the preceding; this fragment is somewhat more graceful and charming, in the dry tradition (Inv. no. S 2655).

5. Istanbul, Museum, without provenance. Various candidates have been proposed for this head, and it may well represent the young Tiberius; on the other hand, there is some likelihood that it is an official Asiatic likeness of Gaius Caesar made shortly before his death (Mendel, *Catalogue*, II, 323, no. 589; Hafner, pp. 53f., NK 12).

6. Assos, now in Istanbul(?), from the agora. This head has been badly broken; the photograph makes the eyes look deeper than they are. The man has a slight beard. The Roman merchants at Assos set up a statue of Gaius between A.D. 1 and 4, and this may be the head from that statue. The portrait is much more sensitive than the Philippi head or that of the Corinthian statue. If Gaius is unacceptable, the portrait is that of Germanicus; the beard may be a sign of mourning for his stepgrandfather Augustus in the year A.D. 14 (F. H. Bacon, *et al.*, *Investigations at Assos* [Cambridge, Mass., 1902], p. 105, fig. 1, right side).

7. Smyrna, art market (said by Giuliano, after V. Poulsen, to have been later in the New York art market): overlifesized head, the very dry stylization being emphasized by the size; this seems to be a cult head of Gaius Caesar, and as Hafner has suggested it is probably to be dated in the reign of Claudius (Hafner, pp. 40f., MK 20; Giuliano, p. 160, no. 21).

Lucius Caesar is known from one bronze statue, one marble statue, and possibly six marble heads.

1. Thasos, Museum, no. 102, from the agora: head, bits of the statue, and an architectural inscription, in the form of a dedication from the Polis, suggesting a heroon to the deceased prince. The head is an ideal, "ephebe" portrait in the tradition of Attic grave reliefs from the circle of Praxiteles, and the statue was carved after the prince's death, probably between A.D. 2 and 4 (Chamoux, *MonPiot* 44 [1950] 83–96; Hafner, pp. 49f., no. NK 5). The statue evidently presented the prince as Hermes.

2. Athens, National Museum no. 3606, from the Royal Gardens. This youthful head in Greek island marble is turned to its own left; it is more lively than the head of the heroic statue in Corinth (Chamoux, p. 88, no. 4; Hafner, pp. 79f., A 33; Hekler, *AA* 1935, pp. 403ff., figs. 5f.). The carving is fine, controlled, and very forceful; the workmanship is somewhat harsh but is not displeasing in this respect.

3. Corinth, Museum. The academic presentation of divine body, with copyist's *puntelli* visible on the left elbow, is based on a type usually called Hermes. Lippold's suggestion that the prototype represented Theseus is very persuasive. Lucius-Theseus would have as his pendant, Gaius-Achilles, if we think of the other statue as being close to the Doryphoros type. This would have given mythological meaning to the heroic statues of the two princes (Johnson, *Corinth*, IX, 72ff., no. 135) (figure 111).

4. Thera, Museum, from the Ptolemaic Gymnasium: head, of radically ideal Greek type. Hafner has related it to the head of the bronze statue in New York; Curtius has suggested it is Germanicus, from a monument of the Claudian period. If it is not Lucius Caesar, then it is the young Claudius, or a private person (Hafner, p. 27, no. R 25 and refs.).

5. Samos, Tigani Museum, from the Castro: this head shows fine work, trying to be free

LUCIUS CAESAR (*continued*)

and plastic in the Hellenistic tradition. The prototype may have been Attic; it is slightly younger in presentation than the pseudo-Augustus likeness of the Corinthian statue (Hafner, p. 39, no. MK 16; Giuliano, p. 158, no. 14).

6. Rhodes(?), now New York, Metropolitan Museum. This half-draped bronze statue shows Lucius as an alert, delicate youth; in its rococo delicacy the statue reflects Rhodian handling of a mainland Greek concept. Lucius must have been about ten years old when this portrait was created (Chamoux, pp. 95f.; Hafner, pp. 17f., R 12; Giuliano, p. 162, no. 1) (figure 112).

7. Berlin, from Asia Minor. This head is possibly Lucius Caesar on the eve of his death, although Hafner has suggested that it is a likeness of the young Tiberius. It seems to be an attempt to copy the Corinthian portrait by a sculptor who could not adhere closely to his prototype; he has removed the youthfulness which is inherent even in the dry Corinthian statue (Blümel, p. 8, R 17, pl. 8; Hafner, pp. 13f., R 6).

8. Nicosia, Cyprus Museum: a rather lifeless, hesitant rendering, since the bare pupils are like dried almonds, of a portrait circulated just before or after the Caesar's death (Chamoux, p. 88, no. 6; P. Dikaios, *A Guide to the Cyprus Museum* [Nicosia, 1961], p. 90, pl. XIX, 4).

TIBERIUS, Emperor A.D. 14 to 37

The following list of portraits omits the head in Berlin described under Lucius Caesar (no. 7) and sometimes identified as Tiberius; it also leaves out the head in Istanbul from Cyme, which is more likely Augustus (no. 21) than Tiberius. The head from Rhodes is included here, although it also appears under Augustus (no. 16); the absence of the nose and the insular quality of the work make definite decision between the two nearly impossible. The basic collection of Tiberian portraits has few from the East: L. Polacco, *Il volto di Tiberio* (Padua-Rome, 1955).

1. Larissa Museum, no. 825, from below the cathedral of St. Achillios: overlifesized head with wreath of maple or cypress, carved in northern island marble. There is red paint in the pupil of the left eye. The shape and turn of the neck seem to suggest the head came from a seated, heroic statue.

2. Athens, now in Berlin: head, from a statue set up shortly after his accession. The portrait, with its turn of the head and strong carving, follows a Hellenistic, western Asiatic rather than Athenian tradition of carving (Blümel, pp. 9f., R 20, pl. 12; Hafner, p. 80, A 34; Fabbrini, *BdA* 4 [1964] 318, figs. 28, 31, 34, as Drusus Senior).

3. Athens, National Museum: a tiny gold statuette in the H. Stathatos collection shows Tiberius as Hermes; he stands with purse in one hand and caduceus in the other. The artist may have made this votive image as an unconscious portrait, an imitation of a major work of art or another piece of metalwork (P. Amandry, *Collection Hélène Stathatos*, III, *Objets antiques et byzantins* [Strasburg, 1963], p. 235, no. 171).

4. Athens, National Museum: a rather indifferent likeness of Tiberius, a Greek version of a Roman official portrait, is in the Carapanos (Dodona) Room (no. 910–5).

5. Eleusis, Museum, from the colonnaded building south of the Telesterion: a togate statue, veiled for sacrificing shows Tiberius at a relatively young age, perhaps during the period following the Parthian Settlement (figure 113). The model, if not the statue itself, comes from an Italian workshop; it is of heroic size (Kourouniotes, *Eleusis*, pp. 95f., fig. 40). The Romans enjoyed being represented at the shrine of Demeter in their most Roman costumes, Hadrian and Marcus Aurelius appearing as busts in Roman ceremonial cuirasses. A headless empress as Demeter (Julia or Livia) was found with Tiberius. *See also* NERO, no. 1.

6. Mytilene, Gymnasium, from Lesbos (often wrongly listed as once in Smyrna, in the Evangelical School). This head is a vigorous portrait of Tiberius done in Asia Minor fairly late in the reign of Augustus; the hair is of the "stringy" type, arranged like that of Augustus, but the face is well modeled and vigorous (Lippold, Curtius, *Einzelaufnahmen*, 3201; Hafner, pp. 51f., NK 8; F. Poulsen, under Ny Carlsberg Glyptotek no. 611).

7. Samos, Vathy Museum (Apotheke): a middle-aged East Greek likeness, somewhat between the Mytilene and the Rhodes portraits in age of the sitter (Hafner, p. 111, note 56; L.

Curtius, "Ikonographische Beiträge VIII," *RM* 50 [1935] 309, note 8). I take this to be the head illustrated by L. Fabbrini, *BdA* 4 [1964] 314, figs. 9, 11, 13, while her p. 311, figs. 1, 2, is a younger Julio-Claudian likeness of Tiberius. It is also in the Apotheke. The same atelier produced both these heads.

8. Heraklion (Iraklion) Museum, no. 65, from the agora at Gortyna: head veiled and made for insertion in a statue (figure 114). This is a handsome portrait of Tiberius in his old age, based on a Roman model, the head from Lanuvium in Boston showing a younger version in the same Roman development (Mariani, *AJA* 1 [1897] 268f., fig. 2; Fabbrini, *BdA* 4 [1964] 314, figs. 10, 12, 14).

9. Heraklion (Iraklion) Museum, no. 377: a possible veiled, rather Hellenistic Tiberius. He is characterized by his fairly prominent ears (*BCH* 80 [1956] 341f., fig. 11) (figure 115).

10. Rhodes, Museum: this portrait, whether Augustus or Tiberius, fits well in the class of Julio-Claudian portraits made after Attic and Asiatic models in the Greek islands closest to Anatolia.

11. Troy, now in Berlin, Pergamonmuseum, and found with Augustus no. 17: a youthful head of the Mytilene and Smyrna-Copenhagen types (Blümel, p. 7, R 14, pl. 13; Inan-Rosenbaum, p. 62, no. 13).

12. Pergamon, now in Istanbul: a variant of the above types, which *may* be Germanicus rather than his uncle; the hair is stringy, and the face is dry and precise, in a Hellenistic sense, like the Tigani Augustus (no. 13) (Mendel, *Catalogue*, II, 281f., no. 558; Hafner, p. 53, no. NK 11; Giuliano, p. 157, no. 9; Inan-Rosenbaum, pp. 62f., no. 14).

13. Magnesia ad Sipylum, now in Istanbul. This Eastern, Hellenistic statue of the young Tiberius, or possibly of Germanicus, shows him wearing a himation and tunic, the end of the former being pulled over his head; he displays the rolled fillet of a Hellenistic ruler or man of intellect in his hair. The face is slender and sensitive (Mendel, *Catalogue*, II, 324ff., no. 591; Inan-Rosenbaum, p. 161, no. 209, as a private person).

14. Smyrna, now Copenhagen, Ny Carlsberg Glyptotek: a youthful, western Asiatic Tiberius with turned head and a full mouth; Giuliano speaks of the Rhodian-baroque qualities of the portrait (Poulsen, pp. 432f., no. 625; Hafner,

pp. 52f., no. NK 10; Giuliano, p. 165, no. 16; V. Poulsen, pp. 81f., no. 44, perhaps about 11 B.C. when at the age of thirty he married Julia, daughter of Augustus).

15. Smyrna, once(?) in the Gaudin collection: a head resembling the Troy-Berlin portrait (above, no. 11) (*Einzelaufnahmen*, nos. 1351f.; Giuliano, p. 158, no. 13). A curious wreath, such as the parsley crowns of athletes, encircles the brow. The carving is dry and precise, the top of the head being unfinished. Gaudin, it is remembered, was an early excavator of Aphrodisias, where Tiberius was honored with the Great Ionic Portal.

16. Ephesus, now in the Selçuk Museum. This battered head was found in the Street of the Kuretes opposite the temple of Hadrian; it is a masterpiece and has been classified by Inan-Rosenbaum among the early portraits of Tiberius Augustus, a precise replica of the "coronation" type (p. 63, no. 15).

17. Philomelium (Phrygia), now in the Louvre (no. 1225). This is a standard, western Asia-Minor version of the *Imperium Maius* portraits in Polacco's list, those heads created in the decade from A.D. 10 and especially before Tiberius became emperor. The region of Philomelium was filled with Roman colonies and garrisons (Pisidian Antioch, for instance), and the head must have belonged to a statue sent to one of these. It is dry and competent, but the hair is somewhat summarily treated (Polacco, p. 129, pl. 26, 1).

18. Sinope, now in the Ankara Museum. This provincial portrait has been tentatively named Tiberius by V. Poulsen (*Les portraits romains*, I, 71; from L. Budde, "Vorläufiger Bericht über die Ausgrabungen in Sinope," *Belleten* 5 [1956] pls. 18f.), but E. Rosenbaum confirms Budde's identification as a Republican portrait. See also J. M. C. Toynbee, *JRS* 53 (1963) 221.

19. Fayoum, from the amphitheater of Arsinoë and now in Copenhagen, Ny Carlsberg Glyptotek: bust, found with busts of Augustus (no. 27) and Livia. This portrait follows a Roman model of ca. 5 B.C. to A.D. 4 (the year of his adoption by Augustus) and may have been exported from the capital (Poulsen, pp. 431f., no. 623; V. Poulsen, pp. 82f., no. 45).

20. Alexandria, Graeco-Roman Museum, no. 22237. This head, with neck prepared for insertion, copies an official version of the first portrait of Tiberius; it is more animated than

TIBERIUS (*continued*)

the head in Copenhagen, from Fayoum (N. Bonacasa, "Contributo all' Iconografia di Tiberio," *BdA* 47 [1962] 171–179, figs. 1–3).

21. Alexandria, Graeco-Roman Museum, no. 3368: this head is a local copy of the previous, well handled but with a Greek tendency to summarize the hair behind and simplify the lines of the face in front (Bonacasa, figs. 11–12).

ANTONIA, died A.D. 38

1. Tralles(?), via a collection in Naples and now in Copenhagen: bust, clad in a curious garment tied by shoulder straps. A Roman model has been followed. The carving is hard and precise, resembling the heads in black or green stone so popular at the beginning of the imperial period. The hair is treated in heavy strands, parted severely in the middle and brought around to a "sheep-tail" behind. The severe quality of the portrait is an effort to reflect the austerity characteristic of Octavia's or Livia's portraits. Giuliano is perhaps right in suggesting that this work was exported from Attica (Poulsen, p. 421, no. 607; Giuliano, pp. 158ff., no. 18, figs. 8f.; V. Poulsen, pp. 77ff., no. 42) (figure 116).

2. Athens, Agora Museum: fragment of a head. Harrison has identified this and a perfectly preserved replica in Berlin as Antonia; the head in Berlin is said to come from a Greek island, which V. Poulsen (pp. 77ff.) gives as Samos (Harrison, p. 24, no. 12; Blümel, p. 11, no. R 23). Both heads are officially Julio-Claudian in their proportions and charming in their simple directness, a series of little curls setting off the simply parted hair knotted behind.

3. Istanbul, Archaeological Museum, no. 4503, from Asia Minor. This appears to be a characteristic likeness, made either in an Attic atelier or in a related workshop on the coast of Asia Minor.

AGRIPPINA SENIOR, died A.D. 33

The following portraits have been identified from Greece and Asia Minor:

1. Athens, now Paris, Louvre no. 3133: a classical rendering of Agrippina's classic fea-

tures (*Bull. des Museés de France* 1909, pp. 49f., fig. 1).

2. Syros, Museum no. 111, from Minoa on Amorgos: head and neck, worked for insertion in a draped statue and wearing a necklace (G. Deschamps, "Fouilles dans l'île d'Amorgos," *BCH* 12 [1888] 325; Fabbrini, *BdA* 4 [1964] 326, note 145). Found with a very elegant Germanicus, this Agrippina is a rather commonplace, almost crude Greek transcription of an official Roman model which has passed to Amorgos through some second-rate Corinthian or Athenian workshop (figure 121). The face is bland, and the hair is heavily drilled out; even the quality of the marble is inferior, the surfaces having suffered from weathering, pitting, and flaking. No one would mistake this portrait for anything but a provincial Greek likeness.

3. Troy, now in Philadelphia (Penna.), University Museum: a rather dry copy about twice lifesized; the body, draped in the usual fashion, is said to be in Berlin (Luce, *Catalogue*, p. 190, no. 58; Vermeule, *PAPS* 108 [1964] 110, fig. 14, a–c). The head, very Roman in feeling, was probably carved in western Asia Minor about A.D. 18, when Germanicus delivered an address to Hector at Troy (figure 122).

4. Pergamon, now in Istanbul: this head presents a fairly lively treatment of an Attic prototype which in turn links directly with portraits of Agrippina in Roman museums (Mendel, *Catalogue*, II, 281, no. 557; Hafner, pp. 54f., no. NK 14; Giuliano, pp. 158ff., no. 19; Inan-Rosenbaum, p. 63, no. 16).

5. Trabzon, now in Istanbul (Depot), no. 4503: somewhat mutilated and similar to the head from Pergamon; it is perhaps not as idealized (Inan-Rosenbaum, pp. 63f., no. 17). This portrait has been mentioned in connection with likenesses of Antonia.

CALIGULA, Emperor
A.D. 37 to 41

1. Heraklion (Iraklion) (Candia) Museum, no. 64, from the agora at Gortyna. This veiled head is a Greek version of a portrait of Caligula at the beginning of his reign; it is average work, reflecting a Roman archetype by way of Athens (V. Poulsen, *Meddelelser* 14 [1957] 45, no. 5; Poulsen, p. 444; Studniczka, *AA* 25 [1910] 533; Mariani, *AJA* 1 [1897] 266ff., fig. 1) (figure 124).

2. Istanbul(?), via Paris to Copenhagen: this well-carved head has much color preserved, painted eyes and eyelashes. F. Poulsen wrote, "It is doubtless the best of all the definite Caligula portraits known." The head follows the Roman model so closely that it must have been made in Italy. Poulsen likened it to another Caligula in Copenhagen, a cuirassed bust said to have been found in or near the Tiber but now recognized as an excellent Italian forgery. The head from Constantinople is certainly an ancient Roman export to Asia Minor or Byzantium, unless the provenience is hopelessly inaccurate (Poulsen, pp. 445f., no. 637a; V. Poulsen, pp. 89f., no. 54, where the execution is considered summary and the workmanship Greek; *idem, Meddelelser* 14 [1957] 47, no. II, 3).

3. Nicomedia, now in Istanbul: this is a bust, clad in a cuirass of Roman type, enriched with *gorgoneion* and *fulmen* on the right shoulder strap. Caligula looks more like Tiberius than in his Roman portraits and their replicas. His physical relationship to Nero Drusus and Claudius is also evident. Hafner suggested that this might be Germanicus. This portrait of Caligula was made in western Asia Minor just after his accession in 37 and before the official Roman type had circulated throughout the East. The carving breathes a certain lingering touch of heroic Hellenism (Mendel, *Catalogue*, II, 322, no. 588; Hafner, p. 51, no. NK 7; V. Poulsen, pp. 90f., under no. 56, proposes Claudius, having once made the identification as Caligula: "Studies in Julio-Claudian Iconography," *ActaA* 17 [1946] 37). Jale Inan and Elisabeth Rosenbaum (pp. 65f., no. 22) feel that the bust does not belong; Mendel discusses the point in some detail. Despite its seeming smallness and awkwardness, the bust is Julio-Claudian, and it could have belonged with this head and neck in antiquity.

CLAUDIUS, Emperor
A.D. 41 to 54

The following portraits have been identified with Claudius:

1. Verria, Museum: three times lifesized head of the aging Claudius, wearing a large oak wreath with diadem(?) and cameo in the center. The ends of the wreath appear on the shoulders; the neck is worked for insertion in a draped or cuirassed statue. There are lots of lines on the face. The treatment is very Hel-

lenistic, even to the turn of the neck. The marble is probably northern Greek but may be Pentelic.

2. Thasos, now in the Louvre. This head presents provincial treatment of an Attic type and is probably work of an atelier in northwest Asia Minor. The hair is simply worked to suggest bronze, and the jeweled *corona civica* is almost crude in its carving (Hafner, p. 54, no. NK 13; Fr. Chamoux, *Revue des Arts* 1957, pp. 147–150).

3. Thasos, Museum: head or bust of Claudius (*Guide Bleu*, ed. 1959, p. 629). This is a poorer work.

4. Athens, Agora Museum. This colossal, wreathed head has provoked considerable discussion ever since Shear published it in 1933 and 1935 (Harrison, pp. 27f., no. 17). Its size and general presentation make it difficult to ignore as an imperial portrait; its highly generalized features have led to its being named Claudius (by Hafner), Domitian (by Magi and Vermeule), and Trajan (by Bieber and Daltrop). Harrison first maintained it might be a Flavian priest but has since been swayed to the identification as Trajan, even going so far as to state it "probably belonged to a statue in armor like that of Hadrian" (*Ancient Portraits from the Athenian Agora*, fig. 11). Such bland, godlike features are never found in cuirassed statues; if the wreath is indeed laurel, then it is possible to think of a statue of an emperor as Apollo. A bronze statue of Claudius as Apollo Patroos stood in the agora, and perhaps this head once adorned a like work in marble. A large Roman copy of Euphranor's Apollo Patroos is one of the features of the Agora Museum (B. M. Sismondo Ridgway, American School of Classical Studies *Papers*, 1956, no. 2). Identification as Trajan probably stems from the copious hair arranged in bangs over the forehead; coupled with the highly general face, I take this hair to be symbolic of the divine nature of Claudius (see further Suhr, *AJA* 59 [1955] 321; Hafner, pp. 85ff., no. A 44). Bieber's identification (*AJA* 60 [1956] 206; supported by Daltrop, in Wegner, *Die Flavier*, p. 97) brought forth the comment from Hanfmann, "certainly a Julio-Claudian emperor and certainly not Trajan" (*AJA* 61 [1957] 253). What Julio-Claudian emperor could Hanfmann have in mind other than Claudius? V. Poulsen has also concluded, independently, that the portrait is a posthumous

CLAUDIUS (*continued*)

likeness of Claudius (*Les portraits romains,* p. 95, no. 8 under no. 60).

5. Piraeus, Museum, from the harbor, near the site of the ancient Emporion. This head (and neck worked for insertion), turned to the viewer's left, is a rather dramatic Hellenistic portrait of the emperor. It was carved between A.D. 50 and 54 (Toynbee, *ABSA* 53–54 [1958–59] 285f., no. 1; Stuart, *Claudius,* pp. 74f., no. 29). A cuirassed bust in the Piraeus Museum was considered as Claudius by Stuart (*Claudius,* no. 30), but Toynbee has suggested, probably correctly, this is a Neronian general or official, so far unknown (*ABSA* 53–54, pp. 286ff.). V. Poulsen, however, returns to the identification as Claudius (*Les portraits romains,* p. 94, no. 5 under no. 60); his discussion centers around a head in Copenhagen (Poulsen, no. 460 b) from Greece or the islands.

6. Sparta, Museum: veiled head from a statue. This is a typical Greek version of a Roman model of the period 41 to 50. The workmanship is average (F. P. Johnson, "The Imperial Portraits at Corinth," *AJA* 30 [1926] 164, fig. 5).

7. Olympia, Museum, from the metroon. This half-draped statue of Claudius as Zeus is signed by two Athenian artists and the stonerougher. It was perhaps carved in A.D. 49, on the occasion of Claudius' marriage to Agrippina Junior (*Olympia,* III, pls. 60, no. 1, 61, no. 1; Hafner, p. 84, no. A 43). The type finds its counterpart in the statue in the Vatican, from Lanuvium. The portrait is sensitive and endowed with considerable pathos (figure 125).

8. Samos, Tigani, City Hall, from the Roman agora in the Castro: head, with wreathed crown. Stuart (*Claudius,* p. 48) suggests it may belong with a dedication to him from the Demos; a Latin inscription found with it has provided the additional information that Claudius restored the temple of Dionysos after an earthquake in A.D. 47 (Schede, *AM* 37 [1912] 217f., nos. 19, 20).

9. Athens, National Museum, no. 328, from Smyrna. This is a baroque likeness, in the Hellenistic tradition of the bronze head of a man from Delos; the official iconography superimposed on this Asiatic work gives it a note of naturalism. The head belongs at the latest to the middle of the emperor's reign (Hafner, pp.

42f., no. MK 23; Giuliano, p. 167, no. 24), but only by the wildest imagination can this be called Claudius. This portrait was evidently crowned by a separate wreath. With its polished face and precise hair, it could be one of the Seleucids (Antiochus III) or even one of the later kings of Bithynia or Cappadocia. The marble comes from western Asia Minor.

10. Once Smyrna, Art Market. This is a young, ideal head, a work that could date before the emperor's elevation to the throne. It is conceived in the most elegant western Asiatic style, having nothing to do with Roman types (Hafner, pp. 41f., no. MK 21; Giuliano, pp. 160f., no. 22). Among other possible identifications, the most persuasive is Britannicus, the ill-fated son of Claudius (V. Poulsen, "Billeder af Nero og Hans Far," *Meddelelser* 6 [1949] 4f., 11, fig. 9).

11. Priene, from the temple of Athena Polias and now in London, British Museum. This head, from a statue, was found on the floor of the temple. It is an official, Roman type of the years around A.D. 50, probably having been made in Athens, Corinth, or even Italy. There is nothing particularly Eastern about it (Hafner, p. 42, no. MK 22; Smith, *Catalogue,* II, 156, no. 1155; Giuliano, p. 161, no. 23; Inan-Rosenbaum, p. 64, no. 18). Only parts of the face and neck are ancient; the rest is restored in plaster.

12. Alexandria, Museum, no. 25713, from the art market in Cairo. This head in marble, once gilded, probably carved in the first five years of his rule, is typically Hellenistic-Egyptian, with long face and neck (longer than the emperor's natural appearance), large ears, hair roughed out, and the back of the head unfinished or completed in stucco (N. Bonacasa, "Ritratto di Claudio del Museo Greco-Romano di Alessandria," *RM* 67–68 [1960–61] 126–132, pls. 37ff.).

13. London, Sir John Soane's Museum, no. 114 L (*Catalogue,* no. 37 A), from Egypt. This small head in island marble, colored black, shows Claudius in an Egyptian headcloth. The eyes were inlaid. The whole statue probably graced a household shrine. The portrait is rough, vigorous, almost impressionistic, but it retains the peculiar features of the fourth emperor: a short face on a long neck with Adam's apple, curved nose, pursed lips, a small chin, and curled ears.

NERO, Emperor
A.D. 54 to 68

The Eastern portraits of the last of the Julio-Claudians are:

1. Eleusis, Museum: a slightly overlifesized statue of the young Nero, at the beginning of his reign. He wears the toga; there is a slight possibility that the head of this statue has been recut to make a portrait of the young Constantine the Great or one of his Caesar sons (K. Kourouniotes, *Eleusis* [Athens, 1934], p. 73, fig. 40; V. Poulsen, p. 100). The first reference belongs with Tiberius, no. 5, the better preserved statue.

2. Olympia, Museum, from a wall between the metroon and the Heraion. V. Poulsen has proposed that this head was a portrait created by a Greek artist after a Roman model of the period when Nero was "heir to the Crown," or else just after his accession. The Greek sculptor has produced a typical late Julio-Claudian portrait, with blurred and roughened hair (perhaps for coloring), large and somewhat sunken eyes, and a face that is both bland and touched by a dreamlike quality (V. Poulsen, *OpusRom* 4 [1962] 110, figs. 8f.; *Olympia*, III, pl. LXI, no. 4). The identification looks convincing when the head is placed beside gold aurei and silver denarii of this period.

3. Tigani (Samos), City Hall, from the Castro: this head has been confused with that discussed under Germanicus (no. 1 in text); it appears to belong to the togate statue on which it is now set. V. Poulsen has identified the subject as the young Nero, and his photograph of the profile makes this identification certain. It is a western Asiatic version of a Roman type (V. Poulsen, "Nero, Britannicus and Others," *ActaA* 22 [1951] 125, no. 8, figs. 15f.). The head is turned to its own left, giving the portrait a romantic quality accentuated by the copious amounts of dryly but precisely carved hair.

4. Samos, Vathy Museum: this head is little more than a badly damaged fragment. The workmanship appears to border on the crude, the hair over the forehead being treated in strong strands and the rest summarily. Giuliano sums up the identification: "Ritratto di un principe giulio claudio . . . Ripete un tipo documentato da numerosi esemplari in tutto l'impero ed attribuito a Nerone giovinetto." (Giuliano, p. 160, no. 20; V. Poulsen, *ActaA*

22, 124, no. 7; Schede, *AM* 37 [1912] 204, no. 4, figs. 3, 4).

5. Cos, Museum, no. 4510: overlifesized head, ca. A.D. 52 to 54, characterized by deep grooving of the locks. The portrait is precisely that of cistophori struck at Ephesus. The face is much mutilated in such a way as to suggest damnatio after the emperor's death: mouth, nose, and eyes have been systematically defaced with a chisel, leaving only enough to indicate the identification, as was the approved technique of damnatio (Laurenzi, *Annuario* 33-34 [1955-56] 140, no. 192).

6. Tralles, now in Istanbul: headless statue of Nero (figure 126). He wears a field cuirass of a type not generally found in statues until ca. A.D. 130 or later, and popular first in statues from Asia Minor. The decoration consists of a double cingulum, large griffins facing beneath, and a row of semicircular tabs, enriched with rosettes and stars. The identification is derived from the inscription of the plinth (Νέρωνα Κλαύδιον Θεοῦ Κλαυδιόν Καίσαρος υἱόν). The marble was colored, gold for the cuirass and rose on the lower part of the tunic (Mendel, *Catalogue*, II, 315ff., no. 584; Vermeule, *Berytus* 13 [1959] 43, no. 76).

7. Stratoniceia, now in Smyrna, New Museum, no. 843: colossal head, with neck made for insertion in a draped statue or as a bust. The young Nero is portrayed at the period when he became emperor, as no. 5 (V. Poulsen, p. 99; Inan-Rosenbaum, p. 66, no. 24). The marble is Aphrodisian.

8. Haifa, City Art Museum: head, of the mature type of the portrait in Worcester, Mass. (ca. A.D. 60). Unfortunately, the provenance of this piece is not given, and it may have come from Western Europe in recent times. (Information from Herbert A. Cahn; compare *Roman Portraits*, Worcester, p. 28, no. 10, and bibliography.)

TRAJAN, Emperor
A.D. 98 to 117

The principal Eastern portraits are:

1. London, British Museum, head, from the province of Macedonia. Much damaged, especially around the nose and eyes, this colossal portrait was found along the road from Salonika to Serres, six kilometers from Salonika. Gross (p. 130, no. 55, pl. 25, b) placed it in

TRAJAN (continued)

the same group with the head in the Piraeus Museum (below, no. 5), but the dry, regular arrangement of the hair suggests a likeness made long after the emperor died, perhaps in the Constantinian period. H. Jucker in his supplement to Gross (AJA 61 [1957] 251, no. 22) has removed the Macedonian head from the list of Trajans and dated it perhaps in the fifth century. Trajan was extremely popular as a subject on medallions or propaganda tokens (contorniates) in the fourth and fifth centuries, and comparable monumental portraits of the "Best of Princes" must have been fashioned.

2. Thessaly, Almyros, head. I have not seen this. It seems to be a separate marble from the following (no. 3).

3. Larissa (Thessaly) Museum, no. 803: twice-lifesized head in northern Greek marble, from below the cathedral. All below the middle of the nose is missing, and the top of the head was made separately. There is a large oak wreath; the hair is strongly defined, like that of the head from the Capitolium of Samos (no. 10).

4. Delphi. The Amphiktyonic Council put up a statue of Trajan in their shrine, and the base survives.

5. Piraeus, Museum, colossal head. This likeness, in fresh Pentelic marble, is both spectacular and conservative in handling.

6. Olympia, Museum. A headless cuirassed statue, with griffins springing at a candelabrum on the breastplate, has been identified as Trajan; it is a dry, academic work which appears to be contemporary with Trajan rather than the Exedra, where it stood.

7. Olympia, Museum, head. Pausanias (V, 12, 6) saw a statue of Trajan dedicated by all the Greeks, and since he mentioned a marble Hadrian in the previous breath this may be the pendant to it.

8. Heraklion (Iraklion, Candia), Museum, from Lyttus: head with oak wreath.

9. Cos, Museum: head, Type I.

10. Samos, Tigani, apotheke of the Castro, from the site which was the acropolis or Capitolium of the Hellenistic and Roman city. Statue, of heroic scale, showing Trajan as divine ruler of the world, nude and with cloak over his left shoulder, orb in his right hand and wreath around his head. The statue belongs with those in Copenhagen and Seville, showing the emperor with orb and parazonium; the work is crisp and dry, a careful copy of a prototype perhaps created in Rome about A.D. 103.

11. Samos, from the excavations in front of the Heraion: fragment of a head, comprising the face from the eyes to the chin, of a heroic statue of Trajan, in the Hellenistic manner (Boehringer, Neue Deutsche Ausgrabungen, pp. 221f., fig. 26). C. Fernandez-Chicarro (Festschrift für Max Wegner [Münster Westfalen, 1962] pp. 71–73, pl. 16) compares it with the heroic, nude Trajan in Seville. Coincidences of damage may be partly the cause of similarity. Counting the statue from the agora-acropolis of Samos itself (no. 10), this fragment would give the area its second representation of Trajan as a divinity or hero. The fragment manifests considerable quality, strength, and delicacy of carving.

12. Berlin, Pergamonmuseum, from the cella of the Trajaneum at Pergamon. This cult statue, of which the head survives, perhaps presented Trajan as Zeus and had as its acrolithic pendant a cuirassed Hadrian; they were both placed near the altar (Inan-Rosenbaum, p. 68, no. 28).

13. Ankara, Museum, from a large building, perhaps the Bouleuterion of Ancyra: bronze tondo portrait of Trajan, shown in civic dress and in old age, similar to certain of the panels at Beneventum (figure 132). The look of age is stressed or exaggerated in such a way as to destroy the individual characteristics of Trajan, the broad head and the high cheekbones, with flesh on the cheeks. There is none of the plumpness seen in posthumous portraits of Trajan from Italy (as Sotheby Sale, 1 July 1963, no. 165, fig.). A dedication to Trajan has also been recorded from the city. J. Inan and E. Rosenbaum consider this bronze tondo to be the portrait "of a distinguished citizen made in the time of Hadrian but still showing characteristics of the Trajanic style" (p. 208, no. 286). See also L. Budde, "Die Bildnisse des Marcus Ulpius Traianus Pater," Pantheon 24 (1966) 69–78, as Trajan. Also L. Budde, "Imago Clipeata des Kaiser Traian in Ankara," Antike Plastik 4 (1965) 103–117; Art Treasures of Turkey (Smithsonian Institution, Washington, D.C., 1966), p. 93, no. 146.

PLOTINA, Wife of Trajan, died A.D. 121 or 122

1. Athens, National Museum, no. 357: colossal head from Crete. Her head is turned to her own left; she wears a large diadem. This is an overly ideal, classicizing likeness in very crystalline island marble. The turn of the head and the angle of the neck contribute to the idealization and suggest that Plotina, made youthful, was represented as a draped Aphrodite.

2. Heraklion, Museum, no. 189: head, from a statue. The likeness is well executed but is somewhat on the stiff, dull, and routine level so far as the viewer's feelings are concerned (figure 133).

3. Paris, Louvre, from Cyme: a statue, the head and body appearing to belong together.

HADRIAN, Emperor
A.D. 117 to 138

(The numbers of the list given here refer to groups of portraits as well as to individual pieces. The cuirassed statue found in a semicircular hall of the agora at Thasos was carved about 125, a Roman head, on a Greek body. See Vermeule, *Berytus* 16 [1966] 55f.)

1. Thebes (Greece), Museum, no. 167. Christos Karouzos has conjectured that a headless, nude figure with swordbelt from right shoulder to left side, parazonium in left arm, and an unadorned cuirass as support by the left leg might be Hadrian. The stance and proportions of this statue, found at Coroneia, are a heavy version of the Kyniskos of Polykleitos.

2. Athens, National Museum. This collection contains nine heads or fragments of statues of Hadrian; none of the statues are togate, palliate, or in the heroic nude. One or two of the cuirassed representations come from the Acropolis, but they may have been carried there as building material in the Middle Ages. One cuirassed torso of the type already discussed can still be seen near the northeast corner of the Parthenon's stylobate. National Museum, no. 371 (a head) comes from Sparta; if contemporary, it is crude and provincial. Eyes, nose, ears, and lips are unfinished. No. 3729 (*ArchEph,* 1939–1941, Chronika, pp. 12ff., fig. 19) has a large wreath with sculptured cameo in the center, undercut curls, and a pinched, baroque face.

3. Piraeus, Museum: colossal head from foundations on the waterfront. This forbidding likeness is wreathed. A large fragment of the chest suggests that the statue represented the emperor in armor. The head is covered with sea incrustations (New York *Times,* 25 Aug. 1963: ΚΑΘΗΜΕΡΙΝΗΣ, 15 Aug. 1963). See also *Berytus* 16 (1966) 56f.

4. Eleusis, Museum. On the marble pile in front of the epigraphic storeroom (middle bay) beneath the terrace of the museum there is the back half of a twice-lifesized marble head of Hadrian in middle age, with full curls over his ears; it may well have belonged with the cuirassed bust in the museum garden. Both may have belonged to one or more tondo portraits from the side arches of the Great Propylaea. See *Berytus* 16 (1966) 51f.

5. Epidaurus, Museum no. 14: head, of a type similar to Rome, Museo delle Terme no. 8618. This is an Athenian or Corinthian version of a portrait created in Rome at the height of Hadrian's career. It was circulated to some extent, but heads with less emphasis on the rolled locks over the forehead proved more popular.

6. Heraklion, Museum no. 341: head; although battered, the work in hair and beard is very sensitive. In addition to Louvre MA 3131, the head no. 3132 also comes from the Cretan capital. The first two are Greek versions of a very sober Roman type (Wegner's Imperatori 32) with tightly treated hair and beard; the last is an ideal, almost dreamy, rendering which also originated in Italy.

7. Chania, Museum no. 77 is the head from the cuirassed statue found in 1913 in the Dictynnaion and mostly destroyed by fire over a decade later (figure 135). No. 82 is another head from the same site (figure 136). The first was a Greek creation dependent on no Roman type. It was, from the date of the cuirassed statue (assuming the two belonged), probably carved *after* Hadrian's death; the portrait even looks something like Antoninus Pius, a fact that would confirm the date. The second head in Chania was found at the same time and in the same place; it appears to have been a Cretan version of a portrait created in Rome and transmitted to the island by way of Corinth or Athens. This head is much more Hellenistic in flavor, and the statue to which it belonged was draped rather than cuirassed.

HADRIAN (*continued*)

8. Thera, Museum no. 13, from the Basilike Stoa, is a head with part of the toga pulled over the back. The work is on one hand strikingly forceful and on the other rather crudely executed.

9. Manisa (Magnesia ad Sipylum), Museum. This is also a head with drapery drawn up over the back of the hair, therefore showing the emperor in the act of sacrificing according to the Roman rite. This head diverges enough from the normal Greco-Roman (export) types that the identification has been questioned by several authorities. It may be early Antonine and could be posthumous (or nearly so), like the Hadrian in the reliefs from Ephesus.

10. Bergama (Pergamon), Museum. The heroic statue from the Asklepeion has been discussed as a document of deification during Hadrian's visit of 123. A date of 131 or later has been also suggested. It belongs to the group of statues showing Hadrian in poses based generally on the so-called Diomedes of Kresilas. The type is Romano-Athenian. The head is strongly delineated in western Asiatic fashion, after an Athenian intermediate type; even in its abraded state it is very lively (Boehringer, *Neue Deutsche Ausgrabungen*, pp. 157f., fig. 25; Inan-Rosenbaum, p. 70, no. 31). A head of Hadrian was also found on the colonnaded street connecting the Asklepeion with the lower Roman city (*AJA* 71 [1967] 170).

11. Berlin, Pergamonmuseum, from Pergamon: head and legs of a colossal cuirassed statue from the Trajaneum. The face has the dreamy cast of early Antonine private portraits from western Asia Minor, such as the man from Tralles in Boston. In other respects the sense of removal from reality is almost frightening, like the posthumous head of Trajan in Ostia. This portrait of Hadrian made an excellent temple image. A head of Trajan was found in the same spot (*q.v.*) (Inan-Rosenbaum, pp. 69f., no. 30).

12. Izmir (Smyrna), Old Museum: section of a colossal head wearing an oak wreath. This head was seen by me in 1957, but I did not find it on visits in later years. It is not to be confused with the head identified as Commodus (below, no. 4), which, oddly enough, looks like a posthumous Hadrian from the front.

13. Vienna, from Ephesus: head, no. I 857, found in the fill of the tower of Mithridates;

the type is an original creation, probably for the visit of 123. Wegner has related it to two Roman models, but the sculptor of this head was clearly local, a man who looked as much at Hellenistic ruler portraits as at other likenesses of Hadrian (Inan-Rosenbaum, pp. 70f., no. 33).

14. Miletus, Museum: overlifesized head in island marble with a wreath represented in his hair and neck turned to the right. This is a characteristic early portrait, battered and weathered (Inan-Rosenbaum, p. 70, no. 32).

15. Antalya, said by Wegner on the authority of Hommel to be in the Museum, from Kaş (ancient Antiphellus); head. E. Rosenbaum reports, however, that Hommel recalls no such piece and that there is nothing pertinent or even vaguely possible in the Antalya Museum inventory.

16. Perge: cuirassed statue of Hadrian, set up between 117 and 122, probably in 121, in the forecourt within the Hellenistic gate (Vermeule, *Berytus* 15 [1964] 104, no. 173; Inan-Rosenbaum, pp. 68f., no. 29) (figure 140).

17. Beirut, American University, no. 4996: head with oak wreath; there is a cuirassed torso of the standard type in the Lebanon National Museum, to which this may belong. A head also in the National Museum and from Antioch may be a revivalist portrait of the third century, when commemorative coins were struck with portraits of the deified emperors and when Eastern cities were still proud of the title "Hadrian" in their names. Such is also the case with a battered head from Corinth (Sc. 1454), which plainly echoes in forceful crudity the profile of a standard Hadrian like Terme 8618. The fourth-century sculptor at Corinth has caught the roll of hair around the forehead and the character of Hadrian's beard (figure 134).

18. Alexandria, Graeco-Roman Museum, no. 3595: head in limestone.

19. No. 20851: cuirassed bust. This portrait is another replica of Rome, Museo delle Terme 8618 (see above, under no. 5). It was probably carved in Italy and exported to Egypt.

20. No. 20885: colossal head, from Athribis. Wegner has classified this as a provincial creation after Terme 8618, that is after an export model such as the previous.

21. Bronze head, from Kena; it seems to be a provincial likeness of Hadrian.

22. The colossal head sold in Zurich-Lucerne in 1959 (Ars Antiqua Sale, 2 May 1959, no. 40) comes "perhaps from the Greek East." The head is decorative in the sense that it is bold and crude in a baroque way. The flaming eyebrows and globular beard are ancient counterparts of Bernini's work in the seventeenth century. This portrait was carved in the early Antonine period and, in its bizarre restlessness, recalls the colossal Domitian from Ephesus. In its present, somewhat reworked, condition it is impossible to tell into what type of statue the neck fitted, or whether it was broken from a statue in the godlike nude. Could this head be the portrait at one time reportedly stolen from Miletus, or the head reportedly (once) in Antalya, from Kaş? There could have been two Hadrians at Miletus, and he was much commemorated along the Lycian shore.

23. Persepolis, head in marble, seen in 1966 in the art market, New York. V. Poulsen, who noticed this otherwise routine, rather battered head, has reminded me that, aside from the bronze head of Augustus found at Meroe (no. 29), this seems to be the only major imperial portrait discovered beyond the confines of the Roman Empire.

ANTONINUS PIUS, Emperor
A.D. 138 to 161

The Greek portraits of Antoninus Pius are:

1. Athens, National Museum no. 3563, found in the "Stoa Basileios," that is, the Stoa of Zeus in the agora. Colossal head from a statue; of Attic marble; eyes were another material, and head had a metal wreath. The top of the head was made separately. This is a highly ideal, almost godlike portrait which depends on a Greek model created early in the emperor's reign. The carving of the beard is worthy of Michelangelo.

2. Eleusis, Museum. This small marble head from a statue has been identified as Hadrian (Jucker, *Bildnis*, p. 92), and it does have a vague resemblance to some of his late portraits, but the beard is too long and the face too blandly patriarchal to support the identification. The portrait is more likely an early Antoninus Pius, perhaps carved on the occasion of his initiation (by proxy) at the sanctuary.

3. Corinth, Museum: overlifesized head, with inset eyes. The brow was encircled by an olive or laurel wreath with a medallion (possibly a cameo) in the hair. This is a Greek version of a type created in Rome; there is influence of the Pergamene tradition in the Greek sculptor's hand.

4. Olympia, Museum: head, from south of the Exedra of Herodes Atticus (A.D. 147–149). The head is crowned by a laurel wreath in the center of which is a medallion or cameo carved in the form of an eagle.

5. Crete, Heraklion Museum no. 73 (head) and Gortyna: colossal seated statue, found in the amphitheater. The emperor is presented in Greek dress. This is a crude portrait, with a very squarish face.

6. Rhodes, Museum: head, perhaps from a dedication after A.D. 155 when Antoninus Pius' charities alleviated the results of an earthquake. The portrait is a powerful local creation in the best sculptural traditions of Greek imperial Asia Minor. It derives in a very general way from Naples, Museo Nazionale no. 6031.

7. Cos, Antiquarium, from Cos; an early portrait.

8. Istanbul, no. 1604 (Mendel, *Catalogue*, III, no. 1391): head from Alabanda in Caria, the precinct of the large temple of Apollo. This early portrait, to be dated about 140, is an Asiatic version of a likeness created in Rome. It is not a work of great quality (Inan-Rosenbaum, p. 74, no. 39).

9. Sardes, fragment of a colossal head from the temple. The muscles of the neck show how strongly the face was turned to the left. Further fragments of this head from one of the several Antonine cult statues at the building were reported to have been found in 1961, but they may belong to the head of Marcus Aurelius (below, no. 10). The carving of the beard is splendid, and the complete portrait must have been a thrilling experience, among the best such high imperial monuments of the cult of the emperors (Inan-Rosenbaum, pp. 74f., no. 40).

10. Smyrna, Museum no. 504: cuirassed torso, from Nysa on the Maeander; found with a base dated A.D. 146. A group of statues of the Antonine family was set up in the Bouleuterion.

11. Adana Museum, from Seleuceia ad Kalykadnos. Another head like those from Athens and Corinth, this is somewhat overlifesized (0.275m., chin to crown). Jale Inan and E.

ANTONINUS PIUS (*continued*)

Rosenbaum doubt the identification (Inan-Rosenbaum, pp. 203f., no. 280).

12. Ankara, Museum: front half of a bronze head, from a statue. Brought from Adyamian near Arsameia-on-the-Nymphaios, it represents the early type, similar to Naples, Museo Nazionale no. 6031 (figure 143).

13. Cairo, Egyptian Museum, no. 41 650: head from Ashmunein. This is an Egyptian likeness of the emperor, a forceful provincial treatment after a Roman model copied in Alexandria.

FAUSTINA I,
Wife of Antoninus Pius,
died A.D. 141

The Greek portraits of Faustina I are:

1. Athens, National Museum no. 3663: head, found in Constitution Square, in front of the palace. This is an Athenian version of a portrait represented in Rome by Museo Capitolino, Imperatori 36.

2. Olympia, Museum: head and upper body, from the Exedra of Herodes Atticus. The statue is a replica of the Larger Lady from Herculaneum, and the head is based on the Roman type of no. 1, with modifications. M. Bieber ("The Copies of the Herculaneum Women," *PAPS* 106 [1962] 118f., fig. 13a) identifies another, headless, replica from the Exedra as Faustina I, but a matron of the Herodes Atticus family seems more likely.

3. London, British Museum: colossal head, from Sardes. This cult image from the Artemision is a modified version of the same, standard Roman type; the back of the head may have been covered by a veil (Inan-Rosenbaum, pp. 75f., no. 41) (figure 144).

4. Denizli, School, Garden: head. Jale Inan and E. Rosenbaum report that this piece seems to be lost (1963).

MARCUS AURELIUS, Emperor
A.D. 161 to 180

The Greek and Asiatic Portraits
of Marcus Aurelius

1. Athens, National Museum no. 514: head, from Athens. This is Greek work; the hair is tightly controlled in a tangible, plastic fashion. There is no traceable dependence on a Roman model in this likeness of the later years, for the face is rather thin in relation to the massive mop of hair (see Papadimitriou, *ArchEph* 1937, pp. 698f., figs. 3f.). Only the carving of the top of the hair relieves the rather weak, mechanical quality of the portrait.

2. Athens, National Museum no. 572: head, type of Terme no. 726. From the partly plastic, partly linear handling of the beard, this is evidently Athenian work of good quality. The length of the face and the masses of hair are exaggerated, suggesting the portrait was carved under Commodus, about A.D. 185. The cast of the eyes also bears this out (see Papadimitriou, *ArchEph* 1937, pp. 700f., figs. 5ff.). The face is minimized by the streaked veined quality of the marble, which may be Proconnesian.

3. Paris, Louvre no. 1161: cuirassed bust from Probalinthos (see text). This portrait also relates to Terme no. 726. The workmanship is masterful in a rather cold way. The sculptor has succeeded in translating a bronze prototype into marble without loss of style, feeling, or detail.

4. Athens, National Museum no. 3251: head, found near Corinth. This is a good Greek portrait of the youthful Lucius Verus rather than Marcus Aurelius; the face is too thin and sensual to be the latter. There is excellent drilling of the hair, and the face is well smoothed from the Greek mainland marble. Damage to the lip gives the aristocratic face a sneer. The back of the head presents a mass of unruly hair.

5. Preveza in Epirus (ancient Acarnania), Museum, from Kamarina: head, perhaps Marcus Aurelius and found as a pendant to Faustina II (see below). This is a rather crude portrait, by a local sculptor without a good Greek or Roman model. He had created a form of literary likeness, turning Marcus Aurelius into somewhat of an Alexander the Great.

6. Corcyra, Corfu Museum no. 137: cuirassed bust, type of Terme no. 726 (see no. 2). Wegner has also related this head and part of a cuirassed bust to Athens no. 572. The work is less forceful, the sculptor having been timid about the hair (soapy) and eyes (uncertain).

7. Istanbul, Archaeological Museum no. 4492, from the ancient city. This slightly overlife-

sized, Proconnesian marble head (chin, lower jaw, and neck missing) is a near-replica of the head in Tarragona (Wegner, pl. 16) and therefore represents an official type of about 160. The cuirassed statue in Alexandria (below, no. 16) is another member of this group. The carving is very precise; the head was reused as building material (figure 145).

8. Istanbul, Archaeological Museum no. 406 (Mendel, *Catalogue*, II, no. 586), from the sea at Ayvalık (the harbor in front of Pergamon) and a Roman type of Marcus' younger days. Wegner has termed this a provincial simplification of the ubiquitous Terme 726. The work was done by an artist influenced by the Hellenistic portraits of western Asia Minor (Inan-Rosenbaum, p. 76, no. 44).

9. Istanbul, from Kandilli Köyü (Bozhöyük), in northern Phrygia. A mature, urbane portrait in the form of a draped bust, found with a similar bust of Faustina II (see below) (Istanbul Arkeoloji Müzeleri, *Illustrated Guide*, 1956, p. 66, nos. 5129 and 5130; Inan-Rosenbaum, pp. 76f., no. 45).

10. Sardes, on the site. Fragments of a colossal head discovered at the cella of the Artemision (see above, under Antoninus Pius, no. 9).

11. Izmir, Old Archaeological Museum: overlifesized togate statue, excavated at Nysa on the Maeander, along with the cuirassed statue of Antoninus Pius (see above). Marcus Aurelius appears as Caesar, since the group is dated A.D. 146 from the inscribed base of the statue of Antoninus Pius. The head, worked separately, is missing, as are the feet.

12. Istanbul, no. 1390, from near Adalia: underlifesized statue, about A.D. 175, wearing sagum, tunic, and boots. Doubts about the identification seem, to my mind, to stem from the long face, the unusual costume, and the provincial treatment of the body. Inan-Rosenbaum, p. 215, no. 300; (figure 146).

13. Nicosia, Peirides collection, presumably found on Cyprus: one-third-lifesized head, probably from a statue similar to the previous, in crystalline white marble. This is an old but ideal and elongated, proto-Byzantine portrait. The nose is sharp and slightly aquiline, with a ridge; the pupils were added in paint. The head is further characterized by sensitive treat-ment of lines around the eyes and in the moustache. There are drill points in the hair and beard. The neck was broken not cut or fitted, and there is a large chip off the forehead. This is a very Greek portrait, with the soft and sensitive qualities which distinguish Marcus Aurelius in the last several years of his life from Commodus in the last year or two of his rule (figure 147).

14. Jerusalem, Cloister of St. Etienne: head from Gerasa, perhaps from a draped statue. This provincial, Syrian portrait derives again from Terme no. 726; there is a suggestion that an Athenian model such as that used for nos. 2 and 6 has come between the sculptor and his Roman prototype. The oversized eyes are set off by the rough, simplified hair and beard (M. Cagiano de Azevedo, "Un Ritratto di Bassiano?," *RM* 69 [1962] 160f., pl. 50, 2).

15. London, British Museum, no. 1906: to-gate statue brought from Alexandria in 1801. Since this slightly overlifesized figure has a cuirassed Septimius Severus as pendant, the work is probably posthumous, dating around A.D. 200. This was the period when Severus was in Egypt and when Alexandria received a municipal council (figure 149).

16. Alexandria, Greek and Roman Museum, no. 3520: cuirassed statue of Marcus Aurelius Caesar, from Alexandria. The statue was carved about A.D. 160; as in the case of the Eleusis tympanum bust, Christians have defaced the cuirass with a cross (figure 148).

17. Alexandria, Graeco-Roman Museum no. 21640: cuirassed bust from Kom Trughi. This is Roman work, an indifferent replica of Terme no. 726. It was imported to Egypt, and, in turn, no doubt served as the model for local work.

18. Stuttgart: head, from the Egyptian Delta. This is an Egyptian restyling of the florid, long-faced portrait best known in Rome from Museo Capitolino, Imperatori 38.

19. Cairo, Egyptian Museum no. 27 488: head, with lower part of the face sliced away. This is provincial work, employing good Roman techniques such as the polished surfaces of the face. There is nothing quite like it surviving from the Roman workshops. Wegner cites a portrait in Tarragona.

FAUSTINA THE SECOND,
Wife of Marcus Aurelius,
died A.D. 175 or 176

Eastern portraits include:

1. Salonika, Museum, no. 1054: this head is perhaps the young Faustina II. The marble is island, and the quality is very fine, with a good polish to surfaces of face and hair. No. 1051, also lifesized, in Thasian marble, is not Faustina II.

2. Volos, Museum, no. Λ 529: slightly over-lifesized, island marble head, without the usual knot on the hair of the forehead but with a bun (made separately and now cut out) at the back. This is a spirited portrait with eyes turned upward and slightly to the right. The face seems broader than the three Athens, National Museum, examples. It is closest to no. 6 (3712), from Marathon.

3. Thebes, Museum, in the Garden: possible head, with characteristic hair and chain wreath. The face is very battered, and most of the nose, the left side of the jaw, and the surface of the chin are missing. The head seems to be a good copy of the standard portrait of about 170 to 175.

4. Athens, National Museum no. 359. Head, with neck worked for insertion in a draped statue. This and the following three portraits from the vicinity of Athens are all of the same general type. The model was undoubtedly created in Athens, and they are dated in the years just before Marcus Aurelius became emperor. In this likeness she is older than no. 5 and has long curls falling down behind her ears.

5. Athens, National Museum no. 1687: head, in island marble. The group of portraits is characterized by the elaborately waved hair, done up in a knot in back; one band of curls is brought very low over the forehead, and braids fall behind her ears. The eyes are deeply drilled. She is a pretty young thing.

6. Athens, National Museum no. 3712: head in Pentelic marble, from Marathon. This is a replica of no. 4, with slightly less curl behind the ear. Despite battering, the face is more mechanical. Herodes Atticus must have set this portrait up on his estate.

7. Athens, National Museum: bust, draped. This is the driest copy of the group, although the hair is well preserved. The sculptors of these portraits also produced the likenesses of Polydeukes for Herodes Atticus.

8. Athens, National Museum: small statue in Pentelic marble, as the Artemis Colonna, from Aetolia. The portrait on this variant of a popular Hellenistic and Roman copy is probably a likeness of the young Faustina (S. Karouzou, ArchEph 1953–1954, pp. 63–80). The likeness is, naturally, very ideal; the carving of the face is a masterpiece of work in miniature, like the Julia Domna from the agora. The identification stems from the waves of hair around the forehead and the bun behind (Vermeule, AJA 68 [1964] 331, note 77).

9. Olympia, Museum, no. 141: statue from the Exedra of Herodes Atticus; the body is of the type of the Lesser Lady from Herculaneum, thus making the statue a complete pendant to that of Faustina the Elder. Faustina the Younger has a girlish face, simply modeled; her hair culminates in a large topknot on the upper back of her head. The work is not particularly inspiring, even among the Olympia portraits (figure 150).

10. Preveza, Museum, from Kamarina: head, found with a head which has been identified as Marcus Aurelius (see above). The local sculptor has been more successful with Faustina than with her husband. He has caught the bland quality of her large eyes.

11. Corcyra, Corfu Museum no. 141. This youngish head in island marble, hair done in a bun behind, was found with a cuirassed bust of Marcus Aurelius (see above). The pair must have been made about A.D. 165 to 170.

12. Cos, Museum: veiled head, turned to own right, with upturned eyes.

13. Istanbul, from Kandilli (Bozhöyük). The draped bust was discovered with a similar portrait of Marcus Aurelius (see above). Inan-Rosenbaum group the two with Antonine portraits from Pisidian Antioch (pp. 77f., no. 46).

14. Copenhagen, Ny Carlsberg Glyptotek, no. 709a: colossal head with hair in the Hellenistic topknot of Aphrodite. This portrait is so ideal in concept that it may be Faustina or her daughter Lucilla. It comes from the vicinity of Smyrna, allegedly from Aphrodisias in Caria (figure 151). K. Erim, AJA 71 (1967) 237.

15. Antalya, Museum: head, from an official type that seems slightly older than Louvre no. 1144. This may well be a copy of a portrait

made during her last months in Asia or at her death (photo from G. Daltrop). J. Inan and E. Rosenbaum suggest this is a private person of the period (Inan-Rosenbaum, pp. 215f., no. 301).

16. Perge. Jale Inan has proposed Faustina the Younger for a complete statue from the gateway-forecourt complex (Inan-Rosenbaum, p. 78, no. 47; Mansel, "Bericht über Ausgrabungen und Untersuchungen in Pamphylien in den Jahren 1946-1955," AA 1956, cols. 115ff., fig. 66). The lady in question is represented as the "Grande Herculanaise." It seems that the statue would then have to date between 150 and 160 at the earliest. The style is so like the rest of the statues as to make such a late date impossible, unless the head has been substituted (as the even break or cut might suggest). Of course, a gifted sculptor could have imitated the statues of Trajan's female relations, and Faustina II would have been a logical addition to the complex.

17. Copenhagen, Ny Carlsberg Glyptotek, allegedly from Tarsus. As the head of an Antonine empress as Aphrodite, from western Asia Minor (above, no. 14): a colossal head, with hair in the Hellenistic topknot of Aphrodite. Published originally as an idealization of Faustina the Elder, about 140 (Ars Antiqua, Auktion V, 7 November 1964, no. 10), this is much more likely a similar presentation of Faustina the Younger, made just before or after her death in A.D. 175. The girlish features of her younger days have given way to the rounded jaws and heavier neck characteristic of coin-portraits near the end of her career. The head and neck were designed to be set in a draped statue (V. Poulsen, *Meddelelser* 21 [1964] 1-24).

LUCIUS VERUS, Emperor
A.D. 161 to 169

The following Greek and Asiatic portraits of Lucius Verus have been recognized:

1. Athens, National Museum no. 350: colossal head from a statue and excavated in the Theater of Dionysos. This is a Greek version of the principal portrait of Lucius Verus in the period shortly after he became emperor. A colossal portrait such as this may be connected with the imperial visit of A.D. 162-163, during the expedition against the Parthians. The drill and chisel have been used with suc-

cess in the hair and beard, producing a splendid carving in Pentelic marble. The back of the head is worked roughly. This powerful, brooding likeness stands on the threshold of Late Antique images and gives Verus the look of Neos Dionysos.

2. Athens, National Museum no. 3740: overlifesized head, found in 1934 under no. 13, Odos Kolokotronis. The hair is more summarily treated than in the previous; the drill has been used less; in all, the portrait lacks the force of the previous. A somewhat battered but still characteristic replica of this head was found in the Byzantine reconstructions of the Neapolis Gate at Philippi (J. Roger, "L'enceinte basse de Philippes," BCH 62 [1938] 30, fig. 5).

3. Athens, National Museum no. 1961. This portrait in Pentelic marble is characterized by curious drilling of the eyes and crisp carving of hair and beard. The head, with its piercing sideways glance, was produced by someone who had been carving Cosmetes portraits as a career. The Roman prototype has been considerably altered, and Lucius looks like Mephistopheles. The hair, finished only above the brow, is a masterpiece of patterned carving and drilling; with the beard it rises in bold tongues of flame from the chin to the brow.

4. Oxford, Ashmolean Museum: cuirassed bust from Probalinthos in Attica, dug up with portraits of Marcus Aurelius and Herodes Atticus (see above). This is an extremely fine Greek rendering of the standard imperial portrait; the quality of carving is excellent.

5. Olympia, Museum: young, beardless head from the Exedra of Herodes Atticus. This is one of the best, if not the best, Antonine portraits from Olympia. The sculptor has left marks of the chisel all over the face, as if it had been designed to receive color.

6. London, British Museum no. 1256: lower half of a heroic statue from Ephesus; the inscription on the base dates the statue before 161.

7. Once Smyrna, Evangelical School: head, perhaps from the previous; no photograph appears to exist, although several writers refer to the head.

8. Istanbul, Archaeological Museum no. 2646 (Mendel, *Catalogue*, III, 1378): head, found at Pisidian Antioch in 1912; an elaboration of a Roman or Athenian export type (see above).

LUCIUS VERUS (*continued*)

The drill has been used extensively, and the portrait is a typical Anatolian imperial product (Inan-Rosenbaum, pp. 79f., no. 50).

9. Konya, Museum, said to be from Pisidian Antioch. This fragmentary head with oak-wreath has been identified by Wegner on the basis of Jale Inan and E. Rosenbaum's photographs. It differs from the usual, soapy-haired official portraits of Lucius Verus from Greece and Asia Minor (Inan-Rosenbaum, p. 80, no. 51).

10. Budapest: small bust in glass, found by farmers plowing in Antalya (Adalia, ancient Attaleia). This bust was perhaps made in northern Italy or the Balkans and carried to Pamphylia. The portrait suggests provincial likenesses of Lucius Verus from the Latin West. It is very late in his career, or posthumous (with full beard).

11. Cleveland (Ohio) Museum of Art: head, evidently from Alexandria in Egypt or the general area. This well-drilled vision of curly hair, dripping beard, moustached mouth (partly open), and upturned eyes could only have been created late in the rule of Marcus Aurelius or in the reign of Commodus, when Lucius Verus was merely an Antonine document to be politically remembered or to be exploited for his connections with the dynastic program founded by Hadrian. The dreamful balance of cowardliness and power or decision in this face places the portrait on a level with the best of the Eastern Empire. Drillwork in the hair, moustache, and beard point to an Asiatic school (52.260; *Archaeology* 6 [1953] 198; Vermeule, *PAPS* 108 [1964] 103f.) (figure 152).

COMMODUS, Emperor
A.D. 180 to 192

Portraits include:

1. Athens, National Museum no. 337: head, slightly more than lifesized, carved in island marble. This is an Athenian version of a late portrait of the emperor. The drill has been used freely. The portrait may belong to the Severan period; he looks like Marcus Aurelius, but his head is longer.

2. Athens, National Museum no. 512: overlifesized head in Attic marble. This reflects a portrait of about A.D. 185 to 188; the model may have been created in Rome, but the condition of the head is such as to make judgment difficult. It is the wreck of a splendid likeness, with hair drilled in the best Antonine baroque fashion and with a modest beard.

3. Samos, Vathy Museum no. 130: young head.

4. Izmir, Old Museum, from Smyrna. This oak-wreathed head represents Commodus rather than Marcus Aurelius. It may be a posthumous likeness (Inan-Rosenbaum, p. 83, no. 56).

5. Selçuk, Museum, from Ephesus. This weathered, abraded head, found on the fourth floor of a luxurious apartment block, is a somewhat timid, cursory variant of Braccio Nuovo no. 121 (Wegner, pl. 54) and belongs about A.D. 190. The family resemblance to early imperial portraits of Marcus Aurelius is obviously very strong (F. Eichler, *Die österreichischen Ausgrabungen in Ephesos im Jahre 1961*, Anzeiger der phil.-hist. Klasse der Österreichischen Akademie der Wissenschaften, 1962, So. 2, p. 46, pl. IV; *ILN*, 16 May 1964, pp. 767f., fig. 4; Inan-Rosenbaum, pp. 82f., no. 55).

6. Canterbury, Museum, from Tralles (Aydın): head, with the vine-wreath of Bacchus. This "Hellenistic" portrait seems to continue the concept embodied in the inscriptions from Lydia that speak of Lucius Verus as Neos Dionysos. The head is tilted back, and the eyes look upward and to one side; the hair is drilled in a typical late Antonine or early Severan western Asiatic manner (figure 153).

7. Beirut, private collection, and (later) New York, art market (*Archaeology* 16 [1963] verso of cover). This head (chin and jaw missing) is a general replica of the mature, late, and soul-inspired portrait from Tralles. It undoubtedly comes from a colossal statue of Commodus in cuirass, with divine countenance enframed by the weighty oak-wreath of Jovian imperium. In the middle of this wreath, above the forehead, there is a huge cameo. Unlike the head from Tralles, there is no drilling; the gaze is soulful, but the workmanship is facile or even weak, in the best Athenian tradition. The statue must have stood in a niche, for there is a thick back-support (figure 154).

8. Cairo, private collection: overlifesized head from the Delta. This is a very fine Egyptian version of a Roman portrait of about 186. The head is crowned by a large oak-wreath; the hair is treated in groups of curls with the surfaces

of each drilled. The moustache and beard are also loosely handled, with the drill used to define and break up the monotony of the latter.

SEPTIMIUS SEVERUS,
Emperor A.D. 193 to 211

The surviving portraits of Septimius Severus include:

1. Athens, National Museum: colossal head, dated A.D. 193 to 195 on the basis of coins (F. Barreca, "Un Nuovo Ritratto di Settimio Severo," *Bull Comm* 71 [1943–45] 1947, appendix, pp. 59–64). The portrait is probably that of an unknown Greek of about A.D. 170 to 180.

2. Salonika, Museum, no. 898: overlifesized head in Thasian marble, with enough of the neck and shoulders to indicate it is from a bust in a field cuirass. The face of this early portrait is a polished contrast to the drilled hair and beard. The drilling is of a medium dry quality.

3. Verria, Museum: lifesized head, a youthful, Greek portrait with considerable idealization. The marble is northern Greek; surfaces are worn. The sculptor did not follow an official model, and the emperor looks like a private citizen.

4. Nicomedia (now in Istanbul), found under the new "Papierfabrik": head, early and very precisely carved. This is not an orthodox portrait in the Roman sense. It precedes the Antonine "dynastic" types originated in Rome and might have been produced when Severus was waging war in the East against Pescennius Niger, in 193 or 194. The type is very close to the previous but with less use of the drill in locks and curls. This head is approximately twice-lifesized, and the pupils of the eyes are unincised, a fact which has led many to date the portrait at least fifty years earlier (Dörner, *Istanbuler Forschungen* 14 [1941] 45, pl. 8; Inan-Rosenbaum, pp. 95f., no. 81).

5. Istanbul (Mendel, *Catalogue*, II, no. 587; M. Schede, *Meisterwerke der Türkischen Museen zu Constantinopel* [Berlin, 1928], I, pl. 42), perhaps from Nicomedia, although the old records hint that it came from Beirut. This is an old head, ca. A.D. 205–210, with an oak-wreath crown enriched by a cameo in its center. V. Poulsen noted, from the photographs, the similarity to the Commodus from Beirut (no. 7). The two could have been part of the

same monument, and the Lebanese provenance for this head seems to be confirmed (figure 157A).

6. Bergama, Museum, no. 156, from the acropolis: this worn portrait looks like Septimius Severus, but could be a retrospective, slightly inaccurate Pertinax. Pertinax would have been included in honors to the Severan dynasty at Pergamon (Inan-Rosenbaum, p. 115, no. 122).

7. Ephesus, from the West Hall of the Palaestra. This extremely baroque head has been suggested as Septimius, but (from the photograph) it is more likely a late version of a Pergamene Asklepios (Giuliano, p. 189, no. 37; J. Keil, "XVI. Vorläufiger Bericht über die Ausgrabungen in Ephesos," *JOAI* 27 [1932] Beiblatt, col. 43, no. 8).

8. Smyrna, Old Archaeological Museum, from near Karacasu (near Aphrodisias in Caria). The head is in high relief, and the bust springs from acanthus on a pediment; a small shrine or subsidiary part of a larger building was the source. The portrait belongs to the years before A.D. 200, the period of the struggle with Niger, and is a rather cursory, deeply drilled product of the so-called school of Aphrodisias (Squarciapino, *La scuola di Afrodisia*, p. 71, pl. Ta; Vermeule, *PAPS* 109 [1965] 379, fig. 32; Inan-Rosenbaum, p. 84, no. 58) (figure 155).

9. Istanbul, no. 2675 (Mendel, *Catalogue*, II, no. 428), from Mylasa in Caria. This miniature head is good work of the period A.D. 193 to 200; it is the "Albinus" type, preceding no. 8. It was produced in the same Aphrodisian atelier as Boston's group of a satyr, maenad, and Cupid (C. Vermeule, in *Essays in Memory of Karl Lehmann* [New York, 1964] pp. 359–374). J. Inan and E. Rosenbaum see this head as a private person of the period of Gallienus (Inan-Rosenbaum, pp. 176f., no. 237).

10. Nicosia (Cyprus), bronze statue (see above). Despite the novelty of the "Mars Pater" type used for the emperor, the portrait is an extremely dignified, sober likeness of the years just before A.D. 200 (figure 156).

11. Beirut, Lebanon National Museum, from the colonnaded street at Tyre. This splendid head belongs to the years A.D. 195 to 200, the period of the Parthian wars; the emperor wears a large wreath with a cameo in the center, and he is made to resemble Antoninus Pius. Cut-

SEPTIMIUS SEVERUS (continued)

ting of the tenon below the neck, together with the form of wreath, suggest that this portrait was part of a cuirassed statue. The hair and beard are undercut and broken up by the drill, but the over-all effect is one of strength and insight. The prototype, if not the head itself, probably comes from an atelier in western Asia Minor, such as Ephesus or Smyrna (M. Chéhab, in *Mélanges Mouterde*, II, *Mélanges de l'Univ. de St. Joseph* 38 [1962] 22, pl. IX).

12. London, British Museum, no. 1944: cuirassed statue of Septimius in Diomedes pose, from Alexandria; the breastplate is undecorated, resembling a "field" cuirass. The portrait is early, and the statue is pendant to a togate Marcus Aurelius (see text). The head is well, though far from brilliantly carved; the emperor has short, somewhat curly hair and a relatively small beard. *See also* MARCUS AURELIUS, no. 15.

13. Alexandria, Museum, no. 3371: overlifesized head (H.: 0.42m.), from Alexandria and in the tradition of portraits of Commodus. The hair is still Antonine, only just beginning to hint at the Sarapis curls. The beard is partly drilled but mostly modeled with the chisel. A noble, somewhat idealized portrait of about A.D. 200 (Ev. Breccia, *Alexandrea ad Aegyptum* [Bergamo, 1932], pp. 185f., no. 51, fig. 94).

14. Cairo, recorded in the art market. Of unknown provenance and close to Athenian portraits, this is based on a model made in Rome or Athens no later than A.D. 200 (Harrison, p. 40, note 3; Graindor, *Bustes et statue-portraits*, p. 62, no. 18, pl. 17).

15. Berlin, from Egypt: circular wooden panel showing Septimius and family during their years in Egypt. The emperor wears the *vestis alba triumphalis* and is crowned, like his son, with a golden garland set with gems (Hanfmann, *Roman Art*, pl. XLVIII; Toynbee, *Art of the Romans*, pp. 129f., 258).

JULIA DOMNA,
Wife of Septimius Severus,
Died A.D. 217

Portraits of the Syrian Julia are few in the East and plentiful in the West. Aside from the painted tondo, there are only:

1. Athens, Agora Museum: miniature head, with "expressive eyes and mobile mouth"; a portrait of the later years. Athenians accorded Julia Domna divine honors (*FastiA* 12 [1957] no. 1971; *BCH* 82 [1958] 661, fig. 15; H. A. Thompson, "Activities in the Athenian Agora: 1957," *Hesperia* 27 [1958] 155, pl. 43, b).

2. Athens, Acropolis Museum: a possible typical likeness of the mature years (according to G. Daltrop).

3. Bursa, Museum: head, unpublished and the upper part missing on a line from the right ear to above the left eye. The likeness belongs in the early to middle years of her husband's reign, and it is a well-carved head and neck, intended to be set in a draped statue.

4. Cambridge (Mass.), Fogg Museum of Art: bronze bust, from a draped statue(?). From Salimiyeh, to the east of Hama in Syria, this dry portrait, of the period of no. 3, has Syrian tendencies to elongation and slenderness (Harvard University, *Annual Report 1955–56*, pp. 42f., cover; *Ancient Art in American Private Collections*, p. 29, no. 178, pl. LIV; *ArtQ* 18 [1955] 64) (figure 158).

CARACALLA, Emperor
A.D. 198 to 217

There are, so far, only (excluding the tondo):

1. Athens, Acropolis Museum: head, of his mature period (information from G. Daltrop).

2. Corinth, Museum, sculpture no. 1470, from a Roman deposit in the Hellenistic Stoa, north of the temple of Apollo. Head, showing him with curly hair and the partial beard of early manhood, circa A.D. 208; his forelocks are arranged as those of Sarapis (E. Askew, "A Portrait of Caracalla in Corinth," *AJA* 35 [1931] 442–447). This head is Greek rather than Roman in its plasticity and vigorous cutting; the sculptor has puffed the hair out over the forehead in truly Greek fashion (figure 159).

3. Samos, Tigani City Hall: head as a boy.

4. Drama (probably from Philippi), now in the Louvre: colossal marble head and neck worked for insertion. This is a local version, slightly crude but very forceful, of the portrait seen on coins in the last years of the ruler, A.D. 216 to 217 (Collart, *Philippes*, pp. 515f., pl. 88; Musée National du Louvre, *Catalogue sommaire des Marbres Antiques* [Paris, 1922], p. 63, no. 996).

5. Rumeli Hisar (European side of Bosporus, near Constantinople), now in the University Museum, Philadelphia (Penna.). The stone is pinkish, and the head is slightly overlifesized (H.: 0.31m.); a dowel in the top of the head may have been for fixing a crown or star, or for attachment to a triumphal monument. This is a slightly crude but forceful version of an Asiatic or mainland Greek portrait of the years A.D. 212 to 214. It would have been well placed in an architectural ensemble, blocked-out curls of hair and restless, partly cut or partly incised beard standing out from some distance. The Roman models are seen in two portraits in the Museo Nazionale Romano (Felletti Maj, nos. 266 and 268). The Septimius Severus from Nicomedia, the first of the two portraits identified with this city, seems to have come out of the same general circle, one descended from the men who carved the scene of sacrifice on the Antonine altar at Ephesus. The sculptor, particularly in the puffing-out of the hair, has tried to give Caracalla something of the character of a Greek ephebe (MS no. 216; Luce, *Catalogue*, p. 189, no. 56; Vermeule, *PAPS* 108 [1964] 110, fig. 41 a–c) (figure 160).

6. Istanbul, Archaeological Museum, from the ancient city. This is a lifesized marble head, wearing a large, deeply drilled wreath. It presents a highly emotional, so-called apotheosis portrait of Caracalla, about A.D. 210, and must be a product of one of the schools in western Asia Minor. The statue could have been part of a major Severan monument in the rebuilt Byzantium.

7. Pergamon, Bergama Museum, no. 163 from the Asklepeion, where it was found with a base dated 214. This twice-lifesized, veiled head is carved in a wild, wooly style. The portrait is brutal, like the late profiles of Caracalla on Greek imperial coins (Inan-Rosenbaum, pp. 84f., no. 60) (figure 161).

8. Kula in Lydia, later in the London art market: overlifesized head of Caracalla as a boy. The hair has been undercut with the drill in the fashion of carving in imperial Asia Minor in the Hellenistic tradition, but the portrait is a copy of an official type of the early years of the third century and found in Italy (Vermeule, D. von Bothmer, *AJA* 60 [1956] 344, pl. 111, fig. 30) (figure 162).

9. Antalya region, probably Pisidia, later in the European art market: bronze head (H.:

0.27m.). This is a youthful portrait that could be Geta but seems to be Caracalla at an age somewhat more advanced than Copenhagen no. 727 (L. Budde, *Jugendbildnisse des Caracalla und Geta* [Münster, 1951], pl. 19) (figure 163).

The portrait is very like that of Caracalla on a number of Greek imperial coins of western Asia Minor — large eyes, snub nose, heavy jaw, and a mass of curls over the low brow, large bronzes of Eumeneia in Phrygia or Hypaepa, Sardes, and Thyateira in Lydia being typical in this respect (see SNG, von Aulock, *Lydia*, nos. 2969, Hypaepa; 3159, Sardes; 3225, Thyateira). In the bronze head, the local sculptor has obviously had a master likeness of the young emperor's face as his model, one perhaps sent to the Antalya region from Smyrna or Ephesus. He has had to improvise the hair, and the hair thus departs considerably from the standards of the imperial capital.

What manner of statue was this bronze head of the youthful Caracalla designed to fit? He wears no crown, and there are no traces of any attachments for one. Thus, he was either portrayed in simple civic garb (toga or himation), unlikely in southern Asia Minor at this date, or, more likely, as a young divinity in the heroic nude. A statue modeled on the Alexander with the Lance of Lysippos created around 325 B.C. or on a Hellenistic Dioskouros (a divine identification suitable for Caracalla and Geta) would have been the perfect vehicle for this head. It so happens that just such a bronze statue was discovered in the area whence comes this bronze head of Caracalla. The statue, based on Alexander with the Lance, is now in the Houston (Texas) Museum of Fine Arts (*The Connoisseur*, Nov. 1963, p. 203) (figure 164). Examination of details of the breaks where head meets neck and of the edge of the neck of the headless statue in Houston suggests the two belong together. If the statue were recomposed, it would be as spectacular an ensemble as the bronze Septimius Severus in the guise of Mars Pater in Nicosia or the himation-clad, orating Hadrian from Adana, in Istanbul.

A second bronze head of Caracalla, of similar provenance, is a typically East Greek portrait of about A.D. 215. The eyes recall those of the bronze Antoninus Pius from Adyamian (above no. 12; see *Master Bronzes from the Classical World*, The Fogg Art Museum, 1967–1968, p. 244, no. 234A).

10. Koptos in Upper Egypt, now in the University Museum, Philadelphia. This head is of

CARACALLA (*continued*)

colossal scale, carved in red granite, and comes from the temple of Isis. The proto-Medieval image is crude and powerful. The emperor is crowned with a diadem and a uraeus in front (Vermeule, *PAPS* 108 [1964] 110f.; *Early Christian and Byzantine Art*, Baltimore, Walters Art Gallery, 1947, p. 23, no. 1, pl. 8).

11. Cairo Museum, no. 1210, from el Sheikh-Fadl near Oxyrhynchus, upstream from Cairo. This well-overlifesized, red granite statue shows Caracalla as an Egyptian Pharaoh, in the traditional schema. The portrait, unmistakable, is also of the crude, expressionistic type (H. Jucker, *Jahrbuch des Bernischen Historischen Museums in Bern* 41–42 [1961–62] 309, 312, fig. 31) and was perhaps taken from a work on a much smaller scale, such as a bronze relief. It is paralleled by another, more competent and more classical, statue of Caracalla as a Pharaoh, also in Cairo (Abd El-Mohsen El-Khachab, "Ο "ΚΑΡΑΚΑΛΛΟΣ" ΚΟΣΜΟΚΡΑΤΩΡ," *JEA* 47 [1961] 125, fig. 2).

These Egyptian statues of Caracalla are documents of his interest in Nilotic cults, not only on his Eastern travels but in Rome where he built a giant temple to Sarapis.

GETA, Emperor A.D. 209 to 212

The murdered form and damned memory of Caracalla's younger brother have the tragic distinction of existing east of Italy only in an untenable identification at Argos, in a possible miniature bust in Konya, and in the eradicated features of the tondo in Berlin.

1. Argos, Museum, no. 36, from Argos (J. Marcadé, "Sculptures Argiennes," *BCH* 81 [1957] 472–474). This heroic bust with acanthus support is a mature portrait in the Hellenistic tradition. The head is turned slightly to the right, and the features are somewhat negroid. If Geta, who looked more African than his brother as they grew older, it dates in or near the last year of Septimius Severus' reign. The date of the portrait is in the second or third decade of the third century. Identification as Geta, proposed by Marcadé, seems extremely difficult to support, even with the maximum of wishful thinking, because "Geta" has a cauliflower ear. The subject must have been a boxer of African origin or ancestry who performed in exceptional fashion in the gymnasium at Argos.

2. Konya, Museum. This miniature bust in

tunic and paludamentum has been identified (with a question mark) by Jale Inan and Elisabeth Rosenbaum (Inan-Rosenbaum, p. 84, no. 59).

SEVERUS ALEXANDER, Emperor A.D. 222 to 235

The two Eastern portraits come from Egypt:

1. Cairo, Museum, no. 27480, from Luxor. The identification of this head in white marble seems likely; it is a slightly coarse, somewhat cursory version of a model sent out from Rome (Felletti Maj, *Iconografia*, p. 94, no. 19; Harrison, pp. 56, 95; Graindor, *Bustes et statues-portraits*, p. 62, no. 19; H. von Heintze, "Studien zu den Porträts des 3. Jahrhunderts n. Chr., 6," *RM* 69 [1962] 168, pl. 56, 2, 3).

2. Boston, Museum of Fine Arts, no. 59.51, from Memphis. This colossal head, with much stucco and traces of paint remaining, appears to have been remade from a portrait of Ptolemy VI (181–145 B.C.) or Mark Anthony, for the visit of A.D. 231 when Severus Alexander was in progress to the Persian front. It must have been the focus of a statue showing the emperor seated as Sarapis (Vermeule, *BMFA* 58 [1960] 13–25; H. A. Cahn, Münzen und Medaillen A.G., Auktion XVIII, 1958, no. 14). H. Ingholt, however, considers the head Augustan, not reused, and perhaps Herod the Great, honored at the shrine of the Idumean mercenaries in Memphis (*JARCE* 2 [1963] 125–145) (figure 166).

JULIA MAMAEA, Mother of Severus Alexander, Died A.D. 235

1. Nauplia, Museum, from Petri: head (see epigraphic section, Appendix C).

2. Sparta, Museum, found at the juncture of two walls in a roofed hall of the agora on the acropolis: bronze statue in *orans* (Pietas) or *logos* pose, wearing chiton and himation. The identification as Julia Mamaea, suggested by the excavators, must await restoration of the bashed-in face for confirmation (*Ergon* 1964, pp. 102ff., esp. fig. 133; *JHS*, Archaeological Reports for 1964–65, p. 12, fig. 13).

3. Selçuk, Museum, from Ephesus(?): slightly overlifesized head in island marble. The eyes are turned upward and to the left. Selçuk Mu-

seum no. 148 may be a replica, but the face is mostly gone.

MAXIMINUS THRAX, Emperor
A.D. 235 to 238

1. Cairo, Art Market, bronze head, perhaps from Fayoum, Crocodilopolis. This seems to be an imperial portrait, related to Roman models, although at least one modern bronze "Maximinus Thrax" has turned up in an Egyptian collection (Felletti Maj, p. 120, no. 83; Graindor, *Bustes et statues-portraits*, p. 64, no. 20).

MAXIMUS CAESAR
A.D. 235 to 238

1. Side, Museum. The head set in Antiquity on (or reworked from) the late Antonine cuirassed statue from the Capitolium or Praetorium at Side seems to be Maximus and accords well with his portrait on Roman imperial coins. The statue was found in a large room presumably devoted to the imperial cult (A. M. Mansel, *Belleten* 22 [1958] 221f., fig. 22; idem, *Die Ruinen von Side* (Berlin, 1963), pp. 109ff., fig. 92; Vermeule, *Berytus* 13 [1959] no. 341; M. J. Mellink, "Archaeology in Asia Minor," *AJA* 59 [1955] p. 238; Inan-Rosenbaum, pp. 86f., no. 63, as perhaps Licinius).

BALBINUS, Emperor A.D. 238

1. Piraeus, Museum: heroic, half-draped statue of the emperor, with the Jovian eagle at his side. Found in the harbor, this statue must have been made for export in the months of his reign or under Gordian the Third when his memory as a Senatorial emperor was held in high esteem (Felletti Maj, p. 143, no. 137; Toynbee, *Art of the Romans*, pp. 38f., 246) (figure 167).

PUPIENUS, Emperor
A.D. 238

1. Piraeus, Museum. The mask of the face (nose, mouth, and beard) and the plinth (feet, drapery, and eagle) of the statue made as pendant to the previous also survive (Vermeule, *AJA* 63 [1959] 109; Toynbee, *ABSA* 53–54 [1958–59] 285, note 1).

GORDIANUS III, Emperor
A.D. 238 to 244

1. Tenos, Museum, from the sanctuary of Poseidon at Kionia. In the Antonine period, this sacred spot was evidently also dedicated to the imperial family. The marble head is very much like the profiles on Roman or Greek imperial coins from A.D. 240 onward.

PHILIPPUS I, Emperor
A.D. 244 to 249

1. Athens, National Museum: head, seemingly in Pentelic marble (Kavvadias, no. 334; German Archaeological Institute Neg. no. 509). This is possibly a crude, rather hesitant likeness; the hair is very summarily treated, and the beard is uncertain, assymetric. The profile of the nose and the side-whiskers suit Philip, but the flat head and square jaw suggest a private person.

TREBONIANUS GALLUS,
Emperor A.D. 251–253

1. Istanbul, Archaeological Museum, from Amisus (Samsun). The identification often seems to be derived from the fact that this reused and much-repaired bronze statue, presenting its subject in the heroic nude, resembles the Trebonianus Gallus in New York. It would be a provincial treatment of the emperor, one which exaggerates his nose, which is mostly restored, and the angles of brow and jaw (Felletti Maj, pp. 204f., no. 262); Roman imperial coins show how much his profile could vary (L'Orange, *Spätantiken Porträts*, p. 97). He may have been presented as Herakles, with lion's skin (Devambez, *Grands bronzes du Musée de Stamboul*, pp. 113ff., pls. 38ff.; Inan-Rosenbaum, pp. 103f., no. 101).

VOLUSIANUS, Emperor
A.D. 251 to 253

1. Once at Eskişehir in northwest Phrygia: head, identifiable from coins (German Archaeological Institute, Athens, Neg. no. 174). This is evidently the head long in the Bursa Museum, no. 49 (Mendel, *BCH* 33 [1909] 272, no. 22, fig. 14), which J. Inan and E. Rosenbaum take to be an anonymous man of A.D. 235 to 245 (Inan-Rosenbaum, p. 186, no. 252).

VALERIANUS AND GALLIENUS, Coemperors
A.D. 253 to 260

1, 2. A pair of overlifesized heads in marble have recently entered the collections of the Ny Carlsberg Glyptotek in Copenhagen (nos. 3387, 3388). For two generations more or less they were owned by a Greek dealer and his estate in Paris, a man whose antiquities came equally from mainland Greece and from Asia Minor. These portraits give every appearance of having come from Pergamon, Smyrna, or a similar major Roman city in western Asia Minor. V. Poulsen has recognized them as matching likenesses of Valerian and his son Gallienus, and coins confirm his identification. The presentation of the father follows the Flavian style popular in portraits at Pergamon, and the son is shown in a Julio-Claudian form used for his portraits in the West (figure 168 A, B).

CARUS, Emperor A.D. 282 to 284

1. A cuirassed bust from the Antioch excavations has been identified as Carus (D. M. Brinkerhoff, AJA 67 [1963] 209; see R. Stillwell, *Antioch-on-the-Orontes*, II, *The Excavations of 1933–1936* [Princeton, 1938], p. 172, pl. 5, no. 134). The published photographs suggest that possibly the head was a substitution, for there is a clean cut through the neck. The portrait has somewhat more sophisticated replicas in the Museo Torlonia and at Toulouse. The bust may have been remounted from the upper part of a tenoned, cuirassed statue. The shoulder strap is enriched with a very fine Victoria on orb, in high relief. The Mars-Virtus on the breastplate has parallels on rare coins (aurei) of Carinus, and Carus was in Antioch with his younger son, Numerianus, after a victory over the Sassanians at Ctesiphon. In the head from Antioch, Carus has picked-out hair and similarly indicated, close-cropped beard. Generally, this is a conservative, military portrait in the traditions of Philip the Arab or Trebonianus Gallus, that is, before the Hellenistic restimulation under Gallienus which left scant mark in Asia Minor. From the numismatic standpoint, the identification seems logical, although Carus is usually shown with considerably less hair above his forehead on coins.

The form of the bust is a fairly standard one from the Antonine period onward. It could come from a statue older than the present head

— one that was recut around its lower portions at the time the head of Carus was added — in which case the type of the breastplate could have inspired a die cutter. The Victoria on the shoulder strap seems too fine to be dated in the 280's, for marble cuirasses tended toward simplicity throughout the third century. The cuirasses shown on Roman imperial medallions, however, were extremely complex in the reigns of Probus and his successors.

The Successors to the House of Constantine

JULIANUS II, Emperor
A.D. 361 to 363

1. Thasos, Museum no. 937, from "Magasins VI" of the agora. Thasian marble head wearing a turbanlike crown surmounted by doubleknots ("winged") above the ears and a symbol over the forehead, a rosette below two crescents flanking a circle. With these priestly embellishments to the headdress, this head is a local but well-carved replica of the two Julians in Paris, from Italy. Another wreathed, diademed head of this type is in the Selçuk Museum, probably from Ephesus. The prototype and the surviving copies must have been created during his sole rule (figure 180). The type is very ideal, going back to Hadrianic philosopher-portraits and avoiding the large incised pupils common to this period (P. Lévêque, "Observations sur l'iconographie de Julien dit l'Apostat," *MonPiot* 51 [1960] 105–109). As the champion of a pagan revival, Julian embraced many cults and combinations of religions. This headdress with its crescents may refer to Anatolian divinities like Cybele and Men, or one of Julian's beloved Egyptian cults may have been intended.

2. Athens, National Museum, no. 2006, from the Monastiraki quarter. This slightly overlifesized head wearing an elevated *polos*, with neck worked for insertion in a draped statue, seems to be a Julian related to the previous group as Castriotis pointed out and Lévêque has reaffirmed (*MonPiot* 51 [1960], 112f., fig. 9). The minute treatment of hair, diadem just below the *polos*, and beard have suggested rightly that this head is close to a prototype in bronze. It too is ideal, like the head in Thasos, but is almost Archaistic in style and nature. The size well suits an emperor, but this is no hard-and-fast rule, as the overlifesized "Saint

Paul" from Agia Paraskevi and other late Athenian portraits indicate (figure 183). The provenance is right in the heart of Hellenistic and Roman Athens. Hadrian's Library, part of which is hard by Monastiraki, would have been a perfect setting for a statue of Julian the philosopher-writer emperor. The sculptor based his firmly symmetrical portrait on a likeness of Antoninus Pius. Were it not for the high, filigree crown, it could be even said that the head had been recut from a portrait of that emperor. The small, toothless mouth evokes admiration.

3. Israel, private collection and (sometimes) on loan in the Haifa Museum; bought in Jerusalem: small marble head, with thin diadem; the pupils are hardly expressed, and the beard of this iconic portrayal suggests that the sculptor was used to working in the minor arts. Coins make the identification plausible, especially in the profile of the nose (R. Jonas, "A Newly Discovered Portrait of the Emperor Julian," *AJA* 50 [1946] 277–282, pls. 13–15).

VALENTINIANUS I, Emperor
A.D. 364 to 375

1. Barletta, in the piazza in front of the Duomo. The bronze, cuirassed colossus certainly comes from the East, most likely from Constantinople. The profile accords very well with coin-portraits of this emperor, and the cuirass is Constantinian enough to make the subject Valentinian, rather than Theodosius I or Marcianus (450–457), who have been proposed (see Vermeule, *Berytus* 13 [1959] 74, no. 329, fig. 79 and bibl.). Heraclius as a candidate, after the Persian war (628–629), is much too late; it could have only been reused for that emperor (see F. P. Johnson, "The Colossus of Barletta," *AJA* 29 [1925] 20–25).

GRATIANUS, Emperor
A.D. 367 to 383

1. Krinides (Macedonia), from the agora at Philippi: underlifesized head with gigantic jeweled diadem and inlaid eyes, ca. 380 (Delbrueck, *Spätantike Kaiserporträts*, Nachträge, p. 252; E. Lapaulus, "Tête de Bronze de Philippes," *BCH* 56 [1932] 36off., pl. 20). The work is average to mediocre, allowing for the state of preservation; this makes identification

difficult. A model sent out from Constantinople was undoubtedly used, and this copy may have been merely a bust.

VALENTINIANUS II, Emperor
A.D. 371 to 392

1. Istanbul, Archaeological Museum (figure 181): marble statue from the Hadrianic baths at Aphrodisias, ca. 390 (see above; Mendel, *Catalogue*, II, 199ff., no. 506; L'Orange, *Spätantiken Porträts*, p. 40, no. 94; H. Jucker, *Museum Helveticum* 16, 1959, p. 278; Inan-Rosenbaum, pp. 89f., no. 66). A. Rumpf (*Stilphasen der spätantiken Kunst*, pp. 17f., 56f.) has proposed Valens, but this identification seems to neglect the epigraphic evidence. Valens reigned from 364 to 378 and would hardly be paired with Arcadius. On all counts, Valentinian II remains the leading candidate, although coin-portraits in this period are notoriously confused and inaccurate.

THEODOSIUS I, Emperor
A.D. 379 to 395

1. Damascus, Museum: head (J. Kollwitz, *Annales archéologiques de Syrie* I, 2, 1951, pp. 200ff.).

2. Istanbul, Hippodrome, Base of the Obelisk, ca. 390. Theodosius appears with Valentinian II, Arcadius, and Honorius, the last as a very young Caesar (Delbrueck, *Spätantike Kaiserporträts*, pp. 189ff. and various possible identifications; Toynbee, *Art of the Romans*, pp. 79, 252).

AELIA FLACILLA,
First Wife of Theodosius,
A.D. 379 to 386

1. Paris, Bibliothèque Nationale, Cabinet de Médailles, from Cyprus: marble statuette in court costume with diadem and hair caught up in the elaborately simple manner seen on coins (H. P. L'Orange, "Der subtile Stil," *Antike Kunst* 4 [1961] 68–75, pl. 30, 5–6, 7, and esp. pp. 72f.). L'Orange defends the traditional designation of this elongated, elegant figure and suggests at the latest it might be a posthumous portrait, done in the reigns of her sons Arcadius and Honorius. The statuette is termed

405

AELIA FLACILLA (*continued*)

an excellent example of the high point of L'Orange's "subtle style." Delbrueck (*Spätantike Kaiserporträts*, pp. 163ff., pls. 62–64; see also Vermeule, *AJA* 68 [1964] 340, and note 146) dated the work in the Constantinian period and felt the subject to be Helena. O. Vessberg has expressed the same opinion (*OpusRom* 1 [1954] 165). Profile and hairdress, with pearled diadem, are very characteristic of Flacilla, or one of the several fifth-century ladies of the Theodosian house. These ladies tend to look very much like Flacilla and like each other on their solidi; one of them, Aelia Eudocia, wife of Theodosius II (408–450), seems to be the subject of many bronze steelyard weights from the Greek East (see C. Vermeule, "New Near-Eastern, Greek and Roman Sculptures in the Museum of Fine Arts, Boston," *CJ* 56 [1960] 13f., fig. 16).

ARCADIUS, Emperor
A.D. 395 to 408

1. Istanbul, Archaeological Museum, no. 5028, from near the west wall of the Forum Tauri, about 100 meters north of the Column of Theodosius. This diademed head, circa A.D. 395 to 400, is a masterpiece of careful carving, in the best imperial tradition of the Theodosian "renaissance" (N. Fıratlı, "A Late Antique Imperial Portrait Recently Discovered at Istanbul," *AJA* 55 [1951] 67–71; *Istanbul Arkeoloji Müzeleri Yıllığı* 4 [1950] 10f., fig. 1; and *Belleten* 16 [1952] 17–20, pls. V f.) (figure 182).

Appendix B

WORKS OF ART IN MUSEUMS AND PRIVATE COLLECTIONS

This section includes material from non-Greek sites cited for comparison. The general references are merely random guides. Most single works are identified in the text or in various footnotes. Within a museum, entries are arranged in chronological sequence. Things linked with sites and museums may be listed in appendixes B and C. The term "museum" in connection with a site implies that the object is in a building designed for display and permanent store, rather than in an excavation house. Greece (Salonika) and Turkey (Smyrna-Izmir) are in the process of completing new museums where old ones have thrived for a generation or more. Local patriotism in the two countries has produced new museums in old cities and will lead to the return of antiquities from major museums.

ADANA, Museum

Boundary cippus from Misis, for Cilicia between Mopsuestia and Aegeae and probably in the name of Vespasian (F. Miltner [†], "XXIV. Vorläufiger Bericht über die Ausgrabungen in Ephesos," *JOAI* 45 [1960] 39ff.). Museum no. 2977.

Head of Antoninus Pius(?), from Seleuceia ad Kalykadnum.

AKŞEHIR (Phrygia)

Early fourth-century plaque from Philomelium: two tiers of five soldiers with spears, with a mounted officer to the right of either tier. The style is an offshoot of the small friezes on the Arch of Constantine in Rome and a culmination of Anatolian provincial tendencies (*MAMA*, VII [1956] 42, no. 204).

ALAŞEHIR (Lydia), Recorded on the site
Bust of Commodus, in relief.

ALEXANDRIA, Graeco-Roman Museum
Head of Tiberius, no. 22237.
Head of Tiberius, no. 3368.
Head of Claudius, no. 25713.
Head of Vespasian, no. 25029.
Head of Hadrian, limestone, no. 3595.
Bust of Hadrian, cuirassed, no. 20851.
Head of Hadrian, from Athribis, no. 20885.

Head of Hadrian, bronze.
Cuirassed statue of Marcus Aurelius Caesar, from Alexandria, no. 3520.
Cuirassed bust of Marcus Aurelius, from Kom Trughi, no. 21640.
Overlifesized head of Septimius Severus, from Alexandria, no. 3371.

ALMYROS (Thessaly), Museum?
Head of Trajan.

AMPHIAREION, Museum
Cuirassed statue of Agrippa, fragmentary.
Statue of man, half-draped.

ANKARA, Museum
Head of "Tiberius," from Sinope; a man of the late Republic.
Bronze tondo portrait of Trajan.
Bronze head of Antoninus Pius, fragmentary.

ANTAKYA, Museum
Bust of Carus.

ANTALYA, Museum
Head of Augustus from Myra (Demre).
Head of Hadrian from Antiphellus (Kaş) (not there; evidently an error)
Slab indicating building to Antoninus Pius, from Attaleia.

407

Head of Faustina the Younger.

Sarcophagus with Victoriae and Erotes flanking Gorgoneion shields, from Perge.

APHRODISIAS, Museum and Excavations

Frieze from theater, Time crowning Zoilos.

Head of Claudius(?) (K. T. Erim, "Aphrodisias Excavations, 1964," *Archaeology* 18 [1965] 68).

Statue of Diogenes, wearing himation and high crown with ten or twelve small busts. The busts include portraits of the Antonine and Severan rulers.

APHRODISIAS, Recorded on the site and now in Istanbul

Two statues of ladies, Trajanic or Hadrianic.

Two statues of late fourth-century municipal magistrates.

ARGOS, Museum

Head of a pugilist, identified as possibly Geta.

ATHENS, Acropolis

Two cuirassed statues of Hadrian.

ATHENS, Acropolis Museum

Head of Augustus.

Head of Julia Domna.

Head of Caracalla.

Head of man of intellect, Late Antique.

ATHENS, Agora Museum and site

Portrait head, sometimes identified as Augustus

Fragmentary head of Antonia.

Head of Claudius, or Domitian, or Trajan.

Apollo Patroos, Roman copy.

Cuirassed (headless) statue of Hadrian.

Head of Aelius Caesar.

Giants or marine divinities from the rebuilt Odeon of Agrippa.

Head of Julia Domna.

ATHENS, American School of Classical Studies

Damascene, a Hadrianic grave stele.

ATHENS, National Museum

Statue of "Themis," from Rhamnous.

Aristonautes stele.

Grave relief of horse and groom, fourth century B.C., from near the Larissa Railway Depot (N. Kotzias, *Polemon* 4 [1949] suppl. 5f., fig. 1).

Omphalos Apollo.

Votive relief from Eleusis, first century B.C.

Head of man, from Delos.

Head of Augustus.

Head of Octavia.

Head of Gaius Caesar.

Head of Lucius Caesar.

Gold statuette of Tiberius as Hermes (H. Stathatos collection).

Head of Tiberius.

Head of Claudius, no. 328.

Head of Domitian, no. 345.

Head of Plotina, no. 357.

Nine heads or fragmentary statues of Hadrian.

Head of Sabina, no. 449.

Head of Antoninus Pius, no. 3563.

Head of Faustina I, no. 3663.

Head of Marcus Aurelius, no. 514.

Head of Marcus Aurelius, no. 572.

Head of Marcus Aurelius, no. 3251.

Head of Faustina II, no. 359.

Head of Faustina II, no. 1687.

Head of Faustina II, no. 3712.

Bust of Faustina II, draped.

Statue of Faustina II, as Artemis.

Head of Lucius Verus, no. 350.

Head of Lucius Verus, no. 3740.

Head(?) of Lucius Verus, no. 1961.

Head of Commodus, no. 337.

Head of Commodus, no. 512.

Marble statue of an Antonine general, from Melos (outside museum).

Head of Septimius Severus.

Head of Philip I, or a private person.

Head of Diocletian.

Head of Julianus II, no. 2006.

ATHENS, Tower of the Winds

Reliefs of the Winds.

Head of Augustus.

Head like those of Julianus II.

BALTIMORE, Walters Art Gallery

Head of Vespasian, colossal, said to come from Pergamon (no. 23.119; from the Lambros collection, sale Paris, 17–19 June 1912, no. 268).

BARLETTA

Colossus, perhaps from Constantinople and an emperor variously identified as Valentinianus I, Theodosius I, or Marcianus.

BEIRUT, American University
Head of Hadrian.

BEIRUT, Lebanon National Museum
Cuirassed torso of Hadrian.
Third-century head of Hadrian, from Antioch.
Head of Septimius Severus, from Tyre.

BENEVENTUM
Arch of Trajan (comparison).

BERGAMA, Museum. *See* PERGAMON, Museum

BERLIN, State Museums (West and East Zones)
Refs.: C. Blümel, Staatliche Museen zu Berlin, *Katalog der Sammlung antiker Skulpturen*, vols. III–V, 1929–1938.
Reliefs from the Altar of Zeus, Pergamon.
Telephos Frieze, from Pergamon.
Balustrade of Eumenes, with trophies.
Relief from Pergamon, Mithradates as Herakles, 88 to 85 B.C. (Bieber, *Sculpture of the Hellenistic Age*, p. 122).
Amazon, after statue of the fifth century B.C.
Section of inscription from Ephesus, Artemision.
Slabs from the Gigantomachy-Amazonomachy *in* the temple at Priene.
Head of Augustus, from Troy.
Head of Augustus, from Cairo.
Head of Agrippa, from Magnesia-on-the-Maeander.
Head of Agrippa, or Lucius Caesar.
Head, possibly of Julia.
Head of Lucius Caesar (or perhaps Tiberius), from Asia Minor.
Head of Tiberius, from Athens.
Head of Tiberius, from Troy.
Bust of Nero Drusus.
Head of Antonia, probably from Samos.
Draped statue of Agrippina Senior (the body is said to belong to the head in PHILADELPHIA, Penna.).
Head of Agrippina Junior.
Pilaster relief with head of Domitian or Nerva.
Head of Trajan.
Statue of Hadrian, head and legs only.
Painted wood tondo of Septimius Severus and family.

Fragmentary relief from Sulu Monastir (Istanbul), Christ and disciples, fourth century; part of a sarcophagus or funerary monument (M. Bieber, "Romani Palliati," *PAPS* 103 [1959] 411, fig. 58; Morey, *Early Christian Art*, pp. 25ff.; and *Sardis* V, 1, pp. 30ff., fig. 25).

BITOLA (Yugoslavia), Site
Statue of magistrate, Antonine or Severan periods.
Headless female statue as Persephone, Antonine.

BLOOMINGTON (Indiana), Indiana University, Museum of Art
Posthumous head of Marcus Aurelius, from Ostia.

BOSTON, Museum of Fine Arts
Refs.: Caskey, *Catalogue; Greek and Roman Portraits.*
Statuette of negro boy-orator, Hellenistic (59.11).
Torso of a goddess, second century B.C. (Caskey, no. 51).
Terra-cotta tondo with head of Augustus in relief (64.701).
Relief, with head of Agrippa, from Athens (Caskey, no. 112).
Judgment of Bocchoris cup, Julio-Claudian (24.971).
Inscription from Assos, to Julia Aphrodite, meaning Livia (84.58).
Inscription from Assos, time of Gaius Caesar (84.55).
Veiled head of Tiberius, from Lanuvium (comparison) (Caskey, no. 111).
Gilded silver ladle, from western Asia Minor (61.159).
Head of Titus (63.2760).
Antonine private portrait, from Tralles (Caskey, no. 129).
Head of Septimius Severus (60.928).
Marble group of satyr, maenad, and Eros, from Aphrodisias (62.1).
Head of Severus Alexander (59.51).
Head of Saint Paul (62.465).

BUDAPEST, Private Collection
Bust of Lucius Verus, glass, from Antalya.

BURSA, Museum
Head of Julia Domna.

Head of Volusian.

Head of a Tetrarch, possibly Diocletian, from Afion (Mendel, *BCH* 33 [1909] no. 20).

BUTRINTO, Recorded on the site, and presumably in the National Library at Tirana

Portrait of Agrippa.

Cuirassed statue, signed by Sosikles.

Head of Augustus.

Head of Livia.

CAIRO, Art Market

Head of Augustus.

Head of Septimius Severus.

Head of Maximinus Thrax.

CAIRO, Egyptian Museum

Head of Vespasian, as a sphinx, no. 36500.

Head of Domitian, no. 42 891.

Head of Antoninus Pius.

Head of Marcus Aurelius.

Head of Septimius Severus.

Statues of Caracalla in Egyptian garb.

Head of Severus Alexander.

CAIRO, Private Collection

Head of Commodus.

CAMBRIDGE (England) Fitzwilliam Museum

Caryatid, from the Inner Propylaea at Eleusis.

Head identified as Domitian; in limestone and from Cyprus (Vessberg, *OpusRom* 1 [1954] 164, figs. 10f.).

CAMBRIDGE (Mass.) Fogg Museum of Art

Statue of Trajan, cuirassed (comparison).

Bust of Julia Domna, bronze, from Syria.

Statuette of Men, bronze, second or third centuries A.D.

ÇANAKKALE (Dardanelles), formerly Calvert Collection

Hellenized replica of Vatican head of a Roman (Nero Drusus?).

ÇANAKKALE, Museum

Head of Augustus.

CANTERBURY (Kent), Royal Museum and Slater Art Gallery

Head of Ptolemy III Euergetes, from a statue clad in an aegis; found in the theater at Nysa on the Maeander.

Head of Commodus, as Dionysos, from excavations near the Great Gate of Tralles on the Maeander.

CHAERONEIA, Museum

Base of a statue, with Victoriae of Antonine type crowning a trophy, beneath which kneel two bound Eastern barbarians. The trophy has a V-shaped cuirass similar to that/those on Romans in late Antonine sarcophagus-reliefs (Vermeule, *Berytus* 13 [1959] 25, from photo and information by J. L. Benson).

CHALCIS, Museum

Head of Augustus.

CHANIA, Museum

Head of Hadrian, from a cuirassed statue, no. 77, from the DICTYNNAION.

Head of Hadrian, from a draped statue, no. 82, from the DICTYNNAION.

CHERCHEL, Museum

Cuirassed statue of Hadrian (comparison).

Statue of Demeter, Roman copy of a fifth-century work (comparison).

CHICAGO, Art Institute

Portrait of Constantia, a head, from Athens (Vermeule, *Quarterly* 54 [1960] 9f.).

CLEVELAND (Ohio), Museum of Art

Head of Lucius Verus, posthumous, probably from Alexandria (*Roman Portraits*, Worcester, no. 23).

COLUMBIA (Missouri), University of Missouri

Head of Titus, from Egypt or Judaea.

COPENHAGEN, National Museum

Augustan silver cups, from Hoby.

COPENHAGEN, Ny Carlsberg Glyptotek

Ref.: F. Poulsen, *Catalogue of Ancient Sculpture* (Copenhagen, 1951).

Head of Augustus, bronze, from Megara, no. 460a.

Head of Augustus, no. 611.

Bust of Augustus, no. 610.

Bust of Livia, from the Fayoum, no. 615.

Bust of Livia, no. 616.

Head of Tiberius, from Smyrna, no. 625.

Bust of Tiberius, from the Fayoum, no. 623.

Bust of Antonia, no. 607.

Head of Caligula, no. 637a.

Cuirassed bust of Caligula, no. 637, Italian forgery (comparison).

Statue of Trajan, no. 543a (comparison).

Cuirassed bust of Hadrian, no. 682.

Head of Faustina II, or Lucilla, no. 709a.

Head of Faustina II, as Aphrodite.

Heads of Valerian and Gallienus (V. Poulsen, *Meddelelser* 24 [1967] 1–30).

CORCYRA, Corfu Museum

Bust of Marcus Aurelius, cuirassed.

Head of Faustina II.

CORINTH, Museum

Ref.: Johnson, *Corinth*, IX.

Statue of Augustus.

Statue of Gaius Caesar, only the upper half preserved.

Head of Gaius Caesar, fragmentary (Museum, Workrooms).

Statue of Lucius Caesar.

Head of Nero, or Drusus Caesar.

Head identified as Galba.

Late Antique head of Hadrian (Sc. 1454).

Head of Aelius Caesar (Sc. 2505).

Head of Antoninus Pius.

Sarcophagus, Antonine, with Seven Against Thebes.

Head of Caracalla, as a young man, ca. A.D. 208 (E. Askew, "A Portrait of Caracalla in Corinth," *AJA* 35 [1931] 442).

COS, Museum and Antiquarium

Ref.: L. Laurenzi, *Annuario* 33–34 (1955–56) 140ff.

Head of Augustus.

Head of Agrippina Junior, fragmentary.

Head of Nero, as Caesar or in the first years of his reign (no. 4510).

Head of Trajan.

Head of Antoninus Pius.

Head of Faustina II.

Head of the early Tetrarch period, ca. A.D. 292, with a large wreath and slight beard; perhaps Galerius Caesar.

CRANBROOK (Michigan), Academy

Head of Augustus from Egypt (Ingholt, *JARCE* 2 [1963] 136, pl. 37).

CRETE, Heraklion (Iraklion or Candia), Museum

Ref.: N. Platon, *Guide*, 1955 (revised editions to 1964).

Head of an emperor of the Julio-Claudian family, from Knossos, no. 377.

Head of Livia, from Gortyna, no. 67.

Head of Tiberius, from Gortyna, no. 65.

Veiled head, possibly of Tiberius, no. 377.

Head of Germanicus, from Gortyna, no. 66.

Head of Caligula, from Gortyna, no. 64.

Head of Trajan, from Lyttus, no. 317 (*AJA* 61 [1957] 250f., pl. 75).

Head of Plotina, no. 189.

Head of Hadrian, no. 341.

Statue of Antoninus Pius, seated (Heraklion and GORTYNA) (head: no. 73).

Head resembling Septimius Severus, no. 60, from Gortyna.

Head of Maximianus, as Herculeus, no. 191.

Head of Constantinus I, as Caesar, from Gortyna.

CRETE, Knossos

(Villa Ariadne), Cuirassed statue of Hadrian.

CYPRUS, Nicosia, Cyprus Museum. *See also* SALAMIS, Site

Ref.: Vessberg, *OpusRom* 1 (1954) 160–165.

Head of Lucius Caesar.

Head of a Julio-Claudian, perhaps Drusus Junior, no. E.469.

Limestone head, identified as Caligula.

Head of Agrippina, from Soli.

Bronze statue of Septimius Severus as Mars Pater, from Kythrea (C. Vermeule, *AJA* 59 [1955] 351; D. Levi, *BullMusImp* 6 [1935] 3–9; Hanfmann, *Roman Art*, pp. 85f., no. 56).

CYPRUS, Nicosia, Private Collection

Head of Marcus Aurelius.

DAMASCUS, Museum

Head of Theodosius I.

DELOS, Museum and site

Statue of C. Billienus C. F., first century B.C.

Statue of C. Ofellius.

Cuirassed torso, of general on horseback, ca. 100 B.C.

Standing (Tyche-type) statue of Roma, ca. 90 B.C.

Fragmentary altar, Nereid and Triton.

Head of Augustus.

DELPHI, Museum and site

Base of Monument of Aemilius Paullus.

Base of statue of Trajan.

DENIZLI, School, Garden
Head of Faustina I (seemingly lost).

DRESDEN, Albertinum
Large Lady from Herculaneum.
Small Lady from Herculaneum.

ELEUSIS, Museum, Garden, and Site
Relief dedicated by Lakrateides.
Statue of Livia or Julia as Demeter, headless.
Statue of Tiberius, togate.
Statue of Nero, togate.
Head of Hadrian, fragmentary.
Cuirassed bust of Hadrian, headless.
Small head of Antoninus Pius, early in his reign (Jucker, *Bildnis*, p. 92, note 1).
Bust of Marcus Aurelius in relief, from tympanum of Great Propylaea.

EPHESUS, Museum and site. *See* SELÇUK
Torso of Trajan, in the nymphaeum of Trajan.
Statue of Nerva, in the nymphaeum of Trajan (head and body Hellenistic, not belonging to Nerva's base).
Statue of Publius Vedius (see Inan-Rosenbaum, no. 182).
Head of Septimius Severus(?).

EPIDAURUS, Museum
Head of Hadrian.
Stele of Timokles (Vermeule, *Berytus* 13 [1959] 22f., no. E 10, pl. 19, fig. 56).

GENEVA, Art Market (1964), N.Y. (1967)
Bronze statuette of Oikoumene, replica of marble colossus at Porto Raphti.

GUELMA, Museum
Cuirassed torso, early Antonine (comparison).

HAIFA, City Art Museum
Head of Nero.

HAMBURG, Museum für Kunst und Gewerbe
Head of Germanicus, from Epidaurus (H. Hoffmann, *Jb der Hamburger Künstsammlungen* 7 [1962] 221–224, as from a high relief; Hoffmann, Hewicker, *Kunst des Altertums*, no. 25).
Tondo bust of Apollo, ca. A.D. 150 to 175, from central Italy.

HILDESHEIM, Museum
Silver cup (with rinceaux enrichment) and plates (busts of Cybele, Men-Attis; seated Athena). *Hildesheimer Silberfund*, 1967.
HOUSTON (Texas), Museum of Fine Arts
Bronze statue (probably) of Caracalla as Alexander with the Lance.

ISAURA (Isauria), Recorded on the site
Statue of Septimius Severus.

ISRAEL, Private Collection
Head of Julianus II.

ISTANBUL, Archaeological Museum
Refs.: Mendel, *Catalogue*, I–III; N. Fıratlı, *A Short Guide to the Byzantine Works of Art*, Istanbul, 1955; Devambez, *Grands Bronzes du Musée de Stamboul*.
Sarcophagus from Sidon.
Frieze from Miletus, Propylon, ca. 175 to 164 B.C.
Gigantomachy-Amazonomachy slabs from in or near the temple at Priene.
Fragmentary relief from Cyzicus, first century B.C.
Head of Augustus, from Pergamon.
Head of Augustus, from Cyme.
Head of Augustus, from Pisidian Antioch.
Head of Livia, no. 4772.
Head of Gaius Caesar, or the young Tiberius.
Head of Gaius Caesar, or Germanicus.
Head of Tiberius, or Germanicus.
Statue of Tiberius, or possibly Germanicus.
Head of Antonia, no. 4503.
Head of Agrippina Senior, from Pergamon.
Head of Agrippina Senior, from Trabzon.
Bust of Caligula, cuirassed.
Cuirassed statue of Nero, headless with inscription on plinth; from Tralles.
Base of the statue of Sextus Vibius Gallus, from Amastris, no. 1155; Vibius rides over two fallen Dacians; on the sides are honors won in war.
Cuirassed statue of Celsus, from Ephesus, no. 1373.
Bronze statue of Hadrian, from Kadirli, Vilayet of Adana (A. Ogan, "Bronzestatue aus Adana," *AA* 49 [1934] cols. 411–416, figs. 1f.; Inan-Rosenbaum, pp. 71f., no. 35).
Statue of Hadrian, from Hierapytna.
Head of Antoninus Pius.

Statue of the personified (Jovian) Demos, from Ephesus.

Head of Marcus Aurelius, from Byzantium-Constantinople, no. 4492.

Head of Marcus Aurelius, from Ayvalık, no. 586.

Head of Marcus Aurelius, from Kandilli.

Statue of Marcus Aurelius, from Adalia, no. 1390.

Head of Faustina II, from Kandilli.

Sarcophagus of Claudia Antonia Sabina, from Sardes.

Head of Lucius Verus, no. 1378.

Head of Lucilla, from Ephesus.

Statue of Tyche, from Tralles.

Head of Septimius Severus, from Nicomedia.

Head of Septimius Severus, perhaps from Nicomedia or, more likely, Beirut, no. 587.

Head of Septimius Severus, from Mylasa, no. 428.

Head of Caracalla, from Constantinople-Byzantium.

Statue, perhaps Trebonianus Gallus, from Amisus (Samsun) (Devambez, pp. 113ff.).

Large sarcophagus, from Sidamara.

Head of Diocletian, from Nicomedia. (V. Poulsen, *Meddelelser* 24 [1967] 16, fig. 13, as perhaps Claudius II Gothicus, under whom NICAEA's walls were rebuilt.)

Supplication and rescript, A.D. 311 to 312, to Daza, Constantine, and Licinius; from stadium at Arycanda in Lycia; no. 779.

Head of Helena, from Nicomedia.

Head of Constantine the Great, formerly in Mendel, no. 1107.

Head of Constantine, in the Julio-Claudian tradition, from his Forum.

High relief of Victoria, from the "Hunter's Gate," no. 667.

Relief of an eastern barbarian kneeling, trophy at his back, no. 695.

Statue of Valentinianus II.

Head of Arcadius, ca. 395 to 400, no. 5028.

Christian triumphal sarcophagus, Nikai supporting Christogram, ca. 350 to 420.

Four roundels, the Evangelists, fifth century.

Angel, fragment ca. 450 to 470, in the style of the Nike on the base of the Column of Marcianus.

Double-faced dais or parapet relief, fifth century; from Yedikule, civilians facing, no. 1317.

Base of the statue of the charioteer Porphyrios, ca. 490 to 510.

"Grand Ambon de Salonique," ca. 500 to 550, no. 643.

ISTANBUL, Hippodrome
Base of the Obelisk of Theodosius, ca. 390.

ISTANBUL, Private Collection
Head of Constans, diademed; dated ca. A.D. 340 (Delbrueck, *Spätantike Kaiserporträts*, pp. 154f., pls. 58f.). See NEW YORK.

IZMIR. *See* SMYRNA

JERUSALEM, Cloister of St. Etienne
Head of Marcus Aurelius.

KLEITOR (Arcadia)
Stele to Polybius (seemingly now lost; head seen shortly after World War II) (H. Möbius, "Diotima," *JdI* 49 [1934] 57, figs. 5, from cast; 6, direct photograph, without head and right arm).

KONYA, Museum
Head of Augustus.

Head of Lucius Verus, said to be from Pisidian Antioch.

Head of Lucilla or Crispina.

Miniature bust of Geta.

KRINIDES (Macedonia), Museum
Head of Lucius Verus, from Philippi (see Appendix C).

Head of Gratianus, bronze, from Philippi and underlifesized, with jeweled diadem (F. Lapaulus, "Tête de Bronze de Philippes," *BCH* 56 [1932] 360ff., pl. 20).

LARISSA, Museum
Head of Livia or Julia, daughter of Augustus (Biesantz, "Griechisch-römische Altertümer in Larissa und Umgebung," *AA* 1959, 102ff., fig. 22).

Head of Tiberius, no. 825.

Head of Trajan, no. 803.

LENINGRAD, Museums
Three silver *largitio* plates, from Kertch, with portraits of Constantius II, A.D. 343 (Delbrueck, *Spätantike Kaiserporträts*, pp. 144ff., esp. pl. 57).

LEPCIS MAGNA
Arch of Septimius Severus (comparison).

LIVERPOOL, Ince Blundell Collection
Statue of Athena (comparison).
Statue of Cappadocia or Phrygia, from Tivoli (comparison).

LONDON, Art Market
Head of Caracalla, from Kula.

LONDON, British Museum
Ref.: A. H. Smith, *A Catalogue of Sculpture* (3 vols.; London, 1899–1904), esp. vol. III.
Poseidon from the West Pediment of the Parthenon.
"Apotheosis of Homer" relief, second century B.C., no. 2191 (Bieber, *Sculpture of the Hellenistic Age*, p. 100).
Choiseul-Gouffier Apollo.
Fragment of high relief from an altar-wall at Delos: marine divinity, no. 2220.
Section of inscription from Ephesus, Artemision.
Head of Augustus.
Head of a Julio-Claudian, perhaps Drusus Junior, no. 1882, from Kyrenia (Vessberg, *OpusRom* I [1954] 162).
Inscription to Caligula, from Calymnos.
Head of Claudius.
Portland Vase (comparison).
Julio-Claudian silver cups.
Section of Flavian "frieze" from gate at Xanthus: triglyphs and metopes, with busts of Apollo and Artemis, no. 964.
Head of Trajan.
Fragmentary relief of barbarian, from Alexandria, so-called Palace of Trajan at Ramleh (no. 1772; Reinach, *Rép. stat.*, II, 197, fig. 7).
Antonine inscription, from Ephesus, odeon.
Head of Faustina I, from Sardes.
Statue of Marcus Aurelius, togate, no. 1906.
Statue of Lucius Verus, lower half, no. 1256.
Statue of Septimius Severus, cuirassed, no. 1944.

LONDON, Sir John Soane's Museum
Head of Claudius, in Egyptian dress.

MADRID, Museo Arqueológico
Hellenistic relief, from Troy, Alexander on Bucephalus(?).

MANISA (MAGNESIA AD SIPYLUM), Museum
Head of Hadrian.

MARBURY HALL (Cheshire)
Menander (comparison).

MARMARIS (Caria), Schoolhouse (1963)
Head of Livia. (Moved to Tourist Office.)

MILETUS, Museum
Head of Hadrian (at one time reportedly stolen).

MUNICH
Ref.: A. Furtwängler, P. Wolters, *Beschreibung der Glyptothek zu München*, 2nd ed., Munich, 1910.
Black-figure kylix with Dionysos, by Exekias.
Marine thiasos from the so-called Ahenobarbus base (comparison); *see* below, under PARIS, Louvre.
Silver bowl, Hadrianic or Antonine.

MYTILENE, Gymnasium
Head of Tiberius.

NAPLES, Museo Nazionale
Ref.: A. Ruesch, *Guida*, Naples, n.d.
Puteoli basis, Julio-Claudian period.
Head of Vespasian (comparison).
Head of Domitian (comparison).
Head of Antoninus Pius, no. 6031 (comparison).

NAUPLIA, Museum
Head, perhaps of Julia Mamaea.
Head of Galerius.

NEW YORK, Art Market
Head of Gaius Caesar (formerly SMYRNA, Art Market).
Head of Hadrian, said to be from Persepolis.
Colossal head of Commodus, said to be from Beirut (*see* WINNETKA).

NEW YORK, Metropolitan Museum of Art
Ref.: G. M. A. Richter, *Roman Portraits*, New York, 1948.
Lansdowne Amazon, after statue of the fifth century B.C.
Bronze head of Agrippa (comparison).
Bronze statue of Lucius Caesar.
Head identified as that of Titus (Vessberg, *OpusRom* I [1954] 163f., fig. 8; J. L. Myres, *Handbook of the Cesnola Collection of Antiquities from Cyprus*, The Metropolitan Museum of Art [New York, 1914], no. 1316; L. Cesnola, *A Descriptive Atlas of the Cesnola Collection of Cypriote Antiqui-

ties in the Metropolitan Museum of Art, New York, vol. I [Boston, 1885], pl. CXXXIX, no. 1035); in limestone and from Cyprus.

Bronze statue of Trebonianus Gallus.

Head of Constans or Crispus, from ISTAN-BUL, Private Collection (*BMMA* [1967] 83, fig.; 67.107).

NEW YORK, Private Collection

Head of Titus, from Egypt or Judaea (now COLUMBIA, Missouri, University of Missouri).

NICAEA (Iznik), Museum

Head of Lucilla (Inan-Rosenbaum, pp. 81f., no. 54).

NICAEA, Site (City Walls)

Reliefs of a Tetrarch monument.

NICOSIA, Cyprus Museum. *See* CYPRUS

OBERLIN (Ohio), Oberlin College, Allen Memorial Art Museum

Fragmentary bound Parthian, or bearded divinity with Phrygian cap; section of a large Asiatic (Lydian) sarcophagus (40.39; *Bulletin* 9, no. 2, 1954, no. 8; *The Dark Ages*, Worcester Art Museum, 1937, no. 36); third-century A.D., and said to have come from Ephesus by way of the art market in Smyrna (Morey, *Sardis* V, 1, p. 43, fig. 69).

OLYMPIA, Museum

Ref.: *Olympia*, III.

Cult statue of Augustus, fragmentary, from the metroon.

Head of Nero Drusus.

Statue of Claudius.

Statue of Agrippina the Elder.

Head of Agrippina the Younger.

Head of Nero.

Head of Octavia.

Statue of Poppaea.

Cuirassed statue of Titus.

Statue of Julia, daughter of Titus, in civic dress.

Cuirassed statue of Trajan, headless.

Head of Trajan.

Cuirassed statue of Hadrian.

Head of Antoninus Pius.

Head, and upper body, of Faustina I.

Statue of Faustina II.

Head of Lucius Verus.

OXFORD, Ashmolean Museum

Head of Titus.

Bust of Lucius Verus, cuirassed, from Marathon.

PARIS, Bibliothèque Nationale, Cabinet des Médailles

Grand Camée de France (comparison).

Kantharos, silver, from the Berthouville treasure (comparison).

Marble statuette of a late Roman empress, from Cyprus, perhaps Aelia Flacilla, first wife of Theodosius I, A.D. 379 to 386 (H. P. L'Orange, "Der subtile Stil," *Antike Kunst* 4 [1961] 68–75, pl. 30; Delbrueck, *Spätantike Kaiserporträts*, pp. 163ff., pls. 62–64).

PARIS, Louvre

Ref.: Reinach, *Rép. Stat.*, I.

Nike, from Apollonia in Epirus, high relief.

Relief from Smyrna, second century B.C. (no. 3295; *Istanbuler Forschungen* 17 [1950] 98f., pl. 42a and b).

Frieze from Miletus, Propylon.

Slabs with Gigantomachy-Amazonomachy from in or near the temple at Priene.

Borghese Warrior.

Scene of sacrifice, from the so-called Ahenobarbus base (comparison) (K. Schefold, "Zur Basis des Domitius Ahenobarbus," *Essays in Memory of Karl Lehmann* [New York, 1964], pp. 279–287).

Mask of (marble) head of Augustus.

Head of Tiberius.

Head of Nero Drusus, no. 3515.

Boscoreale silver.

Head of Agrippina Senior.

Head of Claudius.

Statue of Plotina.

Head of Hadrian, no. MA 3131.

Head of Hadrian, no. 3132.

Head of Hadrian, no. 1187.

Relief of city-goddesses, Hadrianic (comparison).

Bust of Marcus Aurelius, cuirassed, from Marathon, no. 1161.

Bust of Faustina II (comparison).

Head of Herodes Atticus, from Marathon, no. 1164.

Colossal head of Caracalla, probably from Philippi (Drama).

Reliefs from the so-called Incantada at Salo-

nika (L. Guerrini, "'Las Incantadas' di Sa-lonicco," *ArchCl* XIII [1961] 40–70).

Ninth milestone from Thessalonica toward Pella; period of Constantine the Great.

Statue of philosopher, "Julian The Apostate" (comparison); a similar statue is in the Cluny.

PATRAS, Museum
Cuirassed statue, replica of one at Butrinto.

PERGAMON, Museum
Head of Vespasian, no. 157.
Head of Domitian, now lost.
Statue of Hadrian.
Head of Hadrian.
Head of a man, possibly Pertinax, no. 156.
Head of Caracalla, no. 163.

PERGAMON, Recorded on the site
Head of Hermes.
Head of Eros.

PERGE, Depot
Head of Hadrian, on a cuirassed statue.
Head of Sabina, on a replica of the Large Lady from Herculaneum (Inan-Rosenbaum, pp. 72f., no. 36).
Statue of Faustina the Younger.
Head of Lucilla (Inan-Rosenbaum, p. 81, no. 53).

PHILADELPHIA (Penna.), University Museum
Head of Agrippina Senior; the draped body is said to be in Berlin; from Ilium (Luce, *Catalogue*, p. 190, no. 58).
Head of Caracalla, from Koptos.
Head of Caracalla, from Rumeli Hisar (Luce, *Catalogue*, p. 189, no. 56).
Head from Syria, identified as Constantius II Caesar.

PHILIPPI, Museum
Head of Gaius Caesar.

PIRAEUS, Museum and Garden
Head of Claudius.
Cuirassed bust, probably of Neronian (general or) official.
Head of Trajan.
Colossal head of Hadrian.
Statue of Balbinus, standing, half-draped, with eagle on plinth (von Schlieffen, West, "Eine

römische Kaiserstatue im Piraeus-Museum," *JOAI* 29 [1935] 97–108).

Statue of Pupienus, only the plinth, feet, and Jovian eagle remain; in the Garden in 1957 (Toynbee, *ABSA* 53–54 [1958–59] 285, note 1).

PREVEZA (Epirus), Museum (bombed in 1941)
Head, perhaps of Marcus Aurelius.
Head of Faustina II.

PROVIDENCE (Rhode Island), Museum of the Rhode Island School of Design
Sarcophagus perhaps from Anatolia (Pamphyl-ia), exported to Rome in antiquity; Achilles dragging the body of Hector before the walls of Troy; hunting scenes with genii.

PRUSIAS AD HYPIUM
Cuirassed statue of Hadrian, fragmentary.
Base of statue of Hadrian.

RHODES, Museum
Bust of Augustus, or Tiberius (M. S. F. Hood, *JHS, Arch. Rep. for 1958*, pp. 15f., fig. 22).
Cuirassed torso of a Julio-Claudian ruler, probably Augustus, as Hermes-imperator (A. Maiuri, "Sculture del Museo Archeologico di Rodi," *Annuario* 4–5 [1921–22] 247f., fig. 9, suggests Tiberius).
Head of Antoninus Pius.

ROME, Monuments about the city, cited alphabetically for comparison
Ref.: S. B. Platner and T. Ashby, *A Topographical Dictionary of Ancient Rome*, Oxford, 1927.
Ara Pacis Augustae.
Ara Pietatis Augustae.
Arch of Constantine.
Arch of Septimius Severus.
Arch of Titus.
Baths of Caracalla.
Baths of Diocletian.
Campidoglio, bronze statue of Marcus Aurelius on horseback.
Column of Marcus Aurelius.
Column of Trajan.
Forum Romanum, Base of the Tetrarch Column.
Giardino della Pigna, Antonine Column Base.
Hadrianeum.

Porta Argentariorum.

Pyramid of Caius Cestius.

Temple of Antoninus Pius and Faustina.

Temple of Apollo Sosianus.

Temple of Venus and Rome.

Tomb of Cecilia Metella.

Tomb of the Baker.

Trofei di Mario, on the Capitoline balustrade.

ROME, Museo Capitolino

Menander (comparison).

Head of Faustina I (comparison).

Head of Marcus Aurelius (comparison).

Head of Helena, on body of so-called Agrippina (comparison).

ROME, Museo delle Terme

Ref.: S. Aurigemma, *The Baths of Diocletian and the Museo Nazionale Romano*, 4th ed., Rome, 1958.

Head of Hadrian, no. 8618 (comparison).

Antonine sarcophagus, bound barbarians (comparison).

Head of Marcus Aurelius, no. 726 (comparison).

Head of young girl, from the Palatine (comparison).

ROME, Museo Profano Lateranense

Relief from the Tomb of the Haterii.

ROME, Museo Torlonia

Head of Carus.

ROME, Palazzo dei Conservatori

Augustan or Julio-Claudian marble bowl (comparison).

Relief from the podium of the Hadrianeum: a province or city holding a large *vexillum* in her right hand.

ROME, Vatican Museums

Ref.: W. Amelung, G. Lippold, *Die Sculpturen des Vaticanischen Museums*, I–III, Berlin, 1903–1956.

Belvedere torso (comparison).

Laocoon (comparison).

Augustus Primaporta (comparison).

Head of a Roman boy, set on an alien *togatus* (suggested as Nero Drusus about age ten) (comparison).

Statue of Claudius, from Lanuvium (comparison).

Marble votive biga, partly restored (comparison).

Cancelleria frieze (comparison).

Antonine copies of the Caryatids from the Porch of the Maidens in Athens.

Base of the Column of Antoninus Pius and Faustina (comparison).

Severan empress as Omphale.

Sarcophagus of Constantia.

Sarcophagus of Constantius and Helena.

Sarcophagus of Junius Bassus (Crypt of St. Peter's).

ROME, Villa Torlonia-Albani

Marble group of Zeus enthroned in a zodiacal circle.

SABRATHA, Museum

Headless Flavian emperor, probably Vespasian (comparison).

SALAMIS (Cyprus), Site (Famagusta Museum)

Cuirassed statue of Vespasian or Titus, headless.

Cuirassed statue, perhaps of Trajan.

SALONA (Split or Spalato)

Palace of Diocletian (comparison).

SALONIKA, Museum

Head of a plump, elderly man, Hellenistic rather than Vespasian, no. 1055.

Front of the head of Julius Caesar, slightly overlifesized, no. 1279; the hair resembles that of the statue in Copenhagen, no. 576.

Heroic statue of Augustus.

Head of Herakles with features of Titus.

Head of Faustina II, no. 1054.

Head resembling Faustina II, no. 1051.

Head of Septimius Severus.

Portrait of a young girl, Severan.

Series of Antonine and later sarcophagi with the deceased reclining on the lid, represented as an elaborate couch.

SALONIKA, Small Arch (Old Museum garden)

Arch or Niche from the Palace of Galerius, below the Tetrapod Arch (no. 2466; G. Daux, "Chronique des Fouilles en 1957," *BCH* 82 [1958] 757ff., figs. 4f.; R. Hoddinott, *Early Byzantine Churches in Macedonia and Southern Serbia* [London, 1963], pl. 9, b and c; Vermeule, *PAPS* 109 [1965] 380).

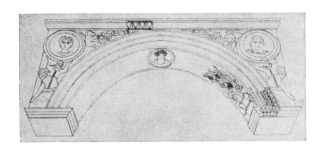

On the left, Attis as a Winter Season supports a medallion bust of Tyche, while an Eros symbolizing Spring holds an end of the wreath spanning the arch. The tondo on the right contains a bust of Galerius, details finished in paint; Eros as Summer grasps the wreath, while Attis as an Autumn Season holds up the shield or circle. The medallion in the vault contains a bust of Dionysos wearing a heavy wreath. A complex vine springs from a kantharos at either side. Figures of Pan and a nymph on the ends are not visible in the drawing. The quality of the carving is very good. The molding is dry and rich. Galerius wears a tunic with a jeweled barbarian fibula; his is a young, forceful bust.

SALONIKA, Site
Fragmentary Tetrarch statues and reliefs, Arch of Galerius.

SAMOS, Tigani, Castro, City Hall and Museum
Head of Augustus.
Head of Lucius Caesar.
Head of Germanicus.
Head of Claudius (City Hall).
Head of Nero, set on a togate statue (City Hall).
Head of Octavia.
Statue of Trajan (Castro, apotheke).
Fragment of head of Trajan (Heraion).
Head of Caracalla (City Hall).

SAMOS, Vathy Museum
Head of Augustus.
Heads of Tiberius (Apotheke).
Head of Nero.
Head of Commodus.

SARDES, Excavation Houses and site
Remains of a colossal head of Antoninus Pius,

pendant to the Faustina the Elder in London.
Remains of a colossal head of Marcus Aurelius.
Sarcophagus of Claudia Antonia Sabina (*see* ISTANBUL, Archaeological Museum).

SELÇUK, Museum
Battered head of Augustus or Tiberius.
Splendid head of Augustus(?).
Lifesized Augustus, with overlifesized Germanicus and Agrippina the Elder.
Head of Germanicus.
Head of Commodus.
Head of Julia Mamaea.
Head, perhaps a replica of the previous, no. 148.
Head of Julianus II.

SEVILLE, Museo Arqueológico
Statue of Trajan (comparison).

SIDE, Recorded on the site and/or in the Museum amid the ruins
Neo-Hittite or archaic Greek lotus-bud altar.
Head of Augustus.
Antonine cuirassed statue, with head recut with or replaced by later portrait, possibly Licinius or Maximus Caesar.

SIKYON, Museum
Head of a Julio-Claudian prince, probably Germanicus.

SIPHNOS, Museum
Head of Augustus.

SMYRNA (or IZMIR), Evangelical School (destroyed in 1922)
Head of Lucius Verus (now destroyed); lower section of heroic statue in British Museum.
Six medallions, fourth century A.D., tondo busts (now lost).

SMYRNA, Museum in the Culture-Park (New Museum)
Head or bust of the young Nero, from Stratoniceia, no. 843.
Head and arm of Domitian, from the Flavian temple at Ephesus (Giuliano, p. 170, no. 6; Keil, "XVI. Vorläufiger Bericht über die Ausgrabungen in Ephesos," *JOAI* 27 [1931] Beiblatt 59ff., pl. 3; *Guide*, no. 670; Wegner, *Die Flavier*, p. 86).
Head of Hadrian, fragmentary.
Head of Lucilla (Inan-Rosenbaum, pp. 80f., no. 52).

Sarcophagus from Laodiceia Combusta, with heads resembling Antoninus Pius and Faustina Mater (Museum Garden).

SMYRNA, Old Archaeological Museum

Frieze of the Great Ionic Portal from Aphrodisias (G. Jacopi, "Gli Scavi della Missione archeologica italiana ad Afrodisiade nel 1937 [XV–XVI]," *MonAnt* 38 [1939] 74ff.).

Orthostate blocks from the Antonine Altar at Ephesus.

Cuirassed torso of Antoninus Pius, A.D. 146, from Nysa.

Togate statue of Marcus Aurelius, from Nysa, head missing.

Head of Commodus.

Pediment with bust of Septimius Severus, no. 1200; from Karacasu near Carian Aphrodisias (Jucker, *Bildnis* I, 102ff., ST 52, II, pl. 42).

Fragment of a sarcophagus with Erotes and Gorgoneion shield, from Smyrna.

SMYRNA, Once Art Market

Head of Gaius Caesar.

Head of Claudius.

SMYRNA, Once in the Gaudin Collection

Head of Tiberius.

SMYRNA, Site

Bust of Faustina II, in relief (agora, portico).

Head of Lucilla, from the agora.

SPARTA, Museum

Head of Claudius.

Bronze statue of a lady, about A.D. 225, possibly Julia Mamaea (*Ergon* 1964, pp. 102ff., fig. 133).

SPLIT (SPALATO)

Palace of Diocletian (comparison).

STUTTGART, Museum

Head of Marcus Aurelius.

SYROS, Museum

Head of Germanicus, no. 110.

Head of Agrippina the Elder, no. 111.

TARRAGONA, Museum

Portrait of Marcus Aurelius (comparison).

TCHUKUR-KEUÏ, Recorded on the site

Statue of Septimius Severus.

TENOS, Museum

Fragments of altar, early Augustan period.

Head of Augustus, fragmentary.

Five cuirassed torsos, Hadrianic period, of Hadrian, Trajan, Nerva, Aelius, and Antoninus Pius.

Head of Gordianus III.

THASOS, Museum

Head and fragments of statue of Lucius Caesar.

Head of Claudius.

Cuirassed statue of Hadrian (Rolley, Salviat, "Une Statue d'Hadrian sur l'Agora de Thasos," *BCH* 87 [1963] 548–578; *Deltion* 18 [1963] 259).

Cuirassed torso of Hadrianic style, possibly reused for a portrait of Caracalla.

Head of Julianus II, no. 937.

THEBES (Greece), Museum

Marble copy of Nero's speech at Isthmia in A.D. 67, from Akraiphnion.

Statue of Hadrian, headless.

Large marble *imago clypeata* of a Roman emperor wearing a cuirass with big, archaistic Gorgoneion and a baldric, paludamentum over left shoulder. The head with wreath was made separately, was doweled in, and is now missing. The sculpture is very like the tondo of Marcus Aurelius at Eleusis, but the work seems earlier. Probably Hadrian was represented.

Head of Faustina II.

THERA, Museum

Bust of Augustus, or of an imperator of 45 to 30 B.C.

Head of Lucius Caesar, the young Claudius or a private person.

Head of Hadrian.

TIVOLI, Villa Hadriana (Sculptures are on the site or in the Casino Fede.)

Caryatids (comparison).

Statues of Amazons after Pheidias and Polykleitos (comparison).

Helmeted warrior (comparison).

Hermes (comparison).

Fragment of a statue of Virtus or, more likely, a geographical personification.

TOLEDO (Ohio), Toledo Museum of Art

Silver cup, with Dionysiac motifs, probably from Asia Minor (61.9; *Museum News,*

The Toledo Museum of Art, vol. 5 [1962] p. 54).

TORONTO, Royal Ontario Museum of Art
Head of Germanicus, from Lower Egypt.

TOULOUSE, Museum
Head of Carus.

TRIESTE, Museum
Relief with Caligula, and Germania personified, from Kula in eastern Lydia.

VAISON
Theater (comparison).

VENICE, Private Collection
Flavian torso, from the Peloponnesus.

VENICE, San Marco
Tetrarchs, porphyry, from Constantinople.

VERRIA (Macedonia), Museum
Head of Claudius(?).
Head of Septimius Severus(?).

VIENNA, Kunsthistorisches Museum
Silver dish from Aquileia.
Gemma Augustea (comparison).
Head of Hadrian.
Reliefs from the Antonine altar at Ephesus.
Head of Constantine the Great, as Caesar and from Ephesus; ca. A.D. 306 (Delbrueck, *Spätantike Kaiserporträts*, pp. 110f., pl. 26).

VOLOS, Museum
Head of Faustina II.

WINNETKA (Illinois), James Alsdorf Collection
Head of Commodus, said to be from Beirut.

ZURICH-LUCERNE, Art Market (1959)
Head of Hadrian, colossal (Ars Antiqua A.G., Antike Kunstwerke, Auktion I, 2 May 1959, no. 40) (*see* above, under ANTALYA and MILETUS).

ZURICH, Art Market (1963), London (1967)
Bronze head of the young Caracalla, from the Antalya region. *See* above, under HOUSTON.

Appendix C

WORKS OF ART AND INSCRIPTIONS BY SITE

This appendix is not intended to be a topographical bibliography or a corpus of inscriptions. The monuments included give a comprehensive survey of Roman Republican and imperial art in the Greek world. Since the chapters are arranged by topic or by imperial eras, many facts and conclusions are restated in this index under the city with which they are associated. In this way Roman art can be assessed by region as well as chronologically. Within each city, the indexing is roughly chronological, or by city-area.

The ancient names of cities or regions are given in block capitals; modern or later names are given in lower case and in parenthesis. There is no consistency in the Romanization of Turkish names; I have given them as the topographers, epigraphers, or travelers wrote them down, the systems of 1880 to 1920 obviously being different from those of the modern Turkish nation. Romanization of Greek names follow what seems most sensible in the light of frequent modern usage.

The topographical system is roughly that of B. V. Head's *Historia Numorum*, area by area clockwise around the Mediterranean and alphabetically by city within each region or province. The second volume of D. Magie, *Roman Rule in Asia Minor*, comprises nearly a thousand, solidly printed pages of notes; where reference is made to a page of these notes, it is indication that further reading on historical questions and bibliography will be found there.

THE MAINLAND OF GREECE

MACEDONIA

AMPHIPOLIS (near Provista)

Lucius Tarius Rufus, Procurator of the Tenth Legion, builds a bridge in the name of Tiberius (*ArchEph* 1932, Chronika, 3).

Column, with dedication in Greek by the City, in the names of Septimius Severus, Caracalla, and Geta, A.D. 209 (*BCH* 85 [1961] 168).

Statue of Caracalla, from the City, ca. A.D. 198 to 211 (*ArchEph* 1932, Chronika, 2, fig. 1).

DIUM (Colonia Iulia Augusta Dium) (Malathria)

Tablet, A.D. 101, in the name of Trajan, a boundary stone on the slope of Mount Olympus (*CIL*, III, 1, no. 591).

DRAMA

Colossal head of Caracalla (Collart, *Philippes*, pp. 515f.).

HERACLEIA AD LYNKESTIS (LYNCENSIS) (Bitola)

Statue, and perhaps a monumental arch, at the time of a probable visit by Septimius Severus in 202 (F. Papazoglou, "Septimia Aurelia Heraclea," *BCH* 85 [1961] 162-175).

Statue of a magistrate or man of learning, wearing a himation and holding a scroll; this has been reerected on its pedestal in the agora. Near him is the headless statue of a young lady as Persephone.

NEAPOLIS (Cavalla)

Milestone in Latin to Septimius Severus and Caracalla, 198 to 201 (*BCH* 47 [1923] 80f., no. 1; *BCH* 85 [1961] 167).

PHILIPPI (near Krinides)

Ref.: Collart, *Philippes*.

Head of Gaius (rather than Lucius) Caesar (*JHS, Arch.Rep.* for 1957, 22).

Dedication in the name of Tiberius, A.D. 36

PHILIPPI (near Krinides) (*continued*)

to 37, and of Drusus his son; the blocks were recut with the titles of Vespasian and Titus, A.D. 78 to 79 (P. Lemerle, *BCH* 58 [1934] 449–454).

Dedication (stele) to Hadrian, and another to him with Sabina as Juno (*BCH* 58 [1934] 454ff., fig. 1). See also, P. Collart, *BCH* 62 (1938) 412f., no. 4.

Dedication to Antoninus Pius, 138 (P. Lemerle, *BCH* 61 [1937] 410–412).

Temple of the deified Antoninus Pius, with a monumental Latin inscription on the architrave, in the agora; the date is early in the reign of Marcus Aurelius (P. Collart, *BCH* 56 [1932] 192–200).

A similar temple on the opposite side of the agora was probably dedicated to Faustina the Younger before 175; the base of a statue to FAVSTINAE AVGVSTAE, in the name of a priest, was found in the cella (P. Collart, *BCH* 57, [1933] 340f., no. 10).

Head of Lucius Verus, from the Neapolis Gate (J. Roger, *BCH* 62 [1938] 30, fig. 5).

Proscenium-relief from the theater: bull's head supporting a garland; masklike heads to left and right above, all in aedicula enframement (*BCH* 85 [1961] 827, fig. 2). The work seems to be early Antonine, like the orthostate blocks at Ephesus.

Arch of Kíemer: simple, Anatolian-type triumphal arch over the Via Egnatia; colonial arch, just outside the pomerium to the west (see also Picard, *Les trophées romains*, p. 244 and bibl., no. 2).

Stele commemorating a sacrifice offered in honor of Septimius Severus, Caracalla, and Julia Domna by five local cities, including Hadrianopolis (J. Roger, *BCH* 62 [1938] 37–41).

Cuirassed torso, said to be Caracalla, and perhaps connected with his projected visit of A.D. 217, canceled by his assassination (Collart, *Philippes*, pp. 515f.).

Small base honoring Victoriae Germanicae of Caracalla.

Three milestones of Caracalla, in the last months of his reign, along the Via Egnatia.

Dedication, in altar form, to Carinus, A.D. 282 to 283 (P. Collart, *BCH* 62 [1938] 414–418).

Base of a statue of Constantine the Great, as *Maximus Victor*, 324 to 337 (*BCH* 56 [1932] 209–213).

Small bronze head identified as Gratianus,

about A.D. 380, found in the agora (*BCH* 56 [1932] 360ff., pl. 20). (In Krinides; see Appendix A).

STOBI (Sirkovo)

A dedication, an altar, or statue, to Hadrian, A.D. 119 to 120 (*CIL*, III, 1, no. 629).

THESSALONICA

Refs.: Char. I. Makaronas, *Robinson Studies*, I, 380–388 (milestones; ten have survived, all late); P. Collart, *BCH* 59 (1935) 395–415 (milestones along the Via Egnatia, in the names of Trajan (2), Hadrian, Marcus Aurelius, Septimius Severus, Caracalla (4), and the junior Tetrarchs).

Gate with reliefs on the socles, left and right: Dioskouroi representing Vespasian and Titus, or Titus and Domitian(?) (L. Heuzey, H. Daumet, *Mission archéologique de Macédonie* [Paris, 1876], pl. 22 bis; Vol. I, 272f.). Traces of an inscription (VIO) suggest a Flavian dedication; in the Greek list of officials putting up the arch (inscribed on a base) is T. Flavius Sabinus.

Milestone of Trajan, A.D. 108, the fifth, on the road toward Lete; now in the rotunda of St. George: "viam a Dyrrachio usque Neapolim per provincam Macedoniam longa intermissione neglectam restituendam curavit, a Thessalonica V."

Late Hadrianic or early Antonine monumental funerary or commemorative relief, now in Istanbul: horseman with two followers rides to right, endeavoring to spear a boar beneath a snake-entwined tree. This is a Roman interpretation of a Hellenistic design, in the Pergamene style (Mendel, no. 492; L. Budde, *Belleten* 17 [1953] 475–482).

So-called Incantada (Stuart, Revett, *Antiquities of Athens*, III, pl. 13): a double-storied colonnade with the square pilasters surmounted by the high reliefs, back-to-back, as the upper order; the whole monument is a Greco-Roman, third-century alteration of a Hellenistic design.

The Arch of Galerius (K. F. Kinch, *L'Arc de triomphe de Salonique* [Paris, 1890]; H. von Schoenebeck, "Die zyklische Ordnung der Triumphalreliefs am Galeriusbogen im Saloniki," *BZ* 37 [1937] 361–371).

Arch from a building (nymphaeum?) in the Palace of Galerius: medallion portraits of Galerius and the Tyche of Thessalonica.

Milestone successively inscribed to the three combinations of Tetrarchs from 284–286 to 305–306; it was the first on the road toward

Lete and is now in the Museum of Thessalonica.

Ninth milestone, found on the road to Pella, in the name of Constantine the Great, Licinius, and their families; now in the Louvre, Paris.

Pulpit, in Istanbul, ca. 500 to 550: the "Grand Ambon de Salonique" (Mendel, *Catalogue*, no. 643). The scenes, in niches of the type used for elaborate Asiatic sarcophagi, include the Magi's search for Christ, a shepherd, and the Adoration of the Virgin, enthroned with Christ Child, by the Magi coming from left and right. The sculptural tradition is that of the Arch of Galerius; this ambon is one of the latest documents of three-dimensional triumphal art in the Greek East.

ILLYRIA — MACEDONIA

LYCHNIDOS (Ochrida)

Stele to Septimius Severus and Caracalla (*BCH* 85 [1961] 168), along the Via Egnatia. (*See also* under MACEDONIA, AMPHIPOLIS.)

EPIRUS

APOLLONIA (Pojani)

High relief of Nike carrying a trophy over her left shoulder, Hellenistic period; now in the Louvre, Paris.

NICOPOLIS

Ref.: J. Gagé, "Actiaca," *MélRome* 53 (1936) 37–100; Picard, *Les trophées romains*, pp. 253ff.

Commemorative monument built by Augustus at the point where his tent overlooked his camp and the action with Anthony. (Augustus) ". . . urbem Nicopolim apud Actium condidit . . . et ampliato vetere Apollinis templo, locum castrorum, quibus fuerat usus, exornatum navalibus spoliis, Neptuno ac Marti consecravit" (Suetonius, *Augustus*, 18).

Statue of Apollo above captive prows: circular, trophylike structure in porticoed temenos; monumental, commemorative inscription on the trophy.

Bronze prow from Actium, found in 1839 off Preveza (W. M. Leake, *Trans Royal Soc Lit* 1 [1843] 246–253).

Altar to Augustus, from the Aigeroi (Aegae, later Edessa, the old capital of Macedonia) and probably with a statue: *Ergon* 1961, 118.

CORCYRA

Statue base of Agrippa.

AENUS (Enez)

Mutilated inscription to the whole Severan family, including Caracalla's wife Plautilla, found near the town and evidently the third milestone (*IGRR*, I, no. 828).

Statue of Tranquillina, from the Boule and Demos (*IGRR*, I, no. 827).

ANCHIALUS, on the Black Sea

Statue of Caracalla, A.D. 211 to 213, from the Boule and Demos of Ulpia Anchiala, through Flavius Claudianus.

AQUAE CALIDAE (Burgaski bani, Bulgaria)

Dedication, in Latin and Greek, to Hadrian and dated A.D. 124, in the name of Q. Tineius Rufus, the Legatus (*IGRR*, I, no. 770; *CIL*, III, no. 14207).

AUGUSTA TRAJANA (Eski Zaghra or Stara Zagora)

Ref.: *IGRR*, I.

Dedication to Commodus, evidently an altar, A.D. 187 (no. 745).

Milestone in the names of Septimius Severus, Caracalla, and Geta, A.D. 199 to 210 (no. 741).

Dedication in the names of Septimius Severus and Caracalla, in connection with a shrine to Sabazios, A.D. 202 (no. 744).

No. 746 is evidently an altar to Septimius Severus, and no. 747, found in a neighboring village, repeats the dedication.

Dedication to Septimius Severus, Caracalla, and Julia Domna (no. 748).

Altar to Caracalla (no. 749), and another very like it (no. 750).

Dedication to Julia Domna (no. 751); the last seven all name local officials.

Statue base to Severus Alexander, with a damnatio (no. 752).

Milestone to Severus Alexander, with a damnatio, now at Akbunar (no. 753). No. 754 seems to be a votive in the name of Alexander.

Dedication, perhaps an altar, to Maximinus Thrax (no. 755).

Altar or similar dedication to Gordian III (no. 756).

Dedication to Philip the Arab and Otacilia Severa (no. 757).

Dedication to Philip I, Philip II, and Otacilia Severa, A.D. 247 to 249 (no. 758).

Dedication to Gallienus, seemingly in connection with a statue (no. 759).

BYZANTIUM — CONSTANTINOPOLIS
(Istanbul)

A.D. 300 to 400

Column in the Seraglio Gardens, usually attributed to Claudius II, although ascribed by some to Constantine I and others to Theodosius I (C. Mango, *AJA* 55 [1951] 62). S. Eyice (*Istanbul* [Istanbul, 1955], p. 8) suggests that, if it commemorates Constantine the Great's victories, it ought to have been erected around 332.

Relief, an Eastern barbarian kneeling, hands bound, before a small trophy (Mendel, *Catalogue*, no. 695); this dates shortly after the founding of the city.

High relief of Victoria running to the left, with wreath or garland in her right hand and palm in the left; first set up about 325 and then set into the walls probably in Byzantine times (Mendel, *Catalogue*, no. 667; Wegner, *Istanbuler Forschungen* 17 [1950] 159f., pl. 65).

Twice-lifesized head of Constantinus Magnus, a late Eastern type, widely disseminated and probably from a cuirassed statue. Formerly set on the statue that is Mendel, no. 1107, this head is probably from Constantinople rather than Crete (Canea, as given in the old records) (N. Fıratlı, *A short guide to the Byzantine works of art in the Archaeological Museum of Istanbul* [Istanbul, 1955], p. 43, pl. 1; *idem*, *Istanbul Arkeoloji Müzeleri Yıllığı* 7 [1956] 75–78, figs. 24ff.).

Column of Theodosius I, erected after 386 and destroyed in 1517; it stood in the Theodosian Forum which included a monumental triumphal arch (J. Kollwitz, *Oströmische Plastik der theodosianischen Zeit* [Berlin, 1941], pp. 3ff.; S. Eyice, *Istanbuler Mitteilungen* 8 [1958] 144–147, pl. 36). A fragment shows four soldiers moving to the left.

Base of the Obelisk of Theodosius I, showing Theodosius enthroned amid his family and court, presiding at receptions and games; erected about 390 in the Hippodrome (Kollwitz, *Oströmische Pastik*, pp. 115ff.; G. Bruns, *Obelisk* [Berlin, 1935]).

The Golden Gate, a freestanding arch of Theodosius I, later built into the land walls; the façade of the propylaea reused older reliefs and had reliefs of arms and armor possibly carved for the occasion (*AA* 1929, 338f., fig. 10; B. Meyer, *Mnemosynon Th. Wiegand* [Munich, 1938], pp. 87–99).

Triumphal Gate of Theodosius I, on the main street and with water channels on either side (*AA* 1929, 332ff., figs. 3f.).

A.D. 400 to 500

Column of Arcadius, begun about 402 and completed about 421 by Theodosius II with a statue of his father wearing a crown or crowning him; the base and the lower part of the shaft survive (G. Q. Giglioli, *La colonna di Arcadio* [Naples, 1952]). The column stood, until shortly after 1730, in the Forum of Arcadius.

Egyptian recumbent sphinx from near the column; probably brought by Theodosius with the obelisk of Tothmes III about 390 (Mendel, *Catalogue*, no. 1136).

Head of Arcadius, found near the west wall of the Forum Tauri, one hundred meters north of the Column of Theodosius; dated about A.D. 395 to 400 N. Fıratlı, *AJA* 55 [1951] 67–71; N. Fıratlı, *Istanbul Arkeoloji Müzeleri Yıllığı* 4 [1950] 10f., fig. 1; *idem*, *Belleten* 16 [1952] 17–20, pls. Vf.).

Base of a statue of Eudoxia, found in 1848 on the site of the Augustaion and now in the garden of St. Sophia, A.D. 403 or later (*CIG*, no. 8614; *CIL*, III, no. 736; Dessau, no. 822).

Column of Theodosius II: the massive base, now in the garden of St. Sophia (no. 3907), bears a mutilated inscription in Latin (C. Mango, *AJA* 55 [1951] 66; R. Demangel, *Contribution à la topographie de l'Hebdomon* [Paris, 1945], p. 35ff.).

Column of Marcianus, A.D. 450 to 457, with a scene on the base of Victoriae holding a wreath with cross, crown encircling a shield with cross tressée, and Victoriae holding a wreath. The pedestal on top of the Corinthian capital at the top had reliefs of eagles at the corners (Delbrueck, *Spätantike Kaiserporträts*, p. 224 and bibliography; *RA* 14 [1902] part II, 1ff., fig. 1).

Base of a statue of the charioteer Porphyrios, once in the Hippodrome, later in the atrium of St. Irene, and now in the Archaeological Museum. It supported a bronze statue of Porphyrios standing on foot, holding his palm, and probably with one of his horses beside him, as on Late Antique contorniates. On two sides, Porphyrios is seen in his chariot, holding wreath and palm, with spectators below. On the third side, Porphyrios appears in a frontal quadriga, with Erotes to right and left below and Victoriae above. In the predella of this side, two charioteers exchange teams. On the fourth side Porphyrios stands in racing cos-

424

tume, with wreath and palm; Erotes at the upper left and right hold his cap and whip. The date is about 490 to 510, a perpetuation of the Theodosian style (Dalton, *East Christian Art* [Oxford, 1925], p. 193; A. J. B. Wace, A. M. Woodward, in W. George, *The Church of St. Eirene at Constantinople*, 1912, Appendix, p. 79). Another such statue base of Porphyrios was discovered in 1962 in the second court of the Topkapi Saray (N. Fıratlı, A. N. Rollas, *Yıllığı* 11–12 [1964] 199–206; *AJA* 69 [1965] 149).

Double-faced dais or parapet relief, found at Yedikule; Mendel (*Catalogue*, no. 1317) dates the work in the sixth century A.D. Five persons are standing, facing, and wearing himations; they hold scrolls in their left hands. The reverse, with decorative patterns, may be later.

Section of historical or Early Christian relief: five Senators or Apostles move to the right, the two on the left holding scrolls. The style recalls the Tetrarch Base in the Forum Romanum, but the date is in the fifth century A.D. (N. Fıratlı, *Yıllığı* 5 [1952] 60ff.).

CALLIPOLIS (Gallipoli or Gelibolu)

Statue of Hadrian, A.D. 124 (*IGRR*, I, no. 814).

Didymoteichon (PLOTINOPOLIS?)

Gold bust identified as Marcus Aurelius.

HADRIANOPOLIS (Edirne)

Gregorovius, *Hadrian*, pp. 356f.: on the founding of cities in Thrace, Macedonia, Illyria, Pontus, Bithynia, Lycia, Caria, and Paphlagonia.

Milestone dedicated to Severus Alexander and Julia Mamaea (*IGRR*, I, no. 772), found near the city and with the imperial names effaced.

HERACLEIA-PERINTHUS (Erekli)

Domitian, A.D. 88 to 90 (*IGRR*, I, no. 781), an altar to a local Zeus, in the names of Q. Vettidius Bassus, Procurator, and other officials.

Matidia, a statue of Trajan's niece, from the Boule and the Demos (no. 783).

Statue of Hadrian, A.D. 126 (no. 784). In the years 129 to 138 he receives a shrine and statues; Sabina is included as Nea Demeter (no. 785).

Dedication to Antoninus Pius (*CIL*, III, 1, no. 730).

A statue of Septimius Severus is erected by the Boule and the Demos after an imperial visit (*IGRR*, I, no. 786; Magie, p. 1550).

Lengthy dedication to Septimius Severus and Caracalla, A.D. 196 to 198, from the worshipers of Dionysos (*IGRR*, I, no. 787).

Statue of Traianus Decius, from the city of Perinthus, 249 to 251 (no. 788).

Statue to Diocletian, from Heracleia, 293 to 305 (no. 789).

Statue to Maximianus, designed to accompany the previous (no. 790).

Statue to Galerius, with the previous two (no. 791).

Statue to Constantius, with the previous three (no. 792). One Domitius Domninus was the official involved in all four instances.

MARONEIA

Statue of Hadrian, from the Demos (*IGRR*, I, no. 830).

MESEMBRIA, on the Black Sea (Nesebăr)

Undated inscription records a dedication of statues of Claudius, Hermes, and Herakles by Gnaeus (*AE* 1928, 150; *Rozpravy*, 74 [1928] 44f.).

PAUTALIA (Kjustendil)

Milestone in the name of Elagabalus (*IGRR*, I, no. 670).

Milestone in the name of Severus Alexander, from Rutilius Crispinus, who held various imperial offices (*IGRR*, I, no. 669).

Altar to Gordian III (*IGRR*, I, no. 672), found on the road to Serdica.

Rescript of Gordian III, in the portico of the Trajanic baths (no. 674).

PHILIPPOPOLIS (Plovdiv)

Ref.: *IGRR*, I: a number of these inscriptions have been found in small villages in the vicinity.

Dedication probably to Trajan, from Tiberius Claudius Polemarchus, Archiereus (no. 708).

Boundary-marker between Cortocopius and Rhodopeidos, in the name of Antoninus Pius (no. 709).

Dedication to Marcus Aurelius and Lucius Verus, A.D. 163 to 166 (no. 710), which may have involved construction of a gate and a shrine.

Bilingual inscription to Marcus Aurelius, A.D. 172 (no. 712), concerning repair or building of the city's walls through the Legatus C. Pantuleius Graptiacus.

Statue dedicated in the name of the Legatus and the chief Archon to Commodus (no. 713).

425

PHILIPPOPOLIS (Plovdiv) (*continued*)

Four inscriptions honor Septimius Severus (nos. 702, 714, 715, 716), the last three seeming to be milestones.

Two inscriptions honor Caracalla (nos. 702, 717). The second was a dedication, probably an altar, from the guild of tanners or leather-merchants.

A lavish inscription commemorates Caracalla and Julia Domna (no. 718), mentioning their houses, shrines, and the Roman people.

Two inscriptions to Severus Alexander (no. 719 and, probably, no. 720).

Lavish inscription to Balbinus (no. 722), an altar with a decree.

One inscription honors Gordian III and his wife Tranquillina (no. 723), and there are two milestones of the emperor alone (nos. 724, 725).

PIZUS

Lengthy dedication and lists of citizens, in the name of all the Severans, A.D. 202 (*IGRR*, I, no. 766).

PLOTINOPOLIS(?). *See* Didymoteichon

Dedication to Valerian Jr., 256 to 258 (C. Vatin, *BCH* 90 [1966] 240f., no. I).

SELYMBRIA (Silivri)

Dedication in the name of Maximinus Thrax and Maximus Caesar (*IGRR*, I, no. 778).

Altar to Gordian III and inscribed rescript from him.

SERDICA (Sofia)

Ref.: *IGRR*, I.

Statue of Antoninus Pius, from the Boule and the Demos in 144 (no. 683).

Milestone of Marcus Aurelius or Caracalla (no. 685), on the road to Philippopolis.

Milestone of Elagabalus (no. 687), on the same road and with damnatio.

Milestone of Alexander Severus (no. 688), with the same formula and also erased.

Statue of Cornelia (Julia) Paula, Augusta, wife of Elagabalus (no. 689).

Milestone in the names of Maximinus and Maximus Caesar (no. 691).

Milestone, presumably as the previous, although the emperor's name has disappeared (no. 692).

Milestone of Gordian III (no. 694), on the road to Philippopolis.

Milestone of Philippus I and Otacilia Severa (no. 695).

Milestone of Gallienus on the same road (no. 696); as Valerian as Augustus(?) also is mentioned, the date must be 253 to 260.

Statue of Salonina (no. 697), from three locals.

SESTUS

Agrippa crossed the Hellespont here on his way to the East, and the Demos erected statues of him and of Julia (*IGRR*, I, no. 821; Magie, p. 1339). The date was probably 16 to 13 B.C.; the statues were on one block (*AJA* 50 [1946] 390, no. 1).

<p align="center">THESSALY</p>

DEMETRIAS

Marble statue of Julius Caesar erected on a Doric column capital which originally supported a bronze statue of Caelius, a tribune active against Caesar before Pharsalia; Caesar's statue was set up shortly after the victory (Raubitschek, *JRS* 44 [1954] 66, no. (I)).

HYPATA or Aeniania

The city dedicated a group of statues on a single base: Augustus, Gaius, and Lucius Caesars; no date is indicated (*SIG*, no. 778; *AJA* 50 [1946] 392). There were also statues of Germanicus and Drusus Junior as sons of Tiberius (*CIG*, I, 5, no. 1774).

LARISSA

Statue base, perhaps to Marcus Aurelius, used in the wall of the Castro. The inscription is in Greek.

MAGNETES (the people of the Magnesian Peninsula; *see* DEMETRIAS)

Statue base to Septimius Severus, from the Koinon Magneton; the statue stood on a separate (marble?) plinth (Volos Museum, no. E 684).

<p align="center">AETOLIA</p>

THERMON

There was an exedra with seven large blocks, statue bases, to Ptolemy III Euergetes (246–221 B.C.) and his whole family. This monument, dating between 224 and 221, was a prototype for many such structures and dedications in the Greek world under the emperors (See *IG*, IX, Ed. Min. 1, 1, no. 56).

BOEOTIA

CHAERONEIA

Statue of Macrinus, A.D. 217 to 218 (*CIG*, I, 5, no. 1620).

CORONEIA

Statue of Claudius, set up by the cities of Central Greece (*IG*, VII, no. 2878).

Statue of Hadrian, from the Boule and the Demos (*CIG*, I, 5, no. 1615); another inscription hails him as Divus, in connection with an altar and possibly a statue (no. 1616).

Altar to Antoninus Pius, A.D. 140 (no. 1617).

LEBADEIA (Livadia)

Statue of Drusus Junior, A.D. 14 to 23, with base reused (*IG*, VII, no. 3103).

Statue to Trajan, probably bronze, by the city, A.D. 98 to 102 (J. Jannoray, *BCH* 64–65 [1940–41] 36–59; *AJA* 51 [1947] 319).

Statue of Hadrian, by the city, A.D. 118 (*BCH* 64–65 [1940–41] 57f.).

Dedication to and possibly a statue of Saloninus, son of Gallienus (*CIG*, I, 5, no. 1621).

Statue of Constantius Chlorus, A.D. 293 to 305, and 305 to 306; base reused at Hosios Loukas (C. Vatin, *BCH* 90 [1966] 246f.).

TANAGRA

Round base to Augustus (*IG*, VII, no. 569).

THEBES

Ref.: *CIG*, I, 5.

Statue of Claudius (no. 1610, after Cyriac).

Statue of Domitian as Caesar (no. 1611).

Statue of Titus, as Divus and after his death (no. 1612).

Hadrian(?), honored as patron and benefactor (no. 1623).

The city dedicated a big statue of Caracalla, with full titles (no. 1619).

Statue of Claudius II, 268 to 270, from the city (no. 1622).

THESPIAE (including the nearby Sanctuary of the Muses)

Ref.: A. Plassart, *BCH* 50 (1926) 446–458.

Statue of Julius Caesar, probably 46 B.C. (*IG*, VII, no. 1835; Raubitschek, *JRS* 44 [1954] 70f.).

Statue of Augustus, 30 to 27 B.C. (*IG*, VII, no. 1836).

Livia(?) is honored in an epigram of Honestus, as compeer of the Muses (W. Peek, *Geras An-*

toniou Keramopoullou [Athens, 1953], pp. 631ff.).

Curved base-blocks at the sanctuary have inscriptions belonging to statues of Agrippa and Agrippina (one stone), Julia, Gaius, Lucius, and (perhaps) Livia, between 16 and 13 B.C. (*BCH* 50 [1926] 447ff.; *AJA* 50 [1946] 390, no. 3).

Statue of Tiberius, just before the death of Augustus (no. 1837).

Bronze statue of Britannicus, son of Claudius (*BCH* 50 [1926] 451f., no. 90).

Statue of Hadrian as benefactor and founder, from the city (*CIG*, I, 5, no. 1614).

Statue of Commodus as Caesar, before A.D. 177, on two blocks and dedicated by the city (*BCH* 50 [1926] 453, no. 94).

Altar of Septimius Severus (no. 1618).

Statue of Gordianus III, from the city; inscription carved on an older imperial base (*BCH* 50 [1926] 453f., no. 95).

Base of a statue of Gallienus, A.D. 253–268, reused in 286 to 305 for Maximianus by inscribing right side (*BCH* 50 [1926] 454f., nos. 96, 98).

Base of a statue of Numerianus, A.D. 283 to 284, a reused stele with two proxeny decrees on another face (*BCH* 50 [1926] 454, no. 97).

Statue of Constantine the Great, on a reused base (*BCH* 50 [1926] 455, no. 99). A dedication to the family of Constantine comprised a group of statues set on the semicircular blocks of an exedra (455ff.).

Base to Valentinian and Valens (*BCH* 50 [1926] 457).

THISBE

Statue of Trajan (*CIG*, I, 5, no. 1613).

EUBOEA

CHALCIS

Dedication, probably a statue, to Gaius Caesar, with the name in the nominative and as son of Augustus (*IG*, XII, 9, no. 940).

Two fragments of Diocletian's edict concerning prices have been found on Euboea (see *JHS* 72 [1952] 106).

PHOCIS

AMBRYSUS (Distomo)

Statue of Trajan, from the Boule and the Demos (*CIG*, I, 6, no. 1734).

Statue of Commodus, as a Divus, from the city

AMBRYSUS (Distomo) (*continued*)

and officials, evidently set up in the time of his "brother" Septimius Severus (no. 1736).

Dedication to and, evidently, a statue of Severus Alexander (no. 1737).

DELPHI

Refs.: J. Bousquet, "Athènes et Auguste. Inscriptions de Delphes," *BCH* 85 (1961) 88–90; C. Vatin, *BCH* 86 (1962) 229–241: fourth-century emperors.

Frieze from the monument to Aemilius Paullus, about 150 B.C. (*Berytus* 13 [1959] 14, B 3; P. Levêque, *RA* 1949, part II, 633ff.).

Base, perhaps for a portrait herm, dedicated to Augustus after 12 B.C., from the Athenian Demos and all the Greeks. Delphi was evidently a cult center for the worship of Augustus.

Portrait inscriptions of Lucius, perhaps Gaius, Julia (mother), and Agrippina Senior (before A.D. 5), evidently all belonging together and before 13 B.C. (*SIG*, no. 779; *AJA* 50 [1946] 390, no. 4).

Column to Drusilla, Caligula's sister, after her death in A.D. 38 (J. Jannoray, *BCH* 60 [1936] 382–385).

Dedication to Nero, a statue from the Amphictyons (J. Jannoray, *BCH* 60 [1936] 374–381).

Domitian restored the temple of Apollo in A.D. 84, and a giant Latin inscription in the museum commemorates the event in majestic prose:

IMP.CAESAR.DIVI.VESPASIANI.F.DOMITIANVS
AVG.GERMANICVS.PONT.MAXIM.TRIB.POTEST
III.P.P.IMP.VII.COS.X.DES.XI
TEMPLVM.APOLLONIS.SVA.INPENSA.REFECIT

Dedication to Nerva, a statue set up by the city in the heroon west of the sanctuary (*BCH* 76 [1952] 625ff.).

In the center of the Roman paved portico, before the entrance to the sanctuary, there is a statue base to Trajan and another to Hadrian. (See *CIG*, I, 6, no. 1713: statue of Hadrian.)

Statue of Carus, A.D. 282 to 284, from the sacred city of Delphi (*CIG*, I, 6, no. 1714: after Cyriac of Ancona). It was rediscovered in 1935 (J. Jannoray, *BCH* 70 [1946] 259f.).

Two bases in honor of Constantine the Great. The first (now lost) was near the portico of the Athenians; the second (no. 897) was found east of the temple. Both have dedications from the city; the inscriptions are late in his reign,

when the sons of Constantine are called "kings."

Base to Constans, A.D. 337 to 340. See also above, under Carus; a dedication on the same base, between 333 and 337. The base with dedication as Augustus was first used for Vibullius Polydeukion.

Base to Valentinian and Valens, a large block which supported two statues in bronze. These statues were standing together, perhaps in the fraternal embrace of the porphyry Tetrarchs at Saint Mark's in Venice. The city again took credit for the statues (Vatin, p. 328, figs. 4f.; no. 7714).

ELATEIA

Statue of Caracalla, from the Boule and the Demos (*CIG*, I, 6, no. 1735).

TITHOREAE

Statue of Nerva, A.D. 98, from various officials (*CIG*, I, 6, no. 1733).

ATTICA

Conspectus of Imperial Inscriptions in Attica as a whole (based on *IG*, III, 1, and *IG*, II–III, Ed. Min. 3, 1, nos. 3222–3422). (Some inscriptions were found on the Athenian Acropolis, but whether they were placed there in Antiquity or brought later as building material is difficult to tell.) Augustus, 18. Livia, 2. Julia, 1. Drusus Senior, 1. Drusus Junior, 12. Antonia, 3. Gaius Caesar, 1. Lucius Caesar, 2 (1 a base for a stone statue, perhaps as a small boy; *AJA* 50 [1946] 397). Tiberius, 11. Germanicus, 3. Caligula, 1 (with praenomen erased). Claudius, 16 (including 4 building inscriptions). Nero, 2 (including 1 damnatio). Vespasian, 2 (1 as Theos). Domitian, with his father, 1. Domitian, alone, 2 (1 as Zeus Eleutherios). Nerva, 5 (as Theos). Trajan, 15 (including 1 on the Acropolis). Hadrian, over 90. Antoninus Pius, 17. Marcus Aurelius, with Lucius Verus, 4. Marcus Aurelius, alone, 3 (2 being later than Verus). Commodus, 7 (1 damnatio and 2 as Theos). Septimius Severus, 5 (including one with Caracalla and one with Caracalla and Geta). Geta, 1 (alone and damnatio). Elagabalus, 1. (Six Roman emperors were Athenian citizens; Caracalla and Elagabalus, or Severus Alexander, appear to be in the Attalid prytany-lists; *Hesperia* 20 [1952] 65, 346ff.). Maximinus and Maximus Caesar, 1. Diocletian and Maximianus, 4. Constantius and Galerius, 1. Valentinianus and

Valens, 1 (on a rectangular column at Daphne). Theodosius and family, 1. Arcadius, 1. Honorius, 1.

AMPHIAREION

Half-draped statue of a man which may belong to the Lysimachus base or to one of the bases to Roman Republican generals, in the museum.

Inscribed base to Agrippa (U. Kahrstedt, *Das wirtschaftliche Gesicht Griechenlands in der Kaiserzeit: Kleinstadt, Villa und Domäne* [Bern, 1954], p. 59).

Fragments of a cuirassed statue; the marine scenes suggest Agrippa (*Berytus* 13 [1959] 34, no. 15), and the statue could belong with the previous base (*Berytus* 15 [1964] 98, no. 15).

ATHENS

Refs.: Hill, *Athens*; *IG*, III, 1 (totals of inscriptions are for Attica as a whole).

JULIUS CAESAR AND AUGUSTUS

Statue of Julius Caesar in the agora, just after Pharsalus (no. 428; Raubitschek, *JRS* 54 [1944] 65f., no. (F)).

Colossal statue of Caesar, holding a spear; associated with his visit in the autumn of 47 B.C. and with the donation of the Roman agora (Raubitschek, 68f.).

Anthony as Neos Dionysos, in 39 to 38 B.C. (Raubitschek, *TAPA* 77 [1946] 146f.).

Base of a statue of Augustus as Founder (no. 430; see also *IG*, II–III, Ed. Min., no. 3226).

Base of a double statue of or dedication to Augustus and Tiberius (no. 431).

Statue of Marcus Agrippa, died 12 B.C., on the pillar at the entrance of the Acropolis, by the Demos.

Agora, Odeon (*Guide*, 1954, pp. 59ff.). The odeon was built about 15 B.C., as a gift from Agrippa; it was rebuilt in the second century (about A.D. 150), and then used for lectures rather than concerts. It was destroyed in the Herulian raid of 267. The Gymnasium, using the Antonine giants and tritons in the façade, was built about 400.

Agora, foundations of a Roman trophy(?), in the south corner (*JHS* 72 [1952] 102f.).

Roman honorary columns, late Republican to early Augustan; none are of emperors (A. A. Rapprecht, Jr., ASCS *Papers*, 1957, no. 3; cf. IONIA, CLAROS, where L. Robert reports a complete column supporting the statue of the Governor Sextus Appuleius, 8.60 meters high, with four drums and a Corinthian capital.). The agora also honored a legate of Augustus and/or Tiberius (*JHS* 75 [1955] 131 and bibl.).

Temple of Roma and Augustus, on the Acropolis, a round temple on a square base, dedicated after 27 B.C. (*IG*, II², no. 3173; Bodnar, *Cyriacus*, p. 37, no. 2; *Mostra Augustea della Romanità, Catalogo*, p. 168, Sala XV, no. 14, pl. XLIII, reconstruction).

The Roman agora of Augustus had a gate dedicated to Athena Archegetis, erected by the people from gifts made to them by Julius Caesar and Augustus. The inscription relating this is on the pediment of the west portico. The base remained of an equestrian(?) statue of Lucius Caesar, carried out before A.D. 2, which stood above the pediment (no. 445; Hill, *Athens*, 206; *Hesperia* 28 [1959] 85). The complex thus became a kind of Kaisareion. The statue, which could equally have shown him seated, was dedicated by the Demos; a statue of Gaius could have stood nearby, perhaps over the inner façade of the same gate (*AJA* 50 [1946] 397; see also *IG*, II–III, Ed. Min. 3, 1, nos. 3175, 3251).

A tablet in the Asklepeion contained a dedication to Asklepios and Hygeia and Augustus, 9 to 8 B.C. (*IG*, II–III, Ed. Min. 3, 1, no. 3176).

A base near the portico of the Roman agora held a statue apparently of Julia Augusta (Livia), as Providentia (Stuart, Revett, *The Antiquities of Athens*, I [London, 1772], p. 2; *IG*, III, 1, no. 461). The base of a statue of Livia as Salus was found east of the Propylaea (no. 460).

Seat in the Theater of Dionysos for "priestess of Hestia on the Acropolis and of Livia and Julia" (*IG*, II², no. 5096; *Hesperia* 30 [1961] 186ff.).

Near the Theater of Dionysos a statue base, set up by the Demos, honored Gaius Caesar as the new Ares (no. 444; Bodnar, *Cyriacus*, p. 40, no. 111; M. and E. Levensohn, *Hesperia* 16 [1947] 68f.). He may have been represented as the Ares Borghese, without helmet; the statue probably commemorates the capture of Artagira.

JULIO-CLAUDIAN

Pergamene monument, in front of the Stoa of Attalus, probably originally to Attalus, was rededicated to Tiberius, divine honors having been offered to him near the beginning of his reign (E. Vanderpool, *Hesperia* 28 [1959]

JULIO-CLAUDIAN (*continued*)

86–90). Five statues to him were put up before his adoption, and one was erected to the west of the Parthenon with other Julio-Claudians after his adoption.

Epistyle in the Asklepeion, with a dedication to Asklepios and Hygeia for the welfare and health of Tiberius as Augustus (*IG*, II–III, Ed. Min. 3, 1, no. 3181).

Monument resembling the Ara Pietatis Augustae set to the right of the Propylaea and below the south bastion of the Acropolis.

Group of statues of Augustus, Germanicus, Drusus Junior, and Tiberius, set up near the Parthenon (*IG*, III, 1, nos. 447–450). They stood in a row, with Drusus Junior on the left end, Tiberius and Augustus in the middle, and Germanicus on the right end.

Pair of bases, one reused to honor Germanicus in A.D. 18, when he visited Athens. The equestrian statue or pair of statues was by Lykios, son of Myron; the other reused statue must have represented Drusus Junior (A. E. Raubitschek, *Dedications from the Athenian Akropolis* [Cambridge, 1949], 146ff., under no. 135, esp. 149ff.; W. Judeich, *Topographie von Athen* [Munich, 1931], 99, 229, note 1).

The base of a statue of Drusus son of Tiberius has been found near the Erechtheum (*IG*, III, 1, no. 443). There was also a statue and an altar to Germanicus Caesar (nos. 452, 453).

A building inscription or base to Claudius was found west of the Parthenon (*IG*, III, 1, no. 385), and another was unearthed in or near the Theater of Dionysos (no. 338).

A bronze statue of Claudius as Apollo Patroos was made by Euboulides and dedicated by Dionysodorus (Stuart, Revett, p. 57; *IG*, III, 1, no. 456; *IG*, II–III², no. 3274). The over-lifesized wreathed head of an emperor found in the agora (Harrison, 27f., no. 17) may be Claudius and may go with the Apollo Patroos body also found there, making an imperial marble after the fourth-century original by Euphranor. There was another statue of Claudius below the Acropolis (no. 457), and yet a third in the city (no. 458). The metroon or a building nearby had a dedication in the name of the imperial family and the city (see also *IG*, II–III, Ed. Min. 3, 1, no. 3184).

Dedication to Nero inscribed on the eastern architrave of the Parthenon (*IG*, II–III, Ed. Min. 3, 1, no. 3277). His name also appears on a column found nearby (*IG*, III, 1, no. 440), and another column recorded a dedica-tion from the Demos and Council of the Areopagus (no. 439).

Epistyle in or near the Theater of Dionysos, to Dionysos Eleutherios and Nero, A.D. 66, in connection with "Liberty of Greece" and enlarging of the theater (*IG*, II–III, Ed. Min. 3, 1, no. 3182).

TRAJANIC

Statue base to Trajan, found on the Acropolis, east of the Parthenon (*IG*, III, 1, no. 462).

Library of Pantainos, dedicated to Athena Polias and to Trajan and to the city, by T. Flavius Pantainos (R. E. Wycherley, *Agora*, III [Princeton, 1957], no. 464).

Monument to Caius Julius Antiochus Philopappos, with statues of the deceased and of Antiochus IV of Commagene; also with a scene of the deceased in the *processus consularis* of A.D. 100 (*Annuario* 3–4 [1941–43] 154–253).

HADRIANIC

Temple of the Olympian Zeus. There was a row of statues of Hadrian, dedicated by various cities, inside and along the north peribolus wall; the area was known with good reason as "Hadrian's Palace" in the Middle Ages (Bodnar, *Cyriacus*, pp. 39f.; Gregorovius, *Hadrian*, pp. 362f.; L. Bevier, *Papers* ASCS 1 [1882–83] 208ff.; P. Graindor, *Athènes sous Hadrian* [Cairo, 1934]; *IG*, III, 1, nos. 471–486; recent excavations: Vanderpool, *AJA* 64 [1960] 268). Cyriac of Ancona copied eight of these bases, none of which seems to have survived. Magie (p. 1478, note 27) gives a list of the thirteen Asiatic cities of which records have been taken; and lists (note 28) the Anatolian cities honoring Hadrian as Olympius. A statue of Augustus was also moved to or commissioned for the precinct (no. 436).

A statue base of Hadrian in the Theater of Dionysos has him as Archon under Trajan, in A.D. 112 (no. 464).

Bilingual statue base of Hadrian, with a dedication from Alexandria Troas in A.D. 132, TRP XVI COS III RESTITVTORI COLONIAE SVAE TROADENSES, now lying in the middle of Hadrian's Library.

Gate of Hadrian, between "his city and that of Theseus."

Statue of Sabina, in the agora (no. 525).

Head of Aelius Caesar, of heroic size, perhaps carved in A.D. 162 or 163, when Lucius Verus visited Athens (Harrison, no. 28; *idem, Ancient*

Portraits from the Athenian Agora [Princeton, 1960], no. 13).

ANTONINE

Inscription to Antoninus Pius at the entrance to the reservoir on the slope of Lycabettus, the part to the left of the arcuated lintel being preserved in the Royal Gardens (Stuart, Revett, III, 1794, pp. 27ff.; Bodnar, *Cyriacus*, pp. 128f., 133, 138, 185; *CIL*, III, no. 549).

Small building of the Agoranomion in the Roman agora was dedicated to Antoninus Pius; the arches of the loggia stand south of the Tower of the Winds, with a dedication to Athena Archegetis and the *Sebastoi Theoi* (*IG*, II–III, Ed. Min. 3, 1, no. 3183). A large arch of Hymettos marble, near the gate of Athena Archegetis, records a dedication of the Agoranomion to Antoninus Pius by the Boule (Hill, *Athens*, p. 207).

Statue of Antoninus Pius, A.D. 140, near the Theater of Dionysos (no. 529); this was perhaps in connection with the honors paid him for his building programs.

Columns and entablature of a small building, in the Royal Gardens, dedicated in the name of Antoninus Pius rather than Marcus Aurelius (*IG*, III, 1, no. 391). The date would be A.D. 145 rather than 154 (*Speculum* 37 [1962] 264).

Colossal head of Lucius Verus, found in the Theater of Dionysos.

Documents (letters, decrees, and commemorations) mark Commodus' interest in Athens and his willingness to hold offices therein (A. E. Raubitschek, *Hesperia* Suppl. VIII, 1949, 279–290).

SEVERAN AND LATER

Roman military relief, with phalerae and wreaths, second or third century A.D., walled up in the Little Metropolitan. (A similar monument, a cippus, is in the garden of the Archaeological Museum in Istanbul.)

Dedication to Agatha Tyche, in the name of Septimius Severus, Caracalla, and Geta, found below the temple of Nike (no. 536).

Column, near the odeon of Herodes Atticus, to Maximinus Thrax and Maximus, A.D. 235 to 238 (no. 538).

So-called head of Diocletian, in the National Museum (L'Orange, *Spätantiken Porträts*, p. 103, cat. no. 53, figs. 98, 99).

DAPHNE

Rectangular column used three times: to an emperor, now damned; to Valentinian and Valens; and to Arcadius and Honorius, in Latin (*IG*, III, 1, nos. 405–407). In the Latin inscription the Procurator was Eusebius (*CIL*, III, no. 572).

ELEUSIS

Late Hellenistic relief dedicated to the Eleusinian gods and goddesses by Lakrateides (B. Grossman, "The Eleusinian Gods and Heroes in Greek Art," Ph.D. thesis, Saint Louis, 1959, pp. 334ff.; Kourouniotes, *Eleusis*, pp. 80ff.).

Inner Propylaea of Appius Claudius Pulcher, 40 B.C.

Inscribed statue-base to Tiberius (*IG*, III, 1, no. 454).

Togate statues of Tiberius and the young Nero, the latter perhaps recut as a portrait of Constantine the Great or one of his sons.

Fragmentary head of Hadrian.

Cuirassed bust, with thunderbolt on the strap, perhaps Hadrian and perhaps from a tondo three-fifths the size of the bust of Marcus Aurelius (see below). There were two Hadrianic triumphal "arches" to the left and right of the Great Propylaea.

Head, from a small statue and perhaps Antoninus Pius, early in his reign, on the occasion of his initiation (?).

Bust of Marcus Aurelius, in tympanum of Outer or Great Propylaea (*AM* 62 [1937] 73–81; *Istanbuler Mitteilungen* 7 [1957] 11–55, especially 26).

Bases to Diva Faustina and Diva Sabina (*IG*, II², no. 2958; cf. *Hesperia* 3 [1934] 193, note 1; *JHS* 42 [1922] 178f.).

Base to *Theos Antoninos*. There was a statue of Marcus Aurelius, A.D. 172 (*IG*, III, 1, no. 534).

Altar to Septimius Severus (*JHS* 6 [1885] 148f.). There was also a base evidently for statues of Severus and Julia Domna (*IG*, III, 1, no. 537).

Large imperial inscription (date?) in front of the temple (*IG*, III, 1, no. 389).

KEPHISSIA

Shaft of a herm of Polydeukes, found in the ruins of a church and now in Oxford, Ashmolean Museum (*CIG*, no. 989; A. Michaelis, *Ancient Marbles in Great Britain* [Cambridge, 1882], p. 583, no. 177). Herodes Atticus had a large estate ("villa") at Kephissia (U. Kahrstedt, *Das wirtschaftliche Gesicht Griechenlands* [Bern, 1954], pp. 54f.).

KEPHISSIA (*continued*)

Busts of Herodes and Polydeukion, and an arm of Memnon, found in 1961 in a garden shrine of the estate (*AJA* 65 [1961] 299, pl. 97).

MARATHON

Marble trophy, statue of Kimon, statue of Miltiades, and figure of a Persian captive, perhaps of the Roman period (Picard, *Les trophées romains*, pp. 49f.). A fragment of the ensemble is in the British Museum (A. J. Reinach, "Trophées," in Daremberg-Saglio, *Dictionnaire des antiquités*, IX, 503, note 8). This is a late Hellenistic or early imperial support for a statue and may not come from Marathon (E. Vanderpool, *Hesperia* 36 [1967] 108–110, pl. 31).

The estate of Herodes Atticus, like the Villa Hadriana, had busts of Verus (now in Oxford), Marcus Aurelius (Louvre), and Herodes Atticus (Louvre) (*Hesperia* 5 [1936] 221).

PRASIAE (or Porto Raphti)

Colossal marble statue on the island in the mouth of the harbor: a late Hadrianic, early Antonine beacon-light in the form of Oikoumene seated (*Hesperia* 31 [1962] 62–81). Bronze replica found nearby (*see* GENEVA, Art Market). Now (1968), New York, M. Komor.

RHAMNOUS

Dedicatory inscription to the deified Livia on the east epistyle of the temple of Nemesis, with mention of Augustus Caesar and the priest of the goddess Roma. Livia died in A.D. 29 and was deified by Claudius in 42 (W. B. Dinsmoor, *Hesperia* 30 [1961] 186ff.; *IG*, II–III, Ed. Min. 3, 1, no. 3242).

Altar to Claudius (*IG*, III, 1, no. 459). There may have been a statue in this connection, a suggestion inherent in the form of the dedication.

AEGINA

Refs.: *IG*, IV; G. Welter, *Aigina* (Berlin, 1938).

Statue of Lucius Verus, A.D. 164 (*IG*, IV, no. 15).

Statue, most likely of Commodus, from the Boule and the Demos (no. 16).

Statue of Caracalla, as emperor (no. 17); in the eighteenth century the base was being used as a mooring block for boats.

At the temple of Aphrodite, statue(?) of Philippus I, with that of one Nicostratus, from the Boule and the Demos (no. 19).

MEGARA

Refs.: *IG*, VII; *CIG*, I, 3.

Statue of Julius Caesar, shortly after Pharsalia (*IG*, VII, no. 62; Raubitschek, *JRS* 44 [1954] 67, no. (L)).

Statue in the name of Octavius (*CIG*, I, 3, no. 1069).

Statue of Augustus as Apollo (*IG*, VII, no. 36).

Statue of Augustus, between 30 and 27 B.C. (no. 63).

Double dedication to Agrippa and Julia or, less likely, Livia (nos. 64, 65), probably 16 to 13 B.C. and from the Boule, and the Demos (*AJA* 50 [1946] 390, no. 2).

Statue of Livia, after Augustus' death (no. 66); dedication to Livia (Julia) from the Boule and the Demos in connection with the Megarian Apollo (*CIG*, I, 3, no. 1070).

Statue of Tiberius (*IG*, VII, no. 195).

Inscription honoring Claudius, A.D. 47 (*IG*, VII, no. 67).

Base to Nero, son of Claudius (no. 68; see *CIG*, III, 1, no. 1071).

Hadrian restored the temple of Apollo at Megara and widened the road over the Isthmus (Gregorovius, *Hadrian*, p. 364). There was a statue base to Hadrian as Olympian and Panhellene from Megara as "the city of Hadrian" (*CIG*, I, 3, no. 1072). The same officials, including Julius Canditus with Proconsular powers, were responsible for a statue of Sabina as Nea Demeter (no. 1073). There were other honorary inscriptions to Sabina (nos. 73, 74; Robert, *REA* 62 [1960] 291).

Double statue base to Marcus Aurelius and Lucius Verus, with identical genealogical inscriptions, from the Boule and the Demos in the name of an official (no. 1074).

Statue base of Caracalla, A.D. 198 or later, with full titles and with Julia Domna as Mater "Stratopedon," dedicated by the city of Megara (no. 1075).

AEGOSTHENA

Statue of Constantine the Great, A.D. 313 to 314 (C. Vatin, *BCH* 90 [1966] 242ff.).

Statue of Constantinus II as Emperor, A.D. 337 to 340, from the city (A. K. Orlandos, *Praktika* 1954, 141f.; C. Vatin, *BCH* 90 [1966] 242f.).

CORINTH

Refs.: *Corinth*, VIII, Part 1, *Greek Inscriptions, 1896–1927.* Part 2, *Latin Inscriptions, 1896–1926.* Part 3: *Corinth*, VIII, Part 3, *The Inscriptions 1926–1950*, by J. H. Kent (Princeton, 1966).

Head of Julius Caesar.

Statue of, or altar to, the Deified Julius Caesar, in the Theater (part 3, no. 50).

Augustus, Diva Julia (Livia), and Tiberius are mentioned in a reused inscription in connection with games (part 1, no. 19).

Slab, plaque, to the Deified Augustus, in the South Stoa (part 3, no. 51).

Plaque on a building in the southeast area of the agora, dedicated to the Deified Augustus by a local priest (part 3, no. 52).

Cylindrical statue base to the Deified Augustus from the Augustales, in the agora near the Bema (part 3, no. 53).

Base dedicated to Augustus (part 3, no. 69; part 2, nos. 14 and 214).

A building(?) dedicated to Livia, by her grandson the emperor Claudius in A.D. 42 (part 3, no. 55).

Dedication to Agrippa, 18 to 12 B.C., an inscription belonging to a series in his honor at the order of the local senate, by each of the city's tribes (part 2, no. 16).

Dedication, in or near the Julian Basilica, to the family of Caligula, early in A.D. 37, including Tiberius Gemellus and Antonia Augusta, perhaps in connection with Corinth's shrine to the *Gens Iulia* (part 2, no. 17). A large pedestal may have been involved.

The Julian Basilica, with imperial statues, was built about A.D. 40, with the interior colonnade rebuilt in marble in the Hadrianic period (S. S. Weinberg, *Corinth*, I, part 5 [Princeton, 1960]).

Propylaea, or triumphal-arched gateway into the agora, surmounted by gilded bronze quadrigae with Helios and Phaeton.

Slab from a monument in the southeast part of the agora is dedicated to Claudius and Britannicus by the colony, A.D. 47 to 50 (part 3, no. 77).

Dedication to Nero in the lifetime of Claudius (part 2, no. 18).

Building block, from an "important building," probably containing the name of Vespasian in A.D. 78, and perhaps in connection with im-perial help after a major earthquake (part 2, no. 20).

Monument to Trajan, probably a statue, set up A.D. 112 to 114; the inscription is in Greek (part 3, no. 99).

Plaque dedicated to Trajan by P. Cornelius Crescens, a tax official, in the southeast section of the agora (part 3, no. 100).

Dedication, evidently to Hadrian after a visit (part 2, no. 21). There was a statue of Hadrian, from the Polis, probably after the visit of 126 (part 1, no. 84).

Plaque to Hadrian, from the Achaeans, in Greek, A.D. 119 to 126 (part 3, no. 102).

Slab to Hadrian, from east of the Odeon, in Greek (part 3, no. 103).

Base with the torso of a statue of Antoninus Pius, A.D. 138, from II Vir L. Gellius Menander, recorded by Cyriac of Ancona and later in the Museo Nanio in Venice (*CIL*, III, nos. 7269, 501, the latter wrongly as PATRAE).

Statue of Faustina the Elder (part 2, no. 22). The monument was set up by the city of Corinth (part 3, no. 107, fuller reading).

The court of Peirene was remodeled by Herodes Atticus, with statues in niches. The base of Regilla's statue survives (see R. Scranton, *Corinth*, I, 3 [Princeton, 1951], 69).

Monument, a revetment slab, to Marcus Aurelius, A.D. 175 to 180, found in a Roman building south of Oakley House; in Greek (part 3, no. 110).

Faustina II, pendant inscription to the previous (part 3, no. 109).

Façade with supports in the form of Parthian captives and personifications; this has always been called Antonine (A.D. 165 or later) but may be Severan, just after A.D. 200 (*Corinth*, I, 2, pp. 55ff.; IX, pp. 101ff.).

Two temples of the time of Commodus, dating A.D. 185 and 190, on the west terrace of the lower agora, built by Cornelia Baebia. One may have been dedicated to Poseidon; the dedication of the other is uncertain (R. Scranton, *Hesperia* 13 [1944] 315–348).

Bronze statue of Trebonianus Gallus, A.D. 251 to 253, probably 252, in the Central Shops east of the Bema; in Greek (part 3, no. 116).

Statue, probably of Gallienus, the base found west of the temple of Apollo; in Greek (part 3, no. 117).

Statue, perhaps of a private citizen and perhaps reused as a monument to Claudius Gothicus (268–270) or Aurelian (270–275); found near

433

CORINTH (*continued*)

the Central Shops, in a late series of rebuildings; in Greek (part 3, no. 118).

Dedication (revetment) to Diocletian, found in pieces in the region of the northwest stoa (part 2, no. 23). There were accompanying dedications to Galerius Caesar, A.D. 293 to 305 (nos. 24, 25).

Dedication to Valentinian (*SEG*, XI, nos. 127, 128).

Near the northwest stoa there was a flowery dedication to Theodosius, A.D. 393 to 395, with Arcadius and Honorius as Augusti. This was shortly before the sack of the city by Alaric (part 2, no. 26).

ISTHMIA

Statues of Nero and of Dionysos stood in the theater (O. Broneer, *Hesperia* 31 [1962] 8f.).

Neronian(?) relief of a standing man, perhaps a votive by one of the builders of the abortive canal, is cut in the rock along the canal's face.

Hadrian built baths and an aqueduct which carried water from Lake Stymphalus (Gregorovius, *Hadrian*, p. 364).

ACHAIA

DYME (Kato Achaia), a Roman colony.

Dedication to Octavius (Augustus) as IMP CAESARI DIVI F, found with a statue in armor (torso and part of one arm) (*CIL*, III, no. 7255; *BCH* 2 [1878] 100; *AM* 3 [1878] 74). This is perhaps the torso now in the Patras Museum as "from Achaia" (*Berytus* 13 [1959] 40, no. 50, pl. VII, fig. 22; *Berytus* 15 [1964] 100, no. 50). If this is so, the two statues (nos. 49, 50) in the group may have been part of a series made for Octavian between 31 and 27 B.C., or the dedication at Dyme may be Julio-Claudian, despite the absence of the title AVGVSTVS on the base found with it.

PATRAE

Dedication to Antoninus Pius, from L. Gellius Menander (*CIL*, III, no. 501, Addendum), who also set up a statue at Corinth, unless there is a duplication (*see* above).

Dedication to the Tetrarchs (*CIL*, III, no. 502).

Dedication to Valentinian and Valens, with perhaps a building in the imperial honor (*CIG*, no. 1558, copied from Cyriac of Ancona and therefore also perhaps a confusion with inscriptions copied at CORINTH).

OLYMPIA

Refs.: *Olympia, V, Die Inschriften von Olympia*, ed. W. Dittenberger, K. Purgold (Berlin, 1896): "Römische Kaiser mit ihren Familien," pp. 478ff.; building inscriptions, pp. 663ff.; P. V. Hill, "The Temple of Zeus Olympios on Augustan Coins," *NumCirc* 68 (1960) 23f.

Inscription honoring Caesar, from the roof of the temple of Zeus (no. 365).

Plaque in pavonazetto (marble) to Marcus Agrippa, commemorates repairs to the temple of Zeus, about 27 B.C. (no. 913).

Inscription to Augustus (no. 366), possibly an architrave block of the metroon.

Statue base to Augustus, from the east front of the temple of Zeus (no. 367).

Large base to Tiberius, Nero Drusus, Drusus Junior, and Germanicus (no. 369).

Statues of Tiberius (nos. 370, 371).

Base to Germanicus and Drusus Junior, A.D. 14 to 19 (no. 372).

Statue of Claudius as Zeus, from the metroon.

Monument to Nero as Princeps Iuventutis, A.D. 50 to 54 (no. 373).

Statue base to Nero as emperor (no. 375).

Latin inscription to Nero, A.D. 67 (no. 915), from a commemorative structure, with a fountain basin.

Plaque to Vespasian (no. 376). Wegner, *Die Flavier*, p. 77, calls this a statue base and identifies it with the Heraion.

Cuirassed statue of Titus, from the metroon (*Berytus* 13 [1959] no. 86).

Plaque to Domitian (no. 377).

Draped statue of Julia, daughter of Titus, from the metroon.

Plaque to Trajan, A.D. 103 to 114 (no. 378).

Plaques to Hadrian (nos. 379, 380).

Building inscription of Antoninus Pius (no. 654), and in A.D. 153 his name appears on a marble tile from the temple of Zeus (no. 655).

Statue of Faustina I or II, A.D. 138(?) (no. 382).

Exedra of Herodes Atticus: fourteen members of Herodes' family were honored with statues by the Eleans. Members of the imperial family included Trajan, Hadrian, Sabina, Antoninus Pius, Faustina I, Marcus Aurelius Caesar, Faustina II, their two children, and Lucius Verus.

Statue of Caracalla, A.D. 211 or 213 to 215 (no. 386).

A statue of Julia Domna was set up during the lifetime of Septimius Severus at the east front of the temple of Zeus (no. 387).

MESSENIA

ABIA (or ABEA) (Ira)
Cippus to Hadrian in connection with the cult of Jove (*IG*, V, 1, no. 1352). There was perhaps a statue of Hadrian as Zeus (*CIG*, I, 4, no. 1307).

ASINE (Koroni)
Statue of Germanicus (*IG*, V, 1, no. 1411), recorded in the church of St. Demetrius in modern Corone. The dedication reads, "To Germanicus Caesar, from the City."

Fragment of Diocletian's edict on prices.

CORONE (Petalidion)
Statue(?) of Agrippina, wife of Germanicus, set up by one Ias. Philokratos in the name of Caligula after A.D. 37 (*IG*, V, 1, no. 1394). The deceased is, naturally, named as mother of Caligula.

Base for a small statue of Septimius Severus, A.D. 193 to 195, from an official of the region (no. 1412).

Columnar milestone, A.D. 323 to 326, in the names of Constantinus Magnus, Crispus, Constantinus II, and Constantius (presumably the Second) (no. 1420).

LIMNAE, The shrine of Artemis (near Kalamai)
Fragments of an epistyle with an imperial dedication (*IG*, V, 1, no. 1373).

MESSENE
Sebasteion, consisting of two long halls between a staircase attached to the north side of the agora; an inscription names it (*BCH* 85 [1961] 697–702; see also *IG*, V, 1, no. 1462).

Altar to Augustus and Tiberius, A.D. 4 to 14 (*IG*, V, 1, no. 1448), including a stele in a columned aedicula.

Base for a statue of Nero (no. 1449), A.D. 54 to 68, with his genealogy given in the titles; the statue was dedicated on behalf of the city by the chief priest and priest of Roma, and so on.

Base for a bronze statue of Nero (no. 1450), set up near the "Klepsydra" fountain and also from the priests.

Bronze statue to Marcus Aurelius Caesar, A.D. 139 to 161 (no. 1451), from a well-known official of the Achaean League.

Statue of Lucius Verus, A.D. 164, from two Latins or, more likely, a Latin and a Greek, the former an important official in the Peloponnesus (*CIL*, III, no. 495).

Plaque to Septimius Severus, A.D. 197 to 198, from the City; Caracalla was not yet emperor (no. 1452).

PHERAE (Kalamata)
Dedication to Divus Augustus, Tiberius, and family, A.D. 30 to 31 (*IG*, V, 1, no. 1359); it was reused for the Price Edict of Diocletian.

Epistle from Marcus Aurelius and Commodus (name erased), A.D. 177 to 180, concerning a dispute between PHERAE and SPARTA.

THURIA
There are imperial coins from Severus to Geta.

Base for a statue of Trajan, A.D. 102 to 114, with enriched moldings (*IG*, V, 1, no. 1381). The statue was dedicated from the city to the savior of Sparta, through a local official; the base was used much later as an altar in the church of St. George at Aslagana.

Milestone, number XI, of Diocletianus and Maximianus (his name erased), A.D. 286 to 305 (no. 1382).

LACONIA

ASOPUS
There are imperial coins from Severus to Geta.

Base of a statue of Trajan, from the Polis; now in Oxford (*IG*, V, 1, no. 968).

Dedication to Constantius Chlorus, in Oxford (no. 969).

GYTHIUM, The port of Sparta
A decree regulated the conduct of the imperial cult (*JHS* 75 [1955] 134).

Dedication to Castor and Pollux, DOMVS AVGVSTI DISPENSATOR DEDIT ET DEDICAVIT (*CIL*, III, no. 493).

Base to Augustus, set up against the wall of the theater (*IG*, V, 1, no. 1160).

Statue of Agrippa, 18 to 12 B.C., from the City and in honor of his naval exploits (no. 1166).

Inscription of Tiberius declining divine honors. (See under the list in J. R. Rietra, C. *Suetoni Tranquilli Vita Tiberi neu kommentiert* [Amsterdam, 1928], pp. 13ff.) There was a Kaisareion in his time (*PBSR* 26 [1958] 177f.).

GYTHIUM, the port of Sparta (*continued*)

Statue of Nerva, from the (Free) Laconian League (*IG*, V, 1, no. 1161).

Statue of Trajan, A.D. 98 to 102, from the Polis of Gythium (no. 1162).

Statue(?) of Caracalla, from a large group, in the name of the Polis (no. 1163).

OETYLUS

Statue of Gordianus III, A.D. 238 to 240, from the city of BEITULEON (*IG*, V, 1, no. 1294; *CIG*, I, 4, no. 1323).

SPARTA

Refs.: *CIG*, I, 4; A. M. Woodward, "Sparta and Asia Minor under the Roman Empire," *Robinson Studies*, II, 868–883.

Temple of Divus Augustus and Lacedemonia, with Corinthian columns (*CIG*, I, 4, no. 1298).

Marble arula to Augustus, found next to the theater (*IG*, V, 1, no. 373).

Stele or base to Agrippa (no. 374; also *CIG*, I, 4, no. 1299, and *CIL*, III, no. 494).

Statue of Lucius Caesar, dedicated by the city. Gaius was also present, and fragments of both oversized statues, which stood near the stage of the theater, were found (*BSA* 26 [1923–1925] 205f.).

Statue of Germanicus (the inscription being restored after Muratori), an offering from the Polis (no. 375; *CIG*, I, 4, no. 1300).

Possible statue of Nero (*IG*, V, 1, no. 376); this base is perhaps too small to have held a statue and may, therefore, be an altar.

Letter from Vespasian to the Lacedemonians in A.D. 78 (*CIG*, I, 4, no. 1305). Vespasian was also responsible for a building, of unknown type.

Base of a statue of Trajan, A.D. 115; this large dedication, with information about the setting up of the statue, was brought to Venice (*IG*, V, 1, no. 380; *CIG*, I, 4, no. 1306).

Altar to Hadrian, A.D. 125, found near the acropolis (J. Bingen, *BCH* 77 [1953] 642ff.) and dedicated by a local patrician. There were at least twenty-seven other altars, cippi, or bases to Hadrian there (644, note 1; see also *IG*, V, 1, nos. 381–405); a dedication to him was made in connection with the baths (no. 406; *CIG*, I, 4, nos. 1310, 1312).

Numerous tablets and dedications incorporated the names of the Antonine emperors (nos. 407–445).

Statue of Antoninus Pius, A.D. 147 (no. 446).

Round altar to Marcus Aurelius and Lucius Verus as the New Dioskouroi (no. 447; *CIG*, I, 4, no. 1316).

Statue of Caracalla as Caesar, set up by local officials in 197 to 198, on the eve of his being named Augustus (no. 448).

Bronze statue of a lady of about A.D. 220; she wears chiton and himation and raises both hands, palms outwards, in the *Orans* or "Pietas" pose. The excavator has suggested that she is Julia Mamaea (*Ergon* 1964, 102ff., esp. fig. 133); the face has been pushed in, and restoration should prove whether or not she is a lady of the later Severan house. The statue was found at the juncture of two walls in a roofed hall of the agora.

Statue of Gordian III, from the City (*CIG*, I, 4, no. 1322).

Milestone of Florianus, A.D. 275 to 276, inscribed in Greek (no. 449). (*See also* under ARCADIA, TEGEA.)

Honorary column to Constantius Chlorus (no. 450).

Dedication to members of the family of Constantine, mentioning Augusti (*CIG*, I, 4, no. 1324).

TAENARUM or TAENARON, also called CAENEPOLIS, with the shrine of Poseidon on the promontory. (Kyparissia)

Dedication to Agrippa(?) (*CIL*, III, no. 491).

Round base, a cippus or an altar, to Marcus Aurelius, A.D. 166 to 169 (*IG*, V, 1, no. 1237). Connected with this is a rectangular base, of dark-blue stone, for a statue (no. 1238).

Statue of Lucius Verus, possibly set up after his death in 169 and evidently designed to match the previous (no. 1239).

"Column" dedicated to Caracalla, A.D. 213 to 217 (no. 1240).

Dark-blue stone base, with moldings, presumably for a statue of Gordian III, 238 to 244 (no. 1241).

THALAMAE

Marble base, with enriched moldings and holes on the top for two statues; these were of Caracalla and Geta, A.D. 209 to 212, with the latter's name erased (*IG*, V, 1, no. 1318, recorded in a nearby town).

ARCADIA

KLEITOR

Stele in honor of Polybius, after 146 B.C.

LYCOSURA

Statue of, or dedication to, Claudius or Nero in the temple of Despina (*IG*, V, 2, no. 532).

Base of a statue of Trajan, A.D. 115 to 117, from the pronaos of the shrine, an offering from the city of MEGALOPOLIS; the dedication, and presumably the statue, were changed to honor Hadrian (no. 533).

MANTINEIA

Temple to Antinous (Gregorovius, *Hadrian*, p. 365). Hadrian also dedicated a monument to Epaminondas, with an inscription written by himself, and he encased the original wooden temple of Poseidon Hippios in a new building. A statue of Hadrian was put up in 125 to 128 by the magistrate of the shrine, one A. Maikios Phaidros (*IG*, V, 2, no. 302).

Statue of Lucius Verus, A.D. 165 to 169, from the city of Mantineia (at Tegea?: *IG*, V, 2, no. 303, in the Tegea Museum).

MEGALOPOLIS

A bilingual inscription to Augustus, on one of the bridges (*pontem fecit*) over the Alpheus, also mentions pasturage rights (on imperial land?) and baths (*CIL*, III, no. 496; *IG*, V, 2, no. 456).

Domitian restored a portico after a fire in A.D. 93 or 94; this generosity is commemorated in a *tabula ansata* with splendid Latin and Greek letters, a dedication from the city of Megalopolis; it is now in the museum there. The emperor's name has suffered erasure (*CIL*, III, suppl. no. 13, 691; *IG*, V, 2, no. 457).

Milestone E, in Latin, dedicated A.D. 116 or 117 in the name of Trajan (*IG*, V, 2, no. 458, in the museum).

Epistyle in the name of Commodus or Elagabalus, reused in a bridge (*IG*, V, 2, no. 459); the restoration of the letters fits either emperor.

ORCHOMENUS

A local official put up a statue of Septimius Severus, in A.D. 192 to 193, when the emperor was conquering in the East; it is in the name of the city. Septimius Severus gave the rights of local coinage back to the cities of this region (*IG*, V, 2, no. 346).

TEGEA

Statue of Augustus (*IG*, V, 2, no. 25).

Altar to Livia, after A.D. 14 (*IG*, V, 2, no. 301); on one side a bull's head between two olive branches.

Tablet with a dedication to Claudius in 49 or 50 (*CIL*, III, no. 7251).

Hadrian, as Panhellene, put up baths and a stoa (*IG*, V, 2, no. 127); this commemoration was recorded in a church wall (*CIG*, I, 4, no. 1521).

A herm, dedicated to Antoninus Pius and dated A.D. 150 to 151 in the Actian era, also refers to Hadrian in A.D. 124 to 125 (*IG*, V, 2, no. 51, in the museum).

Statue of Antoninus Pius as savior and founder of the world, from the city of Tegea (*IG*, V, 2, no. 130, base recorded near Tripolis).

Base for a statue of Antoninus Pius, from the Boule of Tegea; it was reused upside-down for a private dedication to an important priest and official of the time of Caracalla and Geta (*IG*, V, 2, no. 132). Was the statue reused too?

Statue of Marcus Aurelius, on a molded base, from the city of Tegea in A.D. 161 to 163/4 (*IG*, V, 2, no. 133).

Base, presumably for a statue, of Maximinus, in 235 to 236, from the City (*IG*, V, 2, no. 134, wrongly as his son Maximus; in the museum).

Milestone, dedicated to Florianus in 276, on the MEGALOPOLIS-TEGEA road, reinscribed in Latin to Probus, between 276 and 282 (*IG*, V, 2, no. 5, 132).

Statue of Diocletian (*IG*, V, 2, no. 135).

Base with remains of two statues (drawings existed): on the right, Constantinus Magnus (308–333); and on the left, Constantius Caesar (323–337) (*IG*, V, 2, nos. 136f., with discussion of confusion with Chlorus; also *CIG*, I, 4, nos. 1522, 1523).

Statue of Constantius Chlorus, 292 to 305, once in the agora (*IG*, V, 2, no. 138).

Hexagonal base to Constantinus, a statue set up before he was styled Augustus and probably a pair with the previous, 306 to 307; from the city of Tegea and in the agora (no. 139).

Base, also in the agora, with similar titles to Constans as Augustus, 337 to 350 (no. 140). Thus, it appears that the agora at Tegea was transformed into a kind of Kaisareion for the house of Constantinus Magnus.

ARGOLIS

ARGOS, including the Argive Heraeum, some distance from the city.

Statue of Titus, from the Gymnasiarch Alexander (*IG*, IV, no. 584).

437

ARGOS (*continued*)

Statue (?) of Trajan, an inscribed fragment from the Heraeum (*IG*, IV, no. 534); he is also mentioned in an inscription to athletes (nos. 602–604).

Fragments of a statue base of Hadrian from the Heraeum, A.D. 123 (Amandry, *Hesperia* 21 [1952] 219–221, pl. 60, 7), and the fragment from the ASCS collection (Inv. ASI.8), now in the Epigraphic Museum in Athens.

Inscribed plaque in connection with the inauguration of the aqueduct, in the name of Hadrian (W. Vollgraff, *BCH* 68–69 [1944–45] 397ff., no. 8). There was also a nymphaeum (no. 7).

Similar plaque from the theater, which burned down and was rebuilt (400f., no. 9).

Base to M. Civica Barbarus, paternal uncle of Lucius Verus and, thus, brother of Aelius Caesar; found in the north parados of the theater at Argos (P. Charneux, *BCH* 81 [1957] 121–140). He was similarly honored at Olympia, probably about A.D. 170.

Section of Diocletian's edict on prices, the plaque reused as a circular base after 301 (J. Bingen, *BCH* 77 [1953] 647–659); the marble that remains exhibits a well-carved Greek text.

CLEONAE

In the locality of Volimonti, where the ruins of Cleonae are visible, there was an exedra which was probably on the site of the city's agora. The exedra bears the names and titles of Septimius Severus and Caracalla as emperors (A.D. 198–211) and may have been put up at their expense, or at the expense of an official not named. Statues of the two emperors probably stood on top of the curved blocks (M. Mitsos, *Hesperia* 18 [1949] 76, no. 8).

EPIDAURUS

Refs.: P. Cavvadias, *Fouilles d'Épidaure* (Athens, 1891), pp. 77ff.; *IG*, IV; *IG*, IV, Ed. Min. 1, nos. 593–613.

Augustus is mentioned in a dedication (*IG*, IV, no. 1431).

There was a Julio-Claudian cult center, with statues of princes in armor and imperial ladies as Hygeia. (See *Berytus* 13 [1959] 33, no. 7).

Base to Livia, in the theater (Cavvadias, nos. 214, 215; *IG*, IV, nos. 1394, 1393).

Base to Lucius Caesar (Cavvadias, no. 216; *IG*, IV, no. 1390), the inscription being cut on a reused statue base.

Bases to Drusus Senior (nos. 217, 218; *IG*, IV, nos. 1397, 1398). His cult is also mentioned (*IG*, IV, nos. 937, 938).

Statues of Tiberius (nos. 219, 220; or nos. 1396, 1399).

Dedication to Diva Drusilla, who died in A.D. 38 (no. 221; no. 1400).

Dedication to Claudius (no. 222; no. 1401), evidently a statue. He is also mentioned in a marble tablet, A.D. 45 to 46, concerning the priesthood of Apollo (*IG*, IV, no. 908).

Dedication to Messalina, in 48 (no. 223; no. 1402).

Dedication to Agrippina, wife of Claudius, from A.D. 49 to 54 (no. 224); or to Vipsania Agrippina, wife of Tiberius, from 15 to 12 B.C. (*IG*, IV, no. 1395).

Dedication to Claudius and Agrippina (no. 225; *IG*, IV, no. 1403). Agrippina the Younger appears to be mentioned also in *IG*, IV, no. 1404, a fragmentary tablet.

An altar and a dedication mention Hadrian (no. 226; *IG*, IV, nos. 1051, 1052). A base for his statue (*IG*, IV, no. 1406), 123 to 124, has an inscription to Antigonus Gonatas (about 272 B.C.) or Doson (about 222 B.C.) on the other side (*IG*, IV, no. 1419).

Marcus Aurelius and Lucius Verus are mentioned in a dedication (*IG*, IV, no. 948). There is also a letter from Marcus Aurelius, A.D. 163, at the shrine of Apollo Maleata in the mountain (*IG*, IV, no. 1534).

There were statues of Septimius Severus, Julia Domna, and Caracalla, in bronze and on a common base (*IG*, IV, no. 1157), with dedicatory tablets or plaques set about (e.g. no. 1156). A base for a statue of Caracalla, A.D. 211 to 217, was used on another side for Severus Alexander (*IG*, IV, Ed. Min., 1, no. 612).

Tranquillina, Gordian III's wife, is mentioned twice (no. 227 and no. 228?). The first, a dedication on a plaque, is also *IG*, IV, no. 1158.

HERMIONE

Refs.: *IG*, IV; *CIG*, I, 4; M. Jameson, *Hesperia* 22 (1953) 148.

Fragment of a dedication to Trajan (*IG*, IV, no. 701; *CIG*, I, 4, no. 1213).

Base of a statue to Sabina, from the city of Hermione; the block was taken to Venice in the eighteenth century (*IG*, IV, no. 702). The base had been used at least once before for a

private dedication (*CIG*, I, 4, nos. 1214, 1204, 1205).

Dedication to the children of Marcus Aurelius: Faustina and Lucilla (*IG*, IV, no. 703).

The city put up statues of Septimius Severus(?), Julia Domna (A.D. 209–212), Caracalla, and Geta. Another statue of Severus was dated late in his reign (*CIG*, I, 3, no. 1215). There was a dedication to Julia, Caracalla, and Geta, from the city (*IG*, IV, no. 704); to Caracalla and Julia (no. 706); a statue of Caracalla as emperor was commissioned in the years 211 to 213 (no. 707); and there was a statue of Geta as Caesar and Augustus (no. 705). (See also *CIG*, I, 4, nos. 1216, 1217.)

Statue(?) of Severus Alexander (no. 708), from the city (*CIG*, I, 4, no. 1218).

Dedication and possibly a statue to Aurelianus (no. 709; *CIG*, I, 4, no. 1219). The monument was damaged at a later date.

METHANA

Statue of Marcus Aurelius, probably set up in 176 when he was in Greece; the work of Publius Licinnius Ermogenes, a general of Achaia (*IG*, IV, no. 857).

NAUPLIA

Refs.: *IG*, IV; *CIG*, I, 4.

Statue of Vespasian; the base, recorded in a mosque, bears a simple Greek dedication to Vespasianus Augustus (*IG*, IV, no. 670; *CIG*, I, 4, no. 1163).

Altar to Hadrian, seen in the church (Panagias) on the small island known as Daskaleio (*IG*, IV, no. 675).

Dedication to Valentinianus and Valens (*IG*, IV, no. 674; *CIG*, I, 4, no. 1166).

TROEZEN

Refs.: *IG*, IV; *CIG*, I, 4.

Hadrian is mentioned in a lengthy inscription in connection with offices and priesthoods (*IG*, IV, no. 758, 5).

Statue of Caracalla, between 198 and 211; the base was being used as the altar-table in the church of St. George (*IG*, IV, no. 793; see also *CIG*, I, 4, no. 1185).

Statue of Carus, dedicated in the name of the city and recorded in the ruins of a church (*IG*, IV, no. 794).

The city of Troezen dedicated a statue to Galerius Valerius Maximinus (Daza) at Epidaurus(?); the inscription was carved on a reused base from Epidaurus (*IG*, IV, no. 1610

and 894). Maximinus is hailed as savior of the city.

THE GREEK ISLANDS

AMORGOS

AEGIALE

Dedication to Caligula (*IGRR*, IV, no. 1001), a statue base from the Demos (*IG*, XII, 7, no. 437).

KATAPOLA

Statue base of M. Aurelius Antoninus (Pius), beside the courtyard of the church of Ag. Panageia.

MINOA

Refs.: *IGRR*, IV, nos. 1009ff.; *IG*, XII, 7, nos. 243ff.

Possible dedication to Augustus, a fragment (no. 268).

Dedication to Claudius from the Demos (no. 1009). There was a statue base with a simple inscription (no. 243).

Dedication to Dionysos and Commodus, in a shrine with a statue of Tyche, A.D. 188 to 192 (no. 1011).

Statue of Caracalla from the Boule, A.D. 201– (no. 1012), on a round base (no. 266).

Another statue of Caracalla set up by two local officials (no. 1013; no. 267).

Letter, with a decree, from Septimius Severus and Caracalla, A.D. 208, with full genealogies and honors to them on setting out to Britain (no. 1014; no. 243).

Palliati and togati lying on the site.

Head of Germanicus and of Agrippina the Elder, now in the Syros Museum.

ANAPHE

Fragment of the base of a statue of Augustus, from the Demos of Anaphe (*IG*, XII, 2, no. 264).

Statue of Hadrian (no. 265).

Altar or dedication to Commodus (no. 266).

Small, dark marble base, with moldings, for a statue of Antoninus Pius, from the Demos (no. 267).

ANDROS

Statue of Julia as wife of Agrippa, 15 to 12 B.C., dedicated by the Demos (*IG*, XII, 5, no.

ANDROS (*continued*)

740); it was recorded near the port of Palaeopolis.

Six altars to Hadrian as Olympian, at Andros (nos. 741–746). On at least one, at Palaeopolis, he is "Savior of the Oikoumene" (*IG*, XII, suppl. no. 273).

A dedication to Hadrian was reused for Antoninus Pius(?) (no. 747).

Dedication in Latin to Septimius Severus, Caracalla, and Geta, A.D. 198 to 202 (*IG*, XII, suppl., no. 274), at Palaeopolis.

Dedication to Severina, wife of Aurelian, 270 to 275 (no. 748).

ASTYPALAEA

Refs.: *IGRR*, IV; *IG*, XII, 2.

Dedication to Augustus (*IGRR*, IV, no. 1030).

Stone with a letter from Augustus to the Cnidians, brought to Astypalaea and reused for a letter of Hadrian to the Astypalaeans (*IGRR*, IV, no. 1031).

Letter from Hadrian, A.D. 118 (no. 1032).

Letter from Hadrian, A.D. 129 (no. 1033), written from Laodiceia ad Lycum. (For these letters, on tablets or bases, see also *IG*, XII, 2, nos. 175–177; no. 206 suggests a fourth letter was written from Hadrian to the islands.)

Dedication to Hadrian, a statue(?) (no. 1034).

Statue of Marcus Aurelius, A.D. 164 to 166 (no. 1035; *IG*, XII, 2, no. 207), on a base that had been used earlier, on another side, for an inscription to a private citizen (no. 215).

Statue of Lucius Verus, set up alongside the statue of Marcus Aurelius, either at the same time or before the statue of the senior emperor was commissioned, that is, 163 to 165; the base was reused as a monument for Dominico Sigala in the Middle Ages (no. 1036).

Statue of Caracalla(?) (no. 1037; *IG*, XII, 2, no. 209).

Statue of Gordian III, from the Demos of Astypalaea (no. 1038; *IG*, XII, 2, no. 210).

CALYMNOS

Ref.: M. Segre, *Annuario* 22–23 (1944–45).

Augustus was certainly honored and is mentioned in inscriptions from the temple of the Delian Apollo (Segre, no. 69), but no statue bases are recorded.

Statue of Agrippa, as patron and benefactor (Segre, no. 141).

440

APPENDIX C. WORKS OF ART

Inscription from a statue of or a dedication to Caligula, probably in the years just before Tiberius died (*IGRR*, IV, no. 1022; Segre, no. 109), from the temple of the Delian Apollo and now in the British Museum.

Epistyle block with a dedication to Caligula and the Delian Apollo, from the people of Calymnos (Segre, no. 108).

Round base to Caligula, with divine honors; also a statue(?) (Segre, no. 143).

Statue of Claudius, on a round, marble base (no. 1023; Magie, p. 1401; Segre, no. 144). The island also put up a statue to Claudius' physician (Segre, no. 146).

CEOS

CARTHAEA, in the southeast part of the island.

Ref.: *IG*, XII, 5.

Statue of Julius Caesar, set up near the temple of Apollo shortly after his victory over Pompey (no. 556; Raubitschek, *JRS* 44 [1954] 66).

Another statue of Julius Caesar, set up on a reused base (Raubitschek, p. 66), from near the city's western (seashore) entrance or gate; the date is after his Spanish War but before his death, and he is hailed as "theos" and "savior of the universe."

IULIS, near the center of the island and famed for its archaic lion, carved in the rock above the town.

Ref.: *IG*, XII, 5.

Statue base to Pompey as savior and benefactor in 67 B.C., after the victory over the pirates; there was another dedication in Latin(?) (no. 627).

Statue base, with moldings above and below, to Livia as wife of "Imperator Caesar," 31 to 27 B.C. (no. 628).

Tablet to Augustus, found on the acropolis (no. 629).

Small base with traces of or for a statue on top: Domitian as Imperator, Caesar, Augustus, and Germanicus (no. 630).

CHIOS

Ref.: *IGRR*, IV. On the general epigraphic problems of the island, see W. G. Forrest, *BSA* 58 (1963) 53.

Statue of Julius Caesar, 48 B.C. (no. 928).

Another statue of Julius Caesar (no. 929). The two statues may have been set up at the same time, one honoring Caesar as patron of the

city and the other as savior and benefactor of all the Greeks; the second was bronze (Raubitschek, *JRS* 44 [1954] 67f.).

Statue of Drusus Junior, A.D. 14 to 23, from the Demos (no. 930).

Epistle from Domitian, A.D. 93 (no. 931).

Dedication to Trajan (no. 932).

Statue of Trajan(?), from the Gerousia (no. 933).

Statue of Lucius Verus, A.D. 162 (no. 934), set up when he was on his way to the Eastern wars (Magie, p. 1530).

Dedication to Crispina, wife of Commodus, from the People, A.D. 178 to 182 (no. 935).

COS

Refs.: *IGRR*, IV; Magie, pp. 912ff.

Letter from Tiberius, A.D. 15 (no. 1042).

TOWN OF COS

Statue of Augustus (no. 1050).

Statue of Augustus as Hermes (Magie, p. 1333). Compare the torso of a ruler, probably Augustus, as Hermes, in the Museum at Rhodes (*Berytus* 15 [1964] 98, no. 15 A).

Dedication of an altar to Augustus (no. 1051).

Kaisareion named for Gaius Caesar, and his father Agrippa (no. 1064; Magie, p. 1343).

Statue of Agrippina Junior (?) (no. 1052).

Dedication to Nero as Asklepios Caesar, by his doctor (no. 1053; Magie, p. 1422).

Statue of Caracalla with full titles, A.D. 211 to 217 (no. 1055).

Statue of Geta, 211 to 212, probably put up as a companion to the previous when both were Augusti (no. 1056).

ANTIMACHIA

Dedication to Caligula (no. 1102).

ANTIMACHIA and suburbs.

Statue of Claudius (no. 1103).

HALASARNA

Altar to Gaius Caesar, A.D. 1 to 4 (no. 1094; Magie, p. 1343).

Statue of Julia, daughter of Augustus, 17 to 13 B.C., when she was in Asia (no. 1095); this was a dedication from the Demos. One Artamidos is mentioned as being responsible for the image.

Dedication to Tyche, in the name of Tiberius Caesar (no. 1096).

Statue of Nero, with part of the inscription erased (no. 1097).

Statue of Drusilla, Caligula's sister (no. 1098); she appeared as Concordia (Magie, p. 1366).

Statue of Claudius (no. 1099).

HIPPIA

Statue of Nero Caesar, from the Demos (no. 1090).

ISTHMUS

Statue of Vespasian, A.D. 74 (no. 1105).

Two statues of Hadrian on the island suggest an imperial visit (Magie, p. 1475).

Statue of Antoninus Pius (no. 1106), perhaps as thanks for aid after an earthquake (Magie, p. 1491).

Statue of Geta, with his name erased (no. 1107).

CRETE

Refs. for Roman Crete: Pendlebury, *The Archaeology of Crete* (London, 1939), pp. 365–376; M. Guarducci, *Inscriptiones Creticae* (Rome, 1935–50) (vols. I–IV): cited as *IC*, I–IV.

APTERA

Embellished by Hadrian.

ARCADES

Shrine to the Tyche of Trajan, known from a miserable stele (*IC*, I, no. 9).

ASSI or AXI or AXOS

Statue of Tiberius (*IGRR*, I, no. 958).

CHERSONESUS

Plaque to Tiberius (*IC*, I, no. 8).

Altar to Trajan, after A.D. 102 (*IGRR*, I, no. 978).

DICTYNNAIA (*see also* CHANIA, Museum)

Two (or more) statues of Hadrian; milestone in his name (*IC*, II, no. 6).

Elaborate aqueduct.

ELEUTHERNA

Quintus Metellus entered through a breach in the walls.

Dedication to Tiberius (*IC*, II, no. 27), and cippus to the deified Augustus Caesar (*IC*, II, no. 28).

Dedication to Septimius Severus and his sons (*IC*, II, no. 29).

441

GORTYNA

Temple of the Pythian Apollo.

Dedication (epistyle fragment) to Roma and Augustus; mural-crowned head (of Roma?) found nearby and now in Heraklion Museum basement (*IC*, IV, no. 270: Latin).

Dedication to Augustus between 2 B.C. and A.D. 7 (*IGRR*, I, no. 960).

Dedication to Drusus Junior, before A.D. 14 (*IC*, IV, no. 271: Latin).

Pair of cuirassed torsos, with knotted cloak and Minerva-Victoria on right strap: *Berytus* 13 (1959) 34, nos. 16, 16A; L. Savignoni, *MonAnt* 18 (1907) col. 269, fig. 40.

Group of Julio-Claudian portraits from the agora: Tiberius, Livia, Germanicus, and Caligula. (*See* HERAKLION, Museum.)

Dedication to Iulia Augusta, in the theater (*IC*, IV, no. 273).

Statue of Hadrian (no. 964), A.D. 129, from the Koinon of Crete, in the name of T. Flavius Sulpicianus Dorion, the chief priest. Hadrian embellished the city. See also *IC*, IV, nos. 274–276, and HERAKLION, Museum.

Inscribed stele to Antoninus Pius, for a building program (*IC*, IV, no. 332).

Inscribed stele to Marcus Aurelius and Lucius Verus, A.D. 169, "sacello imperiale" for rebuilding program "ex sacris pecunis Deae Dictynnae" through Procurator Aelius Apollonius (*MonAnt* 18 [1907] pl. VI, not mentioned in text; *IC*, IV, no. 333).

Dedication to Septimius Severus, A.D. 195 (*CIL*, III, no. 4).

Statue of Septimius Severus, A.D. 210 to 211 (no. 965), in the temple of the Pythian Apollo. Statue to Caracalla, after 213, in the temple of Apollo Pythius (no. 1510). See *MontAnt* 18 (1907) 318: these seem to be on repaired columns of the temple.

Inscription to P. Septimius Geta, brother of Septimius Severus (no. 970), who held high offices in the province of Crete and Cyrene.

Dedication to Diocletian and Maximianus, 286 to 297, by Aglaus a Proconsul (*IC*, IV, no. 281, in Latin).

Statue of Maximianus, 286 to 305, near the Pythium (no. 1511): cf. the head of Maximianus as Hercules in the HERAKLION, Museum.

Galerius, 292 to 305 (no. 1512), evidently a dedication pendant to the previous. *MonAnt* 18 (1907) 354f., seems to indicate both in-

scriptions were incised on columns, that is, columnar statue bases, and they were the work of an official of Proconsular authority, one Marcus Aurelius Byzes. See also *IC*, IV, nos. 282–283.

Statues of Gratianus, Valentinianus, and Theodosius, dedicated by the Consul of Crete, Oecumenius Dositheos Asclepiodotos, between 379 and 383. There was also a stele, and they stood in or near the Praetorium (*IC*, IV, nos. 284–285).

HIERAPYTNA

Dedications to Claudius (*IGRR*, I, nos. 1013, 1014; *IC*, III, nos. 25–29).

Statue of Hadrian, in cuirass and with left foot on the back of a captive Jewish boy; Istanbul, Archaeological Museum (*AJA* 61 [1957] 232ff., esp. note 73; *Berytus* 13 [1959] 55, no. 182; Wegner, p. 98).

Statue base to Marcus Aurelius (*CIG*, II, no. 2581; *IGRR*, I, no. 1015), in the name of L. Flavius Sulpicianus Dorion (*Hesperia* 31 [1962] 80).

Pendant base to Lucius Verus (*CIG*, II, no. 2582; *IGRR*, I, no. 1016), A.D. 163 to 165. See also *IC*, III, nos. 16, 17.

Monument to Septimius Severus and his family, ca. A.D. 210 (*IC*, III, no. 19).

Greek sculpture: copy of a "Kore" type of 450 to 420 B.C.: Lippold, *Handbuch*, p. 175, note 4.

Nereid and Dolphin, associated with Timotheos (400–360); Lippold, *Handbuch*, p. 221, note 10.

Bronze statue of a Libyan(?) or Arab boy of the Augustan period (in HERAKLION, Museum).

ITANUS

Dedication to Caligula, A.D. 37 to 41 (*IC*, III, no. 19).

Double statue base to Caracalla and Septimius Severus, A.D. 201 to 210 (*IGRR*, I, no. 1022).

KANTANI (KANTANOS)

Statue or monument of some nature to Trajan at the beginning of his reign (no. 957), in the name of L. Elufrius Severus, the Proconsul (also *IC*, II, no. 2).

Dedication to Septimius Severus, the letters crudely cut (*IC*, II, no. 3).

KISAMOS (KASTELLI)

Cuirassed statue of Hadrian, in the Castello (the Apotheke below the Post Office, no. 30);

an Eastern barbarian at the right leg: *Berytus* 13 (1959) 55f., no. 187; Wegner, *Hadrian*, p. 67f., 90; Hekler, *JOAI* 19–20 (1919) 232f., fig. 161; Savignoni, *MonAnt* 11 (1901) 305ff., pl. 25, no. 1.

KNOSSOS (*Colonia Julia Nobilis*)
Basilica and agora.

Small column to Augustus (*IC*, I, no. 48: Latin).

Stele, confirming lands in name of Nero; rough work (*IC*, I, no. 49: Latin).

Statue of Hadrian, who embellished the city (*Berytus* 13 [1959] 55, no. 185). Wegner, p. 99, sees the Roma as an Amazon type, perhaps the personification of Diktynna.

KYDONIA (CHANIA or KHANIA), including the Museum.

Statue of Hadrian, wearing a cuirass (head is no. 77), mostly destroyed by fire ca. 1938, from the DICTYNNAION: Goethert, *Berytus* 2 (1935) 137, pl. 53; *ILN*, 28 June 1924, 1224f.; Wegner, *Hadrian*, p. 95. The head is cursory but strong work in island marble.

Head of Hadrian (no. 82), also from the DICTYNNAION: Wegner, p. 95 (type Chiaramonti 392). Traces of drapery behind the neck show he wore a himation; the head was crowned with a poet's or Hellenistic prince's fillet and is turned sideways, giving the emperor the dreamy look of a Greek man of intellect.

LAPPA(E)
Base of a statuette of Augustus (*IC*, II, no. 12).

Statue of Hadrian, after 129, when he became "Olympian" in Athens (no. 959), an offering from the city (*MonAnt* 18 [1907] 318).

LATO
Tablet to Augustus, from the city, ca. 27 to 12 B.C. (*IC*, I, no. 36).

LYTTUS
Refs.: *IGRR*, I; *IC*, I, nos. 15–50.

In June 1965 only two statue bases, one of Trajan (*IC*, I, no. 23) and one of Hadrian (no. 1001), could be found on the site. The first was beside the lower church, and the second was along the path to the upper.

Dedication to Claudius (no. 980).

Dedication (statue?) to Divus Titus (*IC*, I, no. 15).

Statue of Domitia, A.D. 84 (no. 981); she is mentioned as wife of Domitian, and the name of the dedicating official is lost.

Altar to Trajan, A.D. 105 (no. 982).

Statue of Trajan, A.D. 106 (no. 983).

Altar to Trajan, A.D. 107 (no. 984).

Altar to Trajan, A.D. 108 (no. 985).

Altar to Trajan, A.D. 112 (no. 986).

Statue of Trajan, dedicated with previous (*IC*, I, no. 23).

Altar to Trajan, A.D. 112/113 (no. 987).

Altars to Trajan, A.D. 112/113 (nos. 988, 989).

Statue of Trajan, A.D. 113/114 (no. 990).

Statue of Trajan, A.D. 113/114 (no. 991). This inscription is identical with the previous, which is a dedication from the city.

Statue of Plotina, A.D. 112 (no. 992). This and the four following are from the city, in the names of various magistrates.

Statue of Plotina, A.D. 112/113 (no. 993).

Statue of Plotina, A.D. 113/114 (no. 994).

Statue of Diva Marciana, no date but perhaps before A.D. 114 (no. 995) or 114 to 117 (see also *IC*, I, no. 37).

Statue of Diva Marciana, A.D. 112 (no. 996).

Statue of Matidia, A.D. 107 (no. 997), who is listed in the following two as daughter of Marciana; all three are also from the city.

Statue of Matidia, A.D. 112 (no. 998).

Statue of Matidia, A.D. 113/114 (no. 999).

Statue of Hadrian, A.D. 123 (no. 1000), who embellished the city.

Statue of Hadrian, A.D. 124 (no. 1001).

Statue of Hadrian, A.D. 125 (no. 1002).

Inscription in the name of Hadrian (no. 1003), an architectural block (*IC*, I, no. 44).

Statue of Paulina, Hadrian's sister, A.D. 125 (no. 1004). This was evidently a pendant to no. 1002.

Dedication to Antoninus Pius (no. 1005), including the name of M. Aelius Aurelius Verus Caesar, A.D. 138 to 161.

Double statue base of Septimius Severus and Julia Domna, A.D. 199 to 210 (*IC*, I, no. 47).

Statue, presumably of Caracalla (no. 1006).

OLOI (OLUS)
Altar(?) or plaque to Tiberius (*IGRR*, I, no. 1011; *IC*, I, no. 12).

Statues in Neapolis Museum: palliatus (no. 11); overlifesized woman (no. 24); both early imperial.

POLYRHENIUM

Ref.: A. X. Makridakis, *I Archaia Polis*, pamphlet, n.d. (sold in Khania).

Statue of Augustus (*IGRR*, I, no. 953), a dedication from the city; the base was originally used for a statue of Ares, King of Sparta, ca. 275 B.C. (*IC*, II, no. 12).

Aqueduct of Hadrian, with monumental inscription in Latin (*IC*, II, no. 66).

PRIANSUS

Elaborate aqueducts.

RHIZENIA? (Prinias)

Latin inscription mentioning public works under Nero (*IC*, I, no. 29).

SYIA

Elaborate aqueducts.

DELOS

Sanctuary of Apollo, other shrines, and the town.

Roman art at Delos can be said to begin with two documented, proto-imperial cuirassed statues. Mithradates was honored in 102 to 101 B.C. in the sanctuary of the Gods of Samothrace (*Berytus* 13 [1959] 32, no. 1; *AJA* 61 [1957] 228ff.). About 100 B.C. Midas, son of Zenon of Heracleia, known benefactor of the Italian colony of Delos, set up against the internal face of the east wall of the Portico of Antigone, near the middle of the wall, a statue to C. Billienus C. F., a Propraetor. He has a prow as support at his right foot. After Archelaos, Mithradates' lieutenant, sacked Delos in 88 B.C., a Roman citizen (A. Attiolenus A. F. Velina) restored the statue and had this fact recorded in Latin above the original Greek inscription (F. Courby, *Délos*, V [Paris, 1912], 41f.; *Berytus* 13 [1959] 32, no. 2).

The standing, Hellenistic, Tyche-type Roma in the cella of the Sanctuary of the Poseidoniasts of Berytus has a numismatic parallel, indicative that this was a standard cult image in the East, in the cornucopiae-bearing figure on ROM ET AVG Ephesian cistophori of Claudius (Vermeule, *Goddess Roma*, p. 103, no. 14A; Ch. Picard, *Délos* VI [Paris, 1921], pp. 7, 56ff.).

In the Agora of the Italians (E. Lapalus, *Délos*, XIX [Paris, 1939] 56f., fig. 48), in a niche with the thanks of the Italians recorded and with the artists' signatures on the base, was found the nude statue of C. Ofellius, by Dionysios and Timarchides of Athens, working in the suave Polykleitan-Praxitelean tradition of the early copyists. The niches often contained statues of rich merchants. Niche no. 68 contained a statue by Agasias son of Menophilos of Ephesus, and no. 25 reads Q. POMPEIVS. Q. F. RVF. COS. At the northeast angle of the Roman agora was found the brilliantly carved cuirassed torso of a general on horseback; this work must also be dated around 100 B.C., rather than in the early Antonine period, when the breastplate was imitated in a group of statues from the Shrine of Poseidon at Kionia on Tenos (*Berytus* 13 [1959] 60, no. 229; N. Kondoleon, *Odigos tis Dilou* [Athens, 1950], pp. 160f., fig. 91).

Like Kionia, Delos had a large statue base or altar which links Pergamon and Rome artistically. This was located at the south entrance of the Sanctuary of the Bulls. In the major fragments, a Nereid moves to the left on a sea beast; fragments of other sections in the area show crossed dolphins and marine motifs, including small prows. The design and execution are prototypes on heroic scale of the Ahenobarbus monument in Rome (K. Schefold, in *Essays in Memory of Karl Lehmann* [New York, 1964], pp. 279–287). Another fragment, with figure of a Triton, is in the British Museum (Smith, *Catalogue*, III, 272f., no. 2220, fig. 36). See, generally, J. Marcadé, *BCH* 75 (1951) 55–89, esp. 79ff., pl. XVI, suggesting the frieze (or friezes?) adorned walls.

The base inscribed in Latin to L. Cornelius Sulla, monumental in its simplicity, must belong to the period after the First Mithradatic War, 84 B.C.

Dedication to Pompey, after the pirate wars, 67 B.C. (Magie, p. 1181).

Statue of Julius Caesar, 48 B.C. (*Inscriptions de Délos*, no. 1587). This statue appears to have been set on one or more reused blocks (Raubitschek, *JRS* 44 [1954] 65, no. (B)).

Statue of Octavian, set up by the inhabitants of the island (no. 1588).

Statue of Augustus, dedicated by his physician (no. 1589; Stuart and Revett, III, ch. 10, p. 57). Another statue of Augustus stood in the cella of the temple of Apollo (no. 1591).

A statue of Julia, wife of Agrippa, was dedicated near the temple by the Athenian Demos and local inhabitants, to Apollo, Leto, and Artemis (no. 1592).

There was a round base to Agrippa in the temple of Apollo (no. 1593).

Dedication to Gaius Caesar (no. 1594).
Statue of Titus, A.D. 79 to 81 (no. 1595).
Statue of Trajan, A.D. 103– (no. 1596).

EUBOEA

Ref.: *IG*, XII, 9.

AEDEPSUS (and ISTIAIA), at the northern end of the island.

In the wall of a vineyard near the baths, statue base with traces of the feet of more than one statue on top: (A) Statue of Hadrian the Olympian as savior and founder, from the Boule and Demos of Istiaia through L. Nonius Optatos, after A.D. 129. (B) On another part of the same base, dedication to the divinity of Constantinus Augustus from the Polis of Aedepsus. The base may have been used once in the interval between (A) and (B) by the Polis of Istiaia (no. 1234).

In the same wall, statue of Septimius Severus, from the Polis of Istiaia (no. 1235).

Statues of Caracalla and Geta, A.D. 211 to 212, from the Boule and the Demos of Istiaia; Geta's name has been erased (no. 1237b).

Dedication to, or statue of, Gordian III, from the Polis of Istiaia (no. 1237a).

Dedication to, or statue of, Theodosius from the Polis of Aedepsus (no. 1236).

CARYSTUS

Fragment of a statue base to Augustus, recorded in a garden wall (no. 19).

Herm of Divus Hadrianus, with a dedication from a long list of Archons and others; now in Athens, National Museum (no. 11).

CHALCIS

Base to Tiberius, recorded by Cyriac of Ancona (no. 939).

Base to Caligula (Caius Caesar Imperator, son of Caesar Augustus) (no. 910). This appears to have been a statue designed to match the previous, and both were evidently set up before A.D. 38.

ERETRIA-AMARYNTHUS, to the east of Eretria.

Tablet or column with a dedication to Diocletian and colleagues, Maximianus Herculeus having been erased, A.D. 292 to 305, and a dedication to Constantinus Magnus and his sons as Caesars(?), resembling a milestone but not (no. 146).

ICAROS

The island was generally a possession of Samos, and the principal town was Oenoë.
Ref.: Magie, p. 892.
Samian colonists pay honors to Augustus, as Imperator Caesar (Magie, p. 1331).

IMBROS

Statue of Livia, from the Demos of Athens; the base was recorded in the Castro (*IG*, XII, 8, no. 65).

IOS

Altar to Roma and Augustus, 27 B.C. or later (*IG*, XII, 5, no. 1013).
Statue base to Marcus Aurelius Antoninus (Caracalla?), from the City (*IG*, XII, 5, no. 1*, and appendix; seemingly a genuine inscription).

KARPATHOS

BRYKOS, with the Shrine of Poseidon Pothmios.
Statue of Domitian, set on a dark marble base, with dedication from local officials and the citizens of Rhodes (*IG*, XII, 1, no. 994; *IGRR*, IV, no. 1151).
Statue of Domitia (no. 995; no. 1152). (On dedications related to these two, see Magie, p. 1428.)

POTIDAEUM

Statue of Trajan (*IGRR*, IV, no. 1153).

LESBOS

ERESUS
Refs.: *IGRR*, IV; *IG*, XII, and suppl.
Statue of Augustus (*IG*, XII, suppl., no. 128).
Letter from Augustus to the magistrates, 15 to 12 B.C. (*IGRR*, IV, no. 7; Magie, p. 1337).
Dedication to the divine Augustus (no. 8).
Bilingual dedication to, or statue of, Julia before Octavius become Augustus in 27 B.C. (no. 9). Another stone, found nearby, suggests the young girl might have been grouped and identified with Venus Genetrix (*AJA* 50 [1946] 394).
Temenos to Gaius Caesar (*IG*, XII, suppl., no. 124).
Statue of Tiberius, A.D. 16 to 18 (no. 10).
Statue of Germanicus, A.D. 18 to 19, with the name of Tiberius rubbed out of the inscription (no. 11; Magie, p. 1356).

ERESUS (*continued*)

Statue of Claudius (no. 12; Magie, p. 1401).

Dedication by priests of Claudius and "the other Sebastoi" (*IG*, XII, 2, no. 541; Stuart, *Claudius*, p. 57).

Statue of Vespasian (*IGRR*, IV, no. 14).

Statue of Trajan (no. 15).

MYTILENE

Refs.: *IG*, XII; A. Benjamin, A. Raubitschek, *Hesperia* 28 (1959) 68 (Augustan dedications); L. Robert, *REA* 62 (1960) 285ff. (Germanicus and family); Hanson, Johnson, *AJA* 50 (1946) 399 (the dedications in groups or compartments).

Altar to Pompey (*see* below; also *IG*, XII, suppl., nos. 39, 40).

Altar to Pompeius Filius (*see* below).

Statue of Augustus (*IG*, XII, suppl., no. 19).

Dedication of altars to Augustus (*IGRR*, IV, nos. 58, 59, 61, 62, 63; *IG*, XII, suppl., nos. 41–45).

Dedication to Augustus as Zeus Caesar Olympios, A.D. 2 to 14 (Magie, p. 1333; *IGRR*, IV, no. 95; *NumCirc*, Feb. 1960, 24).

Statue(?) of Julia, wife of M. Agrippa, dedicated by the Demos (*IGRR*, IV, no. 64).

Double dedication to C. and L. Caesars and Agrippa Postumus, between 12 and 5 B.C. (no. 65).

Double dedication to Gaius and Lucius Caesars (no. 66).

Dedication to Gaius, Lucius (after his death in A.D. 2), and M. Agrippa, before the death of Gaius in A.D. 4 (no. 67).

Dedication to Gaius, Lucius, and Marcus Agrippa (no. 68). For these dedications to Augustus' grandsons, see also Magie, p. 1343.

Dedication to Marcus Agrippa and Julia (?), in the blank (no. 69).

Dedication to Marcus Agrippa (no. 70). For these dedications to Agrippa and a statue, see also Magie, p. 1330.

Altar to Livia as Hera (*IG*, XII, suppl., no. 50).

Two statues of Tiberius (nos. 71, 72; see *IG*, XII, suppl., no. 59; also no. 206).

Statue of Antonia Augusta (no. 73; Magie, p. 1356).

Statue of Nero Drusus, son of Germanicus and Agrippina, died A.D. 31; Germanicus is *Theos* here (no. 74). There was also a double dedication to or statues of Nero and Drusus Caesars, about A.D. 20 to 33 (no. 75).

Statue of Caligula (no. 76); dedication to him (no. 77).

Dedication to Agrippa and Agrippa Postumus, Nero, Drusus, Agrippina, and Drusilla as Nea Aphrodite, in the name of Caligula, about A.D. 37 to 38 (no. 78).

Dedication by Caligula in the names of Pompey the Great, Gaius and Lucius, Julius Caesar, Augustus, Marcus Agrippa, and Agrippa Postumus, A.D. 37 to 41 (no. 79). This compartmented stone also contains one erased dedication and one blank plaque. Another dedication by Caligula was to Pompey Filius(?), Julius Caesar, and Gaius and Lucius Caesars (no. 80).

Letter from Claudius, between A.D. 47 and 50 (no. 43).

Statue of Agrippina the Younger, A.D. 50 or later (no. 81).

Dedication to Trajan, an ornamented altar (no. 82; *IG*, XII, suppl., no. 51); there was a second dedication (no. 52).

Altar or dedication to Hadrian as Olympian (no. 84); there were four others (nos. 85–88) (see also *IG*, XII, suppl., nos. 53–57; no. 53 has erasure of his names.)

Dedication to Antoninus Pius, A.D. 151 to 152 (no. 90).

Statue of Septimius Severus, A.D. 193 (no. 91).

Statue of Caracalla, A.D. 201 or later (no. 92).

Epistyle block to Caesars of the third century A.D. (*IG*, XII, suppl., no. 201, p. 21).

Cyriac of Ancona saw, "conspicium de marmore arcum quem tetrastilon dicunt, olim per praesidem insularum," dedicated to the Tetrarchs A.D. 292 to 305 in the name of Aurelius Agathus Gennadius (*CIL*, III, no. 450).

Dedication to Constantinus Magnus and Constantinus II, A.D. 317 to 337, with Constantinus as Max and Patri Auggg! (*IG*, XII, suppl., p. 210; *CIL*, III, no. 451).

PLAKADOS

Statue of Julia Nea Aphrodite, 15 to 13 B.C. (*IGRR*, IV, no. 114).

THERMIS

Statue of Agrippa, probably from the period when he was in Syria, 22 to 20 B.C. (*IGRR*, IV, no. 21).

Dedication to Agrippina Karpoporus.

MELOS

Ref.: *IG*, XII, 2.

Fragment of the base of a statue of Augustus or Tiberius (no. 1107).

Portrait of Agrippina Senior, dedicated by the Demos; the base was found near the theater (no. 1108).

Altar with inscription to Nero and Agatha Tyche, from Marcus Antonius Glaukos, priest of Zeus Keraunios, and so on (*IG*, XII, suppl., no. 165).

Dedication, a plaque or tablet, to Trajan, from a number of officials; it was found near the spot where the Poseidon in Athens was discovered (no. 1110). This invites comparison with the statue of Trajan as ruler of the sea, found in the citadel of Samos; perhaps on Melos there was a statue of Trajan in the shrine of Poseidon.

A statue to Marcus Aurelius Caesar set up in A.D. 139 by the Boule and the Demos of Melos (no. 1111).

MYKONOS

Statue base to Trajan, A.D. 103– , presumably from DELOS (*AM* 22 [1897] 405; *Inscriptions de Délos*, no. 1597).

NISYROS

Statue (or milestone) of Caracalla (*IGRR*, IV, no. 1109).

PAROS

Altar to Augustus, recorded on the citadel from Cyriac of Ancona's notes (*IG*, XII, 5, no. 267); a tablet or epistyle block was similarly recorded (no. 268).

Group of sarcophagi of the second century A.D.(?). Their form is Greek, but the enrichment is unusual in consisting of Hellenistic-type votive or funerary (hero) reliefs as inset panels. (See *IG*, XII, 5, nos. 371, 389.)

Dedication to Constantinus Caesar, from the city of Paros, A.D. 317 to 337. There was a statue, whose base was taken to Constantinople (*IG*, XII, 5, no. 269).

PEPARETHOS

Statue of Antoninus Pius (*IG*, XII, 8, no. 644).

SELINOS, at the northern end of the island.
Statue of Hadrian the Olympian, from the chief priest of the city (no. 661).

PHOLEGANDROS

Simple rectangular base to the divine Tiberius, son of Divus Augustus, from the people and the priest Termis Sositelous (*IG*, XII, 2, no. 1058).

RHODES

CAMIRUS

Statue of Gaius Caesar, as benefactor (*Clara Rhodos* 6–7 [1932–33] 432, no. 52).

IALYSOS

Large dark marble base to Vespasian from the city; the statue presented the emperor as benefactor of Ialysos (*IG*, XII, 1, no. 679; *IGRR*, IV, no. 1138).

LINDOS

Statue of Tiberius, with a dedication(?), near the Temple of Athena (*IG*, XII, 1, no. 772; *IGRR*, IV, no. 1144).

Statue of Tiberius with one of his wife Julia and his brother Nero Drusus, on the acropolis (Blinkenberg, *Lindos*, II, 2 [Berlin-Copenhagen, 1941], no. 385).

Exedra, rebuilt A.D. 14–19, with places for six statues; from left to right, Tiberius, Drusus Junior, Augustus, and Germanicus. Livia stood next to Tiberius, and Agrippina Senior flanked Germanicus (Blinkenberg, *Lindos*, III, pp. 303f., pl. VII).

Statue of Claudius, on the acropolis (*IG*, XII, 1, no. 805; *IGRR*, IV, no. 1145; Magie, p. 1401).

Statue of Messalina, before A.D. 48 and on a dark marble base (*IG*, XII, 1, no. 806; *IGRR*, IV, no. 1146). This must have been set up as a pair with the previous.

Statue of Plotina, of Trajanic or Hadrianic date, since Hadrian owed his elevation mainly to Trajan's widow (no. 1147).

NEOMARAS

Statue of Poppaea Sabina, as wife of the emperor Nero Claudius Caesar, from the Demos (*IG*, XII, 1, no. 39); the base is of dark marble, and the date was A.D. 63 to 65.

RHODES, the city.
Portrait of Julius Caesar, from the so-called nymphaeum at Monte S. Stefano (Jacopi, *Clara Rhodos* 5 [1931] 63ff., figs. 36f.).

Head, seemingly that of Augustus, from under the modern town.

Statue of Poppaea Sabina, A.D. 63 to 65

447

RHODES (the city) (*continued*)

(*IGRR*, IV, no. 1125). (This seems to be the same as that listed above; see Magie, p. 1422.)

An inscription mentions a priest of Titus, and Athena Polias (*Clara Rhodos* 6–7 [1932–33] 433, no. 53; Magie, p. 1427).

SAMOS

Refs.: *IGRR*, IV; P. Herrmann, "Die Inschriften römischer Zeit aus dem Heraion von Samos," *AM* 76 (1960) 68–183.

Diademed head of Eumenes II, very Pergamene and expressive.

Statue of Pompey the Great, after the war with the pirates, 67 B.C. (*IGRR*, IV, no. 1710; Magie, p. 1181).

Statue of Cicero, erected near the Heraion by the Demos, perhaps during his visit on the way to Asia (*IGRR*, IV, no. 1713; Magie, p. 1250). It may have been set up with one of Quintus, who is said to have restored the island's prosperity.

Statue of Julius Caesar, shortly after Pharsalia (*IGRR*, IV, no. 970; Raubitschek, *JRS* 44 [1954] 67, no. (M)). Two further statues were set up later (Raubitschek, *ibid.*, pp. 69f.). There were Julio-Claudian portrait heads found in the Roman ruins (the agora and stoas) in and near the Castro at Tigani (*Gnomon* 5 [1929] 270ff.). There was also a shrine of the emperors, the gods of the city (Zeus), and, chiefly, Augustus, "in Samo" (*IGRR*, IV, no. 958). Augustus is associated with Zeus Polieus; this dedication belongs to the time of Tiberius (Magie, p. 1333; *Hesperia* 28 [1959] 67ff., no. 45; *AM* 49 [1924] 43).

Dedication to Dea Roma and Augustus, "Sami," by the people of Samos (*IGRR*, IV, no. 975). The first of two other dedications to Augustus (nos. 976, 977) tells of a monument erected by Augustus in 19 B.C. Various local worthies collaborated in one more dedication to Augustus (no. 978), and a pedestal to Augustus marked a decree after his visit in 19 B.C. (*AJA* 1 [1897] 355).

Statue of Julia Augusta Filia, dedicated about 19 B.C. by the Demos to Hera (*IGRR*, IV, no. 1717).

Head of Lucius Caesar, in Tigani.

Statue of Agrippa Postumus, set up between his adoption in A.D. 4 and his banishment in 7 (no. 1718).

Monument to Tiberius as savior, from the Demos (Magie, p. 1343 and bibl.).

Statue of Germanicus, about A.D. 18 (no. 979).

Head of Germanicus, in Tigani or Vathy.

Statue of Agrippina Senior, from the Demos (no. 980).

Statue of Drusus Junior, between A.D. 4 and 23 (no. 1720).

Dedication to Caligula (no. 981).

Statue of Drusilla, sister of Caligula, as Nea Charis (no. 1721).

Statues (?) of Livia, her mother, and her father, put up under Claudius by the Demos at the Heraion (nos. 982–984; Magie, p. 1401).

Statue of Claudius (with head surviving?), set up by the Demos after the earthquake of A.D. 47 (no. 1711).

Togate statue of the young Nero.

Statue of Octavia, A.D. 54 to 62. Several other early Julio-Claudians are mentioned (no. 969; Magie, p. 1422).

Heroic statue of Trajan, in the storeroom of the Castro at Tigani; he wears a cloak on his left shoulder and holds an orb in the right hand (*Gnomon* 5 [1929] 271).

Dedication to Hera and Trajan, in the shrine of Asklepios and Hygeia, at Chora (*IGRR*, IV, no. 965).

Dedication to Hadrian, at Samos (no. 985). Another from the same site is dated 129 or later (no. 986), and there was a statue of the emperor with these (no. 987).

Statue of Antoninus Pius, from the local authorities, at Chora (no. 966).

Probable statue of Caracalla, 210 to 217, at Samos (no. 988; Magie, p. 1552).

Head of the young Caracalla.

Statue of Julia Domna, set up at the Heraion between 198 and 211 (no. 1722).

SAMOTHRACE

Refs.: *Archaeologische Untersuchungen auf Samothrake* (Vienna, 1875), p. 36; K. Lehmann, *Samothrace, A Guide to the Excavations and the Museum* (New York, 1960).

Statue of Hadrian, A.D. 132 or 133, from the Boule and the Demos; it was set in a shrine (*IGRR*, I, no. 850). Another statue, dedicated by the Demos in 131 or 132, stood on a round base. (See *IG*, XII, 8, no. 243.)

A statue base to a member of the family of Constantine the Great was recut over an honorary inscription to Severus II and Galerius or Daza, A.D. 317 to 337. Crispus was present

and also erased, after 317 (*IG*, XII, 8, no. 244; A. Conze, A. Hauser, O. Benndorf, *Archaeologische Untersuchungen auf Samothrake*, II [Vienna, 1880], 93f.).

In the realm of proto-imperial dedications, there was a statue of Lucius Julius Caesar, Praetor in Macedonia about 92 B.C. and Consul in 90 (*IGRR*, I, no. 845).

SERIPHOS

A large epistyle block with three fasciae, from a stoa, was dedicated to Augustus and mentions construction in the agora. It was recorded in a church below the acropolis (*IG*, XII, 5, no. 511).

A marble column held a dedication, probably to Augustus (no. 512), which mentions baths and public buildings.

SICINOS

Marble stele dedicated to Antoninus Pius, with his complete imperial genealogy (*IG*, XII, suppl., no. 182).

SIPHNOS

A dedication, in the museum from the castro, is to two or three Sebastoi; these appear to be Marcus Aurelius and Lucius Verus, from the Boule and the Demos (*IG*, XII, 5, no. 485).

SKIATHOS

Statue of Hadrian as Olympian (*IG*, XII, 8, no. 633).

Altar to Septimius Severus (no. 634); another was set up by the Boule and Demos (no. 635).

SYROS

Refs.: *IG*, XII, 5 and suppl.

Letter from Hadrian (no. 657).

A statue of Hadrian, from the Demos, was set up in 119 or later, on an elaborate cylindrical base. It was found in the city, and the statue with it is said to have been taken to Russia (no. 674).

Monument to Hadrian as Olympian and Panhellene, perhaps a statue, A.D. 135 (suppl., no. 239). The dedication, from the Boule and the Demos, is in a tabula ansata on the block, which was recorded in the citadel of the acropolis.

Stele, with crowns, rose, and amphorae, and dolphins below, dedicated to Antoninus Pius

and the Roman Senate from the Demos and an important official, Attalos, and his wife (no. 238).

Stele in the name of Antoninus Pius (*IG*, XII, 5, no. 659); there are a third (no. 660) and a fourth (no. 661), the last also being enriched with a crown and two dolphins.

Stele in the name of Marcus Aurelius and Lucius Verus, A.D. 166 to 169 (no. 662).

Stele in the name of Commodus, A.D. 183 (no. 663).

Stele to Septimius Severus, with crown and branches above (no. 664). There was also a letter from Septimius Severus and Caracalla, A.D. 208 (no. 658). (*See also* AMORGOS.)

Stele to Gordianus III, which mentions Hestia Prytaneia (no. 666).

Dedication mentioning Traianus Decius and Etruscilla, with the two Caesars; dolphins above, A.D. 251 (no. 667). These stelai, evidently a fashion of this island, were a noble, and inexpensive, form of imperial commemoration.

TELOS

Honorary altar to Nerva, in the time of his adopted son Trajan (*Annuario* 41–42 [1963–64] 278f., fig. 63).

Dedication to, probably a statue of Hadrian (*IGRR*, IV, no. 1734).

TENOS

Ref.: H. Demoulin, *BCH* 26 (1902) 399–439.

KIONIA, the Sanctuary of Poseidon and Amphitrite.

Sanctuary and its altar (*BCH* 75 [1951] 189f. and bibl.).

The altar at Kionia, with frieze of Nereids and Hippocamps, is said to be in the form of the altar of Zeus Soter at Pergamon, but the fragments of the altar itself (garlands, bulls' heads, and paterae) remind us of the Ara Pietatis Augustae of the time of Claudius in Rome or the altar in Lyon which is based on the Ara Pacis. Such altars existed all over the empire (*AJA* 61 [1957] 116). The altar at Kionia may have been the forerunner of the Ara Pacis in Rome, and thus a link between Pergamon and the imperial capital; it may be roughly contemporary with the Augustan monument in Rome.

Within a small shrine to Amphitrite, south of the temple at Kionia, were found four cuirassed

449

torsos; another was noted in the eighteenth century. Inscriptions found east of the temple mention Trajan and Hadrian (see below). The statues were probably those of Nerva, Trajan, Hadrian, Aelius, and Antoninus Pius(?) (*Berytus* 13 [1959] 60, nos. 225–228; *see also* above, under DELOS, for the Hellenistic prototype of these statues).

Statue of Trajan, A.D. 98 to 102 (*IG*, XII, 5, no. 935).

Statue of Hadrian the Olympian, from the Demos of Tenos (no. 936).

Statue of Sabina, A.D. 129 or 130, when the imperial couple visited there (*IG*, XII, suppl., no. 322, added to nos. 936 and 948).

Battered head of Gordian III, in the Tenos Museum.

TENOS

Statue of Antoninus Pius, from the agora or (and perhaps later) the city gate (*IG*, XII, 5, no. 937).

KOUMAROS, in the center of the island, inland from Tenos.

Marble plaque to Trebonianus Gallus (no. 938).

THASOS

Refs.: *IGRR*, I; *Études Thasiennes*.

Inscription to Roma and Augustus (*IGRR*, I, no. 833), mentioning construction of a marble shrine, in the agora (*IG*, XII, 8, no. 380 and suppl., p. 166).

Statue of Augustus (*IG*, XII, suppl., no. 387).

Altar to Augustus, found near the odeon (C. Dunant, J. Pouilloux, *Études Thasiennes*, V, *Recherches sur l'histoire et les cultes de Thasos*, II [Paris, 1958], 61ff., no. 177).

Inscription to Livia, Julia, and the latter's daughter Julia, probably involving portraits dedicated by the Demos (no. 835). It has been conjectured from the great height and slight width of the stone that these likenesses of about 12 B.C. were busts (*AJA* 50 [1946] 390f.; also *IG*, XII, 8, no. 381).

Dedication to L. Caesar, A.D. 2 to 4, who had a shrine in the agora (*Études Thasiennes*, V, no. 178).

Dedication to Claudius set up by Paranomos in the agora (no. 180). A building in the agora was perhaps rededicated, bearing an inscription to Claudius on the architrave (no. 181).

Agora, no. 757: letter of a procurator of Vespasian at Thasos to settle a dispute with one of the colonies (*BCH* 74 [1950] 353ff., no. c, fig. 76).

Altars to Hadrian the Olympian and Sabina as Nea Hera, a cylinder with bucrania and garlands, near the odeon and elsewhere (*IG*, XII, suppl., no. 440; *BCH* 56 [1932] 284ff., fig. 28; *BCH* 62 [1938] 413f.); there is another, also after A.D. 129 (no. 441). See G. Daux, *BCH* 52 (1928) 61f., no. 14.

Statue of Hadrian as Olympian (*Études Thasiennes*, V, no. 187).

Fragment of a statue base (R. Martin, *BCH* 68–69 [1944–45] 161, no. 5).

Cuirassed statue of Hadrian, dated about A.D. 120 but perhaps late in his reign; found in an apsidal cult room off Portico IX (C. Rolley, F. Salviat, *BCH* 87 [1963] 548–578; *Deltion* 18 [1963] 259, pl. 297, pl. 296a showing it lying face down in the area).

Monumental arch near the Herakleion, A.D. 213 to 217, dedicated to Caracalla, Julia Domna, and the deified Septimius Severus; Caracalla is titled GERMANICUS MAXIMUS, giving the dating (*IG*, XII, 8, no. 382; Collart, *Philippes*, pp. 515f.; R. Ginouvès, *BCH* 78 [1954] 205).

Torso and feet of a cuirassed statue, possibly Caracalla (Mendel, *BCH* 26 [1902] 478, no. 8, fig. 7; M. Launey, *BCH* 57 [1933] 182f., note 2). This statue may have been the one adorning the arch mentioned above (*Berytus* 15 [1964] 96).

Statue of Constantius Chlorus, A.D. 293 to 305 (*Études Thasiennes*, V, no. 357).

THERA

Refs.: F. Hiller von Gaetringen, *Die Insel Thera* (Berlin, 1899–); *IG*, XII, 2, nos. 469ff.

Head of Ptolemy I Soter, found on the terrace of the "Kaisareion" (*Thera*, I, 245f., pl. 21; G. H. McFadden, in *Robinson Studies*, I, 719, pl. 84c, d).

The gymnasium was built by the Ptolemaic garrison.

Altar to Octavius Caesar, of circular form with garlands and bulls' heads, "metopes and triglyphs" above (31–27 B.C.); found near the small temple, of Dionysos (*IG*, XII, 2, no. 469).

Statue base of Augustus, 30 B.C., found near the stoa (no. 470).

Marble head of Augustus.

Tiberius as patron of the Gymnasion of the Ephebes was commemorated with a cylindrical dark marble base with bulls' heads and garlands, A.D. 4 to 14 (no. 471).

Tablet to Germanicus, father of Caligula (no. 472), found in the Stoa Basilike and now in the Louvre (thanks to Fauvel). It may be connected with portrait-inscriptions to Germanicus and Agrippina, as parents of Caligula, a group which later included Flavians, that is, Vespasian (*AJA* 50 [1946] 393, no. 17). This row of joining blocks (Vespasian, Agrippina, Germanicus, and Caligula) was found in front of the skene of the theater. There was at least one more statue, perhaps Titus, on the left (see *IG*, XII, 3, suppl., nos. 1392–1394).

A cuirassed torso in the agora may be connected with one of the Augustan or Julio-Claudian statues, most likely that of Augustus or Germanicus (*Berytus* 15 [1964] 99, no. 16E).

Marble head of Lucius Caesar or Germanicus, or perhaps even the young Claudius (*Berytus*, 99, under no. 16E).

Base of a statue of Claudius was found in the orchestra of the theater (no. 1395); another statue of Claudius, A.D. 41 to 54, was found nearby (no. 473).

Base of a statue of Trajan, carried off to the Vatican as "from Malta" but dedicated by a noted Theran (no. 475).

Portrait of Hadrian, toga drawn over his head (Wegner, pl. 31).

Cylindrical column or base to Hadrian (no. 476); another cylinder, also possibly a statue base, was found in the agora (no. 477).

The Stoa Basilike, in the agora, had inscriptions to Antoninus Pius, Marcus Aurelius, Lucius Verus (with Marcus), and Faustina (the Elder?), probably dated A.D. 149 and connected with Fl. Kleitosthenes' restoration of the stoa. Antoninus Pius stood on a cylindrical base (no. 1396); a local official was responsible.

Two statues of Marcus Aurelius, both in the agora, one being from the Boule and Demos and local officials (no. 478), and the other from further officials (no. 479).

Two statues of Septimius Severus, both in the agora, one being from the Boule and Demos (no. 480), the other from three Archons (no. 1397).

Statue of Caracalla, A.D. 213 to 217, with a lengthy inscription from a group of officials (no. 481). There seem to have been other Severan circular bases or altars.

Statue of Alexander Severus, A.D. 222 to 235, from the agora; this is documented from a cylindrical base with carved upper moldings (no. 484).

THE NORTHERN COASTS OF THE BLACK SEA

SARMATIA
Ref.: *IGRR*, I.

Near OLBIA
Augustus and Tiberius, A.D. 4 to 14, including the dedication of a stoa (no. 853).

OLBIA
Septimius Severus and Caracalla, a monumental dedication (no. 854).

Caracalla and Geta, A.D. 198 to 209; very likely twin statues and from the Boule and the Demos (no. 855).

Severus Alexander, a dedication which includes mention of a stoa (no. 856).

BOSPORUS
PANTICAPAEUM (Kerč)
Ref.: *IGRR*, I.

Dedication to Augustus, perhaps a statue, from Queen Dynamis, before 16 B.C.

Dedication to Nero, with full titles, from King Cotys, son of Aspurgus (no. 876).

Hadrian, A.D. 133, from T. Julius Rhoemetalcis (no. 877).

Caracalla, A.D. 201, from T. Julius Sauromatis II (no. 878). These last three may all have involved statues.

PHANAGORIA (Taman)
Ref.: *IGRR*, I.

Statue to Augustus by Queen Dynamis, wife of Asandrus (no. 901) (see above).

Statue to Livia by Queen Dynamis (no. 902).

Statue to Vespasian, A.D. 77– by Tiberius Julius Rhescuporis, king A.D. 77 to 92 (no. 903).

There was evidently a local Kaisareion (no. 904; *PBSR* 26 [1958] 177f.).

ASIA MINOR AND CYPRUS

PONTUS

Ref.: *IGRR*, III.

AMISUS (Samsun)

Statue of Britannicus (G. Bean, *Belleten* 20 [1956] 213ff., pl. 1).

Statue of Nero (*ibid.*).

Statue of Poppaea (*ibid.*).

Bronze statue, in heroic nude; possibly (in its remade form) Trebonianus Gallus; in Istanbul (L'Orange, *Spätantiken Porträts*, p. 97; Inan-Rosenbaum, pp. 103f., no. 101).

HERACLEIA

Ref.: Magie, pp. 1191f. (Ereğli).

Dedication to Antoninus Pius (*IGRR*, III, no. 78).

Architrave to Marcus Aurelius, A.D. 167 (G. Mendel, *BCH* 25 [1901] 47, no. 192).

PARTHENIUM (Bartin)

Between Bartin and Amasra an inscription of the time of Claudius records cutting of the "mountain" at the defile of Kuş Kaya (Magie, p. 1193); there was a statue of Claudius, in pallium, on a round base and an image of an eagle on a pillar or Tuscan column (*CIL*, III, nos. 321, 6983).

Milestone on road from Amastris: Septimius Severus, Caracalla, and Geta Caesar, A.D. 198 (*IGRR*, III, no. 82). Another milestone, no. VIII on the road from Tieium to Parthenium (Bartin), was erected by Antoninus Pius (A.D. 141) and replaced by Septimius Severus with another stone in 198 (Magie, p. 1193).

TRAPEZUS (Trebizond or Trabzon)

Dedication to the First Tetrarchs (*CIL*, III, no. 236).

BITHYNIA

APAMEIA-MYRLEIA

Ref.: Magie, pp. 1189f. (Mudania).

Dedication to Germanicus, A.D. 11 (*CIL*, III, no. 334); Inan-Rosenbaum (p. 45, no. 1) term this a statue.

A dedication in the orchestra of the theater mentions Vespasian (*CIL*, III, no. 335).

Statue of Hadrian (*CIG*, II, no. 3725; Inan-Rosenbaum, p. 47, no. 1).

Statue of Macrianus Junior, A.D. 261 to 262, from the Polis (*IGRR*, III, no. 27). (*See* below, Phrygia, NACOLEIA.)

BITHYNIUM-CLAUDIOPOLIS

Refs.: F. K. Dörner, *Bericht über eine Reise in Bithynien*, AbhWien 75, 1 (1952); Magie, p. 1190 (Bolu).

Inscription of Hadrian on architrave section from portico or temple (from the shrine of Antinous?); it has rich scrollwork between bead and reel, and egg and dart above (pp. 37f., no. 73).

Statue base to Hadrian, A.D. 134, dedicated by the Phyle Apollonis (p. 41f., no. 84). Also honored at the same time by the Phyle Sebaste (cf. *IGRR*, III, no. 72; also Inan-Rosenbaum, p. 47, nos. 3, 4, for alleged statue bases).

Statue of Hadrian from Boule and Demos, A.D. 131 (*IGRR*, III, no. 71).

Milestone in Latin of Traianus Decius (Dörner, p. 42, no. 85).

Milestone of First Tetrarchy, A.D. 293 to 305 (p. 42, no. 86).

In vicinity (p. 63, no. 176); sculptured block from an official monument or large tomb, with, left to right, shield, plumed helmet, two spears, and cuirass flanked by greaves; it belongs to the century following 125 B.C. At Güçduran, near Bolu, there was a large altar to Hadrian, A.D. 134 (G. Mendel, *BCH* 27 [1903] 316f., no. 5; see above, the monument from the Phyle Sebaste; also Inan-Rosenbaum, p. 47, no. 6, as a statue base).

CIUS

Ref.: Magie, pp. 1188f. (Gemlik).

Inscription suggesting a cult of Domitian (*IGRR*, III, no. 23).

Dedication to Trajan, by a group of six locals (*IGRR*, III, no. 24).

Statue of Hadrian, by the priest M. Ulpius Lupus (*IGRR*, III, no. 20; *CIG*, 3725).

DACIBYZIAE or DACIBYZA (Gebze)

Altar to Caracalla, A.D. 206 to 207 (*IGRR*, III, no. 1).

Gueul-Bazar

Dedication to Nero, 62 to 63 (*IGRR*, III, no. 51).

Dedication to Trajan, 102 to 110 (*IGRR*, III, no. 50).

Hamidiè or Hamidiye

Altar to Hadrian, A.D. 125 to 126 (*IGRR*, III, no. 3).

NICAEA (Iznik)

Refs.: Ch. Fellows, *Asia Minor* (London,

1839), pp. 115ff., 322; Magie, pp. 1186, 1471; A. M. Schneider, "Die Römischen und Byzantinischen Denkmäler von Iznik–Nicaea," *Istanbuler Forschungen* 16 (1943); A. M. Schneider and W. Karnapp, "Die Stadtmauer von Iznik (Nicaea)," *Istanbuler Forschungen* 9 (1938).

Two big bilingual inscriptions to Nero, 58/59 for repair of road from Nicaea to Apameia (Texier, *Description*, p. 52), cut in rock on shore of Lake Ascanius (*IGRR*, III, no. 15; *CIL*, III, no. 346).

New city gates under the Flavians, ca. A.D. 71 (*IGRR*, III, no. 37; *CIG* 3759).

Dedication to Trajan, A.D. 102 to 116 (*IGRR*, III, no. 38).

East Gate restored by Hadrian after earthquake, ca. A.D. 124 (*IGRR*, III, no. 37). He added markets, piazzas, and walls, as at NICOMEDIA.

One gate honors Hadrian, from the Demos (A. Baumeister, *Denkmäler des klassischen Altertums*, III [Munich and Leipzig, 1888] 1894).

Claudius II honored on two gates, A.D. 269 (*IGRR*, III, no. 39).

Relief(s) in city wall from a triumphal monument, commemorating war with Alamannia under Constantius Chlorus in A.D. 298 (H. von Schönebeck, *FuF* 1937, 159f.).

Site, one hour, by foot, from NICAEA on road to NICOMEDIA

Obelisk of C. Cassius Philiscus, son of C. Cassius Asklepiodotus.

NICOMEDIA

Refs.: N. Fıratlı, *Izmit* (Istanbul, 1959), 40 pp.; F. K. Dörner, "Inschriften und Denkmäler aus Bithynien," *Istanbuler Forschungen* 14, 1941 (Izmit).

Group of statues dedicated to the Julio-Claudian family (see Giuliano, *RivIstArch* 17 [1959] 157), including Lucius Caesar (*CIL*, III, no. 323).

Shrine and temple to Vespasian, A.D. 70/71, erected under the auspices of M. Plancius Varus, Proconsul (*IGRR*, III, no. 4).

Temple of Commodus (Cass. Dio., LXXIII, 12, 2).

Statue base with inscription honoring Caracalla in A.D. 202 (identical to one at Synnada) after capture of Ctesiphon (Texier, *Description*, I, 20f.).

Statue of Caracalla as son of Septimius Severus, A.D. 212 (*IGRR*, III, no. 5).

Caracalla built baths at Nicomedia; they were rebuilt by Diocletian and Justinian (Magie, p. 1552 and refs.; esp. *CIL*, III, no. 324).

Julia Domna honored as Mater Castrorum with a statue and flowery stele, in the name of M. Claudius Demetrius, a consul suffectus (Texier, *Description*, I, 21; *IGRR*, III, no. 6).

Head of Septimius Severus, a Greek portrait; now in Istanbul.

Column with wreath-bearing Nikai at top, now Istanbul, no. 4922: Latin inscription to the Severan family, in connection with civic restorations.

Head of Diocletian, with large wreath; now in Istanbul. He also built a mint and an arms factory. His statue base is recorded (*CIL*, III, no. 324; Inan-Rosenbaum, p. 52, no. 1).

Dedication to Maximianus Herculeus (*CIL*, III, no. 325), listed as statue by Inan-Rosenbaum (p. 52, no. 1).

Statue of Constantius Chlorus, A.D. 294 (*CIL*, III, no. 326).

Head of Helena, twice-lifesized and in the style of Faustina the Elder; now in Istanbul (Dörner, p. 48, no. 7, pl. 12).

PRUSA (AD OLYMPUM)

Ref.: Magie, p. 1187 (Bursa).

Cult of Augustus, probably established much later than his principate (Magie, p. 1294).

Vespasian, Titus, and Domitian (as Caesar) are honored, A.D. 77 to 78, in connection with road repair: L. Antonius Naso was the Procurator (*CIL*, III, suppl., no. 6993). (Near Prusa.)

Statue of Hadrian, from the Gerousia of HADRIANI; the base found in one of the gates of the Medieval(?) city (G. Mendel, *BCH* 33 [1909] 404f., no. 403).

Letter from Hadrian, concerning the city's hot springs (*BCH* 64–65 [1940–41] 288).

Statue of Antoninus Pius, A.D. 139, dedicated by Attinas Glaukon, the strategon; the base was recorded in the town of Beïdjè or Beice, near Prusa (*IGRR*, III, no. 35; Inan-Rosenbaum, p. 48, no. 2).

PRUSA-CIUS Road

Milestone no. V of Gordianus III (*CIL*, III, no. 347 = 6996; Magie, p. 1188).

PRUSIAS AD HYPIUM (Üskübü)

Refs.: F. K. Dörner, *Bericht über eine Reise in Bithynien*, *AbhWien* 75, 1 (1952) 7–31; Magie, p. 1190 (Üsküb).

PRUSIAS AD HYPIUM (Üskübü) (*continued*)
Base of statue of Hadrian, A.D. 126 (Dörner, p. 16, no. 9).
Fragment of cuirassed statue of Hadrianic type, with scene of Victoriae crowning Virtus on the breastplate (Dörner, p. 30, no. 63).
Dedication to Hadrian, after A.D. 129 (*IGRR,* III, no. 52).
Statue of Alexander Severus, giving his titles descending from Caracalla and Septimius Severus (*IGRR*, III, no. 53).
Similar inscription, with fuller titlature and damnatio (*IGRR*, III, no. 54).

MYSIA

Aidindjik or Aydıncık (near Cyzicus)
Statue of Trajan, A.D. 115 to 116, from Bittius Proculus, proconsul of Asia; the statue was set on a grey stone column (*IGRR*, IV, no. 172).

APOLLONIA

Ref.: *IGRR*, IV.
Statue of Domitian, Caesar A.D. 69 to 70, from an archon (no. 120).
Dedication to Hadrian, ca. A.D. 123 (no. 121).
Dedication to Hadrian (no. 122). See Inan-Rosenbaum, p. 47, no. 9, an altar rather than a statue base.
Dedication to Hadrian (no. 123).

ARGIZA (Pazarköy)

City dedicated to Valentinianus (*CIL*, III, 7084, from Bulia Bazar).

Bigaditch or Bigadiç

Altar to Marcus Aurelius(?) Antoninus (*IGRR*, IV, no. 517).

BLAUDUS

Dedication to Caracalla, A.D. 206 (*IGRR*, IV, no. 239).

CORYPHANTIS

Dedication to Diocletian, Maximianus, and the Caesars Constantius Chlorus and Galerius, A.D. 292 to 305 (*IGRR*, IV, no. 265).

CYZICUS (Balkız)

Refs.: B. Ashmole, "Cyriac(o) of Ancona and the Temple of Hadrian at Cyzicus," *JWarb* 19 (1956) 179–191; Magie, pp. 1472f. (on the temple); F. W. Hasluck, *Cyzicus* (Cambridge, 1910).

Statue of Augustus dedicated by Aristander Eumenis.
Statue(?) of Drusus Junior (*IGRR*, IV, no. 172).
Statue of Tiberius, A.D. 23– (*IGRR*, IV, no. 137).
Dedication of triumphal arch to Augustus, Tiberius, and Claudius, by the Cyzicenes and the Roman residents (*CIL*, III, 7061; *Rev. arch.* n.s. XXXI, 100).
Pedestal in honor of Augustus, Tiberius, and Claudius, perhaps A.D. 51 to 52, in conjunction with the previous (Stuart, *Claudius*, p. 54; H. Dessau, *Inscriptiones Latinae Selectae*, 217).
Dedication of a statue of Domitian, A.D. 84, by the archons.
Temple of Hadrian: earthquake at Cyzicus in 123; Hadrian visited the city in 124 and ordered work on an earlier building. This was completed in A.D. 139 or as late as a dedication under Marcus Aurelius in 167 (Gregorovius, *Hadrian*, p. 358). There were niches for statues of the twelve Olympians, with Hadrian as the thirteenth; the architecture was richly carved, and the frieze appeared to have shown the Olympians in various actions.
Nine dedications from Cyzicus region to Hadrian "as Olympian, Founder of the Colony" (see *IGRR*, IV, nos. 138, 139).
Two dedications to Antoninus Pius.

Hodja-Bunar or Pinar (CYZICUS)
Dedication (statue?) to Drusus Junior (*IGRR*, IV, no. 187).
G. Mendel (*Catalogue*, II, 49f., as no. 288) publishes a large fragment from a rectangular base. The presence of a *vexillum* among the shields, trophy, arms, and armor indicates a commemoration involving Romans. He deduces that the relief comes from Cyzicus (by way of the Bursa area) and from a monument set up by the Cyzicenes after the retreat of Mithradates, the victory of Lucullus and the deliverance of the city (73–72 B.C.) from a major siege (Hasluck, pp. 178ff.). The relief comprises trophies left and right, cuirass and *vexillum* in the center, helmet and greaves at the lower right, round and rectangular shields above, and various swords, lances, and so on. The artistic influence stems from Pergamon. This monument is one small indication that there is really more "Roman" art in Greece and Asia Minor in the late Republic than in any period before A.D. 300.

GERME (near Savastepe-Kiresin)

Statue of Hadrian, A.D. 128 to 129 (*IGRR*, IV, no. 519).

Statuette of Eros, consecrated to the Nymphs, the emperor Hadrian, and the native city (Patrida) by a citizen; the base was found at Halkapınar, the site of the city's nymphaeum a few kilometers away and has helped L. Robert fix the site of Germe (L. Robert, *Villes d'Asie Mineure, Études de géographie ancienne*, 2nd ed. [Paris, 1962], pp. 404ff.).

HADRIANI

Statue of Aelius Caesar, A.D. 137, in the name of Attinas Glaukon as Praetor (*IGRR*, IV, no. 240).

LAMPSACUS (Lapseki)

Statue and base set up to Julia Augusta (that is, Livia), as Nea Demeter, A.D. 14 to 29 (L. Robert, *REA* 62 [1960] 291; *IGRR*, IV, no. 180). Magie dates the statue in the time of Claudius (p. 1402).

MILETOPOLIS

Statue of Pompey the Great (*JHS* 27 [1907] 64, no. 7).

Dedication to Hadrian (*IGRR*, IV, no. 128).

Dedication to Hadrian (no. 129).

Mumurt-Kale

Temple of Cybele, Doric and distyle in antis, with a dedication, to the Mother of the Gods from Philateiros the son of Attalos, across the architrave (A. Conze, P. Schazmann, *Mamurt-Kaleh, JdI, Ergänzungsheft* IX, 1911, pl. V, a reconstruction).

PARIUM (Kemer)

Statue of Trajan (*CIL*, III, no. 376; Inan-Rosenbaum, p. 47, no. 1).

Dedication to Hadrian: IOVI . OLYMPIO . CONDITORI . COL (*CIL*, III, no. 374).

PERGAMON (Bergama)

Refs.: *IGRR*, IV; *Altertümer von Pergamon*, Iff. (Berlin, 1890–1930); esp. VIII, 1, 2, *Die Inschriften*, 1890, 1895; also IX, *Das Temenos für den Herrscherkult*, 1937, pp. 84ff. (on various cult buildings at Pergamon from the Attalids into Roman times); J. L. Ussing, *Pergamos* (Berlin, 1899).

Attalids develop to its high point the symbolic expressions of triumphal and state art: monumental trophies, relief balustrades, altars, enriched pilasters, and bases.

Prototype of the Ara Pacis seen not only in the Altar of Zeus Soter but in the small complex around a round basis or altar of the type dedicated by Eumenes II. The front panels left and right bear foliate tendrils and stems springing from a central calyx-shaft; the short sides of these plaques carry caduceuses and torches (F. Winter, *Altertümer von Pergamon*, VII, 2 [Berlin, 1908], 317ff., no. 406).

Statue of Julius Caesar, 63 B.C. (*IGRR*, IV, no. 303; Raubitschek, *JRS* 44 [1954] 67 (J)); the inscription is a standard one.

Dedication to Julius Caesar, after Pharsalia and not before November 48 B.C. (no. 304; Magie, p. 1258; L. Robert, *Anat. Stud. Buckler*, p. 230). Inan-Rosenbaum (p. 44) term this a statue base.

Statue of Julius Caesar, in the gymnasium, 48 B.C., not later than December and from the Demos (no. 305; Magie, p. 1258; illustrated in Raubitschek, *JRS* 44).

Dedication to Julius Caesar after Pharsalia, in the temple of Athena, probably a statue (no. 306).

Statue of Julius Caesar (no. 307; Raubitschek, *JRS* 44 [1954] 67 (K)).

Dedication to Julius Caesar (no. 308).

Statue of Augustus, after 29 B.C. (no. 309).

Statue(?) of Augustus, 20 to 19 B.C., in the temple of Athena (Minerva) (no. 310).

Statue of Augustus, in the gymnasium (no. 311).

Statue, from the Demos (no. 312).

Another statue, or a dedication (no. 313).

Statue, from the Roman citizens of the free and allied city of Amisus (no. 314).

Dedication in the temple of Athena (no. 315). Inan-Rosenbaum (p. 44) term this a statue base; they also include no. 317.

Dedication to Augustus, Livia, and the gods of the gymnasium (Hermes, Herakles) (no. 318).

Heads of Augustus, Agrippina the Elder, Germanicus(?), Hermes, and Eros, found in a cistern near Temenos of Demeter (Mendel, *Catalogue*, II, nos. 555–559).

Dedication to Livia (Julia) (no. 319).

Statue(?) of Tiberius, before his adoption by Augustus in A.D. 4 (no. 320). The same (no. 321). Inan-Rosenbaum (p. 45) consider both to have been statues.

Tiberius as Caesar, A.D. 4 to 14 (no. 322). Inan-Rosenbaum also list this as a statue (p. 45).

PERGAMON (Bergama) (*continued*)

Statue of Octavia Maior (no. 323).

Statue of Drusus Junior in the temple of Athena (Minerva) (no. 324).

Statue of Germanicus, A.D. 18 to 19 (no. 326).

Statue of Germanicus, from the Demos (no. 327).

Julia Livilla, sister of Caligula (A.D. 37–) as Nea Nikephoros (no. 328), or before her exile by her brother in 39 (see also no. 464 and Magie, p. 1366); she had priestesses in common with Athena Nicephorus and Athena Polias.

Statue of Julia, daughter of Drusus Caesar, A.D. 43 (no. 325).

Statue of Claudius (no. 329).

Statue of, or dedication to, Nero or, possibly, Claudius (no. 330).

Statue of Trajan, A.D. 114 to 116 (no. 331). A similar statue is no. 332.

Temple of Asklepios dedicated to Trajan, A.D. 97 to 102 (no. 333).

Inscription from a major statue of Trajan, between the theater and the Trajaneum (no. 334).

Dedicatory inscription on the Trajaneum (*CIL*, III, suppl. 7086).

Inscription in the Trajaneum, about A.D. 122, to Diva Plotina Augusta; the temple area also had inscriptions and dedications to Trajan (no. 335). It was surrounded on three sides by colonnades built under Hadrian (Magie, pp. 1451ff. and refs.). Plotina's monument was a statue (Inan-Rosenbaum, p. 47, no. 1).

Statue of Hadrian, A.D. 120 (no. 339).

Dedication to Hadrian, near the temple of Athena (Minerva) (no. 340).

Dedications to Hadrian (nos. 341, 342).

Dedications to Hadrian, all also seeming to be altars (nos. 343, 344, 345, 346, 347, 348, 1685, the last as Olympian).

Letter from Hadrian, set up near the Trajaneum (no. 349).

Letter from Hadrian, in the gymnasium (no. 350).

Letters from Trajan and Hadrian in the gymnasium (no. 351; also no. 1678, including no. 350 above).

Temple records (no. 353; also no. 1679).

Statue of Hadrian as the Diomedes of Kresilas, dedicated by Flavia Melitine in her library in

the Asklepeion, perhaps for the visit of A.D. 123 (Wegner, *Hadrian*, p. 105).

Statue base to Aelius Caesar with Greek inscription at the Asklepeion. There is also a statue of Antoninus Pius from the local officials (nos. 1932–1933). See Inan-Rosenbaum, p. 49, no. 3.

Statues of Antoninus Pius (nos. 354, 355). See also Inan-Rosenbaum, p. 48, nos. 5–7.

Letter from Antoninus Pius (no. 356).

Dedication in the name of Antoninus Pius (letter?) (no. 357).

Letter from Antoninus Pius (no. 358).

Temple of Faustina I, at the extreme northern corner of the acropolis and beyond the Trajaneum, also dedicated to Faustina II in A.D. 176 or later (no. 361).

Statue of Julia Domna (Inan-Rosenbaum, p. 50, no. 3).

Temple of Caracalla (no. 362). Frieze enriched with bulls' heads and eagles supporting garlands, patera above; the design connects with coins.

Dedication to Caracalla, on the epistyle of the temple: "To the Emperor from Pergamon, the City of the Third Neocorate" (no. 363). Evidently this temple was rebuilt from a shrine to Asklepios (Magie, p. 1551).

Edict of Caracalla in the Trajaneum, where dozens of officials are also honored (no. 364).

Statue base to Caracalla in the Asklepeion, in Latin and with damnatio of the donor, A.D. 214.

Statue of Elagabalus (Inan-Rosenbaum, p. 51; cites *AbhBerl* 1932, 5, p. 54, no. 7). The same inscriptions honored Julia Soaemias and Julia Mamaea.

PRIAPUS (Karobogae or Karabiga)

Dedication to Hadrian as Jove, the Olympian, and founder of the colony (see under *CIL*, III, no. 374).

TROAS

ALEXANDRIA (Eski Stamboul; near Kemalli)

Dedication to Drusus, son of Germanicus, as Pontifex, A.D. 33 (*CIL*, III, no. 380: in vestibule of Cambridge Public Library). This plain panel, about 3½ feet square and 4 inches thick, is now in the Fitzwilliam Museum (J. Reynolds).

Career inscription of a Roman official, "VIII trib. dilectus ingenuorum quem Romae habuit Augustus et Ti Caesar" (with other Latin in-

scriptions from this colony in the floor of the mosque at Tuzla: *JHS, Arch. Rep. for 1959*, p. 30).

Statue of Claudius(?), A.D. 37 to 41, from the local military commander (*CIL*, III, no. 381). Inan-Rosenbaum accept this as a statue from the period before his accession (p. 46, no. 2).

Statue of Nero, A.D. 55 to 57 (*CIL*, III, no. 382).

Dedication to Hadrian by the local officials (*CIL*, III, no. 7071).

Statue of Marcus Aurelius as Caesar, A.D. 140 to 141 (Inan-Rosenbaum, p. 49, no. 2). There was a companion statue to Lucius Verus.

Capital of a pillar inscribed to Galerius Caesar, as Princeps Iuventutis (*CIL*, III, no. 383).

ANTANDRUS (Altınoluk)

Statue of Marcus Aurelius, by a group of local officials (*IGRR*, IV, no. 261).

ASSOS (Behramkale)

Refs.: J. R. S. Sterrett, "Inscriptions of Assos," *Papers* ASCS 1 (1882–83) 3–90; *IGRR*, IV, nos. 247–260; J. T. Clarke, F. H. Bacon, and R. Koldewey, *Investigations at Assos* (Cambridge, 1902), pp. 64ff.

Stoa dedicated to the god Caesar Augustus and the people by Quintus Lollius Philetairos. Statue of the goddess Livia, the new Juno, the wife of the god Augustus (Texier, *Description*, p. 203). The building was connected with the Gymnasium (Sterrett, pp. 35ff., no. XV).

Temple to Augustus, like that at Ankara(?).

Bath, dedicated to Livia (rather than Julia, daughter of Augustus) and the People (Sterrett, p. 40, no. XVI). "Lollia Antiochis, wife of Quintus Lollius Philetairos, first of women, who was queen in accordance with ancestral customs, dedicated this Bath and its belongings to Julia Aphrodite and the people." The plaque, set in the wall, is now in Boston. The epistyle inscription (Sterrett, pp. 41ff., no. XVII) is much the same, adding that Lollia Antiochis is wife of Quintus Lollius Philetairos, "priest for life of Divus Caesar Augustus . . ."

Statue of Gaius Caesar, ca. A.D. 1 to 4, set up by Roman merchants (*IGRR*, IV, no. 248; Sterrett, p. 30, no. XIII; Magie, p. 1344). The "stele," in reality a base, is now in Boston.

Portrait inscriptions of Octavia, Antonia, Britannicus, and Nero(?) (Stuart, *Claudius*, pp. 18, 55). This is a wrong identification, evidently by Stuart, and belongs under ILIUM.

Bronze tablet congratulating Caligula on his accession, decree of A.D. 37, found below the Bouleuterion (Sterrett, pp. 50ff., no. XXVI).

Stoa dedicated to Claudius, Agrippina, their children, the Senate, Athena Ilias, and the Demos by Tiberius Claudius Philocles (Stuart, *Claudius*, pp. 18, 55). Stuart seems to have erred, and this belongs only under ILIUM.

Head of Claudius or Gaius, from the agora.

Statue of Julia Domna Augusta, mother of the camp, erected by the Senate and the People, in the agora (Sterrett, pp. 58f., no. XXIX; Inan-Rosenbaum, p. 50, no. 2).

Pier of the west gateway in the agora had statue of Constantius II (337–361), erected by Caelius Montius (Sterrett, pp. 59ff., no. XXX). Montius was murdered by Constantius Gallus Caesar in 353.

Pedestal in the agora inscribed to Constantinus II (A.D. 337–340).

Milestone(?) of Valentinian, Theodosius, and Arcadius, A.D. 383 to 385, formerly an altar (*CIL*, III, no. 7080; Sterrett, no. XXXI, pp. 61f. quotes similar inscription "in the fountain on the pass of Belcaive" [Belkahve] near SARDES and mentioning Valentinian, Theodosius, Gratian, and Arcadius). The Assos cippus was found at the principal gateway opening upon the western street of tombs.

ILIUM (TROY)

Refs.: H. Schliemann, *Troja* (New York, 1884); *idem, Ilios* (Paris, 1895); *IGRR*, IV; A. R. Bellinger, *Troy, The Coins* (Princeton, 1961); C. Vermeule, *CJ* 58 (1962) 88f.; B. M. Holden, *The Metopes of the Temple of Athena at Ilion* (Northampton, Mass., 1964).

Relief in Madrid, Alexander on Bucephalus, early Hellenistic (*Berytus* 13 [1959] 13f., no. B1; *Einzelaufnahmen*, no. 1744).

Statues or honorifics to L. Julius L. f. Sex. n. Caesar, Cos 90– (*IGRR*, IV, nos. 194, 195).

Statue of Pompey the Great, 66 to 62 B.C., as imperator III and from the Demos (*IGRR*, IV, no. 198).

Statue(?) of Augustus, with flowery tribute from the city (*IGRR*, IV, no. 200). Similar dedication (no. 201). Inan-Rosenbaum (p. 44) list these as statue bases.

Dedication to Augustus, on the temple of Athena Ilias, which he rebuilt (no. 202); built by Lysimachus. The temple had been destroyed in 85 B.C. by Fimbria.

Statue of Augustus, 12 to 11 B.C., in the name of Melanippides Euthydikos (no. 203).

ILIUM (*Troy*) (*continued*)

Julio-Claudian portrait of Augustus, in Berlin. Statue of Marcus Agrippa, 18 to 13 B.C. (no. 204).

Statue of Gaius Caesar, ca. 1 B.C., from the acropolis and dedicated by the Boule and the Demos, as son of Augustus and patron–benefactor of Ilium. Gaius was governor of Asia; hence the connection with Julius Caesar and the Trojan legend in this dedication (*IGRR*, IV, no. 205; *Ilios*, p. 825f., Magie, p. 1343).

Statue of Antonia Augusta, A.D. 14 to 19 (*IGRR*, IV, no. 206; *AJA* 50 [1946] 393; Magie, p. 1357). The remarkably long Greek inscription is on a circular pedestal, 2 feet in diameter.

Statue of Tiberius, from a local official; it was set up in a building near the theater (*AM* 15 [1890] 217, no. 1).

Statue of Tiberius, A.D. 32 to 33 (*IGRR*, IV, no. 207; *AM* 15 [1890] 217f., no. 2). This monument was dedicated by the Boule and the Demos. The date of the pair of statues seems to have been A.D. 31, but there is some confusion in the numbering of the Tribunician Power.

Portrait of young Tiberius, East Greek type, now in Berlin. Found with the Augustus and with Agrippina Senior (head in Philadelphia, Penna., and body in Berlin).

Dedication to Claudius and Agrippina II, in connection with a stoa put up by Ti. Claudius Philocles (no. 208). *See* under ASSOS.

Dedication to the children of Claudius, including Nero (no. 209); there were four statues: Antonia, flanked by Octavia and Britannicus, and Nero; they stood in the portico mentioned previously (Magie, p. 1400). *See also* under ASSOS.

List of donors who gave toward building of the Gens Flavia temple (no. 210).

Triple statue base(?) to Vespasian, Titus, and (badly damaged) Domitian(?) (no. 211).

Altar to Hadrian (no. 212).

Theater (Schliemann, pp. 797ff.): tondo medallion of *Lupa Romana* (fig. 1558), Hadrianic or Antonine periods.

Dedication and honors paid Zeus and Minerva in the names of Diocletian and Maximian, A.D. 293 to 305 (*IGRR*, IV, no. 214). See also D. Hereward, *ABSA* 57 (1962) 182ff., dedication to Athena found at Yalova.

Statue of Constantinus II, probably in A.D.

458

324 (*AJA* 39 [1935] 591f., no. 5; Inan-Rosenbaum, p. 52, no. 1).

AEOLIS

AEGAE (Güzel Hisar)

Refs.: R. Bohn, *et al.*, *Altertümer von Aegae, JdI, Ergänzungsheft* II, 1889; Magie, pp. 1358f. (on the earthquake).

Inscription to Tiberius: fragments of epistyle blocks from a public building near the agora; enough survives to show a standard inscription known here and elsewhere (MAGNESIA in Lydia) in Greek. This long stoa or porticus honored the help to Asia after the earthquake of A.D. 17 (*CIL*, III, suppl. no. 7096).

Dedication to Claudius, by the local citizens (*IGRR*, IV, no. 1179).

Dedication to Septimius Severus (no. 1180).

Tetrarch dedication nearby (*see* under LARISSA).

CYME (Nemrut Köy)

Ref.: Magie, p. 906.

A dedication to Tiberius, after the earthquake, ca. A.D. 34 to 35, was found in a round building with a veiled head of Augustus (in Istanbul) and heads or statues of local genii or heroes and female personifications (Magie, p. 1359). There must have been a shrine to Tiberius, the Julio-Claudians, and the gods of the city (see S. Reinach, *RA* 11 [1888] 85f., 383, pl. XV; *CIL*, III, no. 7099). Tiberius was certainly honored with a statue (*IGRR*, IV, no. 1739; cited by Inan-Rosenbaum, p. 45).

Altar to Hadrian, Olympian, A.D. 129– (*IGRR*, IV, no. 1301).

Between CYME and MYRINA

Statue of Nero, son of Germanicus, perhaps at the time of Caligula (*IGRR*, IV, no. 1300).

ELAEA or ELAIA (Zeytindağ)

Ref.: *IGRR*, IV.

Milestone, on the road from Ephesus, to Vespasian, A.D. 75, in the vicinity of Elaea (no. 267).

Dedication of an altar to Hadrian (no. 268).

Milestone(?) to Gordianus III, on the Smyrna–Pergamon road, in the vicinity of Elaea (no. 269).

LARISSA

Ref.: Keil, von Premerstein, I, 92ff.

Statue base(?) to Maximinus II Daza, with

Constantinus I and Licinius mentioned as Augusti (or the last as Caesar), A.D. 311 to 313 (no. 198; *RA* 1909, II, 507, no. 195).

MYRINA (Aliağa Çiftliği)

Refs.: *IGRR*, IV; Magie, p. 1334.

Dedication to Augustus and Pax suggesting the completion of the Ara Pacis Augustae in 9 B.C. (no. 1173).

Altar to Hadrian, A.D. 129– (no. 1174).

Dedication to Gordianus III (no. 1175).

TATEIUM

Dedication to Hadrian, and Sabina as Nea Hera from the town (*IGRR*, IV, no. 1492).

TEMNUS

Bilingual milestone on the road from Smyrna to Pergamon, to the Tetrarchs (*IGRR*, IV, no. 1385).

LYDIA

ACRASA or ACRASUS

Ref.: Magie, p. 979.

Dedication in Latin to Septimius Severus, and (on the left) in Greek to Tacitus from the Boule and the Demos, evidently a milestone (*IGRR*, IV, no. 1163).

APOLLONIS (near Palamut)

Ref.: Magie, p. 981.

Statue base or, more likely, a building dedication to Livia after A.D. 42, or Julia Domna (Keil, von Premerstein, I, 45ff., no. 98; *IGRR*, IV, no. 1183).

Balidje (*see* THYATEIRA)

Town inscription in the name of Elagabalus (*IGRR*, IV, no. 1287).

BLAUNDUS (Sülünlü)

(This city was almost exactly on the border between Lydia and Phrygia.) Refs.: Keil, von Premerstein, II, 144ff.; *IGRR*, IV; Magie, pp. 1001f.

Dedication (perhaps a statue) to Tiberius Caesar Augustus (*IGRR*, IV, no. 714).

Building possibly dedicated to Claudius, a temple put up together with a stoa by wealthy local Romans; epistyle blocks are very damaged. The temple had Ionic columns and a maeander ornament in the frieze (see also *CIL*, III, no. 361).

Dedication in the name of the people to Titus Augustus and the native gods (*IGRR*, IV, no. 715).

Dedication to Antoninus Pius and family, from Flavia Magna (no. 716).

CAESAREIA TROCETTA

Ref.: Keil, von Premerstein, I, 12.

Bilingual inscription from a building (stoa?) dedicated to Vespasian (or Titus) and gods (Keil, no. 17; *IGRR*, IV, no. 1495).

Stele, perhaps an altar, to Domitian, A.D. 86, with damnatio. As COS XII with Servius Cornelius Dolabella Petronianus (Keil, no. 19; *IGRR*, IV, no. 1496).

Dedication to Antoninus Pius, from the otherwise unknown deme(?) of Selindus (*IGRR*, IV, no. 1497); Inan-Rosenbaum term this a statue base (p. 48, no. 13).

DUREIOUCOMA or DARIUCOME

Statue of Hadrian; the inscription is incomplete (*IGRR*, IV, no. 1353).

HERMOCAPELIA

Ref.: Keil, von Premerstein, II, 59ff., no. 123ff.

Base for the colossal statue of Septimius Severus, as Germanicus (no. 123).

Base dedicated to Constantinus I and his three sons (A.D. 333–337), reused under Honorius (A.D. 393–423) (no. 124; Robert, *Carie,* pp. 365ff., cited under no. 189).

HIEROCAESAREIA

Small base to Septimius Severus.

Column found at Bey Oba, a milestone(?) in Greek, set up by Thyateira in the rule of Carus and Carinus, A.D. 282 to 283, on the road from Thyateira to Sardes (Keil, von Premerstein, I, no. 121; *IGRR*, IV, no. 1305).

HYRCANIS

Statue of Antoninus Pius, the base once thought to be that of Caracalla, in the name of various local magistrates and evidently of major proportions (*IGRR*, IV, no. 1354). For the alteration in identification, see L. Robert, *Hellenica* 6 (1948) 17; Inan-Rosenbaum, p. 48, no. 12 as opposed to p. 51, no. 12.

Dedication to Trebonianus Gallus and Volusianus (*IGRR*, IV, no. 1487).

Jaja Keui or Yaya Köy

Statue of Tranquillina, probably from Hermocapelia or Thyateira (*IGRR*, IV, no. 1164; Magie, p. 1564).

Dedication to Tacitus on a milestone on the road between Thyateira and Pergamon. The Tetrarchs appear on the same stone (no. 1165).

JULIA GORDUS

Refs.: J. Keil, A. von Premerstein, I, 68ff.; *IGRR*, IV.

Dedication with the name of Domitian (*IGRR*, IV, no. 1297).

Statue of Trajan, from the Demos (no. 1293).

Stoa and porticoes complex dedicated to the gods and Commodus, by the family of Poplius Aelius Prontonianus, A.D. 180 to 190 (Keil, von Premerstein, nos. 145f.; *IGRR*, IV, nos. 1294, 1295). This agora was begun in 177 to 180, during the joint rule of Marcus Aurelius and Commodus; columns and epistyle were found. Other local officials had been in on the initial construction.

Kenes (on the road from Mermere to THYATEIRA-Akhisar)

Milestone to Gordianus III, 238 to 239, number four from THYATEIRA to SARDES (*IGRR*, IV, no. 1315).

Kula

Dedication of a relief to Caligula and Germania, now in Trieste; man on horseback, and woman, commemorating Caligula's German war in folk-art style (*IGRR*, IV, no. 1379; *AM* 13 [1888] 18–21).

Column (milestone?) with Greek inscription to the Tetrarchs, A.D. 299 to 302, and Latin inscription to the family of Constantine, A.D. 323 to 326 (Keil, von Premerstein, I, 83, no. 182; *IGRR*, IV, no. 1380).

MAGNESIA AD SIPYLUM (Manisa)

Refs.: Keil, von Premerstein, I and II; *IGRR*, IV; Magie, p. 976.

Altar to Claudius, A.D. 43 to 46 (*IGRR*, IV, no. 1331). It may have been connected with the regulation of the water supply in the region of the lower Hermos (see Magie, p. 1401 and refs.).

Statue of Claudius, dedicated by the town of TYANOLLUS (*IGRR*, IV, no. 1332; Magie, p. 1402).

Statue base of Trajan, 102 to 117, reused in Tschessingir–Djami (Keil, von Premerstein, I, no. 3; *IGRR*, no. 1333).

Inscription mentioning two emperors, probably Marcus and Lucius (*IGRR*, no. 1334).

Statue bases to Septimius Severus put up for the Demos or Polis by city magistrates (*IGRR*, nos. 1335, 1336, 1337).

MAEONIA

Ref.: Keil, von Premerstein, II, 78ff.

Base of a statue to Lucius Verus, A.D. 163 to 166; he is called Armeniacus and Neos Dionysos, suggesting the latter date, on his triumphal return (Keil, von Premerstein, p. 79, no. 165; *IGRR*, IV, no. 1374; Magie, p. 1532).

Monghla

Base of a statue to Tiberius, from the Demos (*IGRR*, IV, no. 1288).

MOSTENE

Refs.: *IGRR*, IV; L. Robert, *BCH* 53 (1929) 535.

Dedication to Tiberius, A.D. 31, a monument in connection with restoration of the cities after the earthquake (no. 1351; Magie, p. 1359).

Statue of Claudius or Nero (no. 1347).

NACRASA

Ref.: Magie, pp. 972ff., 979.

Statue of Hadrian, erected by the Boule and Demos of the "Macedonian" colony (*IGRR*, IV, no. 1160).

NYSA ON THE MAEANDER (near Sultan Hisar)

Refs.: W. von Diest, *et al.*, *Nysa ad Maeandrum*, *JdI, Ergänzungsheft* X, 1913; K. Kourouniotes, *Deltion* 7 (1921–1922) 1–88, 227–246; Magie, pp. 989ff.

Head from a statue of Ptolemy III, diademed, radiate, and wearing aegis; found in the theater and now in Canterbury (*AJA* 63 [1959] 146, pl. 36, fig.).

Priesthood of Tiberius, mentioned in 1 B.C. (Magie, p. 1297).

Statue of Nero (Inan-Rosenbaum, p. 46, no. 9: this may belong at TRALLES).

Statue of Hadrian (*SEG*, I, no. 441, IV, no. 417; Inan-Rosenbaum, p. 48, no. 35).

Statue of Antoninus Pius (*SEG*, IV, no. 408; Inan-Rosenbaum, p. 48, no. 18).

Gerontikon or Bouleuterion

Part of frieze comprised bulls' heads with swags of garlands, and large rosettes or paterae above; cornices and other moldings very elaborately carved in the late Hellenistic or Roman manner.

Commemorative shrines of the Antonine house, sponsored by Iulius Antoninus Pythodorus (*Deltion* 68ff., figs. 55ff.); group of statues and inscribed bases included cuirassed torso of Antoninus Pius (*Berytus* 13 [1959] no. 278; *Berytus* 15 [1964] 107). The date is 146, and statues of Marcus Aurelius as Caesar, Faustina

the Younger, and Lucius Verus as Caesar, A.D. 146 (*Deltion*, 246), also stood in the building, against the walls facing the semicircular seats. See also the various references, Inan-Rosenbaum, pp. 48f.

Base for a colossal statue of Diocletian or Constantine, in the Gymnasium (*JdI, Ergänzungsheft* X, p. 45).

PHILADELPHIA (Alaşehir)

Refs.: *IGRR*, IV; Keil, von Premerstein, I, 24ff.; Magie, pp. 982f.

Statue of Pompey the Great (Inan-Rosenbaum, p. 44).

Statue of Hadrian, from the Demos, A.D. 117 to 128 (*IGRR*, no. 1617; Keil, p. 27, no. 40). Hadrian probably visited the city in A.D. 123 to 124.

Commodus, Aedicula, with Erotes; the names of twenty-two men of the Guild of the Erotes are listed (*IGRR*, no. 1618).

Stele of pedimental shape, with letter from Caracalla in A.D. 213 granting neocorate; dedication on epistyle to Caracalla who appears as founder of a temple of the Augusti (*IGRR*, no. 1619).

Letter of Valerian and Gallienus, to the People (*JHS, Arch. Rep. for 1959*, p. 39; J. Keil and F. Gschnitzer, *Anz Akad Wien* 1956, 219ff.).

Statue base to Constantine the Great, set up after the defeat of Licinius in A.D. 323; recorded at the ruins of the great church (Keil, von Premerstein, p. 28, no. 41).

SARDES (Sart)

Refs.: Keil, Wilhelm, 15ff.; W. H. Buckler and D. M. Robinson, *Sardis*, VII, 1, 176f., index II; *IGRR*, IV, nos. 1502ff.; G. M. A. Hanfmann, *Abh Mainz* 1960, No. 6; G. M. A. Hanfmann, *A Short Guide to the Excavations at Sardis* (New York, 1962); Magie, pp. 974ff.

Herm or bust of Cicero set up near the temple of Artemis by rhetorician Polybios in the second century (*Sardis*, VII, 1, no. 49).

Augustus mentioned or honored in 21 inscriptions. There was a shrine to Augustus (5 B.C.) and a kaisareion to Gaius Caesar (Magie, pp. 1343, 1614).

Conspectus of Imperial Inscriptions: Agrippa, 1. Julia (wife), 1. Gaius Caesar (son), 8 or 9. Tiberius, 2. Germanicus, 1. Drusus, son of Germanicus, 1. Antonia, 1. Caligula, 1. Claudius, 4. Vespasian, 1. Titus, 1. Domitia, 1. Hadrian, 2. Antoninus Pius, 1. Marcus Aurelius, 3. Faustina II, 1. Lucius Verus, 1. Commodus, 3. Septimius Severus, 6. Caracalla, 3. Severus Alexander, 1. Tetrarchs, 4.

Statue of Tiberius, (A.D. 17, after the earthquake (*IGRR*, no. 1502). Each of the city's tribes probably honored him for his generosity (*Sardis*, no. 34; *IGRR*, no. 1503; Inan-Rosenbaum, p. 45).

Statue of Drusus, son of Germanicus (*IGRR*, no. 1504; *Sardis*, no. 35).

Aqueduct completed by gift of Claudius, A.D. 53 to 54, being commemorated by a bilingual inscription: *instante Ti Claudio Demetri f. Quenna Apollophane* (*IGRR*, no. 1505; *CIL*, III, no. 409; *Sardis*, no. 10). Statue, probably at SARDES (*Sardis*, no. 39).

Dedication to Antonia, perhaps part of a memorial to Claudius and family (*Sardis*, no. 37), or a mere conjecture (*AJA* 50 [1946] 394).

Statue of Tiberius Iulius Celsus Polemaeanus, famous native son, about A.D. 82 (*Sardis*, no. 45).

Statue of Antoninus Pius (*IGRR*, no. 1506; *Sardis*, no. 58). Although erected after his death, the titles are as of A.D. 139, suggesting this as the year of the second neocorate.

Fragments of colossal statues of Antoninus Pius and Faustina I (G. M. A. Hanfmann and K. Z. Polatkan, *Anatolia* 4 [1959] 64, note 28).

Statue of Diva Faustina (the Younger), wife of Marcus Aurelius, from Claudius Antonius Lepidus (*IGRR*, no. 1507; *Sardis*, no. 59).

Statue base of Lucius Verus, in the Gymnasium, dedicated to him by Claudius Antonius Lepidus, for the city, A.D. 165 (*Archaeology* 12 [1959] 57f., fig. 7; L. Robert, *REG* 75 [1962] 200f., no. 290; Inan-Rosenbaum, p. 49, no. 3).

Statue of Septimius Severus, with Latin text; pedestal reused in 459 and 535 (*CIL*, III, no. 7105; *Sardis*, no. 71). See also *Sardis*, no. 73, a Greek fragment from Kasaba.

Statue of Caracalla, with the full and flowery titles of the city; from the hall behind the marble court (*BASOR* 177 [1965] 22ff.).

Entrance façade to central room of Building B (Gymnasium), and perhaps whole building, dedicated to Severan family, with Julia Domna as Mater Castrorum and Geta's name erased (*Archaeology* 12 [1959] 283; *Archaeology* 14 [1961] 10f., fig. 13: inscribed entablature over the triple gate).

Possible statue of Severus Alexander (*Sardis*, no. 72).

SARDES-SMYRNA Road

Sixth milestone from SMYRNA, names Aurelianus and his wife Ulpia Severina (C. J. Cadoux, *Ancient Smyrna* [Oxford, 1926], p. 299).

SARDES-THYATEIRA Road

Diocletian and his three colleagues (Maximian, Constantius, and Galerius, the latter two as Caesars) appear on the same inscription, the seventh milestone from SARDES to THYATEIRA and PERGAMON (*IGRR*, no. 1751; *Sardis*, no. 84).

STRATONICEIA-HADRIANOPOLIS (near Siledik, above the plain of Kırkağaç—Indipedium)

Refs.: J. and L. Robert, *Hellenica* 4 (1948) 80ff.; *IGRR*, IV; Magie, p. 978.

Letter from Hadrian to the city on great stele in Manisa (Robert, no. 26; *IGRR*, no. 1156).

Statue of Hadrian, as Olympian and Panhellene, A.D. 129– (*IGRR*, no. 1157).

Construction dedicated to Antoninus Pius (Robert, *Hellenica*, p. 84, no. 27; *IGRR*, no. 1158 ?).

Tekekeui or Tekeköy (near ATTALEIA, in the Pergamene countryside)

Milestone to the Tetrarchs on the road from PERGAMON to MYRINA (*IGRR*, IV, no. 1172).

Tekeli — Mermere Road

Milestone to Constantine and Licinius, between A.D. 313 and 317 (Keil, von Premerstein, I, 45ff., no. 132).

THYATEIRA (Akhisar)

Refs.: Keil, von Premerstein, II, 18ff. "Kaiserinschriften"; L. Robert, *Hellenica* 6 (1948) 70–79; *IGRR*, IV; Magie, pp. 977f.

Dedication to Augustus (Robert, *Hellenica*, no. 23).

Bilingual milestone to Vespasian, mentioning repair of the roads, A.D. 75 (*IGRR*, IV, no. 1193).

Milestone used twice, in Latin and Greek, Domitian, A.D. 92, and Nerva, A.D. 97 (Keil, von Premerstein, no. 30; *IGRR*, no. 1194). Domitian did extensive marking of the roads along the Ionian coast, in Lydia and into Phrygia.

Dedication to Nerva in the name of the Demos, with mention of the Senate and the Roman power (*IGRR*, no. 1195).

Small altar to Hadrian, A.D. 128 to 138 (Keil, no. 31).

Shrine to Hadrian, termed the Hadrianeum (*CIG*, 3491). There was a gymnastic cult (Hadriana Olympia); coins of Valerian record this Agon.

Dedications to Hadrian, all A.D. 129 on, and all like the altar mentioned above (*IGRR*, nos. 1196, 1197, 1198, 1199).

Large statue(?) base to Annius Verus, A.D. 166 to 169; he was the son of Marcus Aurelius and Faustina, and died in his seventh year (Keil, no. 32; *IGRR*, no. 1200).

Statue of Commodus with damnatio, A.D. 180 to 182 (Keil, no. 33; *IGRR*, no. 1201).

Base, small plaquelike fragment, from the Boule and Demos of HIEROCAESAREIA to Septimius Severus (Keil, no. 34; *IGRR*, no. 1202). See also Inan-Rosenbaum, p. 50, no. 17.

Statue, very probably of Julia Domna, rather than Livia Augusta (*IGRR*, no. 1203).

Statue(?) of Caracalla, A.D. 213– (no. 1204).

Statue(?) of Caracalla, A.D. 213– (no. 1205).

Milestone of Elagabalus, A.D. 220 to 221 (no. 1206), the first on the road to SARDES; bilingual and recording proconsular repairs.

Dedication or statue to or of Severus (Alexander?), with full, flowery titles and mention of magistrates known from coins (no. 1207).

Severan Agon: base to Herakles, in the time of Severus Alexander.

Milestone, used twice, in Greek only, to the First Tetrarchy, A.D. 292 to 305 and the three sons of Constantine, A.D. 337 to 340 (Keil, no. 35; *IGRR*, no. 1208).

Between THYATEIRA and HIEROCAESAREIA

Milestone of Gordianus III, A.D. 238 to 239, on the PERGAMON–THYATEIRA–SARDES road (Keil, von Premerstein, I, 45ff., no. 103). Elagabalus, Tacitus, and Diocletian, from the same road.

Milestone of Licinius Senior and Licinius Junior, between A.D. 317 and 323/4 (*ibid.*, no. 104).

TRALLES (Aydın)

Refs.: Sterrett, ASCS *Papers* 1 (1882–83) 113f.; Magie, pp. 991f.

Reliefs from walls of proscenium in theater;

462

Nike, flanking one of the doors, and man holding bridled horse (Mendel, *Catalogue*, II, pp. 51f., nos. 290f.).

Statue of Julius Caesar mentioned in connection with a portent of the victory at Pharsalia (Magie, p. 1258; Raubitschek, *JRS* 44 [1954] 65).

Statue of Claudius (*CIG*, II, no. 2922; cited by Inan-Rosenbaum, p. 46, no. 11).

Priestesses of Agrippina the Younger are mentioned (Magie, p. 1357; *BCH* 5 [1881] 342, no. 2).

Headless inscribed statue of Nero in field cuirass, now in Istanbul (*Berytus* 13 [1959] 43, no. 76).

Dedication to Nerva from Onesimus, at Aydın (Sterrett, pp. 114ff., no. XV).

Head of Commodus as Dionysos, found near the "Great Gate" and now at Canterbury (Dumbarton Oaks *Papers* 15 [1961] 9, fig. 17; *AJA* 63 [1959] 146, pl. 36, fig. 15).

Turgutlu (on the road Manisa to SARDES)
Dedication to Sabina as Nea Hera, perhaps from Sardes (*IGRR*, IV, no. 1492). No. 1492 is described as a dedication to Hadrian and Sabina as Nea Hera, from Tateium near SMYRNA, recorded at Kassaba (*see* under IONIA).

TYANOLLUS
Statue of Claudius (*IGRR*, IV, no. 1332; Magie, p. 1402, discussed in connection with engineering projects on the lower Hermos).

Uludjak
Work carried out in the name of Trajan, A.D. 103 to 105 (*IGRR*, IV, no. 1384).

IONIA

ALMURIS
Dedication by a town of the city to Caligula (*IGRR*, IV, no. 1657).

CLAROS
Statue of Augustus, before his title "Sebastos" (*AJA* 62 [1958] 99).

Titles of Hadrian on the architrave of the temple, Dec. 135 or later (L. Robert, *REG* 75 [1962] 199, no. 283; *idem*, "épigraphie," *Encyclopédie de la Pléiade* [Paris, 1961], p. 44, fig. 5).

CLAZOMENAE (Urla)
Ref.: *IGRR*, IV.
Statue of Tiberius, with Drusus on the right

and Germanicus on the left, A.D. 14 to 19 (perhaps A.D. 18) (no. 1549).

Statue of Claudius, dedicated by a man and his wife who may have been freed by Claudius (no. 1550).

Altar to Hadrian the Olympian, 129 or later (no. 1551).

CLAZOMENAE — TEOS
Milestone on TEOS–SMYRNA road to Diocletian and Maximianus, A.D. 286 to 292 (no. 1552).

Milestone to Tetrarchs and Arcadius, Honorius, and Theodosius, A.D. 402 to 408 (no. 1553).

COLOPHON
Statue of Lucius Verus, 162 to 166 (*IGRR*, IV, no. 1584).

DIDYMA (Yeni hisar)
Temple of Apollo. Ref.: A. Ogan, *Didim'de Apollon Mâbedi Kilavuzu* (Istanbul, 1951).

Base(?) to Hadrian and the Apollo of Didyma (Texier, p. 339).

Inscription referring to temple built by Caligula to himself at MILETUS, in name of the Province of Asia (J. and L. Robert, *Hellenica* 7 [1949] 206–238). He appears to have been honored with a statue (Inan-Rosenbaum, p. 46, no. 1).

EPHESUS
Refs.: F. Miltner, *Ephesos, Stadt der Artemis und des Johannes* (Vienna, 1958), 140 pp., 115 figs., 2 maps.; J. Keil, *Ephesos*, 3rd ed. (Vienna, 1955), guide to site.

Reliefs from a monument to Sulla(?), a round building; two plaques: a warrior with spear, wearing swordbelt and short tunic. Connected with *Sullae Felicis nepos Caio Memmio consule* (*JOAI* 44 [1959] 353ff., Beiblatt).

Statue of Julius Caesar, soon after Pharsalia (Raubitschek, *JRS* 44 [1954] 65 and refs.).

Sanctuary (*tempietto*) of Roma and Augustus, within precinct of Artemision.

Peribolos wall of Artemision, with bilingual inscription to Augustus from Proconsul Gaius Asinius Gallus, husband of Vipsania, in 5 B.C. (British Museum, *Guide to the Select Greek and Latin Inscriptions* [London, 1929], pp. 22f., no. 522; *CIL*, III, no. 6070; Berlin, *Beschreibung der antiken Skulpturen* [Berlin, 1891], pp. 456f., no. 1177).

Agora, double-winged, triple-arched (south) gate of Mazaeus and Mithridates (4–3 B.C.),

EPHESUS (*continued*)

dedicated by these freedmen of Agrippa to Augustus, Agrippa, Livia, and Julia. Foliate-scroll frieze, and statues of the imperial family on the central attic (Keil, *Ephesos*, pp. 80f., fig. 50). The inscriptions were in Greek on the inset central, arched area and in Latin left and right on the wings. Gaius and Lucius Caesars may also have been present, with inscriptions in Latin (*AJA* 50 [1946] 391f., no. 12).

Statue of Germanicus Caesar, with simple bilingual inscription and no titles (*CIL*, III, no. 426).

Two statues of Claudius, one in the agora (Inan-Rosenbaum, p. 46, nos. 5, 6). There may have been a statue of Messalina also (Inan-Rosenbaum, p. 46, no. 1).

A municipal building, a fishmarket(?), was dedicated to Nero and Agrippina (Magie, p. 1422 and refs.).

Statue of Vespasian (*Forschungen in Ephesos*, II [Vienna, 1912], no. 48; Inan-Rosenbaum, p. 46, no. 2).

Statue of Titus (*JOAI* 26 [1930] Beiblatt, cols. 58ff., fig. 26, A.D. 80; Inan-Rosenbaum, p. 46, no. 4).

Temple of Domitian. Altar with reliefs of scene of sacrifice, arms, and shields. The temple was probably erected in honor of Vespasian, but Domitian's colossal statue therein led it to be known popularly as his shrine (Magie, pp. 1433f.). Ephesus had more than one statue of Domitian (*Ephesos*, II, 166, nos. 47, 48; Inan-Rosenbaum, p. 46, nos. 2, 3).

Statue of Nerva (Magie, p. 1450).

Nymphaeum of Trajan, restored under Theodosius. A twice-lifesized statue of Trajan stood over the water channel; the chest and inscribed plinth survive (*JOAI* 44 [1959] Beiblatt, cols. 326ff., fig. 174; Inan-Rosenbaum, p. 47, no. 5). Ti. Claudius Aristion and Iulia Lydia Laterane were responsible, between A.D. 98 and 114. Nerva, clad in himation, was honored on a pedestal (*ILN*, 8 Feb. 1958, 222, fig. 10), but this statue has been shown not to belong (*JOAI* 44 [1959] Beiblatt, col. 332, fig. 175; Inan-Rosenbaum, p. 46, no. 2).

The base of a statue of Trajan was carried off to the British Museum (*Inscriptions in the British Museum*, III, no. 500; Inan-Rosenbaum, p. 47, no. 6).

Matidia the younger, sister of Sabina, a statue

from the *"bule et civitas"* in the ruins of the Artemision (*CIL*, III, suppl., no. 7123).

Propylon, on street east of nymphaeum, going north of Kouretes Street: architrave block, A.D. 114 to 116, records dedication to Ephesian Artemis and Trajan (Miltner, *JOAI* 44 [1959] 346f., fig. 187, Beiblatt).

Statue base to Trajan, in name of the Boule and Demos, about A.D. 112 in proconsulship of Vettius Proculus; dedication proposed by Aristobulus, Asiarch and Grammateus of Ephesus (British Museum, *Guide to Inscriptions*, p. 28, no. 500).

Library erected in honor of Ti. Julius Celsus Polemaeanus, Proconsul of Asia about A.D. 106 to 107 (*see* under SARDES), by his son Ti. Julius Aquila Polemaeanus, Consul suffectus in 110 (Magie, p. 1445 and bibl.).

Temple and Gate of Hadrian: restored under Theodosius (inscriptions in Texier, *Description*, p. 284). Diocletian put up Tetrarch monument in front of temple with bronze statues on columns; inscriptions in Latin and by Proconsul Iunius Tiberianus (Miltner, *JOAI* 44 [1959] 85f., no. 20, Beiblatt; Miltner, *Ephesos*, pp. 52ff., no. 11, fig. 43).

Statue of Theodosius, father of Theodosius I, set up before temple of Hadrian where Galerius had stood. Plaque (Miltner, fig. 90) built into frieze of temple is Theodosian, dated 383 to 393. Three others are early third century. There are scenes of founding of the city, gods and goddesses. The Ephesian Artemis is flanked by the heroized deceased, and by Theodosius I, the empress, and Arcadius (*JOAI* 44 [1959] 269ff., 287, fig. 133, Beiblatt; Miltner, *Ephesos*, pp. 52ff., no. 11, fig. 43; N. Saporiti, *Essays in Memory of Karl Lehmann*, [New York, 1964], pp. 269–278).

Statue of Hadrian, in the year 118 (*JOAI* 25 [1929] 15f., Beiblatt). Other statue bases have been found at various places about the city (see Inan-Rosenbaum, p. 47, nos. 15, 17).

Statue of Sabina, perhaps after her death (Magie, p. 1475). Inan-Rosenbaum list five statue bases (p. 48, nos. 1–5).

Reliefs from the great Antonine altar, now in Vienna.

Two statues of Antoninus Pius (Inan-Rosenbaum, p. 48, nos. 8, 9; citing *Ephesos*, II, 167f., nos. 49, 50).

Statue of Marcus Aurelius (Inan-Rosenbaum, p. 49, no. 3; citing *Ephesos*, II, 167, no. 49).

Statue of Faustina II (Inan-Rosenbaum, p. 49, no. 2; citing *Ephesos*, II, 112, no. 49).

Statue of Commodus (Inan-Rosenbaum, p. 50, no. 1; citing *JOAI* 23 [1926] Beiblatt, col. 265).

Various statues of Septimius Severus, Julia Domna, Caracalla, and Geta (Inan-Rosenbaum, pp. 50f.). At least one of these, at the Council church, was a multiple dedication.

Altar complex to the Severans (Texier, *Description*, p. 283).

Two statues of Gordianus III and one of Tranquillina (Magie, p. 1564 and refs.). One Gordian, a Pupienus as governor of Asia, and Tranquillina all stood in the Artemision (Inan-Rosenbaum, pp. 51f.).

Statue of Tacitus, in the agora (Inan-Rosenbaum, p. 52).

Statue of Constantinus Magnus.

Statue of Julianus II, in the agora (Inan-Rosenbaum, p. 53).

Flying Nike relief, from a Late Antique gate over a road (near meeting of "Katzenkopfgasse" or Khedibashisokak): she flys to right with palm in right hand and wreath in left, and is a Romanized version of a late Hellenistic relief from APHRODISIAS; relief reused in A.D. 368 (Miltner, *JOAI* 44 [1959] 353ff., fig. 194, Beiblatt).

Fountains on east side of street of the Kouretes: (A) North: originally Augustan, and probably restored under Geta; restored again under Theodosius. Statue of Diocletian erected in front of northern basin, and statue of Maximian in front of southern counterpart (contemporary with the four Tetrarchs in front of temple of Hadrian). (B) South: erected in honor of Sextilius Pollio (who built an aqueduct over Dervendere in A.D. 4 to 14) and enlarged under Domitian (it stood on the square with his temple); not restored under Theodosius. First-century sculptures on upper rim of apsidal water basin, Greeks and Amazons(?).

Large circular reservoir (Keil, pp. 102ff.): cuirassed statues from time of original construction, about A.D. 150 to 175, were probably reused for portrait statues of Constantius II and Constans (*Berytus* 13 [1959] 62, nos. 240, 241). They stood between the four columns of one of the side or flanking structures (*JOAI* 15 [1912] 173; *Forschungen in Ephesos* III [Vienna, 1923] 256).

Great theater (Smith, *Catalogue*, III, 185ff.). Sculptural decoration consisted of Athena, Poseidon, a Roman emperor, draped female figures, and several heroic, partly draped and mythological male figures; frieze of satyrs and frieze of Cupids. There was a statue of Septimius Severus (Inan-Rosenbaum, p. 50, no. 7; citing *Ephesos*, III, no. 51). Julia Domna, Caracalla, and Geta were honored with statues, evidently on the same stylobate. There was a dedication to Diocletian in Latin.

Odeon, dedicated between 138 and 161 by P. Vedius Antoninus and his wife Flavia, contained statue of Lucius Verus in heroic nude: lower half with inscribed base in British Museum; trunk lost in shipwreck; head once in Smyrna, Evangelical School. See Inan-Rosenbaum, p. 49, no. 3. Letter from Antoninus Pius to Council and People, A.D. 140 to 144; inscription was on proscenium (British Museum, *Guide to Inscriptions*, no. 489). Letter from Hadrian (*ibid.*, no. 488), whose statue was also there (see Inan-Rosenbaum, p. 47, no. 16). Fragment of a second heroic statue could have been Marcus Aurelius, or Antoninus Pius.

Gymnasium and peristyle, originally built under Domitian; baths connected with it were rebuilt at the end of the second century (Magie, p. 1444).

Large baths, built in second century and rebuilt under Constantius II. The two water basins on the north side were surrounded by the orthostate blocks from the Great Antonine Altar, now in Vienna (see Appendix A, and Keil, *Ephesos*, p. 62).

Aqueduct built by Augustus and Tiberius as Caesar, after A.D. 4 (Magie, p. 1332; *JOAI* 35 [1943] Beiblatt 101f., no. 2). An inscription, perhaps a reused block, is a dedication to Hadrian from the Procurator (of nearly everything in Asia Minor), who seems to be L. Julius Vestinus (*CIL*, III, no. 431). There were other dedications to Hadrian, seemingly statue bases, in connection with the aqueduct (see Inan-Rosenbaum, p. 47, nos. 13, 14).

Harbor gates: there were statues of Septimius Severus, Julia Domna, Caracalla, and Geta in connection with this monument. See Inan-Rosenbaum, pp. 50f., no. 8, etc.; citing *Ephesos*, III, 220, no. 87.

EPHESUS-TRALLES Road

Thirty-first milestone, to Tiberius(?) (Sterrett, ASCS *Papers* 1 [1882–83] 113f., no. xiv).

465

ERYTHRAE (Ildır)

Ref.: *IGRR*, IV.

Statue of Marcus Aurelius, with full genealogy, from the Boule and Demos (no. 1535).

Statue of Lucius Verus, from the Demos (no. 1536). Inan-Rosenbaum (p. 50, no. 4) term this Septimius Severus.

Kassaba (near SMYRNA)

Ref.: *IGRR*, IV.

Dedication to Claudius (no. 1491). It is in connection with work on an extensive water system, probably that of SMYRNA.

Statue of Septimius Severus (no. 1493).

LEBEDUS

Dedication to Constantius Chlorus and Galerius Maximianus (*IGRR*, IV, no. 1583).

MAGNESIA ON THE MAEANDER (Tekir)

Refs.: Texier, *Asie Mineure*, pp. 351f.; Texier, *Description*, pp. 94f.; O. Kern, *Die Inschriften von Magnesia am Maeander* (Berlin, 1900).

Hellenistic altar in front of temple of Artemis Leucophryene.

Statue of Drusilla, as the New Goddess Aphrodite (Inan-Rosenbaum, p. 46).

Statue of Nero (Kern, *Inschriften*, no. 157; Inan-Rosenbaum, p. 46, no. 8).

Statue of Vespasian (*Inschriften*, no. 167; Inan-Rosenbaum, p. 46, no. 3).

Statue of Nerva in front of temple of Artemis Leucophryene, beside altar(?) set up by chief priest in A.D. 98 (see *Inschriften*, nos. 168, 169; Magie, p. 1450).

Fragments of a cuirassed statue (Inan-Rosenbaum, p. 47, under no. 4).

Statues of Trajan (*Inschriften*, nos. 170–172; Inan-Rosenbaum, p. 47, nos. 16–18).

Statues of Hadrian (*Inschriften*, nos. 174–177; Inan-Rosenbaum, p. 48, nos. 30–34). The first is after A.D. 119, and the next two are A.D. 120 or 121.

Statues of Antoninus Pius (*Inschriften*, nos. 183, 184; Inan-Rosenbaum, p. 48, nos. 16, 17).

Statues of Marcus Aurelius, one also set up in front of temple of Artemis by group of priests (see Robert, *REG* 75 [1962] 199, no. 284; *Inschriften*, no. 185, as Caesar, A.D. 139; no. 186, as Caesar; no. 187, A.D. 162; Inan-Rosenbaum, p. 49, nos. 9–11).

Dedications to Caracalla (Magie, p. 1552;

Inschriften, nos. 197, 198); Inan-Rosenbaum term them statues (p. 51, nos. 9, 10).

Statue of Julian the Apostate (*Inschriften*, no. 201; Inan-Rosenbaum, p. 53, no. 3).

METROPOLIS

Ref.: *IGRR*, IV.

Bilingual monument, possibly a statue base, to Augustus (no. 1597; *CIL*, III, no. 7113).

Milestone dedicated to Domitian (no. 1598).

Altar dedicated to Hadrian, as Olympian (no. 1594).

Dedication to Sabina as Nea Hera (no. 1595; Magie, p. 1479).

Statue of Caracalla (Inan-Rosenbaum, p. 51, no. 3).

Tetrarch milestone on SMYRNA–EPHESUS road (no. 1596).

MILETUS (Balat)

Bouleuterion, with so-called heroon in the courtyard.

Ref.: H. Knackfuss, *Milet*, I, 2 (Berlin, 1908), 100ff.

Frieze of the Propylon, about 175 to 164 B.C., with trophies, arms, and armor.

Honorary inscription to Augustus, on the wall of the North Hall (no. 5). Another was in the theater (no. 5A).

Statue base of Trajan, after 102, found in the late city wall (no. 17).

Milestones of Trajan and Hadrian, 135 to 136, found 300 yards from the temple (Magie, p. 1451; and no. 20).

Three altars to Hadrian, one outside, two inside the Bouleuterion (nos. 21–23).

Altar to Julia Domna(?) (no. 25).

Baths of Faustina and Gymnasia

Ref.: A. von Gerkan, F. Krischen, *et al.*, *Milet*, I, 9 (Berlin, 1928), 143ff.

Base of statue of Divus Augustus (no. 335), from the Baths of Capito.

Cuirassed statue, from the Museion, perhaps Marcus Aurelius (pp. 100f., no. 4, fig. 115) and possibly pendant to a statue of Faustina II.

Great Nymphaeum Façade

Ref.: J. Hülsen, *Milet*, I, 5 (Berlin-Leipzig, 1919), 53f.

Built by burghers of MILETUS (names missing) under Trajan and in honor of his father. Lower architrave inscription (p. 53) in Latin to Marcus Ulpius Traianus, Legatus of Syria A.D. 76 to 77, Proconsul of Asia 79 to 80;

Vespasian and Titus are mentioned as Divi. Statue bases in Latin to M. ULPIUM TRAIANUM PATREM, and FILIUM IMPERATOREM.

Upper architrave, A.D. 241 to 244, inscription in Greek. Copies of Greek statues include a Muse or nymph, a Silen, an "Electra" type, a hero, Artemis-type Nike, the usual fountain nymph, Venus Genetrix, and so on, some attributed to the period of Gordianus III (Strong, *Art in Ancient Rome*, II, 165).

Delphinion

Ref.: G. Kaiverau, A. Rehm, *Milet*, I, 3 (Berlin, 1914), 381ff.

Letter of Claudius, A.D. 48 (no. 156).

Base for a bronze statue to Seleucus I, in the name of the Demos, a dedication to Apollo (no. 158); the statue may have had its features altered to that of a Roman emperor.

North Market and Port at the Bay of the Lions

Ref.: A. von Gerkan, *Milet*, I, 6 (Berlin and Leipzig, 1922), 100ff.

Hellenistic circular base reused as an altar to Domitian (no. 189). Inan-Rosenbaum call the monument to Domitian a statue base (p. 46, no. 4).

South Market (and area)

Ref.: H. Knackfuss, *Milet*, I, 7 (Berlin, 1924), 148ff., figs. 164f.; Inscriptions, pp. 309ff.

Dedication to Pompey the Great, posthumous(?) (no. 253).

Dedication to Marcella Minor (no. 254).

Statue base to Trajan, after 102, in names of Roman and local officials (no. 226). There were at least three other statues (nos. 227–229). See also *CIG*, no. 2876; Inan-Rosenbaum, p. 47, no. 12.

There were at least three statues of Hadrian (nos. 230–232; Inan-Rosenbaum, p. 47, nos. 20–22), and eight altars (nos. 290–297).

Two statue bases to Antoninus Pius, the second A.D. 154 or 155 (nos. 233–234).

Statue bases to Marcus Aurelius: in A.D. 154 or 155 (no. 235, matching no. 234); in about 169 to 170 (no. 236); after 173 (no. 237); and after 175 (no. 238). The last was perhaps the base of a cuirassed statue for the east niche of the upper story of the front (north side) of the Market Gate. A matching statue of Lucius Verus in the heroic nude was in the west niche, about 178 to 180. The central niche may have had the Tyche or a divinity.

Statue base to Commodus, before A.D. 183 (no. 239).

Statue base to Septimius Severus (no. 240).

A number of imperial letters included one from Macrinus (no. 274).

Temple to Caligula

Refs.: J. and L. Robert, *Hellenica* 7 (1949) 206–238; Magie, pp. 1366f.

Dio Cassius (LIX, 28, 1) reports that Caligula had a temple built to himself by the province of Asia in A.D. 40; an inscription from DIDYMA discusses this.

Sacred Way

Rebuilt under Trajan; arches at either end of the road bore bilingual inscriptions (Magie, p. 1451 and refs.).

NOTIUM

Statue of Trajan (*IGRR*, IV, no. 1654).

PHOCAEA (Foça)

Refs.: A. Salač, *BCH* 51 (1927) 388f.; *IGRR*, IV.

Statue of Julius Caesar (L. Robert, *Hellenica* 10 [1955] 257f., pl. 31, 1).

Fragment of a dedication(?) in the name of Hadrian (no. 9); see also *IGRR*, IV, no. 1319.

Cylindrical altar to Hadrian as the Olympian Zeus, savior and founder of the city (no. 10; *IGRR*, IV, no. 1320).

Decree in honor of the emperors Marcus Aurelius and Lucius Verus, Dec. 161 to Jan. 162, from the people of Phocaea (no. 13).

Statue of Septimius Severus, from the Demos (no. 1321).

PRIENE (Güllübahçe)

Refs.: Th. Wiegand, H. Schrader, *Priene* (Berlin, 1904); C. M. Schede, *Die Ruinen von Priene* (Berlin, 1935); F. Hiller, *Inschriften von Priene* (Berlin, 1906), with numbering used below.

Altar, in front of temple of Athena, probably dedicated to Athena Polias and to Augustus (*Priene*, pp. 120–126). Inscription on altar and architraves of temple dedicated shrine to Augustus, the altar being associated with Hermogenes and dated late in the second century B.C. (*Die Ruinen von Priene*, p. 38).

Statue of Julia, daughter of Augustus, 12 B.C. or later, from the Demos (no. 225). Inan-Rosenbaum note (p. 45) that she is listed as *Thea*.

Small statue of Lucius Caesar (no. 226); this

PRIENE (Güllübahçe) (*continued*)

and the preceding were found on the terrace of the temple of Athena.

Dedication to Tiberius (no. 227); Inan-Rosenbaum (p. 45) term it a statue base.

Base to Diva Drusilla (no. 228).

Statue of Domitian, from a small shrine in the court of the upper gymnasium (no. 229).

Fragments of a gigantomachy, Amazonomachy frieze from the area of the temple, perhaps from a balustrade. The work is later than the temple, perhaps as late as the Antonine period; the frieze is divided between Berlin, Istanbul, and London (Mendel, *Catalogue*, II, 93ff., nos. 338–346; *Priene*, pp. 111f.; Reinach, *Rép. rel.*, I, 229; *Antiquities of Ionia*, IV, pl. XIX).

Statue of Julia Domna, between the years 196 to 212 (no. 230).

SMYRNA (Izmir)

Refs.: C. J. Cadoux, *Ancient Smyrna. A History of the City from the Earliest Times to 324 A.D.* (Oxford, 1926); J. Keil, "Die Inschriften der Agora von Smyrna," *Istanbuler Forschungen* 17 (1950) 54–68; *PBSR* 26 (1958) 178ff.: the "Agora" as possibly a Kaisareion; *IGRR*, IV.

Statue of Tiberius, A.D. 4 to 14, from the Demos (*IGRR*, IV, no. 1391; Cadoux, p. 236; Magie, p. 1360). Inan-Rosenbaum (p. 45) list *IGRR*, IV, no. 1392, as another statue; since the inscription is combined with a dedication to Livia, these statues must be connected with the following.

Temple to Tiberius, Livia, and the Senate, perhaps near the stadium, overthrown in the earthquake of 178 (Cadoux, p. 240).

Claudius may have rebuilt or renovated the theater after an earthquake, but the evidence is based solely on the name Claudius in a doubtful and lost inscription (Magie, p. 1401).

Aqueduct finished by Trajan's father in 79 to 80 (*IGRR*, no. 1411); later repaired by Proconsul L. Baebius Tullus between 102 and 112 (*CIG*, no. 3147; *IGRR*, no. 1412), more than one copy of the inscription being found (Cadoux, p. 254).

Dedication to Titus, A.D. 80, and Domitian, A.D. 83 (*IGRR*, no. 1393).

Bronze statue of Domitian, close to the river Meles (Melas) (Cadoux, p. 251).

Fragment of sima molding from an aedicula

for a statue of Trajan, late 114 and perhaps connected with Parthian wars (Keil, no. 8).

Large base, statue of Hadrian, A.D. 129 or later, as Olympian; connected with the cult of Dionysos Briseus (Keil, no. 9).

Temple to Hadrian, erected on the promontory. Hadrian "gave a million in one day" to Smyrna; city built a corn market and gymnasium (Gregorovius, *Hadrian*, p. 359; Magie, p. 1513). His friend, the celebrated Polemon, lived there; *CIG*, no. 3148 records these great benefactions. The city assumed the surname Adriana and celebrated games (the Olympia Hadriana) with special magnificence.

Two altars to Hadrian, Olympian (*IGRR*, nos. 1394, 1395).

Statue of Hadrian (*IGRR*, no. 1396). Another, as Olympian, was found near the *hieron* of Dionysos at the foot of Mt. Pagus (*BCH* 57 [1933] 308).

Fragment of a relief (Hadrianic?), with Dionysos facing slightly to the left (in Berlin: *Beschreibung der antiken Skulpturen* [Berlin, 1891], p. 359, no. 889); from a frieze similar to the theater balustrade at APHRODISIAS.

Letter from Antoninus Pius on honors for Hadrian as Olympian (*IGRR*, no. 1397).

Inscription to Antoninus Pius and river Hermos, found at Cordelio, and possibly connected with drainage (*IGRR*, no. 1388; Cadoux, p. 272).

Letter from Marcus Aurelius, on the *collegia* (*IGRR*, no. 1399); another with Lucius Verus (no. 1400).

Monumental, molded architrave, with inscription to Marcus Aurelius and Commodus, or the Severan family, from the entrance passage of the west hall of the "Agora" (Keil, no. 2).

Section of a soffitted architrave, without fasciae, probably from a monument honoring Septimius Severus, Caracalla, and Geta (Keil, no. 10).

Letter from Septimius and Caracalla on the Sophists, A.D. 198 to 209 (*IGRR*, no. 1402).

Caracalla granted PERGAMON and SMYRNA permission to dedicate temples to him; worship combined with Roma (Cadoux, p. 291).

Arch from building dedicated to Gordianus III (Keil, no. 3).

Letter from Valerian and Gallienus, A.D. 253 to 260 (*IGRR*, no. 1404).

Head from a colossal statue of the Virgin, represented in the tradition of the heads of Con-

stantine and Constantius in Rome. This head, which appears to come from SMYRNA (or EPHESUS) has been dated about 431 and could come from a half-figure in a niche or a statue over 4½ meters high (W. Haland, "Theotokos. Eine Kolossalplastik aus der Zeit des 3. Ephesischen Konzils," *Robinson Studies*, I, 780–793, pl. 98).

VICINITY OF SMYRNA

Sevdiköy

Milestones to Vespasian, A.D. 75, on road south, one at village, another on road (*IGRR*, no. 1486).

Dedication to Gallus and Volusianus, 251 to 253, by the "City of the Hyrcanians," found at Sevdiköy (Cadoux, p. 298; *IGRR*, no. 1487; *see* under HYRCANIS). Also Inan-Rosenbaum, p. 52, no. 1.

Bunarbashi or Pınarbaşı

Milestone to Antoninus Pius at Bunarbashi, to the east and on the road to SARDES, reused with Latin inscription to Diocletian and Maximianus (Cadoux, p. 301).

Milestone once at Bunarbashi, in names of Crispus, Constantinus II, and Licinius II Caesars (317–323) (Cadoux, p. 302).

Tepejik-Burnabat or Tepecik

Extensive overhaul of roads by imperial authority under Tetrarchs, A.D. 293 to 305. Thus, milestone near Tepejik (one mile from SMYRNA) to two Augusti and two Caesars; another west of Burnabat (five miles from SMYRNA) to the same (Cadoux, p. 301).

Hajilar or Hacılar

Milestone to the Severans and Aurelian, no. VI on SMYRNA-SARDES road, at Hajilar, reused to Diocletianus and Maximianus, in Latin (*IGRR*, no. 1482).

Menemen

SMYRNA-PERGAMON road at Menemen: inscription at eighth mile from SMYRNA to Tetrarchs; a fragment in Latin also to the two Caesars (Cadoux, p. 301).

TEIRA

Ref.: *IGRR*, IV.

Dedication to Trajan (no. 1660).

Dedication to Marcus Aurelius, A.D. 170 to 175, in the names of local men of means (no. 1662).

Vicinity of TEIRA

Dedication to Hadrian the Olympian (no. 1661).

Büyük Katefkès

IMP CAESAR AVGVSTVS FINES DIANAE RESTITVIT, and in Greek (*IGRR*, IV, nos. 1672, 1673).

TEOS

Refs.: *IGRR*, IV; *BCH* 49 (1925) 309f.; two large architrave fragments, one of an Ionic portico, with inscriptions to emperors.

Statue of Titus (no. 1559).

Base of a statue of Nerva, A.D. 96; reused in Byzantine times and from the area of the temple (*BCH* 49 [1925] 311).

Dedication to Hadrian (no. 1560), who probably restored the temple of Dionysos (see Magie, p. 1480; Robert, *Hellenica*, III, 86f.).

Dedication to Antoninus Pius (no. 1561).

Statue of Faustina II (no. 1562).

TOLOKAISAREA

Baths and market dedicated to Hadrian (*IGRR*, IV, no. 1607).

PHRYGIA

ACMONIA (Ahatköy)

Refs.: *MAMA*, VI (1939) xvii, 89ff.; Ramsay, *Cities*, I, 2, pp. 621ff.; *IGRR*, IV (Ahat).

Hamilton saw a fragment with a giant from a gigantomachy.

Two separate inscriptions on a building or buildings with dedications to Nero, perhaps a tomb complex, built by Julia Severa and her descendants; there were "porticoes and other amenities" (*MAMA*, pp. 93f., under no. 254).

Altar to Britannicus, at Ahat (*MAMA*, p. 92, no. 250); his dedications are rare (cf. Lydia, SARDES).

Fragments of inscription, after A.D. 84, on a monumental gateway, probably to the marketplace, to Vespasian, Titus, and Domitian by M. Clodius Postumus, who was probably a Roman official and perhaps a citizen (*MAMA*, pp. 92f., no. 251; Ramsay, no. 538).

Architrave fragment, not connected with previous, in cemetery of Ahat (*MAMA*, no. 253).

Dedication to Dionysos and Hadrian as Olympian, 129 or later; it indicates a stoa was built (*IGRR*, no. 640).

Votive to Hadrian Augustus(?) (*MAMA*, suppl., p. 148, no. 150a*; Ramsay, no. 612?).

ACMONIA (Ahatköy) (*continued*)

Septimius Severus Augustus, by the city of DIOCLEIA (*MAMA*, suppl., p. 149, no. 161a*; Ramsay, no. 615).

Altar to Dionysos and to Severus Alexander, at Emiraz (*MAMA*, p. 89, no. 240; Ramsay, no. 541; *IGRR*, no. 641).

Dedication to Constantinus and Licinius, in Latin, and Crispus, Licinius II, and Constantinus II in Greek, A.D. 317 to 323 (Ramsay, nos. 608, 609).

AEZANI (Çavdarhisar)

Ref.: *IGRR*, IV.

Statue of Claudius, by his temple-wardens (*IGRR*, no. 558; Magie, p. 1402).

Altar to Claudius in connection with the statue (no. 559); Inan-Rosenbaum (p. 46, no. 3) list this under Britannicus.

Letter, A.D. 50, with praise of Nero and Agrippina (no. 560).

Games in honor of Claudius; there was a neocorate of Claudius and Britannicus (no. 584; Magie, p. 1401).

Altar to Hadrian, with cognomen of the Aezani Apollo (no. 562); Inan-Rosenbaum term this a statue base (p. 48, no. 36).

Statue of Sabina (no. 563; Inan-Rosenbaum, p. 48, no. 6).

Hadrianic and Antonine correspondence inscribed on walls of temple of Zeus (Texier, *Asie Mineure*, pp. 402f.; Texier, *Description*, I, 103; *IGRR*, nos. 571, 573, 575, 576).

Statues and dedications to Marcus Aurelius and Lucius Verus on their accession in 161, set up by a local of importance (no. 564).

Dedication to Commodus (no. 565).

Letter from Septimius Severus, giving his full "genealogy" from all the Antonines, A.D. 196 (no. 566).

Statue of Septimius Severus or Caracalla, in connection with the cult of Jupiter and from an archon (no. 567; Magie, p. 1552). See also Inan-Rosenbaum, p. 51, nos. 16, 17.

Statue of Geta (Inan-Rosenbaum, p. 51, no. 5; citing *CIG*, III, no. 3841d, suppl.).

Dedication to Diocletian, from Aurelius Eumenos Merogenos Apollinarios (no. 568).

AMORIUM

Statue base to Commodus, found in the vicinity (*IGRR*, IV, no. 550; Inan-Rosenbaum, p. 50, no. 6).

ANCYRA

Cult of Augustus and Livia described by tablets on doors of shrine; there was a temple of Apollo in this connection (*IGRR*, IV, nos. 555, 556).

APAMEIA

Refs.: *MAMA*, VI (1939) pp. xv, 64ff.; *IGRR*, IV; Magie, pp. 983f. (Dinar).

"Basis," A.D. 65/66 to 69, evidently a statue, to Vespasian (*MAMA*, p. 67, no. 177).

Pair of statue bases, part of a Trajanic cult group (nos. 178, 179); they are to Marciana, 105 to 115 (*IGRR*, no. 774), and Matidia, 107 to 117 (*IGRR*, no. 775; Ramsay, *Cities*, pp. 457f., dates it perhaps A.D. 105).

Inscription to Plotina, about 108 to 122, in the name of the Boule and Demos, from Marcus Attalus, who was in charge of the agora (*MAMA*, p. 145, no. 96; *IGRR*, no. 773; *BCH* 17 [1893] 313, no. 7). The monument was a statue (Inan-Rosenbaum, p. 47, no. 2).

Altar (bomos) to Marcus Aurelius and Lucius Verus or Commodus, 161 to 167 or 176 to 180 (*MAMA*, p. 70, no. 183).

Inscription to Salonina, evidently a statue and related to the following (*MAMA*, p. 145, no. 97; *IGRR*, no. 777; *BCH* 17 [1893] 304, no. 3; Ramsay, *Cities*, no. 284).

Inscription to Cornelius Saloninus Valerianus Caesar, 257 to 259: dedications or statues to two sons of Gallienus as Augusti; in the first year the younger became Augustus, and in the second the elder was killed (*IGRR*, no. 776).

Maximianus Augustus, 305 to 311, probably one of a group (*MAMA*, no. 99; Ramsay, no. 287; *CIL*, III, no. 364; Hamilton, no. 192).

Galeria Valeria Augusta (*MAMA*, no. 100; *CIL*, III, no. 13661).

Iovianus, A.D. 363 to 364, evidently a milestone, and another on the road here, at Tralla, coming from PHILADELPHIA (*MAMA*, no. 101; *CIL*, III, suppl. no. 7054; *BCH* 7 [1883] 309; Ramsay, no. 288).

APOLLONIA (SOZOPOLIS), in eastern Phrygia or northwest Pisidia

Refs.: *MAMA*, IV; *IGRR*, III (fragments in Uluborlu); Magie, p. 1315.

Large pedestal inscribed with Greek copy of *Res Gestae Divi Augusti*, supported statues of Augustus, Livia, Tiberius, Germanicus, and Drusus Junior, about 14 to 19 (*MAMA*, no. 143, fig. 17; Stuart, *Claudius*, p. 30, note; *IGRR*, no. 312). A. Benjamin and A. Raubi-

tschek, *Hesperia* 28 (1959) 68, note, however, that the subscriptions may refer not to the statues themselves, if there were any, but to the altars set up in front of them. Inan-Rosenbaum (p. 45, no. 2) suggest Drusus Senior rather than Junior.

Dedication, possibly statues, from the Demos, on a double base, to Augustus and Tiberius (*IGRR*, no. 694; possibly with APOLLONIA in LYCIA and therefore not here).

Inscription in temenos to the imperial family, mentions shrine of Roma and three equestrian statues of Tiberius with crown princes Germanicus and Drusus Junior; the shrine of Roma was earlier than the cult of the emperors (*MAMA*, p. 48, no. 142).

Pedestal of a statue to "Tiberio" (*MAMA*, no. 145).

Pedestal of a statue of Claudius, or Nero, or Trajan (*MAMA*, no. 144); the inscription was in both Greek and Latin.

Stoa and exedra put up by family of Julia Severa, about A.D. 75; the former had a lengthy inscription.

Statue base of Trajan, A.D. 102 to 114, in the name of the Demos and from a testator whose name is lost (*MAMA*, no. 146; *CIL*, III, no. 6868; *IGRR*, no. 313).

Pillar, east of APAMEIA at summit of ridge leading into valley of APOLLONIA, dedicated by the Council and People of APOLLONIA to the "gods of the march on behalf of the Emperor Hadrian" (*MAMA*, VII, p. ix).

Statue of Septimius Severus, from the Boule and Demos, about A.D. 198 (*MAMA*, no. 147; Anderson, *JHS* 18 [1898] 95f., no. 35).

Milestone to Septimius Severus and Caracalla, 199–208 (*MAMA*, no. 148).

Caracalla, from the Boule and the Demos, (*IGRR*, no. 314).

BENNISOA

Dedication to, or in the name of Trajan, at the altar and shrine of Zeus Bennius; Trajan set up a bomos (*IGRR*, IV, no. 603).

BRUZUS or BROUZOS

Inscription to Septimius Severus, A.D. 199 to 210, by members of the supreme board; the names of three members were added. This was possibly a statue, in the name of the city (Ramsay, *Cities*, I, 2, no. 634; *IGRR*, IV, no. 681).

CIBYRA

Refs.: Head, p. 669; *IGRR*, IV, nos. 898–914; Stark, *Alexander's path*, pp. 191f.; Magie, pp. 1122f. (Horzum).

Dedication to Britannicus, son of Claudius, a statue or building inscription(?) (*IGRR*, no. 898).

Dedication of an altar(?) to Britannicus (no. 899; perhaps the same as no. 898).

A Legatus of Claudius, Q. Veranius, did public works in the emperor's name in Asia about A.D. 43 or later and was honored by the city; he was Consul in 49 (no. 902; Magie, p. 1401 and bibl.).

Long inscription in the theater, recording acts by a local benefactor during the reigns of Tiberius, Caligula, and Claudius (no. 914).

Inscription to Hadrian, in or near theater (Stark, pp. 191f.).

Statue of Aelius Caesar, A.D. 137; the Archons M. Claudius Flavianus and Publius Aelius Orestes were responsible (no. 900).

COLOSSAE

Refs.: *MAMA*, VI (1939) pp. xi, 15–18ff.; Magie, pp. 985f.

There is no modern town on the site of this city, which is on the south bank of the Lykos, southeast of LAODICEIA and near the slope of Mt. Kadmos. Here Hamilton saw architraves, a theater, and other ruins.

Altar to Trajan Augustus (*MAMA*, p. 142, no. 46*; *BCH* 11 [1887] 354, no. 12; *IGRR*, IV, no. 868).

Altar to Hadrian Augustus as Olympian, by a tribunus militium (*MAMA*, p. 142, no. 47*; Anderson, *JHS* 18 [1898] 90, no. 25; *IGRR*, IV, no. 869); Inan-Rosenbaum term this a statue base (p. 48, no. 37).

Pedestal, with inscription in Latin, after 1 May 305 to Constantius Augustus, A.D. 305 to 306, and Galerius (erased) (*MAMA*, p. 15, no. 38, recorded at Honaz).

DIOCLEIA or DIOKLEIA (Ahur Hisar)

Statue of Septimius Severus, probably put up late in his reign by local officials who had served throughout his rule in various capacities (*IGRR*, IV, no. 664).

DIONYSOPOLIS

Ref.: *MAMA*, IV (1933) 95ff. (Sazak).

Stele to Augustus, 27 B.C. to A.D. 14 (pp. 109f., no. 292).

Pedimented stele, about A.D. 90, with name of Domitia Augusta, wife of Domitian (no. 293).

DIOSCOMA

The town was a vicus of the city of SEBASTE. Monument to Philippus I and the imperial cult, perhaps an altar, A.D. 245 to 246 (*IGRR*, IV, no. 635; Ramsay, *Cities*, p. 608, no. 498).

DOCIMIUM (Escekarahisar)

Refs.: *IGRR*, IV; Magie, p. 1002 (Esçekarahisar).

Statue of Septimius Severus, A.D. 199 to 211, from the city (no. 611).

Dedication to the Tetrarchs, 292 to 305, and to Constantine, Licinius, and Constantinus II, 317 to 323, both parts being from the city (no. 612).

DOCIMIUM-ACROENUS Region

Ref.: *MAMA*, IV (1933).

Unfinished block to Marcus Aurelius and Lucius Verus, A.D. 161, at Afion Karahisar (no. 8).

Milestone of Septimius Severus, at Afion (no. 9; *CIL*, III, no. 14,200).

Bilingual milestone to Constantine and family (no. 13).

DORYLAEUM (Eskişehir)

Ref.: *MAMA*, V (1937) 1ff., nos. 1ff.

Head of Demosthenes, in Oxford, Ashmolean Museum.

Block with molding, perhaps from a stoa, to Titus or Antoninus Pius, reused by builders of a mosque in the lower town (*MAMA*, p. 1, no. 1). Compare the similar large structure dedicated at PESSINUS in Galatia to Titus as Emperor (*AM* 25 [1900] 439, no. 64).

Statue of Maximianus, A.D. 285 to 305, from the city and in the name of a local official (*IGRR*, IV, no. 523).

Milestone to the First Tetrarchs, 293 to 305, for repair of roads leading to the south (*MAMA*, pp. 1f., no. 2; see also *BCH* 20 [1896] 116f.).

Inscribed statue bases, set up by various city tribes to the Equestrian Q. Aelius Voconius Stratonicus Acamantius between 212 and 253 (*JOAI* 16 [1913] 73f., no. 8, Beiblatt). Ten or twelve bronze statues on bases 2.50m. high; bases bundled without ceremony into city walls between 253 and 270. Statues presumably melted for military purposes.

DORYLAEUM-AMORIUM Road

Milestone, recorded at Sarısu, of Gallus and

Volusianus, A.D. 251 to 253, no. XII on the road (*IGRR*, IV, no. 534).

EULANDRAE

Dedication, perhaps a statue, to Marcus Aurelius in the name of the Demos, from the imperial administrator of the region (*IGRR*, IV, no. 679).

EUMENEIA

Refs.: Ramsay, *Cities*, I, 2, p. 377; *IGRR*, IV; *MAMA*, IV (1933) 122ff.; Magie, pp. 984f. (Işıklı).

Honor to Germanicus by a group of local officials, probably in A.D. 18 when he was in Asia (Ramsay, no. 201; *IGRR*, no. 723); Inan-Rosenbaum term this a statue base (p. 45, no. 5).

Statue of Marcus Aurelius (*CIG*, III, no. 3884; Inan-Rosenbaum, p. 49, no. 16).

Inscription to Septimius Severus, A.D. 196 (*MAMA*, no. 328). He restored Praesidium of the Camp, through Vitellianus Procurator of Asia, after an earthquake; during this period EUMENEIA was a garrison town.

Geceler (near APPIA)

Ref.: *IGRR*, IV.

Milestone, on the APPIA–ACMONIA road, in the names of Septimius Severus, Caracalla, Geta, and Julia Domna, A.D. 209 to 211 (no. 599). Geta and the "Sebastos" of Caracalla have been erased.

Milestone VI, A.D. 292 to 305, to the Tetrarchs (no. 600).

GOLIS or GOLOI

Ref.: *IGRR*, IV.

Statue dedicated to Claudius by Diodoros Kleandros, a local official (no. 551).

Statue of Hadrian the Olympian, from the pro-imperial Gerousia and local officials (no. 552).

Haidarlar (near APPIA)

Milestone XIII, on the APPIA–ACMONIA road, to the Tetrarchs, A.D. 292 to 305 (*IGRR*, IV, no. 601).

HIERAPOLIS

Refs.: C. Humann, C. Cichorius, W. Judeich, and Fr. Winter, *Altertümer von Hierapolis*, *JdI*, *Ergänzungsheft* IV, 1898; Magie, pp. 987f.; P. Verzone, *Annuario* 39-40 (1961-1962) 633-647; and *Annuario* 41-42 (1963-1964) 371-389 (Pamukkale).

Frieze, with architectural molding, from the

theater, including a Triumph of Dionysos (Humann, pp. 60f., figs. 6f.; Verzone, 1961–62, fig. 24).

Antonine or Severan frieze from the theater, resembling the Zoilos frieze from APHRODISIAS in Caria (Humann, pp. 61f., figs. 8f.): Muse with mask; Dionysos(?); man in short tunic and cloak; man in himation crowning a youth; and (at right) an athlete crowning himself. The Italian mission has discovered new sections.

Bilingual inscription in a "portico," to an emperor once identified as Commodus, Septimius Severus, or Caracalla; towers or gates are mentioned. The emperor involved now seems, without doubt, to be Domitian (*IGRR*, IV, no. 811; *CIL*, III, nos. 368, 7059, 14192[8]). This inscription, from both sides of the northern ceremonial gate, dates between 84 and 86, Domitian's name being erased from in front of his titles. The famous author and administrator Sextus Julius Frontinus was responsible (G. Monaco, *Annuario* 41–42 [1963–64] 409f., figs. 1–3).

Porticus inscription, in Latin and Greek, perhaps to Alexander Severus, A.D. 232, near the gate and agora; the title [PER]SICO is recognized.

Tetrarch milestone with name of Probus (276–282) erased; Diocletian added, 284 to 286; Diocletian and Maximian added in Latin, 292; and Constantius Chlorus and Galerius Maximianus added in Greek (*IGRR*, IV, no. 695).

Cuirassed statue, perhaps of Hadrian, for a bound barbarian remains beside the left leg; from the temple of Apollo (G. Carettoni, *Annuario* 41–42 [1963–64] 428, fig. 36).

Ilyas (MAXIMIANOPOLIS or, more likely, VALENTIA, the pre-Christian name unknown)

Refs.: Ramsay, *Cities*; *IGRR*, IV; G. E. Bean, *AnatSt* 9 (1959) 82.

Statue of Trajan, with full titles; in the name of Flavia Tatia and her connections (*IGRR*, IV, no. 877; Ramsay, p. 334, no. 151).

Statue of Septimius Severus and Julia Domna, on a double pedestal; the dedicator, M. Aemilius Longus, also founded athletic festivals (*IGRR*, no. 878; Ramsay, p. 333, no. 148).

Japuldschan (near Cadi)

Petition, in 244 to 247, from Marcus Aurelius Eglectus, Proconsul, to Philippus I, II, concerning public works in a number of towns; imperial names erased. The petition was in Greek with the imperial reply in Latin (*IGRR*, IV, no. 598).

Karajuk Bazar (on the Carian border near CIBYRA and LAODICEIA AD LYCUM)

Milestone of the Tetrarchs (*IGRR*, IV, no. 884 and extensive bibliography). Karajuk Bazar was suggested as an ancient site: Eriza or Themisonium.

KERAMON AGORA

Refs.: *IGRR*, IV; Magie, p. 1431 (Öksüz Köy).

Dedication to Titus and Domitian Caesars of a propylon in the agora (no. 636).

Mutilated inscription, perhaps to Vespasian (no. 637); Rufilla, the lady mentioned in the previous as wife of the donor, also appears here (no. 637).

LAODICEIA AD LYCUM, in southwest Phrygia

Refs.: *MAMA*, VI (1939) pp. xf., 1–14; Ramsay, *Cities*, I; *IGRR*, IV; Magie, pp. 986f.; T. T. Duke, "The Festival Chronology of Laodicea ad Lycum," *Robinson Studies*, II, 851–857; Deia Sebaste Oikoumenika, Deia Kommodeia, Antoneia Kommodeia, and Antoneia Geteia Olympia. (Near Denizli, which Ramsay suggested as the medieval city.)

Inscription to Titus, son of the deified Vespasian, on the moldings of the stadium, by Nicostratus (N. Revett, *Antiquities of Ionia*, II [London, 1797], pl. XLVIII, pp. 31f.). Nicostratus the Younger, son of Lycias, dedicated it; his son Nicostratus finished the job; and Trajan's father as Proconsul consecrated it. Another nearby inscription, on a pedestal, indicates that the stadium was turned into an amphitheater for Roman gladiatorial shows by the Nicostratus family, late in A.D. 79 (Ramsay, p. 73, no. 4; *IGRR*, no. 845; *CIG*, no. 3935).

Statue base to Titus, A.D. 79, by Nicostratus Theogenes, in connection with the dedication of the stadium (*MAMA*, p. 6, no. 9; *IGRR*, no. 846; Magie, p. 1431).

Votive to Titus, by Nicostratus son of Lycias, also in A.D. 79 (*MAMA*, p. 140, no. 3*).

Blocks of a triple-arched gateway, dedicated to Domitian, about A.D. 88 to 90 by a Proconsul. The inscription identifies these arches with the gates and towers of Tiberius' rebuildings after the earthquakes of A.D. 17 to 19 (*MAMA*, p. 1f., no. 2; Ramsay, p. 74; *IGRR*, no. 847; J. G. C. Anderson, *JHS* 17 [1897] 408).

LAODICEIA AD LYCUM (*continued*)

Domitian's name has been erased (Magie, p. 1441, and parallels in Anatolia).

Large, richly marbled building adjoining the stadium, perhaps a gymnasium, probably dedicated A.D. 123 to 124, to Hadrian and Sabina from the Boule and Demos through the Proconsul Gargilius Antiquis (Ramsay, pp. 47f., inscription p. 72; *IGRR*, no. 848).

Votive to Hadrian and Sabina, about A.D. 129.

Block dedicated to Aelius Caesar, A.D. 136 to 137, and to Hadrian, among the ruins of the big theater (*MAMA*, pp. 2f., no. 3).

Dedication to Antoninus Pius (*IGRR*, no. 849).

Dedication to Septimius Severus, from local officials (*IGRR*, no. 850).

Dedication, or statue, to Julia Domna Augusta (*IGRR*, no. 851; *MAMA*, p. 140, no. 10*).

Building inscription to Julia Domna, on architrave (*AM* 23 [1898] 365, no. 5; *MAMA*, p. 140, no. 11*).

LUNDA

Refs.: Ramsay, *Cities*, I, 245f.; *IGRR*, IV.

Statue of Antoninus Pius, from the official Apollodotus Diodorus, who also strikes coins (Ramsay, no. 86; *IGRR*, no. 769).

Statue to Septimius Severus by the Boule and Demos, A.D. 195 to 199 (Ramsay, no. 84: at Isa Bey; *IGRR*, no. 770).

Milestone IV, on the LUNDA–Pelta road, inscribed to Trajan Decius, with addition of Etruscilla and Herennius, A.D. 249 (Ramsay, no. 87).

MELISSA

Milestone to the Tetrarchs, A.D. 292 to 305, and to the Caesars Crispus, Licinius, and Constantinus II, A.D. 317 to 326 (*IGRR*, IV, no. 750).

MEIROS

Dedication to Gallienus from the cities of PRYMNESSUS and NACOLEIA; the site seems to have had an imperial shrine (*IGRR*, IV, no. 592).

Statue of and dedication to Salonina, from the Kome of Meiros (no. 593).

METROPOLIS or METROPOLITANUS CAMPUS

Ref.: *MAMA*, IV (1933) 40ff.

Base for a statue of Septimius Severus, A.D. 197, by one of two possible dedicators, local citizens (*MAMA*, no. 125; *JHS* 4 [1883] 65,

no. 7; *IGRR*, IV, no. 764; Ramsay, *Cities*, I, 2, pp. 760f., no. 703).

MOTELLA

Exedra and stoa, A.D. 136 to 137, in the name of Hadrian and Aelius Caesar, Zeus Soter, and the Demos, dedicated by Attalus, son of Attalus, Zenon (*IGRR*, IV, no. 751).

NACOLEIA

Ref.: *MAMA*, V (1937) 92ff. (Seyit Gazi).

Dedication to Antoninus Pius by the freedman T. Aelius Aurelius Niger, who put up other monuments (*IGRR*, IV, no. 544).

Marble basis, presumably an altar, to Commodus (*CIL*, III, no. 349; *MAMA*, p. 92, no. 197): "Craterus, dedicating the bomos, on the city's behalf, in Latin, employs a terminology more appropriate to a Roman city." Inan-Rosenbaum (p. 51, no. 18) speak of a statue base to Caracalla.

Marble milestone to Septimius Severus, Caracalla, and Geta, A.D. 198 to 209, in Latin and with Geta Caesar chiseled away; much Severan roadwork was done in this area (*MAMA*, p. 93, no. 198).

Marble altar, A.D. 260 to 261, to Quietus, with a flowery dedication from the city (*MAMA*, pp. 93f., no. 199). (*See* above, under Bithynia, APAMEIA).

Dedication to Julian, as Victor, Triumfator, and Perpetuus Augustus (*CIL*, III, no. 350; *MAMA*, p. xxviii); Inan-Rosenbaum (p. 53, no. 4) list this as a statue base.

NAUS or NAÏS

Ref.: *IGRR*, IV.

One Macer, footing the bill, had a propylaea and stoa inscribed to Nero, who had suffered damnatio; the Demos is also honored in the dedication (no. 712).

Dedication to Domitian, probably an altar, with damnatio, A.D. 88, in the name of the Consul Lucius Minucius Rufus (no. 713).

ORCISTUS

Statue base to Marcus Aurelius, A.D. 172 to 180, by a large group of local officials; at Alikel (*MAMA*, VII, 69, no. 304; *IGRR*, IV, no. 547, evidently the same dedication).

Statue base to Theos Commodus, from the Demos and Gerousia; at Baglitsa (*MAMA*, I, no. 416; *IGRR*, IV, no. 550; *AM* 14 [1889] 91, no. 10).

Rescripts of Constantinus Magnus, A.D. 331,

on a large base with heavy moldings top and bottom (*CIL*, III, no. 7,000).

OTROUS or OTRUS

Refs.: Ramsay, *Cities*, I, 2; *IGRR*, IV.

Statue of Septimius Severus, set up by the archons in A.D. 193; at Kelendres (Ramsay, no. 639; *IGRR*, no. 693).

Statue to "Alexander of Macedon, Benefactor of the City," about 200 to 215 or at some time in the Christian era, the imperial period (*IGRR*, no. 692).

PHILOMELIUM

Ref.: Magie, p. 1313 (Akşehir).

Plaque with reliefs of spearmen led by mounted officers, in two tiers; the style is Romanoprovincial, about A.D. 300 (*MAMA*, VII, 42, no. 204).

PISEA

Statue presented to Septimius Severus from the people of the city through an official (Anderson, *JHS* 18 [1898] 114f., no. 56).

PRYMNESSUS

Ref.: *IGRR*, IV.

Statue of a Roman emperor, either Marcus Aurelius, Commodus, or Caracalla, from the local citizens (no. 671); Inan-Rosenbaum (p. 51, no. 19) list it under Caracalla.

Base to Caracalla, A.D. 198; at Seulun (*MAMA*, IV, no. 11).

Letter of Septimius Severus to the Senate and the people of the city, A.D. 195 (no. 672).

Statue of Septimius Severus (no. 673).

Statue of Julia Domna, set up by Q. Tineius Sacerdos and Domitius Aristaeus Arabianus; at Seulun (no. 674; *MAMA*, IV, no. 10). (*See* under SYNNADA for another Julia Domna set up by these two imperial officials.)

SEBASTE

Refs.: Ramsay, *Cities*, I, 2, pp. 600ff.; *IGRR*, IV; Magie, p. 1334 (Selçukler).

Dedication to Tiberius (*IGRR*, no. 683); Inan-Rosenbaum (p. 45, no. 20) call this a statue.

Dedication to Domitian in 88 to 89 by the local Roman traders, with damnatio (Ramsay, no. 474; *IGRR*, no. 684).

Statue of Marcus Aurelius (*IGRR*, no. 685).

Statue of Caracalla (*IGRR*, no. 686; Magie, p. 1552).

Honorific to Septimius Severus by the board of magistrates (Ramsay, no. 472).

Southeastern PHRYGIA and PISIDIAN Frontier

ALOUDDA, LEONNA Region

Ref.: Ramsay, *Cities*, p. 608

Altar to Tiberius (no. 501).

West Side of Banaz–ova

Ref.: Ramsay, *Cities*.

Altar or similar monument to Nero or Augustus; there are two fragments, and the gap is uncertain (no. 513).

Altar or similar monument to Domitian (no. 511).

Statue of Hadrian, A.D. 119 (no. 515).

Statues of Marcus Aurelius and Lucius Verus, A.D. 167 (Ramsay, no. 516; *CIG*, no. 3865c).

At Salir

Statue of Septimius Severus, A.D. 198 to 209 (*MAMA*, VIII, no. 372).

At Kara Ağaç

Statue base, to Maximus Caesar(?), A.D. 235 to 238, in Latin and from the city of "Cillanis" (*MAMA*, VIII, no. 348).

Miscellaneous Milestones

Refs.: Ramsay, *Cities*, I, 330ff.; *IGRR*, IV; Magie, pp. 1137f.

Augustus built a royal road through his Pisidian colonies in 6 B.C.; Septimius Severus built a system of roads radiating from CIBYRA into Pisidia and Pamphylia.

Milestones of Septimius Severus and his family on the way to Lake Ascania (Burdur); the repairs date about 205 (Ramsay, no. 141, and others; *IGRR*, no. 926, II milestone on CIBYRA–Pisidia road at Sener Mesarlik).

Milestone XX, on CIBYRA–Themisonium road, to Septimius Severus and family; at Hedje (*IGRR*, no. 924). A similar stone was recorded at "Tchamkeui" (no. 925).

Dedication, probably a milestone, to Diocletian and his colleagues (Ramsay, no. 144).

Reg Esalamara District: The southern part of Lake Ascania into Sagalassian territory.

Ref.: Ramsay, *Cities*, I, 336.

Inscription by various Roman magistrates to Nero and family (no. 165).

Dedication to Marcus Aurelius, Lucius Verus (no. 166).

Dedication to the Four Tetrarchs (no. 167).

475

PISIDIAN Frontier of PHRYGIA

Ref.: Ramsay, *Cities*, I, 280ff.

Big imperial estates belonged to the family of Marcus Aurelius, in the Killanian district, descending through his sister well into the third century.

Kılıç (a village just north of the upper end of Burdur Gölü)

Ref.: G. E. Bean, *AnatSt* 9 (1959) 82–84. A detailed map on p. 69 shows the ancient sites and modern towns in the Lake Ascania (Burdur Gölü) to central Pisidia regions.

Dedication of a building, probably to Claudius and Agrippina the Younger; the inscription was lengthy and possibly adorned a stoa of the agora (Bean, no. 27).

Statue of Caracalla, from the Boule and Demos of an unnamed city (Bean, no. 26).

The site is related to that at Ilyas (*see* above).

Three boundary inscriptions of the early part of Nero's reign have been found at Düver, southwest of Lake Burdur. They record the fixing of a boundary between SAGALASSUS and the village of Tymbrianassus (Örenler), an hour north of Düver (G. E. Bean, *AnatSt* 9 [1959] 84–88). This area was evidently also an imperial estate.

STECTORIUM

Statue base to Nerva, A.D. 97; in the turbe of Mentesh-Baba, Mentesh (Ramsay, *Cities*, I, 2, p. 704, no. 640; *CIL*, III, no. 12, 238). The inscription is written in bad Latin; one hopes the statue was better.

Dedication mentions Marcus Aurelius, either with Lucius Verus in 161 to 169 or with Commodus in 177 to 180 (*IGRR*, IV, no. 749).

SYNAÜS or SYNAI (Simav)

Statue of Antoninus Pius, set up in the name of the Boule and the Demos; the man in charge was a frequent Archon named Menandros Asklepides, son of Menekleos (*IGRR*, IV, no. 594).

SYNNADA (Şuhut)

Refs.: *MAMA*, IV (1933), 14ff.; *IGRR*, IV (Shohut Kasaba or Şoğut); Magie, p. 1001 (Suhut).

Pedestal to Theos (Adrianos) Antoninus Pius; at Shohut Kasaba in the bridge over the Kumalai Su (*MAMA*, IV, no. 54).

Building(?) blocks or slabs with dedication in Latin from Verna, a freedman, as Procurator to Antoninus Pius (*MAMA*, IV, no. 55).

Two or three statue bases to Septimius Severus: one after 195 (*MAMA*, IV, no. 56); one from the city (Texier, *Description*, p. 147; *BCH* 17 [1893] 281, no. 82; *IGRR*, no. 697); and, possibly, a third by Aurelius Sanctus and Plautia Agrippina (*IGRR*, no. 699); Inan-Rosenbaum (p. 51, no. 22) list the last under Caracalla's statue bases.

Statue of Julia Domna, set up by the Procurator Q. Tineius Sacerdos and Legatus Domitius Aristaeus Arabianus (*IGRR*, no. 698); *see also* above, under PRYMNESSUS.

Statue base to Caracalla, in 202 under Septimius Severus and after the capture of Ctesiphon (Texier, *Description*, pp. 20f.).

Altar to Zeus Pandemos, Septimius Severus, Caracalla, and Geta; at Şoğut (*MAMA*, VI, 127, no. 370). Two men dedicate various things, including a cornice-architrave, meaning a stoa, and statues.

Statue base to Constantius Chlorus Caesar, A.D. 293 to 305; at Shohut Kasaba (*MAMA*, IV, no. 59; *IGRR*, no. 700).

Milestone of the Tetrarchs and Constantinus I and Licinius; at Altı Hisar. The inscription is in Greek (*MAMA*, IV, no. 58).

TACINA or TAKINA (on Asar hill, near Yaraşlı village and lake)

Ref.: G. E. Bean, *AnatSt* 9 (1959) 89–91. Baths in the name of the Severan family, with Geta's titles rubbed out; Julia Domna is Nea Hera, A.D. 202 to 203 (*IGRR*, IV, no. 881).

TEMENOTHYRAE FLAVIOPOLIS

Ref.: Magie, pp. 999, 1429 (near Uşak). Dedication to Commodus(?), apparently an altar (*IGRR*, IV, no. 613).

TRAJANOPOLIS

Refs.: *IGRR*, IV; Magie, p. 1452.

Statue of Hadrian, A.D. 119 to 120, at the time or just after the city was founded: LOCO CIVITATIS GRIMENOTHYRARIS (no. 623; Inan-Rosenbaum, p. 48, no. 39).

Dedication of an altar to Hadrian, A.D. 130 to 131, in a suburb or deme (no. 624).

Statues of Marcus Aurelius and Lucius Verus, A.D. 166 to 167, in the name of the Polis and from local officials (no. 625).

Statue of Trebonianus Gallus, A.D. 251 to 252, from local officials; the inscription has suffered damnatio (no. 626; Magie, p. 1566).

CARIA

Acharaca

Statue of Nero (*CIG*, no. 2942b; Inan-Rosenbaum, p. 46, no. 5).

APHRODISIAS (Geyre)

Refs.: Mendel, *Catalogue*, II; *ILN*, 18 Dec. 1937, pp. 1096f.; Squarciapino, *La scuola di Afrodisia*; *MAMA*, VIII, 72ff. and full bibliography (Geyre). Also J. M. R. Cormack, *ABSA* 59 (1964) 16–29. K. T. Erim, *National Geographic* (Aug. 1967), pp. 280–294. Most surviving inscriptions are in the city walls.

Asylum decree of Mark Anthony.

Block, with panel, a votive to Augustus Caesar as divine patron (*MAMA*, VIII, no. 431).

Right end of a marble architrave, with pair of ox-heads above and on the right; so and so (mostly missing) is described as Chief Priest of Divus Augustus Caesar (no. 432).

Top of a marble basis, a statue of Tiberius Caesar, son of Divus Augustus, Augustus (no. 434); see also Inan-Rosenbaum, p. 45, no. 13.

Two pieces of marble cornice, and a block with a panel, dedicated to Aphrodite and the Theois Sebastois (nos. 435, 436).

On the seventh and ninth columns of the temple one Eumachos Diogenes had had a dedication carved in *tabula ansata* to Aphrodite and in the name of the people; he is styled "Philokaisar" (nos. 437, 438).

Dedication to Livia (Robert, *REA* 62 [1960] 291; *CIG*, 2815).

Frieze of the Great Ionic Portal, perhaps from an enclosure of the agora (Magie, p. 1361; Jacopi, *MonAnt* 38 [1939] 9f., 209f.; Vermeule, *PAPS* 109 [1965] 372f., fig. 23).

Decree by Caligula renewing privileges of the city (Texier, *Description*, p. 155).

Portrait of Claudius erected jointly by the people and Menander, Chief Priest of Claudius and Dionysos. The base is in the city wall (*CIG*, no. 2739; *MAMA*, VIII, no. 447 and bibl.).

Statue of Nero (*CIG*, no. 2740; Inan-Rosenbaum, p. 46, no. 7).

Molded marble block, part of a lintel(?), dedicated to Aphrodite and Domitian and the houses of the Caesars and the people, in connection with the water supply, from the Priest of Helios and the Chief Priest of Vespasian (*MAMA*, VIII, no. 449).

Three sets of Gigantomachy Reliefs: one from the so-called Gymnasium (see Mendel, *Catalogue*, II, 207ff., under nos. 511–514) and dating from the time of the baths (same workshop as the pilasters and capitals); second set, drawn by Texier, is Reinach, *Rép. rel.*, II, 100, nos. 3–5; and third set consists of mutilated plaques found on the surface by Gaudin in 1904.

Inscriptions mention priests or priestesses of Augusti, Livia as the New Demeter (*vide supra*), the emperor Claudius, the god Titus, the god Nerva. The temple of the Sebasti was outside the city. Statue of Domitian(?).

Hadrianic Figured Pilasters, from the Baths (Tyche reclining right; Demos reclining left: Mendel, *Catalogue*, II, nos. 494, 495). There are diverse subjects on the Figured Consoles: Medusa, Herakles, Perseus, Minotaur, Herakles, Nereid; tradition of Ionic Portal, but even less *Romanità*.

Late Hadrianic Reliefs (Theater Balustrade?) in Honor of Zoilos (*ILN*, 25 April 1959, pp. 712ff.; A. Giuliano, *Annuario* 37–38 [1959–1960] 389–401).

Inscription to Septimius Severus in the Bouleuterion.

Statue of Caracalla, provided for from the bequest of Fl. Attalus, set up during the lifetime of Septimius Severus, from the people and certain magistrates (LeBas, Waddington, no. 1623; *MAMA*, VIII, no. 451).

Statue of Julia Domna, Mater Castrorum (*MAMA*, VIII, no. 452).

Group of a satyr, maenad, and Eros, in Boston, a work of about A.D. 220 (M.F.A., *Calendar of Events*, June–Summer 1962, pp. 2f.).

Decree of Gordianus III, in the theater.

Administrative letter, A.D. 250, from Traianus Decius and Herennius (*MAMA*, VIII, no. 424).

Statue of Salonina, from the city (no. 453).

Inscription by Diocletian and Maximianus in southeast wall of the theater, A.D. 286 (Fellows, *Lycia*, pp. 302ff., no. 16).

Six medallions of period of Constantine the Great, once in SMYRNA, Evangelical School, from a building (*Einzelaufnahmen*, nos. 3204–3208 and text nos. 32f.). Subjects included: Menander; a Philosopher of the "Julian" type (cf. Arndt-Bruckmann, nos. 681–685); a Constantinian youth; a city-goddess like Constantinopolis on coins; a child (a Caesar?); and a woman with a diadem (an Empress?) (Ver-

APHRODISIAS (Geyre) (*continued*)

meule, *PAPS* 109 [1965] 373ff., figs. 24–27).

Inscription over the west gateway (the Trallian Gate) honoring Constantius II and Julian or Constantius Gallus, for the erection of the gate or repair of an earlier one (Fellows, *Lycia,* p. 304, no. 18; *CIG,* no. 2744; Ammian. Marcell., XVII, 7). The inscription dates A.D. 358 to 361, and Flavius Quintus Eros Monaxius as Governor was responsible (*MAMA,* VIII, no. 426, gives bibliography and restorations).

Inscription, inside the west gateway, facing the city, honors Constantius II (Texier, *Description,* p. 159; *MAMA,* VIII, no. 427, gives bibliography and notes that the name Stauropolis was added in an erased area after A.D. 600).

Statue of Valentinianus II, in Istanbul.

Statue of Arcadius (see under Mendel, *Catalogue,* II, 201, no. 506).

APOLLONIA SALBACE, in Caria or southwest Phrygia

Refs.: *MAMA,* VI (1939), pp. xivf., 56ff.; Robert, *Carie,* ch. IV, pp. 231ff.; *BCH* 9 (1885); Magie, p. 1334 (Medet).

"Block" to Nero (*MAMA,* p. 56f., no. 156, pl. 27; *BCH,* 344, no. 27); Robert calls it a statue (p. 276, no. 150, pl. 43, 2). Artemidoros, the son of Artemidoros, is described as priest of the imperial cult, one which developed in the lifetime of Claudius, since only the names (Nero: erased) Claudius Drusus Caesar Germanicus are given.

Statue of the Tyche of APOLLONIA standing, headless, and with cornucopia on left forearm, on molded base; she wears high-girt chiton and ample himation around the waist. It is a good work, probably of the second century A.D. (*MAMA,* no. 159, as in the school at Yerengume).

Statue of Hadrian, 128/9 or 129/30 (Robert, pp. 276f., no. 151).

Statue, dedicated to Commodus between A.D. 185 to 192 (*MAMA,* p. 57, no. 157; *BCH,* no. 28; Robert, no. 152).

Statue of Constantinus, in mosque of Garipköy (Robert, p. 278, no. 153).

ATTOUDA

Ref.: *MAMA,* VI (1939) pp. xiiff., 24ff. (Hisarköy).

Monument erected in the lifetime of Augustus,

about A.D. 3 to 10, to Thea Livia, from Tatius Aristonomos; now at Hisarköy (*MAMA,* p. 25, no. 66).

Monument put up by the city to Marcus Aurelius Lydius, Procurator of the Augusti, about 162 to 180 or in the reigns of one of the sets of coemperors (Anderson, *JHS* 17 [1897] 399, no. 2).

CERAMUS

Probable inscription in honor of Agrippa and Julia (Magie, p. 1340; *JHS* 11 [1890] 128, no. 15).

CIDRAMUS

Refs.: Robert, *Carie,* ch. VI, pp. 337–375; *idem, Villes d'Asie Mineure* (1935) pp. 203–234.

Imperial funerary inscription from KARPATHOS gives testimonia of the city.

Statue to Valerian, 253 to 260, from the city. According to Robert (pp. 365f., no. 189), the base may have been used formerly for an inscription in honor of Otacilia Severa, whose memory was condemned in 249.

CINDYA, near BARGYLIA

Ref.: Magie, p. 907.

Priest of Artemis Cindyas and the emperor Titus mentioned in an inscription (*BCH* 13 [1889] 37f., no. 5).

CYS

Dedication made by Eratophanes of RHODES, who describes himself as the priest of "the god Sebastos and founder of the city of Zeus Eleutherios" (Stuart, *Claudius,* p. 57; A. D. Nock, *HSCP* 41 [1930] 40). There was apparently a priest of Divus Augustus; the date is A.D. 50 (Magie, II, 1333, 1402).

HALICARNASSUS (Bodrum)

Ref.: Magie, pp. 909ff.

Roman trophies, with figures of captive barbarians, may have been set up in the Mausoleum *peribolos* and at nearby MYNDUS (see G. E. Bean and J. M. Cook, *ABSA* L [1955] 92 and note 43; Möbius, *AM* L [1925] 45). One head seems to have worn a Phrygian cap.

Dedication to Augustus as savior of the world and mankind (V. Ehrenberg and A. H. M. Jones, *Documents illustrating the reigns of Augustus and Tiberius,* 2nd ed., 1955, no. 98).

Statue of Tiberius (Inan-Rosenbaum, p. 45, no. 15).

Statue of Drusus Junior (Inan-Rosenbaum, p. 45, no. 3).

Marble shield dedicated to Claudius and Delian Artemis (C. T. Newton, *A History of Discoveries at Halicarnassus* [London, 1862], p. 698, no. 6a).

Statue of Sabina as Nea Hera, rather than Julia, daughter of Titus (Inan-Rosenbaum, p. 46, no. 1; *BCH* 4 [1880] 396, no. 3).

Column (not a milestone?) dedicated to the First Tetrarchs (*CIL*, III, no. 449).

Fragment of the Price Edict of Diocletian (G. Cousin, *BCH* 14 [1890] 108ff., no. 10).

HERACLEIA SALBACE, in Caria or southwest Phrygia

Refs.: *MAMA*, VI (1939) pp. xiv, 33ff., 143f.; Robert, *Carie*, pp. 166f. (Vakif).

Statue base to Lucius Caesar, grandson of Augustus (*MAMA*, p. 144, no. 66*; Robert, no. 47; *CIG*, no. 3953e).

Statue base to Nerva, A.D. 97; the lettering is very good and, presumably, so was the statue (*MAMA*, p. 33, no. 90, pl. 17; Robert, pp. 166f., no. 48).

Statue to Trajan, at Karahisar, probably in A.D. 113 on the occasion of his passage to the Parthian wars and erected by his physician T. Statilius Criton, from a bequest (*MAMA*, p. 34, no. 91, pl. 17; Robert, p. 167, no. 49).

Inscription on statue base to Hadrian, probably dedicated in A.D. 129, in the name of the Demos (*MAMA*, p. 35, no. 92, pl. 17; Robert, no. 51); at Vakif.

Votive monument to Hadrianus Augustus, by T. Statilius who was Prefect of the thirtieth legion (*MAMA*, p. 143, no. 63*).

Marble block from the entablature of a colonnade, probably a stoa or a temple dedicated to the Fortune of Trajan and Hadrian (*MAMA*, p. 35, no. 93; Robert, p. 168, no. 50); at Karahisar.

Milestone used three times in the upper section and once below: above to Theodosius II, Valentinianus III, 435 to 450; to the sons of Constantine as Caesars, 337 to 340; and to Arcadius, Honorius, 395 to 408; and below in the time of the Caesars Constantius, Galerius Maximianus, 292 to 305 (*MAMA*, p. 35, no. 94; Robert, p. 199, no. 123).

Milestone to the First Tetrarchs, in Greek and Latin (*MAMA*, no. 96; Robert, no. 122).

Milestone to Arcadius (*MAMA*, no. 95; Robert, no. 124).

IASSUS or IASUS (Asinkale or Asin Kurin)

Refs.: Texier, *Description*, pp. 138ff.; Magie, pp. 906f.

Column to Germanicus Caesar (V. Bérard, *BCH* 15 [1891] 545, no. 10).

Statue of Antoninus Pius, hailed as the Olympian (A. E. Kontoleon, *BCH* 11 [1887] 218, no. 11: the provenance perhaps not positive, PASSALA being a possibility; Inan-Rosenbaum, p. 48, no. 15).

Exedrae with double row of porticoes between, dedicated to Artemis Astias or Astiadis and to Commodus, by Diocles who built this in memory of his dead son, a stephanophoros.

Dedication to Divus Severus and to Caracalla (*BCH* 8 [1884] 458).

Statue base to Julianus II, with dedicator's name erased (by Christians?) (D. Levi, *Annuario* 39–40 [1961–1962] 580, no. 8).

IDYMA (near Kozlu Kuyu, at the end of the Sinus Ceramicus)

Dedication to Vespasian, giving the city's name (G. E. Bean and J. M. Cook, *BSA* 52 [1957] 69).

KALLIPOLIS or CALLIPOLIS (perhaps at Asar, east-southeast of IDYMA)

Altar to Domitia, wife of Domitian, from the people of the city (G. E. Bean, J. M. Cook, *BSA* 52 [1957] 81f.).

LAGINA (Leina)

Ref.: J. Hatzfeld, *BCH* 44 (1920) 70–100, especially 73, no. 4.

Statue of Nerva, A.D. 96, in connection with restoration of privileges.

Muğla

Statue of Tiberius (Inan-Rosenbaum, p. 45, no. 16; *IGRR*, IV, no. 1288).

MYLASA (Milâs)

Ref.: Magie, pp. 907f.

Altar(?) to the Tyche of Gaius Caesar (Magie, p. 1343; *BCH* 12 [1888] 15, no. 4). Lucius is also mentioned.

Dedication to Claudius by the Senate in the priesthood of Tiberius Claudius Meneitas. Inan-Rosenbaum (p. 46, no. 10) suggest a statue.

Head of Septimius Severus, now in Istanbul (Mendel, II, no. 428?).

Fragments of the Price Edict of Diocletian (*CIL*, III, 2, p. 820).

MYNDUS (Gümüşlük?)

Dedications to divinities, mentioning Trajan (L. Robert, *BCH* 60 [1936] 199f.).

Head with a Phrygian cap, from a monument in the form of a set of trophies (possibly now in Izmir).

PANAMAROS

Statue of Augustus, at the temple of Zeus (*BCH* 12 [1888] 271, no. 56).

PHYSCUS

Head of Livia (recorded in Marmaris).

Circular altar to Marcus Aurelius and Lucius Verus (A.D. 163–164), probably with statues (Robert, *REG* 75 [1962] 203f., no. 298).

SEBASTOPOLIS (Kızılca)

Refs.: Robert, *Carie*, II, 313–336, Imperial inscriptions, pp. 317ff.; Magie, p. 1334.

Statue(?) of Trajan, 116 to 117, perhaps set up by P. Statius Hermas with statue of Nike on the occasion of the Parthian victory; this is an honorary inscription (Robert, no. 168). Inan-Rosenbaum (p. 47, no. 19) list it among the statue bases.

Statue of Severus Alexander. The *curator reipublicae* is also mentioned (no. 169), and there is the (usual) partial damnatio.

Statue of Julia Domna or Mamaea (no. 170), the base being of local, reddish marble; in the name of the Boule and Demos, from local archons who are epimeletes for the erection of the statue. See also Inan-Rosenbaum, p. 50, no. 13.

STRATONICEIA (Eski Hissar or Hisar)

Price Edict of Diocletian, inscribed in Latin on the exterior of the temple (*CIL*, III, 2, pp. 804ff.).

TABAE

Refs.: *MAMA*, VI (1939), pp. xv, 59ff., 145; Magie, p. 1003 (Kale Tavas).

"Honorific" to Tiberius Augustus (*MAMA*, p. 145, no. 91*; *BCH* 14 [1890] 626, no. 29).

THERA (Yerkesik)

Ref.: P. M. Fraser and G. E. Bean, *The Rhodian Peraea and the Islands* (Oxford, 1954), p. 48, no. 47, pl. 12.

Possible fragment of a decree stele or commemorative aedicula in the name of Vespasian, from the Koinon of THERA; the lettering on this section of cornice or lintel is rather crude.

Found just outside village, at Pazaiyeri, with many ancient stones and foundations.

THYSSANUS (On the western side of the Peninsula of Loryma)

Dedication to Domitian and Domitia by Jason (Magie, p. 1427).

There was a large Severan dedication, evidently with statues, to Septimius Severus, Julia Domna, Caracalla, and Geta (Inan-Rosenbaum, p. 50, under no. 18; citing *Sb. Ak. Wiss. Wien*, 175, no. 1 [1913] 52f.).

TRAPEZOPOLIS, in Caria or southwest Phrygia

Ref.: *MAMA*, VI (1939), pp. xii, 22f. (Boh.).

Marble pedestal to Hadrian, by Titus Flavius Maximus Lysias (*MAMA*, p. 22, no. 60; Anderson, *JHS* 17 [1897] 402, no. 8).

Relief of a large eagle flanked by a woman who is Nike, a nymph, or possibly a personification. Inscription gives the name of Apollonios son of Menekratos from PHOCAEA in Ionia. The monument is a curious mixture of Hellenistic funerary decoration and Roman imperial iconography (*MAMA*, p. 22, no. 62, pl. 12; on funerary eagles, see G. E. Bean, *AnatSt* 10 [1960] 62f., note 38).

TYMNUS

Statue of Claudius (*SEG*, XIV, no. 703; Inan-Rosenbaum, p. 46, no. 12).

LYCIA

For cults of the emperor in Lycia, see Magie, p. 1392 and bibl.

ACALISSUS

Statue of Commodus (*TAM*, II, 3, no. 879). (Inan-Rosenbaum note "the base has two sets of marks for feet on the top, and therefore supported two statues, possibly that of Crispina, although she is not mentioned in the inscription" (p. 50, no. 9).

ANDRIACA

Refs.: *IGRR*, III; Magie, pp. 1357, 1375.

Statue of Germanicus, from the Demos of MYRA, hailing him as savior and rejuvenator (*IGRR*, III, no. 715).

Statue of Agrippina Senior, pendant to the previous, ca. A.D. 17 to 18 (no. 716).

Statue of Nero Claudius Drusus; this is perhaps Drusus the son of Tiberius rather than Drusus son of Germanicus; the Demos hails him as patron and rejuvenator too (no. 717).

Inan-Rosenbaum suggest that it is Drusus brother of Tiberius (p. 45, no. 3).

The Hadrianic granary and shipsheds contained statues and inscriptions from the time of the Julio-Claudians (J. S. Reid, *The Municipalities of the Roman Empire* [Cambridge, 1913], p. 364). There were double inscriptions or statue bases to Augustus the savior and to Agrippa, likewise hailed, from the Demos of MYRA (no. 719). There was a statue of Livia as Julia Augusta, after A.D. 14, and as mother of Tiberius (no. 720) and a statue of Tiberius Augustus (no. 721).

Niches in the façade of the granary for busts of Trajan and Hadrian or Hadrian and Sabina (*CIL*, III, nos. 232 and 6738, with sketch). The inscription runs along the outer wall, and the "protomes" are left and right over the arched door.

APERLAE (on isthmus at eastern end of the Bay of Asar)

Ref.: Magie, p. 1376.

Baths were built on the sea, near Aperlae with the inscription honoring Titus and certain legates; senate and people of city and people of their republic constructed this bath and entrance portico from the foundation to the top, A.D. 80. Chief official is Titus Aurelius Quietus, Consul Suffectus in 82, as Legatus, Propraetor (Texier, *Description*, p. 233; *IGRR*, III, no. 690).

Big inscription (and statues?) dedicated by the City to the Tetrarchs, 292 to 305 (*IGRR*, III, no. 691); possibly a Kaisareion.

APOLLONIA

Double dedication (two statues on one base?) to Augustus and Tiberius, from the Demos (*IGRR*, III, no. 694).

ARALISSUS or ARALISEIS

Neocorate. Statue of Commodus with damnatio (*IGRR*, III, no. 656).

ARAXIS or ARAXA (Örenköy)

Ref.: *IGRR*, III.

Statue of Antoninus Pius, from the Boule and Demos (no. 504).

ARNEIS or ARNEAE (Ernes)

Ref.: *IGRR*, III.

Statues of Claudius, Messalina, and Britannicus, after A.D. 44 (Magie, p. 1406).

Statue of Vespasian (Inan-Rosenbaum, p. 46, no. 6).

Statue of Nerva (Magie, p. 1450).

Public works in connection with living or housing accommodations in a gymnasium area carried out by locals in name of Trajan, A.D. 112 to 117 (*IGRR*, III, no. 639).

Dedication to Caracalla (Magie, p. 1552). Inan-Rosenbaum list a statue base (p. 51, no. 23; citing *TAM*, II, 3, no. 764); they cite the same source for a statue base of Geta (p. 51, no. 6).

ARYCANDA (Aruf or Arif, near the Bashgöz Chay or Başkozçay [river])

Ref.: *IGRR*, III.

Dedication, in A.D. 258, to the family of Valerian, Gallienus from the Boule and Demos (no. 643).

Supplication and rescript of A.D. 311 to 312 to Caesars and Augusti Galerius Valerius Maximinus (Flavius Valerius Constantinus) and Valerius Licinianus Licinius, found in the lower part of the stadium and now in Istanbul (Mendel, *Catalogue*, II, 571f., no. 779; *CIL*, III, suppl. II, nos. 12132, 13625b).

BALBURA (Katara)

Refs.: *IGRR*, III; Magie, p. 1377.

Long dedication to Vespasian, Titus, and Domitian, A.D. 84 to 85 (*IGRR*, no. 466).

Letter written in 158 by Antoninus Pius to the Balburians concerning Meleagros, son of Castor, a musical victor (no. 467).

Dedication to Septimius Severus and Caracalla (no. 468). *See also* below, under the modern village of Kozağaci.

Road from BALBURA to OENOANDA

Milestone with inscriptions to Septimius Severus and Diocletian, found at Dont (Magie, p. 1373).

CADYANDA (near Üzümlü)

Ref.: *IGRR*, III.

Public works in honor of Vespasian with (statue or) stone set up in his honor (*IGRR*, III, no. 507; *TAM*, 651).

Another similar stone to Vespasian, in connection with a large Doric temple (no. 508).

Milestone, on road through Lycia to CAUNUS in Caria, to Septimius Severus and Caracalla, found at Üzümlü (*IGRR*, III, no. 509; Magie, p. 1374).

Dedication to Caracalla, a statue; he bears the name and titles of Marcus Aurelius (*IGRR*, III, no. 510; Magie, p. 1552). See Inan-Rosenbaum, p. 49, no. 20.

481

CHIMERA (Yanartaş)

Ref.: Magie, pp. 1375f.

Statue base to Hadrian by town council of Olympus (Stark, *Lycian shore*, p. 169); not surely, the same as the following?

Dedication (altar?) to Hadrian, from the Boule and Demos (*IGRR*, III, no. 752).

COMBIS (Gömbe) (*see also* PINARA)

Ref.: *IGRR*, III.

Double statue base of Julia, daughter of Divus Titus, and Domitia, wife of Augustus Domitianus, A.D. 81 to 91, from the Boule and Demos of PINARA (no. 573).

Statue of Valerian, ca. A.D. 256, from the Boule and Demos (no. 572). Inan-Rosenbaum mention a statue base of Valerian, son of Gallienus (p. 52, no. 2; *TAM*, II, 3, no. 734).

CORYDALLA (Hajjivella, that is; near Haciveliler and Kumluca)

Ref.: *IGRR*, III.

Statue of Marcus Aurelius, from the Boule and Demos (no. 743).

Statue of Septimius Severus, A.D. 210 to 211 (no. 744).

Statue of Caracalla (*TAM*, II, 3, no. 936; Inan-Rosenbaum, p. 51, no. 24).

CYANEAE (Yavi or Ya'u)

Refs.: Head, p. 695; Stark, *Alexander's path*, p. 170; *IGRR*, III.

Arched gate to Hadrian, with inscription and "disc" in relief.

Statue of Antoninus Pius, who did much for the Lycian cities after an earthquake (*IGRR*, III, no. 701).

Letter to the Lycian communities, after A.D. 143, from Antoninus Pius (*IGRR*, III, no. 702).

HEPHAESTION

Statue of Hadrian, A.D. 128 to 138 (*TAM*, II, 3, no. 1172; Inan-Rosenbaum, p. 48, no. 40).

IDEBESSUS

Ref.: *IGRR*, III.

Statue of Divus Commodus, "Savior and rejuvenator of the universe," for the city (no. 644).

Statue of Caracalla, from the city (no. 645; Magie, p. 1552). Inan-Rosenbaum list two statue bases (p. 51, nos. 25, 26; citing *TAM*, II, 3, nos. 828, 829).

Gordian III, from several cities in alliance, a dedication and perhaps a statue (no. 646).

Kozağaci

Statue of Septimius Severus, with full titles relating to his Eastern wars, set up by the town of Toriaion, one of five villages in the territory of BALBURA (G. E. Bean, *BSA* 51 [1956] 156, no. 59; Inan-Rosenbaum, p. 50, no. 30).

LETO or LETOON (about four miles southwest of Xanthus) (Kumluova, Tümtüm)

Refs.: *IGRR*, III; Magie, p. 1384.

Statue of Trajan, A.D. 102, from the city and the Lycian metropolis (*IGRR*, no. 600).

Statue of Hadrian(?) (no. 601; see also Inan-Rosenbaum, p. 48, no. 48).

Faustina II as Augusta, 146 to 176 (no. 602).

LIMYRA and vicinity (Dernek)

Stoa built and dedicated to Domitian (*IGRR*, III, no. 729).

Milestone to Septimius Severus and Caracalla as Augustus, A.D. 198 to 199, showing course of the road along the left bank of the Arycandus and found a few miles north of LIMYRA (*IGRR*, III, no. 730; Magie, p. 1374).

Milestone of Constantine, along western shore of Lake Söğüt (Magie, p. 1374).

MYRA (Demre or Köycik)

Refs.: *IGRR*, III; Magie, p. 1375.

Inscription to Divus Caesar Augustus (*IGRR*, III, no. 722). See the colossal head of Augustus in the Antalya Museum, which appears to be post A.D. 14.

Dedication to Augustus as savior of the world (*BCH* 85 [1961] 90; Ehrenberg and Jones, *Documents illustrating the reigns of Augustus and Tiberius*, no. 72).

Statue of Titus (*IGRR*, III, no. 723).

Statue to a legatus of Titus (*IGRR*, III, no. 724).

NEISA

Statue of Marcus Aurelius(?) (*TAM*, II, 3, no. 738; Inan-Rosenbaum, p. 49, no. 21).

Dedication to Caracalla (Magie, p. 1552).

Monument, dedication to Tranquillina (Magie, p. 1564); Inan-Rosenbaum (p. 52, no. 3; citing *TAM*, II, 3, no. 739) term this a statue base.

OENOANDA (Inceveliler or Injealilar)

Refs.: *IGRR*, III; Magie, p. 1377.

Dedication to Caesar (Octavian) and the Demos by Moles who had been connected with Octavian's cult at Xanthus (Magie, p. 1386).

Altar to Hadrian, a fragmentary inscription (G. Cousin, *BCH* 24 [1900] 343, no. 8; Inan-Rosenbaum, p. 48, no. 41, as a statue base).

Statue of Antoninus Pius, as savior and benefactor of the Kosmos, from the city (*IGRR*, III, no. 483).

Altar to Septimius Severus (no. 484).

OLYMPUS (Delik Taş; Jirali or Çıralı)
Ref.: Magie, pp. 1168f., 1375.

Statue to Hadrian, from the Boule and Demos (LeBas, Waddington, no. 1342).

Statue of Marcus Aurelius, from the Boule and Demos, "in consequence of kind gifts twice" (*IGRR*, III, no. 747). The pedestal was recorded in the doorway of the (a) temple (Fellows, *Asia Minor*, p. 213).

Temple dedicated to Marcus Aurelius (Stark, *Lycian shore*, p. 165).

PATARA (Kelemiş)
Refs.: W. Pars, *Antiquities of Ionia*, III, 85ff.; *IGRR*, III; Magie, p. 1375.

Triple arch at the entrance to the city; principal inscription a dedication from the Demos to Patara the Principal City (Metropolis) of the Lycian League.

Dedication to Vespasian by Sextus Marcius Priscus, over the door to the second chamber of the large bath (*IGRR*, III, no. 659; *TAM* 396).

Statue of Matidia (*TAM*, II, no. 419; Inan-Rosenbaum, p. 47, no. 2; see also under Hadrian, p. 48, no. 42).

Statue of Hadrian (*IGRR*, III, no. 660).

Dedication to Hadrian, Olympian, after A.D. 131 (*IGRR*, no. 661); this is called a statue base by Hicks (*JHS* 10 [1889] 77, no. 29).

Dedication to Hadrian, Olympian (*IGRR*, no. 662).

Base of statue of Sabina Augusta, between A.D. 128 and 136, as Nea Hera (*IGRR*, no. 663; Magie, p. 1479). It evidently stood with the dedications to Matidia and Hadrian (see also Inan-Rosenbaum, p. 48, no. 7).

Inscription on wall of the theater to Antoninus Pius, A.D. 147, by Velia Procula (Fellows, *Lycia*, 416f., no. 169; *IGRR*, no. 664; *CIG*, no. 4283). Fellows gives a full translation of the fascinating, now destroyed inscription.

Group of statue bases or single base with three statues: Marcus Aurelius in the center with Faustina II on the left and Lucius Verus on the right, A.D. 147(?) (*IGRR*, no. 665).

Altar to Lucius Verus, on the way to the Eastern wars (*IGRR*, no. 666; *CIG*, no. 4283b; Magie, p. 1530).

PHASELIS (Tekirova)
Refs.: *IGRR*, III; G. E. Bean, *Belleten* 22 (1958) 77ff.; Magie, pp. 1370f.

Dedication to Vespasian, after A.D. 73 (*IGRR*, III, no. 754). There was a statue (Inan-Rosenbaum, p. 46, no. 7).

Dedication to Domitian (with damnatio), A.D. 93 to 94 (*IGRR*, no. 755). Both this and the preceding are evidently statues, although this at least was inscribed "sur une porte" (V. Bérard, *BCH* 16 [1892] 440f., no. 89).

Temple with Trajan's name and oak and ivy leaves carved on the cornices (Stark, *Lycian shore*, p. 174). There was a statue of Trajan (*TAM*, II, 1189; Inan-Rosenbaum, p. 47, no. 22); Plotina was honored in this fashion (*TAM*, II, 1190; Inan-Rosenbaum, p. 47, no. 3).

Fragment of a building inscription, same as previous and to Hadrian rather than Trajan (Fellows, *Asia Minor*, pp. 211f.). Bérard saw Hadrian's name on a fragment of a large architrave in the theater (p. 443, no. 92).

Series of dedications by various Lycian cities in honor of Hadrian's visit to PHASELIS, probably in A.D. 129 to 130 (see *TAM*, II, 1191–3). Inscriptions from the port record his arrival (*CIG*, nos. 4336, 4337, 4334, 4335 and p. 1157). Dedication to Hadrian, ca. 129, from the city of AKALISUS (*IGRR*, no. 756) and pendant dedication from the city of CORYDALLA, also to Hadrian (*IGRR*, no. 757).

Statue of Hadrian, after 129, by two citizens (no. 758).

Dedication to Hadrian, 131– (no. 759).

Dedication to Hadrian, 131, by the city of PHASELIS (no. 760). There were other dedications by other cities and by private individuals.

Statue base(?) or, at least, dedicatory inscription to Hadrian, with full titles, by Boule and Demos (Bean, *Belleten* 22).

Statue of Antoninus Pius (*IGRR*, no. 761). See also Inan-Rosenbaum, p. 48, nos. 25, 26; they cite *TAM*, II, 3, nos. 1196, 1197, which appear to be this and the following, both as Antoninus Pius.

PHASELIS (Tekirova) (*continued*)
Statue of Marcus Aurelius (no. 762).
Statue of Caracalla (Inan-Rosenbaum, p. 51, no. 27; *TAM*, II, 3, no. 1198).

Road from PHASELIS to ATTALEIA
Milestone of Diocletian, found two hours west of Antalya (Magie, p. 1137).

PINARA (*see also* COMBIS) (Minare)
Refs.: *IGRR*, III; Magie, p. 1375.
Statue of Julia, daughter of Titus (*IGRR*, III, no. 573; Inan-Rosenbaum, p. 46, no. 2). Domitia was likewise honored at the same time.
Statue of Trajan, A.D. 102– , from the Boule and Demos (*IGRR*, III, no. 574).
Statue of Hadrian, from the Boule and Demos (no. 575). Inan-Rosenbaum (p. 48, no. 27) give this as Antoninus Pius.

PYDNAE to XANTHUS
Milestone to the Tetrarchs, 292 to 305, found between the river Xanthus and PYDNAE, on the coast (*IGRR*, III, no. 606; Magie, p. 1373).

RHODIAPOLIS (Eski Hisar)
Statue of Antoninus Pius, from the Boule and Demos (*IGRR*, III, no. 734).

SIDYMA (Todurga)
Refs.: *IGRR*, III; Stuart, *Claudius*, p. 59; Magie, p. 1376.
There was a temple, apparently erected by Q. Veranius, imperial legate under Claudius, probably to all the Augusti (*IGRR*, III, no. 577; Magie, p. 1042).
Dedication to and separate statue of Claudius by two local men. One was Ti. Claudius Epagathus, the freedman, doctor and *accensus* of Claudius, and the other was Ti. Claudius Livianus; they also dedicated a stoa to their benefactor, in their home town (*IGRR*, nos. 578, 579). See also Inan-Rosenbaum, p. 46, no. 17.
Statue of Diva Plotina (died 122) by the Boule and Demos (no. 580).

TERMESSUS MINOR (south of Cibyra, in Caria–Phrygia–Lycia triangle; probably at Asar Kemer near OENOANDA)
Refs.: L. Robert, *REA* 62 (1960) 322f. cites Dessau, 8870; *IGRR*, III, 481; Magie, p. 1377.
City had Sebastophoroi, numbered among the ephebes, as at ATHENS and TANAGRA. Gold, silver, and gilded bronze images of the emperors in the provinces, here and elsewhere, were carried in procession to and from the imperial temple. The custom is mentioned specifically at the outset of Valerian's reign.
Priest of Hadrian is honored (*IGRR*, III, no. 1496).
Priestess of Julia Domna is honored (no. 1497).

TLOS (Düver)
Ref.: *IGRR*, III.
Statue(?) of Augustus put up to the benefactor and savior of the people by the religious officials and the Gerousia (no. 546).
Altar to Domitian, A.D. 85, through P. Vaivius Italicus, Legate and Propraetor (no. 548).
Dedication to Sabina as Nea Hera (Magie, p. 1479). Inan-Rosenbaum indicate a statue base (p. 48, no. 8; after *TAM*, II, 2, no. 560).

XANTHUS (Kınık)
Ref.: Magie, pp. 1372, 1375, etc.
Triumphal gate, arch with inscription, from the time of Vespasian and in the name of Sextus Marcius Priscus as Legatus Propraetor (Fellows, *Lycia*, pp. 409f., nos. 160f.; *IGRR*, III, no. 610; *CIG*, no. 4271). A portion of the triglyphs and metopes (with busts of Apollo and Artemis) are in the British Museum (Smith, *Catalogue*, II, under no. 964).
Dedication to Vespasian on a statue base near the gateway, also dedicated by Sextus Marcius Priscus (Fellows, no. 159; *IGRR*, III, no. 609; *CIG*, no. 4270).
Statue of Trajan (*IGRR*, III, no. 600; Magie, p. 1451).

PISIDIA

ADADA
In the third century A.D. a local benefactor named Hoplon receives a statue in a street just north of the temple of the emperors; he performs sacrifices to the imperial images and offers other celebrations in their honor (L. Robert, *REA* 62 [1960] 320f.; for imperial images in precious metals, at EPHESUS and elsewhere, see also Robert, *Annuaire Collège de France*, 53° *année* [1953] 226ff.; citing and disagreeing with K. Scott, *TAPA* 62 [1931] 101–123). The temple of the emperors may be the hexastyle, Ionic building, with *imago clypeata* in the pediment and with high bases like the Artemision at Ephesus, labeled TRAIANEION on a large bronze of Valerian and Gallienus: M.F.A. no. 63.868; Hesperia

Art *Bulletin* XXV, no. 91; R. E. Hecht, *NumChron* 1964, p. 164.

AGRAE

An epistyle block with DIVO AVGVSTO (*CIL*, III, no. 6869).

ANTIOCH (Yalvaç)

Refs.: D. M. Robinson, *ArtB* 9 (1926) 5ff.; Magie, pp. 1315f.; Levick, *AS* 17 (1967) 101ff.
Round column to IMP CAESAR AVGVSTVS PP (*CIL*, III, no. 6803).
Triple arch of Augustus (Victoriae and genii with garlands; captive Pisidians).
Propylaea, with frieze of marine motifs.
Statue of Drusus (*JRS* 2 [1912] 100, no. 32); Inan-Rosenbaum (p. 45, no. 4) suggest this is Drusus Senior.
Dedication to Domitian (*CIL*, III, no. 6804).
Triple city gate, with inscription of Gaius Julius Asper, Consul in A.D. 212; kneeling Parthians with *vexillum*, standard in central panel (Levi, *Num Notes Monogr.* 123, 1952, pp. 8f.; Robinson, pp. 45ff.).
Statue of Omonoia (Concordia) erected by LYSTRA and TAVIUM in the Severan period (Magie, p. 1320 and bibl.).
Rectangular base to Constantine the Great (*CIL,* III, no. 6805). Buildings also existed.
Dedication to Gratian and his fellow Augusti, in Latin and set up A.D. 367 to 375 (B. Levick, *AS* 15 [1965] 53–62). The inscription is cut on a block with remains of an Antonine or earlier dedication, also in Latin, to a distinguished colonial official.

ARIASSUS

Roman triple gate of the time of Hadrian (Stark, *Alexander's path*, p. 99).

COLBASA to SAGALASSUS

Statue of Hadrian (*IGRR*, III, no. 331).

Yarı-Keuï or Yazı Köy, at the southwest end of Lake Burdur
Dedication to Marcus Aurelius, Lucius Verus, from the city of SAGALASSUS (*IGRR*, III, no. 332).
Dedication to Septimius Severus, Caracalla, Geta (rubbed out), and Julia Domna (no. 333).
Deir or Düver, near the southwest corner of Lake Burdur
Dedication to the Tetrarchs, on the borders of SAGALASSUS (*IGRR*, III, no. 336).

COLBASA to SAGALASSUS

El-Majiik or Elmacık
Statue to Julia Domna, Mater Castrorum, from the Boule and Demos (*IGRR*, III, no. 337); Inan-Rosenbaum (p. 51, no. 21) list this under LYSINIA (*see* below).

On a column, near SAGALASSUS

Dedication as no. 333 (above); Geta seems to have been rubbed out here too (*IGRR*, III, no. 341).

COMAMA (by the fountain of Şerefönü, between Ürkütlü and Garipçe)

Refs.: Ramsay, *Church*, pp. 32f.; G. E. Bean, *AnatSt* 10 (1960) 53–55.
Statue of the Boule, as on coins, set up in imperial times (Bean, no. 102).

Milestone, in the ruins of the city, commemorates roads built by Augustus to connect his Pisidian colonies. One led to OLBASA, COMAMA, and CREMNA; it is called the Via Regalis on the milestone.

CONANA (Goinân)

Statue of Septimius Severus, from the Boule, Demos, and Roman inhabitants (*IGRR*, III, no. 325).

Dedication to Caracalla, a statue (*CIL*, III, no. 6870 = 12,146).

CREMNA (near Gürmeği or east of Bucak; also cited as at Girme)

Refs.: Magie, p. 1317; J. B. Ward Perkins and M. Ballance, "The Caesarum at Cyrene and the Basilica at Cremna," *PBSR* 26 (1958) 135–194.
Epistyle inscription to Nerva (*CIL*, III, no. 6873).

Latin inscriptions record the dedication to the emperor Hadrian and to the Colony of Cremna of a basilica, forum, and exedra, erected by a certain Longus. The inscription appears to have run, in two lines, along the outer face of the east wall of the forum. A second copy apparently occupied the architrave of the forum colonnades (*CIL*, III, no. 6874).

Epistyle fragment, A.D. 196 to 197, to Septimius Severus, Julia Domna, Caracalla Caesar, and Julia Maesa, from the priests of the colony (*CIL*, III, no. 304).

Statue of Caracalla (*IGRR*, III, no. 397).

485

HADRIANI (Gâvur Ören; perhaps on old inhabitation refounded)

Ref.: G. E. Bean, *AnatSt* 9 (1959) 110.

Large statue base of Lucius Verus from the Boule and Demos (Bean, no. 80).

Large statue base of Caracalla from the Boule and Demos (Bean, no. 79).

Kestel

Statue of Caracalla (*IGRR*, III, no. 397; Inan-Rosenbaum, p. 51, no. 38).

LYSINIA (near Karakent on headland near southwest extremity of Burdur Gölü)

Refs.: G. E. Bean, *AnatSt* 7 (1957) 25; G. E. Bean, *AnatSt* 9 (1959) 78–81, with full publication of the inscriptions.

Statue base to Hadrian, inscribed by the Boule and Demos, on the site. The city and a local official are named (Bean, no. 22).

Dedication to Marcus Aurelius as Emperor, from the Boule and Demos in the names of local officials. This is part of a building which may have stood where the stone was found (Bean, no. 23).

Milestone to Constantine and Licinius, the third from Lysinia (Bean, no. 24). Two others from the same road are given (nos. 34, 61).

MILYAS (?) (Melli-Milli or Milli Başköy)

Refs.: G. E. Bean, *AnatSt* 10 (1960) 76f.; *IGRR*, III.

Early Hellenistic walls, theater; mass of ruins, overthrown by earthquake.

Bérard found six statue bases of Roman emperors (*BCH* 16 [1892] 436ff., nos. 70–75). Bean saw only one of these. Inan-Rosenbaum list no. 70 as a statue of Antoninus Pius (p. 49, no. 35).

Dedication to Antoninus Pius, perhaps an altar and hailing him as savior of the universe, in the name of the Boule and Demos (*IGRR*, III, no. 386).

Dedication to Antoninus Pius or Marcus Aurelius (*IGRR*, no. 385 = Bérard-Bean, no. 76), a building.

Statue of Marcus Aurelius, as savior of the universe (*IGRR*, no. 387). See also Inan-Rosenbaum, p. 49, nos. 27, 28, which are Bérard's nos. 71, 72.

Statue of Commodus or (Septimius) Severus (*IGRR*, no. 388 = Bérard-Bean, no. 73).

Statue of Septimius Severus (*IGRR*, no. 389).

Statue, probably of Caracalla (*IGRR*, no. 390; no. 391 may join it).

MOULASSA

A statue(?) of Septimius Severus in the name of the Demos; he is styled savior of the universe (*IGRR*, III, no. 384).

OLBASA (near Belenlü or Belenli)

Round base of a statue to Claudius, A.D. 42 to 43, from the Colonia Olbasena (*CIL*, III, no. 6889).

OSIENI area. (The name of the city east of the Burdur-Antalya road, near Karaot, was probably SIA).

Refs.: *IGRR*, III; G. E. Bean, *AnatSt* 10 (1960) 74f.

Statue of Marcus Aurelius (no. 418).

Pendant statue of Lucius Verus (no. 419); Inan-Rosenbaum (p. 50, no. 39) list this as a statue of Septimius Severus.

Statue of Septimius Severus, also in the name of the Demos (V. Bérard, *BCH* 16 [1892] 435, no. 67).

Caracalla (no. 420).

Geta (no. 421). These were evidently statues also (see Bérard, 435f.).

Many Severan "family" groups with the Antonines in this area.

PEDNELISSUS

Ref.: R. Paribeni, *et al.*, *Annuario* 3 (1916–1920) 73–133, 143–159; B. Pace, 149ff. (inscriptions). These references presuppose that the Roman city near Chozan or Hozan is PEDNELISSUS; extensive Italian exploration and some excavation during the period of Allied intervention (and before) uncovered inscriptions in the impressive ruins of massive Roman architecture, but the city was not named. Others place PEDNELISSUS to the southeast; the inscriptions published by Pace may therefore refer to the unnamed city.

Altar to Hadrian, from the local priest of Zeus; he was also connected with the cult(s) of the emperors (p. 152, no. 87).

Temple dedicated to the Augusti and the patria from local citizens (pp. 154f., no. 93).

Statue base to Nerva, from the Demos (p. 156, no. 97).

Statue base to Trajan, from the Demos. This statue and the preceding may have flanked a gate (no. 98).

Statue base, possibly to Commodus or Sep-

timius Severus (inscription very damaged) (p. 157, no. 99).

POGLA (Çomaklı)

Refs.: *IGRR*, III; G. E. Bean, *AnatSt* 10 (1960) 55–65. The old name of the modern village, Fuğla, seems to derive from the ancient.

Statue of Hadrian Olympian (no. 403).

Architrave mentioning Julia Domna as Mater Castrorum (V. Bérard, *BCH* 16 [1892] 423). Inscription honoring Caracalla and Julia Domna, 213– , evidently statues (no. 404; Magie, p. 1552).

PROSTANNA (near Eğirdir)

Ref.: M. H. Ballance, *AnatSt* 9 (1959) 124–129, with a plan of the site.

One of two marble blocks, evidently once supporting a statue and inscribed to Nero from a retired standard bearer of the XIII or XV Legion. It was found on the acropolis reused in a rough wall not far from a building (C) that may have been a small temple (p. 128, no. 3).

SAGALASSUS (Ağlasun or Ağlason)

Refs.: Lanckoroński, pp. 127ff., 224f. (inscriptions); *IGRR*, III; Magie, pp. 1139f.

Dedication in Latin and Greek to Claudius, A.D. 42, on a square block (statue?) in the ruined buildings of the lower forum (*CIL*, III, no. 6871; *IGRR*, III, no. 344).

Dedication to Nero, as Neos Helios and therefore comparable to his Colossus in Rome (*IGRR*, no. 345); Inan-Rosenbaum (p. 46, no. 14) term this a statue.

Statue of Trajan, from the Boule and Demos (*IGRR*, no. 346).

Statue of Hadrian (*IGRR*, no. 347).

Temple of Antoninus Pius, large like the Trajaneum at PERGAMON and enclosed by temenos wall with propylaion; honorary columns or triumphal arches were within, and there were statues of emperors standing to the west of the building. Inscription to Antoninus Pius, from the first pro-Roman city of Pisidia (*IGRR*, no. 348). The area was an Antonine cult center. For a statue of Antoninus Pius, see also Inan-Rosenbaum, p. 49, no. 37; citing *CIG*, no. 4370.

Statue(?) of Marcus Aurelius Caesar, from the Boule (*IGRR*, no. 349).

Statue of Marcus Aurelius (*CIG*, III, no. 4370; Inan-Rosenbaum, p. 49, no. 31).

Statue of Commodus (no. 350).

Three further dedications(?) to Commodus; Macellum repaired or rebuilt in the name of Commodus (no. 351).

Six-sided statue base under the Propylaea, northwest of the temple of Apollo Klarios, to Septimius Severus. Statue of Septimius with usual titles of the city (no. 352).

Statue of Caracalla, with full titles, A.D. 199– (*IGRR*, no. 353; Magie, p. 1552).

Dedication to Severus Alexander and Julia Mamaea by a priest of the emperor (*IGRR*, no. 354).

Dedication to Gallienus and Salonina (no. 355).

Dedication to the Tetrarchs, A.D. 292 to 305 (*Annuario* 3 [1916–20] 38f., no. 21).

Six-sided statue base on east side of the market to Constantine the Great or Constantine II.

SAGALASSUS Vicinity

Statue of Marcus Aurelius (*IGRR*, III, no. 363).

Dedication to Septimius Severus, Caracalla, Geta, and Julia Domna on a column near SAGALASSUS. Geta was apparently rubbed out (*IGRR*, III, no. 341).

SELEUCEIA SIDERA (CLAUDIOSELEUCEIA)

Statue of Claudius (*IGRR*, III, no. 328; Magie, p. 1406).

SELGE (Serik)

Ref.: Magie, p. 1137.

Statue of Commodus (*IGRR*, III, no. 380).

TERMESSUS MAJOR (Göllük or Güllük)

Refs.: Lanckoroński, II, 21ff.; *IGRR*, III; Magie, pp. 1136f.

Circular altar or statue base, in the temple of Zeus Solymeus; typically Roman scene of sacrifice, with victim, *victimarius*, and two flute players, as on the late Republican bases from Rome. The figures appear to be in Greek costume (Lanckoroński, pp. 48f., figs. 7f.).

Statue of Augustus (?), as savior and restorer, from the Demos (*IGRR*, III, no. 426).

Statue of Trajan (no. 427).

Statue of Hadrian (no. 429). For these dedications, the statue bases, see Inan-Rosenbaum, p. 48, nos. 63–66.

Propylaion of Hadrian with dedication on the architrave (Lanckoroński, pp. 120ff., figs. 92ff.; see *IGRR*, no. 425); a modest, unpretentious little building.

APPENDIX C. WORKS OF ART

TERMESSUS MAJOR (continued)

Altar(?) to Hadrian as Olympian, from the Demos (IGRR, no. 430).

Statue of Commodus, from the Boule and Demos (no. 431). There were two of these: TAM, III, 1, nos. 41, 42; Inan-Rosenbaum, p. 50, nos. 16f.

Statue of Septimius Severus (no. 432).

Statue of Caracalla (no. 433; Magie, p. 1552).

Statue of Constantine the Great (Inan-Rosenbaum, p. 52, no. 7; cites TAM, III, 1, no. 45: A.D. 310–324).

Milestone with inscriptions to Diocletian, and Constantine and his sons, erected by the city and found on the right bank of the Istanos Çay near the crossing of the Taurus (Magie, p. 1138).

Statue of Constantius II, A.D. 324 to 337 (Inan-Rosenbaum, p. 53, no. 3; TAM, III, 1, no. 46).

THYMBRIADIS or TIMBRIADA

Dedication to Hadrian (IGRR, III, no. 329).

TYMANDUS

Refs.: MAMA, IV (1933) 82ff.; Magie, pp. 1314, 1501f.: on the APAMEIA–APOLLONIA–ANTIOCH road (near Yaztu Veran).

Limestone milestone, in Latin, to Hadrian, A.D. 122 (MAMA, p. 85, no. 234).

Pedestal from a statue of Antoninus Pius, A.D. 140; recorded at Senirgent, "on the grave of Haji Arif effendi, donor of the large mosque" (MAMA, pp. 85f., no. 235; IGRR, III, no. 311), perhaps commemorating elevation to the status of polis (Magie, p. 1502). See also E. Legrand, J. Chamonard, BCH 17 (1893) 258f., no. 40; Inan-Rosenbaum, pp. 48f., nos. 19, 38.

Twentieth milestone on the APOLLONIA–ANTIOCH road, at Büyük Kabaja, to Constantine, Licinius I and II, Crispus, Constantinus II, and Constantius II (MAMA, pp. 84f., no. 233).

Yazaköy

Statue of Hadrian (CIG, no. 3956e; cited by Inan-Rosenbaum, p. 48, no. 67).

PAMPHYLIA

ASPENDUS (Balkiz)

Refs.: Magie, p. 1134; G. E. Bean, Jahrbuch für Kleinasiatische Forschungen II, 201ff.

Inscription over each door of the theater in Latin and Greek to the Antonine house. The architect Zenon was also honored (Texier, Asie Mineure, p. 718).

ATTALEIA (Antalya or Adalia)

Refs.: G. E. Bean, "Inscriptions in the Antalya Museum," Belleten 22 (1958) 23ff.; IGRR, III; Magie, p. 1133.

M. Plautius Silvanus, evidently the Consul of 2 B.C., is honored as Legatus Pro Praetore of the emperor Caesar Augustus (Magie, p. 1305 and bibl.).

Large bilingual milestone, to Claudius, A.D. 50, from the procurator M. Arruntius Aquila, who repaired the roads (IGRR, III, no. 768; CIL, III, no. 6737).

Statue of Claudius or Nero (IGRR, no. 769).

Statue base to Vespasian, from the Kale of Antalya, in the name of the Gerousia of ATTALEIA (Bean, p. 23, no. 1).

Priestess of Julia Augusta (daughter of Titus) and Roma (Annuario 3 [1921] 11; Magie, pp. 1431f.). Statue of Julia Titi, in connection with a building (Annuario 3, 16f., no. 7).

Statue base to Hadrian, from the Kale, in the name of the Boule and Demos. He is hailed as savior of the universe, probably at the time of his visit in A.D. 129 (IGRR, no. 770 ?).

Altar to Hadrian, from the Boule and Demos (no. 771). See also Inan-Rosenbaum, p. 48, nos. 49, 50; G. E. Bean, p. 23, nos. 1, 2.

Dedication in gilded bronze letters on the front of the triple-arched gate of Hadrian. This two-tiered gateway had engaged columns and a simple entablature with vine-scroll frieze above (IGRR, no. 772; G. Moretti, Annuario, 6–7 [1923–24] 453–478, esp. figs. 3f.; Lanckoroński, I, 154ff.).

Statue of Domitia Paulina, sister of Hadrian and wife of L. Julius Ursus Servianus, from Julia Sancta (IGRR, no. 773).

Altar to Antoninus Pius, in A.D. 138 (no. 774). A similar slab is now in the Antalya Museum.

Half-lifesized statue of Marcus Aurelius, in sagum, tunic, and boots, with cuirass and helmet supporting his left leg; ca. 175; now in Istanbul (Mendel, Catalogue, III, 600f., no. 1390; Greek Roman and Byzantine Studies 2, 1 [1959] 17f.).

Statue base to Lucius Verus, from the Kale, dedicated by the Boule and Demos (Bean, no. 4).

Statue base to Divus Verus, from the Kale. The alternate lines of lettering were colored red and blue (Bean, no. 5).

488

Statue bases to Commodus, from the Kale; these dedications, ca. A.D. 177 to 180, were simultaneously from the Gerousia and the Boule and Demos (Bean, nos. 6, 7).

Statue base to Julia Domna from the Boule and Demos; she is titled Mater Castrorum (Bean, no. 8).

Votive to Elagabalus and his cult; partly erased.

Round base (statue?) to celebrate accession of Philip the Arab, A.D. 242. Probably from ATTALEIA and in the name of the Geraioi.

Ayasofya

Statue of Septimius Severus (Inan-Rosenbaum, p. 50, no. 31; citing unpublished note by Bean-Mitford).

Statue of Caracalla (Inan-Rosenbaum, p. 51, no. 28; same source).

Statue of Diocletian (Inan-Rosenbaum, p. 52, no. 4; same source).

LYRBOTON KOME (Bazar–Ghediyi Örenlik or Barsak village)

Refs.: H. A. Ormerod, E. S. G. Robinson, *ABSA* 17 (1910–11) 217ff., fig. 2; Mansel, Akarca, p. 63.

Small tower with inscriptions, built in the reign of Domitian. Later inscriptions include dedication during the rule of Hadrian. The right of asylum at the temple of Artemis Pergensis is mentioned.

PERGE

Refs.: *IGRR*, III; Lanckoroński, I, 40f., 165, *passim*; Mansel, Akarca; Magie, p. 1134 (called Murtana); A. M. Mansel, *AA* 1956, cols. 97–120.

Dedication to (statue of) Caligula (*Annuario* 3 [1916–1920] 29f., no. 13). See also Inan-Rosenbaum, p. 46, no. 2.

Statue to Claudius, from the Demos (*IGRR*, III, no. 788; Magie, p. 1402).

Gymnasium(?) with bilingual inscription to Claudius or, more likely, Nero, by C. Julius Cornutus and his wife and freedman (*IGRR*, no. 789). The Greek inscriptions were on the street entrance over the doors and windows, and the Latin on the side. The building may have originally honored Caligula, at least on its oldest side. Cornutus also similarly honored Claudius or Nero, again probably the latter, on the epistyle of the West Gate (see *CIL*, III, no. 6734).

Building dedication to Trajan (*IGRR*, no. 790).

Hadrianic dedications in rebuilt gateway and forecourt, dated between the deaths of Trajan and Plotina (A.D. 117–121/122): the gateway and forecourt and arch at the rear introduced the main street to the acropolis, the broad, paved and colonnaded avenue, with a water channel down the middle. Plancia Magna was the foundress of the entire complex, as rebuilt around the Hellenistic city gate and oval court. The colonnaded niches of the court (doubled in Roman times) were provided with statues of the benefactors (Plancia; her father, M. Plancius Varus, governor of Bithynia and perhaps Proconsul of Asia under Vespasian; and her brother, C. Plancius Varus); statues of deities (Apollo, Hermes, Dioskouroi, Pan, Herakles, Aphrodite, and so on); and statues of the mythical founders of the city (such as Mopsos, Kalchas, the Lapith Leonteus, Rixos son of Lykos, and Machaon son of Asklepios). The two-tiered monumental, arched gateway, like that of Hadrian at Antalya, with four piers and a large pediment, was across the rear of the oval court. The dedicatory inscription in the center of the façade, a large *tabula ansata*, states that Plancia Magna, priestess of Diana Pergensis, dedicated this monument to her fatherland. Four statues of Nike, less than lifesized, decorated the corners of the attic or pediment. North, or beyond the three-winged arch, stood statues on bases with inscriptions in Greek and Latin. There were: Diana Pergensis, Genius Civitatis, Divus Nerva, Divus Traianus, Diva Marciana, Diva Matidia, Plotina Augusta, Sabina Augusta, and Hadrianus Augustus. (See S. Jameson, *JRS* 55 [1965] 54–58, pls. 6–8, for illustrations of the bases and suggestions about the careers of M. Plancius Varus.) Cuirassed Hadrian: *Berytus* 16 (1966) 54.

Twin statues from the Gerousia to Gordianus Africanus Pater, Filius; double base or bases (*IGRR*, nos. 791a, b).

Statue of Gordianus III, said to be after 242, from the Gerousia and pendant to the preceding two (no. 792).

SIDE (Eski Antalya or Selimiye)

Refs.: A. M. Mansel, *Die Ruinen von Side* (Berlin, 1963); A. M. Mansel, *AA* 1956, cols. 34–96; Magie, pp. 1133f.; G. E. Bean, *The Inscriptions of Side* (Ankara, 1966).

Statue of Claudius (Bean, *Inscriptions*, no. 147).

Building dedicated to Claudius or Nero (A. M. Mansel, G. E. Bean, J. Inan, *Die Agora von*

SIDE (Eski Antalya or Selimiye) (*continued*)

Side und die Benachbarten Bauten [Ankara, 1956], p. 83, no. 50).

Monument to the Flavian dynasty, a pedimented niche flanked by two covered projections; a statue of Vespasian stood in the center and a man in himation on the left (A. M. Mansel, *Festschrift Max Wegner* [Münster, 1962], pp. 38–41).

Statue of Sabina (Bean, no. 102).

Statue of Antoninus Pius, Marcus Aurelius, or Caracalla (*IGRR*, III, no. 805; Magie, p. 1552).

Statue of Septimius Severus, A.D. 211 (Bean, no. 104).

Statue of Caracalla (Bean, no. 103).

Statue of Caracalla, as Caesar, A.D. 196 to 197 (Bean, no. 105).

Dedication to Julia Domna Augusta, with Caracalla mentioned as her son; these were evidently statues (*IGRR*, no. 806).

Building "B," the Capitolium or Praetorium; statues include cuirassed emperor, with head cut off and changed to Maximus Caesar (*Berytus* 13 [1959] 76). Mansel (*Belleten* 22 [1958] 221f.) has suggested Licinius or Maximinus Thrax, Carus (*Ruinen*, p. 118). The niches of the building had statues of gods, imperators, and citizens (male and female) mixed together. See also *Berytus* 16 (1966) 57f.

Statue of Valerianus (Bean, no. 183), with another of Gallienus.

Dedication to Helena, an altar or base (*CIG*, no. 4349; Inan-Rosenbaum, p. 52).

SILLYUM (Asar Köy)

Ref.: Magie, p. 1135.

Milestone, under Valentinian and Valens, on the bank of the Cestrus, erected by the city of SILLYUM (Paribeni, Romanelli, *MonAnt* 23 [1914] 74, no. 57).

PAPHLAGONIA

ABONOUTEICHOS or ABONUTEICHUS (Inebolu)

Ref.: Magie, pp. 1082, 1087, 1283f.

Statue of Septimius Severus, A.D. 210 (*IGRR*, III, no. 91).

Caracalla, 211 to 217 (*IGRR*, no. 92; Magie, p. 1552).

AMASTRIS (Amasra)

Refs.: Magie, pp. 1192ff.; *IGRR*, III.

Base of the statue of Sextus Vibius Gallus, dedicated by Sextus Vibius Cocceianus to his patron. On the front, Vibius rides over two fallen Dacians; on either side are *vexilla, coronae murales, hastae purae, coronae vallares,* and other honors won. The style recalls Thracian–Anatolian reliefs, but the schema is common to the Latin West. In Istanbul (Mendel, *Catalogue*, III, 388ff., no. 1155).

Statue of Hadrian as benefactor and Neos Helios (Magie, p. 1472).

Long dedication to Marcus Aurelius and Lucius Verus, A.D. 165 (*IGRR*, III, no. 84).

Altar or similar dedication to Commodus, on a base before the gate (*CIL*, III, nos. 6985 and 453, the latter wrongly at Mytilene).

Dedication to Caracalla, A.D. 213 (Magie, p. 1552 and refs.).

HADRIANOPOLIS or CAESAREIA – HADRIANOPOLIS (Viranşehir)

Refs.: *IGRR*, III; Mendel, *BCH* 25 (1901) 9.

Dedication to Nerva by the Boule and Demos (*IGRR*, III, no. 148 = 1454; Magie, p. 1477). This is a large plaque of porous limestone with engaged columns flanking the inscription. See also Inan-Rosenbaum, p. 47, no. 8.

Statue of Antoninus Pius, from T. (and Cn.) Claudius Severus, a patron-founder (*IGRR*, no. 1458).

Dedication to Septimius Severus (*IGRR*, no. 149); Inan-Rosenbaum term this a statue (p. 50, no. 3).

Statue of Septimius Severus, at Tchukur-Keuï (Çukurköy) (no. 147). Inan-Rosenbaum place this town in Bithynia and date the statue base 210 to 211 (p. 50, no. 1; *BCH* 24 [1900] 426, no. 141).

Statue of Constantius Chlorus, 292 to 305, from the Boule and Demos (no. 150); Inan-Rosenbaum place this in Bithynia Pontica (Hadrianopolis-Viranşehir: p. 52, no. 2).

NEOCLAUDIOPOLIS

Dedication to Hadrian, A.D. 122 (*IGRR*, III, no. 138).

Statue(?) of Carinus, evidently as Caesar, A.D. 282 to 283 (no. 139).

POMPEIOPOLIS (Taş Köprü)

Dedication to Commodus (*IGRR*, III, no. 1446).

Statue of Salonina (Inan-Rosenbaum, p. 52, no. 1).

SINOPE (Sinop)
Ref.: Magie, pp. 1074ff.

Head of Tiberius; now in Ankara.

Honors to Agrippina the Elder, from the Demos of the Greek city, evidently a portrait (*IGRR*, III, no. 94; Magie, p. 1267; *AJA* 50 [1946] 398).

Milestones of Vespasian, Carus, and Diocletian (*AJA* 9 [1905] 327ff., nos. 75–77).

Column with dedication in Latin to Antoninus Pius, A.D. 145 (G. Doublet, *BCH* 13 [1889] 302, no. 4).

Epistyle fragment (seen in the city's walls): a dedication, with full titles, to Marcus Aurelius and Commodus, A.D. 176 (*CIL*, III, nos. 238, 6977).

Round base of a statue of Divus Marcus Aurelius from the Colonia Iulia Felix Sinopensium (*CIL*, III, nos. 239, 6978).

THERMAE PHAZIMONIACAE
Bilingual milestone to Hadrian (*IGRR*, III, no. 145).

ANCYRA (Ankara)
Refs.: *IGRR*, III; Texier, *Description*, I, 171ff.; Magie, pp. 1308ff.

Temple of Augustus and Roma, with inscription including the names of Tiberius and Livia (*IGRR*, III, no. 157; Magie, p. 1318; Krencker, Schede, *Der Tempel in Ankara* [Berlin and Leipzig, 1936], p. 52). The death dates of Germanicus (A.D. 19), Drusus (23), Julia Augusta (29), and Tiberius (37) indicate that the monument was thought of as a Julio-Claudian cenotaph; the inscription is on an anta (see W. M. Ramsay in *Anat. Stud. Buckler*, pp. 218ff.). A priest set up a statue of Tiberius (Inan-Rosenbaum, p. 45, no. 25); Livia was honored in similar fashion (no. 7).

Dedication to Trajan (*IGRR*, no. 160).

Bronze tondo bust, crowned and wearing a toga, probably of Trajan in the last year or two of his life, found in a large building, possibly the Bouleuterion at ANCYRA (N. Gökce, *A Portrait of Trajan Recently Discovered in Ankara* [Ankara, 1957]; Giuliano, p. 172; Vermeule, *PAPS* 109 [1965] 376, fig. 29).

Hadrian appears in an inscription honoring Tiberius Severus, legate in Asia, and so on, by Marcus Julius Euschemon, recipient of benefactions, with Tantalus and Socus his son.

Monumental architectural block, perhaps from a commemoration of Trajan's Eastern campaigns; frontal Victoria, trophy, and captive (*Berytus* 13 [1959] 22). In the museum garden.

Statue of Antoninus Pius(?) (*IGRR*, no. 161).

Dedication to Antoninus Pius, including nearly one hundred names (no. 162).

Name-lists (Celtic) in reigns of Tiberius, Trajan, and Marcus Aurelius (C. Bosch, *Jahrbuch Kleinasiatische Forschungen* II, 283ff.). Bosch also listed a statue of Marcus Aurelius (no. 181; Inan-Rosenbaum, p. 49, no. 26).

Possible temple of (Divus) Marcus Aurelius, probably meaning Caracalla (Texier, pp. 188f.) according to a Latin inscription from the cemetery. P. Sempronius Aelius Lycinus sextumvir was "very devoted to his divinity," and was given a monumental building by Q. Blaesius Apollinaris (a heroon or an agora?); one of those dedications was A.D. 211 to 212 (see *CIL*, III, nos. 6751 and 243–245, the first being a statue base).

Caracalla and Geta (damnatio) (*IGRR*, no. 163). Inan-Rosenbaum (p. 50, no. 36) list this as a statue base of Septimius Severus, and also include it under Caracalla (no. 36) and Geta (no. 8).

Dedication to Caracalla (*IGRR*, no. 164; see also *CIL*, III, no. 244, *above*, the one involving Lycinus and Blaesius).

Dedication — architectural or a statue base — to Constantinus Magnus (*CIL*, III, no. 6751).

There appears to have been a column (not a milestone) to Valerian (erased) and Gallienus (*CIL*, III, no. 246).

Dedication, on the outer arch of the wall, to Julianus (A.D. 262) as Lord of the Whole World from the British Ocean to the Tigris (*CIL*, III, no. 247).

The roads leading to, radiating from and passing near ANCYRA have produced clusters of milestones in the name of Nerva, Maximinus, Traianus Decius, Aurelian, Diocletian, and Constantine. Most of them bear inscriptions in Latin (Magie, pp. 1308f., where details and bibliographies are given).

Road from ANCYRA to Parnassus (Parlasan) in the northwestern corner of Cappadocia to TYANA and thence to the CILICIAN GATES had Galatian milestones to Domitian, Severus,

ANCYRA (continued)

and Caracalla, Gordian III, Aurelian, Diocletian, Constantine (two), and Valentinian. Again Latin was the language (Magie, p. 1310).

ASPONA (Chedit-Eyuk or Çedit Hüyük)

Salonina, in the name of Ancyra, metropolis of Galatia and city of the second neocorate (*IGRR*, III, no. 237). Inan-Rosenbaum list this as a statue base (p. 52, no. 6).

CINNA (Akardja or Akarca; Yaraşlı or Omaranlı)

Dedication to Gordianus III (*IGRR*, III, no. 235).

PESSINUS (Balhisar)

Ref.: Magie, pp. 769f., a center of the worship of Cybele.

Statue of Augustus (*IGRR*, III, no. 230; Inan-Rosenbaum, p. 44).

Building dedicated to Titus.

Fragments of four epistles, three from Trajan to Claudius, A.D. 102 to 116 (*IGRR*, III, nos. 228, 1466).

TAVIUM (Büyük Nefesköy)

Ref.: Magie, pp. 1309ff.

Ornamented epistyle of white marble, bilingual, and mentions an IMPERATOR VI, perhaps Trajan, who was so remembered on the coins, or perhaps a later emperor (*CIL*, III, no. 6750). (*See* under TAVIUM in Cappadocia.)

Road from TAVIUM to AMASEIA had milestones of Nerva (two), Septimius Severus, Severus Alexander, Gordian I, and Constantine (Magie, p. 1310, in Latin).

Road from TAVIUM to SEBASTOPOLIS has yielded milestones of Gordian III and Constantine; a *castellum* seems to have guarded the road in the plain of the upper Kanak Su (Magie, p. 1310).

LYCAONIA

Akören (site between LYSTRA and the Çarşamba Su)

Ref.: *MAMA*, VIII.

Rough stele, slightly rounded at the top, to Galerius Valerius Maximinus (Daza), Licinius, and Constantinus (*MAMA*, VIII, no. 67).

DERBE (Devri Şehri, near Sidrova or Sudurağı)

Dedication to Antoninus Pius, by the Boule and Demos in 157, carved on what is evidently

the shaft of a large statue base (M. H. Ballance, *AnatSt* 14 [1964] 139, and *AnatSt* 7 [1957] 147ff). Inan-Rosenbaum list this among statue bases of Antoninus Pius (p. 49, no. 34).

Black stone base(?) to Gordianus III (*CIL*, III, no. 6783); recorded when the site was thought to be at Losta in Isauria, northwest of Laranda.

ICONIUM (Konya)

Ref.: *MAMA*, VIII.

Dedication to Augustus, in connection with the rebuilding of the theater by a legatus (*IGRR*, III, no. 262 and 1472).

Dedication to Tiberius, from the chief priest (*IGRR*, III, no. 1473).

Inscription, walled-up in "castello," from the people of the city honoring Lucius Pupius, Proconsul of Claudius and Nero in Galatia (Texier, *Asie Mineure*, p. 661).

Statue of Hadrian, A.D. 137, with dedication in Latin from the colony, named after him (G. Mendel, *BCH* 26 [1902] 214f., no. 5). There is a statue base to Aelius Caesar in the Konya Museum (Inan-Rosenbaum, p. 49, no. 5).

Basis to Marcus Aurelius and Lucius Verus, A.D. 161 to 169, with full titles in Latin and probably for statues (*MAMA*, VIII, no. 299). Compare *CIL*, III, no. 6779, which could be for a related building, possibly a stoa.

ICONIUM Plain

A conspectus of imperial milestones in the northern part of the Konya plain runs from Nerva through Valens, A.D. 96 to 378; M. H. Ballance has tabulated forty (*AnatSt* 8 [1958] 230). The principal roads ran from ANCYRA to ICONIUM and LAODICEIA COMBUSTA to SAVATRA. Work seems to have been carried out on the southern section of the ANCYRA to ARCHELAIS road under Macrinus, as a Latin milestone testifies (Ballance, 234, fig. 5).

KANA or Cana (Gene)

Ref.: *MAMA*, VIII.

Dedication, a slab perhaps from an altar, to Trajan (*MAMA*, VIII, no. 211).

Stele, with panel, perhaps from the base of a statue of Probus (no. 212).

LAODICEIA COMBUSTA or CATACECAUMENE, in Lycaonia or eastern Phrygia

Refs.: *MAMA*, I (1928) 1ff.; *MAMA*, VII (1956) 1ff.; Magie, p. 1313 (Ladik or Yorghan Ladik).

Sarcophagus in SMYRNA with late Hadrianic, early Antonine busts of a man and woman in garlands borne by Nikai and Erotes (Aziz, *Guide du Musée de Smyrne* [Istanbul, 1933], p. 83; Giuliano, p. 197, no. 9). It has been related to so-called portraits of Polemon of LAODICEIA (Schefold, *Bildnisse*, p. 180, no. 4).

Small statue base of Commodus by Stephanus Lib., with inscription in Latin and with damnatio (*MAMA*, I, no. 23).

Base(?) to Julia Mamaea, in Latin and by the freedmen of the imperial estates (*MAMA*, I, no. 24).

Rounded limestone pillar with two inscriptions, the second to Maximinus, A.D. 235 to 238 (*MAMA*, VII, 2, no. 7).

Statue of Salonina (Inan-Rosenbaum, p. 52, no. 4).

Round column, probably a milestone, to Marcus Aurelius Probus, A.D. 276 to 282, with inscription in Greek and Latin (*MAMA*, I, no. 18).

Round column, to Carus, Carinus, and Numerianus, 282 to 284; this is evidently an honorary inscription, in Latin, rather than a milestone (*MAMA*, I, no. 17).

Bomos (altar) of coarse-grained white marble to Maximinus Daza, Constantinus I, and Licinius, A.D. 308 to 314 (*MAMA*, VII, 2, no. 8; compare *MAMA*, I, no. 19: the second is an altar).

Milestone, for repair of the road from Amorium to LAODICEIA COMBUSTA and ICONIUM, to Julian, A.D. 363, over an earlier inscription (*MAMA*, VII, 2, no. 9).

LYSTRA (Zoldera, near Hatunsaray)

Refs.: *MAMA*, VIII; Magie, p. 1324; Ramsay, *Church*, pp. 49ff.

Statue of Divus Augustus, with inscription in Latin, for LYSTRA was a Roman colony (*MAMA*, VIII, no. 5).

Milestone with Latin inscription to Hadrian, at Kavak (no. 6).

Milestone with Latin inscription to Maximinus, A.D. 235 to 238, at Hatunsaray (no. 7).

Milestone, similar, to the family of Valerianus, before 259; Valerian, Gallienus, and Saloninus Valerianus are mentioned; at Kavakand the fourth-mile marker from "Lustreis" (no. 8).

PAPPA–TIBERIOPOLIS

Refs.: *MAMA*, VIII (Yonuslar); Magie, p. 1173 (Yunuslar).

Architrave, mentioning Vespasian, A.D. 69 to 79 (*MAMA*, VIII, no. 330).

Statue of Trajan, A.D. 103 to 116 (Inan-Rosenbaum, p. 47, no. 29).

Statue of Otacilia Severa, from Pappa and Tiberiopolis, A.D. 244 to 249; base recorded at Çukurağil in the Pisido–Phrygian borderland (no. 331).

PERTA (Geimir or Giymir Yayla)

Refs.: *MAMA*, VIII; M. H. Ballance, *AnatSt* 8 (1958) 225.

A milestone, the seventh on the road from AMORIUM to TYANA, has a Latin dedication to Hadrian in the year A.D. 129 (*MAMA*, VIII, no. 261).

PISA

Statue of Septimius Severus (*IGRR*, III, no. 239).

SAVATRA (Yalıbayat; inscriptions at Ennek)

Dedication, a stele to Julia Maesa, from the Boule and Demos (*MAMA*, VIII, no. 228).

Panel with decree in the name of Severus Alexander(?), A.D. 224, also from the Council and People (no. 229).

SIDAMARA (Serpek)

Dedication to Hadrian, about A.D. 136 or 137 (*IGRR*, III, no. 273). See also Inan-Rosenbaum, p. 48, no. 57, a statue base recorded at Ambar-Arasu.

Sites in the ISAURO–LYCAONIAN Borderland

Armassun

Block, probably an altar, to Diocletianus and Maximianus Herculeus, A.D. 286 to 292 (*MAMA*, VIII, no. 186).

Milestone to the Four Tetrarchs, 292 to 305 (no. 187).

Gudelisin

Ref.: M. Ballance, *AnatSt* 7 (1957) 147f.

Block, perhaps from an altar, as above, under Armassun (*MAMA*, VIII, no. 192).

Yalıyık Köy (near Lake Seydeşehir)

Statue of Claudius (*CIL*, III, no. 288; Inan-Rosenbaum, p. 46, no. 22).

ISAURIA

ISAURA (Zengibar Kalesi)

Refs.: H. Swoboda, J. Keil, and F. Knoll, *Denkmäler aus Lykaonien Pamphylien und*

APPENDIX C. WORKS OF ART

ISAURA (Zengibar Kalesi) (continued)

Isaurien (Brünn, 1935), pp. 73ff., 125ff.; Magie, pp. 1170ff., 1303; P. Verzone, *Palladio* 9 (1959) 1–18.

Reliefs along "dromos" or wall of passageway to acropolis gate: emblems, arms, armor, in a Hellenistic style paralleled at TERMESSUS MAJOR (Swoboda, figs. 39ff.). These walls, 4 km. in length and protected by fourteen towers, may have been built by Amyntas (Magie, p. 1303).

Barrel-vaulted arch, near the forum, to Hadrian from the Senate and People of the Isaurians (*IGRR*, III, no. 286; Texier, *Asie Mineure*, p. 660).

Another dedication to Hadrian (*IGRR*, III, no. 285).

Dedication in the name of Marcus Aurelius, A.D. 160 to 172 (*IGRR*, III, no. 287), in connection with triumphal arch from M. Marius. Marius as High Priest and his wife as High Priestess also put up a stoa with twenty-four columns. Several lengthy inscriptions of local officials include those involved in Hadrian's arch.

Statue base of Marcus Aurelius, A.D. 175 to 180 (no. 288).

Statue base of Septimius Severus (no. 289).

Arch of Septimius Severus(?).

Triumphal arch to Severus Alexander, from the Boule and Demos; this is a plain, solid monument, with elaborate titlatures.

Dedication to Severus Alexander (*CIL*, III, no. 6784).

Near ISAURA

Dedication to Claudius (an altar) from one of his Legionaries (*CIL*, III, no. 288).

Losta

The site of DERBE was once thought to be here; *see* above, under DERBE in Lycaonia.

CILICIA

Adanda (a site near this village, about seven miles inland from the coast and forming a low triangle between SELINUS and ANTIOCHIA AD CRAGUM; possibly ancient LAMOS)

Ref.: G. E. Bean and T. B. Mitford, *AnatSt* 12 (1962) 207–211.

Small "handsome" building, evidently a temple to Vespasian and Titus. It is attested to by two limestone blocks nearby with monumental letters, a Latin dedication, A.D. 77, to Vespasian

and Titus and Domitian by the Legatus Octavius Memor (p. 208, no. 32). *See also* below, under SELEUCEIA ON THE KALYKADNOS.

Statue of Antoninus Pius (R. Paribeni and P. Romanelli, *MonAnt* 23 [1914] col. 169, no. 117; Inan-Rosenbaum, pp. 48f., no. 29).

Statue of Septimius Severus(?) (Paribeni and Romanelli, cols. 169f., no. 118; Inan-Rosenbaum, p. 50, no. 33). The same inscription also definitely honors Caracalla (Inan-Rosenbaum, p. 51, no. 32), and there was a third statue of Geta (no. 119; Inan-Rosenbaum, p. 51, no. 7). The date is 209 to 212.

AEGEAE (Ayas)

Ref.: Magie, pp. 1150f.

Altar to Augustus (*IGRR*, III, no. 921; Magie, p. 1336).

Dedication to Septimius Severus (*IGRR*, III, no. 922).

Milestone no. XI of Maximianus found at Yaniş, northeast of AEGEAE (*CIL*, III, no. 13623).

Constantinus I destroyed the temple of Asklepios.

Alahan or Koja Kalessi, that is, Koca Kalesi

Refs.: M. Gough, *AnatSt* 5 (1955) 115–123; Hellenic Soc., *Suppl. Papers* II (London, 1892).

Sculptures of the west gate of the monastery, ca. A.D. 450.

ANTIOCHIA AD CRAGUM (at "Chūkur," not far from Endişegüney)

Ref.: Bean, Mitford, "Journeys in Rough Cilicia," pp. 34–42.

Fortifications with full Latin dedication to Constantinus II and Julianus as Nobilissimus Caesar, A.D. 359 to 361 (*CIL*, III, no. 6733).

Ayasofya (inland from HAMAXIA)

Ref.: Bean, Mitford, "Journeys in Rough Cilicia," pp. 9–21.

Statue of Septimius Severus, A.D. 196, in a central position in the agora of the city (no. 18).

Statue of Caracalla, set up at the same time, but at the corner of the terrace of a temple (no. 19). The two stood amid statues of prominent local citizens, the Obrimus-Polemon family.

Statue of Diocletian, set up in the agora at the outset of his reign (no. 25).

CAESAREIA BY ANAZARBUS (Anavarza)

Refs.: Mary Gough, *The Plain and the Rough Places* (London, 1954), pp. 22–64; Michael Gough, "Anazarbus," *AnatSt* 2 (1952) 85–150; *IGRR*, III; Magie, p. 1151.

Statue of Drusus son of Tiberius, A.D. 23, set up by Philopator II, King of Cilicia, who died in A.D. 17, through one of his freedmen (*IGRR*, no. 895; Magie, pp. 1355f.).

Aqueduct "of Domitian's period," with inscription (Gough, pp. 109f.).

Statue of Hadrian, A.D. 136 (*IGRR*, no. 896).

Severan triumphal arch; the entablature is elaborately carved, and broken for freestanding columns (*AnatSt*, pp. 110ff., figs. 2f., pl. XIa).

Inscription in honor of Caracalla (*AnatSt*, pp. 127ff., no. 2).

Milestone, two miles from ANAZARBUS, to Alexander Severus, with description of the glorious metropolis, adorned with Roman trophies.

CESTRUS (Kilisebeleni)

Ref.: G. E. Bean and T. B. Mitford, *AnatSt* 12 (1962) 211–216.

Small temple with two chambers, devoted to the imperial cult. A statue of Antoninus Pius from the Demos stood in the front chamber; a local official donated 1000 denarii, all or part of which must have paid for the statue (pp. 212f., no. 36). Another official donated 70 denarii or more for a statue of Antoninus Pius; the base was found below the temple, which must have been dedicated to him (p. 213, no. 37). The first statue may have been of bronze, the second of marble; this is also suggested by the shallow and large sinkings on their tops.

On the coast two miles to the south was a temple, with inscription offering honors to Trajan; there was obviously a statue (p. 212).

CHARADRUS (Kaledıran)

Milestone of Hadrian, A.D. 137 (Bean, Mitford, "Journeys in Rough Cilicia," pp. 42f.). Statue, 199 to 210, from Antonius Balbus, hailing Septimius Severus as "lord of the universe" (*IGRR*, III, no. 838).

CILICIAN GATES (Külek Boğaz)

Inscription to Caracalla and another emperor (Alexander?) for road repair (*IGRR*, III, no. 892), all the way to ALEXANDRIA. Magie (p. 1152) gives the emperors as Commodus and (perhaps) Alexander (see also *CIL*, III, no. 228, on a rock along the road to the gates).

CLAUDIOPOLIS (Mut)

Ref.: Magie, pp. 1145, 1407.

Septimius Severus and Caracalla, possibly a building inscription (*IGRR*, III, no. 822).

CORASIUM

In 1812 Captain Francis Beaufort (*Karamania*, pp. 229ff.) found "the extensive ruins of a walled town with temples, arcades, aqueducts, and tombs . . . built round a small flat valley, which bears some appearance of having once been a harbour, with a narrow opening to the sea. Many huts were scattered among the ruins, and their inhabitants informed us that the place is called Pershendy."

On a tablet over the eastern gate he saw and recorded a flowery inscription to Valentinian, Valens, and Gratianus in the name of the prefect and magistrate of Isauria, Florianus, who built or restored the gate and wall.

CORYCUS (Korğos or Kızkalesi)

Refs.: *IGRR*, III; Magie, p. 1143.

Dedication to Zeus of CORYCUS and to Trajan, in the temple of Zeus, near CORYCUS (*IGRR*, III, no. 859).

Dedication to Hadrian, after A.D. 129 and as Olympian (*IGRR*, III, no. 854; E. A. Gardner, *JHS* 6 [1885] 362f., no. 181b).

Altar to Septimius Severus (*IGRR*, III, no. 855).

Statue of Julia Domna as Nea Hera, Mater Castrorum (no. 856).

Dedication to the brotherly love of Caracalla and Geta (erased), between 211 and 212, in the temple of Zeus near CORYCUS (no. 860).

Milestone on the side of the street: one in Greek with the Emperor's name erased; the second in Greek, A.D. 306 to 307, to Constantinus Caesar and Valerius Maximinus Daza (latter partly erased).

DIOCAESAREIA

Refs.: *MAMA*, III (1931) 44ff. (Uzundja Burdj); Magie, pp. 1143f. (Uzunca Burç).

Statue of Tiberius, on the bracket of a column in the colonnaded street (Inan-Rosenbaum, p. 45, no. 23; *IGRR*, III, no. 845). *See* below, under OLBA.

Architrave, with dedication to Trajan from the city; evidently a statue of the emperor stood on top of an architectural complex, such as a gate or colonnade, or on a column with a base (p. 70, no. 72). The work is related to the architrave of the large gatehouse in the center

DIOCAESAREIA (*continued*)

of the city. The effect may have been like that of the statue of Lucius Caesar over the gate to the Roman agora in ATHENS. *See* below, under OLBA, for comparable placement of a statue of Tiberius.

Statue base to Arcadius and Honorius, A.D. 395 (p. 71, no. 73).

Town gate inscribed to Arcadius and Honorius.

HAMAXIA (northwest of Selinus and Iotape) (Sinekkalesi)

Refs.: Magie, p. 1145; G. E. Bean and T. B. Mitford, *AnatSt* 12 (1962) 185ff.

Milestone of Septimius Severus (*IGRR*, III, no. 826).

HIEROPOLIS–CASTABALA

Statue bases to Valens, Valentinianus II, and Gratianus (Inan-Rosenbaum, p. 53, citing Heberdey, Wilhelm, *Reisen*, nos. 62, 61, 56).

IOTAPE (on coast northwest of Selinus, beyond Bytschkydschy Kalesi or Biçkeci Kalesi)

Public buildings and temple of Trajan, A.D. 115 to 117 (Heberdey, Wilhelm, *Reisen*, p. 148, no. 250). Inscription on altar within mentions statue (*IGRR*, III, no. 831). Magie suggests that the temple was built immediately after Trajan's death (p. 1467); see also, E. Rosenbaum, *AnatSt* 15 (1965) 13, and Bean, Mitford, "Journeys in Rough Cilicia," pp. 26ff., nos. 30, 31. Iotape may have been Trajan's last port of call early in 114, on his way via Cyprus to Syrian Antioch.

Dedication to Hadrian (*ibid.*, p. 27).

Statue of Antoninus Pius, from the Boule and Demos, hailing him as "lord of the universe" (*IGRR*, III, no. 832).

Kars–Bazar (in eastern Cilicia, near Flaviopolis and on a branch of the river Pyramus)

Altar to Commodus by priests of the imperial cult. Commodus' name is erased (*IGRR*, III, no. 894).

LAERTES (Cebelireṣ)

Ref.: G. E. Bean and T. B. Mitford, *AnatSt* 12 (1962) 194–206, with plan of the site, fig. 2.

Statue of Claudius, set up perhaps in the Council Chamber and probably in A.D. 50 or later by Polemon the son of Nous an Olympic victor (pp. 197f., no. 13).

Cult, priest, and presumably a temple of Ves-

pasian, attested to by a statue base in the "Council Chamber" (p. 198, no. 14).

Statue of Commodus, A.D. 180 to 190, from the Boule and the Demos, in the area of the "Council Chamber" (pp. 204 f., no. 24).

Statue of Caracalla, 213 to 217, from the Boule and Demos; the base is near a semicircular structure known as the exedra; parallels suggest this could be part of an imperial cult (p. 205, no. 25).

Fragments of epistyle from a large monument to Caracalla and Divus Septimius Severus in 213; they were found in the exedra but are not curved (p. 205, no. 26).

Statue base from the Boule and Demos, dedicated to Caracalla, whose name is substituted for that of another emperor (pp. 205f., no. 27).

MOPSUESTIA (Misis)

Refs.: *IGRR*, III; Magie, p. 1148.

Boundary cippus for Cilicia, between MOPSUESTIA and AEGEAE, probably in the name of Vespasian (*JOAI* 45 [1960] 39ff.).

Statue of Trajan, A.D. 99 (*IGRR*, III, no. 914).

Statue of Antoninus Pius, A.D. 140 (no. 915).

Milestone of Severus Alexander, recording rebuilding of the road A PYLIS USQUE AD ALEXANDRIAM IN PIERIA (Magie, p. 1153).

Milestone of Valentinian and Valens (*ibid.*).

Bridge over Pyramus appears on a coin issued under Valerian (see *BCH* 7 [1883] 289, no. 1).

OLBA (Ura)

Refs.: Bent and Hicks, *JHS* 11 (1890); Heberdey, Wilhelm, *Reisen*, 84; *IGRR*, III; Magie, pp. 1143f.; Ramsay and Hicks, *JHS* 12 (1891) 271ff.; milestones from the district, A.D. 197, and one reused, A.D. 305 to 306.

Inscription to Tiberius, for a statue on one of the consoles of the colonnaded street (Heberdey, no. 160; *IGRR*, III, no. 845). Syrian ANTIOCH had statues similarly placed (*see* below).

Statue of Hadrian (*IGRR*, III, no. 846).

Dedication to Marcus Aurelius and Lucius Verus (no. 847).

Dedication to the whole family of Septimius Severus, with damnatio to Geta (no. 848).

Ören Köy

Inscription in or near the town mentions repair of the aqueduct of OLBA under Justinus II

(565–578) and Sophia (*MAMA*, III [1931] 80ff., 93f., no. 106a).

SELEUCEIA ON THE KALYKADNOS

Refs.: *MAMA*, III (1931) 3ff. (Selefke); Magie, pp. 1142f. (Silifke); A. M. Mansel, *Silifke* (Istanbul, 1943).

Dedication to Vespasian and Titus, A.D. 77 to 78 (*IGRR*, III, no. 840), in connection with bridge across the Kalykadnos, built by the governor of Cilicia, L. Octavius Memor (Magie, p. 1430).

Frieze blocks from Corinthian temple: flying Victoriae supporting heavy garlands surmounted by rosettes; early Antonine in style and iconography (*MAMA*, p. 8, pl. 7, fig. 14).

Imperial cuirassed statue, ca. A.D. 150 (*Berytus* 13 [1959] no. 251), now in the Adana Museum (no. 7; *MAMA*, pls. 7, no. 19, 8, no. 20); perhaps set up in connection with the temple.

Torso, an emperor (perhaps Hadrian) as Diomedes(?) (*MAMA*, pl. 9, no. 22).

SOLI–POMPEIOPOLIS (Mezitli)

Refs.: A. A. Boyce, "The Harbor of Pompeiopolis," *AJA* 62 (1958) 67–78; Sir Francis Beaufort, *Karamania*, 2nd ed. (London, 1818), p. 249; K. Lehmann-Hartleben, *Die antiken Hafenanlagen des Mittelmeeres, Klio*, Beiheft 14 (1923) 204; form of port is Hadrianic; city took Hadrian's name; remains are second or third century A.D.: Pauly-Wissowa, *Realencyclopädie*, XXI² (1952) cols. 2043–2045, under Pompeiopolis (also III A, 1, s.v. Soloi, cols. 935–938); destruction in modern times: R. Paribeni, P. Romanelli, *MonAnt* 23 (1914) 87–90; *IGRR*, III; Magie, pp. 1148f.

The stadium-shaped harbor had a large pedestal (for a statue of Pompey, Hadrian, or Poseidon) in the center. Walls of the city were carried on the mole of the harbor. Other prominent features included a long, axial colonnade and a theater.

Inscription evidently in honor of Pompey (*IGRR*, III, no. 869; Magie, p. 1180); Inan-Rosenbaum (p. 44) term this a statue base.

Dedication (statue?) to Augustus from the Demos (*IGRR*, III, no. 870); the statue was set on a bracket of a column of the colonnaded street (Inan-Rosenbaum, p. 44).

Dedication to Lucius Caesar, A.D. 2 (*IGRR*, III, no. 871; *AJA* 50 [1946] 396f.).

Statue of Hadrian (*IGRR*, III, no. 872).

Statue of Commodus (no. 873).

TARSUS

Refs.: *IGRR*, III; Magie, pp. 1146ff.

Statue of Augustus, from the Demos (*IGRR*, III, no. 876). He restored the city's territory, laws and rank, and maritime commands (Magie, p. 1336).

Statue of Trajan (no. 877); Inan-Rosenbaum list this under Hadrian (p. 48, no. 56).

Statue of Faustina II(?) (no. 878).

Statue of Severus Alexander, with lengthy inscription; other inscriptions make him out as a major benefactor of the city (no. 879).

CYPRUS

Refs.: Hill, *History of Cyprus*; Magie, p. 1246; T. B. Mitford, *OpusArch* 6 (1950) 1–95, for Greek and Latin inscriptions; T. B. Mitford, *AJA* 65 (1961) 93ff., for Greek inscriptions; *IGRR*, III.

AMARGETTI (Paphos district, a sacred area in a rustic setting)

Statue of Augustus (T. B. Mitford, *JRS* 50 [1960] 79).

Statues of C. and L. Caesar, evidently within a shrine.

CITIUM (Larnaka)

Statue of Nerva, from the Polis, A.D. 96/97 (*IGRR*, III, no. 976).

Stele with name and German, Dacian titles of Trajan in the curved "pediment" or tympanum; it was probably used to display public notices or to mark the boundaries of the city (A. P. di Cesnola, *Salaminia* [London and New York, 1882], pp. 105ff., fig. 101).

Statue of Julia Domna, with title of Mater Castrorum (*IGRR*, III, no. 977).

KARPASIA

Emperor, probably Trajan, erected a public building, which may have been a gymnasium.

Statue of Hadrian.

KOUKLIA (village at site of Old Paphos)

Oath of Loyalty to the new Augustus Tiberius, inscribed on a plaque (*BCH* 84 [1960] 274f., fig. 53).

Pedestal with dedication to Caligula (*OpusArch* 6 [1950] 56ff.).

KYTHREA or CHYTRI

Base of a statue of Germanicus; inscribed CAESAR GERMANICVS (*OpusArch* 6 [1950] 16f.).

KYTHREA or CHYTRI (*continued*)

Bronze statue of Septimius Severus, from a shrine at the head of the aqueduct to Salamis (*see* CYPRUS, Nicosia, Cyprus Museum).

LAPETHOS

Inscribed altar, telling of a shrine and statue of Tiberius, A.D. 29 (T. B. Mitford, *JRS* 50 [1960] 78).

Statue of Trajan, A.D. 102 to 116 (*OpusArch* 6 [1950] 22ff.).

Statue of Hadrian, (*IGRR*, III, no. 934). (Hadrian was there in 129.)

NEA PAPHOS (Ktima)

Statue, probably of Septimius Severus (*IGRR*, III, no. 937).

Statue of Caracalla, dedicated A.D. 211 at the beginning of his rule with Geta (H. Seyrig, *BCH* 51 [1927] 139f., no. 3).

OLD PAPHOS

Pedestals for statues of most of the Ptolemies are described and discussed by T. B. Mitford, in *ABSA* 56 (1961) 1–41.

Statue of Livia (T. B. Mitford, *JRS* 50 [1960] 79).

Statue, presumably of Julia, daughter of Augustus (*IGRR*, III, no. 940), called "Thea Sebaste." Another statue of Julia was linked with one of Tiberius her husband.

Statue of Agrippa (Mitford, p. 79).

Dedication to Caius Caesar. A pedestal held his statue (Mitford, p. 79).

Dedications to Tiberius in the temple of Aphrodite; statue also (*IGRR*, III, nos. 941f.). There was also an oath of allegiance to Tiberius (T. B. Mitford, *JRS* 50 [1960] 75–79).

Pedestal with dedication to Caligula, from the temple (*OpusArch* 6 [1950] 56ff.).

Statue of Domitian, with the name erased, in the temple of Aphrodite; there are two dedications (*IGRR*, III, nos. 944f.) and also a massive cylindrical bomos.

Statue and dedication to Trajan, in the temple of Apollo Hylatis (*IGRR*, III, no. 969).

Dedication to Marcus Aurelius or Commodus, A.D. 175 to 180, in the temple of Aphrodite (*IGRR*, III, no. 946).

Bilingual milestone, XV, on the road from Curium to Paphos, in the name of Septimius Severus, A.D. 198 (*IGRR*, III, no. 967). See also T. B. Mitford, *AJA* 70 (1966) 89–99, esp. p. 89 and note 5.

Milestone to Septimius Severus, A.D. 198, reinscribed under Constantinus Magnus and others (T. B. Mitford, *AJA* 70 [1966] 89–99).

Statue of Caracalla, dedicated by local officials (H. Seyrig, *BCH* 51 [1927] 140f.).

Milestone to Decius and to Aurelian, 272 to 273 (*OpusArch* 6 [1950] 62f.).

Milestone VII, to Aurelian in Greek, the Tetrarchs (Latin), Iovianus (Latin) (*IGRR*, III, no. 968; also *OpusArch* 6 [1950] 62f.).

Milestone to Jovianus, 363 to 364 (*AJA* 70 [1966] 89–99).

Eleventh milestone, Paphos to Curium, Augustus before 12 B.C. (*AJA* 70 [1966] 89–99).

SALAMIS

Ref.: V. Karageorghis and C. Vermeule, *Sculptures from Salamis*, I (Nicosia, 1964); II (1966).

Dedication to Ptolemy V, Epiphanes, in the Hellenistic gymnasium (*JHS, Arch. Rep. for 1955*, 45).

Altar to Augustus, rededicated to Tiberius, set up by the local High Priest (T. B. Mitford, *JRS* 50 [1960] 78).

Statue of Livia, during the lifetime of Augustus (*IGRR*, III, no. 984).

Dedications to C. and L. Caesar.

Dedication, seemingly to Nero, A.D. 59 (no. 985).

Dedication to Nero, A.D. 60 (no. 986).

Statue of Trajan, from the City, in A.D. 99 (no. 987).

Dedication or altar to Trajan (no. 988).

Dedication or altar to Hadrian (no. 989).

Trajanic and Hadrianic cult or votive statues from the gymnasium (V. Karageorghis, *Atti del Settimo Congresso Internazionale di Archeologia Classica* 1 [1961] 321–328).

Cuirassed statues, perhaps of Titus and Trajan or Hadrian, from the theater (*Berytus* 15 [1964] 101ff.).

Statue of Commodus, in the theater.

Statues of Galerius and Constantius Chlorus as Caesars, in the theater.

SOLI

Dedication to Trajan, from a citizen of Soli, a shrine with a statue, A.D. 116 to 117 (*OpusArch* 6 [1950] 32f.).

Statue of Antoninus Pius (*IGRR*, III, no. 929); a dedication to him was also found nearby (*OpusArch* 6 [1950] 33ff.).

CAPPADOCIA

COCUSSUS and Vicinity

Refs.: J. R. S. Sterrett, *Preliminary Report of an Archaeological Journey made through Asia Minor during the summer of 1884* (Boston, 1885), pp. 20ff. (hereafter Sterrett II); J. R. S. Sterrett, *Papers ASCS*, II (1883–84) 240ff. (hereafter Sterrett I); Magie, pp. 1349ff.

Imperial Inscriptions, mostly Milestones, on the Major Highways and Crossroads from Anatolia to Armenia, Mesopotamia, and Syria.

COCUSSUS or COCUSOS

Dedication to Trajan, A.D. 105 to 106 (*IGRR*, III, no. 128).

Elagabalus (Sterrett I, 269; Sterrett II, no. 13).

Elagabalus (Sterrett I, 274–275; Sterrett II, no. 16).

Maximinus Thrax, later reused by Diocletian and Maximianus (Sterrett I, 272–273; Sterrett II, no. 15).

Gordianus III as Caesar, though Emperor, with Balbinus–Pupienus erased and the Tetrarchs added in the erased area (Sterrett I, 270–271; Sterrett II, no. 14).

COCUSSUS–ARABISSUS (ARABISSOS) Road

Nerva (Sterrett I, 356; Sterrett II, no. 60).

Septimius Severus, Caracalla, and Geta Caesar, 209 to 211 (Sterrett I, 300; Sterrett II, no. 26).

Septimius Severus, Caracalla, and Geta Caesar (Sterrett I, 306; Sterrett II, no. 30).

Similar to the preceding (Sterrett I, 307; Sterrett II, no. 31).

Septimius Severus, Caracalla, and Geta Caesar (below) and Diocletian, Maximianus, Galerius, and Constantius, A.D. 292 to 305 (above) (Sterrett I, 318–319; Sterrett II, no. 41).

Septimius Severus and Caracalla, with Diocletian and the Tetrarchs over it (Sterrett I, 320–321; Sterrett II, no. 42).

Septimius Severus, Caracalla, and Geta Caesar (Sterrett I, no. 341; Sterrett II, no. 52).

Septimius Severus, Caracalla, and Geta Caesar, in the cemetery at Isgin (Sterrett I, 343; Sterrett II, no. 54).

Elagabalus (Sterrett I, 313; Sterrett II, no. 37).

T. Gallus and Volusianus, Elagabalus, and the Tetrarchs (Sterrett I, 325–327; Sterrett II, nos. 46–48).

Elagabalus(?) (Sterrett I, 314; Sterrett II, no. 38).

Elagabalus, in the cemetery at Albistan (Sterrett I, 345; Sterrett II, no. 56).

Maximinus (Sterrett I, 309; Sterrett II, no. 33).

Older milestone corrected to Maximinus Thrax (Sterrett I, 348).

Balbinus, Pupienus Augusti, and Gordianus III Caesar, later changed to Gordianus III Augustus (Sterrett I, 315–316; Sterrett II, no. 39).

Gordianus III as Caesar (Balbinus–Pupienus erased) and then the four Tetrarchs (Sterrett I, 302–304; Sterrett II, no. 28).

Older milestone corrected to Philip and the Tetrarchs (Sterrett I, 346–347).

Philippus I and II (Sterrett I, 310; Sterrett II, no. 34).

Philippus by Antonius Memmius Hiero (Sterrett I, 317; Sterrett II, no. 40).

Philippus I, and Philippus II, with the Tetrarchs on the other side (Sterrett I, 322–323; Sterrett II, nos. 43–44).

Galerius (and Diocletian) (Sterrett I, 301; Sterrett II, no. 27).

Diocletian and other Tetrarchs (Sterrett I, 308; Sterrett II, no. 32).

Diocletian and Maximianus Augusti, Galerius and Constantius Caesars (Sterrett I, 324; Sterrett II, no. 45).

COCUSSUS–COMANA Road

Elagabalus, and Diocletian and Maximianus (Sterrett I, 288–289; Sterrett II, no. 19).

Maximinus Thrax (Sterrett I, 293; Sterrett II, no. 22).

Philip I, Philip Caesar, and the Four Tetrarchs, 292–305 (Sterrett I, 290–291; Sterrett II, no. 20).

Philip I, Philip Caesar (Sterrett I, 292; Sterrett II, no. 21).

Philip I, Philip Caesar. The Legate is M. Antonius Memmius Hiero (Sterrett I, 295; Sterrett II, no. 23).

TAVIUM–Ankara Road

Alexander Severus, A.D. 223, at Ortakieui (Sterrett I, 378; Sterrett II, no. 62). Another at Tchañlykaya, south of Ankara.

TAVIUM (Iskelib)

Ornamented epistyle with imperial Imperator VI Consul . . . on it (Sterrett I, 357) (*see* above, under Galatia).

Nerva (cf. Sterrett II, no. 60).

COMANA-HIEROPOLIS

Refs.: *IGRR*, III; Magie, pp. 1096, 1264 (Şar).

Dedication to Hadrian, evidently a statue erected by the Council and People in the years 120 or 121, perhaps during a visit (*IGRR*, III, no. 121; Magie, p. 1470).

Statue of Traianus Decius, erected in 249 (Magie, pp. 1565f.). Inan-Rosenbaum (p. 52, no. 1 and bibl.) indicate that the base also held a statue of Etruscilla.

Statue of Gallienus, 253 to 268 (*IGRR*, III, no. 123).

Dedication, or statue, to Publius Licinius Cornelius Valerianus, before 259 (no. 122).

Statue of Probus (no. 124).

FAUSTINOPOLIS–HALALA (Başmakçı)

Statue of Gordianus III, A.D. 239, set up by magistrates and people of the colony (M. H. Ballance, *AnatSt* 14 [1964] 140ff.).

MAZACA–CAESAREIA (Kayseri)

MAZACA–MELITENE Road

Milestones from Septimius Severus to Diocletian (Magie, pp. 1349f. and bibl.).

MAZACA–TYANA (Kilissahisar) Road

Milestone to Trajan, no. XXX from MAZACA (Magie, pp. 1350f.).

PONTUS GALATICUS

AMASEIA

Bridge across the river Iris bore a building inscription to Nerva, through Pomponius Bassus Leg. P.P.

Dedication to Marcus Aurelius (*IGRR*, III, no. 100).

COMANA

Ref.: Magie, pp. 1019, 1095f.

Dedication to or statues of Hadrian and Aelius, from the city in the year 136 to 137 (*IGRR*, III, no. 105).

Statues of Antoninus Pius (Inan-Rosenbaum, p. 48, nos. 3, 4).

Dedication to Marcus Aurelius and Lucius Verus (no. 106).

SEBASTOPOLIS (formerly HERACLEOPOLIS) (Sulusaray)

Refs.: *IGRR*, III; Magie, pp. 1329, 1285, 1334; D. R. Wilson, *AnatSt* 10 (1960) 133–

140: milestones on roads to Zela and Comana.

Dedication to Hadrian, A.D. 137, in name of Legate Flavius Arrianus, the historian (*IGRR*, III, no. 111).

Dedication to Hadrian (no. 112).

Dedication to Antoninus Pius (no. 113).

Dedication to Marcus Aurelius (no. 114).

Statue of Gordianus III (*CIL*, III, nos. 6749, 6894).

ARMENIA MINOR

SATALA

Statue of Aurelianus (*CIL*, III, no. 14,184[3]).

ARMENIA MAJOR

Ref.: *IGRR*, III.

HARMOZICAE

Lengthy dedication of monumental size, A.D. 75, to Vespasianus, Titus, and Domitianus, in reign of Mithradates.

Ziata in the plain south of Harput and northwest of the Ergani Pass.

Dedication(s) in honor of Nero, dated A.D. 61 or 64–5 and erected CN. DOMITIO CORBULONE LEG[ATO] AUG[USTI] PRO PR[AETORE], T. AURELIO FULVO LEG[ATO] AUG[USTI] LEG[IONIS] III GAL[LICAE] (*CIL*, III, nos. 6741, 6742, 6742a).

ALEXANDRIA and Vicinity (Iskenderûn)

Ref.: Heberdey, Wilhelm, *Reisen.*

Statue of Septimius Severus, near ALEXANDRIA (*IGRR*, III, no. 927).

Statue base to Septimius Severus, at Pajas (Heberdey, Wilhelm, no. 48).

Roman Triumphal Arch, near Merkes–Kalesi, in the time of Septimius Severus and probably commemorating his defeat of Pescennius Niger at Issus (Heberdey, Wilhelm, p. 19, fig. 2; P. Graef, in A. Baumeister, *Denkmäler des Klassischen Altertums*, III [Munich and Leipzig, 1888], p. 1897). Ramsay supposed the same purpose and date (A.D. 194) for the triumphal arch spanning the road near Bayramlı, three hours north of TARSUS (Magie, p. 1154; *BCH* 22 [1898] 237f.). Magie notes that Aurelian also marched along this route, from TYANA to ANTIOCH.

EASTERN MEDITERRANEAN AND NORTH AFRICA

COMMAGENE

DOLICHE

Dedication to the Tetrarchs, A.D. 292 to 305 (*IGRR*, III, no. 1002).

GERMANICIA

Dedication to Marcus Aurelius or Caracalla, a mutilated milestone(?) (*IGRR*, III, no. 998).

SYRIA

ANTIOCH

Ref.: G. Downey, *A History of Antioch in Syria from Seleucus to the Arab Conquest* (Princeton, 1961), where imperial foundations, constructions, and dedications are taken up according to each reign or dynastic period.

Basilica of Julius Caesar, called the Kaisarion, with open court and vaulted apse, in front of which stood statues of Caesar and of the Tyche of Rome (pp. 154f., 404), founded 47 B.C. and restored in A.D. 371 by Valens.

Agrippa gave a new quarter with a public bath to the city and another bath on or near the slope of the mountain, 23 to 21 B.C. (p. 171).

"Eastern Gate" of Tiberius, on road into the city from Beroea and southern Syria, topped with stone group of the Lupa Romana (pp. 181f.).

Plaza containing a column of Theban stone bearing a statue of Tiberius (map, fig. 8); the plaza was a focal point of the colonnaded street attributed by Malalas to Tiberius (p. 183). The statue was dedicated by the Boule and Demos. Street work perhaps carried out by Germanicus in A.D. 17 to 19 (p. 175).

Vespasian built a Tower of the Winds (pp. 207, 404). A canal, connecting with the Orontes, was built, A.D. 73 to 74, under the governor Marcus Ulpius Traianus, father of the emperor (p. 207).

Domitian presented a bath, on the slope of the mountain near the amphitheater of Caesar; also a temple of Asklepios (pp. 207f.).

Middle gate of Trajan, a monumental triumphal arch, possibly at the end of the secondary colonnaded street (p. 404); this arch also bore a group of the Lupa Romana (p. 215).

Trajan built an aqueduct to bring water from Daphne to the city and a new public bath in connection with it, both before the earthquake of A.D. 115 (pp. 211f.). He completed the un-finished theater, presumably the one rebuilt by Julius Caesar, and enlarged under Agrippa, Tiberius (p. 216).

Hadrian definitely continued and completed the work at Daphne and ANTIOCH in connection with the water supply; he may have also built an aqueduct and a public bath named for him (pp. 221f.). The temple of the Nymphs above the reservoir at Daphne probably contained a great seated statue of Hadrian as Zeus, holding the celestial orb.

"Small and very graceful" temple in honor of the deified Trajan; turned into a library by Julian the Apostate and later burned by Jovian (pp. 220, 396).

Antoninus Pius (or possibly Caracalla) paved the main colonnaded street and all other streets with Theban granite, according to Malalas, who cites an inscription (pp. 224f.).

Marcus Aurelius rebuilt a public bath called the Centenarium, erected a Museum evidently with an ornamental façade which was a nymphaeum; Probus (276–282) placed a mosaic of Oceanus in it (p. 229).

Commodus built Xystos, covered running track, for use in the Olympic Games, with a temple to Olympian Zeus; also a public bath named for himself (pp. 233, 404). In gratitude, the people of ANTIOCH set up a bronze statue of Commodus (p. 234).

Septimius Severus presented a large public bath, the Severianum, on the slope of the mountain (p. 242).

Diocletian built a palace on the island on foundations started by Valerian (pp. 259f.); and dated before 298 since its arched colonnade appears in the background on the Arch of Galerius at SALONIKA. The palace appears to have had stoas and galleries, like that at Salona, radiating from a tetrapod arch as at SALONIKA (pp. 319–323). A "Tetrapylon of the Elephants" stood nearby. Diocletian was also responsible for five baths, principally a public one named for him and on the island near the great circus (p. 324).

Statue "of the Caesar Maximianus" (presumably Galerius) in the vestibule of the palace; a bronze globe was held in one hand (p. 398).

Between A.D. 327 and 341, Constantine and Constantius II built the octagonal Great Church, the *Domus Aurea*, with chambers, exedras, and peribolus walls richly decorated with statues (pp. 342–349). The bronze Poseidon found during construction was melted,

ANTIOCH (*continued*)

made into a statue of Constantine, and set up outside his praetorium (p. 349).

Forum of Valens, built before November 375, near the center of the city; three statues of Valentinianus I were set up, one on a column in the middle of the open space and two others in a vaulted, shell-like apse (pp. 403f., 407).

Public bath of Valens, named for himself, near the hippodrome on the island; later burned and restored by Theodosius II (pp. 410, 453).

The riot of 387 destroyed wooden panels bearing painted portraits of the imperial family, also bronze statues of Theodosius I, his wife, and Arcadius, (pp. 428f.).

Gilded bronze statue of the empress Eudocia voted by Senate for Bouleuterion and bronze statue outside Museum in 438 (p. 451).

Basilica bearing inscription in gold mosaic with the name of Theodosius II (A.D. 439); contained representations of him and Valentinian III.

APAMEIA

Statue of Trajan, dedicated shortly after A.D. 102 (*IGRR*, III, no. 1532).

Caracalla honored on the occasion of his tour of provincial inspection in 214 to 215 (*JHS* 75 [1955] 149 and bibl.).

BAETOCAECE

Letter from Valerian, Gallienus, and Saloninus, confirming rights of the temple of Zeus going back to the Seleucid era (*IGRR*, III, no. 1020; *see* below, under ARADUS).

BAII

Statue of Septimius Severus (*IGRR*, III, no. 1003).

HELIOPOLIS (Baalbek)

Ref.: R. Boulanger, *Lebanon* (Paris: Hachette World Guides, 1955), pp. 159–169.

Balustrades of the north and south pools in the court of the altar, decorated with traditionally Greek imperial marine and funerary themes.

Dedication to the Heliopolitan Zeus in the name of Hadrian (*IGRR*, III, no. 1068).

Latin testimonial of a Syrian legionary offering eighty pounds of silver to Jove, for the health of Hadrian, A.D. 128 to 138 (*RA, L'Année épigraphique*, 1964, pp. 24f., no. 55). There are other such testimonials to Ha-

drian and Antoninus Pius or Septimius Severus. Roughly similar dedication, in the name of Lucius Verus (no. 1069).

Propylaea: bases of three of the columns carry Latin inscriptions to Caracalla (211–217) from an officer who had two of the bronze capitals gilded in honor of the Capitoline Triad.

LAODICEIA (el-Lādhiqiyyah)

Ref.: E. Honigmann, "Laodikeia," *RE* 12 (1925) 715.

Large theater erected by Augustus, with marble statue of himself (John Malalas, *Chron.*, p. 303; *Antiquities of Ionia*, II, 39).

NICOPOLIS

Statue(?) of Trajan (*IGRR*, III, no. 1001).

PALMYRA

Ref.: I. A. Richmond, "Palmyra under the Romans," *JRS* 53 (1963) 43ff.

Statues of Tiberius, Drusus Junior, and Germanicus, set up A.D. 17 by the commander of Legio X Fretensis, with Latin inscriptions.

Dedication to the patron gods in the name of Trajan (*IGRR*, III, no. 1026).

Lengthy trilingual set of laws, in the name of Hadrian, 137 (*IGRR*, III, no. 1056).

Large bilingual dedication (with statues?) in 203 to the whole family of Septimius Severus (*IGRR*, III, no. 1533). Another, without Geta (no. 1534).

Dedication to Claudius II (268–270) and Zenobia, mother of Vaballathus (*IGRR*, III, no. 1027).

Gorges of the River Lycus (Nahr el Kelb)

Ref.: R. Boulanger, *Lebanon* (Paris: Hachette World Guides, 1955), pp. 104ff.

(At the point where the valley road opens onto the main road, at the turning of the bridge).

Inscription, in Latin, in the name of Caracalla (A.D. 211–217) commemorating construction and engineering works carried out by the Third Gallic Legion.

DECAPOLIS

AMMAN–PHILADELPHIA (Raboth–Ammon–Philadelphia)

On the clifflike southeast face of the citadel hill, overlooking the theater, stood a statue of Dedalus — a large, Sperlonga-type figure of the second or third centuries A.D., from the

school of APHRODISIAS (J. H. Iliffe, *Robinson Studies*, I, 705–712).

GERASA (Antioch-on-the-Chrysorhoas) (Jerash)

Ref.: *Gerasa*, New Haven, 1938.

Triumphal arch in honor of Hadrian's visit, 129 to 130: three arched passages, formerly closed by wooden doors and set off by engaged Corinthian columns. A dedicatory inscription was in the pediment above.

Votive for Marcus Aurelius and Lucius Verus (*IGRR*, III, no. 1544).

Statue of Constantius Chlorus (C. Vatin, *BCH* 90 [1966] 247).

PHOENICIA

ARADUS

City sent a decree to Augustus in connection with the temple of Baetocaece (*JHS* 75 [1955] 149; *IGRR*, III, no. 1020).

Statue of Divus Commodus (*IGRR*, III, no. 1014).

BERYTUS (Beirut)

Unknown official or man of wide interests founds a Greek and Latin library in the name of Hadrian (*IGRR*, III, no. 1077).

Colossal wreathed head of Commodus, later in American art market. Now (1967) Winnetka, Illinois, James Alsdorf collection.

SIDON (Saïda)

Dedication to Antoninus Pius, from the Boule and Demos (*IGRR*, III, no. 1098).

Kasyoum, in the ruins of a synagogue near TYRE (Sour)

Votive from the Jews in honor of the whole Severan family, with Geta's name obliterated (*IGRR*, III, no. 1106).

SAMARIA

CAESAREIA ("MARITIMA") (Qaisariye)

Refs.: S. Yeivin, *Archaeology* 8 (1955) 122–129; L. Kadman, *The Coins of Caesarea Maritima* (Jerusalem, 1957).

The port was named Sebastos, the complex being also "Caesarea on Sebastos"; it was founded by Herod and inaugurated in 13 B.C. The tallest tower of the sea wall was called Drusium, in honor of Nero Drusus. The temple of Augustus and Roma had colossal statues of Augustus in the attitude of Zeus Olympos and Roma modeled on the Hera of Argos. Colossal porphyry, seated and draped statue of an emperor(?) facing an imperial, half-draped statue of Zeus or an emperor as Zeus (figs. 5–8): possibly Divus Traianus and Hadrian. They were reset in an early-sixth-century Byzantine building, the porphyry statue being supplied with a new marble chair.

Plaque (*tabula ansata*) to Hadrian, recording work by legionary detachments (*RA, L'Année épigraphique*, 1964, p. 74, no. 189 and refs.).

NEAPOLIS (Shechem, Tell Balatah)

Dedication to Antoninus Pius (*IGRR*, III, no. 1205).

JUDAEA

(including cities associated with the area known as Palestine)

AERA

Dedication to Commodus, by a centurion of the III Legion Gallica (*IGRR*, III, no. 1128).

AERITA

Emperors Nerva, Hadrian, Antoninus Pius, Marcus Aurelius, Commodus, and Septimius Severus mentioned in inscriptions dated in their eras (*IGRR*, III, nos. 1176–1182).

AGRAENA

Dedication to Caracalla, A.D. 208 (*IGRR*, III, no. 1146).

Dedication to Severus Alexander, A.D. 233 (no. 1147).

ASCALON

Dedication to Commodus, A.D. 177 to 178 (*IGRR*, III, no. 1210).

SAURA

Dedication to Marcus Aurelius, 161 to 162 (*IGRR*, III, no. 1143).

ARABIA

ADRAHA (Dera'a)

Fortifications built in the years A.D. 259 to 275, by Valerian, Gallienus, Saloninus, and Aurelian, probably prompted by fear of Arab raids from the desert (H. G. Pflaum, *Syria* 29 [1952] 307ff.).

BOSTRA (the capital of Roman Arabia)

Inscribed mention of the city's refounding by Trajan, after 105 (*IGRR*, III, no. 1319).

Dedication for the health of Antoninus Pius (no. 1320).

BOSTRA (*continued*)

Statue of Caracalla as emperor, from officials (no. 1321).

Dedication to Julia Domna (no. 1322).

Dedication in the name of Gordianus III, A.D. 238 to 239 (no. 1323).

PHILIPPOPOLIS (Chahba)

Dedication to Marcus Aurelius and Commodus, ca. 177, from various military commanders (*IGRR*, III, no. 1195).

Dedications to Philip the Arab and/or to Philip the Younger, 247 to 249 (nos. 1196f.).

Temple to M. Julius Marinus, father of Philip the Arab; he was made a divus (nos. 1199, 1200).

EGYPT

ALEXANDRIA

"Pompey's Pillar"

Column on the plateau of Sarapeum has an inscription to the emperor Diocletian, erected by Postumus, prefect of Egypt. Red porphyry statue(?) stood on column; fragments, found at foot, were in the Choiseul–Gouffier collection. See Ev. Breccia, *Alexandrea ad Aegyptum* (Bergamo, 1922), pp. 115–118.

Kaisareion, built by Julius Caesar (Sjöqvist, *OpusRom* 1 [1954] 86–108).

Captive Eastern barbarian in high relief, from the so-called Palace of Trajan at Ramleh; he kneels and a colossal standing figure stood nearby; perhaps from a monument connected with Lucius Verus' victories; London, British Museum.

Statue of Marcus Aurelius Caesar, cuirassed, ca. A.D. 160 (*Berytus* 13 [1959] 65, no. 263).

Togate statue of Marcus Aurelius, about A.D. 200; London, British Museum (no. 1906).

Head of Lucius Verus, in Cleveland (Ohio) Museum of Art.

Ptolemaic royal figure, red granite, in Minneapolis (Institute of Art) and head in British Museum, has name of Commodus inscribed on the statue (*The Connoisseur*, Nov. 1960, p. 146).

Statue of Septimius Severus, in full cuirass and posed as the Diomedes of Kresilas; London, British Museum (no. 1944; *Berytus* 13 [1959] no. 202, pl. 21).

CYRENE

Cuirassed statue of Hadrian.

Temple of Zeus, with late Antonine cult image.

Severan propylaea, with Hellenistic scene of combat (*ILN*, 23 Feb. 1957, p. 30, figs. 5f.).

Notes

CHAPTER II.
Roman Imperatorial Architecture

1. These examples have been discussed in C. Vermeule, "Hellenistic and Roman Cuirassed Statues" (*Berytus* XIII, 1959) 6–9 (cited hereafter as *Berytus* 13). See also the supplements to this paper: *Berytus* 15 (1964) 95–110, and *Berytus* 16 (1966) 49–59.

2. H. C. Butler, *Sardis* I, *The Excavations, 1910–1914* (Leiden, 1922), pp. 7f., 63ff., figs. 57, 61.

3. G. M. A. Hanfmann and K. Z. Polatkan, *Anatolia* 4 (1959) 64, note 28. One of the two battered heads is evidently Antoninus Pius and the other a splendid Hellenistic Zeus, who must have lent his majesty to the Antonine dedication.

4. A. Dönmez, *ILN*, 25 April 1959, 712ff.; Giuliano, *Annuario* 37–38 (1959–1960) 389–401; K. T. Erim, *Archaeology* 15 (1962) 58f., fragments of "Andreia"; K. T. Erim, *ILN*, 5 Jan. 1963, pp. 20ff.; K. T. Erim, *National Geographic* 132, no. 2 (Aug., 1967) 280ff., showing the seated Roma on the end.

5. E.g. the grave stele of Timokles at Epidaurus: Vermeule, *Berytus* 13 (1959) 22f., no. E 10, pl. XIX; or the grave relief of Philodamos in Berlin: Blümel, R 104, pls. 68f.

6. *Olympia, Text* III, 260–279, esp. 266, fig. 298.

7. Vermeule, *Berytus* 13 (1959) 62, nos. 240f.; R. Heberdey, "IX. Vorläufiger Bericht über die Grabungen in Ephesos 1907–1911," *JOAI* 15 (1912) Beiblatt, 175f., figs. 137f.

8. R. Delbrueck, *Antike Porphyrwerke* (Berlin and Leipzig, 1933), p. 219, pl. 107.

9. *Ibid.*, pp. 216–218.

10. H. Hörmann, *Die inneren Propyläen von Eleusis* (Berlin, 1932).

11. C. Vermeule, *AJA* 61 (1957) 116.

12. *Greek and Roman Portraits*, no. 39.

13. A. A. Boyce, "The Harbor of Pompeiopolis," *AJA* 62 (1958) 67–78; K. Lehmann-Hartleben, "Die antiken Hafenanlagen des Mittelmeeres," *Klio*, Beiheft 14 (1923).

14. C. Vermeule, *AJA* 65 (1961) 192f., and "The Colossus of Porto Raphti in Attica," *Hesperia* 31 (1962) 62–81. See also S. Karouzou, *Eleutherias*, 8 Aug. 1964, p. 3.

15. One legend has it that the head, now missing, was carried off to Venice. No. 52 in the Museo Archeologico, left to the state with the Grimani marbles in 1586, is the only possible candidate that I could find in 1964. It is a Tyche, with veil down the back, and has a high crown in two layers. This crown is high enough for a light bucket and resembles that of the bronze statuette in the presence of holes below the crenelations.

CHAPTER III.
Roman Imperatorial Sculpture

1. Bieber, *Sculpture of the Hellenistic Age*, p. 122, figs. 485ff.

2. C. Vermeule, "Greek Art in Transition to Late Antiquity," *Greek, Roman and Byzantine Studies* 2 (1959) 17f.; Mendel, *Catalogue*, III, 600ff., no. 1390.

3. C. Vermeule, *AJA* 63 (1959) 109.

4. Stuart, *Claudius*; M. Stuart, "How were Imperial Portraits Distributed throughout the Roman Empire?," *AJA* 43 (1939) 601–617.

5. Toynbee, *ABSA* 53–54 (1958–59) 286ff.

6. C. Vermeule, *AJA* 59 (1955) 351; P. Dikaios, *Archaeology* 1 (1948) 146f.; P. Dikaios, *FastiA* 2 (1947) no. 332; Hill, *History of Cyprus*, p. 233, pl. 13; *AA* 1934, cols. 99, 101f.

7. L'Orange, *Apotheosis*, p. 76.

8. Vermeule, *BMFA* 58 (1960) 12–25. Ingholt, *JARCE* 2 (1963) 125–142 thinks the head portrays Herod the Great, perhaps a dedication from his Idumean mercenaries in Egypt. He does not believe the portrait was reused as Severus Alexander, but that it is as executed in the late Republic or early years of Augustus.

9. W. Judeich, *Topographie von Athen* (Munich, 1931), pp. 388f.; M. Santangelo, "Il monumento di C. Julius Antiochos Philopappos in Atene," *Annuario* 19–21 (1941–1943) 153–256.

10. Vermeule, *Berytus* 13 (1959) 13f., B 1; *Einzelaufnahmen*, no. 1744.

11. Vermeule, *Berytus* 13 (1959) 13f.; N. Kotzias, *Polemon* 4 (1949) suppl. 5f., fig. 1; Vermeule, *AJA* 68 (1964) 336, note 122. It is tempting to see the monument as the stele or cenotaph of Leosthenes, one of Alexander's commanders, who fell leading the Hellenic alliance before Lamia in 323.

12. Bieber, *Sculpture of the Hellenistic Age,* 127ff.

13. Kourouniotes, *Eleusis*, pp. 80ff.; B. Grossman, "The Eleusinian Gods and Heroes in Greek Art," Ph.D. Thesis, Saint Louis, 1959, pp. 334ff.; A. W. Lawrence, *Later Greek Sculpture* (New York, 1927), p. 46, pl. 79: dated 100 to 90 B.C.; so also A. B. Cook, *Zeus, A Study in Ancient Religion*, III, 1 (Cambridge, 1940), pp. 309ff., note 3 and figs. 199f. (showing restorations).

14. Vermeule, *Berytus* 13 (1959) 14, B 2.

15. A.-J. Reinach, *JIAN* 15 (1913) 97–142; Mendel, *Catalogue*, III, 484ff.; D. H. Cox, *Coins from the Excavations at Curium, 1932–1953* (A. N. S. Num. Notes and Monogr. No. 145) (New York, 1959), pp. 94ff. (numismatic and historical evidence for the Ptolemies).

16. G. Krahmer, "Eine Ehrung für Mithradates VI. Eupator in Pergamon," *JdI* 40 (1925) 183ff.

17. Louvre no. 3295; Reinach, *Rép. rel.*, II, 299, nos. 2–3; M. Bieber, *Griechische Kleidung* (Berlin and Leipzig, 1928), pl. IX, fig. 2.

18. Caskey, *Catalogue*, pp. 109f., no. 51.

19. A.-J. Reinach, "Tropaeum," in Daremberg-Saglio, *Dictionnaire des antiquités* (Paris, 1913), V, 1, p. 517, no. 13, fig. 7131.

20. Vermeule, *Berytus* 13 (1959) 14, B 3; Ch. Picard and P. de la Coste-Messelière, *Sculptures grecques de Delphes* IV, 1, plates (Paris, 1927), 40f., pl. 78; Toynbee, *Art of the Romans*, pp. 21f., 241; D. E. Strong, *The Classical World* (New York, 1965), p. 133, fig. 62.

21. Bieber, *Sculpture of the Hellenistic Age,* pp. 161f., fig. 691.

22. G. Jacopi, "Gli Scavi della Missione archeologica italiana ad Afrodisiade nel 1937 (XV–XVI)," *MonAnt* 38 (1939) 74ff.; G. Jacopi, *ILN*, 18 Dec. 1937, pp. 1096f.; Vermeule, *PAPS* 109 (1965) 372f., fig. 23.

23. Ideas on the significance of the school of Aphrodisias in Roman imperial art are developed in the *Essays in Memory of Karl Lehmann*, pp. 359–374, in connection with a group of a satyr, maenad, and Eros in Boston (see M.F.A., *Calendar of Events*, June–Summer 1962, pp. 2f.).

24. Nos. 3204–3208; Squarciapino, *La scuola di Afrodisia*, pp. 77f., pl. R; Vermeule, *PAPS* 109 (1965) 373ff., figs. 24–27.

25. Vermeule, *AJA* 59 (1955) 142.

26. Another portrait of the "Julian" type is in the Tower of the Winds at Athens. For the "Julians" in Paris, see Volbach, Hirmer, *Early Christian Art*, p. 321, figs. 48f.

27. Delbrueck, *Spätantike Kaiserporträts*, pl. 6.

28. Vermeule, *Goddess Roma*, pl. V, nos. 6, 7.

29. Vermeule, *Quarterly* 54 (1958) 6–10.

30. Mendel, *Catalogue*, II, 444ff., nos. 661–664; Volbach, Hirmer, *Early Christian Art*, p. 325, no. 74; Vermeule, *PAPS* 109 (1965) 375, fig. 28.

31. C. Vermeule, "Chariot Groups in Fifth-Century Greek Sculpture," *JHS* 75 (1955) 106f., fig. 7 and refs. in note 9.

32. Giuliano, p. 197, fig. 38 and parallels.

33. Mansel, Akarca, pp. 28f., esp. 44, no. 7A; a fragment of a similar sarcophagus, the long side with the Erotes, was found at Smyrna and is in the museum there: Mansel, Akarca, p. 48, fig. 26. They give lists of the Pamphylian sarcophagi.

34. D. E. L. Haynes, "Mors in Victoria," *PBSR* 15 (1939) 27–32.

35. Johnson, *Corinth* IX, 114ff., no. 241.

36. The sarcophagus of Claudia Antonia Sabina and all its parallels are published in full in Morey, *Sardis* V, 1.

37. *Ibid.*, p. 45.

38. *Ibid.*, ch. IX, pp. 90–93.

39. J. D. Young, "A Sarcophagus at Providence," *ArtB* 13 (1931) 138–159; G. Rodenwaldt, "Sarcophagi from Xanthos," *JHS* 53 (1933) 181–213; see also, G. M. A. Hanfmann, *The Season Sarcophagus at Dumbarton Oaks* (Cambridge, Mass., 1951), II, 163, no. (313).

40. Vermeule, *Berytus* 13 (1959) 23.

41. J. B. Ward Perkins, "The Hippolytus Sarcophagus from Trinquetaille," *JRS* 46 (1956) 10–16, and "Four Roman Garland Sarcophagi in America," *Archaeology* 11 (1958) 98–104. F. Matz, *Ein Römisches Meisterwerk, JdI, Ergänzungsheft* XIX, 1958, pp. 82ff., lists the Attic Erotes sarcophagi, and A. Giuliano, "Un sarcofago di Eleusi con il mito di Meleagro," *Annuario* 33–34 (1955–56) 183–205, discusses those with more literary myths.

42. Morey, *Early Christian Art*, pp. 25ff.; Morey, *Sardis* V, 1, pp. 30ff., fig. 25; M. Bieber, "Romani Palliati," *PAPS* 103 (1959) 411, fig. 58.

43. Compare Delbrueck, *Spätantike Kaiserporträts*, pls. 50, 58, 60 and 61.

44. M. Wegner, "Zwei Oströmische Bildwerke," *Istanbuler Forschungen* 17 (1950) 159f., pl. 65; J. Kollwitz, *Oströmische Plastik der Theodosianischen Zeit* (Berlin, 1941), pp. 77ff., pl. 15, dated in the last years of the rule of Theodosius II, that is, 440 to 450; Mendel, *Catalogue*, II, 449ff., no. 667 and full bibl.

45. G. Lippold, *Die Skulpturen des Vaticanischen Museums*, III, 1 (Berlin, 1936), 190f., nos. 586, 591.

46. Mendel, *Catalogue*, II, 494f., no. 695. H.:1.05m.; W.:0.36m. Mendel suggested a date between 400 and 600.

47. W. M. Calder, *MAMA*, VII, 42, no. 204. H.:0.51m.; W.:0.58m. No inscription.

48. D. T. Rice, *The Beginnings of Christian Art* (London, 1957), p. 47, fig. 5; *Guide Illustré*, Istanbul, 1935, pp. 101f., no. I 4508.

CHAPTER IV
Epigraphic and Numismatic Evidences

1. British Museum, *Select Greek and Latin Inscriptions* (London, 1929), no. 399.

2. *Ibid.*, no. 522; Kekulé, *Beschreibung der antiken Skulpturen* (Berlin, 1895), no. 1177.

3. V, Elis I, xii, 8.

4. R. A. G. Carson, "The Gold Stater of Flamininus," *BMQ* 20 (1955) 11–13, pl. VI; A. A. Boyce, *Hommages à Albert Grenier*, Coll. Latomus LVIII, 1962, I, 342–350; F. Chamoux, *BCH* 89 (1965) 214–224.

5. Reference throughout is to A. R. Bellinger, *Troy, The Coins* (Troy, Supplementary Monograph 2) (Princeton, 1961), pp. 37–78, pls. 6–13.

CHAPTER V.
Single Monuments and Important Men

1. D. M. Robinson, "Roman Sculptures from Colonia Caesarea Pisidian Antioch," *ArtB* 9 (1926) 5–69; H. Ingholt, "Parthian Sculptures from Hatra," *MemConnAc* 12 (1954) 19f.

2. A. C. Levi, *Barbarians on Roman Imperial Coins and Sculpture*, A. N. S., Num. Notes and Monogr. 123 (New York, 1952).

3. J. M. C. Toynbee, *NumChron* 1952, 157ff.; Vermeule, *Gnomon* 25 (1953) 471ff.

4. G. Guidi, "Lo Zeus di Cirene," *Africa Italiana* 1 (1927) 3–40.

5. *ILN*, 23 Feb. 1957, p. 30, figs. 5f.; *AA* 1959, cols. 284ff., figs. 25ff. I owe detailed photographs of the propylaea and other sculptures at Cyrene to the Third (1962) Libyan Expedition of the University Museum, Philadelphia, and to Richard Goodchild, Director of the Department of Antiquities, Cyrenaica. Emily T. Vermeule photographed and studied the sculptures as a member of this expedition. See generally, R. Goodchild, *Cyrene and Apollonia, An Historical Guide* (London, 1959), pp. 22f., 40ff.

6. See Chapter III and note 9.

7. Johnson, *Corinth*, IX, 101ff., nos. 217ff.; R. Stillwell, *Corinth*, I, 2 (Cambridge, Mass., 1941), 55ff.; A. H. S. Megaw, *JHS, Arch. Reports for 1963–1964*, 7: early third-century dating.

8. Morey, *Sardis*, V, 1, 43, Smyrna C (and B?); *Festschrift für Friedrich Matz*, 104, no. 1.

9. Lippold, *Handbuch*, p. 302, pl. 108, 1.

10. H. A. Thompson, "The Odeion in the

Athenian Agora," *Hesperia* 19 (1950) 103ff., esp. 119ff.

11. Smith, *Catalogue*, III, part VII, 117, no. 1772.

12. The stone is gray Anatolian marble with a large crystalline structure. H. (max. as preserved): 0.63m. Diam. (reconstructed): 0.63m. Thickness: 0.05m. H. Hoffmann, *Jahrbuch der Hamburger Kunstsammlungen* 8 (1963) 205ff.

13. *MonAnt* 38 (1939) 9ff.; G. Jacopi, "Gli Scavi della Missione archeologica italiana ad Afrodisiade nel 1937 (XV–XVI)," *MonAnt* 38 (1939) 209ff.

14. R. Naumann and S. Kantor, "Die Agora von Smyrna," *Istanbuler Forschungen* 17 (1950).

15. *Einzelaufnahmen*, nos. 3204–3208; Squarciapino, *La Scuola di Afrodisia*, pp. 77f.

16. T. Wiegand, *Baalbek, Ergebnisse der Ausgrabungen und Untersuchungen in den Jahren 1898 bis 1905* (Berlin and Leipzig, 1921–1925), I, pls. 105ff., II, pls. 63ff.

CHAPTER VI.
The Great Antonine Altar at Ephesus

1. Vermeule, *Berytus* 13 (1959) 22, no. E 9, pl. 18; C. Vermeule, *AJA* 61 (1957) 117, 238, note 125; Toynbee, *JRS* 37 (1947) 188; Toynbee, *Hadrianic School*, p. 141, pl. 32; Ryberg, *MAAR* 22 (1955) 133f.; F. Eichler, *VI International Kongress für Archäologie* (Berlin, 1939), pp. 488ff.; F. von Lorentz, "Ein Bildnis des Antoninus Pius?," *RM* 48 (1933) 309 pl. 50; Reinach, *Rép. rel.*, I, 142–145; J. B. Ward Perkins, "The Art of the Severan Age in the Light of Tripolitanian Discoveries," *ProcBritAc* 37 (1952) pl. XV, 1: dated in the sixties of the second century; J. Keil, *Führer durch Ephesos* (Vienna, 1955), p. 90: Parthian wars of Marcus Aurelius and Lucius Verus, and perhaps from an altar building; so also G. Rodenwaldt, *AbhBerl* 1935, no. 3, p. 25; W. Weber, CAH XI, p. 332 and note 4: commemorates accession of Antoninus Pius; Antoninus was governor of Syria, and an honorific decree at Ephesus suggests a public monument; A. Schober, *Die Kunst von Pergamon* (Innsbruck and Vienna, 1951), pp. 183f.: as circa A.D. 169; R. Brilliant, "Gesture and Rank in Roman Art, The Use of Gestures to Denote Status in Roman Sculpture and

Coinage," *MemConnAc* 14 (1963) 137f.: A.D. 138; Toynbee, *Art of the Romans*, pp. 65f., 251: "last year of Hadrian."

2. The ideas proposed in detail in these pages were read at the Annual General Meeting of the Archaeological Institute of America at Detroit, December 1961: *AJA* 66 (1962) 200f.; *Archaeology* 15 (1962) 54.

3. Dr. Rudolf Noll of the Antikensammlung made available every facility for studying the reliefs in Vienna. His assistant, Dr. Wolfgang Oberleitner, kindly showed me a number of points about the marbles which might have escaped observation. Professor Eichler gave most generously of his time and years of experience, during a session in which he explained many points about the reliefs. His efforts have made many details understandable and have saved me from a number of foolish errors. Where I disagree with published conclusions about the monument, it is with full knowledge that my ideas will need revision when a thorough publication appears or when the foundations of the monument itself are found, in the unexcavated area between the two hills of Ephesus (Panayir Daği and Bülbül Daği).

4. Giuliano, pp. 184–186.

5. Bieber, *Sculpture of the Hellenistic Age*, pp. 113–118.

6. A. von Gerkan, *Der Altar des Artemis-Tempels in Magnesia am Mäander* (Berlin, 1929), 35 pp., 10 pls.

7. T. Wiegand, H. Schrader, *Priene* (Berlin, 1904), pp. 120–126; M. Schede, *Die Ruinen von Priene* (Berlin and Leipzig, 1934), p. 38.

8. *AJA* 61 (1957) 246.

9. *The Athenian Agora, A Guide to the Excavations* (Athens, 1954), pp. 44f., no. 9 (Altar of Zeus Agoraios); C. Yavis, *Greek Altars, Origins and Typology* (St. Louis University Studies, Monograph Series: Humanities, No. 1, St. Louis, 1949), pp. 185ff., no. 19; R. Stillwell, "Architectural Studies," *Hesperia* 2 (1933) 140ff.

10. Hill, *Athens*, p. 183.

11. *AJA* 61 (1957) 240; Mendel, *Catalogue*, III, 493f., nos. 1282f.

12. Vermeule, *Berytus* 13 (1959) 59, no. 210, fig. 54.

13. *Ibid.*, p. 58, no. 208, fig. 53.

14. Bieber, *Sculpture of the Hellenistic Age,* pp. 120f.

15. Lippold, *Handbuch,* p. 107, pl. 34, 3 and 4.

16. *Ibid.*, pp. 381f., pl. 134, 3.

17. Reinach, *Rép. rel.,* I, 367.

18. The *vexillum* is properly the attribute of frontier, military provinces, as Cappadocia: Toynbee, *Hadrianic School,* pp. 66ff.; and Pannonia: pp. 133ff.; or Mauretania in one of the reliefs from the Hadrianeum: p. 156, pl. XXXIV, 6.

19. *Ibid.*, p. 157, pl. XXXV, 1.

20. *Ibid.*, p. 141, pl. 32; and Toynbee, *JRS* 37 (1947) 188.

21. Vermeule, *Berytus* 13 (1959) 22, no. E 9.

22. Toynbee, *Hadrianic School,* pl. XXI, no. 1.

23. Ryberg, *MAAR* 22 (1955) 133f.

24. T. W. Heermance, "Grave-Monuments from Athens," *AJA* 10 (1895) 479–484; A. Muehsam, "Attic Grave Reliefs from the Roman Period," *Berytus* 10 (1952–53) 62, 75, 84, pl. XIV, 1; S. Dow, C. Vermeule, "The Statue of the Damaskenos at the American School at Athens," *Hesperia* 34 (1965) 273–297, pls. 61–65.

25. Cf. Lippold, *Handbuch,* p. 181, pl. 63, 4.

26. B. Ashmole, *A Catalogue of the Ancient Marbles at Ince Blundell Hall* (Oxford, 1929), pp. 6f., no. 8.

27. The Demos of Ephesus is a bearded, half-draped figure; neither Boule nor Demos, both so popular elsewhere, appear on Ephesian coins, generally so taken up with the cults of Artemis. The standing Sarapis is very popular in western Asia Minor: H. P. Weitz, in W. H. Roscher, *Lexikon,* IV (Leipzig, 1915), cols. 338–382.

28. Although other figures have been proposed as Faustina II, the fact that this Persephone is every bit the pendant to the Demeter-Faustina I might suggest a conscious balance of mother and daughter as fifth-century goddesses standing in similar relationship.

29. The only marine god on coins of Ephesus is the Marnas; he is beardless, reclining with reed in hand on aes of Domitian: *SNG, Deutschland, Sammlung von Aulock, Ionien* (Berlin, 1960), no. 1880.

30. W. Helbig, *Führer durch die öffentlichen Sammlungen klassischer Altertümer in Rom,* 3rd ed. (Leipzig, 1912), I, 210, no. 319.

31. Vermeule, *Goddess Roma,* pl. 5, no. 16.

32. *Ibid.*, pp. 35–38. The Roma of the apotheosis scene on the base of the column of Antoninus Pius offers a good parallel: p. 89, pl. X, 3.

33. See note 19.

34. See note 18.

35. Reinach, *Rép. rel.* I, 228, no. 3 (right center).

36. Bieber, *Sculpture of the Hellenistic Age,* p. 116, fig. 460.

37. In this respect he parallels the Genius Populi Romani; see E. Rink, *Die bildlichen Darstellungen des römischen Genius* (Giessen, 1933).

38. Giuliano, *Annuario* 37–38 (1959–1960) 389f., figs. 1, 2.

39. Mendel, *Catalogue,* III, 583f., no. 1372.

40. Reinach, *Rép. rel.,* I, 228, no. 3 (extreme left).

CHAPTER VII.
Imperial Metalwork

1. Accession no. 24.971. H:0.103m.; Diam.: 0.095m. W. S. Smith, *Ancient Egypt, As Represented in the Museum of Fine Arts, Boston* (Boston, 1960), pp. 185ff., fig. 126; D. Dunham, *The Egyptian Department and its Excavations* (Boston, 1958), pp. 126ff., fig. 101; D. Dunham, *Royal Tombs at Meroë and Barkal, The Royal Cemeteries of Kush* IV (Boston, 1957), p. 106, pl. 53; D. E. Strong, *Greek and Roman Gold and Silver Plate* (London, 1966), pp. 115, 137.

2. S. Haynes, "Drei neue Silberbecher im British Museum," *Antike Kunst* 4 (1961) 30–36; P. E. Corbett and D. E. Strong, "Three Roman Silver Cups," *BMQ* 23 (1961) 68–86; D. E. Strong, *Greek and Roman Gold and Silver Plate,* pp. 115, 139.

3. A rather different, shorter version of this

chapter appeared in *Antike Kunst* 6 (1963) 33–40.

4. The cup is now in Toledo (Ohio), Museum of Art, and the ladle is in Boston, Museum of Fine Arts. The former is Acc. no. 61.9; H.: 0.07m.; Diam.: 0.09m. The latter is Acc. no. 61.159; L. (max.): 0.17m.

5. Reinach, *Rép. rel.*, I, 83–97, with text on 83 and 97; E. Babelon, *Le Trésor d'argenterie de Berthouville* (Paris, 1916); Picard, *Mon-Piot* 44 (1950) 53ff.

6. Reinach, *Rép. rel.*, I, 159ff.; E. Pernice and Fr. Winter, *Der Hildesheimer Silberfund* (Berlin, 1901); H. Küthmann, "Untersuchungen zur Toreutik des zweiten und ersten Jahrhunderts v. Chr.," Diss. Basel, 1959; U. Gehrig, *Hildesheimer Silberfund* (Berlin, 1967).

7. D. Mustilli, *Il Museo Mussolini* (Rome, 1939), pp. 105f., no. 6, pl. LXI, 243.

8. Basic publication: H. de Villefosse, "Le Trésor de Boscoreale," *MonPiot* 5 (1899); Reinach, *Rép. rel.*, I, 93–97; E. S. Strong, *CAH, Plates*, IV, 128f.; G. Rodenwaldt, "Kunst um Augustus," *Die Antike* 13 (1937) 178ff.; Ryberg, *MAAR* 22 (1955) 141ff.

9. Strong, *Art in Ancient Rome*, pp. 42f., fig. 298; *CAH, Plates*, V, 8f.; K. Friis Johansen, *Nordiske Fortidsminder* II, 3, pl. 8, figs. 33, 35; S. Reinach, "Les Vases d'Argent de Cheirisophos au Musée de Copenhague," *GBA* 1923, 129ff.; National Museum, Copenhagen, *Guide* (1955) pp. 78ff.; G. Lippold, *Abh-München* 33 (1951) 16; Richter, *Ancient Italy*, p. 63, figs. 192f.; Toynbee, *Art of the Romans*, pp. 261f.; G. M. A. Hanfmann, *Classical Sculpture* (Greenwich, Conn., 1967), p. 335, no. 275.

10. *AJA* 61 (1957) 244ff. H. Jucker, " 'Promenade archéologique' durch die Ausstellung der Sammlung Kofler im Kunsthaus Zürich," *Antike Kunst* 8 (1965) 47, suggests the principal figure is Augustus not Tiberius; he also indicates he could be Achilles-Germanicus, but no identification of the secondary persons is offered.

11. Inv. no. 3391; Diam.: 0.13m. U. Hausmann, *Hellenistische Reliefbecher* (Stuttgart, 1959), p. 40, pl. 45, 1–4, and bibliography; H. Jucker, *Antike Kunst* 8 (1965) 52 and note 92.

12. *NdS* 1908, 235ff.; S. Aurigemma, *The Baths of Diocletian and the Museo Nazionale Romano* (Rome, 1958), p. 43, no. 89, pl. XVII.

13. H. Möbius, in *Festschrift für Friedrich Matz*, pp. 80–97 and detailed documentation, and his "Nochmals zum Silberteller von Aquileia," *AA* 1965, 867–882.

14. See C. Vermeule, "Greek, Etruscan and Roman Bronzes Acquired by the Museum of Fine Arts, Boston," *CJ* 55 (1960) 198ff., fig. 7.

15. As has been pointed out by E. Simon, *Die Portlandvase* (Mainz, 1957); see also D. E. L. Haynes, *BurlMag* 99 (1957) 391.

16. Picard, *MonPiot* 44 (1950) 53–82.

17. The Corsini cup, from Anzio, of Athena casting her lot for Orestes, has been related by G. M. A. Richter to works in other media, thereby showing its derivation from older sources, perhaps the pair of embossed silver cups mentioned by Pliny (xxxiii.56) as the work of Zopyros: *Ancient Italy*, pp. 59, 94, figs. 267ff.

CHAPTER VIII.
Numismatic Art

1. General references to Greek Imperial numismatics. (These and further, more detailed works are listed in Vermeule, *A Bibliography of Applied Numismatics*, London, 1956. Some of the works cited below, such as the British Museum Catalogues, not only contain selections for reading but lists of coins; the *Sylloge Nummorum Graecorum* merely lists Greek imperial coins by region and city but illustrates everything listed. Dictionaries, although not included here, can be extremely helpful.)

Bellinger, A. R. "Greek Mints Under the Roman Empire," *Essays Presented to Harold Mattingly*, Oxford, 1956, ch. VIII.

Bosch, Cl. *Kleinasiatische Münzen der römischen Kaiserzeit*, Teil II, Band 1: Bithynien. 1 Hälfte, Stuttgart, 1935.

British Museum Catalogues of Greek Coins. Greece, Asia Minor, and the Near East (by Province).

Curtis, J. W. *The Tetradrachms of Roman Egypt*, Chicago, 1957.

Felletti Maj, B. M. *Siria, Palestina, Arabia*

Settentrionale nel periodo romano, Rome, 1950.

Head, B. V. *Historia Numorum. A Manual of Greek Numismatics,* 2nd ed., Oxford, 1911.

Imhoof-Blumer, F. *Kleinasiatische Münzen,* 2 vols., Vienna, 1901–02.

Jones, A. H. M. *The Cities of the Eastern Roman Provinces,* Oxford, 1937.

Jones, T. B. "Greek Imperial Coins," *North American Journal of Numismatics* 4 (1965) 295–308, esp. 304f., map with nearly 523 mints located or listed. See also T. B. Jones, in *PAPS,* 107, no. 4, Aug. 1963.

Kadman, L., et al. *Corpus Nummorum Palaestinensium,* vols. I–III, Jerusalem, 1950–1960 (in progress).

Magie, D. *Roman Rule in Asia Minor to the End of the Third Century After Christ,* 2 vols., Princeton, 1950.

Picard, Ch. *Ephèse et Claros, Recherches sur les sanctuaires et les cultes de l'Ionie du Nord,* Paris, 1922.

Ramsay, W. *The Historical Geography of Asia Minor,* London, 1890 (reprinted 1962).

Robert, L. *Études anatoliennes. Recherches sur les inscriptions grecques de l'Asie Mineure,* Paris, 1937.

———— *Hellenica,* vols. I–X, Paris, 1940–1955 (in progress).

———— "Sur des types de monnaies impériales d'Asie Mineure," American Numismatic Society, *Centennial Publication,* New York, 1958, pp. 577–584.

———— *Villes d'Asie Mineure, Études de géographie antique,* Paris, 1935.

Sylloge Nummorum Graecorum, Collection H. von Aulock, parts 1–16 (through Galatia) (in progress); Danish National Museum, Copenhagen, fascicules 18–38.

Toynbee, J. M. C. "Greek Imperial Medallions," *Journal of Roman Studies* 34 (1944) 65–73 (and bibliography).

Trell, B. L. "Architectura Numismatica — II: Temples in Asia Minor," Ph.D. Diss., New York University, 1942 (using material at the American Numismatic Society).

———— *The Temple of Artemis at Ephesos,* A. N. S., Numismatic Notes and Monographs, 107, New York, 1945.

Waddington, *Inventaire sommaire de la Collection Waddington acquise par l'état en 1897,* ed. M. Ernest Babelon, Paris, 1898.

Woodward, A. M. "The Cistophoric Series and its Place in the Roman Coinage," *Essays to Mattingly,* ch. IX.

2. *Catalogue,* III, 591, no. 1380. A statuette in the Fogg Museum of Art, a master bronze of the second or third centuries A.D., shows a related, very numismatic type of the standing Men. See *Fogg Art Museum, Acquisitions 1964,* p. 69 (accession no. 1964.126).

CHAPTER IX.
Augustus and the Julio-Claudians

1. On the subject, see O. Brendel, "Novus Mercurius," *RM* 50 (1935) 231–259; *AJA* 61 (1957) 203. Torso in the Archaeological Museum at Rhodes: Vermeule, *Berytus* 15 (1964) 98, no. 15 A.

2. G. M. A. Richter, *Roman Portraits* (New York, 1948), no. 28; K. Kluge and K. Lehmann-Hartleben, *Die antiken Grossbronzen,* II, 3ff., pl. 2 (Berlin, 1927); F. Poulsen, *Porträtstudien in norditalischen Provinzmuseen* (Copenhagen, 1928), 63.

3. Blümel, R 15, pl. 10 and R 16, pl. 11; Hafner, pp. 37f., under no. MK 13. Jean Ch. Balty, "Notes d'iconographie Julio-Claudienne, I," *MonPiot* 53 (1963) 121ff., suggests Claudius about A.D. 37. Inan-Rosenbaum (p. 64, no. 20) classify him as a possible Marcus Antonius.

4. L. M. Ugolini, *L'Agrippa di Butrinto* (Rome, 1932).

5. Vermeule, *Berytus* 13 (1959) 40, nos. 49, 50; the statue base of Agrippa from Corfu is *CIG* 1878.

6. Vermeule, *Berytus* 13 (1959) 34, no. 15. The inscribed base to Agrippa at the site may belong to this statue; *Berytus* 15 (1964) 98.

7. Caskey, *Catalogue,* pp. 195f., no. 112; *Greek and Roman Portraits,* no. 39; *Greek, Etruscan & Roman Art,* p. 222, fig. 231.

8. Poulsen, pp. 427f., no. 615; V. Poulsen, pp. 65–71, no. 34, where an extensive list of early Livias is given. This is no. 1 in Group C. In this connection V. Poulsen cites heads on Samos (*Festschrift A. Rumpf* [Krefeld, 1952], pl. 21), from Marmaris in Caria (G. E. Bean and J. M. Cook, "The Carian Coast III," *BSA* 52, 1957, pl. 16a) and Larissa, from the site of the principal shrine to Achilles (H. Biesantz, "Griechisch-Römische Altertümer in Larissa und Umgebung," *AA* 1959, p. 104, fig. 22). The head from Marmaris is a splendid example and is now in the School there (Inan-Rosenbaum, pp. 60f., no. 11); the forepart

of the head found at Larissa is dry and careful, with some character to the hair. It follows a Roman model of the famous lady's later years. Istanbul, Archaeological Museum, no. 4772, seems to be a typical, middle-aged Livia. It is in one of the lower storerooms. (Livia at Marmaris is now [1967] in the Bureau of Tourism.)

9. Poulsen, p. 428, no. 616; V. Poulsen, p. 71, no. 35. He cites as another possible provincial likeness a head in Ankara from Sinope (L. Budde in E. Akurgal and L. Budde, "Vorläufiger Bericht über die Ausgrabungen in Sinope," *Belleten* 5, 1956, pls. 18f.). The identification seems fairly certain (Inan-Rosenbaum, pp. 59f., no. 10).

10. *RM* 54 (1939) pl. 20.

11. Mariani, *AJA* 1 (1897) 269ff., fig. 3. Heraklion Museum no. 67. She wore metal earrings. The marble of all four portraits in the group from Gortyna is Pentelic. Livia's historical iconography, particularly in Greek imperial coins, is treated in detail by W. H. Gross, *Iulia Augusta* (Göttingen, 1962) (*Abh. Göttingen* III, no. 52).

12. National Museum, no. 355: *RM* 54 (1939) pl. 22; V. Poulsen, pp. 76f., discussion under no. 41. In *AJA* 68 (1964) 320, H. von Heintze lists this as a portrait of Livia.

13. C. Hanson and F. P. Johnson, "On Certain Portrait Inscriptions," *AJA* 50 (1946) 395.

14. See *Mostra Augustea della Romanità* (Rome, 1937), p. 113, no. 28, pl. 22, which is Blümel, pp. 10f., R 22, pl. 15.

15. H. Biesantz, *AA* 1959, cols. 102ff., no. 4, fig. 22.

16. J. Charbonneaux, *Festschrift B. Schweitzer* (Stuttgart, 1954), pp. 331ff., pl. 71.

17. *Olympia*, III, pl. 61, no. 4.

18. Blümel, p. 9, R 18, pl. 9; Hafner, p. 38, MK 14.

19. Harrison, pp. 17ff., no. 7.

20. L. Curtius, "Ikonographische Beiträge VII," *RM* 50 (1935) 276, pl. 45 and fig. 9, the latter being the Calvert head.

21. For the iconography of Germanicus, see R. Bianchi Bandinelli, "Per l'iconografia di Germanico," *RM* 47 (1932) 153–169.

22. L. Curtius, "Ikonographische Beiträge zum Porträt der Römischen Republik. XIV. Germanicus," *MdI* 1 (1948) 72, pl. 26.

23. Hafner, p. 40, no. MK 19.

24. Also by Curtius, as Nero Drusus: *RM* 50 (1935) 272ff., fig. 8.

25. See Appendix A, under Nero, no. 2.

26. So Giuliano, p. 158, no. 15.

27. Hoffmann, Hewicker, *Kunst des Altertums*, no. 25; H. Hoffmann, *Jahrbuch Hamburger Kunstsammlungen* 7 (1962) 221ff.

28. Mariani, *AJA* 1 (1897) 271ff., fig. 4; Fabbrini, *BdA* 4 (1964) 317f., figs. 24–26, as Drusus Senior.

29. G. Deschamps, "Fouilles dans l'île d'Amorgos," *BCH* 12 (1888) 325; Fabbrini, *BdA* 4 (1964) 318, figs. 17–19, as Drusus Senior.

30. Elisabeth Rosenbaum informs me (9 April 1966) of a head of Germanicus from Ephesus and now in the Selçuk Museum. He has a slight, "mourner's" beard and can be compared with Copenhagen, Ny Carlsberg Glyptotek, no. 756: F. Poulsen, 438ff., no. 633 (as Drusus Junior); V. Poulsen, 88, no. 52, pl. 88. See *Österreichisches Archäologisches Institut, Grabungen 1965*, pp. 8f.

31. Vermeule, *PAPS* 108 (1964) 114, fig. 13.

32. *Olympia*, III, pls. 63, no. 2, and 64, no. 1.

33. V. Poulsen, p. 98.

34. Blümel, p. 12, no. R 26, pl. 17; Hafner, p. 55, no. NK 15; Giuliano, pp. 158ff., no. 16; Inan-Rosenbaum, p. 64, no. 19.

35. On this title in connection with the imperial cult in Asia, see L. Robert, "Recherches épigraphiques, V. Inscriptions de Lesbos," *REA* 62 (1960) 285ff.

36. Laurenzi, *Annuario* 33–34 (1955–56) 124, no. 142; Giuliano, p. 160, no. 17.

37. *Olympia*, III, pl. 64, no. 6; Poulsen, p. 441, a confused identification.

38. Johnson, *Corinth*, IX, 76f., no. 137 and bibliography. A. Rumpf, on the other hand, implies that he is Germanicus, probably mourning for Augustus, and compares him with the large head from Lepcis Magna: *Bonner Jahrbucher* 155–156 (1955–1956) 126, pl. 23.

V. Poulsen favors the young Caligula: *Meddelelser* 14 (1957) 44, no. 44.

39. E. G. Suhr, *AJA* 59 (1955) 319-322 has sought a likeness of Claudius on the eve of his accession in a head of unknown provenance in Rochester, N.Y. Since it appears in these pages as a possible Agrippa, I have omitted from the list V. Poulsen's identification of a well-known head in Berlin from Magnesia on the Maeander as Claudius (*Les portraits romains*, p. 91, under no. 56). He suggests that this large head was made during Caligula's rule.

40. V. Poulsen, "Nero, Britannicus and Others. Iconographical Notes," *ActaA* 22 (1951) 135, no. 3; Giuliano, p. 161, no. 24.

41. V. Poulsen, *OpusRom* 4 (1962) 109.

42. *Ibid.*, no. 3, figs. 6f.; *Olympia*, III, 260, pl. 64, no. 6 (but see note 35).

43. *Ibid.*, 258f., pls. 63, nos. 4 to 6; 64, nos. 2 and 3; V. Poulsen, *OpusRom* 4 (1962) 111.

44. T. L. Shear, "Excavations in Corinth in 1926," *AJA* 30 (1926) 454f., fig. 8.

45. E.g., the R. Cyril Lockett collection specimen, Glendining and Co. Sale, part IX, 27 May 1959, lot 2111, as opposed to *BMC, Corinth*, p. 72, no. 579, pl. xviii, 10.

CHAPTER X.
Augustan and Julio-Claudian Commemorations

1. W. B. Dinsmoor, *The Architecture of Ancient Greece* (London, 1950), p. 360, (8) gives a bibliography of the temple.

2. H. Schliemann, *Ilios* (Paris, 1895), pp. 797ff., fig. 1558; for the comparable coin, compare figure 1620 and A. R. Bellinger, *Troy*, Supplementary Monograph no. 2 (Princeton, 1961), pl. 8, T. 157 and T. 182 (Lucius Verus and Commodus). Beatrice Holden's honors thesis at Smith College, on the early Hellenistic date of the metopes of the temple of Athena at Ilium, has been of considerable help in preparing this section. See B. M. Holden, *The Metopes of the Temple of Athena at Ilion* (Northampton, Mass., 1964).

CHAPTER XI.
The Flavian Dynasty

1. *Collections de feu M. Jean P. Lambros d'Athènes et de M. Giovanni Dattari du Caire, vente à Paris le 17-19 juin 1912*, no. 268; Vermeule, *PAPS* 108 (1964) 101, fig. 19; Wegner, *Die Flavier*, pp. 72f.; Walters Art Gallery no. 23.119. Since its appearance in the catalogue, the head has been deprived of much of its patina or encrustation, particularly around the lips, jaws, and chin.

2. R. West, *Römische Porträt-Plastik*, II (Munich, 1941), 9, pl. I. An overlifesized head in the Bergama Museum, no. 157, from the Acropolis, heretofore widely identified as Republican (E. Buschor, *Das hellenistische Bildnis* [Munich, 1949], p. 50, fig. 45; Hafner, p. 63, no. A 7; Giuliano, p. 155, III-9) or early imperial (F. Winter, *Altertümer von Pergamon* VII, 2 [Berlin, 1908], p. 230, no. 278), has been labeled "Vespasian," on the authority of H. Weber, accepted by Jale Inan and E. Rosenbaum (p. 67, no. 26) but not by Wegner (*Die Flavier*, p. 78). This is an extremely plastic, Greek likeness, which bears comparison with the Olympia Titus or the head of Titus in Boston (see below). The identification seems certain. The overlifesized, so-called Vespasian in Salonika (no. 1055) appears to be a private person of the Hellenistic period (Wegner, *Die Flavier*, pp. 82f.).

3. V. Karageorghis, the excavator, kindly provided information and photographs. See "Chronique des Fouilles a Chypre en 1961," *BCH* 86 (1962) 402, figs. 94f.

4. Museum no. 25029; H. Jucker, *Jahrbuch des Bernischen Historischen Museums in Bern* 41–42 (1961–62) 304, 314, figs. 37f.; Wegner, *Die Flavier*, p. 72 (possibly an ideal Galba).

5. Museum no. 36500; Jucker, *Jahrbuch*, pp. 312f., figs. 33f.; Wegner, *Die Flavier*, p. 74 (doubtful).

6. Vermeule, *Berytus* 13 (1959) 45, nos. 86ff. The closest parallel for the head of the statue at Olympia lies in a head of Titus in the collection of Horace L. Mayer, at the Museum of Fine Arts, Boston: Vermeule, *AJA* 68 (1964) 336f., pl. 109, fig. 30; Wegner, *Die Flavier*, p. 85 (not Titus). This head, in Greek marble, is said to come from the Somzée collection, but it cannot be listed here because further provenience is unknown. The likenesses in both instances belong to the middle of Vespasian's reign, about A.D. 75. In East Greek cuirassed statues of the Flavian era, this represented the phase of commemoration after the recovery from the campaigns in Judaea,

when Vespasian was firmly in power and Flavian Greece could turn to thoughts more pan-imperial or iconographically general than the JUDAEA CAPTA motifs.

7. Vermeule, *Berytus* 13 (1959) 4f., note 3.

8. Titus in Oxford: *AJA* 59 (1955) 351; A. Michaelis, *Ancient Marbles in Great Britain* (Cambridge, 1882), p. 557, no. 70; Wegner, *Die Flavier*, p. 90 (doubtful). Titus in Missouri: Vermeule, *PAPS* 108 (1964) 104, fig. 22, and *AJA* 68 (1964) 337; S. S. Weinberg, *Missouri Alumnus*, March 1963, p. 5, fig. 14; Wegner, *Die Flavier*, p. 85 (not Titus). An overlifesized head of Herakles in the Salonika Museum may be a portrait of Titus. He is wreathed, and the pupils are expressed. The hair is unfinished behind, and the marble is possibly Pentelic.

9. F. Poulsen, *Ikonographische Miscellen* (Copenhagen, 1921), p. 71, pl. 30; Wegner, *Die Flavier*, p. 97 (overlifesized).

10. A. Schober, "Vom griechischen zum römischen Relief," *JOAI* 27 (1932) 59, pl. 3, Beiblatt; Inan-Rosenbaum, p. 67, no. 27; Wegner, *Die Flavier*, p. 86 (as a posthumous Titus).

11. F. Winter, *Altertümer von Pergamon* VII, 2, p. 231, Beiblatt 30; Wegner, *Die Flavier*, p. 105.

12. Nerva at Ephesus: *ILN*, 8 Feb. 1958, 222, fig. 10; the nymphaeum and surroundings: F. Miltner, *Ephesos* (Vienna, 1958), pp. 50ff., no. 10; F. Miltner (†), F. Eichler, "XXIII. Vorläufiger Bericht über die Ausgrabungen in Ephesos," *JOAI* 44 (1959) Beiblatt, 332ff., figs. 175f. The nude upper torso of the twice-lifesized Trajan is fig. 174; since there seems to be a himation hanging from the left shoulder, the statue may have shown Trajan seated in the manner of Jupiter Capitolinus.

CHAPTER XII.
Trajan and Hadrian

1. On the portraits of Trajan, see W. H. Gross, *Bildnisse Traians* (*Das Römische Herrscherbild*, II. Abteilung, Band 2) (Berlin, 1940); *AJA* 61 (1957) 223–253.

2. For Plotina, see M. Wegner, *Hadrian, Plotina, Marciana, Matidia, Sabina,* (*Das Römische Herrscherbild*, II. Abteilung, Band 3) (Berlin, 1956), pp. 118–120.

3. Captain Beaufort (*Karamania*, London,

1817) writes of his visit in 1811: "The front wall is of plain cut stone, and nearly perfect; it is two hundred feet long and twenty high, with a pediment at each extreme. The following inscription extends along the whole of the front: HORREA IMP CAESARIS DIVI TRAIANI PARTHICI F / DIVI NERVAE NEPOTIS TRAIANI ADRIANI AVGVSTI COS III. The granary is divided into seven compartments, each of which had a door to the front. Over the centre door are two busts of a male and a female . . ." He goes on to describe figured reliefs perhaps inserted in the walls at later times. The relief of a female with a scepter and crown reclining on a couch, attended by a male figure also crowned and holding a "cup" could be a Tyche-Annona with a geographical personification. Above the granary, on a hill, Beaufort saw "a small ruined temple of very white marble." It may be that this building was the shrine to the Julio-Claudians and their statues or bases were moved to the granary at a later date.

4. Vermeule, *Berytus* 13 (1959) 55f., nos. 180–191, 76; Vermeule, *Berytus* 15 (1964) 95, 105.

5. *IG*, no. 1307; Th. Mommsen, *The Provinces of the Roman Empire* (London, 1902), p. 291, note 1.

6. Vermeule, *Berytus* 13 (1959) 60, nos. 225–230.

7. *IGRR*, III, no. 39; C. Fellows, *Asia Minor* (London, 1839), pp. 115ff., 322.

8. B. Ashmole, "Cyriac of Ancona and the Temple of Hadrian at Cyzicus," *JWarb* 19 (1956) 179–191, gives all information, plans and quotations.

9. F. W. Hasluck, *Cyzicus* (London, 1910), pp. 10ff.

10. Vermeule, *Berytus* 13 (1959) 63, under no. 251.

11. The basic collection of portraits of Hadrian, Plotina, Marciana, Matidia, and Sabina is by M. Wegner, *Hadrian, Das Römische Herrscherbild*, II. Abteilung, Band 3 (Berlin, 1956). The bronze Hadrian in Istanbul from near Adana is discussed on pp. 45, 99.

12. See the remarks in C. Vermeule, *AJA* 58 (1954) 255.

13. F. E. Brown, *Roman Architecture* (New York, 1961), p. 42.

14. D. E. Strong, "Late Hadrianic Architectural Ornament in Rome," *PBSR* 21 (1953) 142.

15. Lippold, *Handbuch*, p. 192.

16. M. Hammond, "A Statue of Trajan represented on the 'Anaglypha Traiani,'" *MAAR* 21 (1953) 163–165.

17. See Vermeule, D. von Bothmer, *AJA* 60 (1956) 331f., pl. 109.

18. See A. W. Van Buren, "News Letter from Rome," *AJA* 62 (1958) 416f.; *ILN*, 5 Oct. 1957, 552f.

19. Toynbee, *Hadrianic School*, p. 67, pl. 24, 4; B. Ashmole, *A Catalogue of the Ancient Marbles at Ince Blundell Hall* (Oxford, 1929), p. 23, no. 42, pl. 27.

20. Vermeule, *Goddess Roma*, p. 113, no. 100.

21. See the remarks in *The Nelson Gallery and Atkins Museum, Bulletin* 3 (1960) no. 2, 1–7.

22. Vermeule, *Berytus* 13 (1959) 29f., note 24.

23. J. M. C. Toynbee, "Picture-Language in Roman Art and Coinage," *Essays in Roman Coinage Presented to Harold Mattingly* (Oxford, 1956), pp. 213f., note 2, fig. 8.

24. Harrison, pp. 38ff., no. 28; identification proposed in C. Vermeule, *AJA* 58 (1954) 255; accepted with a "perhaps" in *Ancient Portraits from the Athenian Agora* (Princeton, 1960), cover and no. 13.

25. Corinth inventory number Sc 2505. Compare Wegner, *Hadrian*, pl. 13.

CHAPTER XIII.
Antonine Art

1. M. Wegner, *Die Herrscherbildnisse in Antoninischer Zeit (Das Römische Herrscherbild*, II. Abteilung, Band 4), Berlin, 1939, gives basic lists of portraits for Antoninus Pius, Faustina the Elder, Marcus Aurelius, Faustina the Younger, Lucius Verus, Commodus, Lucilla, and Crispina.

A lifesized gold bust of Marcus Aurelius was reported in an Associated Press dispatch, dated 5 Dec. 1965, as having been found by "a farmer digging in his field yesterday." The cryptic six lines as printed in the *New York Times* originated from Salonika and gave Salonika University as the source. The newspaper *Hellene Vorra* for 5 Dec. 1965 states, in an article by Nich. Stangkos, that, according to Professor Bakalakis, "one gold head of Marcus Aurelius is one of the most significant finds of the museum at Komotini. The head is almost lifesized and was found at the locality Hagia Petra of the Didymoteichon and is the second golden statue (protome) which exists in the whole world." Professor Eugene Vanderpool has kindly added the following clarification in a letter (3 Jan. 1966): "It is the same find that was reported last summer. It comes from Didymoteichon which Prof. Bakalakis thinks is the ancient PLOTINOPOLIS (Thrace). It was found by soldiers who started breaking off pieces and putting them in their pockets, most have been recovered since. The head is about 25 cm. high and weighs about a kilo. It is of Marcus Aurelius, but the hair-do is "Severan," hence the bust is to be dated a bit after Marcus Aurelius' death." An illustrated lecture given by Mr. Vavritsas revealed (April 1967) that this possible Marcus Aurelius is in mint condition, except for a blow on the left cheek inflicted by the finder (further communication from E. Vanderpool).

Plotinopolis seems to have been prosperous under the Antonines and Severans, most of the imperial coins having been minted under Caracalla.

2. Vermeule, *PAPS* 109 (1965) 337f., fig. 30; Vermeule, *Berytus* 13 (1959) 29, note 24; O. Deubner, "Zu den grossen Propyläen von Eleusis," *AM* 62 (1937) 73ff., pls. 39ff.

3. Inan-Rosenbaum, pp. 83f., no. 57.

4. See D. M. Robinson, "Roman Sculptures from Colonia Caesarea (Pisidian Antioch)," *ArtB* 9 (1926) 69, fig. 127.

CHAPTER XIV.
Severan and Later Portraits and Public Commemorations

1. See Vermeule, *BMFA* 58 (1960) 13–25; L'Orange, *Apotheosis*, pp. 76ff.

2. K. A. Neugebauer, "Die Familie des Septimius Severus," *Die Antike* 12 (1936) 157ff., pls. 10f.; *CAH, Plates* V, 156f.; XII, 364; F. W. Goethert, in *Neue Beiträge zur klassischen Altertumswissenschaft, Festschrift zum 60. Geburtstag von Bernhard Schweitzer* (Stuttgart, 1954), pp. 361ff.; L. Budde, *Jugendbildnisse*

des Caracalla und Geta (Münster, 1951), pl. 5; L'Orange, *Apotheosis*, p. 76 and note 12; G. M. A. Hanfmann, *Roman Art*, pl. XLVIII.

CHAPTER XV.
The Tetrarchs in Greece and Anatolia

1. J. Marcadé, "Sculptures du Musée de Nauplie," *BCH* 86 (1962) 623–626, fig. 6, as a possible Philip I.

2. L'Orange, *Spätantiken Porträts*, p. 103, cat. no. 53, figs. 98f.

3. The head is in Istanbul: Volbach, Hirmer, *Early Christian Art*, pl. 1; F. K. Dörner, *Die Antike* 17 (1941) 139–146; F. K. Dörner, *Istanbuler Forschungen* 14 (1941) 46f., pl. 10. Jale Inan and E. Rosenbaum have, correctly, identified a head in Bursa, from Afion Karahisar as a Tetrarch (Mendel, *BCH* 33 [1909] 271, no. 20, fig. 12); he wears a large, jeweled wreath of oak. On the analogy of the head from Nicomedia, they are right in suggesting Diocletian. The Nicomedia portrait has been published as a possible Claudius II (268–270), whose legates were active in the area, but his face was too pointed, and coins of Diocletian, around 290 to 296, offer many better parallels (see V. Poulsen, *Meddelelser* 24 [1967] 16, fig. 13).

4. H. P. L'Orange, "Ein tetrarchisches Ehrendenkmal auf dem Forum Romanum," *RM* 53 (1938) 1–34; H. P. L'Orange, "Ein tetrarchisches Ehrendenkmal auf dem Forum," *L'Urbe* 1939, no. 7, 1–8; D. E. Strong, *Roman Imperial Sculpture* (London, 1961), figs. 131f.

5. K.-F. Kinch, *L'Arc de triomphe de Salonique* (Paris, 1890); Vermeule, *Berytus* 13 (1959) 27f., G. 7; Ryberg, *MAAR* 22 (1955) pl. 49; Strong, *Art in Ancient Rome*, pp. 175f., fig. 525; *CAH, Plates* V, 150 b; Reinach, *Rép. rel.*, I, 388f.; H. von Schönebeck, *BZ* 37 (1937) 361ff.; J. B. Ward Perkins, "The Art of the Severan Age in the Light of Tripolitanian Discoveries," *ProcBritAc* 37 (1952) 288; G. Rodenwaldt, "Ein Lykisches Motiv," *JdI* 55 (1940) 53ff.; R. Brilliant, "Gesture and Rank in Roman Art, The Use of Gestures to Denote Status in Roman Sculpture and Coinage," *MemConnAc* 14 (1963) 169ff.; Toynbee, *Art of the Romans*, pp. 76f., 252; G. M. A. Hanfmann, *Classical Sculpture*, p. 339, no. 314.

6. See *Dictionnaire d'archéologie chrétienne* (Paris, 1950), cols. 624–713; Ch. I. Mak-

aronas, *Robinson Studies*, pp. 380–388 (esp. pp. 384ff., with bibliographies); P. Salellas, *Ampurias* 15–16 (1953-54) 369–371; Makaronas, *Praktika* 1950, pp. 303–321. The recent basic work is E. Dyggve, *Recherches sur le palais impérial de Thessalonique* (Copenhagen, 1945), incorporating the results of the excavations on the eve of the Second World War. Several important heads were discovered and rejoined in the reliefs on the Arch of Galerius. See generally, L. Vlad Borrelli, "Salonicco," *Enciclopedia dell'arte antica, Classica e orientale*, VI (Rome, 1965), pp. 1080–1085, fig. 1196 being a tolerable photograph of the sculptured niche with medallion bust of Galerius. This is also Hanfmann, *Classical Sculpture*, p. 339, no. 313.

7. On the effect of Diocletian's reform in the arts, see Vermeule, *Berytus* 12 (1956–57) 85–100; H. A. Cahn, *Festschrift Karl Schefold* (Basel, 1967), pp. 91–96.

8. Reinach, *Rép. rel.*, II, 108, no. 2 and older bibliography.

9. See A. M. Schneider, "Die Römischen und Byzantinischen Denkmäler von Iznik-Nicaea," *Istanbuler Forschungen* 16 (1943); A. M. Schneider and W. Karnapp, "Die Stadtmauer von Iznik (Nicaea)," *Istanbuler Forschungen* 9 (1938), and references; H. von Schönebeck, *Forschungen und Fortschritte* 1937, 159ff.; N. Fıratlı, *Iznik*, Shell Touring Service, p. 2 (plan and discussion); K. Bittel, "Das Alamannia-Relief in Nicaea (Bithyniae)," *Festschrift für Peter Goessler* (Stuttgart, 1954), pp. 11–12, pls. 1–12.

CHAPTER XVI.
Constantinus Magnus Augustus and His Successors

1. Mendel, *Catalogue*, III, 344, no. 1107; N. Fıratlı, *Short Guide*, p. 43, pl. 1, 1; N. Fıratlı, *Istanbul Arkeoloji Müzeleri Yıllığı* 7 (1956) 75–78, figs. 24–27; H. Jucker, "Verkannte Köpfe," *Museum Helveticum* 16 (1959) 283f., pl. 3.

2. Head from Ephesus, in Vienna: Delbrueck, *Spätantike Kaiserporträts*, pp. 110f., pl. 26. Head from Constantine's Forum: N. Fıratlı, *Istanbul Arkeoloji Müzeleri Yıllığı* 11–12 (1964) 208, pl. 34, 1–2, who suggests possibly Tiberius.

3. Dörner, *Istanbuler Forschungen* 14 (1941) 48, no. 7, pl. 12.

4. R. Calza, *MemPontAcc* 8 (1955) 107–136.

5. H. Jucker, *Museum Helveticum*, pp. 275ff., esp. p. 280; the head, originally published by V. Müller in "Zwei Syrische Bildnisse römischer Zeit," 86 *BWPr* (1927), is now on loan in the University Museum, Philadelphia, having then been on loan in Berlin. The silver plates are Delbrueck, *Spätantike Kaiserporträts*, pp. 154f., pls. 58f.; pp. 144ff., esp. pl. 57.

6. J. M. C. Toynbee, *Roman Medallions* (New York, 1944), pl. 49, no. 3 (the giant medallion of Justinian, stolen from Paris in the nineteenth century). See also Volbach, Hirmer, *Early Christian Art*, pl. 244.

7. Greek island marble. H.: 8⅞ in. Vermeule, *Quarterly* 54 (1960) 8–10; Hanfmann, *Roman Art*, 103, 187, fig. 98; C. Vermeule, *Archaeology* 18 (1965) 162.

8. Delbrueck, *Spätantike Kaiserporträts*, pl. 11 shows (*inter alia*) the coin portrait of Constantia. For a marble head of the years 300 to 325, cruder work with precisely the same hair style, see the example in the Hermitage: T. Uschakoff, "Ein römisches Frauenporträt konstantinischer Zeit," *AA* 1928, cols. 60–67.

9. The head is in Boston, Museum of Fine Arts, accession number 62.465. H.: 0.463m. MFA *Calendar of Events*, October 1962, p. 2, fig.; *Illustrated Handbook*, 1964, pp. 98f.; *Annual Report for 1962*, pl. p. 36; C. Vermeule, "Greek, Etruscan, Roman and Byzantine Sculpture in the Museum of Fine Arts, Boston," *CJ* 60 (1965) 302f., fig. 17.

10. *Guide Bleu* (Greece, 1955), pp. 187f.; J. Threpsiades, *ArchEph* 1932, Chronika, pp. 6ff., for Classical and earlier remains.

11. E. Dodwell, *Views in Greece* (London, 1819), plates: "Entrance to Athens," "Athens From the Foot of Mt. Anchesmos."

12. F. Gerke, *Der Sarkophag des Iunius Bassus* (Berlin, 1936), pls. 8, 9. The mosaic of Socrates and six disciples, from Apameia-on-the-Orontes, shows how like these heads Socrates and his companions could be in Late Antiquity: see G. M. A. Hanfmann, "Socrates and Christ," *HSCP* 60 (1951) 205–233.

13. C. Davis-Weyer, "Das Traditio-Legis-Bild und seine Nachfolge," *Münchner Jahrbuch der Bildenden Kunst* 12 (1961) 7–45. The key monuments are the Passion-sarcophagus in the Lateran (circa 370) (fig. 1), a grave-plaque from the Catacomb of Priscilla (fig. 10), and the mosaic of the triumphal arch of San Lorenzo fuori le Mura (fig. 21). St. Paul can develop iconographically from philosopher portraits of the third century A.D.: H. P. L'Orange, "Plotinus-Paul," *Byzantion* 25–27 (1955–57) 473–485.

14. See J. Kollwitz, *Oströmische Plastik der theodosianischen Zeit* (Berlin, 1941), *passim*; W. Oberleitner, "Fragment eines spätantiken Porträtkopfes aus Ephesos," *JOAI* 44 (1959) 83–100.

15. G. M. A. Hanfmann, "Sardis Excavations, 1961," *Archaeology* 15 (1962) 59f., fig.; G. M. A. Hanfmann, *A Short Guide to the Excavations at Sardis* (New York, 1962), fig. 9: head of circa A.D. 400 with very plastic hair and beard. Traces of the deep drill and broken points in the hair above and beside the forehead mark this head as work in the tradition of ateliers at Smyrna or inland Aphrodisias. In *Roman Art*, however, G. M. A. Hanfmann, the excavator, now dates the head from Sardes in the late third century, about A.D. 280 (pp. 100, 183, fig. 90). This period is also given in *Art Treasures of Turkey*, p. 94, under no. 149. Inan-Rosenbaum (pp. 166f.) suggest a date around the middle of the fifth century.

16. Harrison, p. 90. Since the agora suffered so badly from the Herulians and since its monuments were tossed into the "Valerian Wall" in the following decade, it is natural that scant traces of fourth-century portraiture have been found there.

17. No. 1313: S. Casson, *Catalogue of the Acropolis Museum*, II (Cambridge, 1921) 222f. Published in detail by G. Dontas, "Kopf eines Neuplatonikers," *AM* 69–70 (1954–55) 147–152. Compare also the head in the National Museum, Athens, no. 2143, found in Vrachano on Hymettos: A. Hekler, *AA* 49 (1934) cols. 263ff., figs. 11f.

INDEX OF PLACES

Scattered mentions of emperors and empresses are noted through reference to spans of pages or to the chapter itself. Appendixes A and B are indexed only under major headings, but people and places mentioned in Appendix C and not in the text are included in this index.

INDEX OF PLACES

INDEX OF PEOPLE AND MONUMENTS

ADDITIONS

Page 95. The total length of the Ephesus frieze fragments, excluding the new fragment of Slab B, is 30.93 meters.

Page 101. Dr. Rudolf Noll reports a new fragment for the right end of Slab B. See F. Eichler, "Die österreichischen Ausgrabungen in Ephesos im Jahre 1965," AnzWien (1966), p. 16.

Page 396, no. 12 bis. Faustina II on Cos: JHS, Arch. Reports 1966–67, pp. 19f., fig. 30, is a private person.

Page 401, no. 9. Seven more bronze statues are now known, including Lucius Verus, Septimius Severus, and a noble as Sophocles.

Page 402. Bronze statue of young Caracalla as a Dioskouros, about A.D. 198, seemingly from Asia Minor, in Art of the Ancients: Greeks, Etruscans and Romans, February 7 – March 13, 1968, Andre Emmerich Gallery Inc., New York, no. 62.

Page 484. Pisidia: B. Levick, Roman Colonies in Southern Asia Minor, Oxford, 1967.

Page 506, note 20. H. Kähler, Der Fries vom Reiterdenkmal des Aemilius Paullus in Delphi, Berlin, 1965; J. M. C. Toynbee, JRS 57 (1967) 265.

Roman Imperial Art in Greece and Asia Minor was composed on the Linotype in Rudolph Ruzicka's *Fairfield Medium* by the Harvard University Printing Office. The photolithographic illustrations are the work of The Meriden Gravure Company. The volume was bound by the Stanhope Bindery. The designer of this book and its jacket is Burton J Jones.